Painting in Na

COVER ILLUSTRATIONS
Front: Caravaggio, *The Flagellation* (Gallerie Nazionali di Capodimonte, Naples)
Back: Stanzione, *Portrait of a Woman* (The Fine Arts Museums of San Francisco)

This exhibition has been organized by the Soprintendenza per i Beni Artistici e Storici di Napoli, in collaboration with the Royal Academy of Arts, London and the National Gallery of Art, Washington.

This exhibition has been made possible through the support of MARTINI & ROSSI LTD.

We are grateful to Her Majesty's Government for its help in agreeing to indemnify this exhibition under the National Heritage Act 1980.

PAINTING IN NAPLES 1606–1705
FROM CARAVAGGIO TO GIORDANO

Edited by Clovis Whitfield
and Jane Martineau

ROYAL ACADEMY OF ARTS LONDON 1982
Catalogue published in association with
WEIDENFELD AND NICOLSON LONDON

General Information

DATES OF EXHIBITION
2 October–12 December, 1982

PRICES OF ADMISSION
Full price £2.50.
Students, pensioners and children and until 1.45 pm on Sundays £1.60.
Pre-booked parties of students in full-time education including
accompanying Members of Staff £1.25 a head.

BUFFET RESTAURANT WITH LICENSED BAR
Open daily.
Access to the Restaurant is from the Ground Floor, Entrance Hall.

Invalids may use their own wheeled chairs or obtain the use of one
without charge by previous arrangement. Application should be made
to Reception for the necessary authority.

Visitors are required to deposit all miscellaneous items other than handbags
with the attendant at the Cloakroom in the Entrance Hall.
The other attendants are strictly forbidden to take charge of anything.

House Editor Vicky Hayward
Art Director Behram Kapadia
Designed by Trevor Vincent
for George Weidenfeld and Nicolson Limited
91 Clapham High Street, London SW4 7TA

ISBN 0 297 78172 3 (casebound)
 0 297 78189 8 (paperback)

Set in Monophoto Sabon and printed by
BAS Printers Limited, Over Wallop, Hampshire
Colour separations by Newsele Litho Ltd., Italy
Colour printed in Italy by Printers Srl for L.E.G.O., Vicenza

Contents

It is both appropriate and gratifying for Martini & Rossi Ltd., the international company with its roots in Italy, to sponsor this exhibition of painting in Naples during the seventeenth century, from Caravaggio to Giordano.

Martini & Rossi's support for the arts, and for this particular exhibition, projects the company's firm belief that art plays an important role in our lives, fostering sensitivity, understanding and creativity.

Martini & Rossi are justly proud to be associated with the Royal Academy, London, in presenting this exhibition and in assisting in the further appreciation of such a significant phase in Italian art.

DUKE OF MARLBOROUGH
Chairman, Martini & Rossi Ltd.

Committees

Committee of Honour

ITALY

On. Emilio Colombo, Ministro degli Affari Esteri

On. Vincenzo Scotti, Ministro per i Beni Culturali e Ambientali

S. E. Andrea Cagiati, Ambasciatore d'Italia a Londra

Ambasciatore Sergio Romano, Direttore Generale per le Relazioni Culturali

Dott. Guglielmo Triches, Direttore Generale per i Beni Ambientali, Architettonici, Archeologici, Artistici e Storici

S. E. Reverendissima il Signor Cardinale Corrado Ursi, Arcivescovo di Napoli

S. E. Mons. Giovanni Fallani, Presidente della Pontificia Commissione Centrale per l'Arte Sacra

Contessa Immacolata Rossi di Montelera

On. Dott. Emilio De Feo, Presidente della Giunta Regionale della Campania

Senatore Dott. Maurizio Valenzi, Sindaco di Napoli

On. Dott. Salvatore Armato, Assessore al Turismo, Sport e Spettacolo della Regione Campania

Avv. Luigi Torino, Presidente dell'Ente Provinciale per il Turismo di Napoli

Dott. Giuseppe Castaldo, Presidente dell'Azienda Autonoma Soggiorno, Cura e Turismo di Napoli

Dott. Antonio Monti, Presidente della Banca Commerciale Italiana

Avv. Marchese Luigi Buccini Grimaldi, Presidente del Pio Monte della Misericordia di Napoli

Professor Bruno Molajoli, già Direttore del Museo di Capodimonte e già Direttore Generale Antichità e Belle Arti

GREAT BRITAIN

The Rt. Hon. Francis Pym, MP, Secretary of State for Foreign and Commonwealth Affairs

The Rt. Hon. Paul Channon, MP, Minister for the Arts

H.E. Sir Ronald Arculus, KCMG, H.M. Ambassador in Rome

J.E.C. Macrae, Esq., Head of Cultural Relations

Sir William Rees-Mogg, Chairman, The Arts Council of Great Britain

His Eminence the Cardinal Archbishop of Westminster

Sir Michael Levey, MVO, Director of the National Gallery, London

His Grace The Duke of Marlborough, Chairman of Martini & Rossi Ltd

Gilbert F. Wheelcock, Esq., Exec. Vice-Chairman, Martini & Rossi Ltd.

Sir Ashley Bramall, MA, DL, The Right Honourable the Chairman, Greater London Council

Tony Banks, Esq., Chairman of the Arts and Recreation Committee of the Greater London Council

Sir Harold Acton, CBE

Sir Hugh Casson, KCVO, President of the Royal Academy

Frederick Gore, Esq., RA, Chairman, Exhibitions Committee of the Royal Academy

Scientific and Technical Committee

Mr J. Carter Brown, Director, The National Gallery of Art, Washington, D.C.

Professor Raffaello Causa, Soprintendente per i Beni Culturali e Artistici, Naples

Professor Nicola Spinosa, Director, Museo Duca di Martina, Soprintendente Aggiunto per i Beni Culturali e Artistici, Naples

Professor Sir Ellis Waterhouse, CBE

Executive Committee

Mr John Carter Brown

Professor Raffaello Causa

Miss Jane Martineau

Norman Rosenthal, Esq., Exhibitions Secretary, Royal Academy

Professor Nicola Spinosa

Professor Sir Ellis Waterhouse, CBE

Clovis Whitfield, Esq., Secretary General of the Exhibition

Consultative Committee

Professor Giulio Carlo Argan

Antony I. H. Beardmore, Esq.

Professor Evelina Borea

M. Arnauld Brejon de Lavergnée

Professor Ferdinando Bologna

Dr. Allan Braham

Professor Giuliano Briganti

Professor Maurizio Calvesi

Dr. Marco Chiarini

Professor Michele D'Elia

Dr. Giuseppe De Vito

Professor Andrea Emiliani

Professor Oreste Ferrari

Professor Decio Gioseffi

Professor Mina Gregori

Professor Andreina Griseri

Dr. Sheldon Grossman

Professor Francis Haskell

Richard Herner, Esq.

Denis Mahon, Esq.

Dr. Ann Percy

Professor Alfonso E. Pérez Sánchez

Mr Gaillard F. Ravenel

M. Pierre Rosenberg

Professor Luigi Salerno

Dr. Eric Schleier

Professor Michael Stoughton

Professor Carlo Volpe

Professor Alessandro Vaciago

Professor Federico Zeri

The organizers are also particularly indebted to the following:

Barone Francesco Acton di Leporano, Director of the Museo Civico Gaetano
 Filangieri, Naples
Jack Baer, Esq.
Professor Luciano Berti, Soprintendente per i Beni Artistici e Storici, Firenze e Pistoia
Professor Dante Bernini, Soprintendente per i Beni Artistici e Storici, Rome
Hugh Brigstocke, Esq., National Gallery of Scotland
Dr. Rubina Cariello, Director, Museo Correale, Sorrento
Mr. John Church, H.M. Consul General, Naples
Dr. Andrew Ciechanowiecki
Arthur Cohen, Esq.
Ronald Cohen, Esq.
Viscount Coke, DL
Miss Elizabeth Conran, Director, The Bowes Museum, Barnard Castle
Bryan Crossling, Esq., The Bowes Museum, Barnard Castle
Mr. Frederick J. Cummings, Director, The Detroit Institute of Arts
Mrs. Joan Davis, Director, Bob Jones University Art Gallery and Museum, Greenville, S.C.
Padre Giovanni Ferrari, Pinacoteca dei Girolamini, Naples
Professor Hermann Fillitz, Director, Kunsthistorisches Museum, Vienna
Dr. Teodoro Fittipaldi, Director, Museo Nazionale di S. Martino, Naples
Brinsley Ford, Esq.
Professor Mazzino Fossi, Soprintendente per i Beni Artistici e Storici, Modena
Dr. Kenneth Garlick, Ashmolean Museum, Oxford
Dr Pontus Grate, Nationalmuseum, Stockholm
Mme S. Guillaume, Musée des Beaux-Arts, Nancy
I. E. Gräfin Harrach
Mr. Gregory Hedberg, Wadsworth Atheneum, Hartford
Frederick C. Jolly, Esq.
Mr. William Jordan, The Kimbell Art Museum, Fort Worth
Dr. Robert Keyselitz
Dr. Rudiger Klessmann, Director, Herzog Anton Ulrich-Museum, Brunswick
Dr. Sherman Lee, Director, Cleveland Museum of Art
Mr Thomas P. Lee, Fine Arts Museums of San Francisco
Richard Lockett, Esq., Birmingham City Art Gallery
Dr. Ann Tzeutschler Lurie, Cleveland Museum of Art
Dr. Hugh Macandrew, National Gallery of Scotland
Mr. Roger Mandle, Director, The Toledo Museum of Art
Mr. Jean Patrice Marandel, Detroit Institute of Arts
Patrick Matthiesen, Esq.
Dr. Manuela B. Mena Marqués, Sub-Director, Museo del Prado, Madrid
Professor Hamish Miles, Director, Barber Institute, University of Birmingham
Sir Oliver Millar, KCVO, Surveyor of the Queen's Pictures
William Mostyn Owen Esq.
Dr. Edmund Pillsbury, Director, The Kimbell Art Museum, Fort Worth
Homan Potterton, Esq., Director, The National Gallery of Ireland
Dr. Wolfgang Prohaska, Kunsthistorisches Museum, Vienna
Mr. Joseph Rishel, Philadelphia Museum of Art
Hugh Sackville-West, Esq.
Dr. Leonardo Sampoli
Robert St. John Gore, Esq., The National Trust
Timothy Stevens, Esq., Director, Walker Art Gallery, Liverpool
Colin Thompson, Esq., Director, National Gallery of Scotland
Mrs. M.G. Walker, Burghley House, Stamford
Mr. Ian McKibbin White, Director of the Fine Art Museums of San Francisco
Dr. Otto Wittmann, Getty Museum, Malibu

The restoration of paintings for this exhibition was undertaken in Naples by

Luigi Coletta, Ciro Marcone and Claudio Palma,

with the collaboration of

Silvia Cocurullo, Serenella di Paola, Teresa Donadio, Alessandra
Golia, Antonio Isoletta, Giuseppe Marino, Giovanni Marzano,
Marina Schiattarella; and by
Bruno Arciprete, Umberto Piezzo, Bruno and Mauro Tatafiore, Cooperativa Restauri '81.

Foreword

An unusual combination of circumstances – in part tragic, in part fortunate – has led to the mounting of this spectacular exhibition of great paintings. Last year Clovis Whitfield proposed to us a small exhibition on the theme of Neapolitan painting of the seventeenth century, to be chosen from British collections and to take place in our Private Rooms. Later, as a result of Clovis Whitfield's connections with Professor Nicola Spinosa, deputy Director of the Gallerie Nazionali di Capodimonte, it was suggested that *The Seven Acts of Mercy*, the great masterpiece by Caravaggio, painted in Naples in 1607 for the church of the Pio Monte della Misericordia, be added to the exhibition. This church along with many others, including Naples Cathedral, had been damaged in the severe earthquake that hit Naples in November 1980 and the picture had been removed to storage for its own safety.

This proposal seemed to us so generous that we began to explore the possibility of arranging a more ambitious exhibition, drawing on museums and collections throughout the world, of the very finest works painted in Naples during the seventeenth century by native artists and 'foreigners', both Italian and non-Italian, who had been attached to this great cosmopolitan seaport – then one of the largest cities in Europe.

What we hope will become clear in this exhibition is that Naples in the seventeenth century possessed a tradition of painting that in both extent and grandeur was the equal of any in Europe at the time. Caravaggio provided an impetus that was taken up by great artists such as Caracciolo, Stanzione, Cavallino and Giordano; that such a master as the great 'Spanish' artist Ribera should choose to live and work in Naples, and from there supply his Spanish patrons in Madrid, is indication enough of the stimulating environment that the city provided for its artists. This exhibition and its accompanying catalogue will, we hope, act as a clear demonstration of this richness of talent and vitality.

Painting in Naples 1605–1706 is the first of two exhibitions of outstanding seventeenth-century Mediterranean painting that we have arranged for this autumn and winter. In January 1983 we shall be focusing on the other great port of southern Europe, Seville, which was also part of the Hapsburg empire, when we present in conjunction with the Prado Museum (who have also lent most generously to our Neapolitan exhibition) the first-ever exhibition devoted to the popular Spanish artist, Bartolomé Esteban Murillo.

Many people have helped make this exhibition possible. Our thanks are first due to Professor Raffaello Causa, Soprintendente of the Gallerie Nazionali di Capodimonte at Naples, whose enthusiasm and commitment to making possible this perfect realization of one of the great themes of European art has been vital to the success of our enterprise. He was supported, in all aspects of the preparation of the exhibition, by his deputy, Professor Nicola Spinosa. Many other distinguished persons both in Naples and Rome, including Senatore Maurizio Valenzi, Mayor of Naples, Onorevole Vincenzo Scotti, Ministero dei Beni Culturali and Minister Sergio Romano, have given their total support. We are most grateful also to Martini & Rossi Ltd., whose generous financial support of the exhibition has made possible its realization. After London it will be shown at the National Gallery in Washington, and Mr J. Carter Brown, the Director, has been throughout unfailing in his enthusiasm and support. We are indebted to many other lenders to the exhibition outside Naples as well as the numerous authors and contributors to the catalogue. Finally, Clovis Whitfield in London has steered the project on our behalf to its complete realization. To him and to all his colleagues connected with the exhibition we offer our warmest thanks, and trust that its success will lead to an appreciation of yet another aspect of Neapolitan culture and encourage more people to visit and explore this inexhaustibly rich city.

HUGH CASSON
President, Royal Academy of Arts

Introduction

The aim of this exhibition is to provide a broad anthology of seventeenth-century Neapolitan painting from the arrival in 1606 of Caravaggio, whose genius was responsible for the sudden transformation of the local school of painting, to the beginning of the following century when Luca Giordano was the dominating figure in painting, not merely in Naples but in Europe as a whole. It was a century of exceptional richness and extraordinary personalities who moved between naturalism and the baroque and gave a new face to the innumerable churches and monasteries as well as to the many noble *palazzi*. To achieve this broad perspective works of art have been brought from national museums and collections throughout the world.

This exhibition is also the crowning achievement of a variety of studies, archival researches and photographic surveys that have been undertaken in the last decades, both in Naples and elsewhere – itself an indication of the recent history of criticism. Sergio Ortolani, who organized the exhibition of seventeenth-century painting in Southern Europe in 1938 entitled *Mostra di tre secoli di pittura napoletana* was a pioneer in this field. The exhibition did not have the fame that it deserved, perhaps on account of the impending tragedies that were about to overwhelm Europe, but at a half century's distance the achievements of that exhibition remain vital, a genuinely modern introduction to this recent area of investigation. For Ortolani himself had nothing to rely on apart from the old guides and biographers from De Dominici to Giannone, whose reliability had still to be ascertained, and a few introductory studies by Longhi and local art historians (Spinazzola, De Rinaldis and Ceci). Documentary research had been begun by Strazzullo, but in a fashion very different from our own time, when Prota Giurleo and his colleagues are uncovering and interpreting rich archival sources. Strazzullo worked alone, exhausting himself with the transcription of archival papers and rarely able to check his research against identified paintings, which, apart from a handful of signed works, were inadequately catalogued and had often either been relegated to reserve collections, or passed into foreign museums. Even for the paintings which remained in Italy, only a handful had been researched or identified.

The fate of Neapolitan Seicento painting has been similar to that of the city itself and its political, economic and cultural heritage. After the golden age of the seventeenth and eighteenth centuries, when foreigners flocked to the city and collectors came in search of paintings, there followed a static period and, after a prolonged state of crisis, the ancient capital of the Kingdom of the Two Sicilies was reduced to the status of a provincial centre. The crisis was not solely an economic one, but also involved the ruling class and the church. The old aristocracy had abandoned the countryside and become hopelessly enmeshed in the process of establishing a unified Italy while the church was experiencing, day by day, a diminution in its historic importance and spiritual influence. Overwhelmed by the collapse of the old order, there was a general crisis in southern society and, as a result, Naples and the South for a long time remained outside the profound changes felt elsewhere in Italy.

As a result of this, the vast artistic patrimony of the city, and in particular of the Seicento viceroys, was totally neglected and has only recently begun to be studied again after a century and a half of abandonment. The irreversible collapse of Naples' fortunes dates back to the turning point between the Napoleonic era and the Restoration; indeed the degradation, dispersion and destruction of Naples' artistic wealth during the following 150 years is perhaps the most explicit symptom of that general collapse. Ortolani's exhibition of 1938 shines out as a glowing precedent of this exhibition and as a starting point for the studies of the paintings that had been relegated to oblivion for so long. After the war Roberto Longhi was in the vanguard of scholarship: he emphasized the importance of Neapolitan art for Europe as a whole. Together with his pupils and through his journal *Paragone*, he established a base for the study of Seicento art.

It should also be emphasized that the awakening of interest in Seicento Naples was prompted by a series of exhibitions, which almost annually assessed the state of knowledge of the subject. Among these, *Arte nel Salernitano*, held in Salerno in 1955, which subjected the important phase in the development of Neapolitan painting around 1630 and the neo-Caravaggists like Guarino and Compagni to academic scrutiny for the first time, was of exceptional interest. In 1954, a smaller exhibition based on the theme *La*

Madonna nella Pittura nel '600 had displayed to the public a beautiful and varied series of pictures from that century. There were also many Neapolitan works in another exhibition, *Caravaggio e Caravaggeschi*, which was held in Naples in 1963.

But this cultural growth was accompanied by a negative phenomenon: during these years many – too many – works of art, that until then had been kept in Neapolitan or southern Italian collections, found their way on to the market and were bought by museums and collections abroad. This resulted in an irreversible impoverishment of the city, so creating a second diaspora, that echoed the first one that occurred at the turn of the eighteenth century.

In the meantime, other exhibitions continued to revive interest in the Neapolitan Seicento: Nolfo di Carpegna exhibited seventeenth and eighteenth-century paintings from Naples in the Galleria Nazionale, Rome in 1958 and the great exhibition *Arte in Apulia*, arranged in 1964 by Michele D'Elia in Bari, was devoted to the works of those Neapolitans who had worked in the furthermost limits of the Mezzogiorno and was followed by similar shows in Basilicata and Calabria. There were also signs of interest outside Italy: an exhibition at the Ringling Museum, Sarasota, entitled *Baroque Painters of Naples*, arranged in 1961 by Creighton Gilbert, *Neapolitan Masters of the Seventeenth and Eighteenth Centuries*, put on by Robert L. Manning at the Finch College, New York in 1962 and, in the same year, Tony Ellis's exhibition *Neapolitan Baroque and Rococo Painting*, at the Bowes Museum, Barnard Castle. An exhibition of broader scope, entitled *Secolul de aur al picturii Napolitane*, which could perhaps be regarded as an immediate precedent for this present exhibition in London and Washington, was shown at Naples and Bucharest in 1973; the introduction to the catalogue was contributed by the present writer and the entries by Nicola Spinosa. However, it was almost completely ignored, as was the later exhibition put on by the same team at the Pushkin Museum, Moscow, on the occasion of the visit of the President of the Italian Republic.

It is natural that research should also be taking place outside Italy, and much is due to Alfonso Pérez Sánchez for his rediscoveries of Neapolitan works in Spain, displayed in the exhibition at the Casón del Buen Retiro in Madrid in 1970, which was devoted to all Italian art of the Seicento. A small and excellent monograph on the Seicento published in 1978 in Eastern Europe should also be mentioned, as it marks a further spread of the interest in this field. A quite different debt is due to the late Walter Vitzthum, who with infinite patience and dedication first outlined the scope of Neapolitan drawing in the Baroque period and then showed the results of these endeavours in three contrasting and complementary exhibitions: at Capodimonte, Naples in 1966; at the Uffizi, Florence in 1967; and at the Louvre, Paris, also in 1967. In 1969 Robert Manning exhibited a selection of the Neapolitan drawings from the collection of Janos Scholz with the poetic title *In the Shadow of Vesuvius* at Finch College in New York.

There have also been some studies devoted to single artists, and in this context at least three exhibitions deserve particular mention: that of *Luca Giordano in America*, organized in 1964 by Michael Milkovich at the Brook Memorial Art Gallery, Memphis, Tennessee; the exhibition devoted to the history of the Order of St. John arranged in 1969 at La Valletta, Malta by the Soprintendenza at Capodimonte and the 'teaching' exhibition on *Carlo Sellitto* which was held at Capodimonte in 1977 with the collaboration of the University of Naples. Another show of larger scope devoted to Bernardo Cavallino and his circle is in the course of preparation and will be shown at Cleveland and Naples. But that will follow this present broad survey which we hope will be a major step forward in bringing to a wider audience a new understanding of this subject.

RAFFAELLO CAUSA
Director, Museo di Capodimonte
Soprintendente per i Beni Artistici e Storici,
Naples

Editor's note

This exhibition would not have been possible without the unstinting collaboration and goodwill of many well-wishers and the hard work of many, both in Great Britain and abroad. Particular thanks are due to Professor Raffaello Causa and to Professor Nicola Spinosa, of the Soprintendenza per i Beni Artistici e Storici, Naples, who have co-ordinated the Italian contributions to the catalogue, and organized the Italian loans. The Gallerie Nazionali di Capodimonte have been extraordinarily generous in the scale of their loans. Jane Martineau has given a great deal of time to getting the text of the catalogue in order and my father, Professor J. H. Whitfield, undertook the translation of most of the catalogue in back-breaking time.

It has been a privilege to discuss the show with scholars and museum curators; I would like to mention here Prof. Ferdinando Bologna, Prof. Giuliano Briganti, Prof. Oreste Ferrari, Prof. Mina Gregori, Mr. Denis Mahon, Prof. Alfonso Pérez Sánchez, Sir John Pope-Hennessy, M. Pierre Rosenberg, Prof. Luigi Salerno, Dr. Erich Schleier and Sir Ellis Waterhouse.

I would like to thank particularly warmly Richard Herner of Colnaghi & Co. and Dr. Giuseppe De Vito, whose enthusiasm for the exhibition was instrumental in bringing about my involvement in it, and indeed the exhibition itself. Colnaghi's and Matthiesen Fine Art have generously contributed towards the restoration of the picture by Stanzione from Kingston Lacy lent by the National Trust.

The restoration of many of the Italian loans has been undertaken with conspicuous generosity by the Soprintendenza in Naples, and many of them are a revelation even to those who are familiar with the pictures. Rizzoli Editore were also very kind in lending a whole group of colour transparencies from their archive, and we are grateful to Dr. Gianfranco Malafarina for arranging this.

Norman Rosenthal's enthusiasm and support has been of inestimable value throughout the inception and planning of this exhibition. He has been ably assisted by Nicola Figgis of the Royal Academy. Vicky Hayward at Weidenfeld and Nicolson has worked on the catalogue with great dedication.

The exhibition has been arranged by the Soprintendenza per i Beni Artistici e Storici di Napoli, in collaboration with the Royal Academy of Arts and the National Gallery of Art in Washington.

CLOVIS WHITFIELD

Notes to users

Paintings indicated by an asterisk (*) are exhibited at the National Gallery, Washington, only. Paintings indicated by a dagger (†) are exhibited at the Royal Academy only.

Catalogue entries for the paintings are listed under the artists represented in the exhibition; the artists appear in alphabetical order. In those cases where the artists are known by two different names, they have been classified under the one by which they are best known, with the alternative also given. There is a short biographical introduction for each artist and the catalogue entries for the paintings by each artist are listed in approximate chronological order.

All works are painted in oil on canvas unless otherwise stated. Sizes are given to the nearest 0.5 cm; height precedes width. The dimensions of pictures are in certain cases discussed in *palmi*; one *palmi* measures 26.4 cm. Inscriptions on the pictures are transcribed in full.

The provenance of a painting is given where it is known, unless it has remained in its original location.

Bibliographical references within the text are given in abbreviated form; exhibition catalogues are indicated by location and date, books and articles by author and date. Full bibliographical details are given in the general bibliography (p. 281).

Catalogue references within the text refer to pictures in the present exhibition and appear in brackets. Figure references are to illustrations in the introductory essays.

The text of the catalogue is the work of many authors; it has not seemed necessary to impose editorial consistency at every point. In some instances, the contributors treat the same subjects or themes from different points of view which have an interest of their own.

Catalogue entries and the biographies of other painters in Naples are signed with the initials of the following authors:

A.A.	Annachiara Alabiso
G.C.A.	Gina Carla Ascione
I.C.	Ileana Creazzo
B.D.	Brigitte Daprà
G.D.V.	Giuseppe De Vito
F.F.	Flavia Ferrante
O.F.	Oreste Ferrari
C.F.	Ciro Fiorillo
L.G.	Laura Giusti
P.G.	Paola Giusti
M.G.	Mina Gregori
R.L.	Riccardo Lattuada
P.L.d.C.	Pierluigi Leone de Castris
I.M.	Ida Maietta
R.M.	Roberto Middione
M.M.	Mariaserena Mormone
M.N.	Mariarosaria Nappi
D.M.P.	Denise Maria Pagano
F.P.	Flavia Petrelli
L.R.	Lilia Rocco
A.S.	Angela Schiattarella
E.S.	Erich Schleier
N.S.	Nicola Spinosa
M.S.	Michael Stoughton
A.T.	Angela Tecce
M.U.	Maria Utili
C.W.	Clovis Whitfield

Translations by Prof. J. H. Whitfield
Exhibition Assistant: Miss Nicola Figgis

Preface

HAROLD ACTON

Paradoxically, the visual arts flourished in Naples as never before during the seventeenth century under the domination of the Spanish viceroys. Otherwise it was a century memorable for disasters – earthquakes, volcanic eruptions, epidemics, famine and riots, caused by excessive taxation and culminating in Masaniello's revolt on 7 July, 1647, with its bloody aftermath. The meteoric rise and fall of that obscure young fisherman from Amalfi assumed epic proportions in local lore, inspiring much romantic fiction and at least one opera, Auber's *La Muette de Portici*, which is seldom, if ever, heard nowadays.

In spite of the flagrant misgovernment foreign visitors were as impressed by the splendour of Naples' architecture as by the beauty of its situation. The Baroque became accentuated in the vicinity of Vesuvius and, though commerce languished, the viceroys continued to build churches, palaces, bridges, new roads and grandiose public fountains, transforming the face of the ancient capital.

In 1645, two years before Masaniello's rebellion, the prolific diarist John Evelyn wrote: 'The building of the city is for the size the most magnificent of any in Europe, the streets exceeding large, well paved, having many vaults and conveyances under them for the sillage, which renders them very sweet and clean, even in the midst of winter. To it belongeth more than 3,000 (*sic*) churches and monasteries, and these the best built and adorned of any in Italy. They greatly affect the Spanish gravity in their habit; delight in good horses; the streets are full of gallants on horseback, in coaches and sedans . . . The women are generally well featured, but excessively libidinous. The country people so jovial and addicted to music that the very husbandmen almost universally play on the guitar, singing and composing songs in praise of their sweethearts, and will commonly go to the field with their fiddle; they are merry, witty, and genial; all which I much attribute to the excellent quality of the air . . . This I made the *non ultra* of my travels . . .'

Whatever their sins of omission and commission as administrators, most of the viceroys were assiduous patrons of artists, some on a prodigious scale, and the present exhibition, sponsored by the discriminating generosity of Martini and Rossi, is a proof of the stimulus they gave to painting in particular. Once again this life-enhancing firm has drawn the attention of a wider public to an important phase of art which has been caviar to the general public and we are indebted to the Company for encouraging so bold an enterprise.

During the first half of the seventeenth century the most energetic art patron among the viceroys was the Count of Monterrey, brother-in-law of Philip IV's favourite, the Count-Duke Olivares. Forty shiploads of paintings and antique sculpture accompanied him when he sailed back to Spain in 1637. Many of these are now the pride of the Prado.

During the latter half of the century, that paragon of viceroys, the Marchese del Carpio, collected some 1,800 paintings and when he died in 1687 Luca Giordano, no courtly flatterer, said that Naples had lost a loving father and her artists a valiant support.

While the Neapolitans enjoyed the spectacular pageantry of their Spanish overlords, they ridiculed their bombast in the popular comedy of masks. The nobility, as John Evelyn remarked, imitated their gravity, their pointed beards and moustaches and their elaborate courtesy, while resenting their claims to precedence on ceremonious occasions. They shared the hidalgo's addiction to sonorous titles and their poet laureate was Giovanni Battista Marini, whose florid *Adone* (1623), densely incrusted with rococo conceits, had innumerable imitators throughout Italy and even in France.

Another paradox is that none of the founders of the Neapolitan school of painting were of Neapolitan origin. Caravaggio, the most influential, was a Lombard who fled from Rome to Naples after killing a rival ball player in 1606. He only stayed there till the late summer of 1607, but during that short period he painted *The Flagellation* for S. Domenico Maggiore and the *Seven Acts of Mercy* for the Monte della Misericordia, and other paintings which have vanished. The dramatic intensity of these compositions, which seem to have been improvised by flashes of lightning – the sculpturesque torso of Christ between two bestial executioners in sinister shadow; the variety of symbolic figures and properties in the latter, a problem-picture if ever there was one – had an overpowering impact on his Neapolitan contemporaries. Here was a style quite new to them, and its stark realism and vivid contrasts appealed to their passionate instincts.

The atmosphere of Naples must have suited Caravaggio's fiery temperament. He drew his models for saints from everyday life without attempting to sweeten or refine them. This was naturalism as opposed to the current Bolognese classicism and, set against a gilded baroque setting, the result was sensational.

The strength of Caravaggio's influence is most obvious in the work of his follower Ribera, known as lo Spagnoletto, born near Valencia but Neapolitan by adoption. Through Ribera and his patron, the viceroy Monterrey, Italian and Spanish painters developed in the same direction. Velasquez was a friend of Ribera and he, too, seems to have been affected by Caravaggio in Los Borrachos and in Vulcan's Forge. Some 15 years younger than Caravaggio, whom he never met, Ribera soon endeared himself to the viceroy as a compatriot of genius. The sadistic martyrdoms he depicted with such gusto realized Monterrey's notions of what religious painting should be, and Ribera became an arbiter of taste at his court.

With Belisario Corenzio and Battistello Caracciolo – the former a Greek, the latter a true-blue Neapolitan – Ribera formed a tyrannical cabal. We know little that is nice about the personalities of this triumvirate. Bernardo de Dominici, the Neapolitan version of Vasari, was prone to embellish his anecdotes, but they undoubtedly contain a foundation of truth since they have been corroborated by others. According to him, no painter could execute any major commission in Naples without the trio's consent. All the eminent artists who were invited from Rome to decorate the chapel of S. Gennaro in the Cathedral were driven away by their stubborn persecution. This Cappella del Tesoro, as it was called, is Naples' holiest shrine, for it contains the patron saint's skull and a phial of his blood which liquefies twice a year, so that the intrusion of outsiders to decorate it was bitterly resented.

The trials of alien artists brave enough to accept the commission were prolonged over many years. When Guido Reni came in 1621, his assistant was so badly wounded that he hurried back to Rome; the vindictive Corenzio was arrested on suspicion but released for lack of evidence. After the indigenous Santafede failed to satisfy the commissioners Corenzio was offered the job, but even he failed and his frescoes were obliterated. Domenichino was then invited from Rome. This highly sensitive artist accepted the challenge with misgiving, and soon after his arrival he received a letter threatening his life unless he withdrew. He appealed to the viceroy for protection and though this was promised with assurances for his safety, he hardly dared to leave his lodging except to go to work. When the first of his frescoes was uncovered a year later he was so harassed by his local rivals, led by Ribera, that 'he rode day and night almost without rest' to Cardinal Aldobrandini's villa at Frascati in a state of collapse. It took him another year to decide to finish the frescoes in Naples. By then he had lost favour with the viceroy and the painters redoubled their vexations. Poor Domenichino was reduced to such a state of nerves, as Passeri wrote, that his meals become a torment for fear of poison, and his nights for fear of the dagger. And when he died at Naples in 1641 his widow was convinced that he had indeed been poisoned.

Annibale Carracci was also reputed to have died as an indirect result of the cabal's harassment. Others were inveigled on board a galley, which immediately weighed anchor and sailed for a mysterious destination. As we know from Benvenuto Cellini's autobiography, distinguished artists considered themselves above the law and even won respect for their arrogance. Caravaggio's brawls were essential to the image of terribiltà he wished to impose. Ribera behaved despotically to his Neapolitan rivals. When Massimo Stanzione painted a dead Christ for the entrance to the Certosa di S. Martino which won general admiration, Ribera persuaded the monks to let him clean it under the pretext that it was too dark. In doing so he ruined it with a corrosive liquid. Such malice is hard to reconcile with the piety of his devotional paintings. His disciples were legion and they exaggerated his gruesome traits – what one critic called 'the poetry of the repulsive'.

Some of Ribera's most lurid pictures were painted for Gaspar Roomer, a Flemish merchant-shipowner reputed to be the richest man in Naples. A voracious art collector, he had a peculiar preference for the macabre-grotesque. Ribera's horrific Apollo and Marsyas and his repulsive Drunken Silenus (Cat. 123 and 120) were originally in Roomer's collection; so were the two exotics, Ruben's Feast of Herod (Cat. 138) and Van Dyck's Susanna and the Elders (Alte Pinakotek, Munich; fig. 16), which exerted a cathartic influence on the Neapolitan artists who saw them, dazzled by their colour and bold brushwork. Bernardo Cavallino was the most deeply affected and the precocious Luca Giordano began to emulate Rubens.

Neopolitan still-life painters were equally galvanized by the Flemish canvases of flowers and fruit in Roomer's gallery, but their own still lives were altogether fleshier and juicier, evoking the fertility of the Vesuvian soil. Recco, Ruoppola, Porpora – their very names suggest pendulous clusters of grapes and piles of purple figs.

Among the cabinet paintings, genre and topographical scenes, Monsù Desiderio's fantastic towers of Babel and Babylon quaking or licked by tongues of fire were perhaps the most extraordinary. According to recent research Monsù Desiderio was the pseudonym of two artists from Metz, of whom François Nomé was the more prominent. These paved the way, as Wittkower pointed out, for Micco Spadaro's

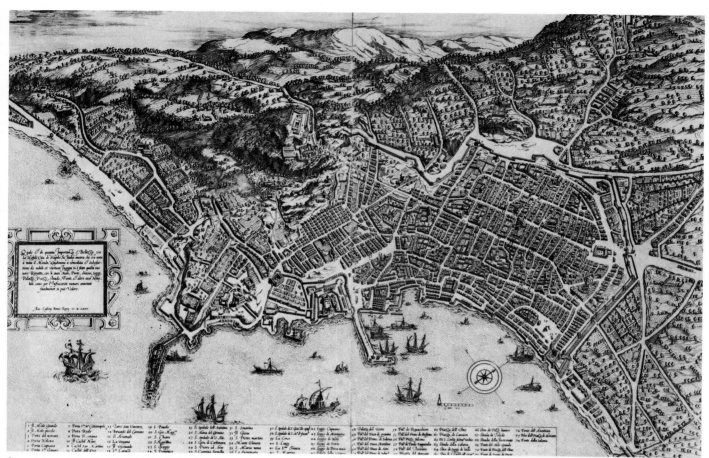

fig. 1 Plan of Naples in 1566 (by A. Lafrery)

'microcosmic views' as well as Salvator Rosa's romantic battle-pieces.

Had he been less versatile, Salvator Rosa would have been a greater painter, for he was also a prolific poet, mime and musician. He learned more from Aniello Falcone, the battle painter, than from his first master Ribera and he had so many imitators that the extreme originality of his landscapes is often overlooked. During his lifetime they were more appreciated than his ambitious historical paintings. Sir Joshua Reynolds wrote of him, 'He has that sort of dignity which belongs to savage and uncultivated nature; but what is most to be admired in him is the perfect correspondence which he observed between the subjects which he chose and the manner of treating them. Everything is of a piece; his rocks, trees, sky, even to his handling, have the same rude and wild character which animates his figures.'

Lady Morgan's enthusiastic *Life and Times of Salvator Rosa* (1824) established his vogue in pre-Victorian England, where he was even more valued than in Italy. He was seen as a Byronic precursor, and his name became a synonym for the ultra-picturesque.

The terrible plague of 1656 (commemorated by Micco Spadaro in this exhibition) exterminated over half the population of Naples. It raged furiously for six months and 10–15,000 people perished every day in the height of the summer. The graves were so glutted that corpses were burned or thrown into the sea. On 8 December, when it was officially reported to have ceased, a survivor remarked that he seemed to be lost in a wood. Out of a population of 450,000 the plague had claimed 250,000 victims, according to Gino Doria's conservative estimate. Among the finest painters who succumbed were Bernardo Cavallino, Massimo Stanzione, Aniello Falcone, and Pacecco de Rosa.

The economic effects of this catastrophe and the timely reforms of more competent viceroys brought a return to comparative prosperity, so that by 1688 the population reached 286,000, including 12,000 clergy. The traumatic horrors of the plague may have helped to change the character of Neapolitan painting in the latter half of the century. There was a reaction from the brutal realism of Ribera and artists borrowed luminous colour schemes from the Venetians. Though traces of Caravaggio lingered in the frescoes of Mattia Preti, known as *il Cavaliere Calabrese* from his place of origin, his style was

more akin to that of Guercino. Luca Giordano and Francesco Solimena became the champions of Neapolitan painting whose performances were universally admired until the nineteenth century. These opened Caravaggio's windows on to a blaze of light.

The most glamorous of Ribera's pupils, Luca Giordano, soon became a byword for the rapidity and eclecticism of his performances. For his brilliant imitations of Titian, Correggio, Guido Reni and Rubens, he was called the Proteus of painting, and at one time his pastiches were more prized than his original productions. Almost every church in Naples and gallery in Europe contains one of his works. For ten industrious years till the end of the century he frescoed vast areas of the Escorial, the palace of Buen Retiro, the sacristy of Toledo Cathedral, the Royal Palace and many churches in Madrid. The Palazzo Medici-Riccardi in Florence contains one of his masterpieces: a vast hall frescoed with the last of the Medici, depicted as gods of light among the deities of Olympus, on the ceiling, and a cycle of human life along the walls. On his return from Spain, when he was over 70, he completed a vigorous series of frescoes in the Certosa di S. Martino within a couple of days.

His long-lived friend and successor Francesco Solimena, alias *l'Abate Ciccio*, leads us well into the eighteenth century. His enormous facility and speed rivalled Giordano's, and he was showered with far more commissions than he could cope with. Born in 1657, he died rich and famous at the age of 90. One of the English travellers who called on him, Edward Wright, wrote that in 1721 'Solimene was esteem'd the compleatest Master in Italy . . . We went to pay a visit to this excellent Master, and found him very civil and obliging, notwithstanding some reports we had heard of him to the contrary. He dresses as an ecclesiastic, which is very frequent there with those that are not in orders. Besides other pieces of his work he showed us a large one he was doing for Prince Eugene, the story of

Cephalus and Aurora, extremely beautiful. As I remember, 'tis that part of the story where Aurora is taking up Cephalus into Heaven, which she is said to have done when all other means she had used to induce him to a breach of his conjugal vow to Procris had proved ineffectual.'

This was a far cry from the Caravaggesque scenes of martyrdom and massacre which had predominated in the first half of the century. There is no crude realism in this ethereal sphere, no leprous limbs or mud and blood-stained feet. The cherubs on fleecy clouds are beckoning to Tiepolo, the mythological nymphs to Boucher.

It is a curious fact that most of the *tenebrosi*, as the realist-naturalists were called, from Caravaggio on died before middle age, as if consumed by the intensity of their involvement with Biblical tragedies, whereas their illusionistic successors were constantly rejuvenated by their protean qualities and lived to a ripe old age. Thus, the Neapolitan school may be divided between the exponents of chiaroscuro and those of light. Luca Giordano and Solimena experimented in many styles before they found their own – the former at his zenith in the Palazzo Medici-Riccardi frescoes, the latter in the Gesù Nuovo fresco of Heliodorus being driven out of the temple.

But frescoes covering spacious walls and lofty ceilings cannot be transported, and these were among the aesthetic triumphs of the painters whose portable works are exhibited here, several from buildings that were damaged during the calamitous earthquake of November 1980. Consequently this exhibition provides a short cut through an intricate maze of contrasting personalities who imposed their kaleidoscopic vision on the seventeenth and even on the eighteenth century. The leading exponents of Neapolitan genius and virtuosity are assembled here, a few steps from the traffic of Piccadilly, like a symphony orchestra under the baton of Martini and Rossi. Let us be grateful for such a crescendo of visual harmony.

Seicento Naples

Clovis Whitfield

This is the first exhibition in England in which Caravaggio's work is featured prominently; it was at Naples that his impact was felt most strongly. Before his arrival there for two brief visits in 1606–07 and 1609–10, one can hardly talk of a Neapolitan school of painting; afterwards it is not a case of tame imitation, but of a creative variety that parallels the romance and violence of Caravaggio's own life. A fugitive from justice in Rome for the tennis-court murder of Ranuccio Tommasoni, he was as hotly pursued by collectors anxious to secure a work from his hand. His art was literally sensational, like the *Death of the Virgin* painted in Rome, where he used as the model for the Virgin Mary a prostitute whose bloated corpse had been dragged from the Tiber. The impetus for this naturalism may indeed owe its origins to the encouragement given to artists by the Counter-Reformation to use more direct vehicles of expression than the convoluted imagery and symbolism still employed by most late sixteenth-century painters. But Caravaggio's effects were consciously theatrical, and his work was admired not only by the religious foundations for which he worked. Many of Caravaggio's Neapolitan paintings, though profoundly religious in subject matter, were painted for, or soon owned by, private collectors and this attitude towards art was as new as was the realism of the imagery. From this period onwards, the Spanish viceroys became enthusiastic collectors of Italian art, and this in itself meant that painting could become the freest form of expression under a repressive regime, a vehicle all the richer for the variety of cultural strands, the contrasts of riches and poverty and the superstition and calamities present in seventeenth-century Naples, at that time the largest and most active cultural and commercial centre in the Mediterranean.

Caravaggio's *The Seven Acts of Mercy* is the most appropriate work with which to begin this exhibition, its title emphasizing the necessity of pious works in Naples in a century punctuated by the plague, the vicissitudes of Spanish rule and earthquakes.

With this painting and the few other pictures Caravaggio painted during his first short stay in Naples (1607), he brought about an artistic revolution equal in magnitude to Impressionism. It introduced naturalism in exchange for the tired epithets of the sixteenth century, and also carried with it a new appreciation of art for its own sake. The fact that Caravaggio was a foreigner was an element in assuring the receptivity of Neapolitan patrons to artistic innovations from outside the city, as opposed to dependence on the native tradition, and this is a characteristic that repeats itself again and again. The cosmopolitan connections of the city were therefore exploited to the full in artistic terms, and the arrival of a painter or even an individual picture, like Rubens's *Feast of Herod*, had extraordinary repercussions. It seems to have thrived despite, and because of, the suffering through natural disasters like the earthquakes, the plague and the capriciousness of Spanish rule. Neapolitan Seicento painting is not characterized, like the Bolognese and Roman schools, by an artistic consistency; much more by the individual and special qualities of each painter.

Naples was at this period the largest city in southern Europe (three times the size of Rome) and the first half of the century saw a further great expansion of its population; from 300,000 to over 450,000 at the time of the plague in 1656. The natural wealth of the land supported the population well, even though only one in six of the population did some kind of work, according to Campanella at the end of the sixteenth century. There were 10,000 slaves in Naples itself. It was also the most active port in the Mediterranean, with close trading links not only with Spain and the East and the other Italian maritime powers like Genoa, Rome and Livorno, but also with Flanders, Holland, England and Germany.

Merchants from all these countries resided in the city and their interests were always considerable in both commerce and local politics; the Genoese residents, down to the smallest shopkeepers, had all their property sequestrated by the Spanish authorities twice during the century. Gaspar Roomer was only the most celebrated of the Flemish merchants who lived in the city; he took an active part not only in supporting the arts, but also as a munificent patron of many charities. The English were largely in charge of the active textile trade; it is probable that much of the canvas on which the pictures in this exhibition are painted, an open-weave type characteristic of Naples for a long period, was in reality of English origin. English merchants are said to have spread the rumour in 1677 that war

was imminent between England and Spain, so successfully promoting the sale of English woollens. Lace, too, was imported from England, some of it bought originally in Brussels, and hosiery was another notable English product. The European fame and popularity of Masaniello is illustrated by the existence of medals, produced in Holland, with the *capo-popolo* on one side, and Oliver Cromwell as Lord Protector of England and Ireland on the other (fig. 2).

The French represented a constant military threat, but this did not prevent French fashion predominating; indeed Spanish prohibitions, for example against the long-bottomed wig (which came into being because of Louis XIII's baldness), often had the reverse effect. The Neapolitan barbers supplied the new demand with characteristic resourcefulness, buying the hair of those who had been executed or condemned to the galleys. But there was always great variety of costume, both in terms of fashion and as a natural consequence of the different nationalities present; Spanish, German and Flemish troops, fishmongers wearing Turkish garb and turbans decorated with jewellery. Even the smaller households aimed to dress their servants in livery, and the wealthier classes dressed extremely lavishly, with much embroidery and jewellery. At the top of the social scale, the Spanish women would be wearing hoopskirts like those we know from Velasquez's Spanish portraits, so cumbersome that it is said that when they were wearing them they even had to be fed by their servants at table; at the other end, the Neapolitan populace was completely informal, although always aware of precedence and rank. In the midst of all this variety it is still surprising not to find a more pronounced national sentiment; even Masaniello upheld the King of Spain, while decrying the taxes his officers introduced to advance the cause of Spanish imperialism.

For the eighteenth century, Naples was the country of Salvator Rosa, the romantic south where the wild and sublime landscape was peopled with *banditti*. And Lady Morgan would have it that at the time of Masaniello's revolt, Rosa himself 'amused himself in the cave of the conspirators by drawing all their fierce pictures by torchlight'. Cardinal Fesch showed her another 'original picture', supposedly also by Rosa, of 'this piscatory demagogue . . . dressed in his fisherman's simple and picturesque habit'. Naples was still at the edge of Europe, the 'ordinary termination of the stranger's pilgrimage to Italy'. There were indeed brigands, and a determined campaign was fought by the Marchese del Carpio towards the end of the seventeenth century to combat them. But Rosa's paintings were themselves a romantic excursion, painted in the main after he left Naples, a genre more imaginary than real. Nonetheless, there was enough of the picturesque and the extraordinary in Naples to excite the imagination, often provoking a proto-Romantic impression, particularly among visitors.

Naples was in reality a city of contrasts; between the richness of the land and the poverty of some of her inhabitants, between the ample space and proportions of many of her buildings and the overcrowded centre. A decree limiting building to within the city walls was in force throughout the seventeenth century and this put great pressure on housing in the centre, especially in view of the scale of the religious institutions and the great number of churches (more than 500 by the end of the century). Even in crowded areas, like the Market (where there were, even then, wooden shanties in the square), space was willingly surrendered for more churches, monasteries and convents. Not all of these were as wealthy and privileged as the Certosa di S. Martino, the most lavishly decorated of them all, but there was nevertheless a conspicuous

fig. 2 Seventeenth-century medal portraying Oliver Cromwell, *left*, and Masaniello, *right*

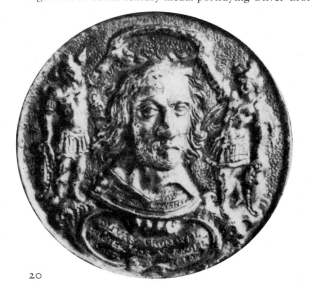

difference between the lip service paid to alleviating poverty and the great wealth accumulated by institutions like the Certosa and the Pio Monte della Misericordia. Fortunately for posterity, more money was spent on art and architecture than on social causes.

An astonishing number of the population were in holy orders (over 8,000 clergy died in the plague); it was easy to become ordained and few had any serious training. The religious institutions themselves housed some of the enemies of society, for there was right of sanctuary; murderers were immune from arrest in a monastery and prostitutes could operate from a haven in a convent. Not only credulity and superstition flourished; Naples produced many genuinely saintly figures, like S. Francesco di Geronimo and Cardinal Giacomo Cantelmo Stuart, whose role was likened to that of S. Carlo Borromeo, trying with individual dedication to compete against huge odds. The ecclesiastical administration varied enormously with the personalities of the archbishops; Cardinal Filomarino, responsible during the Revolt and the Plague, left the ministry in a sorry state, but was followed by Innico Caracciolo, who was an active reformer.

The enthusiasm with which Caravaggio's work was met is symptomatic of a new attitude towards paintings. Many patrons were anxious to secure a work by him, even though these were often profoundly religious in subject matter, and few pictures – *The Seven Acts* being a notable exception – stayed in the place for which they were originally intended. The Duke of Mantua, through Rubens' agency, had acquired the *Death of the Virgin* and Louis Finson took back with him to Antwerp the *Madonna of the Rosary*. The Conde de Benavente, Viceroy of Naples, took the *Crucifixion of St. Andrew* to Madrid, while the *Martyrdom of St. Ursula* was sent to Genoa even before the varnish was dry.

The account of Marcantonio Doria's patronage for this picture (Cat. 19), which has only very recently been published, is one of the most extraordinary and complete documentations of its kind in the whole Seicento. Caravaggio rewarded his Genoese patron with one of his most moving interpretations; instead of portraying the 11,000 virgins who were supposed to have been martyred with St. Ursula, he showed her on her own, disarmingly stunned at the arrow which transfixes her. The urgency with which Marcantonio Doria pursued Caravaggio for this picture is paralleled by that of the Spanish authorities, presumably inspired by the newly-arrived viceroy, Conde de Lemos, who on hearing of Caravaggio's death (18 July, 1610), sought insistently to secure the painting of *St. John the Baptist* that the artist had taken with him in the felucca to Porto Ercole. Denis Mahon has made the suggestion in conversation that this painting was the *Salome* (Cat. 20) now in the National Gallery, the prominence of the severed head of St. John accounting for its being described in this way in what amounted to a seventeenth-century police report. It would seem possible, in terms of style, for this to be Caravaggio's last work, and comparison with the other pictures from his Neapolitan period will be particularly interesting in view of this suggestion.

It was an extraordinary gesture to commission Caravaggio and the other painters who contributed altarpieces to the Pio Monte, and the governors themselves appreciated the significance of the works they secured. They resisted the attempts of the Conde de Villamediana in 1613 to buy *The Seven Acts*, allowing him only to have a copy made on the premises and by an artist of their choice. The original church was so small that the altarpieces seemed almost on top of each other according to contemporary accounts, and it is an indication of their importance in the eyes of the governors themselves that when they came to rebuild the church around the middle of the century, they did so around the original paintings. This concern for artistic excellence is characteristic of other transactions undertaken by the governors of the Pio Monte, and by the administrators of the Cappella del Tesoro in their pursuit of the right painter to decorate this most important Neapolitan shrine. In this case too, they sought a foreigner to do the work and their ultimate choice was Domenichino; the search for artistic excellence was conscious, but there was no local institution with the authority of the Roman Accademia di S. Luca.

This attitude accounts for the extraordinary impact that a whole succession of artists had on the native tradition in Naples in the seventeenth century, some instances of which are vividly illustrated in this exhibition, from Guido Reni and Castiglione to painters like Vouet, Rubens and Van Dyck, who either did not travel to Naples or were there only briefly, their works being sought out by Neapolitan collectors and painters.

Ribera's Spanish nationality certainly found him ready patronage in Naples and yet his art is as Neapolitan as Poussin's and Claude's was Roman. This exhibition assembles probably the finest representation of his paintings ever assembled, and these themselves make it easy to comprehend the immense impact they had in his own day. As with Salvator Rosa, the eighteenth century embroidered the life and work of Ribera with romance, with Byron speaking of his

> . . . *Stories*
> *of martyrs awed, as Spagnoletto tainted*
> *His brush with all the blood of all the sainted.*
> (DON JUAN, XIII, 71).

Earlier accounts of his life have him meeting

Caravaggio in Naples in 1606, and 'giving him instruction very liberally', but this was only an attempt to make sense of the evident affinities, particularly of subject-matter and realism, for Ribera did not in fact settle there until several years after Caravaggio's death. Ribera's painting has the directness and force of Guido Reni's, and his naturalistic imagery, though at first as sensational as that of Caravaggio, is an extraordinarily individual and gentle observation of life, a quality that is almost impossible to convey in reproduction. For example, the imagery that he employed in the great *Pietà* from S. Martino (Cat. 122) is relatively conventional; its force, which was immediately apparent to all when it was finished in 1637, lies in its compelling, tender immediacy.

The 1630s were a marvellously creative decade, when there was a very wide range of artistic talent active in Naples, from Domenichino and Lanfranco to Cavallino and Stanzione, to mention but a few. The richness of the culture can be appreciated not only in the perfection of Cosimo Fanzago's interior of the Certosa di S. Martino, whose marble perfection is completed by the works of an amazing range of artists employed there by the wealthiest Neapolitan religious foundation, but also in the picturesque interior of a church like S. Gregorio Armeno. Here, in the most crowded part of the Greek quarter, off Via Tribunali, Fracanzano's great canvases of this eastern saint, St. Gregory of the Armenians (Cat. 56 and 57), bring with them the exotic quality of the Armenian community. It is a pity that the impression created by these surroundings cannot accompany the works, but they may give many the enthusiasm to see them *in situ*.

The environment of Naples offered an ingredient that was never so vividly portrayed elsewhere, and that was violence. When Stanzione, who was already much taken with Guido Reni's style, saw Poussin's *Massacre of the Innocents*, which represented a further distillation in the classical idiom to Reni's treatment of the subject, he sought an even more intense shock for the spectator in his own interpretation. Poussin's contemporary *Martyrdom of St. Erasmus* was to be his last attempt to convey such violent realism; but the Neapolitans, perhaps because they were more used to the real thing, continued with great enthusiasm along this path. It was the arrival of Rubens' *Feast of Herod* in Gaspar Roomer's collection that reinforced Mattia Preti's choice of this kind of subject; but equally, the sight of dogs devouring Jezebel on the streets of Jezreel in Luca Giordano's powerful image (Cat. 69) recalls accounts of the savaging of bodies washed up on the Riviera di Chiaia during the plague of 1656. The city was indeed a strange mixture of *paura e meraviglia*, fear and wonder, which at a distance easily becomes romantic, like Salvator Rosa's *banditti*.

It goes without saying that there are characteristic Neapolitan themes; 214 churches in Naples in the seventeenth century were dedicated to the cult of the Madonna, and patron saints like S. Gennaro and St. John the Baptist (the latter adopted officially towards the end of the century) were always popular. Foreign communities are reflected in the various national churches, from S. Giacomo degli Spagnuoli to the Genoese church, or S. Gregorio Armeno in the Greek quarter. It is less easy to see the domestic environment of Seicento Naples, although we can gain some idea of the rich hangings and materials from the backgrounds of some pictures. It is interesting to see the genre of landscape painting taken over from the Carracesque tradition and developed both in fresco decoration (for example by Micco Spadaro in S. Martino) and in oil paintings, such as those by Filippo Napoletano and Salvator Rosa, rivalling Brill, Tassi and Claude. But the more portable pictures were most likely taken away by Spanish and other collectors; few pictures by Goffredo Wals, for instance, survive, although we know that Gaspar Roomer possessed over 60, and Brill's known work in Naples is limited to frescoes. A similar fate must have overtaken portraits; those of the Spanish tend to be exceptionally formal and there are very few of known Neapolitan sitters in existence. Another important range of subject matter was of course the still-life, and here the Spanish predilection for the *bodegón* struck a really fertile vein among Neapolitan artists. Painters and patrons alike seemed to have shunned the low-life subject matter of the *Bamboccianti*, whose concern for the realism of Roman day-to-day life was not consistent with the naturalism of the more recent Caravaggesque tradition, nor with the loftier ideals of the classical trend; but there was enthusiasm for other genres, like the battle scene, which was impressively established by Falcone and Salvator Rosa.

The character of Neapolitan Seicento painting is dominated by the eager embrace of outside influences, and this accounts for the wide range of foreign painting included in this exhibition. Caravaggio's meteoric passage through the city left an enduring appreciation of art for its own sake, and subsequent Spanish and local patronage was also characterized by a readiness to look towards other Italian centres for inspiration. The Accademia di S. Luca, unlike its counterpart in Rome, did not provide an institutional background to taste. It is possible to chart the evolution of Neapolitan painting through the impact of other schools; the influence of Guido Reni, for example, who came in 1621, was particularly significant. Neapolitans like Stanzione and Cavallino were particularly struck with his refinement and sheer painterly quality. And it was not just the pictures that were

fig. 3 Portrait of Masaniello (attributed to Onofrio Palumbo; whereabouts unknown)

could be that the taste of an influential patron like Cardinal Ascanio Filomarino, who brought with him an important collection of paintings, largely from artists in Rome, would tend towards the classical idiom; but the shattering effects, first of Masaniello's revolt in 1647 and then of the plague in 1656 in which so many painters died, meant that any artistic tradition was bound to be radically transformed.

The plague, which affected the crowded seaport far more severely than other towns in Europe, created a traumatic caesura in the life of Naples. The recovery was nonetheless vigorous, as marked in painting as it was by social phenomena, like the vast increase in marriages. Nor was it accidental that a number of the painters associated with Naples in the second half of the century were also active elsewhere. Salvator Rosa purveyed in Florence and Rome subjects that were associated with Neapolitan life, from brigandage and battles to scenes of superstition and wild landscapes, just as the northern artists were beginning to see the romance of the southern landscape and transforming the objective naturalism of the *Bamboccianti* into a picturesque idiom. Mattia Preti, whose stay in Naples began after the plague itself, when he was already established as a painter, had been drawn in Rome with other non-Roman artists to the ever vital tradition of Caravaggio, but travelled widely throughout Italy (and, De Dominici believed, to Flanders too). Luca Giordano, who first studied with Ribera, was also deeply influenced by his experiences in Rome and in northern Italy, and his career, like that of Rosa and Preti, was largely spent away from Naples. It is interesting to see the beginnings of the much more baroque idiom that Giordano in particular, followed by Solimena, embraced in the period preceding the plague. Even the classically minded Domenichino was drawn in Naples towards this, as the signed and dated (1637) altarpiece of the *Assumption of the Virgin with St. Nicholas of Bari* shows with its Cortonesque movement. The spectacular compositions of Preti and Giordano illustrate how the rich, varied and often cruel spectacle of life in Naples could be transformed into some of the most powerful images in baroque painting. Even in a genre like still life, Giuseppe Recco could transform a decorative, intimate genre into bold compositions on a grand scale, like the two shown in this exhibition that were bought by the fifth Earl of Exeter directly from the artist himself. All these painters remained bound, and their patrons with them, by an enquiring pursuit of artistic excellence, something that had originally been inspired by Caravaggio's sensational innovations at the beginning of this dramatic century.

painted in, or sent to, Naples that were significant; Neapolitans travelled extensively, and Rome especially was no great distance away. In the 1630s the group of painters from Rome, Genoa and Naples, which included Castiglione, Poussin, Testa, Andrea di Lione, Falcone, Stanzione, Fracanzano, Salvator Rosa and others, was quite exceptionally creative. It is unclear whether Vouet actually travelled to Naples, but certainly his paintings in Rome, like the decorations in S. Lorenzo in Lucina, were well-known. The enthusiasm of patrons for artists from outside Naples was of course the subject of much resentment; it made Domenichino's stay there in the 1630s, executing the most prestigious commission Naples had to offer, which was the decoration of the Cappella del Tesoro in the Cathedral, a most unhappy experience, and after his death in Naples his wife remained convinced that he had been poisoned.

The viceroys, who were constantly on the lookout for paintings to send home to Madrid, chose artists essentially from the Roman world, like Claude and Poussin, Lanfranco and Jan Both, to execute the decorations for Philip IV's Buen Retiro Palace in Madrid. It was natural too, for there to be contact with Flemish art; Naples was receptive to the qualities of Van Dyck (who certainly went to Sicily and may well have stopped off on his return journey) and of Rubens, whose work was famous but known through a few actual examples, including the *Feast of Herod* from Edinburgh (Cat. 138). Certainly it

Society in Naples in the Seicento

GIUSEPPE GALASSO

How many inhabitants were there in Naples at the end of the sixteenth and the beginning of the seventeenth century? Giulio Cesare Capaccio, well-informed on Neapolitan matters and long secretary of the city's administration, said there were 300,000 people, distributed in 44,000 families and 20,000 dwellings. The general impression was that there were many more. But these were enough to make it by far the largest Italian city (Rome, Milan, Venice, Florence and Genoa had between 80,000 and 170,000 inhabitants) and the second largest in Europe after Paris. Moreover, the city must have been far larger halfway through the seventeenth century after three decades of tumultuous and dramatic events which attracted more immigrants from the southern regions.

The extraordinary size of the city was due to constant immigration from the countryside and from the smaller centres of the Kingdom of the Two Sicilies, of which Naples had unexpectedly become the capital in 1266. This role increased its population from some 30,000 to 100,000 inhabitants at the beginning of the sixteenth century. To understand this growth it is necessary to look more closely at the structure and physiognomy which Naples had acquired. Her function as capital had been the cause of the growth by which Naples had first drawn close to the size of the other great Italian cities and then, from the beginning of the seventeenth century, outstripped them. Economic reasons had been less important in this than political, institutional and social ones.

From the mid-fifteenth century the monarchy had gradually concentrated in Naples the administration of the Kingdom, which covered most of southern Italy. In 1503 the Kingdom had passed to the House of Aragon and thus, in 1516, became a part of the Hapsburg patrimony. The Spanish Hapsburgs, from Charles V (1516–56), Philip II (1556–98), Philip III (1598–1621), Philip IV (1621–65) to Charles II (1665–1700), reigned over Naples for two centuries. Their power rested on great military forces, both on land and at sea, that were stationed in Naples. It was powerful enough to deny the feudal lords the possibility of local resistance which they had offered the rulers of the House of Anjou and Aragon in the past, often reducing the royal power to a shadow. Now the barons had to renounce their claim to act as semi-autonomous

rulers on their own estates. They had to accept their role as courtiers, subjects who were privileged and titled, but still subservient. The power that in theory was supposed to be delegated to them by the sovereign, and which they had traditionally used as a platform for their antagonism to the sovereign himself, was far more firmly controlled.

Under the new régime most of the barons were induced to abandon their residences in the provinces and live in the capital. Power games now revolved around the royal government at Naples. The obligations of loyalty imposed by the new balance of power, the etiquette and demands of a culture and society that had changed profoundly since medieval times and the elements of city life that at this date made it more refined and attractive than the provinces, induced the most powerful and wealthy families to migrate *en masse* to Naples. Transformed into modern gentlefolk, they formed a circle round the court of the viceroy, the *alter ego* of the King, giving an unprecedented worldliness to the social life of the capital.

Neapolitan feudalism evolved into a modern monarchy on French lines, rather than the anarchy that resulted from the ruinous predominance of the nobility over the monarchy, as, for instance, in Poland. The French model led to the pre-eminence of royal power, to the modern authoritarian State, where the capital was both a product and an image of power: a great bureaucratic metropolis that supported its nobles, courtiers and law-courts, while the lower orders remained poverty-stricken. The same pattern was repeated in Madrid, Vienna, Rome, Berlin and Paris. In an age of absolutism, Naples was one of the largest such centres in Europe, marked by the exceptional colour and individuality of Neapolitan life.

The vast population was concentrated in a restricted area, within a circumference of eight miles – 12 including the suburbs. The population density cannot therefore have been less than 7,000 to the square kilometre. However, the very spacious religious, civic and military buildings, the vast green spaces still present here and there in the central zones as well as in many outlying areas, the grandiose administrative buildings and embassies and the scale of the great houses of the aristocracy and the bourgeoisie, all combined to reduce considerably the area available for the

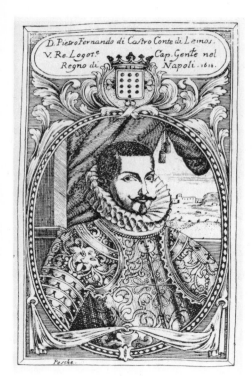

fig. 4 Conde de Lemos, Viceroy of Naples
1610–16

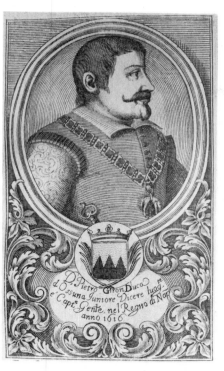

fig. 5 Duque de Osuña, Viceroy of Naples
1616–20

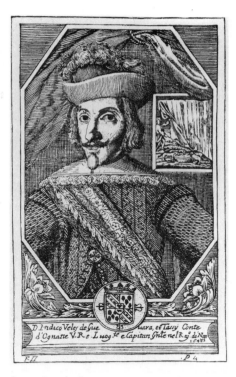

fig. 6 Conde de Onate, Viceroy of Naples
1648–53

mass of the population and so to increase the density of inhabitants in the dwelling quarters.

This soon led to frenetic building, with space being intensively exploited. Most of the houses in Naples had four to six stories while in other cities they rarely exceeded three. The effect was enhanced by the fact that the city plan was still, with very few alterations, that of the Greek settlers who had founded it around the seventh century BC: a checkerboard of long and narrow streets, overshadowed by continuous high buildings removing air and light from the lower stories and the street, but giving welcome cool shade in hot weather and an overall impression of metropolitan grandeur.

The crowding was, and still remains, everyone's first impression of Naples. 'I see in every street, every alley, at every corner so many people who jostle me and tread on me, and I have difficulty in getting away from them', wrote Capaccio. 'I go into churches, of which there are so many, and I find them full of people; yet they are all there outside, not to mention all those who are at work, at home or in the offices and other buildings; one sees the streets, not just one or ten, but all of them full of people on foot, on horseback, in carriages'. With the crowds went noise, another characteristic immediately noted in modern Naples 'a murmuring everywhere as if it were the buzzing of bees'. And with the crowds and the noise, 'Nothing', concluded Capaccio, 'is more difficult than getting about in Naples, wherever I go and at whatever time of day'.

The height of the buildings was possible because of the solid local stone and mortar. But Capaccio, although a great admirer of his city, recognized that this height and bulk was not matched by aesthetic and monumental qualities, and he found Naples inferior in this respect to cities like Rome, Florence or Venice. But this did not mean that there was a lack of great palaces worthy of aesthetic appreciation. Indeed, in the sixteenth and the seventeenth centuries there was a resurgence of palace building. It was then that the historic centre assumed the aspect which it still preserves; for decades it was a great and ceaselessly busy building-site. Building became perhaps the greatest economic activity in Naples, and rent from properties the biggest item in the income of many social groups. Overcrowding led to the occupation of grottoes, courtyards, warehouses, attics and mezzanines as make-shift homes, in precarious conditions and devoid of any comfort. Many slept in the streets, on or by their stalls, under porticoes or in open lobbies, wherever some shelter could be found.

In contrast, there was certainly no lack of work. The churches, government, bureaucracy, middle classes, army and the fleet needed an artisan class to provide them with essential services. The scale of Naples made it a great market and centre of trade. Some commodities were of international trading importance: its silks and cloths were in demand throughout Europe, so much so that the Madrid government was anxious to protect similar Spanish goods.

To give an idea of the extent to which the city was a consumer market, we may cite the figures for annual consumption of foodstuffs given by Capaccio: 4,000 *tomola* (approx. 600,000 lb.) of wheat a day (ie. about $1\frac{1}{2}$ million a year), 30,000 barrels of wine in public wineshops alone, discounting private production, 1,000 bushels of oil, 15,000 *cantaia* (a barrel of approx. 45 litres) of salted meat, 6,000 cheeses and 20,000 fish. He also estimated that 100,000 large and small beasts were slaughtered annually, without counting goats, chickens etc., that more than 30,000 *scudi* a month were spent on greens and vegetables, and that 300 cases of goods and groceries, and 2,000 of white wax along with 20,000 *cantaia* of almonds, arrived in the town every year. In terms of monetary expenditure, four million ducats were spent annually on imported cloth and 200,000 on Italian cloth; 300,000 *scudi* on Venetian cloth and 200,000 on Flemish cloth, as well as 150,000 *scudi* on jewellery and silverware and 40,000 on pins. In addition, Naples was a banking centre: no fewer than eight great banks served the city's needs and handled millions of ducats; their holdings were not less than some ten million ducats and their reserves at least two million ducats per annum.

Great merchants and financiers formed one of the most important classes in Neapolitan society. Their growing presence and influence was based on their close relations with the government and the city administration, and the involvement of the nobility, religious bodies, the rich bourgeoisie and professional men in their affairs. This economic relationship between the nobility and merchant class became an important factor in the social development of Naples: the nobility were urged into business by the capital they had at their disposal and by the large surplus of foodstuffs they produced, which the royal administration needed for its military forces and the civic administration to supply the capital.

Against a background of congested streets and constant building, the political, administrative, judicial, military and financial workings of the city took place. The influx into Naples had been stimulated by the possibilities of work there, although this soon became more of a myth than a reality. Many arrived in the entourage of their lords, or to be employed by the religious institutions or the army. The great court of the viceroy, dozens of smaller courts in noble houses, the innumerable churches and religious centres, the civil and military offices of all kinds, and extensive wholesale and retail trade, a myriad of workshops and the extensive building trade all demanded a work force. The sea also played an important part in the life of the city; apart from military and commercial considerations, there were thousands of fishermen, fish-sellers and boatmen, and the fish market was one of the most important in the city. The merchant fleet of Naples was not large, but its commercial maritime importance was nevertheless great, because the port of Naples was in practice the only great port in the country and the trade of a large part of the kingdom therefore converged upon it. Around it there revolved the very variegated world of the trades and activities that commerce and ships encouraged.

But immigration exceeded the high threshold of work available. Why did so many flock to the city, preferring to eke out a precarious existence in crowded quarters rather than staying in their homeland? This was due in part to the privileged conditions of Naples, which contrasted violently with the squalor and oppression of the provinces. The citizens of Naples were exempt from paying any other than municipal taxes, but the inhabitants of the provinces had to pay the royal taxes, which in the sixteenth century had reached intolerable levels. With the growth of the city, and after some worrying experiences in 1508 and 1547, the government's prime concern was that Naples should remain calm and that revolt should be avoided at all costs. To this end the government ensured provisions for the city even in times of scarcity and high prices. The city administration saw to the supply of corn in massive quantities, stowing it in the great warehouses known as the grain-pits and keeping it in reserve for times of crisis. Corn and bread were almost always available and, in spite of the drag on the city's finances, they were sold at controlled prices.

But in the provinces, which produced and supplied Naples with corn, neither the prices nor the availability of corn were ever assured. And apart from royal taxation, the provincials were subject to the heavy social pressure exerted by the local ruling classes, especially the feudal lords. At times of famine the immigration into the capital was intensified, but it was constant at all periods: a precarious life in Naples could not be worse than the permanent prospect of poverty and oppression in the country, where petty banditry was endemic, underlining the social unrest.

For these reasons the population of Naples tripled in the course of a century. The gradual increase of fiscal pressure, due to the needs of the House of Austria during the Thirty Years' War and the economic difficulties provoked by the recession which occurred throughout Europe, led to an increase of the urban population which, by the mid-seventeenth century, had reached a figure far beyond the estimate of 300,000 made by Capaccio 30 or 40 years earlier. The estimates which put the population at the onset of the plague in 1656 at just under 400,000 (360–370,000) may be close to the truth.

So it was not economic, but social factors that made this vast expansion of Naples unstable. At the end of the seventeenth century there was no

fig. 7 *Tribuna della Vicaria* (by Asciano Luciani). The picture depicts tortures ordered by the *Tribuna*, the main judicial tribunal in Naples.

bourgeoisie to produce the entrepreneurs of the economic boom who could consolidate it in the interests of the city. Most commerce remained in the hands of the great international merchants, who had controlled it in the south for centuries. They were also in charge of the financial operations connected with commerce, the public administration and the state finances. Although Naples was the base on which the kingdom was founded, it was not an autonomous, self-controlled economic and financial organism.

There was also a lack of effective planning control. In the 1560s the government had forbidden building in the city and its suburbs beyond certain limits, but in 1615 it was obvious that the ban had been largely ignored. The suburbs had become, according to seventeenth-century writers, like those of so many big cities. The lure of building speculation had become so great that some time before 1634 several Genoese merchants offered to provide for a new circuit of walls to increase the perimeter, if the public areas taken in and the space from the old walls that were knocked down were granted to them. The government rejected the proposal, considering

that the enlargement would only encourage further immigration.

The arts still flourished in Naples. In 1224, before the city became the capital of the Kingdom of the Two Sicilies, Frederick II had established a university there, which was to remain the only one in southern Italy for many centuries. From the time of the Renaissance, Naples had assumed a position of great prominence in European culture. Academies and societies maintained a constant debate. There were numerous plays in the theatres and strong civil and religious patronage maintained or attracted reputable artists; in the first half of the seventeenth century the poets and writers of Naples were among the most famous in Italy.

There were many links between 'high' culture and popular culture, although it is difficult to reconstruct the pattern of this process and its translation into elements of thought and behaviour. On the other hand, the entire social body of Naples had increasingly felt the influence of Spanish, or to be more precise, Castilian mores throughout the sixteenth century and this was no doubt a factor which united the classes. Spanish formalism, respectful etiquette in greetings and address, care for appearance and a certain gravity of manner in approach were elements that were absorbed into Neapolitan manners, even at a plebeian level. These endured even when circumstances changed.

Other changes resulted from the immigration into the city. Some chroniclers said that from this time the physical appearance of Neapolitans changed: they were shorter in height, had more swarthy skins and less gentle features. But physique was also affected by the foodstuffs available in the city. In the sixteenth century, pasta replaced vegetables as the staple food and the Neapolitans passed from being 'leaf-eaters' to being 'macaroni-eaters'. The difficulty of feeding such a swollen population, the pressure of people and buildings on land intended for growing vegetables, the fixed price and ensured continual supply of grain all contributed to the change in feeding habits. But, more important than this, we must also take into account the general poverty, the precarious nature of existence, the unhealthy dwellings, or maybe literally *ab Divo*, the abysmal conditions in hygiene and sanitation, as possible causes of what appears to be a physical deterioration of the Neapolitan population that certainly left its mark for many centuries.

Massive immigration introduced other traditions to the city. The great majority of the newcomers were of rural extraction. A coarse and extravagant sense of humour was applied to serious subjects; complex symbolism, a tendency to melancholy and a love of ceremonial became part of the Neapolitan sensibility.

The few indications that have survived show that some earlier characteristics remained, such

as a love of festivity, noisiness, gracefulness, a caressing manner of designating and naming both people and objects, an easy, tender sentimentality and a particular sensitivity to the subject and symbolism of blood. The elements of the old and new did not always merge and contradictions and tensions remained unresolved in what has been described as *napoletanità*.

Contemporaries noticed the loss of their old identity. In the seventeenth century there was frequent nostalgia for the 'gentle' Naples of the century before. The social and cultural repercussions of the enlarged population are commented on even in a text like the *Candelaio* of Giordano Bruno. However, there soon followed a sense of identification with the new Naples. The *Forastiero* of Capaccio is the most mature document of this phase. The saying 'See Naples and die' of two centuries later, is in substance anticipated here: 'There is nobody who does not desire to see it, and who does not desire to die here'. Naples, concludes Capaccio, 'is the whole world'.

In the new Neapolitan identity religion acted as an essential coagulating agency, as the enactments of the Council of Trent gradually came into force. Tridentine Catholicism, with its spectacular ceremonial and a predilection for devotion, was particularly strong in Naples. To Berkeley the tendency to *bella devotione* was an essential part of Neapolitan religiosity. Religious experience in Naples was complex and, combined with Tridentine elements, it created a delicacy and depth of religious feeling. Religion was not only a determining element in the formation of the new identity of Naples, but acted also as a link for integration and cultural communication between the various levels of a complex and varied society; and the influence of the clergy, of male and female monasticism, of the authorities and of the religious princes was from that time more than ever before, a stable element in the city.

Capaccio may still be our guide when we consider the varied character of Neapolitan society in the sixteenth and seventeenth centuries. He analyzes not only social classes, but also various strata and groups, beginning with the foreigners. In fact he insists on the importance of the presence of foreigners. He had a well-developed sense of the metropolis; it is not fate or the stars that determine the greatness of cities, but commerce and the concourse of people, as is seen – he notes – in Antwerp, Amsterdam, Lisbon, Seville and Paris. Naples is included in this list, since by 'the number of inhabitants it became so great in Europe' and 'has received and every day receives more nobility and splendour'.

Amongst the foreigners, after mentioning the Pisans, Capaccio names the Jews. They had been driven from the Kingdom by the Viceroy Pedro de Toledo in 1500 because of their 'most cruel usury', but 36 families had remained, becoming Christians to avoid expulsion. But they showed, in Capaccio's opinion, a lamentable attachment to their old traditions, as well as having 'on their faces the Jewish stamp'. The Catalans, who gave their name to one of the streets in the port area, and the French were less important, although the latter had a chapel in S. Chiara, where 'some days they dispensed bread and performed ceremonies'. The French, like the English and the Ragusans, had a consulate in Naples. The Germans also had a church, and they had gained prestige when the Viceroy Duque d'Osuña (1616–20) had substituted them for Spaniards in the viceregal guard. The Flemings had begun to assume importance at the time of Charles V, who was also responsible for the settlement of the Greek refugees from Mordone and Corone after the Turkish conquest. The Spaniards were treated with great regard, as was natural for the nation of the reigning sovereign.

But it was the Italians who featured most prominently: 'Florentines and Lombards, some Venetians and, above all, Genoese. The Lombard Church was highly praised by Capaccio; it had works 'by very excellent painters, and by Caravaggio one sees the rarest pictures, how sad that the poor man has died unfortunately'. In the church of the Florentines he noted the works of Marco di Siena, a pupil of Michelangelo, 'who, if he had not been so prodigal with his paintings . . . would be priceless'. The Venetians, though it could not be said that they formed a colony, had a residence. But the splendours of all other Italian communities in Naples were dimmed by the Genoese, who, said Capaccio, there as elsewhere were plotted against or hated because of their immense fortunes, but lent funds to the royal finances without which he wondered 'how we should have passed the dangers of many storms'. He commented also that they had property and fiefs in the Kingdom, that they had recently built a new church and that some of them had even entered the Neapolitan nobility.

Capaccio goes on to categorize Neapolitan society into Nobility and the Third Estate which was further divided into a bourgeoisie (the People) and the plebeian classes. The Nobility was either of the *Piazza* or outside it. The *Piazze* (Seats) were the divisions of the city aristocracy: divisions that were not territorial, but purely associative. There were five of them (Capuana, Nido, Porto, Portanova and Montagna) and comprised in all about 130 families. The noble families outside the *Piazza* might be more or less illustrious: some belonged to the oldest aristocracy of the Kingdom and looked down on the city patricians; some were of feudal rank, others not; some were noble because they were recognized as such in the Kingdom or in other cities; some from old illustrious families, others only recently ennobled; some rich, some poor. The difference

between the *Piazza* nobility and those outside it was fundamental: the first took part in the government of the city; the second were excluded from it.

In the bourgeoisie, which Capaccio called the People, he distinguished three categories. The first was of 'Gentlemen who through antiquity, possession of fiefs, noble style of living' were in fact considered to be nobility although they did not have its patents, and who refused to fulfil popular offices in order not to prejudice their ascription to the nobility. The second was of 'persons esteemed by the Tribunals', and they filled, among other things, the offices of public administration, so that in the name of the king they gave orders to the nobility. The third was of those 'engaged in trade and commerce', who were in consequence rich, with a comfortable standard of living.

The rest of the Third Estate constituted the plebeian classes, but here the distinctions were even greater, with 'three grades, where some live reasonably by their crafts, some are declining in their standards and some with the humblest occupations are reduced so low that they cannot rise to any sort of real citizenship'. In effect, the plebeians comprised all the artisans and craftsmen, apart from the printers, goldsmiths, painters, architects and silk merchants, who belonged to the People, or bourgeoisie. Capaccio's opinion of the Plebeians was low.

They were said to be a potential element for disorder, inclined to revolt, characterized by the 'unhappiness of craftsmen, shopkeepers, boatmen, muleteers and such like, mere numbers without substance, acting for self-interest, not by reason'. Certainly, between the condition of well-off shop-keepers or craftsmen and those at the bottom of the scale there was a series of intermediate conditions, but the common factor was that of a social class disinterested in the maintenance of order because they lacked all material possessions and so were prone to riots and disorders which might lead to anarchy. In particular, the lowest levels of the plebeians included the great mass of those who, whether old or recent inhabitants, were outside the structure of society, and who constituted a subproleteriat, ragged, hungry, petulant and vulgar, who lived and earned in the most precarious way. These were the *lazzaroni*, as they were called in the first half of the seventeenth century, and it was from the spectacle they presented that Naples came to be defined as a 'paradise inhabited by devils'.

The social categories outlined by Capaccio have two great merits: they are accurate and they also express the contemporary attitude to status and social prestige. In the course of the sixteenth century, the nobles of the *Piazza* and the People (in Capaccio's sense) had established a strict control over the administration of the

fig. 8 *The Killing of Don Giuseppe Carafa* (by Micco Spadaro). Carafa was killed in 1647. on Masaniello's orders, for leading a counter-revolt against the people's rebellion.

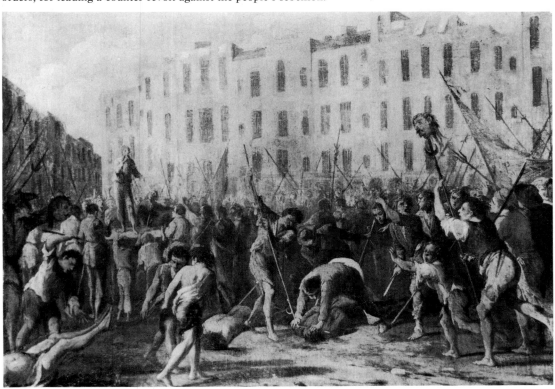

city. The government of Naples was then exercised by a council composed of one representative for each of the five noble *Piazze* (the Montagna had two but with a single vote) and one representative of the People; it also included a *Piazza* which comprised the whole urban territory. The noble *Piazze* elected their representatives each year. The representative of the People, however, was nominated by the viceroy from a list of six names, chosen by elections by the procurators of the *Ottine*. The *Ottine* were 29 in number, corresponding to the districts into which the city was divided. The viceregal nomination was valid for six months, but could be confirmed indefinitely or revoked at any moment. So the position of the People in the city council was on the one hand extremely precarious, because it depended entirely on the whim of the viceroy, and on the other hand very strong, because it was known that the opinion expressed by the People's representative was almost invariably that of the royal government.

Corn merchants and the Silk Guild dominated the popular *Piazza*; their antagonism to the nobles was chronic. The nobility for their part struggled against royal pressure and endeavoured to exercise some sort of safeguard of tradition and of Neapolitan interests. Both groups, however, were united in off-loading onto the lower classes the burdens that fell on the city, and in exploiting for their own advantage the enormous potential of the Neapolitan municipality through involvement in the supply of food for the city, for public works and for fiestas, and the other initiatives of the administration. To give an idea of the extent of the business potential, it is sufficient to say that the public debt of Naples was in 1615 about 13 million ducats, which was a little less than half the entire public debt of the Kingdom (30 million ducats) some 15 years later.

This explains the sharpness of the struggle in the *Piazze* to be included among the *Eletti*, as the members of the city council were called, and why Naples was agitated by risings among the classes who were excluded from real influence and from the advantages to be obtained in municipal government. This happened in 1585 and again in 1620–22: the first time because of a scarcity of bread and an increase in its price, the second because of grave economic difficulties caused by the monetary policy of the government. Contemporaries perceived that the situation was too often near the limits of dramatic breakdown. In general they hoped that a close union between the nobility and the upper classes (Capaccio), or an oligarchical-bourgeois block (Tutini), would reinforce the political and administrative organization of the city, and stabilize class relations.

Reality rarely follows theory. Spanish participation in the great European wars from 1618 onwards and the European crisis caused the monarchy to bring great fiscal, administrative, political and financial pressure to bear on Naples and the whole Kingdom. In these troubled times the possibilities for financial speculation were great and led to an unprecedented intensification of the collusion between the privileged classes, public administration, financiers and merchants. The accelerating pressure of taxation, high inflation and the influence of a long-term recession pushed social tensions to their limits and forced many beyond the edges of society. It was the imposition of a new tax on fruit which unleashed the revolt of Masaniello on 7 July 1647. He died only ten days later, but the revolt lasted until 5 April 1648. The plebeian classes, with some support from the People, struggled against the nobility and the rest of the bourgeoisie.

The outcome was the triumph of the government and royal power over all other interests, and the formation round the viceroy Conde de Oñate of a block comprising the most moderate sections of the People and the nobility. But the absolutist grip, the violent deflation, the decline of the Mediterranean economy in comparison with the Atlantic and the position of Spain in Europe had a negative influence on the condition of Naples. Although politically the city remained important as the seat of government and of the viceroy, and its parliaments continued to give formal consent to the financial measures of the government up to 1642, the year of their last convocation, there is no doubt that after the middle of the seventeenth century, Naples no longer appeared in that pre-eminent European position which it had held before.

Moreover, in 1656 it was struck by a plague of unprecedented violence; one can reckon that 60 per cent of the population were killed by it. Although, once again, a high rate of immigration and a rapid growth in the birthrate immediately afterwards quickly repopulated Naples, at the end of the seventeenth century it still had roughly 25 per cent less inhabitants than in 1656 while other European cities, including London and Vienna, rapidly outstripped it. The economic and social recovery was slow and, in any case, it never exceeded the limits of modernization already achieved in the first half of the seventeenth century; instead it aggravated these, and handed on to the future structural problems such as would be found in few other great Italian or European cities.

By way of recompense, intellectual activity and the political and civil conscience underwent a renaissance during this period of recession in the second half of the seventeenth century. It was to constitute the basis for a great attempt at alliance between monarchy and intellectuals in the eighteenth century. But above all, it allowed Naples to reach a new level of cultural achievement and prestige that would mark perhaps the finest moment of its modern history.

The Counter-Reformation and Painting in Naples

ROMEO DE MAIO

Naples as Capital of the Counter-Reformation

Even taking into account the dogma and tradition of Rome, the bigotry and missionary fervour of Munich, the mysticism and repression of Madrid and the variety of Parisian culture, Naples can be regarded as the real capital of the Counter-Reformation: it is the mirror of its successes, its ambiguities and of its failures.

The Counter-Reformation directives on painting arrived later than its juridical and pedagogical teaching. Indeed, orthodox Counter-Reformation works of art were only produced after the uniformity of thought and conduct essential to the movement had already foundered, and it was only after the deaths of Venceslao Cobergher (1634) and Belisario Corenzio (after 1640) that reformist themes were fully expressed in painting. The Neapolitan churches that illustrate the development of Counter-Reformation imagery, in painting from Pino to Giordano, and in sculpture from Giovanni da Nola to Cosimo Fanzago, are the Annunziata, the Franciscan churches of S. Maria Nova, S. Lorenzo Maggiore and S. Francesco delle Monache, and the two Dominican churches of the Sapienza and S. Caterina a Formiello.

After the death of Santafede (1628), there was no correlation between sacred art and the piety of the patrons and painters; amoral patrons, as the monks were on the whole, even asked artists with criminal backgrounds, like Corenzio and Falcone, to paint frescoes of mystic subjects. Two other points should be mentioned. Firstly, the exploitation of art for gain and to rival other orders was already rife in the first decade of the Seicento and increased as the religious orders degenerated. Secondly, the iconographical content of church painting has little to do with Naples specifically. Much of it was prompted by the mania for relics, devotional literature or religious practices imported from elsewhere. Naples was open ground for any religious novelty and, although the fervour was short lived, the failure of one religious ecclesiastical fashion opened the way for others.

The first promoters of the Counter-Reformation to arrive in Naples were Spanish Jesuits and Theatines. Later came S. Camillo de Lellis and the disciples of S. Filippo Neri. Caravaggio, Annibale Carracci, Reni, Ribera, Lanfranco and Domenichino were all in Naples at almost the same time as S. Giovanni Leonardi, S. Giuseppe Calasanzio (Salvator Rosa was his novice for a very short time) and S. Lorenzo da Brindisi. Bartolomeo Agricola and Giovanni Kostist (called Jeremy of Valacchia by the Capuchins), introduced the experience of the German and Slav Franciscans to Naples, Raimondo Kunrath imported Bavarian Dominican thought and Jerónimo Gracián de la Madre de Dios brought with him the ideas of St. Theresa of Avila, whose confessor he had been. The Visitandines of St. Francis of Sales and the Lazzarists of his friend St. Vincent de Paul introduced the ideas of the French school, which had already served as the inspiration of the Neapolitan doctrinaires, and Miguel de Molinos' followers brought his *Guia Espiritual* which became extremely popular in Naples after it was translated into Italian by the Alcantarine Fra Giovanni di S. Maria. The *Guia Espiritual* also provided the Inquisition with an occasion for intervening in Naples in style: its latest targets or 'successes', as they were called, had been Campanella and the Galileians. The Inquisition had also concerned itself with the case of Miss Mary Ward, who had come to Naples with an idea that could have solved the tragedy of the 5,000 cloistered nuns in the city, social outcasts for the most part who were both alienated and idle. Mary suggested they should be freed from the cloister and dedicate themselves to the needs of the community. She and her companions must have disappeared quickly after their first timid attempts at reform.

Naples presented three very positive features to the world: the miracles of S. Gennaro, populous monasteries and a prodigal culture. Closing their eyes to material conditions and to the abject spirit of her inhabitants, preachers and theologians alike called Naples faithful and immune, or immune and happy. Painting gave the lie to this idyllic picture. God the Father was represented as implacable, despite the intercession of saints; the population was decimated by plagues and beggars languished, despite the ostentatious alms-giving of St. Augustine and S. Carlo as portrayed by Giordano and by Preti. But preachers and visitors were fired by the spectacle of sacred buildings.

The clergy preached that charity was the

greatest virtue; it was, in fact, essential since 10,000 ecclesiastics had to be fed. Yet many of the Neapolitans were homeless. At night they took refuge among the benches in the market, and were called benchers, as well as *lazzaroni*; criminals, however, found refuge in sacred precincts, by virtue of their right of asylum. There was no space available for citizens' houses. But government and lawyers had no means of stopping illicit building, which continued even during the gravest economic and food crises, because Naples was a papal city and feudal rights were asserted by the Roman Curia both in the diplomatic sphere and in fiscal policy.

Naples was more a museum of the institutions of the Counter-Reformation than a centre of religious experience. It was the emporium of devotion, of exhortatory literature and hagiography, but no socially innovative or provident institutions emerged during this period, whereas earlier centuries had created the Annunziata, the Incurabili and the Bianchi della Giustizia. Over 30 Neapolitans were canonized, but even the saints had only founded more clerical institutions. Naples was, however, the capital of the rhetorical Counter-Reformation. Two things stand out in the sources and ecclesiastical literature: the celebration of the triumphs of faith and the assertion of being ready to defend it. But against whom? Associations of knights of the faith sprang up, who took oaths that they would shed their blood in its defence, but the only serious aspiration that remained (cf. the archive *Indipetae* in the Roman Archives of the Jesuits) was the desire of some young monks to work as missionaries and even to die amongst the infidel as martyrs to their religion. Were they inspired by pictures they saw in churches or by heroic biographies and reports from overseas?

The psychology of the individual was crushed by the preaching of the sublime and by the terror of the supernatural; the order of society was undermined by the assumption of privileges and the consequent inequalities. According to the jurists, learned and devout men, this system was diametrically opposed to the principles of the function of the priesthood. The correlation between pontifical rights and widespread clerical corruption has been commented on; the most degrading aspect, as Campanella reported, was the monastic and clerical idleness which went unpunished.

In spite of bouts of periodic repression by the Inquisition, the passage from anticlericalism to intellectual laicism was quick. Superstition and belief in magical rites also flourished. A positive aspect of the failure of the Counter-Reformation in Naples was that it did not destroy the essential qualities of the Neapolitan people, but only added devotional hysteria and sceptical quietism to their characteristics.

Paintings and Patronage

The Counter-Reformation, with its emphasis on elaborate ritual and its affirmation of the importance of chastity and the care of souls, needed many church buildings. This had two consequences: great sums were spent on building and decorating the churches and monasteries and, tragically, civic building was completely neglected.

The rivalry between the monastic orders, especially between the Theatines and Jesuits, over the magnificence of their edifices was only partially expressed in the work of their architects, Francesco Grimaldi and Francesco Guarino, who built the Oratory of Divine Love for the Theatines, and Giuseppe Valeriano and Tommaso Carrarese, the architects of the Gesù. The rivalry between these two pillars of the Counter-Reformation was so bitter that it gave rise to a hagiographical literature and was mocked by lay chroniclers. Ribera painted a symbolic peace of *S. Ignazio Meeting S. Gaetano*, but it needed a real peace treaty with full juridical backing to bring it into effect in the late Seicento. The Neapolitans expressed their scepticism through satire, and in fact the treaty did not last.

Apart from the Oratorians, whose houses were ample and richly decorated, the new clerics could not compete with the Theatines and Jesuits, yet all the minor orders built, inevitably to the detriment of any new plans for the city. The new orders of nuns were so greedy for sacred sites that on occasion they illegally occupied the precincts of other convents and refused to withdraw, even after police intervention. Capaccio remarked that the furnishings of just two convents could have provided for a whole city; there were in fact 40 such opulent dwellings by the end of the century, as well as 33 conservatories. The nuns were mainly victims of primogeniture and usually lacked any vocation. By 1692 there were 504 religious buildings in the city, according to Celano, and the works of art they contained amounted to a treasure trove (much of which has since been lost).

The wealthiest patrons were convents and monasteries, sustained by high revenues and exempt from taxation. Wills also provided an income for the church, especially the so-called 'wills of the soul', wrested from the faithful in moments of conscience and illness, or during death-throes. The Franciscans, an order consecrated to poverty, boasted of the precious stones set in their church tabernacles. There is a close connection between the wealth of the church and the hunger and cold of about half the population. The merchant Gaspar Roomer also built churches and convents and he was detested by the poor as much as the Jesuits, the Theatines and the Carthusians.

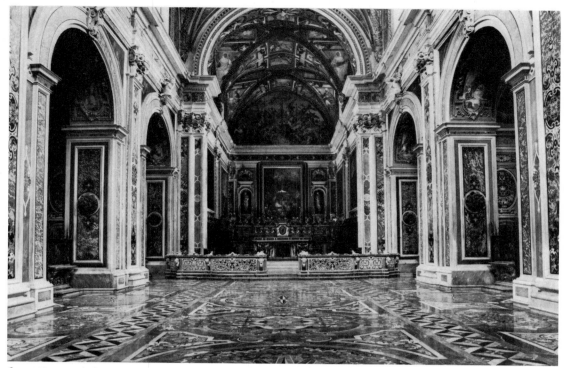

fig. 9 Certosa di S. Martino, Naples; interior of the church

The patronage of the secular clergy is in a sphere of its own. The parishes were very poor and the confraternities were wretched, but the Duomo was grandiose and the Chapel of S. Gennaro was immensely rich. Of the eight Seicento archibishops, only Ascanio Filomarino was a great patron: he shared the taste of the Barberini, whose client and friend he had been, and was a friend of artists like Reni, Cortona and Poussin. His collection included exceptional examples of the art produced during his long reign (1641–67). His predecessor Buoncompagni was rumoured to be a miser and had a wretched collection; Domenichino's commission for the frescoes in the Treasury was the idea of the Oratorian Muzio Capece and not of Archbishop Buoncompagni.

Most of the art of the period did follow the dictates of the Counter-Reformation; only Caravaggio's work is disquieting and stands apart. The intricate history of the *Madonna of the Rosary* (fig. 10) and the fact that neither it nor *The Seven Acts of Mercy* (Cat. 16) were imitated suggests that they were obscure, even at the time.

Patrons imposed rigid programmes on their artists who seemed perfectly willing to execute their wishes. Apart from some great architects, the orders produced only a handful of painters. The Theatine painters Francesco Maria Caselli and Giambattista Brancaccio, the Carthusian Bonaventura Presti and the Franciscan Diego Carreri were of minimal importance. A Franciscan nun, Suor Luisa Capomazzo of S. Chiara, was a painter, but all her work has been lost. But

lay artists of great imagination, including Caracciolo, Ribera, Domenichino, Lanfranco, Preti, Giordano and Solimena, were attuned to the dictates of the Counter-Reformation and illustrated its tenets. The most important themes were the sacraments, original sin as expressed in the Fall of Man and the cults of the saints and virtues. Obedience was the supreme quality; there were also many allusions to charity and chastity, the primacy of the Pope and the privilege of the priesthood.

Counter-Reformation art in Naples was Aristotelian and Thomist: Ribera illustrated Augustinian doctrine and Giordano that of the Jesuits. In 1608 Thomas Aquinas was proclaimed the eighth patron saint of Naples. The Jesuits saw to the control of the minds of the painters at the end of the century by forming a special Congregation; the governor Francesco de Maria revealed its intentions when he said he felt pained by the 'cursed liberty of conscience' of Giordano. But artists and patrons were subject to sterner shackles: the vigilance of the Inquisition and the synodal laws. The doubts of Rosa expressed in *Job on the Dunghill* and of Ribera in the *Scene of Torture* were never developed beyond drawings. The case against Jacob Isaczoon Swanenburgh, the future master of Rembrandt, showed that the Counter-Reformation in Naples expected absolute orthodoxy.

Censorship was on the whole an effective deterrent and cases were rarely brought against painters. Only in private patronage or at a very plebeian level is it possible to check cases of

denunciation; great patrons would have merely rejected the pictures. That Caravaggio's *Madonna of the Rosary* was denounced, as has been maintained, might be logical but would have been beyond the critical discernment of his patrons.

Painting, together with anti-Lutheran poetry, was one of the vehicles for the expression of a loathing of heresy. Heresy was frequently depicted through allusions in such subjects as the expulsion of Lucifer, the conversion of Saul, the disputes of Jesus with the doctors, Catherine of Alexandria with the infidels and Dominic with the Albigensians. The opposite extreme was depicted in such works as *Catholic Faith Triumphant through the Work of the Dominican Order* by Solimena and *Religion Triumphant over Heresy through the Work of SS Francis Xavier and Ignatius* by De Matteis.

Public Paintings and Popular Images

The Counter-Reformation required the artists of Naples to keep the interpretation of religious subjects within careful bounds. The mind of the artist was required to be subservient and unequivocal. After the open condemnation of Michelangelo's *Last Judgement*, explicit allegory was discouraged: the *Last Judgement* as painted by the Master of Montecalvario, by Gramatica, Corenzio, and Giordano are 'historical', in that they follow the dictates of iconographic treatises. After the condemnation of Copernicus and the trial of Galileo, only a literal reading of the Holy Scriptures was permissible: the intellectual *pauperes*, which included at least 90 per cent of the population, believed that their Bible was an exact and literal picture of a superhuman reality. Patrons did not wish to encourage deep thoughts, but merely to present a suitable universal language. Allegorical ambiguity might lose sight of dogma in myth and mystery, therefore artists had to state each theme with clarity.

But the subject of the Immaculate Conception shows that intelligent artists such as Ribera, Battistello, Fracanzano and Giordano took for granted the debate among theologians on the matter of the Conception before it was codified, and expressed, with reservations, Scotist findings and the nuances of Dominican theology far more skilfully than Cavallino, Beltrano, and Guarino. Such artists could work within, and interpret the rules of, Counter-Reformation decorum with great subtlety. Paradise as depicted by Lanfranco or Giordano is a majestic place compared with the concepts of Gramatica or Beinaschi. Whereas mediocre painters portrayed God the Father only as a god of wrath, Battistello, Ribera, Preti and Giordano presented a Thomist idea of divinity.

Patrons, preachers and painters at the time of the Counter-Reformation all delighted in vengeance. Was the savagery of the decapitation of Holophernes or the Baptist, the massacre of the Innocents, the expulsion of Hagar and the sacrifice of Isaac, for instance, a reflection of the fact that violence was so common a sight in the city that it usually went unpunished; or was daily life a reflection of art? And since the painting of ecstasies created faked mystic occurrences, as is known from examinations for canonization which were abandoned, could not the painting of cruelty have had similar results? There appears to be an exact correspondence between the contempt for the heretic and the infidel as expressed in church art and the brutal treatment of the 10,000 slaves then in Naples: Don John of Austria tested the effect of carbon monoxide on two slaves in the *Grotta del Cane* and killed a third who resisted with his own hands, to the horror of Moryson and Evelyn, but to the indifference of the Neapolitans.

In Naples mysticism was a late importation from Spain and France. The artists, whether Cobergher or Lanfranco, Andrea Vaccaro or Giordano, Luigi Garzi or Mattia Preti, had no conception of its anguish. Those who in Naples passed for mystics, even with the theological investigator, on the whole turn out to be either hysterics or frauds. In the trials for the canonization of Orsola Benincasa, Maria Villani and Serafina di Dio, the usual confusion between sexual excitement and diabolic presence is evident. The case of the nun Giulia De Marchi, who, as the Inquisition discovered, gave sexual favours to her confessors and said she received other, more spiritual favours from heaven, was only the precursor of more serious ambiguities between mystic exaltation and moral anarchy into which several quietists fell. The fact that these included lofty spirits like Giuseppe Valletta shows that mysticism was the last escape from the pharisaism of official controls: the escape upwards was by individual communion with the divine; downwards there was agnosticism and atheism.

The friars Gregorio da Napoli, Lorenzo Maria Brancaccio, Domenico Gravina and Francesco Filomarino (brother of the Archbishop) endeavoured to cast light on mysticism and particularly on visions, and the artists took account of this. Yet the painting of visions is closest to the sometimes abstruse accounts of Neapolitan mystics, especially of cloistered nuns governed by the Theatines, Jesuits and Dominicans.

The extent to which the painting of visions involved popular psychology can be measured by the near-epidemic of celestial apparitions which struck Naples in the Seicento. According to popular legend, the Madonna del Carmine appeared to Masaniello who exhorted the people to worship her. The Trinity or the Virgin

intervened in terrestrial affairs for the most trivial ends; in a city overloaded with sacred buildings, they asked for new oratories – the larger they were, the more pleasing to heaven. The history of visions in the Counter-Reformation is in great part an insult to the idea of God.

The painting of apparitions reflects the corporate spirit of the friars: if Giordano makes God appear to S. Vincenzo Ferrer, the Trinity appears to S. Francesco dell'Altobello; if Lanfranco sees Jesus entrust his cross to the Theatines, Vouet and Preti catch the Madonna in the act of handing to St. Bruno and St. Simon Stock the rules of the Carthusian Order and the scapular of the Carmine respectively. The Madonna appears, either alone or, more frequently, with the Christ Child, to the saints of the most influential orders – the Theatines, Jesuits, Franciscans and Dominicans – and especially to S. Gennaro. The secular clergy could also express its corporate iconographical beliefs with S. Gennaro and S. Carlo. Carlo Borromeo had been the friend and confidant of several Neapolitan archbishops; immediately after his canonization in 1612, a relic of his was sent to the ambiguous Giulia De Marci by Cardinal Federico Borromeo. The earliest painters of S. Carlo Borromeo in Naples were Azzolino, Rodriguez and Carlo Sellitto, the most conspicuous Giordano and Solimena.

It was the painting of happy mendicity which came closest to real life. The tradition of the Neapolitan *scugnizzo* (urchin), stricken and smiling, continued. The real condition of Neapolitan beggary was shown not so much in the *Good Samaritan* (Giordano, Corenzio) or in paintings of monastic saints pouring out gold coins to the poor, as in Ribera's paintings of children: one accompanies a blind man, another is crippled (the *Cripple* copied by Matisse). The real poor were painted by the Master of the Annunciations, Micco Spadaro and Mattia Preti.

Another type of painting was used by the clerics to attract the endowments of the faithful; S. *Gaetano Receiving and Distributing Alms* by Andrea Vaccaro is a typical example. One must read into paintings of the Adoration of the Shepherds, as into those of the Magi, the concept that nobody, rich or poor, should present himself to Christ – and, by implication, to the Church which is His incarnation – without offering presents. The scale of the profits of these religious institutions and the fact that they were squandered on vanities became proverbial: huge amounts of money were contributed, but they were held in mortmain. The Seicento saw the maximum proliferation of rhetorical exhortation, illicit profit and interested legislation in private charity.

The true popular art was that of miraculous images; it was never artistically important, but it was immediately intelligible and held the promise of possible magical attributes, or divine intervention. The most venerated of the seven miraculous Crucifixes in the city was at the Carmine; the most famous, which was said to have thanked St. Thomas Aquinas for his writings, was at S. Dominico. In 1620 an *Ecce Homo* was added to the list. Devotion to the Crucifix was encouraged by the collection and exhibition of the relics of the Passion: by the end of the Seicento, Naples could claim 17 holy thorns, 13 pieces of the Cross along with nails, the sponge, flails, the seamless robe, fragments of the Holy Shroud and even the Blood of Christ. The deepest expressions of meditation in painting are reached by Naccherino in S. Carlo all'Arena, Battistello at the Certosa, Ribera at the Oratory and Preti at S. Lorenzo; the high point of devotion by Stanzione, Andrea Vaccaro and Francesco Di Maria.

Miraculous images of Mary were even more numerous. After the sumptuous architecture designed by Fra Nuvolo for the Madonna di Costantinopoli, Canon D'Eugenio thought the age of disasters was over for Naples. However, six other images entered the list of miracle-makers apart from the newly instituted pilgrimages to the Madonna dell'Arco for which Nuvolo built a splendid edifice. A copy of the highly venerated S. Maria in Portico came from Rome in 1632, donated by Princess Maria Felice Orsini who built a church around it and entrusted it to the Lucchesini; its *History*, published in Naples in 1638, contributed to its fame. Three images of the Madonna were in monasteries: S. Maria d'Ognibene of the Pii-operai, S. Maria della Verità of the Theatines and, under their auspices, the Conception of Suor Orsola Benincasa. The two miraculous Madonnas painted on walls and venerated by the working people were rehoused in splendid buildings in 1625 and 1635, when miracles were reported and alms donated. All these images were carried in procession together during the plague of 1656, but to no effect. The viceroy asked the Augustinian nuns to pray for peace after the death of Masaniello. Later they, together with the Theatines and Jesuits, demanded money and other goods, claiming that their prayers had been answered and attributing the salvation of Naples to their saints.

NOTE
For a full bibliography see *Società e vita religiosa a Napoli nell'età moderna (1656–1799)* (Naples 1971) and the essay on the Neapolitan Counter-Reformation in *Riforme e miti della Chiesa del Cinquecento* (Naples 1973), both by the present writer. New sources and a further bibliography are included in the writer's forthcoming book *Pittura e Controriforma a Napoli*.

Caravaggio and Naples

MINA GREGORI

Caravaggio's work in Naples is at present the focus of the most important research on his work and the area in which major discoveries of both paintings and documents have been made in recent years. While it had long been recognized that Caravaggio's presence in Naples had a great impact on the local school – one of the most important and original in Italy in the seventeenth century – research on his own work in Naples was certainly overdue, given the comparative lack of familiarity with Caravaggio's late style.

The reports of Caravaggio's movements when he left Rome after killing Ranuccio Tomassoni on 29 May 1606 were imprecise and fragmentary; his Roman biographers, Giulio Mancini (c. 1619–21) and Baglione (1642), merely mentioned paintings done in Naples without giving any details. The manuscript additions made by an anonymous commentator on Mancini's *Considerazioni sulla Pittura*, based on information supplied by Teofilo Gallaccini (d. 1642), provide the first summary account of Caravaggio's paintings in Naples. Bellori (1672) and Scaramuccia (1674) first published references to the works painted for the churches, but their lists are either inaccurate or incomplete. *The Flagellation* (Cat. 15) is mentioned only by Bellori, perhaps because it was difficult to see in the church of S. Domenico Maggiore; other works referred to include *The Acts of Mercy* (Cat. 16) in the church of the Pio Monte (the Mancini commentary speaks of other paintings by Caravaggio there) and the paintings made for the Fenaroli (a family from Brescia) Chapel in S. Anna dei Lombardi which were lost at the end of the eighteenth century. Caravaggio's *Resurrection* was on the altar of this chapel; it must have been an exceptionally important work, and also the most disconcerting, to judge from visitors' remarks (Scaramuccia 1674; Cochin 1763). In the eighteenth century *The Flagellation* was the most admired for its perfect composition and the noble figure of Christ of classical inspiration. Both Bellori and De Dominici (1742–45) accorded generous praise to a *Denial of St. Peter* in the sacristy of S. Martino, in place of which there is now a painting of the same subject, probably by a Flemish follower of Caravaggio.

Bellori is the only author to give any information about Caravaggio's works painted in Naples as private commissions outside churches. One of these was 'a half figure of Herodias with the head of St. John the Baptist', which Caravaggio sent to placate the Grand Master of the Order of Malta, Alof de Wignacourt, after he had fled the island. So this work, which has been identified with two different pictures, must have been painted after his return to Naples.

Bellori stated, or wanted to believe, that Caravaggio died in the summer of 1609, the same year in which Annibale Carracci and Federico Zuccari died, but in fact he died a year later at Porto Ercole on 18 July 1610. Until 1928, when Longhi published the two epitaphs by Marzio Milesi, Bellori's statement was accepted, despite the fact that the true date had already been published by Orbaan (1920). While this inevitably contracted the final period of Caravaggio's career, there were a number of scholars, like Mahon (1951) and Hinks (1953), who attempted to date some of Caravaggio's works to his final months in Naples. But the most significant contribution, the rediscovery of Caravaggio's final period in Naples after his Sicilian journey, was made by Longhi (1959, 1978). Caravaggio arrived in Naples in early October 1609; on 24 July 1610 the Duke of Urbino's correspondents wrote to say that the artist had been wounded or killed in Naples. This second stay in Naples lasted, therefore, about ten months.

This discovery made it necessary to redate the works mentioned in the sources and the paintings that had later been identified with them. Even taking into account the great speed at which Caravaggio worked, there seemed to be too many paintings to fit into the space of the few months from October 1606, when Caravaggio first arrived in Naples, to July 1607, when he was already in Malta. *The Acts of Mercy* (Cat. 16) was thoroughly cleaned and restored only for the exhibition of *Caravaggio e i Caravaggeschi* (Naples 1962–63). Its poor legibility had contributed to misunderstandings of the work, even relatively recently. In the years following 1970, when Causa published the X-rays of *The Acts of Mercy* great progress was made on the study of Caravaggio's Neapolitan work, facilitated by the discovery of a number of original paintings, the majority of which were hitherto unknown, even through copies. Among these, the *Salome Receives the Head of John the Baptist* (Cat. 20) which was published by Longhi in 1959 as a very late work, was acquired in 1970 by the National

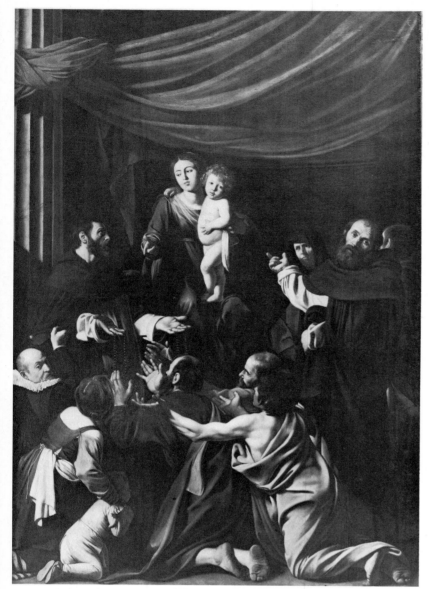

fig. 10 Caravaggio *Madonna of the Rosary* (Kunsthistorisches Museum, Vienna)

an unrestored state (1982), has reinforced the writer's conviction that this is a damaged original.

These four paintings, which must beyond any reasonable doubt date from Caravaggio's second stay in Naples, make it necessary to reconstruct his final period of work. It is also worth considering whether the artist received commissions for large-scale religious paintings, as he had during his first stay of 1606–07.

Circumstantial documentary evidence suggests that the *Annunciation* painted for the Eglise Primatiale at Nancy, founded in 1609 through the endowment of Henry II of Lorraine who succeeded to the dukedom in 1608, dates from this time. The attribution of this painting to 'Michelangelo of Rome', whom it is hard not to identify with Caravaggio, was published by Pariset in 1948 and accepted by Longhi in 1959. Stylistic considerations also suggest that the *Crucifixion of St. Andrew* (Cat. 17), which the Viceroy Conde de Benavente took back with him to Spain in 1610 (Bellori), was painted by Caravaggio in the months preceding his departure, probably on an *ad hoc* commission.

The reconstruction of Caravaggio's two stays in Naples has been greatly facilitated by documentary research. Taking into consideration the new transcription of the documents in the Pio Monte della Misericordia made by Causa (1970), it seems very likely that documents found by Pacelli (1977) relating to payments of a substantial sum to Caravaggio by Tommaso de Franchis on 11 and 27 May 1607, evidently for an altarpiece, refer to *The Flagellation*. The picture must, therefore, have been painted during Caravaggio's first stay in Naples, and not during his second, as Longhi had proposed (1959). It should be added that these payments were not final, and there was very little time left to work on the painting before 13 July, when we know the painter was already in Malta. Pacelli (1980) has made other important discoveries: the documents relating to the *Martyrdom of St. Ursula* and the Cappella Fenaroli in S. Anna dei Lombardi date both these works to the final Neapolitan period, as had previously been only surmised.

Caravaggio's first stay in Naples, which lasted only a few months and ended before 13 July 1607, is represented by three great altarpieces, *The Acts of Mercy* (Cat. 16), the *Madonna of the Rosary* (fig. 10) and *The Flagellation* (Cat. 15). The altarpiece commissioned by Niccolò Radolovich and paid for on 6 October 1606 (Pacelli 1967) should perhaps be added to this list. That Caravaggio should have received such important commissions for works destined for public exhibition in so short a period of time is a measure of his fame on his arrival in Naples. This is confirmed by the payment of 400 ducats for *The Acts of Mercy* (twice the sum the artist had accepted for the Radolovich picture

Gallery, London. A few years later, Cellini discovered another original, the *Denial of St. Peter* (Cat. 18). In 1975, the present writer proposed that Caravaggio was the author of the *Martyrdom of a Saint* included in the 1963 Naples exhibition as a work by Preti; later documents discovered by Pacelli (1980) proved that the painting was the *Martyrdom of St. Ursula* (Cat. 19) painted by Caravaggio for Marcantonio Doria in May, 1610, two months before the painter's death. In 1975 the present writer expressed the views that the reference to the *Tooth-Puller* (fig. 12) in the Florentine Galleries (unfortunately deposited in Palazzo di Montecitorio), listed in a 1636 Medici inventory and described admiringly by Scannelli (1657), was to be taken seriously. The painting was exhibited by Evelina Borea in 1970 as the work of an 'Unknown follower of Caravaggio', but recent re-examination of the painting, still in

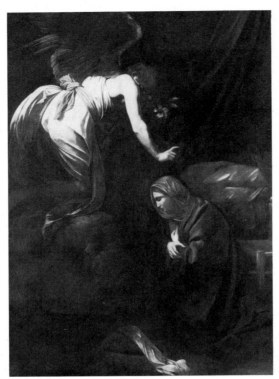

fig. 11 Caravaggio *The Annunciation* (Musée des Beaux-Arts, Nancy)

immediately on arriving in Naples) and by the jealous care with which the Pio Monte guarded the picture, in particular from the avaricious Conde de Villamediana. The interest taken in Caravaggio's painting in Naples, which, as one of the capitals of the Mediterranean, was scarcely less important than Rome, can be deduced from early sources. Bellori alluded to it and De Dominici wrote in the life of Battistello Caracciolo that 'the reputation of Michelangelo Narigi da Caravaggio had grown greatly at this time' with both patrons and artists. And he added, 'Caravaggio came to Naples, where he was received with great acclaim by both painters and lovers of painting, and he painted many works there' (II, 275).

Very many northern painters came to Naples at the beginning of the Seicento. Since we know that Caravaggio was held in high esteem by many of these painters, of whom the most famous was Rubens, it does not surprise us that Pourbus the Younger, linked to Rubens and the court of Mantua, wrote from Naples to the Gonzaga to urge them to buy the *Madonna of the Rosary* and the *Judith and Holofernes*, which were later purchased by Louis Finson and Abraham Vinck, two northern painters resident in Naples. Their knowledge of the new painting style of Caravaggio through these two works and the *Crucifixion of St. Andrew* (Cat. 17) which they had copied before the Conde de Benavente carried it off to Spain, was something which was to have profound historical consequences. Re-

cent research on Battistello and Carlo Sellitto, the two local painters who were most directly involved in the new tendencies, has led to the discovery of some very early dated works directly influenced by Caravaggio's new style. Caracciolo's *Immaculate Conception* in S. Maria della Stella (Cat. 5) which has been dated 1607 by recently discovered documents, although very different in interpretation and showing previous knowledge of Caravaggio's Roman works, was painted while Caravaggio was first in Naples. The *Liberation of St. Peter* of 1615 in the Monte della Misericordia is full of echoes of Caravaggio's picture in the same church, as well as of the later lost *Resurrection*.

The church pictures of the first Neapolitan period are still linked stylistically with the paintings of the Roman years. Just as *The Acts of Mercy* recalls the S. Luigi dei Francesi scenes of St. Matthew, so two other paintings by Caravaggio show him developing ideas which he had begun to explore in Rome for public works of art. In the *Madonna of the Rosary* the figures are arranged according to a Venetian pattern and the hangings and the diffused lighting are repeated from the *Death of the Virgin*, while in *The Flagellation* the painter employed a traditional composition which allowed him to introduce explicit and brutal violence into the painting without it being rejected by the patrons.

The *David* of the Kunsthistorisches Museum in Vienna was certainly painted in the same months as the *Acts of Mercy* and the *Madonna of the Rosary*, and its Neapolitan origin has given rise to the hypothesis that it is the same *David* taken to Spain by the Conde de Villamediana, the man who tried to gain possession of the Pio Monte's *Acts of Mercy* in 1613. Bellori recalls that Villamediana also owned *A Youth Holding a Pomegranate Flower*, of which we have no visual record.

A different problem is posed by *The Flagellation*, for which we know that large sums had already been paid to Caravaggio up to May 1607 (Pacelli 1967): given the two documented payments, it is almost certain that Caravaggio had completed the picture by this date. The brutality of the representation, which is accompanied by a technique of unparalleled violence, seems to separate it from the other two church works of the first Neapolitan period. This explains why it had previously been suggested that the painting could be dated to Caravaggio's last months in Naples, between 1609 and 1610, despite indications in the sources to the contrary. Although we cannot entirely exclude the hypothesis that the work was finished after his return from Sicily, it seems more likely that Caravaggio's need to finish the painting before he left for Malta drove him to adopt the aggressive and summary technique which characterizes the later works, to be seen in Malta in the *Decollation of St. John the Baptist* and, in a

unique way, in the very tragic and intense Sicilian works.

A similar problem of dating is presented by the *St. Sebastian*, going by the copies corresponding to Bellori's description from which we know this splendid conception. The victim inclines his head like the Christ in *The Flagellation* and the nude figure must have been painted before Caravaggio's departure for Malta, at the same period as the picture in S. Domenico Maggiore. We have to think along the same lines for the *Flagellation of Christ* with three-quarter length figures now in Rouen, in which Caravaggio abandons a central composition and follows an engraving by Dürer that had been already imitated in north Italy in the sixteenth century; the first executioner might be taken to be a work of the Roman period. There is a psychological balance and a mental and cultural cohesion characteristic of Caravaggio's first Neapolitan period.

The *Decollation of St. John the Baptist* in Malta represents the artist's identification with the victim and subject of the painting which imbues it with a strong autobiographical presence, a tendency constantly present thereafter in Caravaggio's work. It prompted the painter to choose subjects, such as the *Resurrection of Lazarus* in Messina, in which the sense of the painting could increasingly be turned in this direction. This consideration is an essential premise for reconstructing Caravaggio's work in his last Neapolitan period and has helped to revise the dating of the *St. John the Baptist* and

the *David* in the Borghese Gallery. We now know the date of the *Martyrdom of St. Ursula*, which was sent to Marcantonio Doria in May 1610 just after its completion, two months before Caravaggio's death. This painting has obvious similarities with other works painted for private patrons that also contain half-figures, such as the *Salome Receives the Head of John the Baptist* (Cat. 20) and the *Denial of St. Peter* (Cat. 18). These works, alongside which we should place the *Tooth-Puller* of the Florentine Galleries, constitute a compact and representative group painted in Caravaggio's late style; they are characterized by rapid brushstrokes employing few colours, a kind of pictorial shorthand, and sudden flashes of light which at times appear almost mannered.

The only public works of art that Caravaggio seems to have painted in the months between 1609 and 1610 were the pictures for the Fenaroli Chapel at S. Anna dei Lombardi. The *Circumcision* destined for Santa Maria della Sanità, for which Caravaggio received 100 *aureos*, was completed in 1612 by Giovan Vincenzo Forlì and it is impossible to discern Caravaggio's original intentions. The pictures he painted for the Fenaroli Chapel, for which Pacelli published useful documents in 1980, were the *Resurrection* on the altar, a *St. Francis Receiving the Stigmata* on the wall, attributed to Caravaggio by the anonymous commentator to Mancini; a *St. John the Baptist*, mentioned by Cochin without naming the author (he was also unaware of the painter of the *Resurrection*), was also prob-

fig. 12 Caravaggio *The Tooth-Puller* (Palazzio Vecchio, Florence; on deposit at the Palazzo di Montecitorio, Rome)

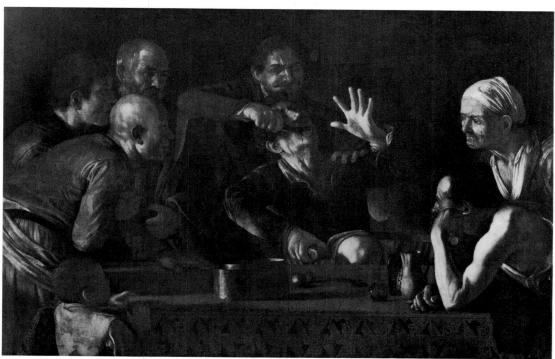

ably by Caravaggio. The *Resurrection* in S. Anna dei Lombardi, which showed Christ leaving the tomb and walking forth among the soldiers instead of rising heavenwards, was a singular conception as commentators have always noted. A picture of this subject, signed by Finson in 1610 (in St. Jean de Malte, Aix-en-Provence), corresponds to the description of Caravaggio's original and we may guess that it was directly inspired by it. The dazzling lights in Finson's *Resurrection* strike one even more than the armour of the soldiers and if, in our mind's eye, we integrate this copy with the flickering light and clots of chiaroscuro that characterized Caravaggio's late style, it can be imagined that the original must have seemed an impressive anticipation of Rembrandt. These characteristics recur in the soldier in the *Denial of St. Peter* (Cat. 18) the armed man in the *Martyrdom of St. Ursula* (Cat. 19) and, finally, the armour of the Proconsul Aegeas in the *Crucifixion of St. Andrew* (Cat. 17). The present writer believes that the *Resurrection*, together with the Nancy *Annunciation*, is part of the small group of large-scale religious works painted by Caravaggio during his second Neapolitan period. The choice of subject and the presence of the crowd reflect the deep transformation that had led Caravaggio to epitomize the massacre of the eleven thousand virgins in the martyrdom of a single figure.

The removal of the *Martyrdom of St. Andrew* to Spain by the Conde de Benavente in the summer of 1610 is perhaps the most famous example of Spanish interest in Caravaggio, but it was evident also in the Conde de Villamediana's attempt to obtain *The Acts of Mercy* and the anxiety of the Conde de Lemos, Viceroy of Naples from 1610–16, to obtain any of the paintings – but especially the *St. John the Baptist* – on board the felucca on which Caravaggio had been travelling near the time of his death at Porta Ercole. Knowledge of Caravaggio's work reached Spain through the Neapolitan viceroys; even the greatest Spanish artists, as Roger Fry wrote at the beginning of this century, would not have painted as they did without Caravaggio. Naples served as a centre from which Caravaggesque innovations were widely diffused to Flanders and Spain.

We should also consider the local consequences of Caravaggio's presence in Naples for almost two years. The Neapolitan school, more than any other in the Italian Seicento, took up and continued Caravaggio's innovations in a powerfully popular vein and echoes of his

naturalism prevailed for generations, despite attempts to sweeten the style. His immediate followers were Caracciolo and, at a certain distance, Carlo Sellitto. By comparing Caracciolo's Caravaggesque work with Sellitto's luminescent painting grafted on to a fundamentally mannerist style of draughtsmanship, it becomes possible to understand better how Caravaggesque elements entered Neapolitan painting.

Sellitto's *S. Cecilia* of 1613 (Cat. 142), the most advanced of his works and the closest to Caracciolo, was particularly innovative since, by combining an intensely luminescent naturalism with elements of form or drawing, it created a formula acceptable to other Neapolitan painters. While it would be incorrect to define the naturalism which continued in Naples until 1630 as strictly Caravaggesque, there is no doubt that a current of naturalism unparalleled in any other Italian centre had been established there; it expressed itself in the popularity of rustic subject matter and in the depth and truth of its emotional charge. In this wider sense, Neapolitan painters were the heirs of Caravaggio.

Battistello was, in contrast, a straightforward Caravaggist. De Dominici's statement that he was apprenticed to Caravaggio could mean that he had learnt from Caravaggio the method of painting directly from life without drawing. This separates him from Sellitto, as does his use of living models to study expression and to increase the charge of feeling like Caravaggio. His interpretation of sacred subjects and their prevalence in his work put him, together with Serodine and a few others, among Caravaggio's closest followers since religious painting interpreted as the 'painting of history' was an idea to which Caravaggio had repeatedly returned.

Ribera also made a decisive contribution to Neapolitan naturalism. He drew on Caravaggio in his youthful Roman works before 1616. *The Acts of Mercy* (Cat. 16) was also one of his sources; the innkeeper was the model for *Taste* (Cat. 19), one of the personifications for the *Five Senses* which Ribera painted in Rome (Mancini) and the presence of Samson in Caravaggio's painting, evoking the antique and the rustic, showed Ribera how to represent the subjects that were later popular with the stoical painters of the 1630s in Rome. From Ribera came the taste for painting rough and silky textures and fine material, which met the demands of the new painterly style; these tendencies show that he had finally departed from the austerity of Caravaggio's painting.

Painting in Naples
from Caravaggio to the Plague of 1656

PIERLUIGI LEONE DE CASTRIS

Caravaggio's arrival in Naples and his work during his visits there (September 1606–June 1607 and October 1609–July 1610) produced a formidable shock in local artistic circles. A few painters may have had some previous knowledge of Caravaggio, but most of them were confronted only with his last, most radical style, which was difficult for painters used to the mannerist idiom to comprehend.

Apart from some copies of Caravaggio's Neapolitan paintings, most notably those of Finson, the first sign of local appreciation of Caravaggio's naturalism is found in Battistello Caracciolo's earliest surviving work, the *Immaculate Conception* (Cat. 5), which is documented in 1607. Despite the crowded figures arranged in one plane and other obvious mannerist tricks, this was the first real response in Naples to *The Seven Acts of Mercy* (Cat. 16). Between 1607 and 1614 Battistello was to establish himself as Caravaggio's most faithful Italian follower with such works as the *Baptism* in the Girolamini (Cat. 6) and various versions of the *Ecce Homo*. The dramatic presentation of a scene, the essential moment caught in a shaft of harsh light, the close grouping of the figures, the chiaroscuro accented with touches of red and white are all characteristics lifted bodily from Caravaggio's work of 1607–10, and confirm that Caracciolo must have copied Caravaggio's paintings as the sources indicate. But Battistello's residual taste for linear outline and his instinct for creating forms through graphic means survived, and this later drew him towards Gentileschi and the Bolognese school.

Carlo Sellitto encountered greater difficulties. He was trained in the mannerist tradition, but in the two *Stories of St. Peter* in the Cortone chapel, S. Anna dei Lombardi (1608–12) he plunged into an impossible contest with the contemporary work of Caravaggio and of Battistello in the neighbouring chapels of the Fenaroli and Noris Correggio families respectively. Sellitto died soon afterwards in 1614; his studio assistant was Filippo Vitale, who may have completed the pictures left unfinished after his master's death.

In 1614 Battistello had visited Rome where he encountered the work of Orazio Gentileschi and he adopted his rotund forms as can be seen in the *Liberation of St. Peter* of 1615 (Cat. 7) and the *Trinitas Terrestris* of 1617 in the Pietà dei Turchini, the first works in Naples in which

Caravaggio's style was adapted to meet the needs of local devotional painting. It was a very successful formula, surviving for at least a decade, and influenced the work of Paolo Finoglia in, for example, the lunettes from the Certosa di S. Martino (Cat. 47–50). Finoglia developed a highly individual style, with an almost obsessive insistence on the physical qualities of the materials portrayed, a factor usually associated with Antiveduto Gramatica's presence at the Camaldoli around 1620 (Cat. 72).

By this date Ribera had appeared on the scene. The changes he brought about between his arrival in 1616 and c. 1630 make him a most important figure in the development of Neapolitan naturalistic painting. Ribera was at first associated with the group of northern Caravaggisti, whose frank naturalism was less tragic, desolate and monumental than Caravaggio's. The *Drunken Silenus* (1626, Cat. 120) and the *Martyrs* (Florence and Budapest) of 1628–29 show how his taste for vivid narrative could sometimes touch on the grotesque and the horrific. His brushwork, so dense and strong in impasto and colour, was imitated by his contemporaries including Caracciolo and Vitale. At the end of the 1620s Ribera held a sort of artistic hegemony in Naples and his work was lauded by the Spanish viceroys.

In the years 1618–26 Caracciolo was travelling between Rome, Naples, Genoa and Florence and was open to many different influences. It was he who first established the artistic link between Naples and Genoa with a painting commissioned in 1610 which was sent by sea and which was followed before 1620 by other works of his, as well as paintings by Ribera, Azzolino and Fiasella.

The alliance formed between Battistello and Vouet strengthened during the 1620s and formed the basis of a reaction against the artistic hegemony of Ribera and his followers. Vouet's style was known through two pictures (Cat. 163, 164) sent to Naples in the 1620s; they were of fundamental importance for Caracciolo and influenced his *Washing of the Feet* (S. Martino, 1622).

Massimo Stanzione, initially a follower of Battistello and Vouet, began to form his mature style in Rome. One of his most important works from this period is *The Adoration of the Shepherds* at S. Martino (1627). Causa has

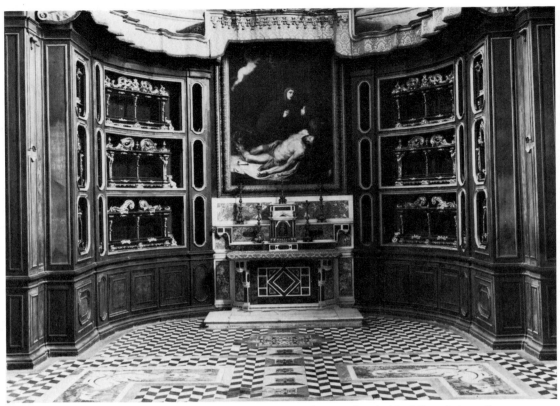

fig. 13 Certosa di S. Martino, Naples; interior of the sacristy, showing the *pietà* by Ribera (1637–38)

argued that by 1627 Stanzione had monopolized prestigious painting commissions to the exclusion of Ribera and his followers. In 1622 the celebrated Guido Reni had come to Naples for a visit of much longer duration to paint the most prestigious commission available in the city, the Oratorians of the Girolamini. He painted three pictures there, including the *Meeting of Christ and the Baptist* (Cat. 118), which are typical of his mature style – elegant, clear-cut and with a predilection for luminous surfaces. Reni's art became a component of Stanzione's style, and the young Andrea Vaccaro used it to modify his Caravaggesque tenebrism.

In the later 1620s Ribera's Neapolitan followers elaborated endless variations on his 'new' naturalism, and influenced artists in both Spain and Italy. From 1623 another Valencian, Giovanni Do, the author of the *Adoration of the Shepherds* (Cat. 40), introduced more Spanish elements into Neapolitan painting. It is also possible that some of Velasquez's naturalistic paintings appeared in Naples during the 1620s; he himself arrived in 1630–31. This is suggested by the work of another great master in Ribera's workshop, the so-called Master of the Annunciations to the Shepherds. During the 1620s and 1630s his work developed from the *tremendo impasto* towards an increasingly radical naturalism; he depicted a social class which had

never appeared so plainly in paint before.

The early work of Francesco Fracanzano is very close to the anonymous master's. In 1635 Fracanzano produced his masterpieces, the two paintings in S. Gregorio Armeno (Cat. 55, 56). These display a luminosity, a painterly interpretation and a refinement of colour which were to remain typical of the artist.

From 1630–36 the fashion for Ribera's *tremendo impasto* declined and there was a move towards a neo-Venetian painterliness. Ribera was in the vanguard of this movement which suggests that he must have been in close contact with Velasquez when he came to Naples in 1630–31. After meeting Rubens in Madrid, Velasquez was already moving towards a lighter, brightly coloured palette. The naturalistic revival affected many artists outside Ribera's circle, both the older generation of Caravaggesque painters and those who had previously used a precise brushwork like Vitale, Falcone and Guarino and who now adopted a more vigorous, open technique. Although Guarino was said to be a pupil of Stanzione, his early paintings (such as the *Annunciation to the Shepherds* in the Collegiata, Solofra) dating from not much later than 1630, are violently naturalistic in style, portray the humblest social classes and parallel the Master of the Annunciation's work.

Yet even at this time, at the height of this naturalistic phase, a neo-Venetian painterliness and classicism imported mainly from Rome were both evident, and indicated the course that Neapolitan painting was to take in later decades of the century.

The sources of the neo-Venetian current were two-fold: Poussin, who had studied Titian's *Bacchanals* in Rome, and Van Dyck, two of whose pictures (*Susanna* and *St. Sebastian*) were in the Roomer collection by about 1630 and whose work became better known in Naples after the arrival of Novelli *c.* 1632–3.

Several of Poussin's pictures are recorded in Neapolitan collections before 1630, including the large *Adoration of the Golden Calf* admired by Valguarnera in the collection of a certain Signor Gosman in about 1630. This neo-Venetian influence was reinforced by the arrival in Naples in 1635 of Castiglione who had transformed still-life and animal painting of the Genoese and Flemish tradition by using a rich and Titianesque technique in emulation of Poussin. His visit had a profound effect on Andrea di Lione and Aniello Falcone, who held a well-attended Academy for the study of the nude in his house. Poussin and Castiglione inspired him to abandon painting pastoral subjects and turn to ancient Rome for inspiration, hence the strange phenomenon of his *Gladiators* and the *Entrance to the Circus* in the Prado. He sometimes painted still-life pictures, and had links with Luca Forte and Porpora.

During the first 30 years of the Seicento an undercurrent of classicism had persisted amongst those artists who chose to study in Rome, but in the 1630s two of the protagonists of the school came to work in Naples, preceded by a fame and welcomed with expectations (and suspicions) comparable only with those that had accompanied the earlier advent of Caravaggio. Domenichino was in Naples for much of the 1630s working on the decoration of the Cappella del Tesoro. Lanfranco was there almost continuously between 1632 and 1646 painting fresco cycles in the Gesù Nuovo, SS Apostoli and S. Martino.

These artists did not have the immediate success which might have been expected in the South. But the most immediate result of Domenichino's visit was the development of the mature style of Stanzione, the 'Guido of Naples', in which Domenichino's influence was at least as important as that of Reni. Stanzione's naturalism was now tempered by an increasing classical rigour, as can be seen in the paintings in the Chapel of St. Bruno in S. Martino: the *Last Supper* (1638–39) and the *Pietà* (Cat. 159) were in a sense a challenge to Ribera. His former magniloquent rhetoric was filtered through a simple and sentimental religiosity, and it was precisely because his classicism was not all-pervasive that his work proved so popular.

In his later works Stanzione was influenced by Artemisia Gentileschi who arrived in Naples after 1630; they collaborated at Pozzuoli Cathedral. He may also have been affected by the possible presence of Spadarino. The 1630s was the most volcanic and contradictory decade in the history of seventeenth-century Neapolitan art, when many disparate currents converged. Several eccentric individuals were active there, each using an idiosyncratic and complex language, the most important of whom was Cavallino. According to source-books he trained in the studio of Stanzione (*c.* 1632–35) and was in close contact with Artemisia Gentileschi. His earliest works, such as the Brunswick *Adoration of the Shepherds* (Cat. 23) show he studied Caravaggio and Caracciolo as well as their Roman followers and in them he used only large-scale figures. From Stanzione he inherited a great sensitivity to sentiment, but he paid attention also to Riberia and the work of the Master of the Annunciations. In the 1630s he was in contact with Falcone and through him with Castiglione, who directed him towards painting compositions with small figures; by 1640–50, he had become the undisputed master of this genre. Similar attitudes can be found in the work of Giovanni Battista Spinelli, which is sometimes extravagant to the point of being grotesque. The third, and probably the most decidedly naturalistic of this group of eccentrics active in Naples in the 1630s was Antonio De Bellis; a fourth was Bartolomeo Passante, a pupil of Ribera's who apparently died in 1648.

At the beginning of the 1640s poor health forced Ribera to entrust the execution of some of his pictures to assistants. At the same time the rising popularity of the classical idiom led him to play down his earlier aggressive naturalism, as is evident in the large *Communion of the Apostles* at S. Martino which was begun in 1638 but only finished in 1651–52. The same tendency can be seen in religious works such as the *Marriage of St. Catherine* (New York).

One of the determining factors in the fashion for classicism in the 1640s was the clearly defined taste of the new Archbishop of Naples, Cardinal Ascanio Filomarino, who took office in 1642. It is not known to what extent Neapolitan painters had access to Filomarino's collection. But even before he become Archbishop he had made public his preferences in the Chapel of the SS Annunziata, built between 1636 and 1640 in the church of SS Apostoli, which was one of the most original pieces of ecclesiastical architecture in Naples with the altar designed by Borromini. When Filomarino became Archbishop in 1642 he chose Lanfranco to fresco the Archbishop's Palace and to paint the altarpiece in the chapel which includes a portrait of Filomarino (fig. 18).

Although Poussin apparently never reached Naples, a few of his paintings did. His rival

Charles Mellin stayed in the city between 1643 and 1647: his works, such as the huge altarpieces in S. Maria Donnaregina and the Buonconsiglio (Cat. 87) are as cold and classical as Domenichino's. It was at this date, between 1640 and 1642, that the monks of the Certosa di S. Martino rejected Ribera's *Holy Family with St. Bruno* and considered replacing it with Guido Reni's *Adoration of the Shepherds*.

It was against this background that Stanzione, who had anticipated these developments as early as 1635, enjoyed his years of triumph from 1640 until 1656, the year of the plague. With an ever-increasing number of assistants he turned out a huge series of canvases and miles of frescoes. Seduced by the easy possibilities of this academicism, Pacecco de Rosa and many other painters tagged on to Stanzione's style.

Even an artist of quite a different calibre like Aniello Falcone reacted to Stanzione's success. In his rare pictures with large-scale figures, such as the *Flight into Egypt* (Cat. 43) of 1641 he modified his naturalism in imitation of Stanzione. But in his small-scale pictures he started an anti-academic reaction which brought him close to the genre scenes of the Roman *Bamboccianti*, some of whom were in Naples at this time.

For Stanzione and his followers, the only valid alternative to this dying naturalism was Van Dyck's 'neo-Venetian' style. By the beginning of the 1640s his paintings were in some Neapolitan collections and it was these that provoked the most interesting developments in Neapolitan painting, particularly amongst the group of artists working between 1640–41 at the Sapienza which included Cesare Fracanzano, Somer, Carlo Rosa and Micco Spadaro, the most interesting of the group, whose use of light owed much to Van Dyck.

De Dominici relates that in 1640, on the arrival of Rubens' *Banquet of Herod* (Cat. 138) in Roomer's collection, Cavallino was among the first to admire it: 'and it seemed so beautiful to him, that, as though enchanted by the magic of those vivid sanguine colours so wonderfully handled, he proposed to imitate it.' This account is probably true. Although De Dominici does not say so, Cavallino obviously studied the various paintings by Van Dyck which we know Roomer possessed by this date. The result of this study was a series of half-length figures rich in grace, vivacity and colour and sufficiently erudite in subject matter to be a great success with collectors and amateurs. A devoted reader of the scriptures, the *Metamorphoses*, Josephus and the *Gerusalemme Liberata*, he caught and extended the sentimental tone and theatrical potential of Stanzione's art. Cavallino was an isolated figure, whose natural elegance distinguished his work from that of his contemporaries. The influence of Van Dyck is also evident in his late work.

The time was approaching when it was possible for Naples to appreciate the baroque, and several paintings by Pietro da Cortona were already in Neapolitan collections. It was only after Masaniello's revolt in 1647 when several classicizing painters fled the city that the Neapolitan painters began to look again at Rubens's *Feast of Herod* (Cat. 138), at the great Van Dyck in the Oratory of the Rosario at Palermo, at the *Adoration of the Shepherds* by Guido Reni, at the Certosa and at Lanfranco's fresco in the dome of the Cappella del Tesoro, which, though not as important as that in S. Andrea della Valle, was one of the foremost works of illusionist baroque decoration in Italy.

After the plague a new type of artist who was closer in mentality to the founders of the baroque, appeared in Naples. The two guiding lights were Preti and Giordano; both had originally studied Caravaggio and both had admired Venetian Cinquecento painting in situ, particularly the work of Veronese. Although they were painted before the plague of 1654–55, Giordano's pictures in S. Pietro ad Aram and S. Brigida, enveloped in light and shade, close one chapter of Neapolitan art and open another.

The Bolognese Tradition and Seicento Neapolitan Painting

ERICH SCHLEIER

This essay discusses the influence of Bolognese art on Neapolitan artists from around 1635 to 1656. That influence was evident well before and after these dates, but these two decades, which saw the emergence of the mature style of Massimo Stanzione (known by De Dominici's day as the Guido Reni of Naples) and the arrival of Artemisia Gentileschi (in 1630 or possibly earlier) were dominated by its impact. The Bolognese current in Naples was brought to an end by the plague of 1656.

Modern Neapolitan painting of that time was dominated by two great painters: Caracciolo, who survived to 1635, and Ribera, who reached the peak of his career in the 1630s, when he found a classical equilibrium that replaced the harsh realism of his earlier years. This shift towards new pictorial values has been explained by earlier scholars in terms of the influence of Bolognese classicism. There were three sources for this: firstly, the works Neapolitan artists saw when they travelled to Rome, secondly, the pictures that Guido Reni painted in Naples during his short visit there in 1620–21 and later sent there from Bologna and, thirdly, the long stay in Naples of Domenichino and Lanfranco, who arrived there in 1631 and 1634 respectively. In reality, the impact of their works was marginal at the time; it was only later that Lanfranco influenced Giordano and Solimena. De Dominici says that Neapolitan painters studied the Carracci at the Farnese Gallery in Rome and more recent historians have noted that Lanfranco's Roman works of 1615–18 had a significant influence on Caracciolo, but Lanfranco's work at this period was not typically Bolognese, being closer to that of Vouet and the Caravaggists than that of Annibale's followers, Domenichino and Albani.

Guido Reni's name is repeated more frequently than that of any other non-Neapolitan painter in De Dominici's lives of Ribera, Stanzione and Fracanzano, and he has long been regarded as one of the principal sources of their style. This is, however, controversial; in 1916 Longhi spoke of the 'myth of Guido Reni' reigning in Naples at the time of Artemisia Gentileschi's arrival there, but later (1969) he denied that Guido influenced Stanzione at all. The importance of Artemisia and, through her, of Vouet is well-known, but Bologna also emphasized the influence of Van Dyck who passed through Naples. He also recalled Velasquez's visit to the city and the influence of the neo-Venetian current of Roman painting in explaining the move away from the naturalism of the 1620s towards a more painterly style that took place around 1635. This change from the *terribile impasto* of the earlier work of Ribera and Fracanzano led ultimately to the sophisticated grace of Bernardo Cavallino.

Stanzione was influenced by Reni's frescoes in Rome as well as by his paintings in the Girolamini, commissioned in 1620–21 when it was planned that he should decorate the Cappella del Tesoro in the Cathedral. This, together with the decoration of S. Martino, was the most prestigious commission in Naples during the first half of the century. In both instances the lion's share of the work went eventually to artists of Emilian background, evidently chosen on account of their Roman associations and much to the anger of local Neapolitan painters, above all Corenzio and Ribera.

As early as 1612, when Reni was briefly in Naples, the *Deputati del Tesoro* apparently tried to persuade him to accept the commission, then in 1616 decided to invite another foreigner, the Cavalier d'Arpino, the last important late mannerist in Rome, who until a few years earlier had been one of the leading artists working for Paul V. He came to Naples in 1618, but did not complete the assignment. The *Deputati* then turned again to Reni, who arrived in December and stayed until April 1621. The programme for the frescoes was agreed upon on 28 April 1621, but Reni left suddenly after his assistant was wounded by an assassin who seems to have been hired by Corenzio. In May 1621 the *Deputati* decided that no Neapolitan artist should be given the work, apart from that already commissioned from the aging Santafede, and in 1622 they asked him to get Cavalier d'Arpino or another Roman painter to accept the commission. Finally, in 1623, they gave the work to Santafede himself, who selected as his assistants Caracciolo and Gessi (Reni's former pupil), each of whom decorated one spandrel of the dome after Santafede's designs. However, the result was not to the liking of the *Deputati* and in 1628 they again solicited designs. Corenzio and Simone del Papa painted the other two pendentives, but without winning approval; finally, in 1630, Domenichino was given the commission. Gessi's

involvement with the work was disastrous and his fresco was torn down, probably by 1633.

Gessi did, however, paint at least one other 'public' work, a *St. Jerome* for the Girolamini. They, being Oratorian Fathers of S. Filippo Neri, had strong ties with the Roman Oratory and so from time to time employed artists who had worked there, like Cristoforo Roncalli (1605), Pietro da Cortona (who in the 1630s painted for them his only Neapolitan altarpiece) and, of course, Guido Reni, who in 1615 painted the famous altarpiece of *S. Filippo Neri* for the chapel dedicated to him in the Chiesa Nuova in Rome.

Reni painted three pictures for the Girolamini: a *Flight into Egypt*, a *St. Francis*, and the *Meeting of Christ with St. John the Baptist* (Cat. 118). It seems that they were not actually completed at the time of Reni's visit to Naples in 1620–21, but was sent later from Bologna. In any case, these paintings were the only examples of his art on display in Naples by the mid-1620s, in other words before Stanzione's style had become fully developed. The combination of monumental composition, spatial organization, lyrical tenderness of expression and rhythmical movement were thoroughly novel to Neapolitan painting, and quite different from the more intricate, twisted style of Caracciolo, even after his visits to Rome, Genoa and Florence. Stanzione had already seen Reni's work, for when he was in Rome in 1617 he certainly saw the frescoes in the Borghese Chapel in S. Maria Maggiore, but at that time he was more interested in the Caravaggesque painters working at S. Maria della Scala and those working at the Quirinal, like Lanfranco, Turchi and Gentileschi.

Stanzione's early development is nonetheless something of a mystery; Caracciolo evidently plays a part in it, as the *Lamentation* of about 1625 (Rome, Galleria Nazionale) shows. Two other events are also relevant; the arrival of Artemisia Gentileschi in Naples, sometime between 1626 and 1630, and the impression made by the two altarpieces sent from Rome by Simon Vouet, *The Circumcision* for S. Angelo a Segno dated 1622 (Cat. 164) and the *St. Bruno Receiving the Rule of the Carthusian Order* painted for S. Martino and dated 1626 (Cat. 163). The former is stylistically close to the virtually contemporary and more Caravaggesque paintings by Vouet in the Alaleona Chapel in S. Lorenzo in Lucina (1624). In the second painting, done by Vouet just prior to his departure for Paris, the Caravaggesque element has disappeared and the Bolognese influence predominates. This is recognizable in the colour scheme, the spatial continuity suggested by the chiaroscuro and the diagonal composition, introduced by Lodovico Carracci and adopted by Reni, Lanfranco and others.

Stanzione apparently went to Rome a second time during the years 1625–30, returning to Naples in 1626 (Novelli Radice 1974). De Dominici says that Stanzione was at this time made a *Cavaliere dell'Abito di Cristo* by Urban VIII after he presented a painting to the Pope and executed an altarpiece for S. Lorenzo in Lucina, which has strangely disappeared although still referred to in the guidebooks until 1903. These years were the culminating point of Lanfranco's Roman career and of his rivalry with Domenichino, the former painting the cupola and the latter the apse of S. Andrea della Valle. This was also the time of the neo-Venetian works painted by Andrea Sacchi, Pietro da Cortona and Poussin, the rising stars of the Barberini court. Little is known of what Stanzione painted in Rome; his return to Naples is documented in November 1630 by a payment for an *Annunciation* in SS Annunziata. In April 1633, he received payment for the St. Bruno chapel decorations at S. Martino and in August of the same year for six canvases for SS Marcellino e Festo. The commissions in the 1630s also included the stories of St. John the Baptist for the King of Spain (Cat. 156).

The arrival in Naples of Domenichino in 1630–31 and of Lanfranco in 1634 was of decisive importance and they received the most prestigious commissions available in the city. But the extent of their influence on local Neapolitan artists is debatable, even though the very existence of their large fresco cycles must have been significant.

Lanfranco's dramatic, high baroque style, which he developed to the full during the long period of his stay in Naples (until 1646–47), was of course itself a move away from Bolognese classicism. His first important commission in Naples was the decoration of the cupola and pendentives of the Gesù Nuovo (1634–36); the cupola was destroyed in the earthquake of 1688, but the gigantic Evangelists in the pendentives are still there, painted in his mature Roman style, so essentially different from Reni's calm lyricism and from Vouet, Artemisia Gentileschi and the Caravaggesque tradition which had influenced him towards the end of the 1610s. Cavallino, in a few easel paintings of arcadian subjects like *Erminia and the Shepherds* (Gallerie Capitoline, Rome) and the Brunswick *The Finding of Moses* (Cat. 34), both probably painted in Naples in the 1630s, reveals a silvery tone in the light that echoes the Van Dyckian influence felt in Naples at this period. There are marginal affinities between Lanfranco's sole contribution to the choir of the Cathedral at Pozzuoli, the *Landing of St. Paul* (Cat. 77) of about 1636–40, and Artemisia's *S. Gennaro in the Amphitheatre* (c. 1635–38), but the noble elegance and calm of her *Adoration of the Magi* there, which could have impressed Guarino, Schönfeld, Beltrano and Cavallino, is fundamentally different from Lanfranco's art. There is a certain homogeneity

in this group of paintings, but it is very superficial, as is illustrated by the two other paintings in the series designed by Lanfranco and painted by his assistants, which are marked by a baroque power and crude execution. The works that Artemisia did after her return from England, such as the large *Bathsheba* (Columbus Museum of Art) painted with Codazzi and Spadaro, have even less in common with Lanfranco and instead show affinities with Stanzione, Beltrano and Cavallino.

Nor do Lanfranco's rare altarpieces seem to be related to contemporary Neapolitan art, as we can see from the large *Annunciation* commissioned by the Viceroy Monterrey for the church of the Agustinas Descalzas in Salamanca, painted around 1635–36. This was even more the case with the frescoes in the nave vault and choir of S. Martino (1637–39/40), where there is a tremendous contrast between their fully baroque style and that of the surrounding works by Neapolitan artists. The influence of these frescoes, specifically that of the heavenly vision of Christ supported by angels, was not felt until much later, in Giordano's figures of the 1670s onwards, like the frescoes at S. Brigida of 1678 and the paintings formerly at Montecassino.

Ribera, on the other hand, was sometimes sensitive to Guido Reni; his famous *Immaculate Conception* of 1635, which is above the altar designed by Cosimo Fanzago in Monterrey's church in Salamanca, certainly reveals the influence of the Bolognese master in its design and bland tonality. Monterrey chose for one of the paintings surrounding the retable a *St. John* by Reni, and the classicizing effect of the ensemble is emphasized by Turchi's *St. Joseph*.

But Ribera was not a fresco painter and neither Stanzione nor Caracciolo before him had embarked on a task of the magnitude of the Gesù Nuovo and S. Martino decorations, which Lanfranco undertook. They felt, however, that they were the true masters of the medium of oil painting, of altarpieces and religious subjects, even though Lanfranco secured the largest share of the series illustrating ancient Roman life for the Buen Retiro Palace in Madrid (Cat. 78). Ribera and Stanzione in fact won the majority of the commissions for altarpieces in Naples in the 1640s; Lanfranco's painting for the chapel of S. Ugo at S. Martino was rejected; it was Stanzione's picture that was eventually accepted (1644). Lanfranco's relationship with his major Neapolitan patrons became difficult; the Jesuits at the Gesù Nuovo found his price exorbitant; he had to sue the Carthusians at S. Martino and stopped working for them.

This did not, however, discourage the Theatines, who employed Lanfranco to decorate SS Apostoli, a project of a magnitude that Lanfranco had never faced before, comprising the choir, the pendentives of the cupola (though not the cupola itself), the vault and lunettes of the transepts, the vault of the nave and the inner façade of the entrance wall. These frescoes and the second huge cupola decoration that he painted in Naples, that of the Cappella del Tesoro in the Cathedral (1643), were again of greater importance for the generation of Neapolitan painters in the second half of the century, including Lanfranco's pupil Beinaschi, Luca Giordano, Paolo de Matteis and Francesco Solimena. In Rome, Lanfranco had by no means been solely a fresco painter; but in Naples the diminishing demand for oil paintings from his hand made it possible for him to do several altarpieces that were sent to cities in Tuscany and Emilia.

Lanfranco and Domenichino had been called to Naples by the *Deputati del Tesoro* and were naturally regarded with suspicion and envy by Neapolitan painters. The latter were, however, aware that they lacked Lanfranco's easy decorative talent as a fresco painter; they respected his abilities in this direction and there was no opposition when he was given the commission to paint the cupola of the Cappella del Tesoro after Domenichino's death in 1641.

In contrast, Ribera and Corenzio had done all they could to terrorize Domenichino and sabotage his works by criticism and intrigue. His classical restraint influenced Stanzione (in the 1640s), Stanzione's pupil Pacecco de Rosa and even occasionally Ribera. However, all the sources name Ribera as Domenichino's arch enemy. Ribera's unfavourable comments are reported by the latter's biographers: 'Domenichino was not a painter, because he did not colour from life, he was only a good, simple draughtsman' (Passeri) and, more viciously, 'Domenico was no painter, and . . . he did not even know what a paint brush was for' (Bellori). Malvasia adds that Lanfranco was an enemy of Domenichino's and De Dominici says that Ribera, Corenzio and Battistello acted together at the time of the intrigues which led to Domenichino's flight to Rome in 1634. Stanzione would have nothing to do with these dirty manoeuvres, according to De Dominici. Two days after Domenichino died on 6 April 1641, the *Deputati* decided that the cupola fresco should be finished by Lanfranco. Stanzione was nominated by Domenichino's heirs to evaluate his work; the *Deputati* nominated Ribera. They both testified that the half-finished frescoes were not by the artist's own hand and that they were so badly executed that it would be necessary to have the whole thing taken down.

Of the six altarpieces of the chapel, Domenichino had painted two major and three minor ones, with a fourth small altar left unfinished. On 6 June 1641, Ribera was commissioned to paint the remaining major altarpiece and Stanzione to make the minor one. Both show the influence of

Domenichino; De Dominici says that Stanzione wanted to 'imitate the softness and sweetness of Domenichino's colours. . . .'. Perhaps the *Deputati* asked the artists to paint in a manner that would blend with the dead master's style. Certainly, this instance of Domenichino's influence is almost unique in Ribera's work (any Bolognese elements are taken from Reni). But this is not the case with Stanzione. Although Stanzione ignored Domenichino's figure style and his handling of paint, the static, hieratic compositions of the *Lives of SS Peter and Paul* (nave vault of S. Paolo Maggiore) are inconceivable without Domenichino's pendentives in the Tesoro chapel. But it seems probable that the classicizing, Roman quality of Stanzione's work was prompted by the subject matter; the lateral paintings in the Cappella della Purità in the same church are of the same date, but are very melodramatic in character and show no trace of Domenichino's influence.

Pacecco de Rosa, Stanzione's most classicizing and also most pedestrian pupil, was more profoundly influenced by Domenichino. De Dominici mentions only that he studied Reni and Annibale Carracci, apart from his master Stanzione and *la bella natura*; Causa has added Domenichino, Vouet and Artemisia to the list. The influence of Domenichino is particularly evident in the *Martyrdom of St. Lawrence* (Cat. 91) the *Finding of Moses* (Santa Barbara, University of California), the *Adoration of the Shepherds* (Montecitorio), *Armida's Farewell* (Capodimonte) *The Massacre of the Innocents* (Cat. 92) and the *St. Sebastian* (Vienna). But Stanzione's influence always remained paramount in Pacecco's style.

Other artists influenced by Domenichino included Andrea Vaccaro, although he was such an eclectic that he could adhere to any style 'without rule, discipline or programme' (Causa). De Dominici says that Francesco Di Maria was a pupil of Domenichino and worked with him on the Tesoro frescoes, but he was only 18 years old when Domenichino died in 1641. He was later to become the leader of a classicizing group, in opposition to Giordano.

Finally, the works of two late arrivals should be mentioned in any discussion of outside influence on Neapolitan art of this period. Charles Mellin's altarpieces painted in Naples between 1643–47 and Guido Reni's *Adoration of the Shepherds* commissioned by the Carthusians of S. Martino, which arrived in Naples after Reni's death.

Mellin may have travelled from Rome to Naples in 1641 in the train of Ascanio Filomarino, the newly elected Archbishop of Naples. In 1643 he was commissioned to paint the high altar in SS Annunziata, where Lanfranco had painted the spandrels over the lateral arches in 1641, and Stanzione *due quadroni* for the side walls of the choir. All these works perished in the fire of 1757. The *Presentation in the Temple* which Mellin finished early in 1645 was certainly his most important Neapolitan work. It was valued at 600 ducats by Stanzione, Ribera and Lanfranco. We know the composition from a contemporary etching, but it is difficult to judge how much he was influenced by Neapolitan artists. Mellin's two works in S. Maria Donnaregina have been preserved: the *Annunciation* and *The Immaculate Conception* (Cat. 87) of 1645–47. Compared to his Roman works of around 1630 the colour scheme has become darker, the modelling harder, but most obviously the proportions have become more slender and elegant (in the *Annunciation*) and more elongated (in *The Immaculate Conception*). It is unlikely that Mellin's altarpieces in Naples would have exerted any influence on Stanzione or any other Neapolitan contemporary; they remain rather isolated artistic statements.

This is not the case with the other arrival; Guido Reni's *Adoration of the Shepherds*, which De Dominici called 'unfinished', sent from Bologna after the artist's death in 1642 and placed on the high altar of S. Martino, replacing a painting by Ribera. De Dominici reported the sensation the arrival of this picture caused and Stanzione's enthusiasm for it. He praised the excellent arrangement of the figures, the happy distribution of light and the nobility of the overall conception, and declared that it was a perfect work in every respect. He also mentioned Ribera's misgivings, which were hardly surprising as his own painting had been rejected. However, despite Stanzione's praise, Guido's late *maniera larga*, so different from his earlier works in the Girolamini, came to Naples too late to affect Stanzione and the artists around him (Pacecco, Beltrano, Cavallino, Vaccaro and Guarino). It bore fruit only 20 years later in Giordano's airy and luminous paintings of the early 1660s, like the *S. Gennaro Frees Naples from the Plague* (Cat. 66) and *St. Michael Vanquishing the Devil* (Cat. 67) in which he quoted directly from Reni's celebrated image in S. Maria della Concezione in Rome. The closest reflection of Reni's *Nativity* is found in Giordano's *Rest on the Flight* of 1664 in S. Teresa a Chiaia, which Ferrari and Scavizzi rightly relate to Reni's late masterpiece and which appeared to De Dominici's eyes 'to be almost by Guido Reni himself, so miraculously had his style been imitated by Giordano'.

Baroque and Classical Tendencies in Neapolitan Painting 1650–1700

NICOLA SPINOSA

The idea that the tragic consequences of the plague of 1656 made a deep caesura in the development of Neapolitan painting has now been disproved. The fact that the pictorial traditions of the first half of the century were superseded was not a direct consequence of the sudden disappearance of the painters who probably died in the plague and who had been the foremost artists in the second quarter of the century. Some innovations are already visible in various paintings dating from before 1656, and some of the leaders of Neapolitan painting after the plague had produced significant work before that date. Those who worked in the second half of the century – from Gargiulo to Vaccaro, from Giordano to Francesco Solimena – believed they were continuing in the tradition of earlier Neapolitan painting.

This was an attitude shared by painters who, like Andrea Vaccaro or the younger Francesco De Maria and Giacomo Farelli, were conservative in their attitude towards earlier painting, and by those who tried to surpass the achievements of the earlier generation. There were precedents for the Neapolitan painters' interest in currents and styles emerging elsewhere in Europe. Caracciolo, Ribera, the Master of the Annunciations, Stanzione, Falcone and Cavallino had all been aware of outside trends. So the plague did not fulfil a purifying and cathartic role; it was simply that Neapolitan painting of the second half of the century was less complex and more uniform in style.

Apart from painters like Mattia Preti (whose stay in Naples was brief but prolific), Luca Giordano, Giovanni Battista Beinaschi, Francesco Solimena and Paolo De Matteis, who were all independently engaged in reviving Neapolitan art and very aware of the developments in the rest of Europe, other artists active in Naples merely painted under the shadow of these masters or followed earlier models.

Having established that the plague of 1656 played no part in the development of Neapolitan painting, despite its grievous consequences for civic life and society in Naples, it becomes necessary to trace the steps by which Neapolitan art was transformed in the second half of the century and the way in which this was effected without a break in continuity. The introduction of the baroque style was in fact due principally to the presence in Naples of Mattia Preti between 1656 and 1660, and of the young Luca Giordano, who after 1656 embarked on an extraordinary adventure with the baroque which carried him over into the rococo of the eighteenth century.

One origin of this baroque movement was the move towards painterliness which took place in the mid-1630s, both amongst naturalistic painters dependent on Ribera and the anonymous Master of the Annunciations, and amongst those of a classicizing tendency, whose chief protagonist was for a long time Massimo Stanzione. This change was prompted by local painters' contacts with the wave of neo-Venetianism in Rome in the years following 1633–34 and by the tendencies that developed in the wake of Rubens' and Van Dyck's visits to Italy. The artists who were involved in this development included both complex naturalistic painters such as Ribera, the Master of the Annunciations, Francesco Fracanzano, Francesco Guarino, Antonio De Bellis and Bernardo Cavallino and classicizing painters such as Stanzione, Aniello Falcone, Andrea Vaccaro and Pacceco De Rosa. This new painterliness was, however, not a reaction against all earlier tendencies, but rather a desire to paint more broadly and tenderly (Bologna 1958, p. 17).

One painter who was a catalyst in this change to the baroque was Giovanni Lanfranco. He was in Naples from 1632, working in the Cappella del Tesoro, at the SS Apostoli, at S. Martino and on the cupola of the Gesù Nuovo, creating the astounding spatial illusionism which he had already painted in S. Andrea della Valle, Rome. At the same time Neapolitan painters were visiting Rome, where they could study the decoration of Palazzo Barberini, the sacristy of the Chiesa Nuova and the work of Pietro da Cortona. Works by Guercino and Pietro da Cortona had already arrived in Naples, both in private collections and in churches. One might expect that, as a result of these contacts, Neapolitan baroque would have paralleled developments in Rome.

But an examination of the painting produced in Naples between 1635 and 1650 makes it apparent that the contacts with the neo-Venetian trend, the painterliness of Rubens and Van Dyck, the work of Castiglione and even the work of Poussin before his final turn to classicism did not produce the same results in Naples as in Rome. Until the middle of the century, the attitude of

the Neapolitans was, if not one of decided opposition to baroque tendencies, either one of indifference or of almost total incomprehension.

The early presence of works by Guercino and Pietro da Cortona passed almost wholly unnoticed in Naples and patronage was determined by the taste of local religious bodies (in particular Theatines and Jesuits) who were influenced by the recent directives of the Counter-Reformation. Lanfranco's paintings were understood locally not to be examples of the rising tide of the baroque, but rather the last off-shoots of the classicizing current deriving from the Carracci.

The influence exerted by the various protagonists of neo-Venetianism and painterliness did, however, succeed in producing a wide variety of tendencies in Neapolitan art, even if they did not produce a baroque style. In the case of painters with a naturalistic background, their attention to some aspects of Rubensian and Vandyckian painterliness produced an extraordinary refinement of the original qualities of their work, in terms of both colour and light, and a softening and greater intimacy in their expressive powers. This reached its peak in the work of Cavallino at the time of his *S. Cecilia* of 1645 (Cat. 28), but was pushed still further by Ribera between 1646 and 1652, to produce works of exhilarating pictorial beauty and truth of expression, without yielding to classicizing solutions or studied academicism.

Amongst Stanzione's followers, things developed differently. Although they shared in the common move towards a painterly style, their ideological notions drove them to refer back to the example of Reni and Domenichino. Consequently they preferred to study the neo-Venetians who had combined precious colouring with balanced compositions and refined elegance of form, artists such as Sacchi, Poussin of the late 1630s and Mellin at the time of his work in S. Luigi dei Francesi and Montecassino where his innate classicism was combined with a cultured sensitivity of expression. Given these strictures, little or nothing could be conceded to the new style of the baroque. In fact, Stanzione's late works, with their monumental compositions, solemn content and reasoned articulation in terms of the structure of the painting reached solutions that were utterly at variance with the overwhelming illusory exuberance of baroque painting.

In broad outline this was the situation in Neapolitan painting from the mid-1630s until the sad days of the plague in 1656. Only Cavallino seems to attempt something different in his small-scale compositions after the *S. Cecilia* of 1645. He followed his own poetic ideal of highly refined images and fragile sentiments which was very different from the sustained courtly elegance of Stanzione.

So it might be argued that for all those infected by the new painterliness in the 1630s, there had been little advance in comparison with the progress made in the same period in Rome. The 'crisis of painterliness' that was so rich in consequences for painters in Rome, did not succeed in abolishing the local naturalistic or classicizing tendencies in Naples. It was only after 1656, with the work of Preti and Giordano, that Neapolitan painting came into line with the modern tendencies that had developed in Rome in the climate of the baroque.

The reason that Neapolitan painters developed independently may be sought in a variety of causes, including the local political, economic and social situation, local cultural patterns and Neapolitan religious attitudes. In this context, it is necessary to recall the influence exerted in Naples by the monastic orders linked to the Theresian and Alcantarian reform over an extensive period and by quietism, which found fertile ground in the south of Italy. This movement favoured a form of mystical devotion with a high emotional content and it revived and diffused devotional practices which encouraged a more direct link between the believer and the divine.

These ideological tendencies were substantially different from those of the Roman church, particularly the Jesuits, who exalted the value of the universal over the particular, favoured religious practices that promised the possibility of overcoming the limits imposed on the human condition and reaffirmed the role of the ecclesiastical institution as the sole valid intermediary between believers and the deity.

It is clear that such a duality would also be reflected in painting, given its function as one of the chief instruments of religious propaganda and as a tangible form for the expression of religious abstractions. It is not without significance that the impulses and certainties of the Roman Church Triumphant in the early Seicento were best expressed in optimistic and overwhelming baroque visions of unlimited space while in Naples the type of religiosity favoured by the Alcantarines, the Theresians and quietists showed itself in the preference for subjects which dwelt on, and even exalted, the pain and suffering of human existence.

In explaining the comparative indifference to the baroque in Naples, we should not forget that the political, economic and social situation of Naples was very different to that of Rome. In these years Rome was dominated by the splendours of a papal court that was intent on reaffirming its past role as a great temporal power and as the universal guide of Christendom by whatever means were available. Both the religious orders and the great patrician families were involved in monumental artistic projects to celebrate the prestige they derived from offices

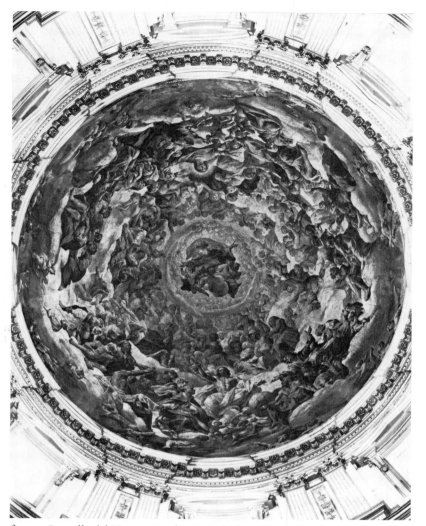

fig. 14 Cappella del Tesoro, Naples Cathedral; ceiling by Lanfranco

ruling classes. It was only after the uprising of 1647–48 and the plague of 1656 that the politicians realized how paintings could be used as an efficacious instrument of ideological affirmation and began to comprehend the great potential of the baroque as it had been employed in Rome.

While in Rome fresco painting had been open to the daring experiments of baroque illusionism since the late 1620s, in Naples, with the exception of Lanfranco and Domenichino, it remained the exclusive domain of painters either tied to the late mannerist tradition (Belisario Corenzio, Luigi Rodriguez), or dependent on the classical tradition and Domenichino (Massimo Stanzione).

By the middle of the seventeenth century, there were signs of artistic exhaustion in Naples. Apart from Ribera and Cavallino, the Neapolitan artists, for example Francesco Fracanzano and Antonio De Bellis, were producing works that were facile and incapable of giving life to new forms of art. In Stanzione's circle, despite some efforts to transcend local experience, Vaccaro and Pacecco de Rosa evolved styles of controlled elegance with increasingly obvious academic involution.

All these traits must have been apparent to the young Giordano when he entered Ribera's workshop around 1650. His work until the eve of the plague of 1656 reflected his desire to retrace the last 15 years of Ribera's activity, from the time of the painterly crisis of 1633–34 to his work after 1646. He was also impressed by the mature work of Stanzione and Francesco Fracanzano, Aniello Falcone and Vaccaro, but the impact of Ribera and the Master of the Annunciations, and his study of Caravaggio's work, clearly shows what aspects of the recent history of Neapolitan painting seemed, to the precocious sensibility of the young Giordano, worthy of consideration.

In particular, he studied the art of the 1630s during the transition period from naturalism to painterliness. The young artist, still not 20 years old, fully understood the richness and fertility of that moment and perceived the value of the way that it had opened up Neapolitan art to the influence of European paintings as a whole, and rescued Naples from the incipient cultural provincialism towards which its painting seemed to be drifting at the beginning of the 1650s. In this regard, his versions of earlier compositions by Ribera, his first, timid imitations of Lanfranco's and Pietro da Cortona's work in Naples and his early adhesion to the ideals encouraged by the Accademia degli Investiganti (documented by the series of *Philosophers* distantly derived from Ribera or Fracanzo) all yielded fertile results.

But it was above all his journey to study at Rome, Parma and Venice around 1653 that affected the direction of his art. The journey assumed a symbolic value, for it was a journey

assigned to them within the new organization of the papal state. In a society governed by precise and rigorous hierarchical laws, the arts became an instrument to promote a policy of consensus among all social classes. And the baroque, in which every element, iconographical detail and the materials used were built into a unified whole presenting the image of an infinite universe directed by Divine Providence, was the most appropriate style with which to convey the principle of hierarchy.

But in Naples, there were deep rifts in society. The increasing political and administrative weakness resulting from the control of government from Madrid with the viceroy as its sole guarantor, the attempts of a fractious nobility to defend its ancient privileges and the existence of an ecclesiastical and monastic class that was powerful both in numbers and property, served to bind the function of images almost exclusively to individual or factional needs. Works of art interpreted the conservative tendencies of the

51

back in time, to study what seemed to him the most important sources for the development of modern art. In Rome he studied not only Michelangelo and Raphael, as was customary, but also Lanfranco, Pietro da Cortona and neo-Venetian works, especially those of Rubens in the Chiesa Nuova. Later he studied Rubens' sources: Correggio in Parma and finally, in Venice, Fetti, Liberi, Strozzi and, most important of all, the paintings of Titian, Veronese, Tintoretto and Bassano, which he recognized as the source of all that was good in contemporary painting.

Giordano's decisive break with Neapolitan traditions and his adoption of the baroque style were prompted by Preti's arrival in Naples with his 'full-bodied thunderous baroque, realistic and apocalyptic' (Longhi). Preti's brief but fertile Neapolitan stay (1656–1660) was exceptionally important, not merely for Giordano's development, but for the quality of works he produced there. In this period, just after his stay in Modena and before he went to work for the Knights of Malta, he produced a series of frescoes, altarpieces and vast canvases for church vaults and private residences. Preti managed to show what Giordano had already sensed: that Neapolitan painting could be revitalized and lifted above the merely provincial through a reconciliation of the naturalistic tradition and the full tide of the baroque.

Preti's early Neapolitan work, which still echoes Lanfranco, also approaches Battistello and Ribera, but the dark, thick paint is interrupted by flashes of incandescent light. He had already absorbed the influence of Caravaggio during his training in Rome; the other artist of fundamental importance to his art, both in terms of breadth of composition and colour, was Veronese. This is particularly obvious in Preti's later Neapolitan paintings – the celebrated feasts reminiscent of Veronese and the canvases which decorate the ceiling of S. Pietro at Maiella (fig. 15) 'in the Venetian manner' which Giordano must have appreciated. These works show Preti's modern feeling for vast, extended space and his transposition of Caravaggism into baroque terms. His technique is broad and fluent, his paintings enveloped in a warm luminosity which amplifies the space of the compositions and enhances the florid forms and colouring derived from Veronese.

He avoided any facile fashionable illusionism; in his work the baroque style, perhaps for the first time, communicated clearly authentic sensations and emotions which retain intact the image of a 'true' humanity capable of deep and real feelings and, as a result, the effect was all the more sincerely 'heroic' and monumental.

Preti's example accelerated tendencies which were already present in Giordano's art. The two artists worked on equal terms. From Giordano's assimilation of the neo-Venetians, Rubens and the masters of the Venetian Cinquecento, Preti was prompted to return to his early study of Veronese's sunny, grandoise compositions. In return, Preti set Giordano 'the valid and stimulating example of a mental attitude which considered the art of the present and the past as an open field that did not impose awe or 'academic' norms, but was freely available for new experiences' (Ferrari 1970, p. 1246).

When Preti left for Malta, Giordano resumed his polemic against tradition with fresh energy, as if he were taking up a sort of crusade entrusted to him, and returned to the study of the Venetians of the Cinquecento and to Rubens. He still made passing references to Ribera, the late work of Annibale Carracci, the young Poussin and, in particular, to Pietro da Cortona.

In his middle phase he had reconsidered Pietro da Cortona's Florentine work, the Correggesque qualities of Lanfranco's painting and Maratta's classicism, but above all his art had been enhanced by contacts with Gaulli's art with its echoes of Correggio and Bernini.

The resulting style was certainly baroque. By this stage Giordano went beyond imitation, giving free rein to his heart rather than his mind, and he translated into coloured fantasy the intense emotions generated by the endless spectacle of light, form and colour in which natural and supernatural reality presented itself to his restless, dreaming mind. He painted with a feeling for the variety and vastness of Nature and the Universe, translating that baroque idea of unlimited, continuous space into images painted in his own modern style.

His altarpieces and secular works were of extraordinary pictorial intensity and he had painted vast, exhilarating fresco cycles in Florence, Naples, Madrid, the Escorial and Toledo. His last work, significantly painted at the beginning of the eighteenth century, was the decoration of the small dome of the Treasury of S. Martino. These *Stories of Judith and other Heroines of the Old Testament* are the most radiant introduction to the new, refined style of the European rococo, the source of all art from Ricci to Tiepolo, and from Giaquinto to Fragonard. They constituted a passionate plea by the aging Giordano to future artists to free creative fantasy from the limits of the real and mundane.

So, after the hesitations and difficulties earlier in the century, the baroque style finally emerged fully with Preti and the classicizing tendencies of Francesco Solimena at the beginning of the eighteenth century.

The art of Giovanni Battista Beinaschi is less innovatory than that of Giordano, but has signs of modernity never found in De Maria or Farelli. He was born in Piedmont and was long active in Naples; he worked in a markedly neo-Lanfranchian vein, close in style to Giacinto

fig. 15 S. Pietro a Maiella; ceiling by Mattia Preti

Brandi in Rome. His vast frescoes and canvases at S. Maria degli Angeli at Pizzofalcone, S. Maria delle Grazie at Caponapoli and SS Apostoli show a successful integration of the proto-baroque characteristics of Correggio present in Lanfranco's work and demonstrated his importance as an artist and source of a baroque style and sensibility who had not renounced, as Giordano had, the need for formal clarity.

Beinaschi's admiration for Lanfranco not only reflected a desire for stylistic continuity, but also coincided with an enthusiasm for Giordano.

But while Giordano was the single most important artist in Naples during the second half of the Seicento, at least until Francesco Solimena's maturity, Neapolitan painting was not entirely dominated by the baroque style. Despite the vast number of prestigious commissions that Giordano received from churches and palaces in Naples, he assumed an attitude of almost ostentatious independence from the local environment, preferring his art to be regarded in an European context. It was only on rare occasions that local patrons could grant him the scope offered by the Palazzo Medici-Riccardi in Florence, the Monastery of S. Lorenzo at the Escorial, the Buen Retiro Palace in Madrid or the Cathedral of Toledo.

So while Giordano was painting his airy baroque visions, and injecting into Neapolitan painting a new life that was vital for later developments, there was greater local enthusiasm for painting of a more traditional nature. Apart from those who belonged to the older generation, like Andrea Vaccaro or Giuseppe Marullo, or whose work was modest in quality, like Giacomo di Castro, we should mention some painters who were trained almost at the same time as Giordano and who set out to compete with him.

Painters like Francesco Di Maria and Giacomo Farelli resisted Giordano's innovations and upheld classical values, maintaining in traditional fashion that form was more important than painterly qualities. However, they did not completely ignore recent developments; in fact, Di Maria often attempted to graft Preti's finer modelling onto his classical style and Farelli borrowed from both Preti and Giordano. But the attitude of Di Maria and Farelli represented an artistic philosophy that, revived by the Arcadian movement, was later the background to the re-evaluation of his painting that had already had a significant impact on Preti's work at Modena, Naples and Malta and even on that of Giordano. Lanfranco's influence was to be decisive for Francesco Solimena's development around 1665–70, after his naturalistic beginnings with his father Angelo and his early interest in Giordano.

With Francesco Solimena, who was after Giordano the greatest artist active in Naples in

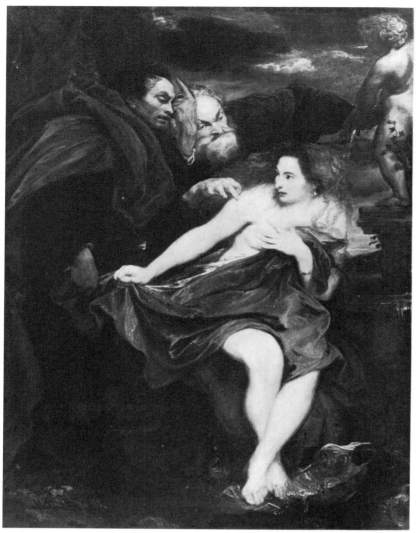

fig. 16 Van Dyck *Susanna and the Elders* (Alte Pinakothek, Munich)

awareness of the Neapolitan naturalistic tradition, as well as of Lanfranco, Pietro da Cortona, Giordano and Preti and even of Maratta's tempered classicism, is marked by a sense of compromise between old and new, between tradition and modernity, that distinguishes it from the work of Di Maria and Farelli.

Unlike Giordano at the same period, Solimena, from the time of his earliest maturity and increasingly around the turn of the century, endowed his art with an ethical as well as an exquisitely aesthetic value. It was a method of presentation, which, while appearing direct, in fact concealed a complex cultural background and it represented a synthesis of the artistic tendencies of the whole century in its pursuit of a style rather than a formula. A style capable of fulfilling needs that went beyond the intentions of baroque painting and of meeting the demands of Neapolitan religiosity, with its Counter-Reformation impulses and quietism as well as the rationalist tendencies of some of the more progressive sectors of southern society.

In this Solimena was close to, and possibly influenced by, Paolo De Matteis who, after a period in Rome in Carlo Maratta's circle, engaged in a sort of compromise between classicism and baroque around 1690. This phase of his work influenced various painters who began with a more rococo manner, such as Francesco De Mura and Fedele Fischetti. Solimena's work, in particular at the turn of the Settecento, surpassed even the brilliance of De Matteis' reinterpretation of Maratta in terms of light and colour.

So while the lesson of Giordano, now tempered by the influence of Genoese late baroque painting, petered out in the decorative, subtly rococo and secular work of Domenico Antonio Vaccaro and Giacomo del Po; Solimena, already one of the foremost protagonists of the new painting in Europe and the only painter in Naples with a positive sense of an uninterrupted continuity of ideas, even more than of style, stood poised between the tendencies of the great seventeenth-century tradition and the new direction of the century that had just begun.

the second half of the Seicento, the various tendencies that had emerged in painting over a span of more than 50 years, from Lanfranco to Preti and Giordano, reached the point of greatest visual impact. His work up to the beginning of the eighteenth century, though showing an

Foreigners in Naples and Outside Commissions

ELLIS WATERHOUSE

A native school of painting, recognized by the outside world as Neapolitan, does not exist before the seventeenth century. In the middle years of the fifteenth century there is an outcrop of puzzling works in a Flemish style, which are associated with a rather mysterious painter named Colantonio, who was said to have been the teacher of Antonello da Messina: but the Court tradition, in both Angevin and Aragonese times, had been to summon artists from outside Naples, beginning with Cavallino and Giotto; or to order splendid works from famous artists, who were unwilling to come to Naples, but whose work would be studied with attention by the local painters. The classic forerunner of such importations was Simone Martini's picture of 1317 which showed St. Louis of Toulouse crowned by Angels, and himself crowning his brother King Robert of Naples, which was probably sent from Siena. In the sixteenth century there were in the Neapolitan church of S. Domenico Maggiore paintings by both Raphael (the *Madonna del Pesce*, now in Madrid) and Titian (the *Annunciation* of 1557, still in the church) which reveal the same tendency; and Vasari had visited Naples in 1544. The ablest local resident painter in the second half of the sixteenth century was a Sienese, Marco Pino (in Naples 1557–87), but local painters seemed out of date to the richer patrons in Naples, the religious orders, whose mother house was often in Rome and who kept an eye on what was considered fashionable in Rome.

The first of these to embark on an ambitious new building programme was the immensely rich Certosa di S. Martino, which was later to become the best patron for the new rising school of Neapolitan painters. The Carthusians began their church in 1580 and in 1586 summoned the most fashionable and promising young painter in Rome, Giuseppe Cesari d'Arpino, to begin the frescoes in the choir. At intervals between 1586 and 1597 he and his brother Bernardino painted frescoes in the choir, on the ceiling of the sacristy and elsewhere for the Carthusians, and, in the mid 1590's, one of the most talented young Flemish painters, Wenzel Cobergher, who owed a good deal to Cesari d'Arpino, was also active in Naples (but all his work there has disappeared). The next foreign visitor from Rome was also a Fleming, Paul Brill, whose frescoes in the atrium of S. Maria Regina Coeli are dated 1602. Their bosky landscapes perhaps introduced a tendency in Neapolitan painting which was to find an outlet eventually in Salvator Rosa.

Caravaggio's thunderous passage through Naples in 1606–07 (see Professor Gregori pp. 36–40) reorientated the attitudes of the more intelligent local painters and this new direction was probably emphasized by the presence in Naples from at least 1608 (and perhaps from prior to Caravaggio's departure in 1607) of the Fleming Louis Finson. Finson remained in Naples until 1612 and was active in picture dealing and painting copies of Caravaggio's pictures, and although he was not an artistic personality of high calibre, he was an active artistic busybody. In 1610 the first of the two Lorraine painters from Metz whose work was long conflated into the personality known as Monsù Desiderio, François Nomé, came to Naples, where he was active until at least 1618 and probably longer. His strange art ultimately derives from Paul Brill and reinforces the Flemish element in the pattern of Neapolitan art.

It was in the autumn of 1616 that the Spaniard Ribera moved from Rome to Naples. He was already familiar with Roman Caravaggismo, but he did not start signing his paintings till the 1620s, when he had already matured his Neapolitan style; he rates from that time onwards, not as a foreigner, but as one of the founders, and perhaps the greatest master, of true Neapolitan painting, and he was to live and work in Naples for the rest of his life.

The lesson of Caravaggio was also to be reinforced during the 1620s by the personality of the Frenchman, Simon Vouet, whose style forms an essential ingredient in that of Ribera's chief rival, Massimo Stanzione. There is no positive evidence that Vouet ever visited Naples, but a visit around 1620 seems highly probable. That is the date on *St. Bruno Receiving The Rule* (Cat. 163), which, although there is no mention of it at the Certosa before the nineteenth century, seems so quintessentially suited to that great Carthusian complex that it can hardly not have been commissioned for it. Vouet was certainly in high favour at Naples in the 1620s for in 1622 (or 1623) he signed and sent from Rome the *Circumcision* for the high altar of S. Angelo a Segno (Cat. 164); at about the same time, he painted a series of *Angels with the Symbols of the Passion* which were famous in the collection of the

Filomarino family, Principi della Rocca, and two of which survive at Capodimonte today. In 1622 also Guido Reni paid a brief visit to Naples, but failed to agree to accept a commission to paint the frescoes in the Cappella del Tesoro of the Cathedral. The fact that it was still felt desirable to get a foreigner to paint in the most sacred spot in Naples is indicative of that hostility to native painters pointed out by Professor Haskell (see p. 60).

By 1630, and possibly a year or more earlier, Artemisia Gentileschi had established her studio in Naples, from which she despatched a steady stream of commissions to other Italian cities, and even, apparently, as far as England. She was a formidable lady and seems to have had a great influence in local artistic circles. She reinforced that substratum of Caravaggesque realism which already prevailed at Naples; she liked the rather gruesome subjects which were locally popular; and she specialized in scenes from mythology and classical or biblical history in which women had played a spectacular role. Judith and Susanna were among her favourite themes. As far as we know, she remained based on Naples – except for a short visit to London from 1639–40 at the time of her father's death in London – until her own death about 1652.

By 1631, Didier Barra, the second Lorraine artist who was confused in the double personality of Monsù Desiderio until they were disentangled by Professor Causa, was already in Naples, where he remained until at least 1647, when he signed the extraordinary *View of Naples* (Cat. 3). Indeed the 1630s were a decade in which a change in direction is apparent in the ethos of Neapolitan painting; broadly speaking this was a modification of the prevailing Caravaggesque realism by the influence of Bolognese classicism. This is discussed in Dr Schleier's essay (see pp. 45–58) and was due largely to the presence and activity in Naples of Domenichino, from 1631–41 (with an interruption during 1634–35) and of Lanfranco from 1634–46.

Other connections with Rome also were present in the 1630s and the influence in Naples of the patronage and collections of Gaspar Roomer (soon to be discussed) began to make themselves felt. There must have been more interchange than we know of between Naples and Rome, then in the grip of Barberini patronage with Urban VIII as Pope, since the close parallel between works of a biblico-pastoral character being painted at Naples and Rome cannot be accounted for simply by the short visit from Rome made in 1635 by the Genoese painter Giovanni Benedetto Castiglione. It seems likely that it was with the studio of Aniello Falcone at Naples, where the pupils included Andrea di Lione and the young Salvator Rosa, that Castiglione was in contact. But the fact that it is still possible today to confuse works by Andrea di Lione (and certain derivations from them by Luca Giordano) with pictures painted in Rome by Castiglione or the Frenchman, Sébastien Bourdon, who was in Rome from 1634–37, suggests some more prolonged relation than a brief visit.

The two chief painters of the Barberini team of painters each received a commission for an altarpiece in this decade: Pietro da Cortona painted an altarpiece for the Girolomini about 1638, and Romanelli painted an altarpiece for the church of S. Giorgio dei Genovesi on commission from the Berio family, Marchesi di Salsa. The most impressive importation from outside, however, was Guido Reni's great picture for the Certosa di S. Martino which must have been installed about the time of the painter's death in 1642. This was followed by the actual visit to Naples from 1643–47 of the Frenchman, Charles Mellin, a pupil of Vouet at Rome, whose two handsome altarpieces in S. Maria Donnaregina Nuova reveal that painting in Rome in the 1640s had moved in the same direction as the native Naples school.

Probably in the later 1630s (but the precise dates are not known) the Dutchman Mathias Stomer, whose pronouncedly Caravaggesque arrangements of light seem to derive largely from Honthorst and other Dutchmen in Rome, appears to have spent some years in Naples before settling in Sicily. He renews the impact on Neapolitan painting of the Netherlandish schools, but a much more powerful (and more modern) impetus in this direction was given by the patronage of Gaspar Roomer, who is also discussed by Professor Haskell (see p. 63). Roomer, who came from a very good family at Antwerp, was not only a voracious collecter and importer and exporter of contemporary paintings, but was also the only collector we know who encouraged the Neapolitan artists who received his patronage to come and study his collection. He lived on until 1674, but in 1634 was already settled at a grand palace (Monteoliveto) with an enormous collection of pictures, though perhaps not so many as he possessed when he eventually died – 1,500! The list of his pictures given by Giulio Cesare Capaccio in 1634 reveals that he not only generously patronized Ribera, Stanzione, Falcone, Cavallino and other Neapolitan painters, but that he also seems to have bought *en bloc*, perhaps with a view to export, the paintings of Flemish painters who were working in Rome – there were 10 pictures by Paul Brill, 60 by Goffredo Wals and 40 by Bramer, as well as a *Susanna* and a *St. Sebastian* by Van Dyck. Later, probably about 1640, he imported the Rubens *Feast of Herod* (Cat. 138) and thus these great Northern painters, who never in fact visited Naples, were able to wield a profound influence on the Neapolitan School.

Still Life Painting in Seventeenth-Century Naples

CARLO VOLPE

An exhibition of Italian seventeenth-century still lifes, even one limited to Neapolitan examples, demands some preliminary reflection on the meaning of this genre in the seventeenth century.

The categorization of paintings according to subject does not assist in their critical appreciation, even if these categories were conceived and used by contemporaries, who assessed the relative importance of a work according to its subject matter. Today we no longer attach great importance to the subject, whether it be landscape or figures, and we often prefer subjects that were once considered less noble; for instance, a landscape by Annibale Carracci or Pietro da Cortona may be more fascinating than a religious subject or a history painting by the same artist. The painter's stature is more important than the subject of his painting.

In the Seicento most painters respected the principle of a hierarchy of genres, with the exception of countries such as Holland where a bourgeois society was less dogmatic in its artistic dictates and there was a general enthusiasm for naturalism and an anticlassical bias. The lay, Protestant, bourgeois art of the North cannot be compared to anticlassical and naturalistic painting in Catholic countries such as Italy, France and Spain. Here, the polemical attitude towards the ideal in art was the result of a conscious reaction against established archetypes and patterns. Caravaggio declared that it was as much effort for him to paint a good flowerpiece as a painting with figures; it was with this revolutionary attitude that genres of painting were abolished.

The essence of the idea of classical beauty is founded on a world of metaphysical models utterly apart from nature and objective reality, for which there are no rules. The concept of the still life, portraying a part of the real world based on empirical knowledge and observation, could be conceived only in the mind of an artist who did not adhere to the canons of classical and Renaissance art and who understood intuitively the universal validity of the new philosophy of nature. The ideas that would be established in the age of enlightenment were already clear in the minds of Galileo and Caravaggio. In art, as in science, there would never again be the insuperable obstacles of the pronouncements of Aristotle or St. Thomas Aquinas.

Still-life painting emerged at the end of the sixteenth century, at the same moment as the more significant achievements of the philosophy of nature. This was the moment of rupture between classical (and Renaissance) and modern aesthetics. So it is somewhat naive to regard the representation of inanimate objects in European painting prior to this date as precocious still lifes, whether they are independent entities or part of larger compositions.

The beautiful, symbolic *Trophy* by Jacopo de' Barbari (Munich) or the *Books* by the Master of the Aix Annunciation (Brussels and Rotterdam), which are so often called precursors of modern still-life painting, are prisoners of a spiritual world from which, as works of art, they derive their entire meaning. It is due to our contemporary over-interpretation that we discern 'modern' content that they do not possess. They are still in the tradition of the *trompe l'oeil* of classical art, and of mimesis. We can only speak of a still life in the modern sense from the time of Caravaggio. He denied the principle of *ut pictura poesis*, and claimed that painting has no didactic function nor poetic delight, but is the mirror of nature.

It is in this context that we should think of the 'still life of flowers' that Caravaggio referred to, or his *Still Life with Fruit* (Ambrosiana, Milan). Throughout the seventeenth century, Neapolitan still-life painting was based on Caravaggio's principles; in fact Naples seems to have been the only place that understood his intentions in this genre. It was only with the advent of the baroque style that his canons were abandoned.

Between 1620 and 1630 there appear in Naples the first examples of indigenous still life. The earliest masters of this tradition are still shadowy figures, some of whom we know only by name: Ambrosiello Faro, Angelo Mariano and Angelo Turcofello. But it is likely that this earliest phase was not distinctive from the artists of the Roman school. In Rome immediately after Caravaggio's death, the painter known as the Master of the Hartford Still Life and Cecco del Caravaggio both produced still lifes; the 1610s and 1620s were dominated by Salini, Pietro Paolo Bonzi and Giovanni Battista Crescenzi. Of these, it was Crescenzi's still lifes, prodigiously naturalistic, which were widely sought after both in Italy and in Spain. It is perhaps his work that

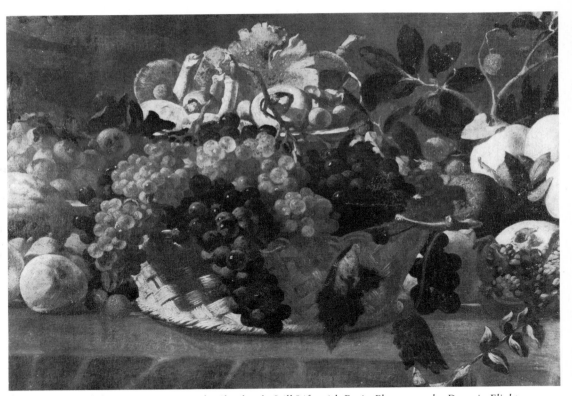

fig. 17 Master of the Annunciation to the Shepherds *Still Life with Fruit, Flowers and a Dove in Flight* (detail; see also Cat. 86)

provided the inspiration for the Neapolitans, assisted also by the probable presence in that city of Agostino Verrocchi and other Roman artists.

Certainly, by the time that Luca Forte (born perhaps before 1607) and the Master of Palazzo San Gervasio were active, probably in the 1620s, these Roman works were already fully assimilated and the study of nature growing increasingly confident, despite the fact that in Rome, where Caravaggesque 'painting from Nature' had first taken root, the artistic climate took an opposite turn. Our knowledge of these two artists is gradually increasing; an understanding of their work is fundamental for the appreciation of the attitudes and subjects of later Neapolitan still-life painting. The rapid development of the school was undoubtedly assisted by awareness of the work of Spanish still-life painters like Giovanni Quinsa, or later, Francesco Herrera, known in Naples as the *Spagnuolo delli pesci*, whose works are still unidentified. The 1630s were a time of exceptional creativity in Neapolitan painting, when figure painters such as Stanzione, Guarino, Cavallino, the Master of the Annunciations to the Shepherds, Aniello Falcone and Francesco Fracanzano were all active. All genres of painting seem to be at their peak, developing Caravaggesque popular naturalism to its fullest extent. It is difficult to believe that other important still lifes were not painted in Naples during these years, as is proved by the survival of a number of pictures that are still anonymous.

Luckily we now know something about Paolo Porpora (1617–73). He was, together with Giuseppe Recco, the most famous Neapolitan still-life painter of his day. By 1632 he was working in the shop of Giacomo Recco (1603–before 1673). Nothing of Giacomo Recco's somewhat timid, Flemish-style flower-pieces survives in Porpora's works, even though flowers were often the subject matter of his painting. Porpora studied the secret vitality of nature and painted the disquieting aspects of vegetative growth, but the force of his pictorial intelligence and the quality of his painting, notably refined when compared with its Caravaggesque antecedents, make it impossible to confuse Porpora's work with the virtuoso style of Flemish painters like Marseus van Schreeck and Matthias Withoos whom he knew in Rome.

Equally original, although with different aims, are the two greatest representatives of the Recco family: Giovanni Battista and Giuseppe. Despite the confusion between the early works of Giovanni Battista Ruoppolo and Giovanni Battista Recco, who used an identical monogram GBR, Giovanni Battista Recco (1610/15–c. 1675) was probably older than Giuseppe, who was possibly his nephew, and the two Ruoppolos. Causa (*Storia di Napoli* 1972) is right in attributing to him the introduction of a powerfully realistic type of still-life painting, one that shows an awareness of the Spanish *bodegón*, with subjects like fish, meats, vegetables, copper

pans and other utensils set in sparse and shadowy interiors. One of his best works in this genre is signed and dated 1653. Giovanni Battista's debt to the Spaniards, from Velasquez to Pereda and Loarte, does not prevent him from infusing his works with a powerful and original feeling, entirely devoid of any idea of elegance or eloquence: more than any other seventeenth-century painter he is faithful to the bare and unadorned image, set in mundane surroundings.

Giuseppe Recco (1634–95) has long been regarded as the most talented of the many genre painters who followed G. B. Recco. Having dismissed the unfounded notion that he trained with Baschenis at Bergamo, it is obvious that the roots of his art are Neapolitan in subject, composition and style, and above all in the sincerity with which he expresses his themes, by then thoroughly established in the local tradition. The tried repertory of his predecessors is re-echoed in his art; the flowers of his father Giacomo, the fruitpieces of Luca Forte and of the Master of Palazzo San Gervasio, and the harsh and penetrating light of Giovanni Battista Recco. The two paintings exhibited here (Cat. 114 and 115) give a good idea of his variety and his imaginative approach to his subject. There is an intensity in these pictures that is akin to that of Courbet, as in the *Still Life with Fish* in Munich and the similar subject in a Neapolitan private collection, the latter signed and dated 1666. But the same severity of representation adopted by his uncle Giovanni Battista for his sparse interiors reappears in his most memorable 'Kitchen Scenes', like the one in the Akademie in Vienna and the beautiful example exhibited here (Cat. 113). The work of his children Nicola Maria and Elena, and that of his numerous pupils, is sometimes difficult to distinguish from Giuseppe's later work, but is not up to his extremely high standard. Giuseppe himself was knighted and died at an advanced age in Spain in 1695, whither he had been summoned by Charles II.

Giovanni Battista Ruoppolo (1629–93) was practically his contemporary, and played a similarly important role in the development of the still life in Naples. This was recognized even by De Dominici who devoted an entire biography to this, the most important member of the Ruoppolo family. His work seemed to epitomize the attitudes and content of an entire century of still-life painting; it is he who finally combined the rhetoric of the Roman school with Neapolitan objectivity, with the colour of the humblest objects painted by Giovanni Battista Recco, the richness of Luca Forte and the opulence of Porpora.

Giuseppe Recco was also influenced by this amalgam of styles in his late years, in works such as the *Still Life with Fruit and Flowers* from Capodimonte (Cat. 114). And indeed it affected the majority of artists towards the end of the century. Unaware of the original motivation behind the creation of the modern still life, they devoted themselves with craftsman-like dedication to a speciality in which the image, rather than the principle of truth to life, would encompass all styles, tendencies and purposes, even the most superficial and decorative. Even the most idealizing classicists and rhetorical painters painted still lifes, including artists from the circle of Giordano. The Italian appellation *natura morta* has an inappropriate ring when we compare it with the older Italian description used for this subject, *soggetti di ferma*, the English *still life* or Sandrart's *still-stehende Sachen*.

It was the arrival of Abraham Brueghel in Naples around 1670 that accelerated the process of adaptation of the Neapolitan still life to the baroque. This is reflected in the work of all the artists who worked in the city in the following years, from the two rather different painters who have been amalgamated into one under the common name of Giuseppe Ruoppolo, the monogrammists G A and I A, Aniello Ascione and the Maestro della Floridiana, up to Marco de Caro and the great Andrea Belvedere (*c.* 1652–1732). In the work of these artists we can see that truth and sincerity have been transformed into a refined sensibility, a cult of the precious, the rare and the amazing, an elegant or spectacular creation.

The Patronage of Painting in Seicento Naples

FRANCIS HASKELL

When Caravaggio arrived in Naples in the autumn of 1606 his fame as a great painter had clearly preceded him from Rome, and this weighed far more with potential patrons than any qualms they might have felt about employing a murderer. He was immediately given a number of notable commissions for which he was paid exceptionally well, and we know that the resulting pictures aroused instantaneous admiration. Indeed, as we will see, for much of the seventeenth century a reputation earned in Rome proved to be of dominating importance for painters hoping to win commissions in Naples – to the indignation of resident artists. There was no local cultivated aristocracy or body of international civil servants delighting, as at the papal court, to look back on glorious traditions of patronage and living in palaces magnificently decorated by generations of forbears. The Neapolitan nobles had only begun moving into the city itself from their huge feudal castles over the last half century or so, urged on by the Spanish viceroys who were keen to keep them under close observation. No great architects had been employed on the construction of their palaces and few pictures or tapestries of much significance hung on their walls.[1] This situation was to change gradually over the years, but when in 1625 the Spanish painter José Martinez was escorted by his fellow countryman Jusepe Ribera round the private galleries of Naples, he found that 'since I had come from Rome, everything seemed small to me, as in this city [Naples] people are more concerned with military matters and horsemanship than with the art of painting'.[2]

Although Caravaggio had at first sought refuge on the estates of the Colonna and had been employed by that great and ancient dynasty while under their protection, once in Naples it was from a family of agricultural merchants (the Radolovich) that he received his first order for an altarpiece;[3] and although some recently ennobled administrators were involved in the commissioning of two of the great paintings in this exhibition (Cat. 15 and 16), these men are not otherwise known for having shown a discriminating love of the arts. Some 15 years later, when the most important religious commission in the city was under discussion, those responsible for it sent an emissary to Rome 'to find someone suitable who is both good and

famous',[4] and this seems to have been the prevailing attitude. Caravaggio's fame, the novelty of his style, perhaps even – who knows? – the sheer quality of his work, certainly struck a deeply responsive chord in Naples, where his pictures were in great demand; but it is exceedingly unlikely that, even had he stayed longer in the city, he could ever have found the kind of highly placed, enlightened patronage (such as that of Cardinal del Monte or the Marchese Giustiniani) which had sustained him in Rome. It is significant that the only two cultivated aristocrats associated with him during his time in Naples were foreigners: Marcantonio Doria, who had already much admired the painter in Genoa, to which city he wanted his *Martyrdom of St. Ursula* (Cat. 19) to be sent as soon as possible;[5] and Don Juan Alonso Pimentel y Herrera, eighth Count of Benavente, the Spanish viceroy, who took his *Crucifixion of St. Andrew* (Cat. 17) back with him to Valladolid when he left Naples in 1610.[6] To the role played by the viceroys in the patronage of Neapolitan art we will return later.

Altarpieces rather than gallery pictures provided the main source of income for painters in Naples throughout the seventeenth century. This period saw an expansion of wealth, and sometimes of autonomous political power, in the hands of the clergy that alarmed the viceroys and that amazed visitors to the city. More new churches and monasteries were built than palaces, many old ones were rebuilt and the demand for their decoration was constant.[7] Thus the Pio Monte della Misericordia, for the high altar of which Caravaggio painted *The Seven Acts of Mercy* (Cat. 16), began its existence in 1601 as a charitable foundation so small in size that it was said to be difficult to stand inside it or hence even to admire the pictures that had been commissioned for the side altars from a series of artists in Naples and Rome; yet within half a century it was totally rebuilt on a large scale.[8] And the monastic church of S. Domenico Maggiore, for which Caravaggio painted *The Flagellation* (Cat. 15), had a few years earlier emerged victorious from an open and astonishing clash with the authorities. Its orthodoxy was perhaps suspect (Giordano Bruno and Tommaso Campanella were both associated with it), but its troubles came because the monks were able to defy all attempts made by leading Dominicans to

introduce, very belatedly, the principles of Counter-Reformation morality. The Pope and the Spanish viceroy agreed with the reformers that something had to be done and the police were sent in. The monks resisted by force (justifying the claim that they were more military than clerical by nature), popular support seemed to be on their side and, from the compromise that ensued, it was clear that they had won.[9] It is most unlikely that any ideological connection can be traced between their intransigence and the nature of Caravaggio's altarpiece, but the whole episode, like the rebuilding of the Pio Monte della Misericordia, demonstrates who in Naples had the authority and the money to dominate patronage of the arts.

Among all the many religious organisations vying with each other for splendid decorations during the first half of the century, two stand out as of special importance: the Cappella del Tesoro of the Cathedral and the Carthusian monastery of S. Martino.

The Cappella del Tesoro which was built at public expense at the very beginning of the seventeenth century, was administered by a Board of Deputies who assumed responsibility for selecting an architect, sculptors and the painters needed to adorn the cupola and other parts of the grandiose structure with frescoes and to produce a series of canvases for the altars.[10] The one consistent policy that can be traced in their choice is the avoidance of local artists whenever possible. In 1621 an unanimous resolution of the deputies declared that the decoration 'must not, and cannot at any time in the future, be entrusted to any Neapolitan or any foreigner at present living in Naples (except for what has been commissioned from Signor Fabritio Santafede), and this decision must not be overturned for any reason whatsoever'.[11] The aim was to attract painters from Rome – not always an easy task in view of the hostility that this policy aroused in Naples. The Cavaliere d'Arpino (who had already worked with great success for S. Martino), Guido Reni, Domenichino, and Lanfranco were all approached between 1619 and 1641, and after many difficulties the latter two eventually painted the frescoes in the cupola, the pendentives and the lunettes, and thus gave the chapel its distinctive character. Caracciolo, who had at an early stage been given a subordinate task when all hope of engaging a reputable painter from Rome appeared to have vanished, had expected that the job of painting the frescoes would be assigned to him and, when these ambitions came to nothing and it seemed that he would not be paid even for what he had done, he sued the deputies. To no avail. It was only in 1641, after his death, that Neapolitan painters became seriously involved, and that Ribera and Stanzione were asked to paint altarpieces (soon after they had been similarly employed at the Certosa di S. Martino).

Indeed, the patronage of the Carthusians, acting under the direction of a succession of energetic priors, was very similar in its broad outlines to that of the deputies of the Cappella del Tesoro, and (as we have seen) their choice of artists often anticipated those employed there.[12] Towards the end of the sixteenth century their old Gothic church was restructured in the modern manner, and magnificent new buildings and cloisters began to be added to it. To decorate the choir of the church with frescoes they first employed the Cavaliere d'Arpino, the most famous painter in Rome, who came to Naples in 1589 and again some years later;[13] Lanfranco was commissioned to paint the frescoes in the choir in 1638–39 and three years afterwards Guido Reni painted (but died before completing) the huge altarpiece of the *Nativity*. Thus the principal painting of the richest church in Naples was carried out entirely by artists whose fame was well established in Rome. However, Neapolitan painters were also sometimes employed: Caracciolo's *Christ Washing the Feet of the Disciples* (Certosa di S. Martino) was commissioned as early as 1622 and was among the canvases let into the walls of the choir. At the same time, he was promised that he would be given the opportunity to paint frescoes in the chapel of S. Gennaro. Unlike the deputies of the Cappella del Tesoro, the Carthusians kept their word and these were completed nine years later.

It was, however, at the end of the 1630s that Neapolitan artists began to make a really substantial contribution to the beautifying of the church. From 1637–38 onwards, both Massimo Stanzione and Ribera were engaged on a series of masterpieces, some of which can be seen in this exhibition (Cat. 159, 122, 124 and 125). The exact circumstances of the commissions are not known, and so much ridicule has been poured on the many fantasies of Bernardo De Dominici, the eighteenth-century biographer of the artists of Naples, that nothing in his account of what happened is now taken seriously. However, it is by no means impossible (or even unlikely) that the Carthusians had – as De Dominici claims[14] – intended to entrust the main work to Stanzione, whose style was held to be so close to that of the Bolognese artists whom they so much admired that he was nicknamed the 'Neapolitan Guido', and that the Spanish painter Jusepe de Ribera was given the lion's share only after persuasion from the Spanish viceroy. However, if there was such persuasion, it was certainly not financial, for the payments to Ribera were all made directly by the Carthusians – or, rather, were not made, for a successful lawsuit brought against them by the artist's heirs demonstrated that he had not been paid, as had been agreed, the 100 ducats for each of the figures in the *Communion of the Apostles*. But there was no reason to regret the

viceroy's intervention (if it did occur), for Ribera's noble *Prophets* in the arches (Cat. 124 and 125) and his *Pietà* (Cat. 122) are among the very finest works in the whole church.

The Bolognese artists imported from Rome, who were so highly admired by the deputies of the Cappella del Torso and by the Carthusians, profoundly affected the development of Neapolitan art, for local painters were as yet considered to be of only secondary quality. It was not until the ascendancy of Luca Giordano in the 1660s (when he was given his first commission by the deputies, to be followed – nearly 40 years later – by his wonderful frescoes in the sacristy of the Certosa di S. Martino) that this situation finally altered.

The impact of the viceroys on Neapolitan art has remained a matter of controversy ever since the seventeenth century. Faced with the most pressing claims for treasure to support the embattled Spanish armies, they were too short of resources to spend much on the beautification of the city over which they usually ruled for a period of some five years. On the other hand, they were often wealthy men personally, most of whom commissioned pictures to be sent back to their palaces or the religious foundations which they sponsored in Spain, and, while Philip IV was on the throne (1621–65), they were keen to win favour at court by contributing old masters and contemporary works to that great art lover's collections in and around Madrid – even if unscrupulous methods were required to make this possible. Moreover, they themselves usually wished to leave some mark of their rule in Naples itself. Thus of Don Pedro de Aragón, viceroy from 1666–71, it was said that 'being keen to leave some great remembrance of himself in the city from which he had taken so many, by removing many statues, including antique statues [and also pictures], he set about thinking what great thing he could do which would be worthy of admiration'.[15]

There was another problem. Many of the viceroys moved to Naples from Rome, where they had previously served as ambassadors and where they had acquired artistic tastes which they were reluctant to abandon when they left the city. Thus the Count of Monterrey, brother-in-law of the Count-Duke Olivarez, a powerful, greedy, vain and munificent patron, who was viceroy from 1631–37, was so determined to obtain for himself and for his king works by Domenichino and Lanfranco when these artists came to Naples, that he over-ruled the clergy who had invited them there and interfered with the commissions that they had been given.[16]

Nevertheless, both he and the other viceroys also employed local artists – above all the Spaniard Jusepe de Ribera, who went out of his way to flaunt his nationality. Ribera was apparently 'discovered' by the Duca di Osuña,

viceroy from 1616–20, who may – as was claimed (without evidence) in the eighteenth century – have given him some sort of official post at court.[17] Certainly the viceroy commissioned from Ribera five large pictures which were installed in the collegiate church of Osuña in Andalusia, but this violent, spendthrift and ambitious ruler would not have had much opportunity to admire them there, for he died in prison soon after the downfall of his protectors following the death of King Philip III in 1621.[18] Thereafter Ribera painted important pictures for most succeeding viceroys, some of whom seem to have given a special direction to his talents. Thus the Duca d'Alcala, viceroy from 1629–31, was a man of exceptional culture who had inherited a large collection of classical antiquities,[19] and it seems to have been for him that Ribera painted the earliest of his *Philosophers* – those rugged, unkempt old men holding huge volumes – which were to be of notable importance for Velasquez, Luca Giordano and other artists.[20] And his *Immaculate Conception*, commissioned by Monterrey for the convent of the Discalced Augustinians at Salamanca, was to have enormous consequences for Murillo and later Spanish painters.

Other artists were also well represented in the collections of the various viceroys. The Admiral of Castille, whose government of Naples between 1644 and 1646 was marked by an unusual concern for the welfare of the city, owned paintings by Mattia Preti and Massimo Stanzione;[21] and the Count of Peñaranda, whose rule began in 1658, two years after the terrible outbreak of plague which had halved the population, gave pictures by Andrea Vaccaro and Luca Giordano (Cat. 66) to the specially built cemetery church of S. Maria del Pianto, and sent paintings by the same artists to the convent of the Carmelite Order which he founded near Salamanca.[22]

It is not known for whom Micco Spadaro painted his disturbingly impressive record of the plague (Cat. 150) and it is hard to imagine who would have wanted such a picture hanging in a gallery so soon after the event (by the middle of the eighteenth century it belonged to one of the great aristocratic families of the city);[23] the other memorable images of the plague – the ex-votos painted by Mattia Preti on the city gates (Cat. 100 and 101) – seem to have been commissioned by the well-meaning viceroy, the Count of Castrillo, who had tried without much intelligence to cope with its outbreak.[24]

However enthusiastic about painting they may have been, the Spanish viceroys did not have the unlimited means and did not remain long enough in Naples to be able to exert a lasting influence on local artists, as did the great papal families of seventeenth-century Rome. Monterrey's commissions to a number of pain-

ters to depict sets of scenes of ancient Roman life for the King of Spain was exceptional.[25] And the most cultivated and enlightened of all the seventeenth-century viceroys, the Marchese del Carpio, who died in office in 1687 after only four years in Naples, showed far greater interest in the paintings he could find in Rome (where he, too, had served as ambassador) and in Venice than in those available in the city over which he ruled with such efficiency: it is significant that it was in Rome that he had first met Luca Giordano, the one Neapolitan artist to win his whole-hearted support.[26]

Sustained and constructive patronage could only come from a resident aristocracy or merchant class, but although from the middle of the seventeenth century onwards we can trace increasing numbers of major pictures in their collections, both in town palaces and on feudal estates, exceedingly few individuals stand out with any clarity, and when they do, they can often be shown not to have been benefactors of local artists. Thus Cardinal Ascanio Filomarino, the over-bearing Archbishop of Naples from 1641–66, who was constantly at odds with the viceroys because of his determination to maintain the privileges of the Church to their utmost limit, was certainly an art patron of notable importance; but he had spent many years in Rome and by far the most significant pictures in his collection – by Annibale Carracci, Poussin, Valentin, Vouet and others – were by artists whom he had learned to love when he was in the service of the Barberini; just as it was from Borromini, also in Rome, that he commissioned the altar that he had built in the church of SS Apostoli. Filomarino's splendid collection – with its allegiance to the neo-Venetian tendencies which flourished in Rome in the 1630s – was undoubtedly of great consequence for Neapolitan artists: but less because of the pictures by them to be found in it than from the encouragement that it gave them to break with the tradition of Caravaggio and his followers.[27]

It would be interesting to know more about Don Angelo Pepe, a cultivated man whose family helped to found the church of S. Maria della Salute on the Vomero, above which he owned a beautiful country house where he would entertain, and collected works by Massimo Stanzione, Micco Spadaro and the still-life painters Ruoppolo and Porpora.[28] Information about his life and circumstances might help to give us just the sort of understanding of Neapolitan art patronage that we so evidently lack and, in particular, it might tell us something about the background to the many remarkable pictures by Micco Spadaro and his imitators which document, with exceptional vivacity, the alternating ceremonies and disasters which punctuated life in seventeenth-century Naples. Pepe, however, remains little more than a name.

fig. 18 Portrait of Cardinal Filomarino, from an altarpiece by Lanfranco (Naples, Arcievescovado)

Fortunately, the activities of the most lavish patron of the time can be reconstructed in some detail. Gaspar Roomer was a Flemish merchant who moved from Antwerp to Naples, where by 1634 he was already the owner of an outstanding gallery.[29] He made a vast fortune as a shipowner and merchant, trading as far afield as Egypt and Scandinavia, but especially with his native Low Countries. He lent money to the viceroys and the King of Spain, and when the revolt of Masaniello in 1647 put him in some potential danger he made shrewd use of his fortune in that direction and escaped unhurt and as rich as ever. He contracted, but recovered from, the plague; and long after his death in 1674 his name survived in the form of a proverb, 'Do you take me for a Roomer?' with which to shake off persistent borrowers.

Roomer owned some 1,500 pictures and, unlike so many of the patrons who have been mentioned so far, he was as enthusiastic about the Neapolitans (including the followers of Caravaggio) as he was about painters from other parts of Europe: Ribera, for instance, by whom he owned seven pictures, including that gross, earlier masterpiece, the *Drunken Silenus* (Cat. 120); and also Caracciolo, Stanzione, Preti and Luca Giordano, all of whom were represented in his gallery. From his recorded comments on the works of these men it is not easy to understand the exact direction of his taste. Naturalism evidently appealed to him, and

violence. He collected battle scenes and landscapes, still lifes and animal pieces. He too sometimes imported pictures from Rome, but, unlike Cardinal Filomarino, he seems to have had little affection for the classicizing Venetian tendencies that were fostered in the Barberini circle. But his main supply of paintings came from the North, and we have vivid descriptions which emphasize the great impact that these made on local artists. The most magnificent picture in his collection, the *Feast of Herod* by Rubens (Cat. 138), arrived in about 1640 (it is not clear whether or not it was actually commissioned by Roomer) and understandably caused the greatest excitement: among those particularly struck by this masterpiece was that most poetic of painters Bernardo Cavallino, by whom Roomer owned a number of small pictures. Roomer also acquired two Van Dycks, among them a *Susanna and the Elders* (fig. 16). Roomer's business partner, Jan van den Einden, was also Flemish and he too was an outstanding collector of Neapolitan pictures. It would be difficult to exaggerate the importance of these two men in the artistic life of the city – an importance all the more conspicuous because of the relative absence of other patrons.

Although De Dominici, writing in about 1740, claimed that pictures by Cavallino (1616–56) – and other Neapolitan artists – were exported all over Europe and especially to England, even in their lifetimes,[30] this is extremely unlikely and is probably a projection backwards of what was happening often enough in the author's own day. Nevertheless, we do know that Roomer exported Neapolitan pictures to the North, as did the viceroys to Spain, and that artists born in the south travelled widely in Italy (Salvator Rosa and Mattia Preti are the most conspicuous examples) and were very highly esteemed. And foreign visitors to Naples sometimes had their portraits painted by masters there even in the first half of the century (Cat. 160).

For all this, however, it is probably due to the absence of any systematic, self-conscious and enlightened patronage in the city that the realization that there was such a thing as a Neapolitan school took so long to win acceptance, despite the fact that, as will be apparent to visitors to this exhibition, there were so many superb painters at work. If the viceroys, the Carthusians, the Archbishops and the Jesuits – all active supporters of painting – felt that they had to look outside Naples for the artists they needed to decorate the palaces and churches of their city, how could the rest of the world be expected to acknowledge what the Neapolitans themselves had failed to grasp? It needed the achievement and career of Luca Giordano, the artist who closes this exhibition, to bring to the notice of Europe (and even of Naples itself) that after Florence, Rome and Venice, yet another Italian city could be added to the list of those whose great masters had permanently added to the artistic heritage of the world.

NOTES
I would like to express my particular gratitude to Don Franco Strazzullo for all the help he has given me in preparing this article.

1. Labrot 1979
2. Pérez Sánchez and Spinosa 1978, pp. 9–10
3. Pacelli 1977², pp. 819–29
4. Catello 1977, pp. 34
5. Pacelli and Bologna 1980, pp. 24–25
6. Tzeutschler Lurie and Mahon 1977, pp. 1–24
7. Strazzullo 1968; De Seta 1973
8. Causa 1970
9. Miele 1963; Villari 1967 (1980 ed.), pp. 75–79
10. Catello 1977; Strazzullo 1978
11. Strazzullo 1978
12. Faraglia 1892, pp. 6567–78
13. Rome 1973², pp. 27, 32
14. De Dominici 1742–45, III, p. 10
15. Celano (ed. Chiarini) 1856–60, IV, p. 402; Coniglio 1967, p. 290
16. Haskell 1980 (second ed.), pp. 171–72
17. De Dominici 1742–45, III, p. 4
18. Pérez Sánchez in Spinosa 1978, pp. 94–95; Coniglio 1967, pp. 205–06
19. Brown 1978, pp. 38–39
20. Fitz Darby 1957, p. 197
21. Pérez Sánchez 1965, p. 65; Coniglio 1967, pp. 249–50
22. Wethey 1967, pp. 678–86
23. De Dominici 1742–45, III, p. 196
24. De Dominici 1742–45, III, p. 133; Galasso in *Storia di Napoli* 1967, VI, I, pp. 41–50
25. Brown and Elliott 1980, p. 123
26. Haskell 1980 (second ed.) pp. 191–92; Ferrari and Scavizzi 1966, I, pp. 93, 124
27. Ruotolo 1977, pp. 71–82
28. De Dominici 1742–45, III, pp. 61, 203; Celano (ed. Chiarini), 1856–60, V, p. 259
29. Haskell 1980 (second ed.), pp. 205–08
30. De Dominici 1742–45, III, pp. 35–36

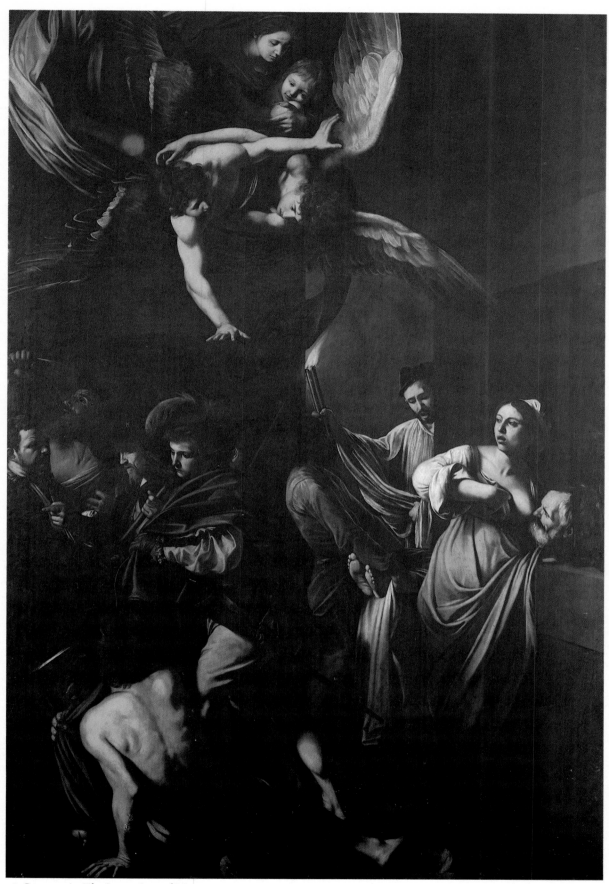

16 Caravaggio *The Seven Acts of Mercy*

16 Caravaggio *The Seven Acts of Mercy (detail)*

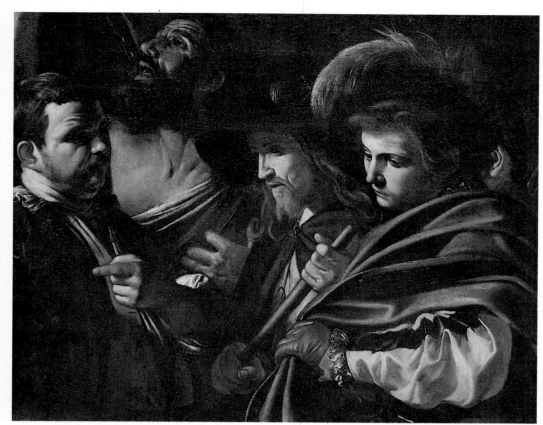

16 Caravaggio *The Seven Acts of Mercy (detail)*

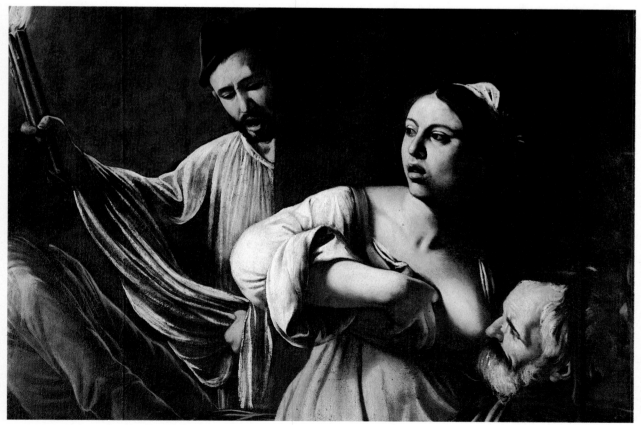

16 Caravaggio *The Seven Acts of Mercy (detail: Roman Charity)*

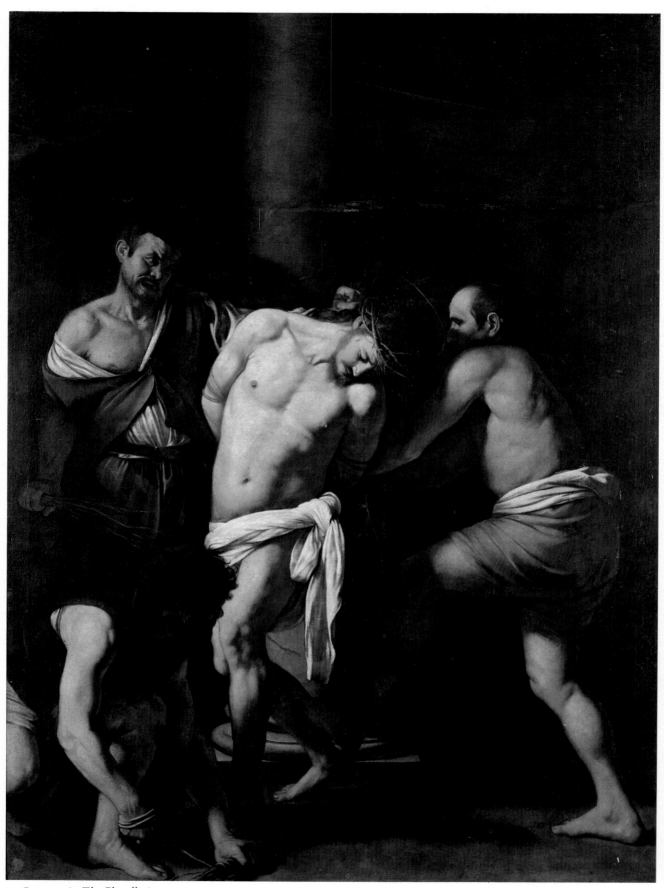

15 Caravaggio *The Flagellation*

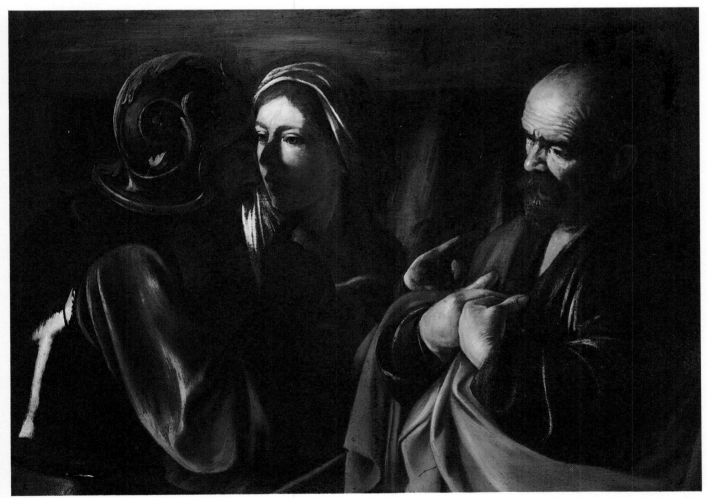

18 Caravaggio *Denial of St. Peter*

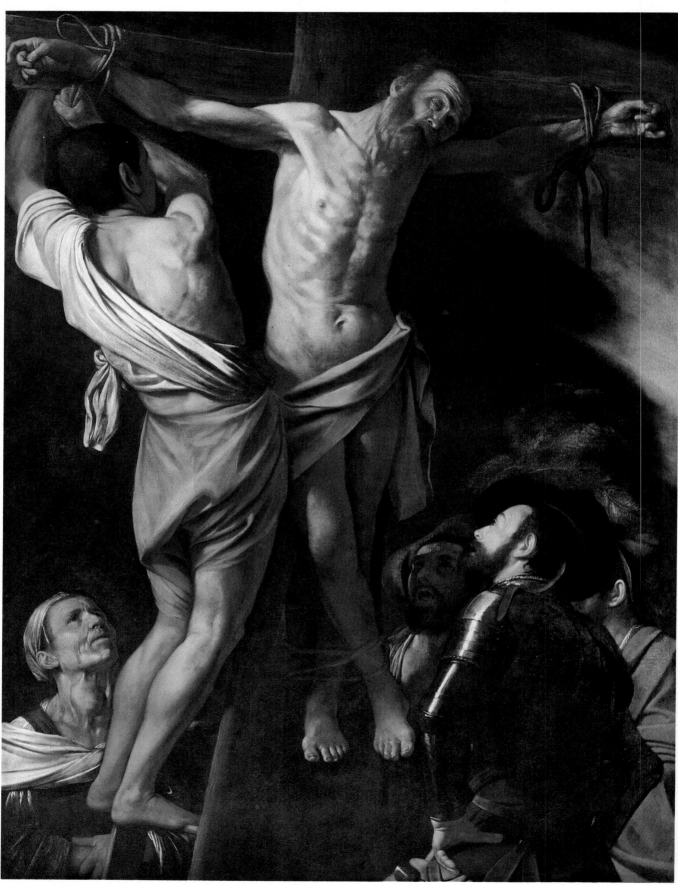

17 Caravaggio *Crucifixion of St. Andrew*

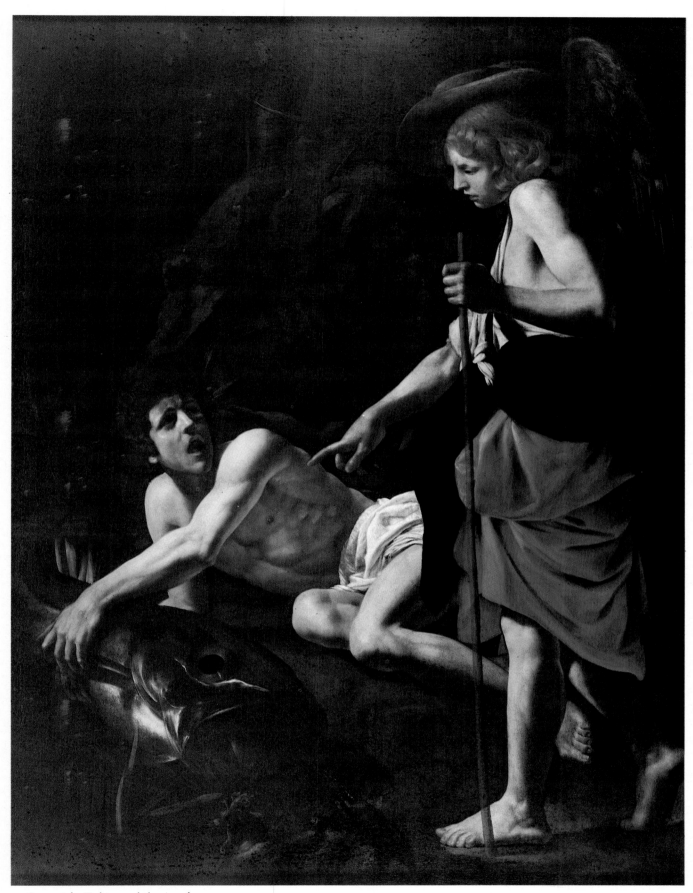

10 Caracciolo *Tobias and the Angel*

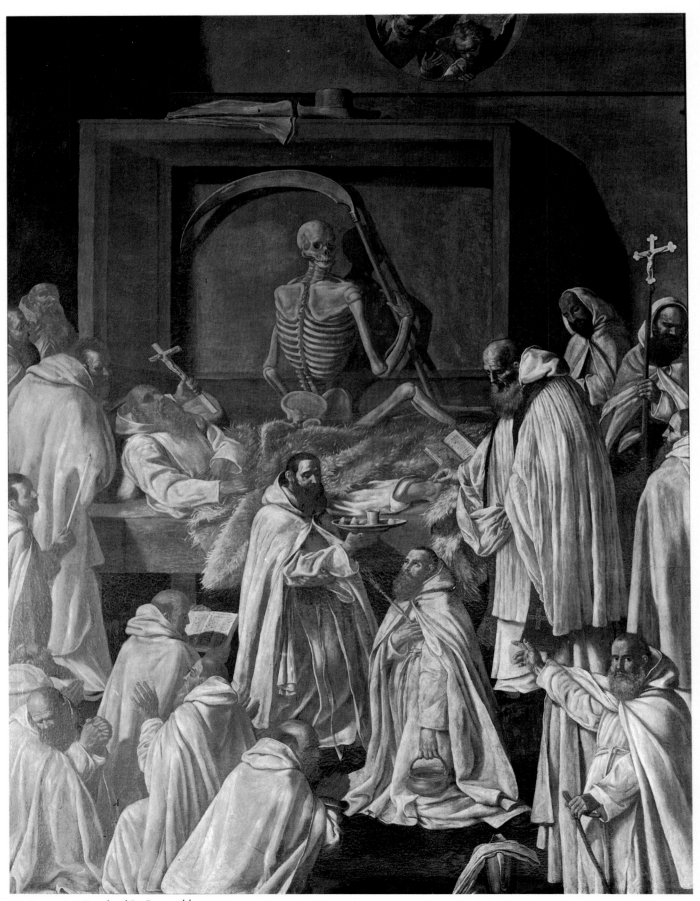

72 Gramatica *Death of St. Romuald*

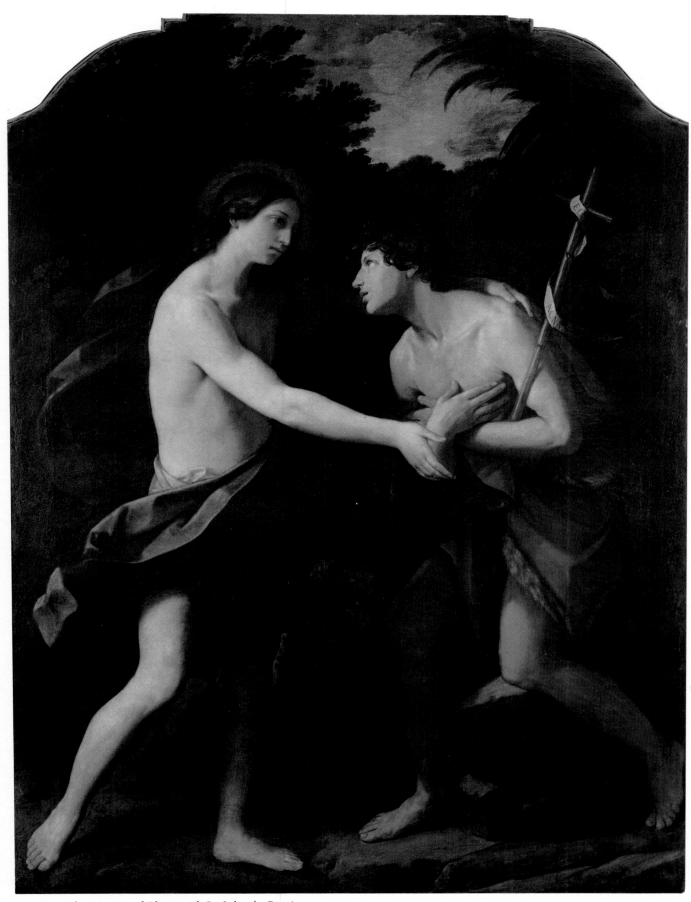

118 Reni *The Meeting of Christ with St. John the Baptist*

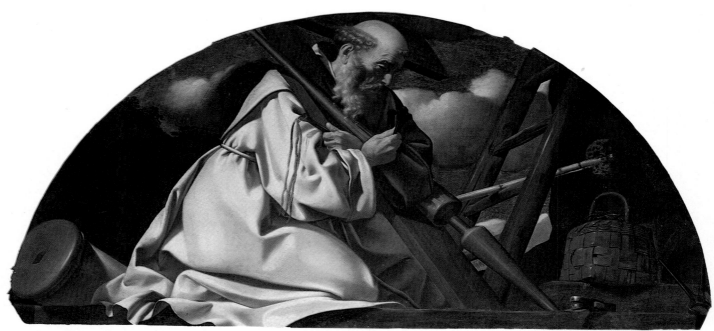

48 Finoglia *St. Bernard*

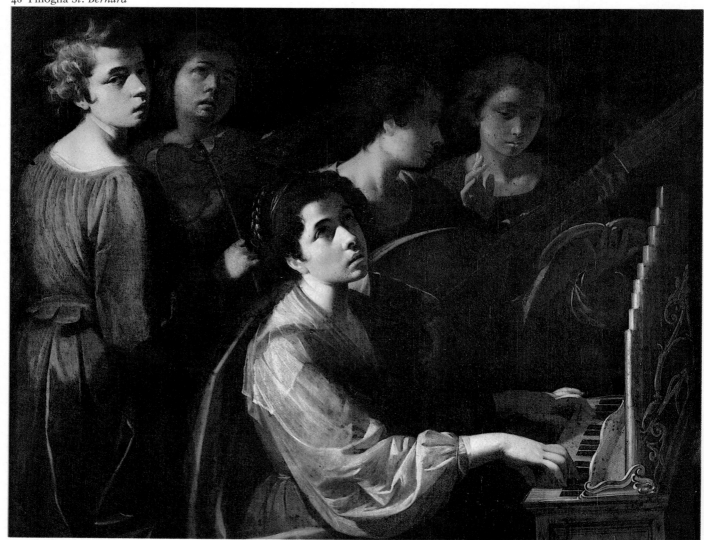

142 Sellitto *S. Cecilia (detail)*

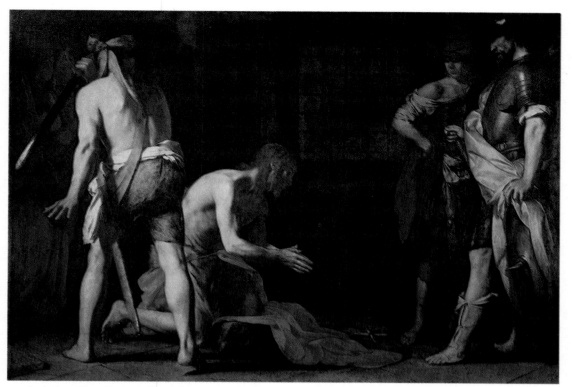

156 Stanzione *Decollation of St. John the Baptist*

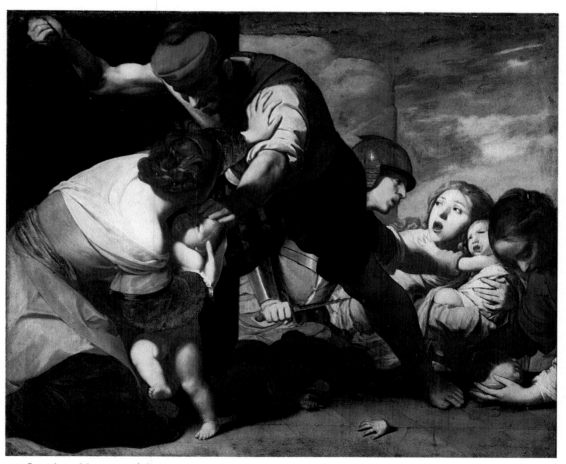

157 Stanzione *Massacre of the Innocents*

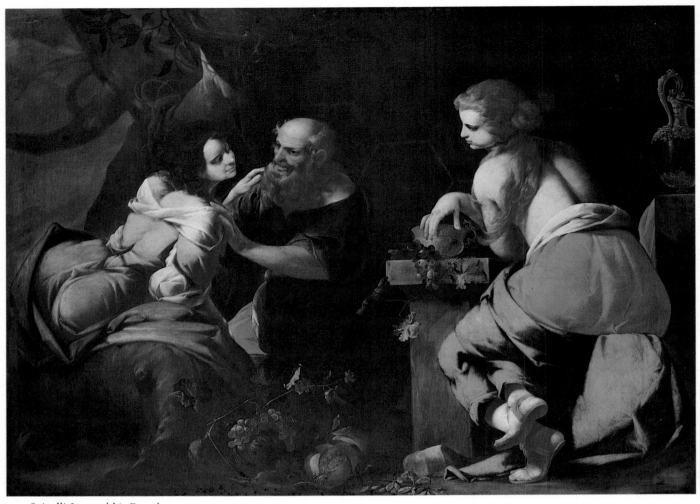

153 Spinelli *Lot and his Daughters*

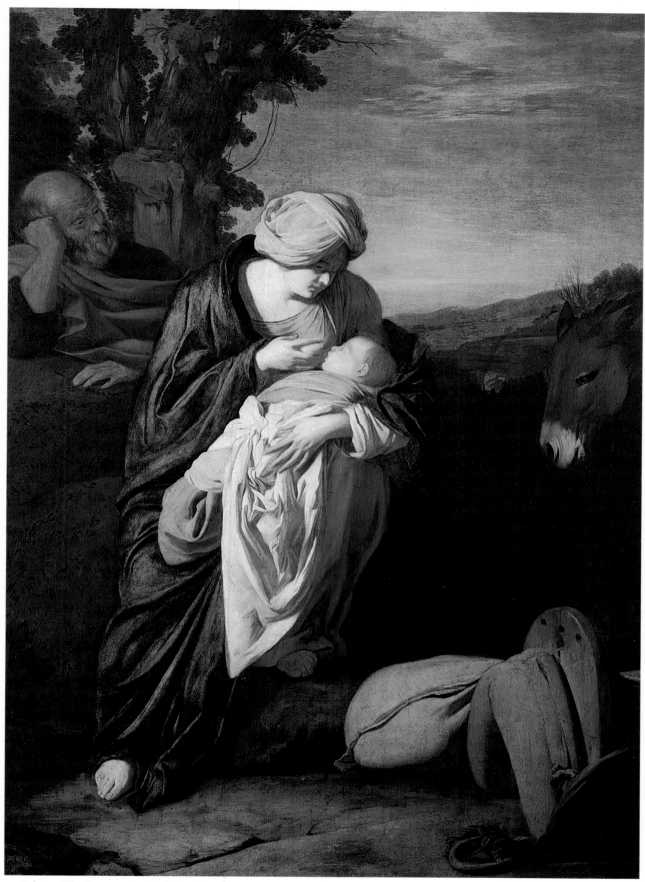

43 Falcone *The Rest on the Flight into Egypt*

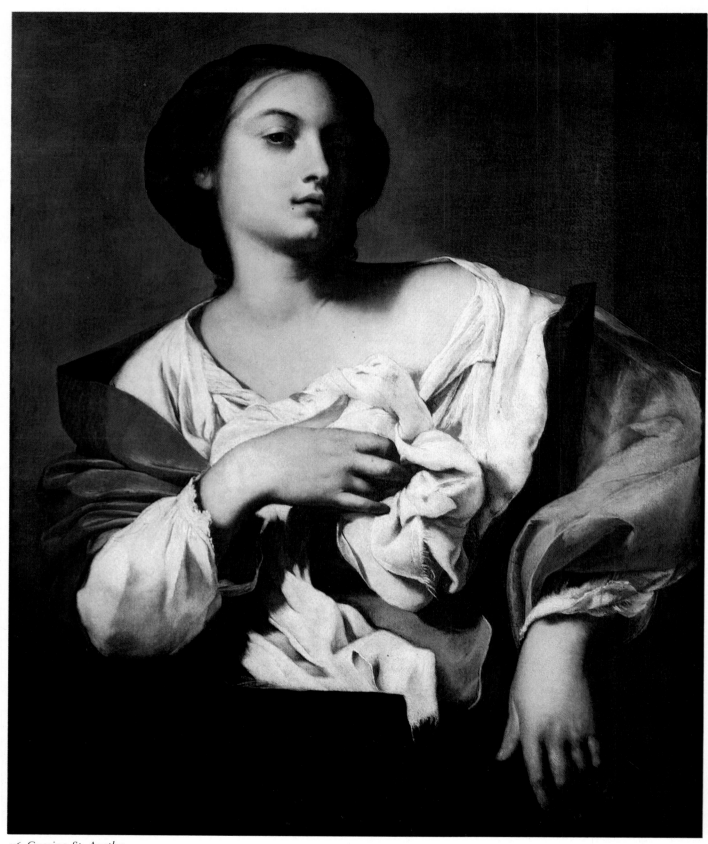

76 Guarino *St. Agatha*

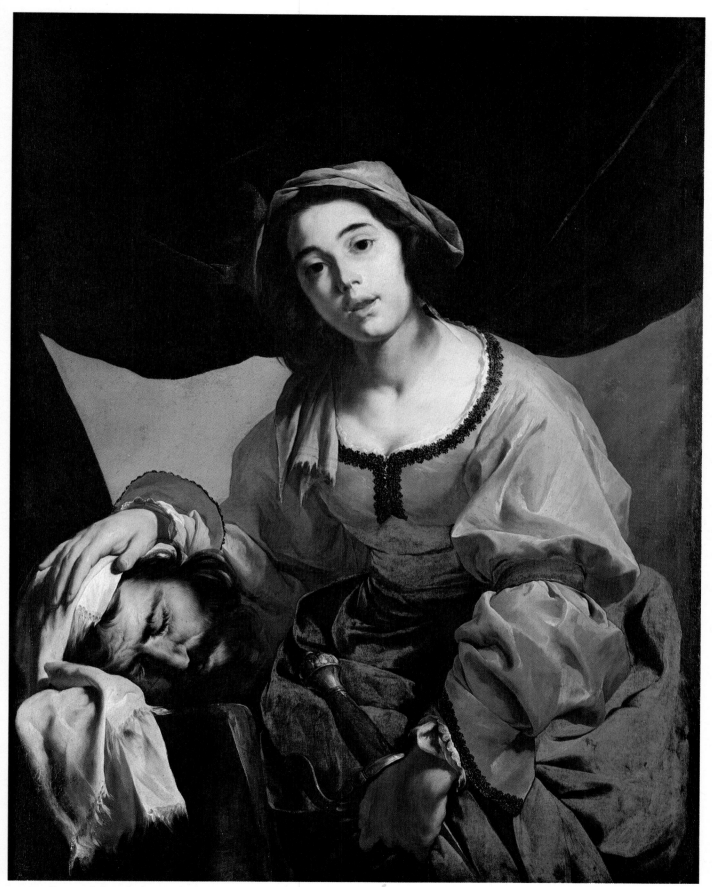

36 Cavallino *Judith with the Head of Holofernes*

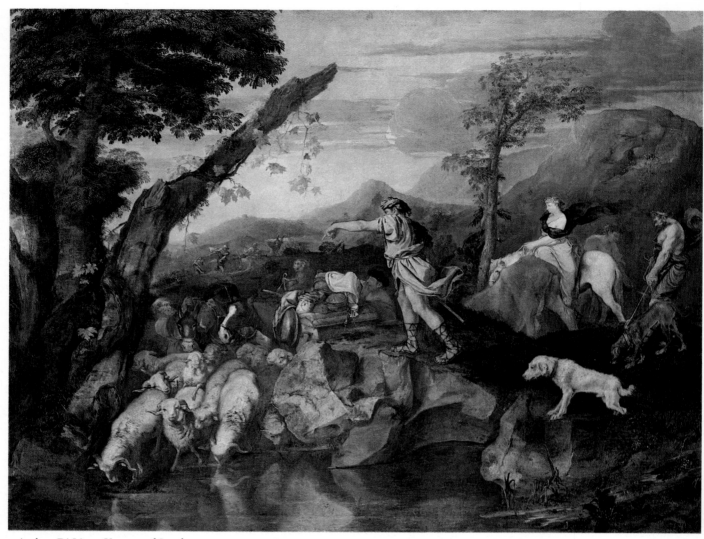

1 Andrea Di Lione *Voyage of Jacob*

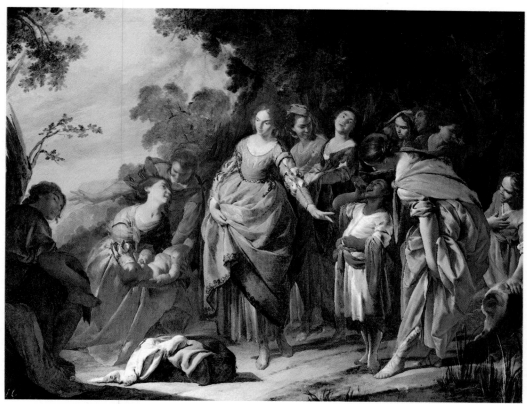

34 Cavallino *The Finding of Moses*

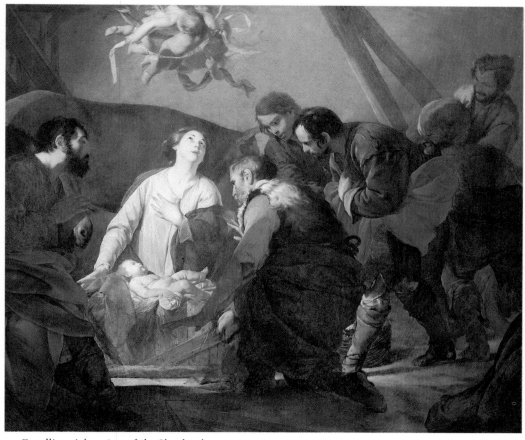

35 Cavallino *Adoration of the Shepherds*

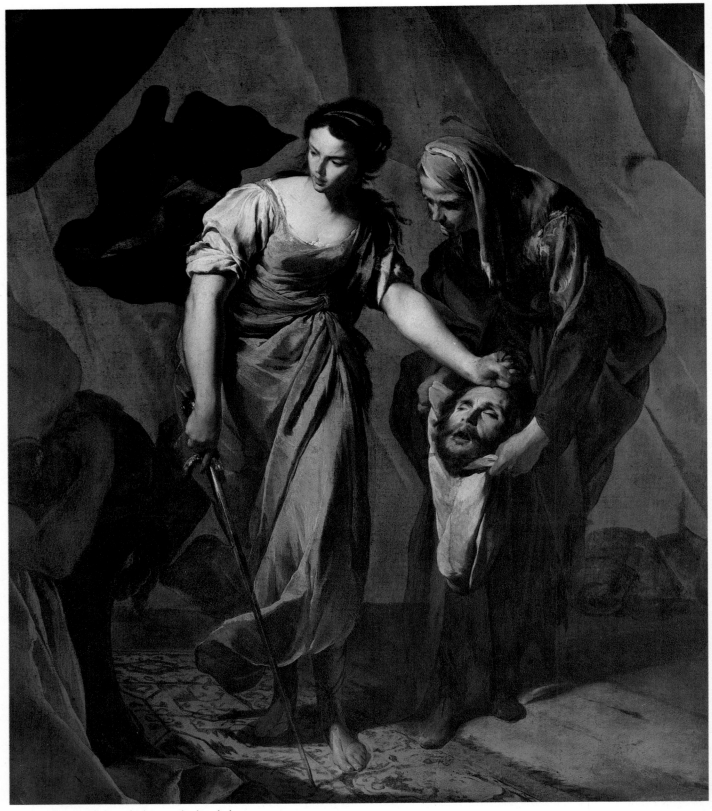

27 Cavallino *Judith with the Head of Holofernes*

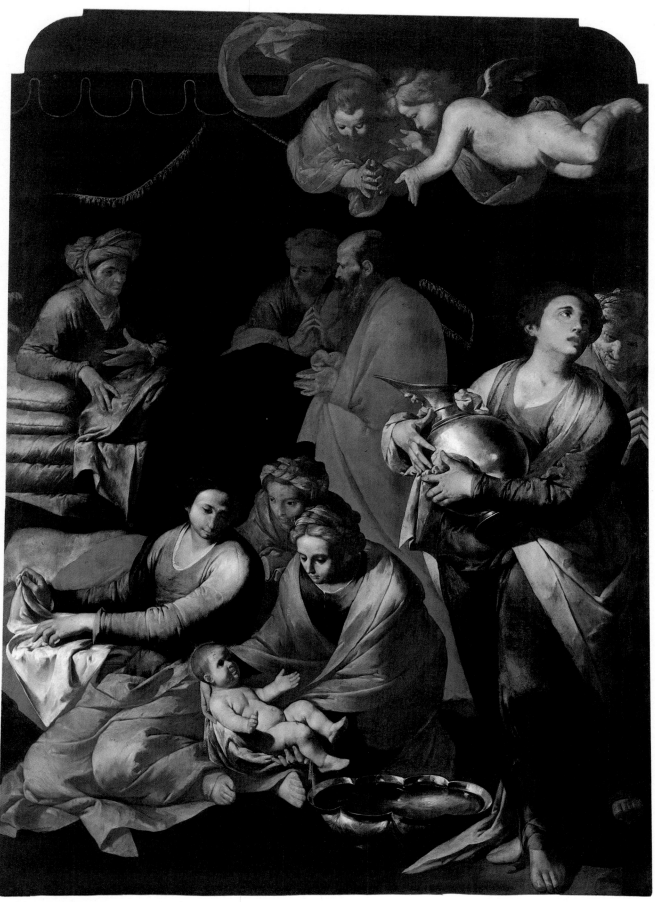

85 Master of the Annunciations to the Shepherds *The Birth of the Virgin*

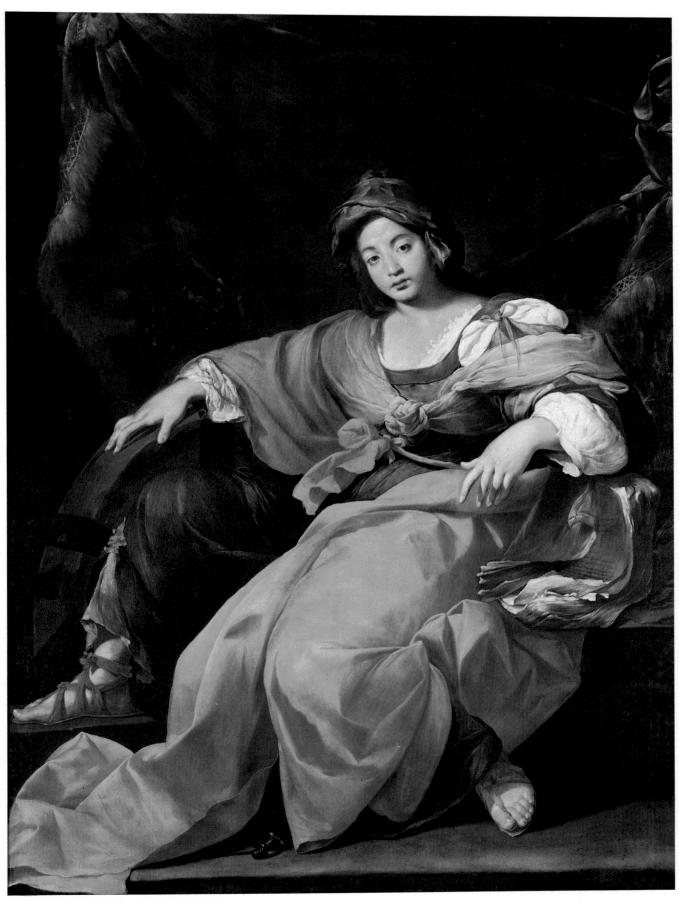

55 Fracanzano *St. Catherine of Alexandria*

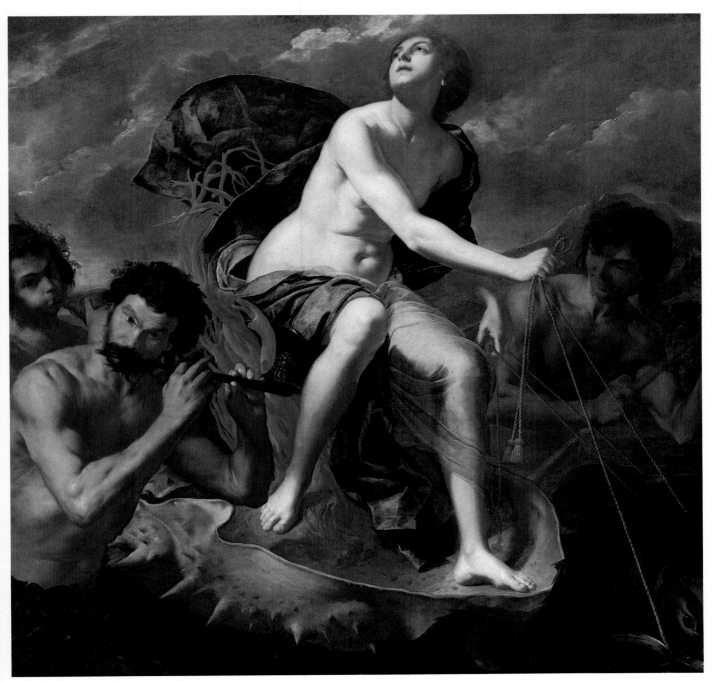

33 Cavallino *The Triumph of Amphitrite (detail)*

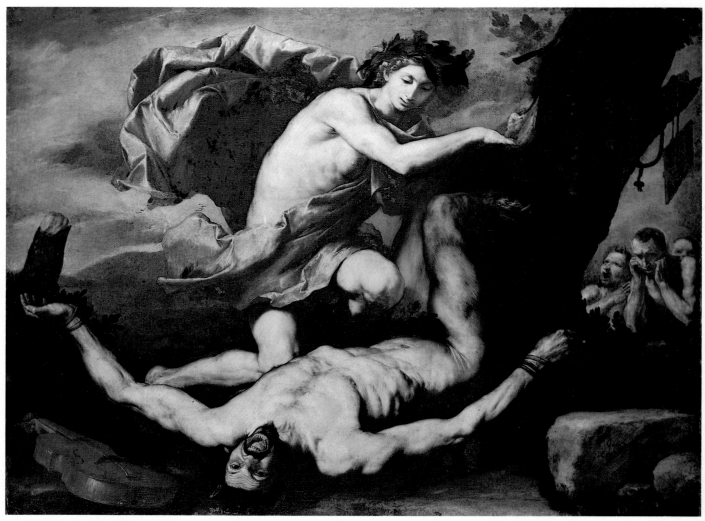

123 Ribera *Apollo and Marsyas*

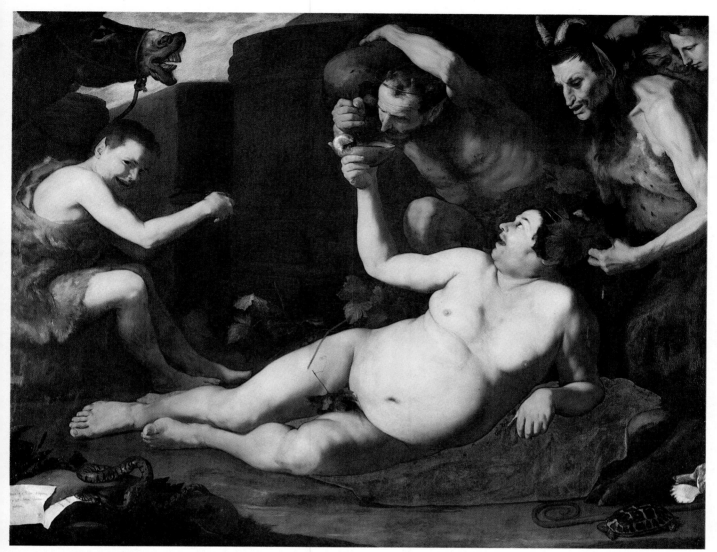

120 Ribera *Drunken Silenus*

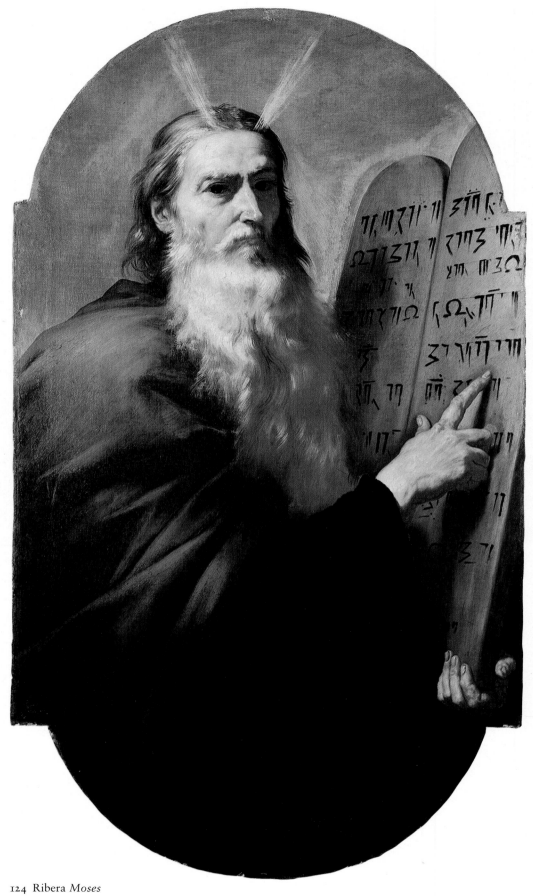

124 Ribera *Moses*

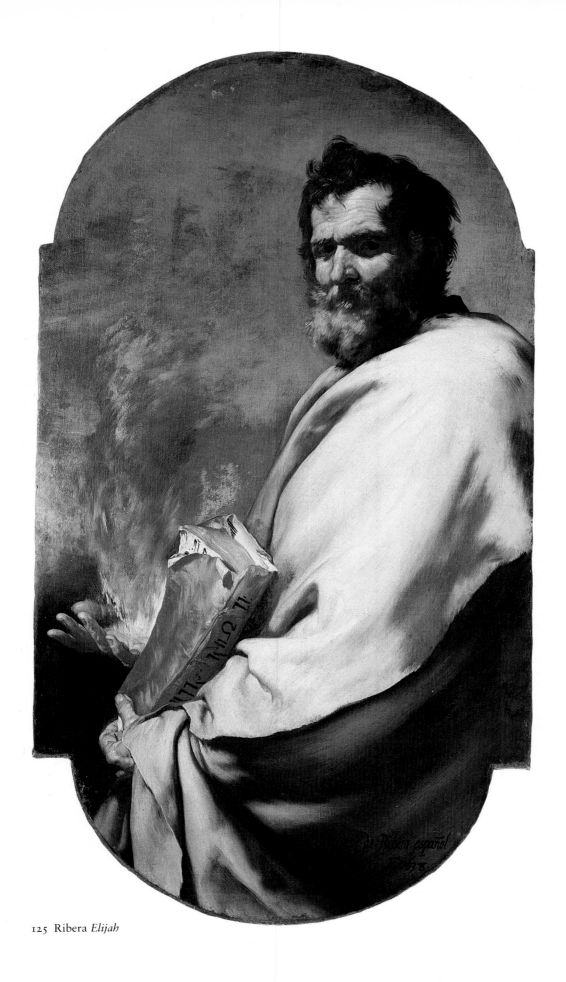

125 Ribera *Elijah*

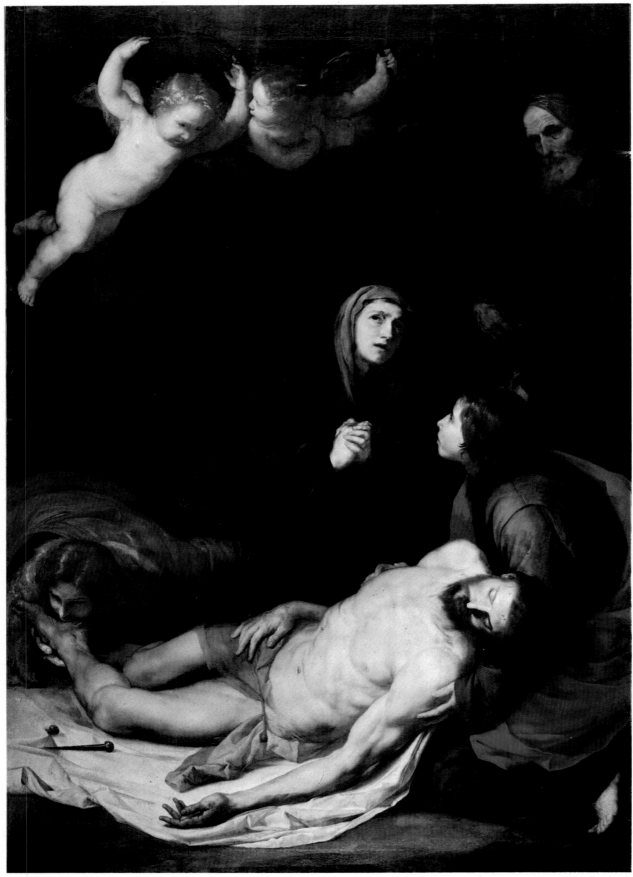

122 Ribera *Pietà*

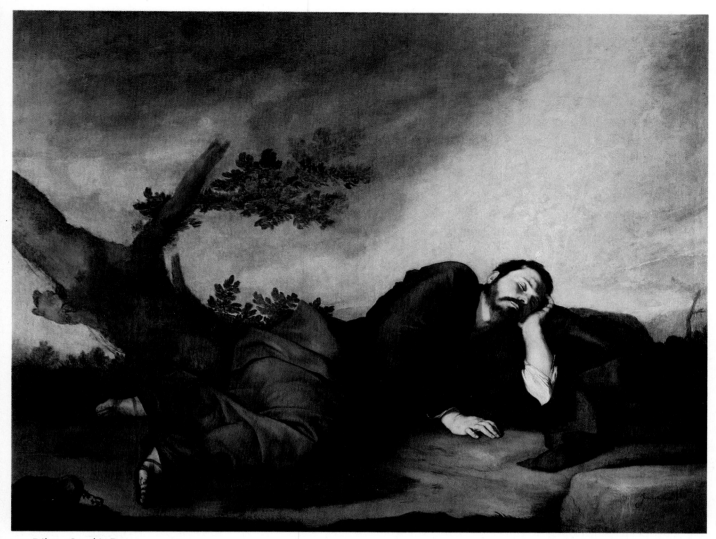

126 Ribera *Jacob's Dream*

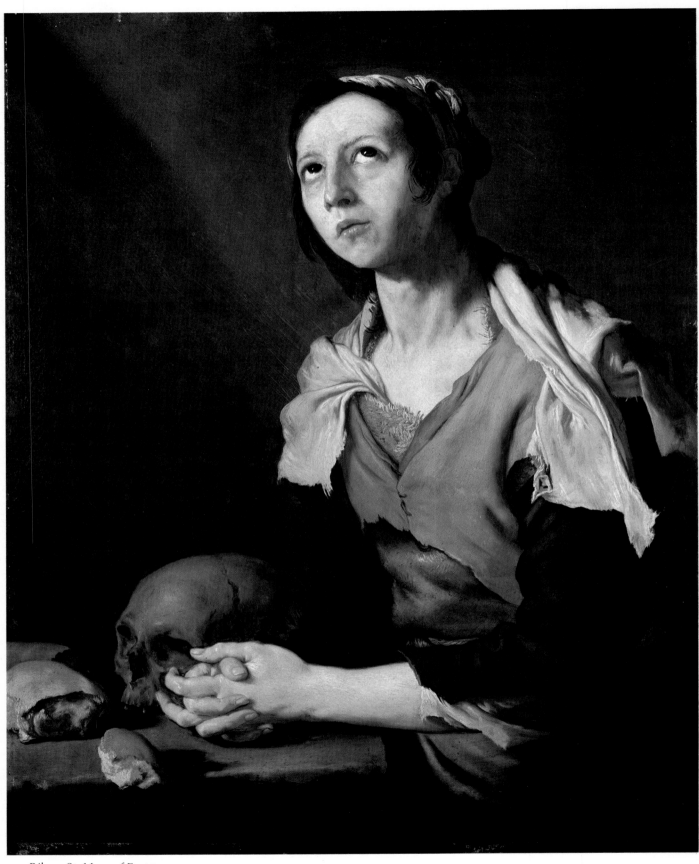

130 Ribera *St. Mary of Egypt*

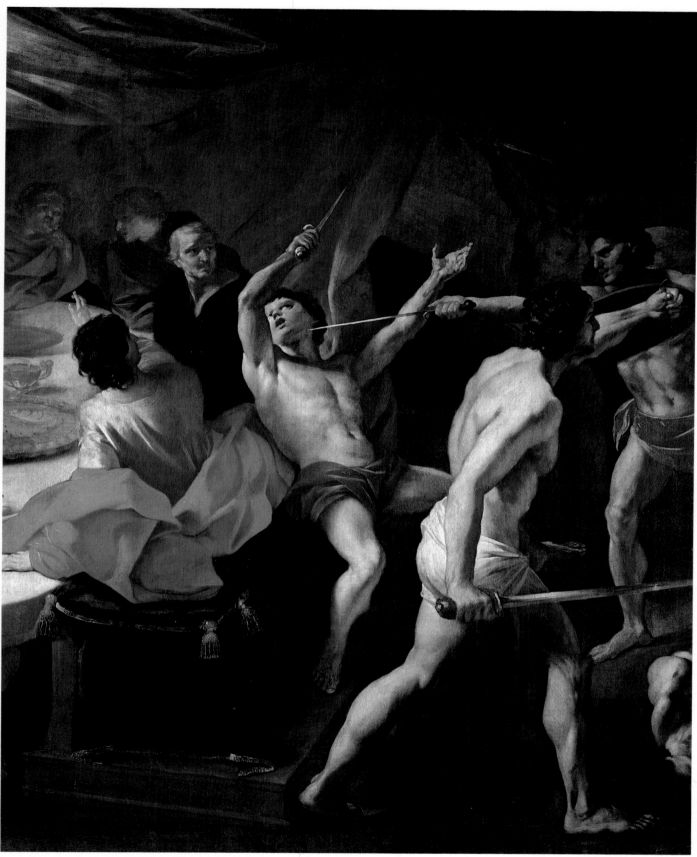

78 Lanfranco *Roman Gladiators Fighting at a Banquet* (detail)

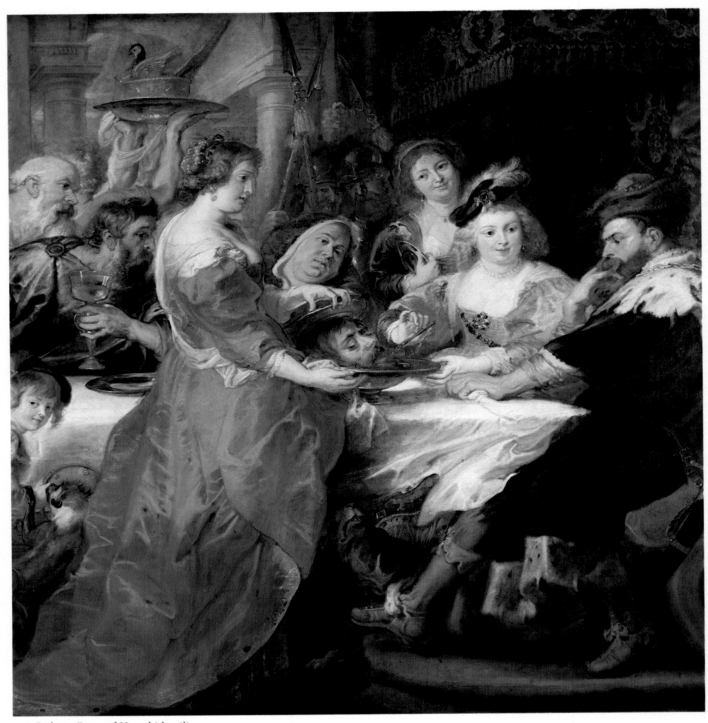

138 Rubens *Feast of Herod (detail)*

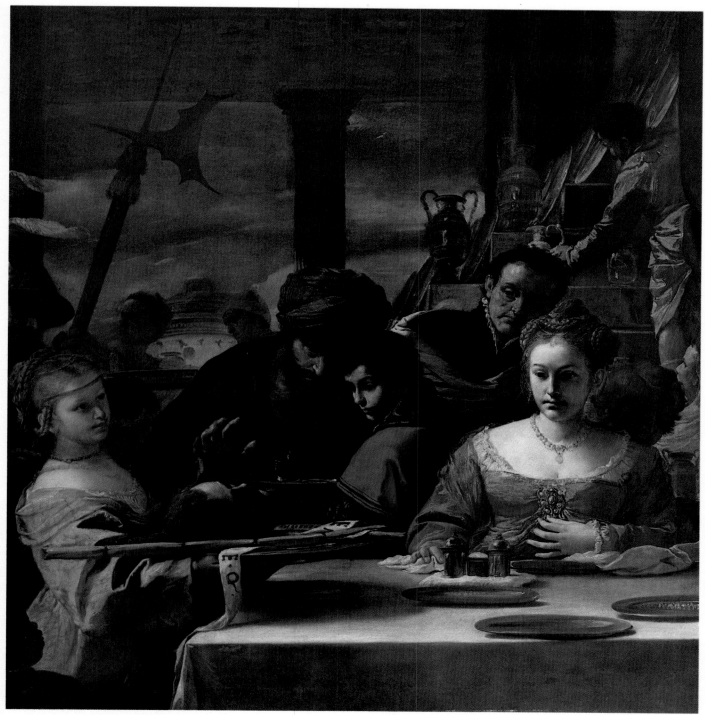

107 Preti *The Feast of Herod (detail)*

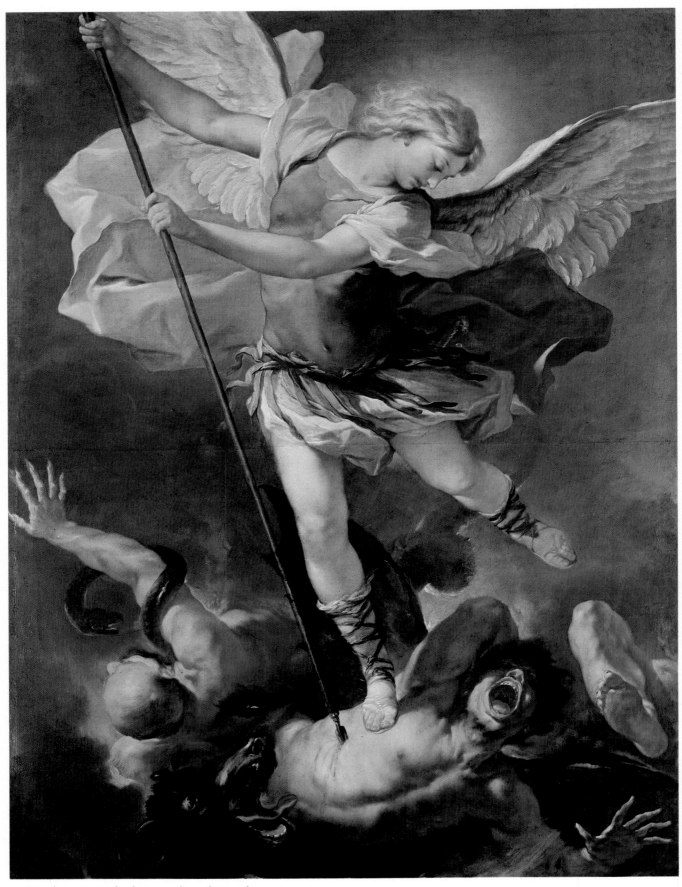

67 Giordano *St. Michael Vanquishing the Devil*

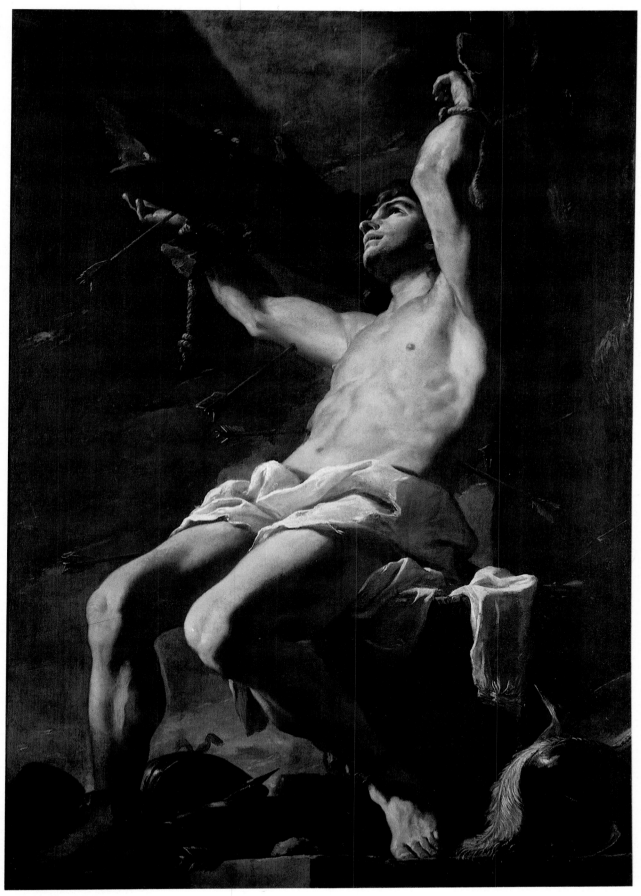

102 Preti *St. Sebastian*

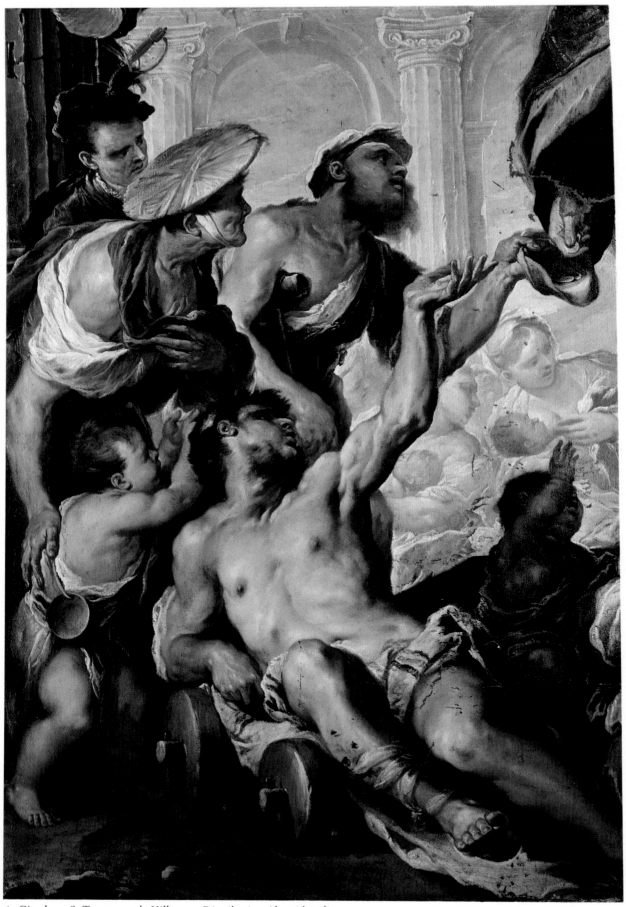

64 Giordano S. *Tommaso da Villanova Distributing Alms (detail)*

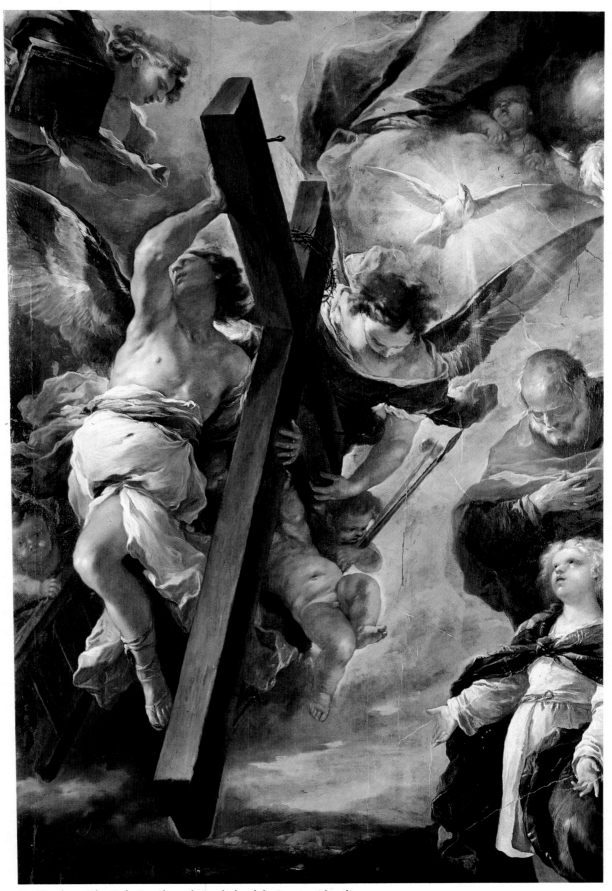

65 Giordano *The Holy Family with Symbols of the Passion (detail)*

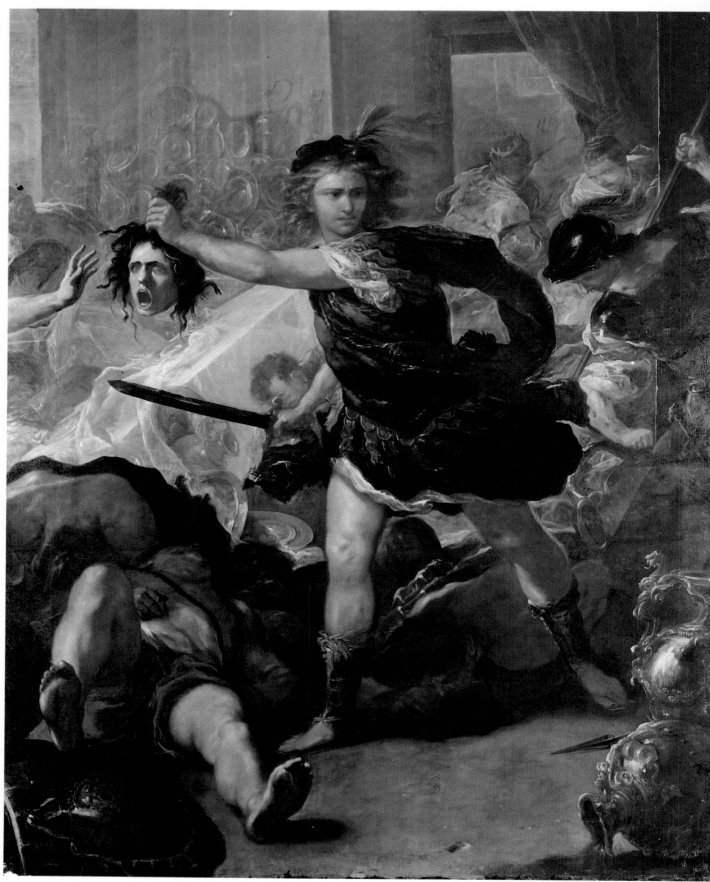

68 Giordano *Phineas and his Companions turned into Stone (detail)*

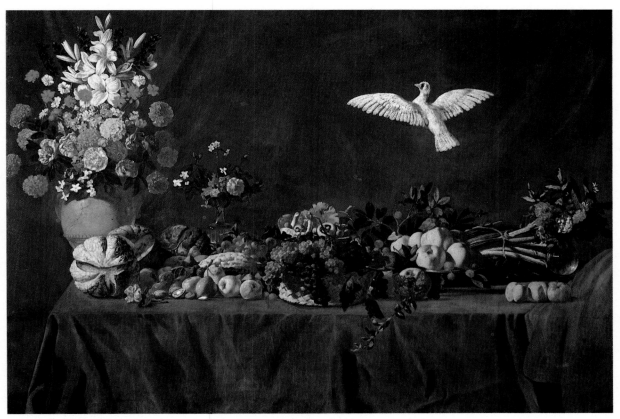

86 Master of Palazzo San Gervasio *Still Life with Fruit, Flowers and a Dove in Flight*

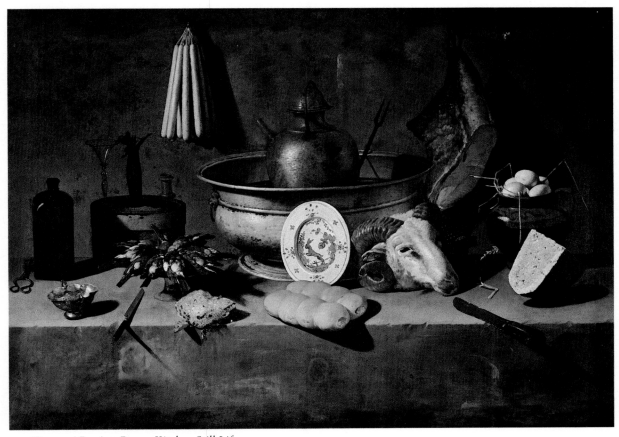

113 Giovanni Battista Recco *Kitchen Still Life*

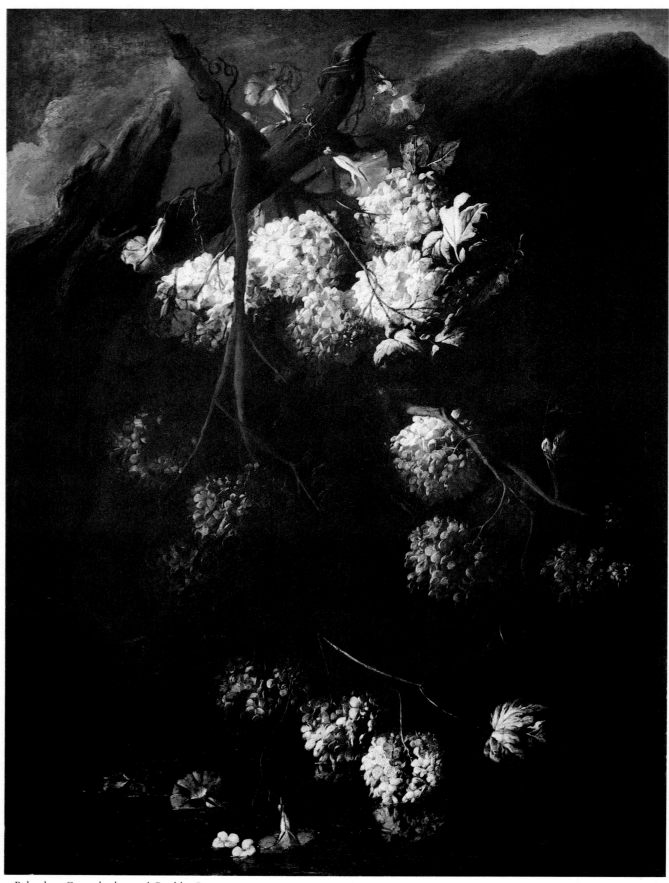

4 Belvedere *Convolvulus and Guelder Rose*

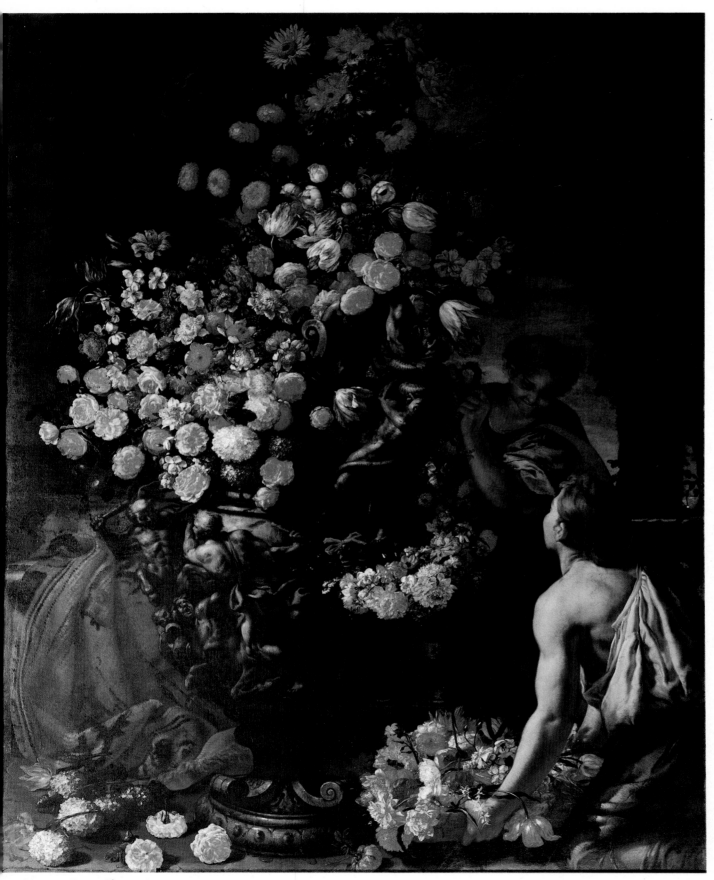

117 Giuseppe Recco *Flowerpiece*

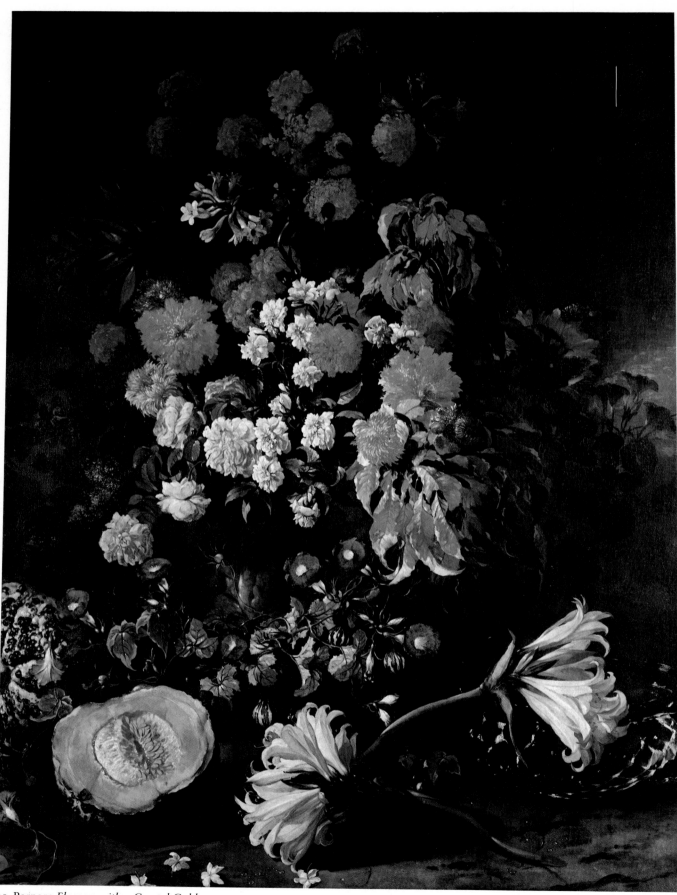

95 Porpora *Flowers with a Crystal Goblet*

The Catalogue

Andrea Di Lione

NAPLES 1610–NAPLES 1685

After being apprenticed to the late mannerist painter Belisario Corenzio, under whose guidance he painted frescoes of battle scenes in the Viceroys' Palace at Naples, Andrea Di Lione set up independently with his brother Onofrio, a modest fresco painter who worked in several Neapolitan churches; but sometime between 1630 and 1635 he joined the circle of artists around Falcone (De Dominici 1742; Blunt 1939). Falcone's influence is evident in the drawings of parts of the human body (eg. two nudes at Capodimonte, nos. 687 and 688). A portrait drawing of a man (Causa Picone 1974, no. 248r) may represent Masaniello, who was often portrayed by painters from Falcone's circle.

A *Portrait of Masaniello* is also one of the few signed paintings by Di Lione (Castellino Coll., Naples, signed and dated 1647): a realistic portrait is combined with a courtly pose. Andrea's style owed much to his master but it was more rhetorical.

Andrea is generally known as a painter of battles and many such scenes, formerly given to Falcone, are now attributed to him (private colls., Naples; Picture Gallery, Burghausen; Hausmann Coll., Berlin; Ruffo Coll., Messina; Prado, Madrid on deposit with the Museo del Cabildo Industrial, Las Palmas). These can be compared to the signed works: a *Battle* monogrammed ADI (Cat. 1) (private coll., Naples), the *Battle between the Hebrews and the Amalekites* (signed, Capodimonte, no. 527) and another *Battle* (Capodimonte, no. 529).

Despite his respect for his master, Di Lione departed from his traditional formulas, and, influenced by the Genoese Giovanni Benedetto Castiglione who was in Naples around 1635, he painted in far brighter colours than his Neapolitan contemporaries. This is true of some other signed works: *Jacob and the Angel* (dated 1670 or 1676, Prado, Madrid), a *Landscape* (Brunswick Museum) and the *Voyage of Jacob* monogrammed ADL (Cat. 1). Working from these paintings it is possible to attribute other works to Andrea; *Tobias Burying the Dead* (Metropolitan Museum, New York) *Jacob's Journey*, *Sacrifice of Noah* and *Elephants in a Roman Circus* (all in the Prado, Madrid, formerly attr. to Castiglione). His paintings of bucolic and pastoral subjects which were listed in the inventories of private collections can now be identified (Soria 1960; Pacelli 1979). Castiglione's influence is evident in these too, synthesized with Poussin's classicism and Cortona's baroque style. The relationship between Castiglione, Poussin and Di Lione is so close, and they so often use the same subject matter, that it has been proposed that Lione was

in Rome at this time (Blunt 1939–40; Soria 1960).

Lione also worked in fresco: the five ruined scenes of *Stories of St. Atanasias* in the Galeota Chapel of Naples Cathedral are dated 1677.

I.C.

REFERENCES
Brejon de Lavergnée, 1982 forthcoming article;
Blunt 1939, pp. 142–7;
Causa Picone 1974, pp. 44–45; Newcome 1978, p. 166;
Novelli Radice 1976, pp. 162–9;
Pacelli 36/7, 1979[1], pp. 165–204;
Salerno 1977–82, II, p. 516; Soria 1960, pp. 23–25

I
Voyage of Jacob

113 × 144.5 cm
Monogrammed: *ADL*
Kunsthistorisches Museum, Vienna, (inv. no. 6786)
[*repr. in colour on p. 80*]

Presented to the Museum in 1931 as a Castiglione, the picture was first attributed to Andrea di Lione by Longhi, who recognized the monogram *ADL* on the jar in the centre of the composition; the subject was identified as the 'Departure of Jacob' (Washington etc. 1949–50) or 'Jacob's Voyage' from *Genesis*, XXXI, 17–18. It has also, however, been interpreted as the 'Transformation of the Bitter Waters of Mara to Sweetness' from *Exodus*, XV, 23–25 (Spike in Princeton 1980). In any case, an Old Testament subject in a pastoral setting was a common theme in the seventeenth century and employed several times by Di Lione himself.

This painting is generally regarded as the masterpiece of his 'bucolic' painting; the colour scheme is dominated by orange-brown, pale green, lemon yellow, vermilion and blue, and nature is portrayed in an animated and romantic light. Lione is at his best as a precious colourist and skilful composer. These characteristics make the *Voyage* fundamental for the attribution of other works to the artist, notably another version of the *Voyage of Jacob* (Prado, Madrid) which had also been catalogued as a Castiglione (Siora 1960; Pérez Sánchez 1965).

The attribution to Castiglione of works that turn out to be by Andrea di Lione is indicative of the close connection between the two painters, particularly after 1635 when the former arrived in Naples. From 1632–34 Castiglione had been in Rome, where he saw Poussin's neo-Venetian paintings of the late 1620s, and he was to draw on them for inspiration. A recently rediscovered work by Castiglione is of great relevance for the present picture: the *Voyage of Jacob* formerly at Stafford House, London, and now in a private collection, New York. The composition of this work, which is signed and dated 1633 and therefore the earliest of Castiglione's known works in Rome, is almost identical to Andrea Di

Lione's painting from Vienna, suggesting that he also travelled there and worked in the circle around Poussin. Both pictures are very Poussinesque in character, and Di Lione used the composition as the basis for a number of paintings (Brigstocke 1980; Spike in Princeton 1980). A further indication that the Vienna painting was done in Rome is provided by the fact that a preparatory drawing for it recognized by Mary Newcome (1978) belongs to an album with many Roman subjects, like a detail from the Arch of Titus and views in the Forum. The drawing shows *Jacob Guiding the Flocks of Laban* and is in the hard, angular style typical of the painter's graphic work. The painting reflects the continuing influence of the artist's first teacher, Aniello Falcone, but these echoes are overlaid by those of Poussin and Castiglione, whose technique and choice of subject are reflected in many Neapolitan painters of the 1630s. Another *Voyage of Jacob* (in the Delbanco Collection, London in 1935) that was attributed to Andrea di Lione by Percy must date from the same period, given the presence of the same Poussinesque figures and naturalistic detail (Percy in Philadelphia 1971; Newcome 1978).

I.C.

PROVENANCE
Presented to the Museum in 1929 by Karl-Hugo and Wolfgang Seilern

EXHIBITIONS
Washington etc. 1949–50, no. 49

REFERENCES
Brejon de Lavergnée, forthcoming article; Brigstocke 1980, pp. 292–98; Buschbeck 1931, p. 153; Newcome 1978, p. 166, fig. 1; Novelli Radice 1976, p. 169; Perez Sanchez 1965, p. 400; Philadelphia 1971, p. 51, n. 52; Princeton 1980, p. 39; Soria 1960, pp. 24–25, 33 n. 14

2

Venus and Adonis

76 × 102 cm
Signed: *Andrea D Lione F.*
Mario Lanfranchi Collection, New York

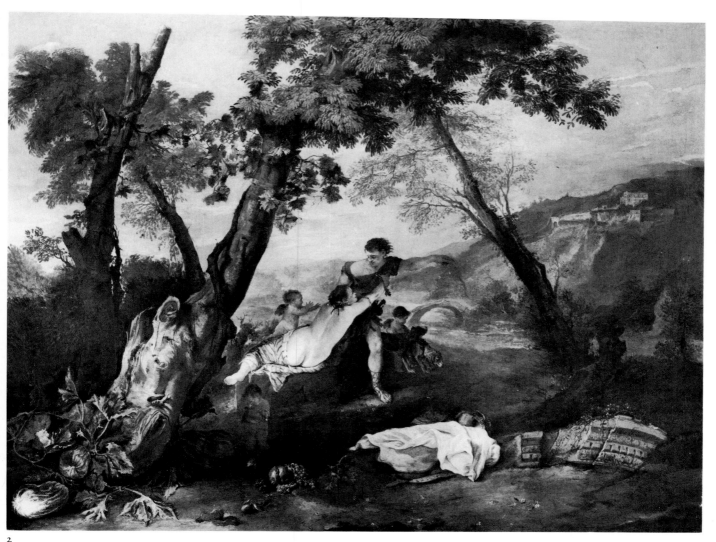

2

Venus attempts to restrain her lover Adonis from leaving for a boar hunt in which he will meet his death. Andrea di Lione, the 'master of the bucolic scene', gives as much prominence to the landscape as to the tragic lovers; as well as such motifs as twisted tree trunks and delicate foliage, misty distances and realistic hounds, which recur in other works by Di Lione, he includes here a still life with fruit. This detail can probably be interpreted as an allegory of death and rebirth in nature, mirroring the myth of Venus and Adonis (Soria 1960).

The pose of Adonis, caught between flight and farewell, is dependent on Titian's interpretation of the myth (*Metamorphoses*, X, 529). Andrea may have known Titian's paintings from engravings or he may possibly have seen one of them if he visited Rome in 1647 as De Dominici reported; the *Venus and Adonis* (Galleria Nazionale, Rome) was already in Rome at an early date. The composition with landscape on either side of the figures is derived from the work of G. B. Castiglione (Spear 1980); the two artists met in Naples in 1635 and Castiglione's influence is particularly evident in Di Lione's early work. The influence of Falcone and Poussin, also important in his first years, is less apparent here, although the athletic figure of Adonis silhouetted against the light sky derives from Aniello Falcone, while the putto on the left carrying a bundle is a direct quotation from Poussin. This subject was repeatedly painted by Poussin following the success of the poem *Adonis* by G. B. Marino, published in 1623.

On the basis of style this picture probably dates from late in Di Lione's career; the wide distances, the overall luminosity and the splendid still life painted with very free brushwork, are all typical of Neapolitan painting of the mid-1650s.

I.C.

REFERENCES
Causa in *Storia di Napoli* 1972, V, II, fig. 355;
De Dominici 1742–45, XX, p. 81;
Salerno 1977–78, II, p. 516, no. 85.2;
Soria 1960, pp. 23–35; Spear 1980, p. 719

Didier Barra

BORN METZ *c*. 1590

Formerly known as Monsù Desiderio, a 'renowned painter of views' (De Dominici) responsible for the panorama of Naples in the picture by Onofrio Palumbo in the Trinità dei Pellegrini, Naples (Cat. 93), the personality of Didier Barra has only recently emerged. He was long confused with another, equally interesting foreign view-painter active in Naples in the first half of the Seicento, François de Nomé, the two painters being merged into one with the common appellation of Monsù Desiderio. Neapolitan historians often used the name Monsù, a corruption of *monsieur*, to indicate the foreign origin of painters active in Naples. The riddle was solved when a signature and date were found on a painting of *Castel dell'Ovo and Posillipo* (Museo di S. Martino, Naples) which reads *Desiderius Barra ex Civitate Metensi in Lotharingia F. 1647* (Sluys 1954, 1961; Causa 1956). In fact this inscription, which is on the back of the relining canvas, does not belong to this picture but comes from another *View of Naples* in the same museum. This problem was only recently resolved following Tribout de Morembert's researches in the Metz archive.

Barra was the son of an innkeeper Clement Pitelin (or Pitelain) and his wife Jeanne, born at Metz probably in the last decade of the sixteenth century; in 1608, when he was aged about 16 or 17, he may already have left home (Sluys 1961). The second artist was identified as François de Nomé, two years younger than Didier and also born in Metz, who was active in Italy at an earlier date. It remained to distinguish between the two; Didier is characterized by Causa as a careful view-painter, who accurately recorded panoramic views of Naples. He was a specialist in the bird's eye view, more of a topographer than a view-painter, but with a lyrical temperament and a lively pictorial style. The second painter, François de Nomé, painted earthquakes, cataclysms and eruptions, and his work is of a very different character, imbued with the imaginary, the whimsical and the extravagant. The two artists did, however, collaborate on some works, and it was this fact that resulted in their being confused.

Once their separate styles were sorted out, two views in the Museo di S. Martino, one in Rome in the Alomello Collection and another in the Everett Austin Collection (exhibited in 1950 at the Ringling Museum, Sarasota) were ascribed to Barra. Other works have also been identified as by him; a painting done in collaboration with Giuseppe Marullo at S. Gennarro dei Cavalcanti, Naples (Causa 1956), a signed view incorporated in a painting by Antonio De Bellis, now at Dubrovnik (Causa, oral communication) and paintings in private collections in Rome and Naples. De Seta's careful analysis of Barra's work (1980) has established that his topographically precise panoramas of Naples were indebted to the work of the Calabrese cartographer Alessandro Baratta. He was a *vedutista* who refined and reinterpreted cartographical information.

F.P.

REFERENCES
Causa 1956, pp. 34–36; De Dominici 1742–45, II, p. 241;
De Seta 1980, pp. 48–49;
Sluys 1954, pp. 1–4;
Sluys 1961, pp. 14, 15, 21, 22, 58

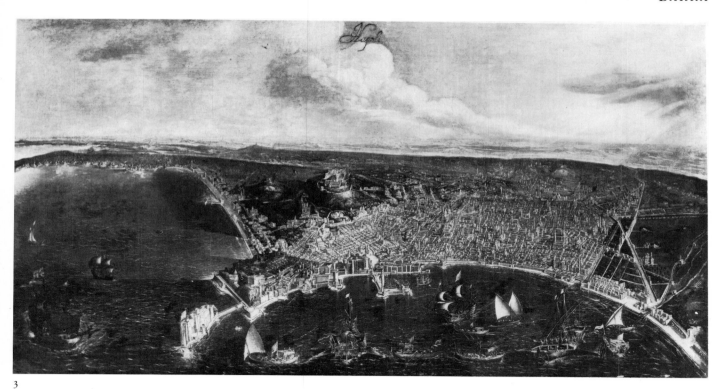

3

3
View of Naples

69 × 129 cm
Inscribed: in the sky NAPOLI, on the back DESIDERIUS
BARRA / EX CIVITATE METENSI / IN LOTHARINGIA F.
1647
Museo Nazionale di S. Martino (Inv. 3566)

Reading from left to right, this view of Naples
from the sea shows the hill of Posillipo,
Mergellina, and the Riviera di Chaia as far as the
promontory of Pizzofalcone and Castel
dell'Ovo. The fort of Sant'Elmo appears, some-
what foreshortened, on the hill in the back-
ground. The coastline continues with the
Castello Aragonese, the basin of the port where
ships are moored, and ends with the estuary of
the River Sebeto. Naples is shown within the
walls constructed during the reign of the Viceroy
Don Pedro de Toledo. The edict of 1565–66
restricting building to the area inside the walls
was still in force during the Seicento and right
through the reign of Carlo di Borbone.

 The painting is signed and dated on the back.
A confusion arose when the inscription was
incorrectly said to have been on the back of
another painting in the Museo Nazionale di S.
Martino, a view of the Castel dell'Ovo and
Posillipo which was consequently said to be
Barra's first documented work (Sluys 1954,
1957, 1961; Causa 1956; De Seta 1969, 1980).

 This *View of Naples* can be taken as the
starting point for a study of Barra's Neapolitan
career. *The Eruption of Vesuvius* (Allomello

Coll., Rome) dates from 1631 and the view
which forms part of Palumbo's *S. Gennaro
Interceding for Naples* (Cat. 93) is slightly
later, around 1651–52. The S. Martino painting
is closest to this last picture. Both show the same
characteristics: they are topographically
accurate views enlivened by light brush strokes
and anecdotal details such as the ships and the
birds in the sky.

 Barra seems to have used engravings by the
Calabrian topographer Alessandro Baratta as a
basis for his panoramas: these provided the
most reliable views of the area. He seems to have
used two engravings: the *Fidelissimae Urbis
Neapolitanae*, drawn in 1616 and published in
1629 (Banca Commerciale, Rome) and the *View
of Naples with Horsemen* of 1630 (Coll. De
Franco, Naples). But Barra takes some liberties
in interpreting Baratta's engravings: he uses a
single viewpoint, shows the town at a more
raking angle and only generally indicates the
buildings in the city. His high viewpoint enables
him to emphasize the promontory of
Pizzofalcone and the Castle of S. Elmo.

F.P.

PROVENANCE
Museo Nazionale di Napoli, 1884

EXHIBITIONS
Rome 1950, no. 10; Naples 1962, no. 8; Naples 1967, no. 19;
Rome 1982, no. 60

REFERENCES
Casanova in Naples 1967, pp. 31–2; Causa 1956, pp. 34–35;
De Seta 1969, pp. 49–50, fig. 30; De Seta 1980, pp. 49–50;
Sluys 1954, pp. 1–4

Andrea Belvedere

NAPLES c. 1652–NAPLES 1732

A complex personality, a man of letters and playwright as well as the foremost flower painter in Naples in the late seventeenth century, Andrea Belvedere rejected the exuberance and facility of baroque decoration and created a naturalistic style which also contained elements of a refined rococo sensibility (Causa 1964). At first he worked in the tradition of Paolo Porpora, whose inventive originality he shared, and he was also influenced by Giuseppe Recco's early style. Although he studied the work of the Spaniard Juan de Arellano, the influence of contemporary Flemish still-life painting suggested by De Logu (1962) must have been very slight. His early works are small in scale and individualize each object, as in the two pairs of pendants with *Carnations and Tulips* (Capodimonte; Museo Correale, Sorrento). The *Vase of Flowers* which Bologna (1968) took to be a mature work, probably belongs to this early period. In his early paintings of fish, Belvedere updates the formal style of Giuseppe Recco by adding a new romantic sensibility which foreshadows the eighteenth century (eg. *Fish*, Museo Nazionale di S. Martino, Naples, monogrammed A.B.).

In his middle years Belvedere refined the baroque style of Abraham Brueghel and the late work of Giovanni Battista Ruoppolo. He assimilated the innovations of fashionable flower painters such as Jean-Baptiste Monnoyer and the German artists Vögelaer (known as Carlo dei Fiori) and Franz Werner von Tamm (Monsù Duprait). To this period belong the *Convolvulus and Guelder Rose* (Cat. 4), the slightly later *Flowers around a Herm* (Stibbert Museum, Florence) and the *Ducks and Flowers* monogrammed A.B. (Pitti Palace, Florence); these are grand decorative compositions, rich in fantasy and subtle in colouring.

From 1694–1700 Belvedere was in Spain, called to the court of Madrid, perhaps on the recommendation of Luca Giordano (Prota Giurleo 1953; Pérez Sánchez 1965). In his later paintings, his refined colour sense disappeared and he failed to repeat the success of the earlier Spanish flower painters Arellano and Perez. When he returned to Naples at the beginning of the eighteenth century he abandoned painting, apparently unable to tolerate the facile decorative compositions fashionable at this date. The last 30 years of his life were spent in the world of the theatre.

Belvedere's work influenced Tommaso Realfonso, Nicolo Casissa, Gaspare Lopez and perhaps the little-known personality of Francesco Bona (Bologna 1968).

R.M.

REFERENCES
Bologna in Bergamo 1968, pl. 55; De Logu 1962, pp. 154–56; Causa in Naples 1964, p. 15; Perez Sanchez 1965, pp. 378–80; Prota Giurleo 1953, pp. 25–30

4
Convolvulus and Guelder Rose

101 × 74 cm
Capodimonte, Naples
[*repr. in colour on p.* 102]

This picture came from the Casa Valletta, Naples where it was known to De Dominici. It shows a branch of guelder rose (*viburnum*) resting against a tree trunk and some convolvulus whose flowers hang down over a pool of water (Causa 1964). In the subtlety of its lighting and inventive verve, this exceptional painting anticipates the mood of the eighteenth-century *capriccio*. It belongs to the early 1680s, from the middle of Belvedere's brief painting career, before he fell under the influence of the French still life painters, particularly Monnoyer, whose style he absorbed through the work of the German painters Vögelaer and Tamm, then active in Rome (Causa 1972). This was the first of Belvedere's lush decorative compositions such as the *Flowers with a Copper Dish* (Museo Correale, Sorrento) and the *Flowers around a Herm* (Stibbert Museum, Florence) whose monumental scale and markedly romantic vein anticipate his work in Spain.

R.M.

PROVENANCE
Casa Valletta, Naples

EXHIBITIONS
Naples, Zurich, Rotterdam 1964, no. 110

REFERENCES
Causa 1964, p. 15;
Causa in Storia di Napoli, V, II 1972, pp. 1053, n.39, 1025;
De Dominici 1742–45, III, pp. 571–2;
De Rinaldis 1928, pp. 22–23; Malajoli 1964, p. 58;
Ortolani in Naples 1938, p. 113;
Rosci 1977, p. 176

Giovanni Battista Caraciolo,
called Battistello

NAPLES 1578–NAPLES 1635

Born in December 1578 into a family described in the sources as noble, although this is not proven, in 1598 Caracciolo married Beatrice di Mario da Gaeta (Stoughton 1978). By this date he was probably already in the workshop of Belisario Corenzio, together with Luigi Rodriguez. The earliest surviving document, dated 1601, which concerns some putti painted on the façade of the Monte di Pietà (now ruined), refers to him in conjunction with these artists. After nearly ten years working in the

mannerist tradition of Cavaliere d'Arpino, from which period no works survive apart from a controversial fresco of putti and drapery around the organ of the church of Monteoliveto (*c.* 1606–07), the arrival of Caravaggio in Naples marked a turning-point in his career.

The *Immaculate Conception* in S. Maria della Stella (Cat. 5), which a newly-published document shows was commissioned in 1607 is witness to his enthusiastic conversion to Caravaggesque naturalism. But even here, this naturalism does not completely obscure his mannerist sense of design. From 1607–14 he assimilated Caravaggio's style completely, imitating his compositions and subject matter. At this time he established links with the Pio Monte della Misericordia (the most active devotional institution in Naples at the beginning of the century) and with the Society of Jesus, who were to be his principal patrons. He enjoyed the close friendship of Giovanni Battista Manso, Marchese di Villa, who was a man of letters, a friend of the poet Marino and was himself something of a poet according to De Dominici. Through this circle he came to know Basile, who dedicated a poem to him in the *Madrigali e Ode* of 1617, and painted his portrait (lost, known through an engraving). In his early period, following Caravaggio's example, he painted religious pictures on a small scale: the *Ecce Homo* (versions in Hermitage, Leningrad, Capodimonte, Paola), the *Madonna and Child* (S. Martino), the *St. Joseph* (Lausanne), the *Baptism* for the Girolamini (Cat. 6) and the *Way to Calvary* (Turin). In 1610 Marcantonio Doria, Caravaggio's patron for the *Martyrdom of St. Ursula* (Cat. 19) commissioned a *St. Lawrence* from Caracciolo, which is perhaps the picture now at S. Martino and for which there is a preparatory drawing in Stockholm. His presence in Naples is documented from 1602–12, during which time his wife bore him five children.

In 1614 he visited Rome, where he came into contact with Orazio Gentileschi. Returning to Naples he executed two large altarpieces between 1615 and 1617: *The Liberation of St. Peter* of 1615 (Cat. 7) in the Pio Monte della Misericordia and the *Trinitas Terrestris* in the Pietà dei Turchini (1617). He also frescoed the chapel of St. Simon Stock in S. Teresa agli Studi (after 1616). He then went to Rome, where he registered in the St. Luke's Guild, saw the work of Annibale Carracci in the Farnese Gallery and was associated with the group of artists working at the Quirinal Palace (Turchi, Tassi, Saraceni, Lanfranco, Spadarino). Next he travelled to Florence, where he painted the *Rest on the Flight* in Palazzo Pitti (1618) and studied early Seicento Florentine painting. He probably met Bilivert, Allori and Artemisia Gentileschi. Finally he went on to Genoa, where in 1618 he frescoed in the *casino* of Marcantonio Doria at Sanpierdarena on which both Gentileschi and Vouet later worked. Having returned to Naples by the end of 1618, he despatched the *Madonna d'Ognissanti* to Stilo for his doctor Carnevale.

He was somewhat influenced by Ribera's successful early works, but his Caravaggism was superseded by a more classicizing and Lanfranchian style derived either from further brief visits to Rome or from Vouet's Neapolitan paintings. His first major success of this phase is the large *Washing of Feet* in S. Martino (1622). In the following years his fresco decorations are painted in very light colours (eg. the chapel of S. Severino in S. Maria la Nova 1923; the chapel of the Assunta, 1623–26; the chapel of S. Gennaro in S. Martino *c.* 1631–33 and the chapel of Mary in S. Diego all' Ospedaletto). In 1623 he also painted a pendentive in the Cappella del Tesoro in Naples Cathedral, which formed part of the prestigious commission given to Santafede; a protracted legal case arose when the *Deputati del Tesoro* suspended payment. Later these frescoes were destroyed to make way for those of Domenichino.

After 1625 his work displays a hybrid quality; increasingly he suggested movement through linear contortions, possibly a survival from his mannerist background. His Caravaggesque chiaroscuro is reinforced, but the drawing is given more prominence and the forms are distorted in a manner reminiscent of Lanfranco. The *Adoration of the Magi* (*c.* 1626) and the other paintings in the Sala del Capitolo at S. Martino, the *S. Luigi Gonzaga* in the Gesù Vecchio (1627), the *bozzetto* for the altarpiece of the church of the Carminiello al Mercato, and the *Assumption of the Virgin* in the chapel of the Assunta in S. Martino (1631) provide points of reference for Caracciolo's chronology at this time.

In his final years, he was increasingly aware of the art of Domenichino and Lanfranco, who were in Naples at the time; he accentuated rhetorical and stage-like effects in a manner that verges on the baroque. Apart from the paintings at S. Diego and S. Martino, this last phase also includes the frescoes in the Oratorio dei Nobili at the Gesù Nuovo and at the Palazzo Reale, and paintings such as the *S. Anna* (Vienna) and the *Judgement of Solomon* (Serlupi Coll.).

P.L.d.C.

REFERENCES
Stoughton 1978, pp. 204–15; Prohaska 1978, *passim*

5

Immaculate Conception with SS Dominic and Francis of Paul

334 × 209 cm
Signed: bottom centre *Batta. Caracciolvs* / *F.*
S. Maria della Stella, Naples

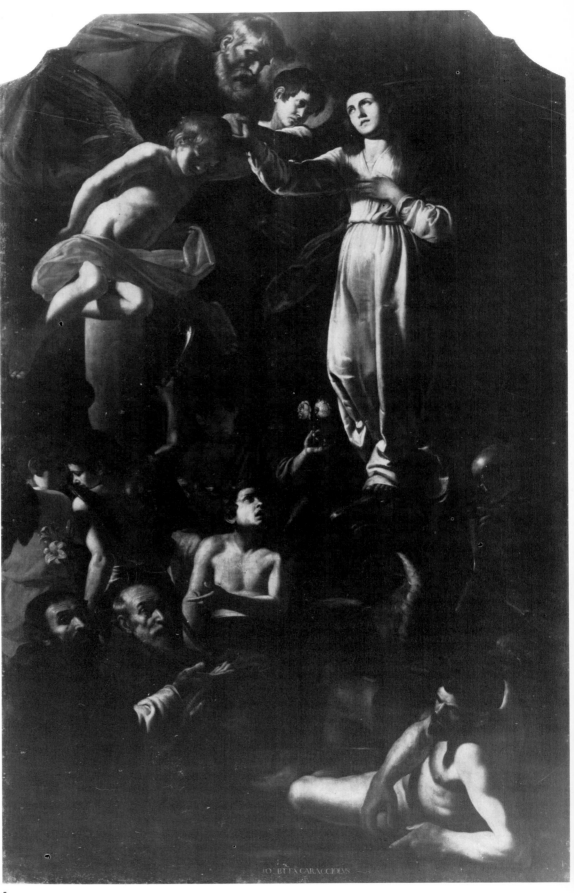

5

On 16 July 1607, Domenico Barile was conceded the second chapel on the left as one enters the church of S. Maria della Stella, with the dedication to the 'S(antissi)ma Concezzione'. He paid 500 ducats with the promise of an additional annual amount of 40 ducats for the celebration of mass there on 8 December, the feast day of the Immaculate Conception (Archivio di Stato, Naples, Monasteri Soppressi, S. Maria della Stella, 4514, p. 166). Almost exactly three months later, in October 1607, Barile wrote a cheque for the amount of 50 ducats in favour of Caracciolo for the 'Quatro della cona della sua Cappella in S(an)ta M(ari)a della Stella' (Archivo Storico del Banco di Napoli, Banco Ave Gratia Plena, Apodissario, Giornale Copiapolizze, Matricola 47, not paginated, cheque cashed 20 October). The wording of the cheque suggests that this was the advance payment and that the painting had not yet been started. Ten days later, Barile made another payment of 20 ducats by cheque to Caracciolo for the same commission, but the work was by that time in progress for the document states, 'Che si fa' (Archivo Storico del Banco di Napoli, Banco di S. Maria del Popolo, Apodissario, Giornale Copiapolizze, Matricola 62, p. 451, cheque cashed 30 October). No other cheques appear to have been paid in cash.

De Dominici wrote in his biography of Caracciolo (1743) that the painting in question was in one of the chapels in the church and added a marginal note that it had been moved to the sacristy, above the door. It remained there, safe from the bombing of World War II which levelled the church itself and, as the only major picture which survived, was moved to the high altar in the reconstructed church where it remains today.

Caracciolo presents the fully developed iconography of the Immaculate Conception. The Virgin stands on the head of a monstrous dragon, representing her triumph over Satan, the cause of Original Sin (De Dominici incorrectly gives the dragon seven heads, actually an appropriate reference to the woman of the apocalypse). The Virgin's triumph over death is symbolized by the skeleton at the right of the dragon which has its clawed paws at either side of the head of Adam, who reclines below, holding the apple. At the left of the composition, angels hold three attributes of the Virgin Immaculate: lilies, a mirror and thornless roses. Above, God the Father representing the Trinity, responsible for preserving Mary from Original Sin, takes one of her hands as she lifts the other to her breast in a gesture of humility (see D'Ancona 1957). In the lower left part of the picture are St. Dominic and St. Francis of Paola, founder of the Minims, the religious order of the monastery and church of S. Maria della Stella. In the early seventeenth century the Franciscans in

particular engendered enthusiasm for a formal definition of the doctrine of the Immaculate Conception from the Papacy.

Now that this major masterpiece by Caracciolo can be dated to 1607, it takes on an added significance as the artist's earliest extant and documented oil painting. It establishes his importance as the earliest and most important of the Neapolitan Caravaggisti and places the emergence of his mature style about a decade earlier than had previously been thought. The arrangement of God the Father with two angels in the top left corner bears comparison with the Madonna and Child with angels hovering above in Caravaggio's Seven Acts of Mercy from which Caracciolo has paraphrased the general composition, as well as the grouping and even certain gestures of some of the figures. More specifically, the details of the face of St. Dominic and of the column derive directly from the corresponding features in the Madonna of the Rosary (fig. 10). Through gesture and glance, Caracciolo's composition builds upward along a diagonal from the two saints at the lower left, through the angel holding a palm branch, to the Virgin Immaculate at the upper right. Caravaggio used similar devices in the Madonna of the Rosary, but the subsidiary elements, particularly the angels holding symbols of the Immaculate Conception at the left of the picture, create a more diffused, less unified composition with less emphasis on the forceful development towards the Madonna and Child. These angels appear to be illuminated by a secondary light source, distinct from that responsible for revealing the major figures, which also tends to divide the figures into groups that are less closely united than in Caravaggio's work.

M.S.

EXHIBITIONS
Naples 1938, no. 1; Naples 1954, no. 4; Naples 1960, pp. 101, 143

REFERENCES
Causa 1957, p. 28;
Causa in Storia di Napoli, V, II, 1972, p. 923, fig. 269;
Celano 1692 (ed. 1860), VI, p. 450;
De Dominici 1742–45, II, pp. 282–83;
Longhi 1915 (ed. 1961), pp. 190–91, 207, n. 21, 209;
Moir 1967, I, p. 160, n. 23; II, pp. 52–53, fig. 181;
Prohaska 1978, p. 212, fig. 156; Roberti 1910, p. 49

6

The Baptism of Christ

116 × 145 cm
Pinacoteca dei Girolamini, Naples

The painting was first seriously discussed by Longhi who established its early date, but his hypothesis that it was a fragment of a larger painting by Caracciolo of the same subject mentioned by the sources in S. Giorgio dei Genovesi has still not been settled. Although

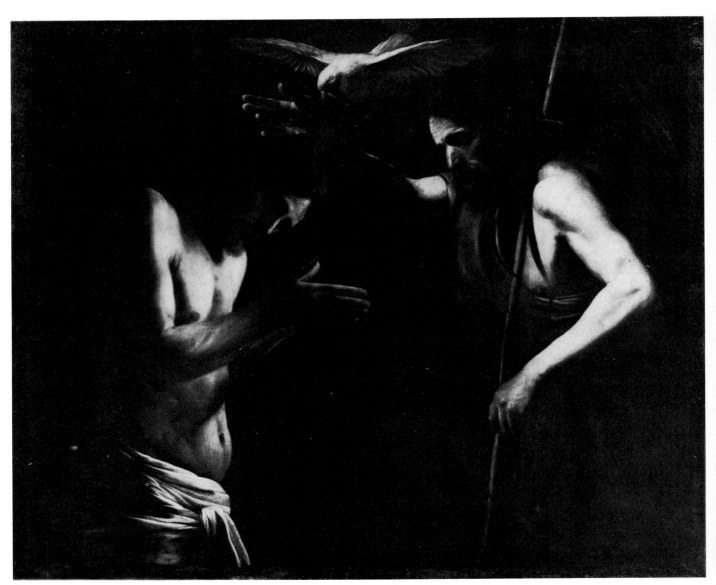

6

several writers mention the *Baptism* in that church (De Dominici, D'Afflitto, Nobile, Chiarini), others (Celano, Sigismondo, Catalani) described a painting of the same subject in the Girolamini. Curiously, no guide mentions both pictures, yet it seems difficult to believe that the same painting was shifted continuously from one church to another. So we may conclude that although the Girolamini *Baptism* has been cut down (the 1953 restoration revealed that the canvas was nailed at the edges to the frame), it cannot be a fragment from the S. Giorgio altarpiece.

The painting is strongly Caravaggesque: half-length figures are closely juxtaposed, the composition is simple, the figures are evidently painted from life and the light hits them from above. In this work more than any other Battistello shows his understanding of Caravaggio's use of light; opaque objects are used to cover the light source although light permeates their edges, and the difference in intensity of the shadow of a figure in the foreground and that of one which blocks a distant shaft of light is observed. The bronze flesh tone lit by a cold light is also Caravaggesque.

This is one of a group of paintings which slightly post-date the 1607 *Immaculate Conception* (Cat. 5) in which Battistello approached Caravaggio closely in the severity of composition. They include the *Ecce Homo* (Leningrad), the *Crucifixion* (Annunziata) and the *St. Joseph* (Lausanne), all of which date from *c.* 1608–10. It seems probable that they are influenced by two paintings of *The Flagellation* by Caravaggio (Cat. 15 and Rouen Museum), but despite the discovery of a document of May 1607 for the first of these, the date given to the two paintings vacillates between 1607 and 1609.

P.L.d.C.

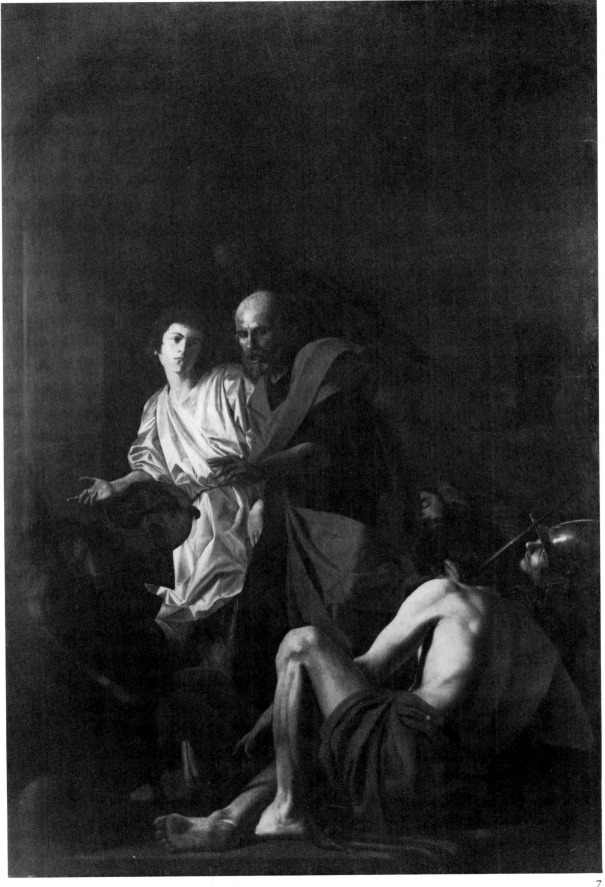

EXHIBITIONS
Naples 1953, no. 14; Athens 1962–63, no. 8;
Naples 1963, no. 14; Paris 1965, no. 15; Bucharest 1972;
Naples 1972

REFERENCES
Catalani 1845–53, I, p. 80; Causa 1966[1], p. 7;
Celano 1692 (reprinted 1970), II, p. 696;
Longhi 1915, (reprinted 1961), pp. 184, 209;
Moir 1967, I, p. 160, II, p. 52;
Prohaska 1978, pp. 210–11 with full bibliography

7

The Liberation of St. Peter

310 × 207 cm
Monogrammed: GBCA
Church of the Pio Monte della Misericordia, Naples

The subject of this picture is the Liberation of St. Peter from the prison in Jerusalem where King Herod Agrippa had confined him (*Acts, XII, 6–10*). The subject was popular with many Caravaggesque painters at the beginning of the Seicento, both in Rome and in Naples, since the nocturnal setting gave scope for a combination of natural and artificial lighting effects. In this case the subject matter (visiting the imprisoned, forgiving sins) was relevant to the charitable purposes of the institution, the Pio Monte della Misericordia, that commissioned the work. The Pio Monte, which had already commissioned Caravaggio's *The Seven Acts of Mercy* (Cat. 16) for the high altar, which alluded to their charitable deeds, decided in 1608 to spend 300 ducats, donated by Don Carlo Caracciolo di Vico, Duca di Vietri and Duchessa Vittoria Caracciolo di Castro on three paintings: *Tabitha* by Santafede, *St. Paul* by Sellitto and the *Liberation of St. Peter* by Caracciolo (A. Corona, ms. Archivio Pio Monte, ms. cartella A, rubr. A, n. III, p. 101).

The history of the commission is complex: possibly Caracciolo delayed or failed to deliver the *St. Peter*, since on 2 July 1613 the commission was given to Sellitto (*Conclusioni particolari* . . . Pio Monte, Vol. 1a). Sellitto's death in October 1614, however, obliged the governors to restore the commission to Caracciolo, who delivered the picture on 15 September 1615, the date of the final payment (Quarta 1939). The work, which is always referred to in the guide-books from then onwards *in loco*, was previously dated to the early period of the artist's career, between 1607 and 1610, and believed to be heavily dependent on Caravaggio or even a work of collaboration between the two artists, but compared to Caracciolo's early works such as the *Immaculate Conception* and the Girolamini *Baptism*, where the image is simplified by dazzling light effects, the *Liberation of St. Peter* has more rounded forms, more silky illumination on the drapery and a more decorative contrast between light and shade. These features, the refined rendering of the

surface details and the balanced composition probably show both the impact of the late work of Sellitto, and also the influence of Orazio Gentileschi, whose works Caracciolo saw in Rome. We now know that Caracciolo was in Rome and studied Gentileschi in about 1614 from a recently published document (Bologna and Pacelli 1980). The *Sleeping Cupid* at Hampton Court must date from this time and was perhaps even painted in Rome for it is a kind of plagiarism of Orazio's painting of the same subject. Also of this period are the *Baptist* (Berkeley), the *Trinitas Terrestris* of 1617 (Pietà dei Turchini), the *Agony in the Garden* (Vho, Vienna [Cat. 8]) and the *Flight into Egypt of 1618* (Palazzo Pitti, Florence).

Despite the variety of artistic influences discernible in the *Liberation of St. Peter*, it remains one of the most beautiful works of Caravaggesque inspiration of the second decade of the century; the heads of the sleeping soldiers are reminiscent of the *The Seven Acts of Mercy*, as is the great nude figure which acts as a kind of *coulisse* in the foreground, with its red drapery and a shoulder half illuminated and half in shade, like the Cyrenian in the *Way to Calvary* in Turin, painted a few years earlier.

P.L.d.C.

EXHIBITIONS
Florence 1922, no. 74; Naples 1938, no. 4;
Milan 1951, no. 77

REFERENCES
Causa 1966[1], p. 6; Linnik 1975, pl. 20–22;
Mravick 1978, pp. 267, 271; Pacelli 1978[1], p. 493;
Pacelli 1978[2], pp. 432–37;
Prohashka 1978, pp. 153–169 with full bibliography;
Stoughton 1973, pp. 86–88, no. 18; Strazzullo 1955, p. 18

8

Agony in the Garden

148 × 124 cm
Monogrammed: by angel's foot CAB
Kunsthistorisches Museum, Gemäldegalerie, Vienna
(inv. no. F.17)

Caracciolo uses the imagery of the subject, taken from *Luke, XXII, 41–44*, to create an intense psychological and emotional bond with the spectator. Prohaska (1978) refers to its association with the Mocking of Christ and the Crowning with Thorns, with an appropriate quotation from S. Francis of Sales (1616) relating to the Christian soul's sharing of the Saviour's sufferings on the Mount of Olives.

At this period, 1614–18, Caracciolo painted several pictures following the educational and pietistic precepts of the Jesuits and the Pio Monte della Misericordia. In 1615 he had completed *The Liberation of St. Peter* (Cat. 7), which is very close to this painting. Like that painting, it also displays a concern for materials, feathers, rounded forms and a refined definition

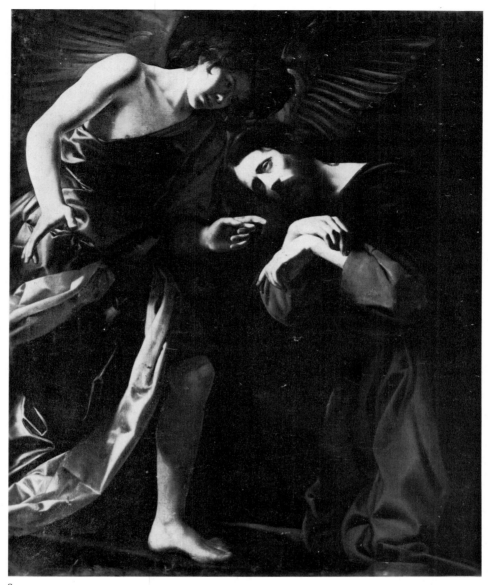

8

of the shadows on the illuminated surfaces, emphasizing the importance of his contact with Orazio Gentileschi in Rome in 1614. Furthermore, the graphic quality of the white highlighting and the drapery folds, and the composition as a whole, is reminiscent of Lanfranco and the artists from Verona who were working at that period in the Sala Regia in the Quirinal. It differs from their work in the Neapolitan intensity of its religious sentiment.

Consideration of the date – which, as has been argued, must be between 1615 and 1617 – is complicated by the existence of a second version of the painting in the parish church of Vho, in Lombardy. Moir (1967) argued that it could actually have been painted there, so associating it with the date of his trip to Genoa, which is now known to have taken place in 1618. This remains problematical, as does the question of the sequence of the two pictures (the Vho painting being larger: 212 × 137 cm).

P.L.d.C.

PROVENANCE
Archduke Leopold Wilhelm; 1659 inventory, under Italian paintings: 'no. 343 A painting in oils on canvas, with Christ on the Mount of Olives, his hands joined, an Angel by him, in a gilt frame with ox eyes, 7 palms 9 ins by 6 palms 7 ins wide. An original by Michael Angelo Caracio'.

EXHIBITIONS
Cleveland 1971, no. 61; Moscow-Leningrad 1980–81, no. 15

REFERENCES
Heinz 1962, pp. 169–80; Moir 1967, II, p. 136; Prohaska 1978, pp. 199–200; Stoughton 1973, no. 20, pp. 89–90

9

A Miracle of St. Anthony of Padua

290 × 224 cm
Monogrammed: upper left GBCA
S. Giorgio dei Genovesi, Naples

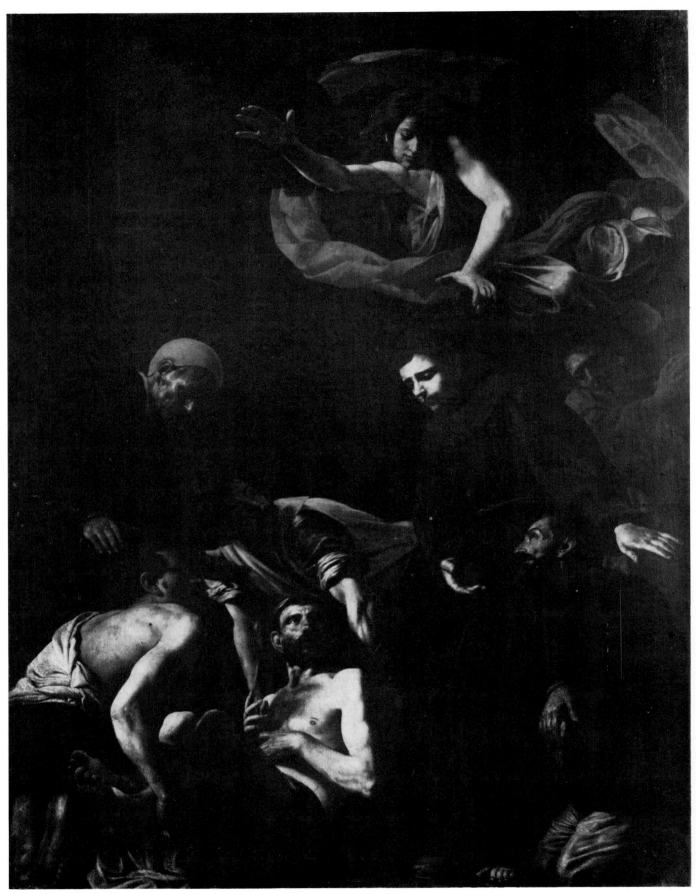

9

Saint Anthony proved his father's innocence when he was unjustly accused of murder, by reviving the dead man and calling on him to bear witness to his father's innocence.

The date of this work is controversial; suggestions vary from around 1606 to 1623–25, and a variety of influences have been seen in it. The difficulties are compounded by the existence of a preparatory *bozzetto* (Pisani Coll., Naples; Causa 1950), in which the angel at the top is omitted. Recently this has led to the suggestion that the altarpiece was completed in two stages (D'Argaville 1972). Although the brown tonality, with occasional accents of red, white and yellow, and the Caravaggesque naturalism might point to an early date, the absence of light-coloured drapery and Gentileschian rotundity in the forms makes this painting quite distinct from the works painted *c.* 1614–17. Compared to even earlier pictures, like the painting at S. Maria della Stella (Cat. 5) with which this altarpiece has often been associated, this work has a coherence of design and a complex spatial organization impossible to imagine prior to Caracciolo's journey to Rome, his study of the Bolognese masters and of Caravaggio's 'history' paintings. In terms of composition this painting has no equivalent amongst his early works: with its central void and the diagonal caesura of the two grave-diggers, the central group of figures dominates the whole composition and recession is suggested by a series of spatial planes (eg. the hand of the old man in a red beret).

The picture should be compared to such works as the *Christ and the Woman of Samaria* (Brera, Milan), the *Madonna dei Marinai* (S. Maria di Portosalvo), the *Dead Christ* at Baranello and the slightly later *Pietà* in the Longhi collection, all of which can be dated between 1618 and 1621, given their stylistic affinity to the *Madonna d'Ognissanti* at Stilo, which it seems certain was painted around 1619 (Pacelli in London 1981). In so far as this date relates to the present painting, it coincides with the building of the church of S. Giorgio dei Genovesi which was consecrated in 1620 (Prota Giurleo, 1962).

It is possible that the figure of the angel, missing in the *bozzetto*, was added during the painting of the picture, which seems to have taken some time. It is similar to the *St. John the Baptist* (Dijon Museum) and to the figure of Tobias in Cat. 10, and its insertion in the composition may be due to Caracciolo's desire to encompass the blank space above the main scene in a manner that was originally Caravaggesque in inspiration, but developed into a form of proto-baroque rhetoric.

P.L.d.C.

EXHIBITIONS
Milan 1951, no. 78; Bucharest 1972; Naples 1972

REFERENCES
Causa 1950, p. 43; D'Argaville 1972, p. 809; London 1981, p. 22; Prohaska 1978, pp. 153–269 with full bibliography; Prota Giurleo 1962, pp. 43, 69

10

Tobias and the Angel

202 × 154 cm
Colnaghi & Co., London
[*repr. in colour on p. 71*]

The picture illustrates the passage from the book of *Tobit* (VI, 2–5) where the young Tobias, having reached the river Tigris on his way from Nineveh to Media, is encouraged by his companion and guide, the Archangel Raphael, to catch a fish and cut out its heart, liver and gall. The first two, when burned, would make it possible to free Sarah of the devil which afflicted her and had caused the death of her husbands, while the gall would restore the sight of Tobit, his father. The figure of Raphael is associated with pilgrimage, and he was venerated both as a protector of travellers and, in a metaphorical sense, as a guide in the voyage of the soul. This aspect of his cult is to a certain extent paralleled by the role of the Guardian Angel.

Stylistically this painting is linked with a group of works that can be dated to 1622; the *Washing of Feet* which is documented in that year (S. Martino), the *Magdalen* (Busiri Vico Coll.), the *Way to Calvary* (from S. Maria del Popolo agli Incurabili, now at S. Martino), the *Noli Me Tangere* (Museo Civico, Prato) and the *SS Cosmas and Damian* (Ballarin Coll.). It is a key moment in Caracciolo's development; a time when he was attempting to create greater spatial articulation through the juxtaposition of figures laid one over the other, placed in diagonals and making informal gestures with their hands and heads. This picture belongs perfectly to that moment; the non-static element consisting of the simultaneous gestures of the two principal figures, the clear diagonal made by the outstretched arms (balanced by the immobile body of Tobias), and the Archangel shown in an oblique stance with his head, shoulders and body twisted, acting as a kind of *coulisse*.

There are similar *profils perdus* in some of the frescoes (*Presentation in the Temple*, *Adoration of the Shepherds*, etc.) in the Cappella dell'Assunta in S. Martino, which date from just after 1622. The drapery of the two figures is comparable to that in these frescoes and the *Noli Me Tangere* at Prato. A date just after 1622 is suggested by the fact that Caracciolo soon after painted the same subject – in a very similar manner – in one of the episodes

from the *Lives of the Angels* in the Cappella Severino, S. Maria la Nova, which can be dated 1623. Nonetheless, the similarity of the figure of Tobias to slightly earlier paintings like the *Woman of Samaria* (Brera, Milan) and the angel in the *Miracle of St. Anthony* (Cat. 9) suggests that this painting is not much later.

The connections with Vouet's paintings in S. Francesco a Ripa, Rome are immediately apparent and Caracciolo also seems to have studied the work of painters working in the Sala Regia at the Quirinal, especially Turchi. A drawing of an angel, connected by Prohaska (1978) with the decorations of the Cappella Severino, could well be a preparatory study for the painting exhibited here.

P.L.d.C.

PROVENANCE
Officers' Mess, Blackheath, until *c*. 1960

REFERENCES
Prohaska 1978, p. 234

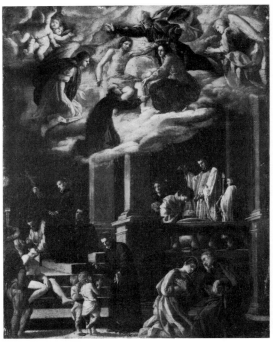

11

11

St. Ignatius in Glory and the Works of the Jesuit Fathers

46 × 35.5 cm
Museo Correale di Terranova, Sorrento

This was published in 1960 by Bologna, who connected it with the small painting of the same subject seen by De Dominici in the collection of Niccolò Salerno. Later it was recognized to be a preparatory study for the large altarpiece painted for the church of the Carminiello, Naples (Stoughton 1973). There are some nineteenth-century descriptions of the altarpiece, which has since vanished, and a document recording the final payment to the artist on 12 June 1629 (Strazzullo 1955).

All descriptions of the painting speak of 'Works of Mercy' and call the figures at the foot of the composition lay members of the Monte della Misericordia. But in fact they are Jesuits, shown performing their fundamental duties: preaching, catechizing, confessing and baptizing, all spiritual acts of mercy. De Lellis recorded that in 1611 the Pio Monte decided to found a church in the poor quarter of the market which was 'full of ignorant people, needing spiritual comfort . . . who should be ministered to by the Jesuit fathers as they are so experienced in this ministry'. The same source tells us that the mission of the Jesuits from the Carminiello was 'to perform for the benefit of those poor people all the spiritual exercises that pertain to the works of spiritual mercy, to enable them to understand the Christian way of life and death' (De Lellis, ed. Aceto 1977). This difference of subject matter and interpretation distinguishes this *bozzetto* from Caravaggio's

The Seven Acts of Mercy. While Caravaggio's painting shows the physical and dramatic side of the Acts of Mercy, Caracciolo's *bozzetto* is an exposition of the role of the Counter-Reformation Church and its duties to the poor; it is a veritable manifesto of devotional propaganda.

As far as we can tell from the *bozzetto*, the architectural setting of the altarpiece was elaborate, including staircases, balusters and columns on staggered levels, similar to those he had used in the *Washing of Feet* of 1622 at S. Martino. These baroque features became more pronounced during the course of the 1620s as a result of Caracciolo's awareness of the baroque solutions of Lanfranco and Vouet. These considerations and the realistic, unrhetorical nature of the foreground figures link this *bozzetto* to such paintings as the *Adoration of the Magi* in S. Martino, the *Trinitas Terrestris* (Gesù, La Valletta, Malta) and the frescoes in the Chapel of the Assumption at S. Martino, all of which are slightly earlier in date.

There are three chalk drawings of Jesuits in the Nationalmuseum, Stockholm which were elaborated on in the altarpiece itself.

P.L.d.C.

PROVENANCE
Nicolò Salerno, Naples 1743

REFERENCES
De Lellis, ed. Aceto 1977, I, p. 469; Bologna 1960, p. 50;
De Dominici 1742–45, II, p. 286;
Fagiolo dell'Arco 1968, p. 53;
Longhi 1915, (as a lost work); Moir 1970, p. 185;
Prohaska 1978, pp. 222–23, 251;
Stoughton 1973, pp. 139–41, no. 54; Strazzullo 1955, p. 19

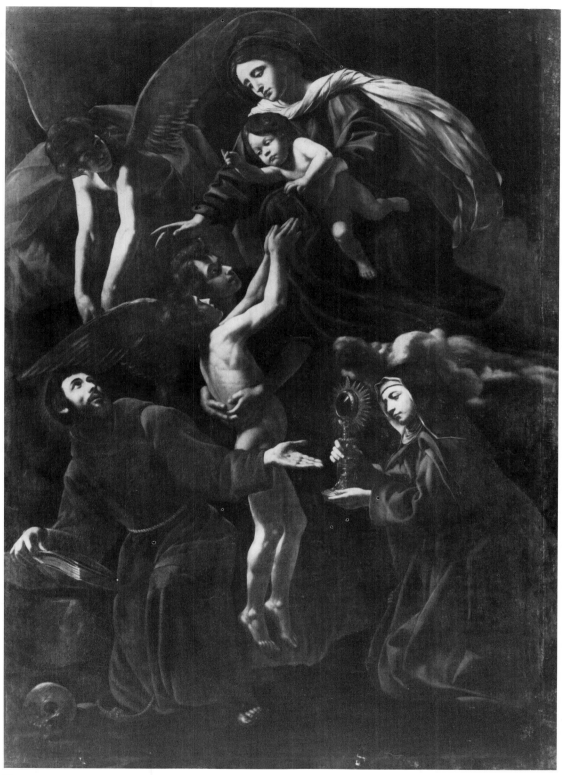

12

12

Madonna of the Purification of the Soul with SS Francis and Clare

290 × 203 cm
S. Chiara, Nola

Framed by SS Francis and Clare, the crowded scene depicts the raising to heaven of a human soul, shown in the form of a naked youth praying and supported by an angel. The Virgin appears in glory above. It is a rare subject, but characteristic of the Counter-Reformation in its

emphasis on salvation achieved through the mediation of the Virgin; and there is also a reference to the role of the angel, perhaps the Guardian Angel, in the salvation of the soul.

This is a relatively recent addition to Caracciolo's oeuvre. It was published as a work by Vaccaro (Commodo Izzo 1951); Brandi (1956) recognized it as a Caracciolo. Its date has been the subject of much discussion: most scholars, noting the derivation of the upper part from Caravaggio's *The Seven Acts of Mercy*, have dated the work before 1617. Causa (1957) first dated it between 1615 and 1622, after Caracciolo's visit to Rome, but later he came to regard it as a late work of 1622–29 (Causa 1972). Recently Prohaska has supported this view, dating it around 1625 and associating it with the *Trinitas Terrestris* at La Valletta (Church of the Gesù), the *Flight into Egypt* at Capodimonte and the *Adoration of the Magi* in S. Martino, which are datable around 1626. Characteristic of this group of works, to which the *Madonna* in the Los Angeles County Museum and the *Cosmas and Damian* at Vienna should be added, is the impressive design of the composition which circumscribes the expanded forms, the sense of movement achieved through the twisting figures and the exploitation of the decorative potential of the juxtaposition of areas of light and shade. The faces have a geometric, stereotyped and mask-like quality, and Caracciolo seems to have made a conscious attempt to render character and emotions by means of set expressions, which seem increasingly divorced from reality.

Nonetheless, it was in these years (1624–25), when he also painted the last frescoes in the chapel of the Assumption at S. Martino (to which this painting is also related), that Caracciolo drew closer to Caravaggio again. In this picture, in the two saints in the Sala del Capitolo, S. Martino, in the *Baptist* (Greco Coll.) and in the Capodimonte *Flagellation*, Caracciolo used Caravaggio both as a source of designs and for a reinforcement of the dark elements in his pictorial language. The duality of his inspiration is to be attributed in turn to the growing influence of Lanfranco and of Vouet's work in S. Lorenzo in Lucina.

There is a preparatory drawing for the figure of the Christ Child blessing in the Nationalmuseum, Stockholm (inv. 1704/1863).

P.L.d.C.

EXHIBITIONS
Rome 1956, no. 32

REFERENCES
Brandi in Rome, 1956, p. 81, no. 32;
Causa 1957, p. 28; Causa 1972, p. 970;
Commodo Izzo 1951, pp. 48, 58, 60;
Cleveland 1971, pp. 63–64;
Fagiolo dell'Arco 1968, p. 53; Moir 1967, I, pp. 87–88;
Pacelli 1979, p. 267; Prohaska 1978, pp. 242–43;
Stoughton 1973, pp. 95–96

13 & 14

Lunettes with the Sacrifice of Isaac and the Story of Jacob

Fresco, each 100 × 150 cm
S. Diego all'Ospedaletto, Naples

The four lunettes belong to the elaborate cycle of frescoes on the theme of the Virgin Mary that Caracciolo painted in the chapel at the end of the left nave of the church of the Ospedaletto. One represents a landscape with a shepherd and his flock, probably Jacob with Laban's sheep, while the others show three episodes from the story of Abraham and Isaac (*Genesis*, XXII, 1–13). In the first, Abraham sets out with Isaac to climb the mountain to perform the sacrifice; in the second, the angel stays Abraham's hand, while in the third, he and Isaac pray by the altar where the sacrificial lamb burns. The lunettes are located on the lower level of the chapel; above are cycles illustrating the *Forbears of the Virgin Mary* (David, Solomon, Roboam, etc.) and the *Allegories of the Virtues*, and, in the centre, three frescoes of the *Coronation*, *Birth* and *Assumption of the Virgin*. The composition of the *Assumption* is derived from the *Assumption* at S. Martino, dated 1631, so it is one of Caracciolo's last works.

The cycle is not of the highest quality and was probably painted with workshop assistance; the figures are puffy and ill-formed, similar to those in other late works like the *Judgement of Solomon* (Serlupi Coll.), while the landscapes are a far cry from the brilliance of his early work in this genre, such as the *Elijah* (Carmel chapel, S. Teresa agli Studi). Caracciolo's preference for the Bolognese school is evident; there are echoes of Annibale Carracci, Domenichino and Lanfranco, who also painted lunettes.

Although he must have known the work of Brill, Elsheimer, Filippo Napoletano and Poelenburgh, here he was still working in the decorative style current in Rome 15 years earlier (Prohaska 1978). These frescoes may be compared to the Quirinal frescoes of 1616–17 by Tassi and Gobbo dei Carracci, which are perhaps the most accomplished synthesis of the various schools of landscape painting (the Flemish tradition of Brill, the classicism of Carracci and the brilliant clarity of Elsheimer). Caracciolo took the bright tonality, the use of the trees as a *coulisse* and the perspective view to one side from Tassi, while the broken tree trunk and the view of a valley dotted with trees are reminiscent of Gobbo. Although these landscapes are less 'in focus' than those of Filippo Napoletano, they must have been important for the formation of Micco Spadaro's style.

P.L.d.C.

13

14

EXHIBITIONS
Bucharest 1972; Naples 1972

REFERENCES
Prohaska 1978, pp. 260–62, no. 74 with full bibliography;
Pacelli 1979², p. 385

Michelangelo Merisi da Caravaggio

CARAVAGGIO or MILAN 1571/72–PORTO ERCOLE 1610

The son of Fermo Merisi, the architect and majordomo of Francesco Sforza Colonna, Marchese di Caravaggio, the artist was first apprenticed to Simone Peterzano in Milan, and established himself in Rome after May 1592. His biographers emphasize the difficulties he encountered at the start; he later entered the workshop of Cavalier d'Arpino, for whom he painted still lifes. The cultivated Cardinal Francesco Maria del Monte, who was interested in art, science and alchemy, was his first important patron. His early works, apart from still lifes, are generally half-length figures of allegorical subjects, genre scenes with moral implications and private religious paintings. His first public success as a history painter was in the

Contarelli chapel in S. Luigi dei Francesci (1599–1602) and this was followed by the two lateral pictures in the Cerasi chapel in S. Maria del Popolo (1600–01).

His radical interpretation of traditional subjects, his insistence, recorded by Van Mander, on painting directly from life without using drawings and his pursuit of an objective representation through the use of light effects based on his knowledge of optics cultivated in his native Lombardy, all caused a sensation in artistic circles in Rome. Nonetheless Caravaggio was not insensitive to the classical world, or to the great painters of the sixteenth century such as Raphael and Michelangelo. The *Deposition* painted between 1602 and 1604 for S. Maria in Vallicella represents a reconciliation of monumentality and naturalism. Subsequently Caravaggio was asked to paint the *Madonna di Loreto* (1603–06), the *Madonna dei Palafrenieri* for the altarpiece of S. Anna dei Palafrenieri in St. Peter's (1605–06) and the *Death of the Virgin* for S. Maria della Scala. These two pictures were rejected on the grounds of their lack of decorum. It was during these years that Caravaggio's aggressiveness and violence began to manifest itself, causing him first to flee to Genoa in 1605, and then to leave Rome again after killing Ranuccio Tomassoni during a ballgame, on 29 May 1606.

Caravaggio took refuge first on the estates of Don Marzio Colonna (who was a relative of the Marchese di Caravaggio) at Zagarolo, Palestrina and Paliano, arriving in Naples in the autumn of 1606. He travelled to Malta (where he is recorded as early as 13 July 1607) at the invitation of Alof de Wignacourt, the Grand Master of the Knights of Malta, of whom he painted two portraits mentioned by his biographers (and perhaps a third), and who made him a knight of the Order. His great canvas of the *Decollation of the Baptist* in Valletta was painted after this election.

But by 6 October of the same year Caravaggio had fled from the island, where he had been held prisoner, and gone to Sicily. There he painted a number of pictures in Syracuse, Messina and Palermo; from December 1608 he was probably in Messina, where he completed the *Resurrection of Lazarus*, donated by his patron to the Padri Crociferi, and also the *Adoration of the Shepherds* in the Church of the Cappuccini. He was probably already in Palermo by August 1609, and he painted the *Nativity with SS Francis and Lawrence* there. On 24 October it was reported that he had been attacked in Naples. He embarked on a felucca, intending to return to Rome, as he knew a pardon was imminent, but died from an attack of fever on the beach at Porto Ercole before succour could reach him.

M.G.

15
The Flagellation

286 × 213 cm
Capodimonte, Naples
[*repr in colour on p. 68*]

The first reference to this work is in Bellori's *Vite*, where it is mentioned after the account of Caravaggio's arrival in Naples. 'In the church of S. Domenico Maggiore he was asked to paint the Flagellation of Christ at the column in the chapel of the Signori Franchi' (Bellori 1672).

The anonymous commentary to Mancini, which includes an account by Teofilo Gallaccini (died 1641) of Caravaggio's work in Naples, does not mention the picture. It was probably not put up in the church for some time, as it is not cited in the guidebooks until that of Celano (1692). Baldinucci (1681 onwards) repeats Bellori's account, with some inaccuracies, and further adds that *The Flagellation* was the first of the pictures Caravaggio painted on arriving in Naples. De Dominici (1742–45) says that the painting was much admired despite the 'ignoble realism' of Christ in it. D'Argaville (1745) saw it, but Nicolas Cochin's observations (1763) are more interesting, as he talks of the colouring, which even then had greatly darkened. He describes the picture as *bien composé*, a sentiment that reflects his appreciation of the grandeur of the composition and the monumentality of the figure of Christ, something that has also struck more recent critics.

The painting was executed for the chapel of the Di Francos or De Franchis, a family of the upper bourgeoisie of Naples, in S. Domenico Maggiore, whose attached monastery had in the sixteenth century counted Giordano Bruno and Tommaso Campanella among its inmates (Villari 1967). It was moved around quite a lot in the chapel itself, and in the church, as noted by Marini (1974[1]) and Pacelli (1977), before being deposited on loan at Capodimonte. The chapel had been given in 1602 by Don Ferdinando Gonzaga, Prince of Molfetta, to the sons and heirs of the late Vincenzo de Franchis, and after 1634 it was extended into the adjacent chapel. The alterations took a long time, and it is likely that the painting was in the meantime kept in the house of the patrons. The chapel was only dedicated to the 'Flagellation of Christ' in 1652, and this suggests that the painting was then placed above the altar. Carlo de Lellis, who described the chapel in some detail in his work published in 1654, did not mention *The Flagellation*; this must be because (Pacelli 1977) he had already finished writing by 1651. In the still unpublished manuscript of *c.* 1672 he describes the painting as 'the most beautiful work ever painted by this famous artist', giving its dimensions as 12 × 9 *palmi*.

However, as early as 1675 it was decided to replace the picture with a statue of the Madonna by Pietro Cerasi; Celano is the first author to refer to the picture in its new location, in a side chapel. According to Pacelli it was, at the turn of the eighteenth century, in the chapel of St. Anthony Abbot; but by the time of Galante (1838) it was back in the Franco family chapel. Perrotta (1830, 1842) and Volpicella saw it in the chapel of St. Anthony Abbot; G. A. Galante (1872) who saw it in the large chapel called 'Di Ziandrea' lost track of the painter's name, turning Merisi into Moriggia. Later the painting was placed in the Cappella di S. Stefano, ending up in the Cappella del Rosario, where De Rinaldis saw it (1928–29). The poor state of conservation was noted in the meantime (Marangoni 1922; Voss 1925) and the painting was restored a few years later (De Rinaldis 1928–29). Pacelli (1977) published details of a number of payments made by the Banco di Santo Spirito on Tommaso di Franco's behalf to Caravaggio: '11 May, 1607, 100 ducats from Tommaso di Franco to Michelangelo Caravaccio to complete 250 ducats, the other 150 he has had in cash, and they are for a (*lacuna*) that he will deliver. . . cash'. This was obviously a payment on account for the altarpiece that had yet to be delivered and, despite the gap that occurs at a critical point in the document, it must relate to *The Flagellation*.

Another payment which was made to Caravaggio through the Banco di Santo Spirito on 28 May 1607 (not 29 or 19 May as reported by Pacelli; cf. Marini 1979) was for 40.09 ducats. This was probably also for the same work, although it may not have been the final payment; or else, as Marini suggests, it could have been for a smaller picture, of which there is no trace in the De Franchis inventories.

The Flagellation has always been regarded as dating from Caravaggio's first Neapolitan period, and sometimes as the first work he painted in Naples. In 1959 (and 1968) Longhi put forward the view that it dated from the second period; this was accepted by a large number of scholars (Kitson 1969; Causa 1966, 1970, 1972; Dell' Acqua 1971; Bologna 1974; Marini 1973[1]; Gregori 1976) while Fagiolo dell'Arco (1968) supported the traditional dating, a view held also by Jullian (1961), Calvesi (1965), Moir (1967), Cinotti (1971) and Mariani (1973). The discovery of the De Franchis payments of May 1607 seems to represent a decisive vindication of the earlier dating, a period some time after *The Acts of Mercy*, which is stylistically very different. Caravaggio was already in Malta by 13 or 14 July 1607 (Valletta 1978), which leaves only a couple of months during which the painting could have been completed.

Bologna (1980), commenting on Longhi's idea

of a date after the return from Sicily, keeps an open mind, observing the similarity between the flagellator on the left with the executioner in the *Salome* (which he calls a 'Herodias', so identifying it as the picture mentioned by Bellori as having been sent by the artist to Malta from Naples in order to placate de Wignacourt). Caravaggio had, however, received 250 ducats in 1607, a substantial sum, which points to the picture being already far advanced. The final figure can not have been much in excess of 400 ducats, the sum Caravaggio received for *The Acts of Mercy* and also that asked for the *Madonna of the Rosary* in September of the same year (Luzio 1913; cf. also Prohaska 1980). It is possible that X-rays could determine the somewhat unlikely eventuality that Caravaggio left the painting unfinished and completed it after his return from Malta. The energetic and fluent brushwork and pentimenti in the gaoler at lower left, and perhaps in the one on the right (Marini 1974[1]), suggest that the painting was completed at great speed, and therefore before Caravaggio's departure for Malta. What is certain is that the overall conception and a great part of the execution date from 1607.

Some classical elements are present even in the *Resurrection of Lazarus* (Roettgen 1969), but they are so pronounced in this picture that it must be dated shortly after Caravaggio's departure from Rome. Berenson (1951) and Friedlaender (1955) underlined the connection with Sebastiano del Piombo's fresco in S. Pietro in Montorio; Calvesi saw another precedent in a *Flagellation* attributed, unconvincingly, to Peterzano in S. Prassede in Rome, and Wagner a derivation from Michelangelo's *Risen Christ* in S. Maria sopra Minerva, Rome. These statuesque and heroic classical recollections are transformed in Caravaggio's Christ into an image of flesh and blood, a Hercules drawn from life. The violence of the gaolers, so markedly in contrast with the figure of Christ (Longhi [1928–29] compared it with a similar quality in Antonio Campi's *Martyrdom of St. Lawrence* of 1581 in S. Paolo, Milan), transforms the traditional imagery of the Flagellation into an event of vivid immediacy and blind violence. The classical motifs are moulded as in Caravaggio's *Crowning with Thorns* (Cecconi Coll.) which also has the feature of the gaoler seizing Christ by the hair, and seem to parallel the work of Rubens in Rome. Another classical reference, to the 'Scythian' (the so-called 'Arrotino' has been observed (Longhi 1952) in the kneeling gaoler, a figure in which Berenson (1951) saw similarities with the early *David* in the Prado.

A picture inspired by *The Flagellation* (private coll.) is Caracciolo's painting of the same subject published by Mormone (1963), now at Capodimonte. Spinosa has drawn attention to a closer derivation in Luca Giordano's painting of the same subject in a private collection, Naples, which must reflect renewed interest in the work around the time when it was placed in a better position in S. Domenico. De Dominici, referring (II, 1743, p. 276) to the copies made by Caracciolo after Caravaggio's work, refers to one beside the high altar in SS Trinità degli Spagnuoli in Naples; he was uncertain whether it was by Caracciolo or Vaccaro. It is no longer in the church, but De Rinaldis (1928–29) thought that it might be the faithful copy which is now in the original chapel in S. Domenico from which the original was removed in 1972. He suggested that it is by Vaccaro rather than Caracciolo, and this very debatable opinion has been followed by most scholars. A picture by Vaccaro of this subject, which shows a familiarity with Caravaggio's painting although it is a very free interpretation, is in the Staatsgemäldesammlung in Munich.

M.G.

PROVENANCE
S. Domenico Maggiore, Cappella De Franchis

EXHIBITIONS
Naples 1938, Sala I, no. 8; Milan 1951, no. 37; Athens 1962–63, no. 4; Naples 1963, no. 4; Paris 1965, no. 29

REFERENCES
Bologna 1974, p. 185; Bologna 1980, pp. 41, 52, n. 8; Gregori 1976, p. 869; Marini 1974[1], pp. 13, 91, 456–58 with full bibliography; Marini 1979[1], pp. 34, 36, 39, n. 65, 40, n. 82–84

16

The Acts of Mercy
'Nostra Signora della Misericordia'
(*also known as* The Seven Acts of Mercy)

387 × 256 cm
Pio Monte Della Misericordia, Naples
[*repr. in colour on p. 65; details on pp. 66 & 67*]

The Monte della Misericordia was founded in 1601. On 19 April of the following year the act of foundation was drawn up (as we know from a document in the Archive of the Pio Monte, the *Regno Assenso* of 1604, the apostolic letter of recognition of the Sacro Monte della Misericordia from Paul V in 1605 and the *Breve Apostolico* of 18 January 1606) which accorded various privileges to the high altar (Causa 1970). The design of the building was entrusted to the architect Giovanni Jacopo Conforti (Ruggieri 1902), and two houses were bought in Piazza di Capuana by the steps to the Cathedral for the new church.

It was to have seven altars, one for each Act of Mercy. But, in fact, the painting for the high altar, entrusted to Caravaggio, would include all the acts while the other six corresponded to the six Deputies of the Works of Mercy named in the 'Royal Assent' of 10 July 1604. Practical considerations meant that the works of mercy

were divided into six kinds, coinciding with the six deputies (for the infirm, the dead, the imprisoned, the wicked, the ignorant, the pilgrim), each of whom could also fulfil alternative functions. A note drawn up by Corona in 1700 gives information about the paintings and the artists (and in some instances even some payments), and from this it emerges that the title of Caravaggio's painting was 'Our Lady of Mercy'. The documents (Notizie 1950; Causa 1950; Cinotti 1971) reveal that payment was made through the Banco di S. Maria del Popolo to Tiberio del Pezzo and via the latter to Caravaggio. He received '370 ducats to complete payment for a painting for the Monte della Misericordia'. This was the second payment he received in Naples after that of 6 October 1606 for an altarpiece for Nicolò Radolovich.

The deputies took great care of the painting, as emerges from notes made in the years following the artist's death, when the pursuit of works from his hand became almost frenetic. The *Conclusioni* of 1613 show that during the course of two meetings (20 and 27 August) it was decided that it could never be sold for any price, and must always be kept in the church; and it was reported that several offers of 2,000 *scudi* had been made for its purchase. The minutes of the meeting of 27 August reveal that despite these precautions, the Governor himself, the Conde de Villamediana, had his eye on the picture; but he was only allowed to have a copy made by one of the artists known to the Pio Monte—Santafede, Sellitto and Caracciolo, and the picture itself was not to be removed.

In 1656, the year of the plague, it was decided to rebuild the church, which was too small for the number of masses celebrated, so some houses were acquired 'between Vico Zuroli and Vico Carboni'. It seems likely that Caravaggio's picture was always on public display; before 1656 it is mentioned by De Pietri (1634) and the anonymous commentator to Mancini (ed. 1956) reporting the observations of Teofilo Gallacini (d. 1641), who is, however, incorrect in referring to 'a number' of paintings by Caravaggio in the church. Bellori's inaccurate description dates from 1672; in 1674 Scaramuccia described the '*modo pittoresco, ed in tutto bizzarro*' of the painting. De Dominici too (1742–45) believed it to be one of Caravaggio's best works, although surpassed by *The Flagellation* (Cat. 15) and the *Denial of St. Peter* (Cat. 18).

The church of the Pio Monte continued to be mentioned by the guides and visited by travellers. The painting, darkened by the time of Cochin (1763) and the Marquis de Sade (1775–76), was still described by the former as '*fort beau*', even though he did not identify the subject any more than Richard (1770), who refers to the function of the Pio Monte in order to explain its meaning. Canova visited the church and in his Diary (1779–80) admired the altar paintings, particularly that of Caravaggio, whom, however, he mistakes for Polidoro da Caravaggio. Even the early Caravaggio scholars (Rouchès 1920, Ortolani 1928, De Rinaldis 1948, Berenson 1951) did not fully comprehend the picture. Subsequently it was recognized as perhaps the most important religious painting of the Seicento (Longhi 1952; Argan 1956).

The painting assembles all the Acts of Mercy in a single complex image, given that some of the figures represent more than one Act. They include: the woman giving suck to the prisoner (Cimon and Pero), an elegant *cavaliere* (whose identification as Lionello Spada is unlikely, but cf. Hess 1954) portrayed as St. Martin, dividing his cloak with a poor man sitting naked on the bare ground (he reminded Longhi [1928–29] of Moretto's *Prophet Micah* at Brescia, another unfortunate who is only half visible in the shadows, and a man, who must be an innkeeper, who appears at the far left and beckons the pilgrims to enter. He seems to have the attributes of St. Roch although Friedlaender (1955[1]) thought – less convincingly – that it was Christ; behind him there is half-visible another pilgrim, hidden by St. Martin, who has a distinguishing staff. These figures personify the following Acts: the woman stands for visiting prisoners and feeding the hungry; the *cavaliere* for giving clothes to the poor and naked, and also for helping the infirm; the innkeeper for giving refreshment to the needy and lodging to the pilgrim.

The paintings done for the altarpieces of the church during the years up to 1615, by Forlì, Baglione, Santafede (two) and Caracciolo, while they are concerned with acts of corporeal mercy, do not ignore their spiritual implications, placing the subjects in their sacred context, with stories with obvious allegorical overtones such as the *Good Samaritan*, the *Entombment*, *St. Paul Freeing a Slave*, the *Resurrection of Tabitha*, the *Liberation of St. Peter*, *Christ and the Woman of Samaria*. This is quite different from Caravaggio. He portrayed them as episodes from daily life, ignoring the presence and class background of those who practised this kind of act of mercy in this establishment, quite differently from the way in which Caracciolo would portray the works of the Jesuit Fathers (Cat. 11). It should also perhaps be noted that Caravaggio does not seem, contrary to Friedlaender's suggestions (1965), to have included portraits of any of the members of the Pio Monte in his painting.

The scene is conceived as if the action had a proverbial meaning, or formed part of a religious drama; the burial gives the impression that death is just around the corner (Longhi 1962; Fagiolo Dell'Arco 1968). And the episode of Roman Charity could have been taken from

the narrow streets of Naples itself, where the rich pattern of life must have struck Caravaggio with all its contrasts of pomp and poverty. The artist respects the unity of time, place and action, that is also observed later in the *Martyrdom of St. Ursula* (Cat. 19). The immediacy of the action and the crowded composition lit from an artificial source, which seem to hark back to some examples of mannerist painting in Cremona (Giulio and Antonio Campi), must have appeared even more dramatic when the picture was in the original building, capable of creating the same illusionistic quality to be found in the chapel that houses the *Decollation of the Baptist* in the Co-Cathedral at La Valletta. Borrowing from genre painting, as evolved in the sixteenth century, was quite legitimate, as it was also in the instance of the *Calling of St. Matthew* at S. Luigi dei Francesi, which is often cited in connection with the moral and didactic significance of the young man with a plumed hat in the centre foreground, not in relation to the decorum of the work. The moral purpose of the representation is fulfilled through the presence of figures from sacred legend – St. Martin, St. Roch and Samson shown drinking from the jawbone of the ass (*Judges*, XV–XIX) – and from the classical world – Cimon and Pero illustrating the story of Roman Charity from Valerius Maximus.

Caravaggio conceived the subject with characteristic Lombard pragmatism, and set out to portray it according to the medieval lay tradition of separate episodes in a single image (for some northern examples, see Friedlaender 1955[1]); he did not conceive it in the usual series of images and he did not intend to include a divine presence. X-rays (Causa 1970) showed that the upper part of the composition had only angels in it originally and that Caravaggio added the Madonna and Child later, certainly at the request of the patrons. However, if one compares *The Acts of Mercy* with pictures of a similar theme painted by Sweerts, done in a new populist vein, and with Falcone's *St. Lucy Distributing Alms* (Cat. 44), which is a kind of Neapolitan *Bambocciata*, the deep meaning of Caravaggio's picture becomes more apparent. It underscores the autobiographical implications of the work, for Caravaggio's desire to redeem himself after the homicide through good works is an element that is strongly emphasized.

The story of Cimon and Pero, rare at the beginning of the century but becoming more frequent later, is to be found in a series of engravings of the 'Seven Acts', dating from around 1650, that Friedlaender believed derived from Venetian sources with which Caravaggio could have been familiar. Stechow noted (1956) an engraving of 1646, a variation of one by Reverdy referred to by Friedlaender, which was closer to the picture in the oblique view of the prison and the crowded composition. Caravaggio must certainly have known Perino del Vaga's fresco in Palazzo Doria in Genoa; he spent almost the whole of August 1605 in the city. He came to know Marcantonio Doria, who in 1610 was his patron for the *Martyrdom of St. Ursula* (Cat. 19). Pero is portrayed in popular costume, although the folds of the garment have a classical cadence; her inclined head recurs in Manfredi's work, showing that Caravaggio's late work was known and studied by the Caravaggists working in Rome. Two paintings of Cimon and Pero by Manfredi are known (Brejon de Lavergnée 1979). A copy after Manfredi, formerly on the art market in Milan (1973) is derived directly from this passage.

The support for the needy demanded by the Church is transformed in the painting into a moving participation in human tragedy, evoked by the text of Matthew, and the symbolism is enhanced by references to High Renaissance painting: the vertiginous fall of the angels recalls Michelangelo's *Last Judgement*, while the raising of the winding sheet is inspired by Raphael's *Deposition*.

To fully comprehend Caravaggio's interpretation, in line with Van Mander's account (1603) that he only painted directly from life, it is interesting to observe that the hand of the angel coming forward, seen in perspective, is shown as if it was resting on a surface, and that Caravaggio must therefore have used a model in an acrobatic position in order to copy it. The uncertainty of the placing of the figures reveals his scant preparation for the composition; the X-rays show that Samson was originally placed at the centre of the painting. The innkeeper, portrayed with a naturalism that seems to anticipate Velasquez, comes from the same background as his counterparts in Caravaggio's two versions of *Supper at Emmaus* (London and Milan) and, equally, Ribera in his *Taste* (Cat. 119).

The documented payment has further implications: the painter received 370 ducats as a final payment, out of a total of 400. This could mean two things: that there was a reluctance to pay a large advance for the artist's first public commission in Naples, or that the painting was finished in a remarkably short time. This view seems to be supported by a letter from the Este ambassador in Rome, who was most interested to follow Caravaggio's movements in order to secure the painting he was supposed to deliver for the Duke's chapel.

The picture was cleaned and restored at the Soprintendenza by Edo Masini for the 1962–63 exhibition. Spinosa has drawn to the attention of the writer a copy by Luca Giordano of the group of the Madonna and Child on the art market in Rome.

M.G.

EXHIBITIONS
Naples 1938, Sala I, no. 6; Milan 1951, no. 36;
Naples 1963, no. 5; Paris 1965, no. 26 bis.

REFERENCES
Bardon 1978, pp. 166–72; Bologna 1974, pp. 182–85;
Brejon de Lavergnée and Dorival 1979;
Marini 1974[1], pp. 39–41, 214, 421–23 with full bibliography

17

Crucifixion of St. Andrew

202.5 × 152.7 cm
Cleveland Museum of Art, Leonard C. Hanna Jr.
Bequest
[*repr. in colour on p. 70*]

This picture came from the collection of José
Manuel Arnaiz in Madrid, and previously was
in a monastery in Castille; in 1976 it was bought
by the Cleveland Museum of Art. First referred
to by Xavier de Salas (Rome 1973),
Pérez Sánchez suggested it might possibly be the
original version (Seville 1973). Its outstanding
quality was confirmed by the cleaning, which
removed some overpainting, and the X-rays
revealed important changes and pentimenti, and
made it possible to recognize it as the original
Crucifixion of St. Andrew referred to by Bellori
(1672), the appearance of which Longhi
recognized (1927, 1939, 1943) in a copy in the
Museo Provincial di Santa Cruz, Toledo
(formerly in the Museo Paroquial de San
Vicente) and from two other versions (Back-
Vega Collection, Vienna; Musée des Beaux-
Arts, Dijon). The painting was published by
Nicolson in 1974, and more fully in 1977 by
Tzeutschler Lurie in collaboration with Mahon.

Bellori (1672) recorded that towards the end
of Caravaggio's life the viceroy of Naples, the
'Conte di Benavente . . . also took with him to
Spain the Crucifixion of St. Andrew'. Don Juan
Alonso Pimentel y Herrera, eighth Conde de
Benavente, left Naples on 11 July 1610 (his
departure is described in Parrino 1692); he had
been viceroy since 1603, so in all likelihood he
knew Caravaggio personally. The painting must
have hung in the family palace in Valladolid,
where it is listed in two inventories drawn up in
1653 following the death of his grandson the
tenth Conde de Benavente, Don Juan Francisco
Alonso Pimentel y Ponce de León. One of them,
dated 20 February, describes the painting as 'A
very large canvas with the naked St. Andrew,
when they are putting him on the cross, with
three executioners and a woman. . .of a value in
all of 1500 ducats. . .it is an original by Micael
Angelo Carabacho' (Garcia Chico 1946;
Tzeutschler Lurie and Mahon 1977). It was
valued higher than any other work in the
collection which included paintings by Rubens,
Ribera, Barocci, El Greco, Cambiaso, and
Bosch, and another Caravaggio, 'a Bishop saint
with his head off . . . an original by Carabacho'

valued at 1,000 *reales*, more than a *Taking of
Christ* by El Greco (Arnaud de Lasarte 1947). It
should be noted that the man who drew up the
valuation was the painter Diego Valentin Diaz, a
friend of Velasquez, and de Lasarte has pointed
out that the painting could well have influenced
Spanish painters at the royal court since this
palace was one of the residences of Philip IV. A
portrait of the Conde de Benavente (Prado,
Madrid) by Velasquez shows him wearing
armour apparently lent by the king, as it appears
in Titian's portrait of Philip II (Prado, no. 411;
now in the Royal Armoury, Madrid; cf.
Tzeutschler Lurie and Mahon 1977).

After 1653 there are no further traces of the
Valladolid *St. Andrew*. Longhi (1943) suggested
that a painting attributed to Ribera in the
Toledo museum was a copy of a lost work of
Caravaggio painted in Naples in 1607 and linked
it to the lost *St. Andrew*. The 1653 inventory,
stating that the picture was in the possession of
the heirs of the Conde de Benavente at
Valladolid, was not brought to light until 1953
by de Lasarte, and so Longhi, misreading
Bellori's comment, supposed that the
Crucifixion had been taken to Flanders and was
the same painting of this subject that a group of
painters had authenticated as a Caravaggio in
1619. He thought that it might have been taken
to Spain later, which would have accounted for
the presence of the Toledo Cathedral picture,
the only copy then known. Longhi's opinion
that the Toledo painting was a copy, damaged
during the Spanish Civil War, was generally
accepted from Mahon (1952) onwards (cf. also
Nicolson 1974[1]), the only exceptions being
Hinks (1953) and Marini (1974[1]).

Another version of the composition was
exhibited at Bordeaux in 1953. This picture,
acquired by Back-Vega, Vienna in 1953,
(200 × 150 cm; formerly in Budapest, later in
Italy and Switzerland) was authenticated by
Fiocco and Voss and published by the owners as
an original (1958). But it was not accepted
except, with reservations, by Jullian (1961) and
Ottino (1967). The harshness of the modelling
and chiaroscuro make it impossible for this to be
an original and it is probably to be identified
with the version that was in Amsterdam in 1619
(Longhi 1960). Friedlaender (1959) and Bodart
(1970) believed that the Amsterdam painting
could have been a copy made in Naples by Louis
Finson. He was the owner of the picture and he
is known to have done copies after Caravaggio
(Longhi 1943, 1951; Bodart 1970). Finson made
out that the work was by Caravaggio himself, as
we learn from the sale of his estate in 1617, when
the picture passed to the merchant Pieter de Wit.
It was sold again in 1619 to François Seghers,
together with an expertise signed by a number of
painters, including Lastman and Adriaen van
Nieulandt. Recently the conviction that the

Back-Vega painting is a copy by Finson has gained ground (Longhi 1970; Nicolson 1974[1]; Tzeutschler Lurie and Mahon 1977). Finson could have painted it in Naples before it was sent to Spain in 1610, as it has been ascertained that he was there before 1612 and even as early as 1604 (Pacelli 1980). In 1605 he is mentioned together with his friend and partner Abraham Vinck (who married a Neapolitan woman).

Another copy of even poorer quality is in the Musée des Beaux-Arts at Dijon (Marini 1974[1]). Mahon (*loc. cit*) suggests that it is a copy after the Back-Vega version, rather than after the original. In this case, it might be the copy known to have been painted by Vinck (cf. de Roever, quoted by Tzeutschler Lurie and Mahon 1977, p. 180).

Pérez Sánchez expressed some reservations about the identification of the present painting as the one that had belonged to Benavente (Seville 1973). One of the difficulties was the total of four executioners in the picture, including the one on the ladder, while the inventory speaks of only three. But the other inventory drawn up on 3 January 1653 enabled Tzeutschler Lurie to ascertain that these were *al pie* (ie. at the bottom) after the mention of 'three tormentors and a woman'. The other objection was that St. Andrew is generally represented on the X-shaped *crux decussata* and not on a Latin cross, as here. This was discussed by Nicolson (1974[1]) who published a woodcut from the *Leggendario delle Vite de' Santi*, an Italian edition of the *Golden Legend* published in Venice in 1600. There, St. Andrew is shown on a Latin cross, similar to the one in Caravaggio's painting, with his hands bound and not nailed, and with various bystanders included. It is not known precisely how widespread the adoption of the *crux decussata* for St. Andrew was; Tzeutschler Lurie observed that Molanus condemned its use towards the end of the sixteenth century, and Lipsius rejected it in 1593. Nonetheless it became widespread, its popularity in Spain encouraged by its adoption by the Order of the Golden Fleece, much loved by the Spanish royal family.

The subject was interpreted by Mahon, who observed that it is not the raising of St. Andrew to the Cross as described in the inventory, but another episode from his martyrdom, rarely portrayed in art but mentioned in the *Golden Legend*. St. Andrew remained on his cross for two days, during which time he preached to crowds that gathered and finally demanded his liberation. Fearing a riot, the proconsul Aegeas of Patras in Achaia ordered the executioner to take him down from the cross, but he was paralyzed in the act (evident in Caravaggio's painting) because St. Andrew declared his wish to die on the cross. The episode is also included in the compilation of 'Lives of the Saints' entitled *Flos Sanctorum* or *Libro de las Vidas de los Sanctos*, collected by the Spanish Jesuit Pedro de Ribadeneyra and published in 1601, with an Italian edition in 1605.

The painting was restored by Jan Dick under the guidance of Luigi Salerno and Denis Mahon. A number of pentimenti were revealed by the cleaning, and some overpainting removed. The head of the man in armour had been repainted to disguise a tear in the canvas at the level of his eye. The throat and the neck of the old woman had become illegible, as the result of a pentimento which the X-rays helped to explain. Caravaggio had originally represented the old woman with her hands raised in a gesture of anguish. In the finished picture he portrayed her with a pronounced goitre, a feature perhaps observed in the mountainous regions of Bergamo or in Campania, and often represented in Neapolitan nativities. Longhi also suggested that Caravaggio drew inspiration for this head from a Hellenistic sculpture, *La vecchia capitolina*, in the crypt of the Cathedral at Amalfi, where the body of St. Andrew is preserved. At the beginning of the seventeenth century Philip III undertook the restoration of the crypt through his viceroys, the Conde de Lemos and the Conde de Benavente, as is recorded in an inscription there. The altar in the crypt was almost complete in 1607, but the space available there excludes the possibility that the painting was intended for it, or for elsewhere in the cathedral. It is more likely that the viceroy commissioned it for a chapel in his residence in Naples or in Valladolid; his devotion to St. Andrew is known from a visit that he paid to Amalfi cathedral in 1610 (Camera 1881).

The date of the commission and destination of the painting, if it was made for the Conde de Benavente, is a question closely linked with its place in Caravaggio's oeuvre, which the present writer has suggested is during his second stay in Naples (Gregori 1975). The Conde de Benavente could have commissioned it with a view to taking it home, and this would still have left time for Finson to paint his copy. Stylistic features like the flickering light, the left hand and feet of the saint, the head of the old woman, the shoulder of the man on the ladder, and the incredibly cursory brushwork, link it to other late works (see Cat. 19, 20). The detail of the armour of Aegeas is close to that in the *Martyrdom of St. Ursula* (Cat. 19) and the lost *Resurrection* formerly in S. Anna dei Lombardi.

The most important derivations of the work in Neapolitan painting are the *Crucifixion* by Caracciolo in the Ospedale dell'Annunziata (Pacelli 1978) and Sellitto's *Crucifixion* in S. Maria in Cosmedin, Naples.

M.G.

PROVENANCE
Conde di Benavente, Naples 1610;

Palace of the Benavente, Valladolid 1653;
unknown convent in Castille;
collection of José Manuel Arnaiz, Madrid

REFERENCES
Bologna 1980, p. 42;
Camera 1881, p. 164;
Gregori 1975, pp. 43–44;
Marini 1974[1], pp. 42, 235, 433–35 with full bibliography;
Marini 1979[1], pp. 16, 18–19; Moir 1976, p. 113;
Nicolson 1974[1], pp. 607–08; Nicolson 1974[2], p. 625;
Nicolson 1979, p. 32; Pacelli 1978[1], pp. 493–94;
Tzeutschler Lurie and Mahon 1977, pp. 3–24;
Salas in Rome 1974, pp. 30–31

18

Denial of St. Peter

94 × 125.5 cm
Inscribed: on back 'ill . . ./8 NM 9'
Anonymous loan
[repr. in colour on p. 69]

The painting belonged to the Imparato
Caracciolo of Naples (it is uncertain whether it
passed by descent), and was attributed to
Caravaggio.

The subject, which was frequently painted in
Caravaggio's circle, is inspired by the passages
in the Gospels (*Matthew*, xxvi, 58 and 69–75;
Mark, xiv, 54 and 66–72; *Luke*, xxiii, 54–62;
John, xviii, 16–18 and 25–27).

We do not know of any early reference
definitely relating to this work. Bellori (1672)
records a *Denial of St. Peter* by Caravaggio in
the sacristy of the Certosa di S. Martino, Naples,
but the picture of that subject still there,
traditionally attributed to Caravaggio, does not
correspond to his description and is possibly by
a Flemish Caravaggist (cf. *I caravaggeschi
francesi* 1973, Jullian 1961, in which the
possibility of it being a copy of a lost original by
Caravaggio is excluded). Marini (1973)
advanced the possibility that Bellori or his
informant, hearing of an original in Naples by
Caravaggio of this subject, may have wrongly
stated that it was at S. Martino. Speaking of the
young Battistello's admiration for Caravaggio,
De Dominici (1743) mentions a copy of a *Denial
of St. Peter* which he had painted and which he
says was also at S. Martino. Moir (1967)
considers that the *Denial of St. Peter* by
Caravaggio has been lost.

But Bellori's citation of a work by Caravaggio
of this subject in Naples assumes a certain
weight after the discovery of this picture which
is exhibited for the first time. As Marini records
(1979[1]), a *Denial of St. Peter* attributed to
Caravaggio, and of similar dimensions, was in
Casa Savelli, Rome ('a maidservant with St.
Peter denying, and another half figure sideways,
palmi 5 × 4'; inventory of 1650; Campori 1870),
but it is impossible to establish at present any
connection with this picture.

Longhi, who in 1952, when the picture was in
a poor state of repair with extensive repainting,

ascribed it to Manfredi, recognized it as an
autograph Caravaggio in 1964 when he re-
examined it after its restoration by Cellini
1959–63 (Marini 1973[1]). In 1971 Cinotti
anticipated Marini's publication of the
rediscovered Caravaggio original (Marini
1973[3]); Rosenberg (1970) and Volpe (1972) both
referred to it, noting connections between this
work (of which no copies are known, Moir
1976) and the picture of the same subject in the
Corsini Gallery, Rome by the Master of the
Judgement of Solomon, a painter whose
connections with the Neapolitan milieu have
already been noted. Benedict Nicolson suggested
in conversation that the *Denial of St. Peter* by
the Pensionante del Saraceni (Vatican Picture
Gallery) was a free derivation, but he considered
the subject was *Job and his Wife* (Nicolson
1979). The ascription to Caravaggio is unanim-
ous; only Ferrari (1978) has expressed doubt.

The dating of the picture has varied widely.
Volpe (1972) suggested Caravaggio's last
Neapolitan period and Moir (1976) the last
months of his life. Marini (1973[2], 1974[1], 1979[1])
dated it to 1607, contemporary with the *Salome
Receives the Head of John the Baptist* (cf.
Cat. 20), noting affinities with works of the first
Neapolitan period – the long-drawn brush-
strokes and the abbreviated drapery – and in
particular with *The Seven Acts of Mercy*
(Cat. 16). The summary execution, which makes
the subject more intense and dramatic, the bold
abbreviations of form (eg. the hands) and the
untidy impasto of some parts (eg. the head of
Peter which presupposes both the *Decollation of
the Baptist* in Malta and the Sicilian works)
seem characteristic of Caravaggio's last period.
The *Denial of St. Peter* has a Neapolitan flavour
common to the works of Caravaggio's first stay
between 1606 and 1607, but that should not
allow us to depart from the dating proposed
here. There is some affinity to the *Martyrdom of
St. Ursula* (Cat. 19), particularly in the
psychological treatment of the subject, whose
restoration to Caravaggio (Gregori 1975) has
recently been confirmed by documents which
date the painting to May 1610, two months
before Caravaggio died on the beach of
Porto Ercole. There is a similarly intensely
dramatic relationship between the figures,
struck violently by light from the side.

In a sober setting we see the fireplace in
which, in conformity with the gospel text, there
burns a flame to which we should probably
attribute a symbolic meaning. St. Peter, at the
very moment in which he betrays his master,
puts his hands to his breast, and expresses both
his repentance and his consciousness of the
inevitability of his sin; the gesture is very close in
meaning to that of St. Ursula who accepts her
martyrdom.

M.G.

PROVENANCE
The Princes Imparato Caracciolo, Naples;
private coll., Lausanne

REFERENCES
Bellori 1672, p. 256; Campori 1870, p. 162;
Cinotti 1971, p. 179, n. 119; Ferrari 1978, p. 372;
Gregori 1975, p. 47; Jullian 1961, p. 182, n. 39;
Marini 1973[2], pp. 189–193, n. 4;
Marini 1974[1], pp. 39–41, 74, n. 312, 224–5, 428–9;
Marini 1974[2]; p. 135;
Marini 1979[1], pp. 15, 36, n. 4;
Moir 1967, pp. 158–59, n. 21; Moir 1976, p. 120, n. 124;
Nicolson 1979, p. 33;
Rome 1973, p. 58;
Volpe 1972, p. 71

19
Martyrdom of St. Ursula

154 × 178 cm
(addition of 13.5 at the top, 7.5 to left side)
Inscription: on the back D.MICHEL *Angelo
da/Caravaggio. 1616*; further to the left a cross
and the monogram MAD; in the added strip at top
in an old cursive hand *Del Caravaggio.*
Banca Commerciale Italiana, Naples

When the painting was exhibited in Naples in
1963, it was called an allegory and attributed to
Mattia Preti by Causa. The catalogue reported
that it was traditionally ascribed to Manfredi,

but in fact this was Longhi's opinion known
through Bologna, who also drew attention to the
painting. In the exhibition catalogue the
painting was illustrated after the Caravaggios,
following a copy of the lost *Sacrifice of Isaac*, so,
despite the attribution to Preti, it may have been
initially intended to exhibit it as a copy after
Caravaggio.

It was published by the present writer in 1975
as an autograph work of Caravaggio on stylistic
grounds, suggesting that it was a late work and
recalling, *inter alia*, its Doria d'Angri
provenance. This and some other new
attributions to Caravaggio made by the writer
have met strong opposition from a group of
Italian critics, but they have been taken seriously
by Testori (1975), who suspended judgement on
this work until it had been restored. Ferrari
(1978) considered the question of attribution of
both this work and the *Denial of St. Peter*
(Cat. 18) unsettled. However, the discovery of
the documents relating to this painting (Pacelli
1980) has confirmed the attribution to
Caravaggio.

It appeared clear that the subject was not an
allegory, but a female saint martyred with an
arrow, probably either St. Ursula or S. Cristina
da Bolsena. Only the recently discovered

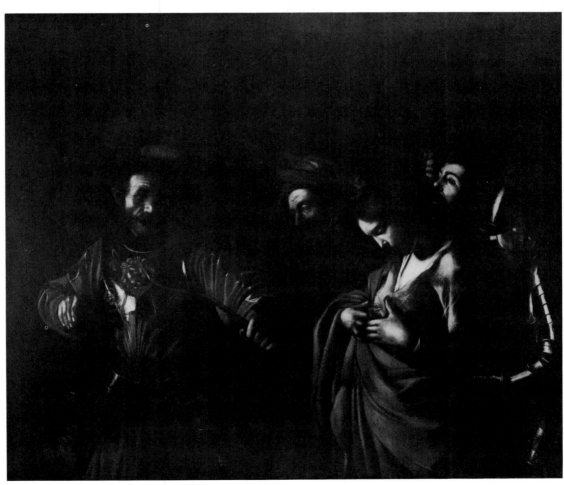

19

documents (Pacelli 1980) have proved that it is the *Martyrdom of St. Ursula*, represented in an unusual way without the virgins who died with her. Bologna (1980) has pointed out that Caravaggio kept strictly to the legend, according to which the saint was killed after her companions and by the King of the Huns himself, who had wished to wed her.

Archival research has shown that the picture was painted in May 1610, two months before Caravaggio died at Porto Ercole, so that it stands as the surest document of his last style and of his pessimistic view of life. In spite of considerable damage, Caravaggio's hand appears clearly in the simultaneity of the two phases of the martyrdom, obtained by the unusually close position of the executioner, so that his aggression appears in all its brutality at the very moment of martyrdom. With this excited and violent conception there goes an almost shorthand technique and characterization (the summarily defined face of the tyrant has very strong affinities with the old woman in the London *Salome*, Cat. 20) and a flaring fragmentation of the light, which in the cuirass of the executioner anticipates, as Bologna noted (1980), the mature Rembrandt. Amongst the figures behind the saint, who seem to push her towards the assassin, there appears the head of a man who wishes to be near to the tragedy. It is a self-portrait of Caravaggio, introduced as a subjective and autographical presence, precedents for which are known in bloody and tragic episodes such as the *Martyrdom of St. Matthew* and the *Taking of Christ* (known in numerous versions, the best of which is at Odessa) and in the two great popular pictures painted in Sicily, the *Burial of St. Lucy* and the *Raising of Lazarus*. Bologna (1980) surmised that the self-portrait was introduced here because the *Martyrdom of St. Ursula* was painted for Marcantonio Doria, who was, according to the new documents (Pacelli 1980), a friend of Caravaggio.

The very late date of the work, which, if not the last, was one of the last before his death, is confirmed by the similarity between St. Ursula's gesture, raising her hands to her breast and gathering up her mantle which falls with classical nobility, and that of the Virgin in the Nancy *Annunciation*, datable to 1609–10 (Pariset 1948; Longhi 1959; Fagiolo Dell'Arco 1968; Cinotti 1971). This motif of submission and the acceptance of fate, is found again, in the present writer's opinion, in the very late *Denial of St. Peter* (Cat. 18).

Another observation has been confirmed by the documents. Stylistically it is possible that this *Martyrdom of St. Ursula* and the lost *Resurrection* for S. Anna dei Lombardi were painted together. This is suggested by the similarity between the dramatic flash of light, falling on the soldier's armour on the right like a neon light and the soldiers in Finson's *Resurrection* at Aix-en-Provence, rightly considered (Longhi 1951) to be derived from the lost Caravaggio. It should be stressed that recent archival discoveries (Pacelli 1980) confirm that this lost work was painted in Caravaggio's last days in Naples, as suspected by Longhi (1968).

Pacelli's research (1980) allows the reconstruction of the history of the *Martyrdom of St. Ursula*, painted for Marcantonio Doria (this accounts for the letters MAD on the back of the canvas) very rapidly just before 11 May 1610. Lanfranco Massa, correspondent and procurator of the Doria family, wrote from Naples on 11 May 1610 to Marcantonio Doria, son of the Doge Agostino and Prince d'Angri, a letter which he received on 26 May, in which he speaks of the 'picture of St. Ursula' which was already in his hands, but was not yet dry. Massa had exposed it to the sun with the result that he had softened the paint ('because Caravaggio puts it on very thick'). Massa proposed to apply to the painter to get an opinion on 'how to act so that it is not spoilt'. He also adds that an unidentified Signor Damiano 'has seen it, and was astounded, as also all the others who have seen it'. In the postscript to the letter a Sister Ursula is mentioned, who turns out to be Anna Grimaldi, the daughter of Isabella della Tolfa who had married Marcantonio Doria as her second husband. Anna Grimaldi was thus the stepdaughter of Doria and it is probable that the painting had been commissioned from Caravaggio in connection with this young nun with whom Doria maintained affectionate relations (his will stated that she 'was loved by the said testator as his very dear daughter').

The *Martyrdom of St. Ursula* was sent to Genoa on the felucca Santa Maria di Porto Salvo, on 27 May and arrived there in 'a long box' on 18 June. It is listed in the inventory of the pictures in Casa Doria, Genoa dated 15 May 1620 (Pacelli 1980, appendix) and the description given of it ('St. Ursula pierced by the tyrant, by Caravaggio') does correspond with the present picture, although it does not conform with traditional iconography. In Marcantonio Doria's will of 19 October 1651 the picture was part of the central block of the inheritance along with other highly prized works of art and some 'notable' relics; it was inherited with these by the eldest son Niccolò, Prince of Angri and Duke of Eboli.

As Pacelli notes, the picture remained in the family. In 1816, following the will of Giuseppe Maria Doria, dictated in his Roman home, in which he referred to the wishes of Marcantonio in 1651, Giovan Carlo Doria received the entailed pictures together with other paintings and objects, but the legacy was to take effect only after the death of the testator's daughter

Maria Doria Cattaneo, and while she lived these works of art were to remain in her house. Maria Doria Cattaneo transferred a good part of the entail of Naples on 8 September 1832; on this occasion Caravaggio's *St. Ursula* is mentioned in a list of 9 November 1831, where it is stated to be a painting of half-length figures, six *palmi* high and seven *palmi* wide (158.4 × 184.8 cm, Bologna 1980). Later (1854–5) the picture was listed in the inventory of Giovan Carlo Doria d'Angri at Spirito Santo, Naples, described as the *Martyrdom of St. Agatha* and with the measurements 'six and three-quarters *palmi* by five and three-quarters' (151.8 × 178.2 cm, according to Bologna 1980), closer than the figures given in the preceding inventory to the present measurements of the picture, which was certainly enlarged at the top and on the left before the nineteenth-century inventories were drawn up. La Volpe and Guerra noted that it had been much restored; evidently a lot of the damage and the flaking had already taken place.

Nobile (1845) mentions the *Martyrdom of St. Ursula* in the Palazzo Doria d'Angri. Pacelli has ascertained that it was not in the auction sale at the palace in 1940.

So far we do not know of any close copies of this work. Bologna (1980) observed that a work of the same subject by Fiasella in the church of S. Anna at Genoa seems to show knowledge of Caravaggio's original, which suggests that this Genoese painter was employed by the Doria. In 1610 Marcantonio Doria already knew Caravaggio, as seems proved by a passage in the letter of 11 May which probably refers to the artist, where it is said that he was even his friend (Pacelli and Bologna 1980). Doria was also an early admirer and patron of the Caravaggeschi, and had dealings with Battistello and Gentileschi (Pacelli 1980). He also had contacts with Vouet, as is shown by a letter of Vouet's from Genoa to Cassiano dal Pozzo (4 September 1621), in which he says that he had been invited to the villa of Sampierdarena and asked 'to paint some portraits for them' (Bottari, Ticozzi 1822–25). An engraved portrait by him represents Marcantonio's brother, Gian Carlo; another portrait has been proposed as a portrait of Marcantonio Doria (Brejon de Lavergnée and Cuzin 1974). The two portraits are closely linked: probably the second is also of Gian Carlo (Biavati 1978).

Caravaggio had taken refuge in Genoa after being denounced on 29 July 1605 for his attack on Mariano Pasqualone (Bertolotti 1881), as is stated in three letters of 6, 17 and 24 August respectively, sent to Conte Giovan Battista Laderchi by the Duke of Modena's ambassador in Rome, Fabio Masetti. In the last of these it is said that Caravaggio had returned to Rome to make peace with Pasqualone and that he had refused to paint a loggia for Prince Doria, who

had offered him 6,000 *scudi* (Venturi 1910; Cinotti 1971). Since, according to Pacelli (1980), the Prince Doria mentioned is almost certainly Marcantonio, the loggia must have been in a Genoese palace or villa and not at Rome, as had been thought. It was very probably the loggia of the Casino of Sampierdarena where later Battistello and Gentileschi were to work.

M.G.

PROVENANCE
Genoa, Marcantonio Doria 18 June 1610;
Nicolò Doria Prince of Angri and Duke of Eboli 1651;
Doria heirs; Naples, Maria Doria Cattaneo 1831–32;
Naples, Palazzo Doria d'Angri at Spirito Santo 1845;
Naples inheritance of Carlo Doria d'Angri 1854–55;
neighbourhood of Eboli, Romano-Avezzano Collection;
acquired by the Banca Commerciale Italiana 1973

EXHIBITIONS
Naples 1963, no. 50

REFERENCES
Bertolotti 1881, II, pp. 71–72;
Biavati in Genoa 1977, pp. 209–11;
Brejon de Lavergnée and Cuzin in Paris 1974, pp. 220–22;
Cinotti 1971, pp. 158–59; Ferrari 1978, p. 372;
Gregori 1975, pp. 44–48; Marini 1979², pp. 29–30;
Nobile 1855, II, p. 334;
Pacelli and Bologna 1980, pp. 24–45;
Pinelli 1981, p. 3; Scavizzi 1963, p. 53;
Testori 1975, p. 3

20
Salome Receives the Head of John the Baptist
91.5 × 106.7 cm
National Gallery, London

There is no early information on this painting. When Longhi first published it in 1959 he linked it tentatively with Bellori's mention of 'a half-length of Herodias with the head of St. John in a basin' (Bellori 1672), that Caravaggio had sent to the Grand Master of the Order of Malta, Alof de Wignacourt, to obtain pardon after his return to Naples sometime before 24 October 1609. Longhi thought it improbable, in view of Caravaggio's habit of portraying half-lengths in terms of action, that the picture recorded by Bellori was just a half-length figure and at first imagined that the painting sent to de Wignacourt could be identified with the *Salome* (Royal Palace, Madrid) documented at the Escorial from 1686 (Longhi 1927). After the discovery of the *Salome* now in London an earlier dating has been proposed for the Spanish picture (Longhi 1959, 1968, who believed it was painted in Malta; Hinks 1963; Levey 1971).

The dating of this *Salome* to Caravaggio's second stay in Naples, has been accepted by many scholars (Jullian 1961; Bottari 1966; Ottino Della Chiesa 1967; Causa 1962 and 1972; Spear 1971; Moir 1976; Bologna 1981). Its placing in the first Neapolitan period was, however, considered by Mia Cinotti (1971) because of its affinities with the *Madonna of the*

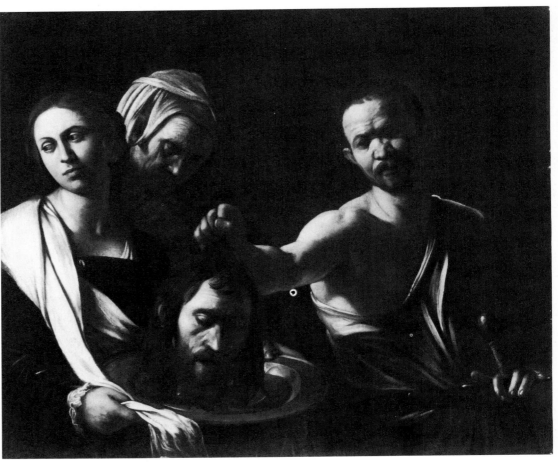

20

Rosary and *The Flagellation*, and by Marini (1973 and 1974[1]), who noted stylistic and formal similarities with the autograph works of this phase. He also observed that Neapolitan derivations like Caracciolo's picture in the Peltzer Collection, Berlin (Moir 1976), the picture attributed to Finson in Brunswick and the copy in the Abbey of Montevergine near Avellino referred to by Causa (Scavizzi 1963) suggest that the work remained in Naples for some time.

Apart from the disputed dates, it is generally agreed that the work was painted in Naples, and this seems confirmed by the existence of the copy at Montevergine (Longhi 1959, Nicolson 1963, Cinotti 1971) and by stylistic and formal affinities with paintings done in Naples, like the *Madonna of the Rosary* (fig. 10) and *The Acts of Mercy* (Cat. 16). Caravaggio used the same model for the Madonna in the former and for the woman personifying Roman Charity in the latter. In the *Crucifixion of St. Andrew* (Cat. 17) the old woman is close to the one in *Salome*; in *The Flagellation* (Cat. 15), the same brutal model used here for the executioner appears again. Dating the picture in 1607, Marini suggests it could be identified with the *Judith and Holofernes* which Frans Pourbus the

Younger reported was on sale in Naples together with the *Madonna of the Rosary* in a letter to the Duke of Mantua of 25 September 1607 (Luzio 1913). Given the similarity of the two subjects Pourbus' error is understandable.

The rapid brushwork (x-rays show no trace of pentimenti but some variations around the contours are visible to the naked eye) is based on a pronounced contrast of light and shade and on a limited use of light colours, which serve in some parts to emphasize, rather than to model, the force of the light with cursory and concise brushstrokes. This manner, characteristic of Caravaggio's last period, is particularly apparent in the executioner's shirt and in the glancing light on his shoulder, as also in the head of the old woman, who is close to Saraceni and seems to anticipate Rembrandt. The apparent stylistic discrepancies noted by Kitson (1969) – the fact that the head of the Virgin is reminiscent of that of the Virgin in the *Madonna of the Rosary* while the executioner is closer to Sicilian works – caused Kitson and Levey to have reservations on the autograph status of this painting, which was described in the 1971 National Gallery Catalogue as 'ascribed to Caravaggio' and was relegated for a period to the reserve collection.

In the light of the better understanding we now have of Caravaggio's last works there is no reason to doubt the painting's autograph status. The present writer thinks that it is a work following Caravaggio's experiences in Malta and Sicily, and therefore from the painter's last period. It should also be stressed that the presence in the picture of elements that occur in other paintings is characteristic of Caravaggio's late practice (Cinotti 1971; Gregori 1975). With *Salome*, and most notably in this version in which the nature of the macabre subject is conveyed also by illusionistic means, Caravaggio introduced into seventeenth-century painting a theme that in the early Cinquecento had been treated with subtle sadism by the Lombard painters of Leonardo's circle (Andrea Solario, Luini).

Mahon has suggested in conversation that this *Salome* may be the *St. John the Baptist* which was among Caravaggio's belongings in the felucca which took him to Porto Ercole.

M.G.

PROVENANCE
French private coll.; Hôtel Drouot, Paris, 1959; Swiss private coll.; Major A. E. Allnatt 1961; loaned to National Gallery; acquired from Allnatt Estate 1970

REFERENCES
Bellori 1672, p. 208; Borla 1967, pp. 8, 13–14 n. 15; Bottari 1966, pp. 12, 31, 36–37; Causa 1966[1], 11, p. 6; Causa 1972, p. 917; Cinotti 1971, pp. 82, 86, 135, 143, 198–199 n. 500; Dell'Acqua 1971, p. 46; Fagiolo dell'Arco 1968, p. 59; Fagiolo dell'Arco and Marini 1970, p. 122; Gregori 1975, p. 43; Hinks 1953, p. 116; Jullian 1961, p. 230; Kitson 1969, p. 109; Levey 1971, pp. 53–56; Longhi 1927, p. 10; Longhi 1959, pp. 21–32; 1968, p. 45; Luzio 1913, p. 278; Marini 1973[2], p. 189; Marini 1974[1], pp. 40, 41, 226, 429–30 (no. 67); Marini 1979[1], pp. 36, 45, n. 180; Moir 1976, pp. 103, 134–35, n. 226; Nicolson 1963, p. 210; Nicolson 1979, p. 33; Ottino Della Chiesa 1967, p. 103; Pacelli 1978[1], p. 493; Scavizzi 1963, p. 21 (n. 9)

Bernardo Cavallino

NAPLES 1616–NAPLES c. 1656

There are almost 80 autograph paintings by Cavallino, but only one, the *S. Cecilia in Ecstasy* of 1645, is dated (Cat. 28). De Dominici is the only source for biographical details and he is often unstrustworthy.

According to Dominici, Cavallino was in Stanzione's workshop when very young. But from our knowledge of pictures which obviously date from the beginning of his career, *c.* 1635–40: the *Martyrdom of St. Bartholomew*, (Capodimonte), the *Adoration of the Shepherds* (Brunswick; Cat. 24), the *Meeting of Anne and Joachim* (Budapest Nationalmuseum), some *Apostles* (divided between Puerto Rico, Madrid and the London market) and the *Adoration of the Magi* (Vienna) – it is evident that at this stage he was strongly influenced by the anonymous Master of the Annunciations with whom he occasionally collaborated. The *Flagellation* (Falanga Coll., Naples) by Cavallino is a pendant to the *Annunciation to the Shepherds* (Cat. 80) of the Master in the same collection.

But while Cavallino was influenced by this master of Neapolitan naturalism and by Velasquez, his style was already more painterly, a characteristic absorbed from Rubens and Van Dyck. A group of small-scale pictures from the period of the late 1630s and early 1640s, including paintings at Capodimonte and the *Feast of Absalom* (Cat. 25), show his interest in the light effects of the *Bamboccianti*, in particular of Michael Sweerts, then active in Rome. Although he did not abandon his early realism – never of a harsh or crude nature – the influence of Sweerts (whose works are documented in Naples), and possibly Falcone, encouraged Cavallino to experiment when he painted his small-scale pictures illustrating episodes from the scriptures and literary subjects, both ancient and modern (Ovid, Livy, Tasso, Marino), which were destined for cultivated private patrons. These display a delicacy in both style and treatment of subject matter; the protagonists' characters are subtly expressed, both they and their accompanying objects are portrayed with great clarity and the play of light is delicately handled. His medium-sized paintings are elegant in composition, courtly in style and intensely vivid colouristically, perhaps due to the influence of Artemisia Gentileschi, and Stanzione and Simon Vouet.

By the early 1640s, Cavallino's small-scale pictures were the most important part of his output. As well as his link with the *Bamboccianti* he showed an interest in the warm, luminous painting of Castiglione, an interest shared by other naturalistic Neapolitan painters. But this phase did not obscure his naturalistic bent evident in the two pairs of *The Drunkenness of Noah* and *Lot and his Daughters* (Silvano Lodi Coll., Campione d'Italia; pair divided between Gosford House and Kaufman Coll., Strasbourg; Cat. 26), and particularly in the *Erminia with the Shepherds* (Capodimonte) and the *Madonna of the Rosary* (Ottawa).

The *S. Cecilia in Ecstasy* of 1645 (Cat. 28) introduces Cavallino's next stylistic phase; whereas his large compositions are still in the tradition of Stanzione and Artemisia Gentileschi, augmented by the influence of Vouet, there are some small and medium-scale pictures (various female martyrs at Capodimonte, Rotterdam, Milan, Boston and York; the two versions of *Esther and Ahasuerus*

in the Uffizi (Cat. 30) and in the Harrach Collection, the *Martyrdom of St. Lawrence* in the de Salas Coll., Madrid) characterized by the use of warm, light tones, sometimes irridescent, in which delicate forms are freely articulated and the whole enveloped with a tender, sentimental grace. This style, deeply influenced by Van Dyck, was brief in duration.

Between 1645 and 1650 signs of a new stylistic direction emerged. While the influence of Artemisia Gentileschi and Vouet lingers on, *The Singer* (Cat. 31), the *Clavichord Player* (Lyons) and large-scale compositions such as the *Triumph of Amphitrite* (Cat. 33) combine echoes of Stanzione and Artemisia with new forms of composition and expression; in small and medium-scale pictures it is evident that Cavallino was searching for more balanced compositions in which the forms were more compact, their polished outlines achieved through the use of a firmer paint surface and brighter, more enveloping light. These figures seem to anticipate eighteenth-century porcelain figurines. This late style of Cavallino, typified by the Capodimonte *St. Anthony*, was to some

extent a reaction to the formal academic elegance of Stanzione. In this he was influenced by the group of French artists working in Rome, including Poussin and Charles Mellin, Sébastien Bourdon and Tassel who synthesized classicism with Venetian colour and technique.

Cavallino's adoption of some aspects of the art of these French painters did not lead him to abandon the qualities of his earlier work; the sentimental tone, mid-way between idyll and elegy, evident in many small compositions of the 1640s, the refined, intimate rendering of his subjects, whether scenes of love or martyrdom, the quiet, almost subdued, exaltation of female beauty which is nevertheless passionate and sincere and, finally, the depiction of tender, everyday affections.

In style and content his painting has more in common with poetry and literature than with the contemporary visual arts; it is permeated with ideals and aspirations that anticipate a subtly bourgeois culture and sensibility; his paintings seem to act as a prelude to the world of Arcadia and of the eighteenth-century musical drama.

It may be significant that Cavallino's influence was only marginal in the mid-Seicento and that it was the rococo painters of a later generation who appreciated his subtle and delicate art.

N.S.

21

21

St. John the Evangelist

128 × 101.5 cm
Colnaghi & Co., London

This painting was formerly in the Conti Collection in Naples, ascribed to an unknown Neapolitan painter of the seventeenth century. It belongs to the early maturity of Cavallino, strongly naturalistic in style and close to the anonymous Master of the Annunciations, especially in their common dependence on Velasquez. It is closer to the *Feast of Absalom* (Cat. 25) in the treatment of light than to the *St. Peter* and *St. Paul* (Cat. 22, 23). It probably dates from the late 1630s.

N.S.

PROVENANCE
Conti Coll., Naples

EXHIBITIONS
London 1979, no. 10

22 & 23

St. Peter
St. Paul

Octagons, each 127 × 94 cm
St. Peter signed: *Ber. do Cav. no*, and book inscribed
VOLUMO.

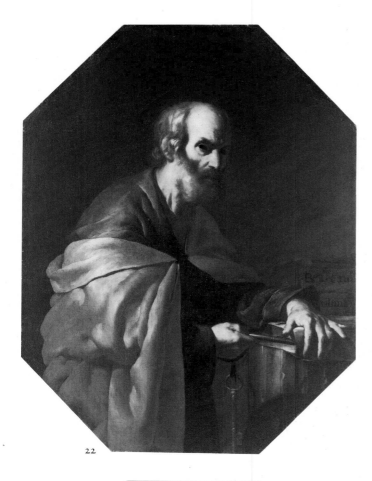

22

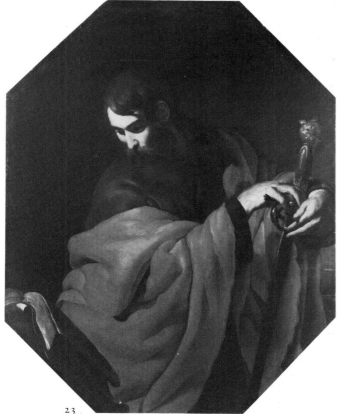

23

St. Paul signed: on sword blade *Bernardo Cavallino*
Trafalgar Galleries, London

Before cleaning revealed the presence of the
signatures these paintings were ascribed to
Ribera. And, indeed, these two apostles derive in
size, composition and in the vigorously
naturalistic rendering from the figures of saints,
apostles, philosophers and prophets painted by
Ribera in the 1630s. These include the series of
the *Apostolado* of *c.* 1630 (Prado, Madrid), and
the group of *St. Peter*, *St. Paul*, *St. Roch* (also in
the Prado) and *St. Matthew* (Kimbell Art
Museum, Fort Worth) of 1632. It is evident that
Cavallino's *St. Peter* derives from that of Ribera
of 1632. These octagons are also close to
Ribera's *Moses* and *Elijah* of 1638 (Cat. 124, and
125).

Moreover the *St. Paul* is identical in
composition to the *St. Paul* in the Conde de
Muguiro's Collection, Madrid; they are also
comparable to the *St. Simeon* in the Museo Ferté
in Puerto Rico and to the *St. John the Evangelist*
(Cat. 21). All these paintings are early works of
Cavallino's, dating from the late 1630s. They
share the play of light which enhances the
quality of flesh and drapery, the strong impasto
and brilliant colour of the *Adoration of the
Shepherds* (Cat. 24), which again emphasizes the
connection between Cavallino's early style and
the mature work of the anonymous Master of
the Annunciations.

The pair may originally have been part of a
larger series of the 12 apostles. Their painterly
delicacy anticipates the *S. Cecilia* (Cat. 28).

N.S.

PROVENANCE
Farnborough Abbey, Hampshire

24

Adoration of the Shepherds

191 × 141 cm
Herzog Anton Ulrich-Museum, Brunswick
(inv. no. 128)

Listed in the museum inventories as a
seventeenth-century 'copy after Caravaggio', the
painting was identified as a work of Cavallino
by Ann Percy. It has been recently published by
De Vito, who rightly dates it between 1635 and
1640, in the middle of Cavallino's development
away from his early naturalistic style. The
picture has been related to the *Martyrdom of St.
Bartholomew* (Capodimonte) of the same
period, and it is rich in echoes of well-known
compositions by Stanzione and Falcone (De Vito
relates the cock and the saddle in the right fore-
ground to Stanzione's *Portrait of a Woman*
[Cat. 158] in the De Young Museum, San
Francisco and to Falcone's *The Rest on the*

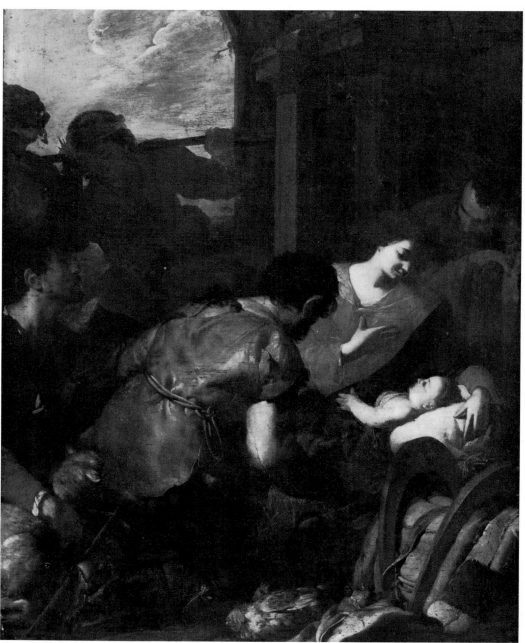

24

Flight into Egypt [Cat. 43] in the Duomo, Naples). The St. Joseph in the right background is close to the *St. Paul* (Coll. Conde de Muguiro. Madrid; Milicua 1954).

This work demonstrates the close links which still bound the young Cavallino to the naturalistic style of the anonymous Master of the Annunciations.

N.S.

PROVENANCE
In the collection of the Elector of Brunswick before 1737

REFERENCES
Milicua 1954, p. 72; Percy 1965; De Vito 1982, pp. 37–39

25
The Feast of Absalom

103 × 133 cm
Graf Harrach'sche Familiensammlung, Schloss Rohrau

Amnon, the son of David, was murdered by his half-brother Absalom during a banquet to avenge Absalom's sister Tamar, who had been raped by Amnon two years earlier (*Samuel*, II, xiii). Ascribed to the Spanish school in the 1856 catalogue of the Harrach collection, and to Mattia Preti in 1897, it was attributed to Gioacchino Assereto by Longhi in 1916, and only in 1921 correctly ascribed to Cavallino.

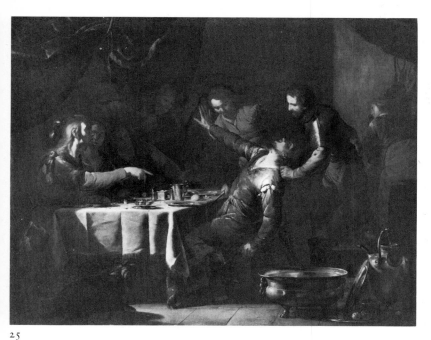

25

It has been dated in the late 1630s or early 1640s, at which time Cavallino was stylistically moving beyond the earlier influence of the Master of the Annunciations and studying Falcone and also the *Bamboccianti* in Rome, in particular the work of Michael Sweerts. His work of this date is characterized by a sharp counterpoint of light and shade and a careful,

naturalistic rendering of even the smallest detail, such as the extraordinary still life on the table in this painting.

It was acquired by Count Alois von Harrach, Viceroy of Naples from 1728–32, together with two other paintings by Cavallino: an *Esther and Ahasuerus* in his late style and a *Denial of St. Peter*, a seventeenth-century copy of a lost early work which is also known from other seventeenth-century copies and which can possibly be identified with the picture formerly belonging to Marchese di Campolattaro and later to the Gaetani d'Aragona at Torre del Greco.

A painting of the same subject but with variations, wrongly ascribed to Cavallino, was recorded in the Tesorone sale of 1918 (Diodati, Naples).

N.S.

PROVENANCE
Acquired by Count Alois Thomas Raimund von Harrach, Viceroy of Naples 1729–32; inv. no. WF197

EXHIBITIONS
London 1930, no. 349; Naples 1938, pp. 65, 138

REFERENCES
Benesch 1926, pp. 245–54;
Causa in *Storia di Napoli*, 1972, v, II, pp. 915–94;
Chimirri, Frangipane 1915, p. 1915;
Delogu 1937, pp. 405–14; Heinz 1960, p. 26;
Juynboll 1960, pp. 82–91; Longhi 1916[3], pp. 370–71;
Masciotta 1942, pp. 147–48; Mitidieri 1913, pp. 428–50;
Refice 1951, pp. 259–70

26

Lot and his Daughters

Oval, 101 × 76 cm
Private collection, Strasbourg

The painting was evidently originally a companion to the *Drunkenness of Noah* (Gosford House, E. Lothian, coll. the Earl of Wemyss and March), since both are of the same dimensions and oval form, and represent two associated episodes from the Old Testament. The painting exhibited here shows Lot made drunk by his daughters so that they might lie with him and perpetuate the human race after the destruction of Sodom (*Genesis*, XIX, 33–5). Thus it refers to the diverse destinies of the descendants of Noah; his son Shem was the progenitor of the Semites, the chosen people of God; another son, Japheth, was the forefather of the Europeans, and Caan that of the Caananites, the Ethiopians and all black races. From the incestuous relationship between Lot, the son of Noah, and his daughters were descended the Moabites, (through Moab, born of his elder daughter) and the Ammonites, descended from Ammon 'the son of my people', the child of the younger daughter. The other picture shows the drunken Noah, who, after planting a vineyard, lay naked and was derided by his son Ham, while the latter's brothers Shem

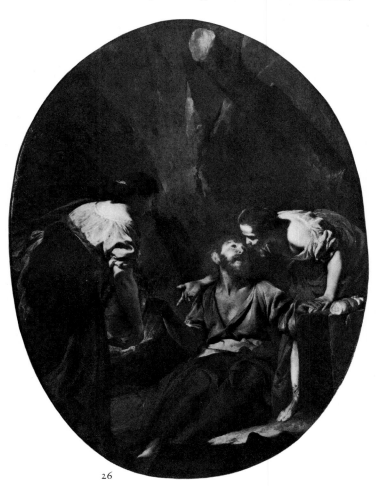

26

and Japeth covered his nakedness (*Genesis*, ix, 20–23).

The two compositions demonstrate Cavallino's amazing capacity, particularly on a small scale, to illustrate biblical episodes as if they were refined, arcadian pastoral scenes. In terms of style and the use of luminous colour, they are close to the *Deposition* (Grenoble) and the *Judith* (Cat. 27) which must be of the same date as this pair; there are echoes of the work of Artemisia Gentileschi and Vouet, and of Castiglione in the warm and luminous colour, although his influence here is not quite so pronounced as in the Capidomonte *Erminia and the Shepherds*. Nor do they possess the exquisite Vandyckian qualities of the *S. Cecilia* of 1645 (Cat. 28) and of its *bozzetto* in Capodimonte. So they probably date from *c*. 1643; the naturalistic elements, certain physiognomic details and the rigour of the distribution of the light and shade makes Ann Percy's suggestion (oral communication) that they were painted in the late 1640s improbable.

There are two other versions of these

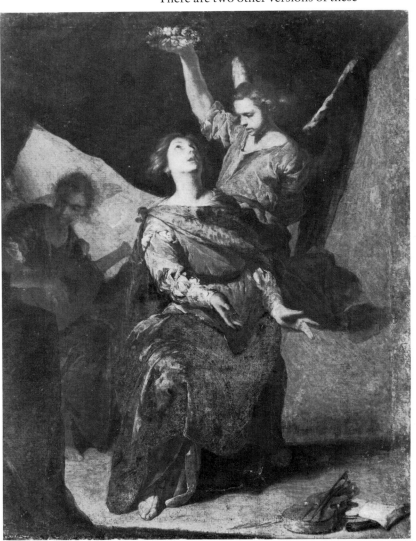

28

compositions in the Lodi Collection at Campione d'Italia; they are circular (41.5 cm diameter). Stylistically they are very close to this pair so they cannot be identified with the two paintings seen by De Dominici, which were also round, measure four *palmi* and were sold to Germany. The subjects were *Lot and his Daughters fleeing from Sodom* and *The Drunkenness of Lot*.

Brejon de Lavergnée published the Strasbourg painting as formerly in the collection of Van den Einden in Naples, but in the inventory of this celebrated collection (Van den Einden was the son-in-law of Gaspar Roomer) only one painting by Cavallino is listed, *St. Margaret with the Dragon*, which passed into the collection of the Colonna di Stigliano and has since been lost.

N.S.

REFERENCES
Brejon de Lavergnée and Dorival 1979, p. 92;
Carritt 1957, p. 343;
Causa in *Storia di Napoli* 1972, v, II, p. 942;
De Dominici, 1742–45, III, p. 37

27

Judith with the Head of Holofernes

88.9 × 76.2 cm
Brinsley Ford Esq.
[*repr. in colour on p. 82*]

Formerly ascribed to Jan Lys, *Judith with the Head of Holofernes* was attributed to Cavallino in 1940 (Fogg Museum). It belongs to a group of paintings strongly influenced by Castiglione, though still with some memories of Van Dyck, which slightly predate the *S. Cecilia* of 1645. Causa praised them, '*per il gioco contenuto degli intenerimenti cromatici delle penombre suggestive*'. It appears to be later than the pair of pictures of *Lot and his Daughters* and *The Drunkenness of Noah* (Silvano Lodi Coll., Campione d'Italia) and the divided pair of the same subjects (Gosford House and Cat. 26), but earlier than the *Immaculate Conception* (Brera) which Causa (1972) rightly believes predates the *S. Cecilia* of 1645 even though Scavizzi put it at the end of Cavallino's life (Naples 1963, no. 18).

Cavallino painted several versions of Judith and Holofernes (*Judith*, XIII) at different moments of his career, illustrating successive episodes in the story: Judith lifting up the head of Holofernes (Capodimonte), Judith giving Holofernes' head to her maid (this painting), and Judith holding the head of Holofernes (Cat. 36; Nationalmuseum of Stockholm). In an inventory of the Tarsia Spinelli Collection, Naples of 1734, a *Judith* is listed measuring 5 × 4 *palmi* (equivalent to 132 × 106 cm: cf. Mormone 1962). De Dominici records in the collection of the Marchese di Grazia a Cavallino picture, also measuring 5 × 4 *palmi*, showing Judith, who, 'having cut off Holofernes' Head, hands it to her

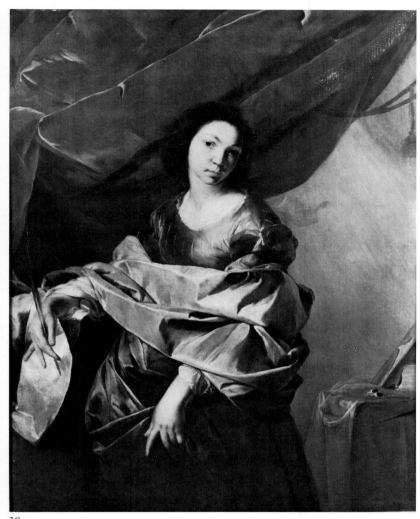

29

This is the only known picture by Cavallino to bear his signature and a date, and it is one of his very rare works painted to decorate a public building. On the basis of Celano (1692) and other eighteenth and nineteenth-century sources, it can be identified with the picture formerly over the high altar of the church of Sant'Antonio delle Monache presso Port'Alba at Naples, from which it was removed in the mid-nineteenth century. Although it is not in a perfect state of preservation, this painting from Cavallino's maturity shows clear signs, both in composition and in the delicate play of light and blending of colour, of the painter's conversion to the style of Rubens and Van Dyck. These had been introduced to Naples ten years earlier through Ribera's influence and had over-whelmed both the naturalistic painters and those of a more classicizing tendency.

S. Cecilia, in both the rarefied elegance of its form, permeated by a subtle mixture of frail eroticism and cultivated mysticism, and its use of colour which is 'shrill, intense, clotted, saturated with light' (Causa), represents the high point of Cavallino's painterly style. It influenced other painters working in Naples including Schönfeld, Micco Spadaro, De Bellis and Niccolò di Simone and they, in turn, influenced Cavallino. After this painting Cavallino progressively modified his Vandyckian style, and gradually adopted more classicizing elements from the work of Mellin and Poussin.

There is an exquisite *bozzetto* for this picture in Capodimonte.

N.S.

PROVENANCE
Sant'Antonio delle Monache, Naples;
Santangelo Coll., Naples 1877;
Paul Wenner Coll., Naples 1920;
acquired for Adolf Hitler, 1941;
recovered by the Italian Government from Germany, 1948;
temporarily transferred to Palazzo Vecchio, Florence

EXHIBITIONS
Naples 1887; Florence 1922 no. 263; Florence 1952 no. 28; Paris 1965 no. 46; Bucharest 1972; Naples 1973

REFERENCES
Catalani 1845, II, p. 12; Causa 1957, p. 42;
Causa in *Storia di Napoli* 1972, p. 944;
Celano 1692, I, pp. 24–25; Dalbono 1878, p. 47;
De Dominici 1742–45, III, p. 36;
De Rinaldis 1920, I, pp. 2–6, 56–59; De Rinaldis 1921, p. 16;
De Rinaldis 1929, p. 41; Giannone 1773, pp. 107–08;
Juynboll 1960, p. 86; Milicua 1954, II, pp. 68–78;
Moir 1967, pp. 176–77; Montini 1952, p. 35;
New York 1967, pp. 28–29; Nugent 1930, p. 574;
Ortolani in Naples 1938, pp. 13–113;
Parrino 1700, I, p. 199; Pevsner 1928, p. 184;
Sigismondo 1788, I, p. 233

old maidservant'. Unfortunately, neither of these can be identified with this picture, given their dimensions, although the subject corresponds with De Dominici's description of the di Grazia version.

N.S.

PROVENANCE
Tryon Coll. 1939; C. Norris Coll. 1945;
C. Pascall Coll. 1951; R. C. Pritchard Coll. 1952;
Hazlitt Gallery, London 1959; Colnaghi, London 1959

EXHIBITIONS
Fogg Museum, Cambridge Mass. 1940–45;

London 1952, no. 332; Hazlitt Gallery, London 1952, no. 8; Colnaghi, London 1959, no. 4; London 1960, no. 389

REFERENCES
Causa in *Storia di Napoli* 1972, p. 944
Mormone 1962, pp. 216–17, 233;
Scavizzi in Naples 1963, no. 18

28
S. Cecilia in Ecstasy

183 × 129 cm
Monogrammed and dated: *BC no. P. 1645*
Palazzo Vecchio, Florence

29
St. Lucy

129.4 × 102.8 cm
De Vito Collection, Naples

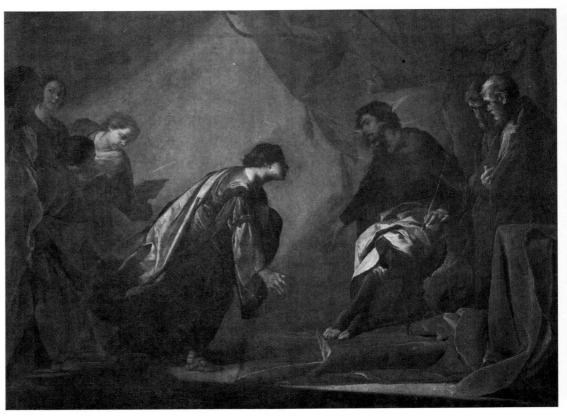

30

The provenance of this picture is unknown, although it seems certain that it came from an old Genoese collection before passing to the De Vito Collection. Several of Cavallino's paintings, known from the sources or from old inventories, or at present on the market, came from Ligurian collections, which confirms that Cavallino and other Neapolitan artists had close links with Genoa, both in the exchange of ideas and styles and in matters of patronage. This *St. Lucy* is an exhilarating representation of feminine beauty, enriched by the rustle of precious silks and the spread of splendid velvets, with rarefied subtleties of form, exquisite colour and an increasing refinement in the play of light and the coloured shadows. The characterization of the saint as passionate rather than pathetic demonstrates the profound effect of Van Dyck's art on that of Cavallino in the mid-1640s.

In terms of style and date, this painting seems close to the S. Cecilia of 1645. If the shrill red of the velvet drapery and the subtle play of chiaroscuro suggests a date near to the *Judith* (Cat. 36), the precious light and colour put it close to the *bozzetto* for the S. Cecilia (Capidomonte) and the *Esther and Ahasuerus* (Cat. 30). The more restrained elegance of the saint and the greater compactness in form are comparable to the style of the Birmingham *St. Catherine* (Cat. 32) and especially close to the

St. Catherine in Rotterdam, which might suggest that the *St. Lucy* dates from slightly after 1645. N.S.

PROVENANCE
Private collection, Genoa

30
Esther and Ahasuerus

76 × 102 cm
Uffizi, Florence (inv. no. 6387)

This *Esther and Ahasuerus* can hardly be the same picture as the one that De Dominici described among the Cavallino works owned by the Neapolitan man of letters, jurist and collector, Giuseppe Valletta (1636–1714). The picture shows an episode from the story of Esther (*Esther*, v): a Hebrew maiden, the niece of Mordecai, she was chosen by the Persian King Ahasuerus as his bride in place of his repudiated wife Vashti. In both this picture and that in the Harrach Collection, Vienna, Esther presents herself, splendidly attired and accompanied by her handmaids, to the king to intercede on behalf of her people.

But the picture formerly in Casa Valletta, according to De Dominici's description, showed a later episode: the queen, distressed by the king's anger against the Jews, faints into her maids' arms. It was this episode which is shown by Cavallino in two other pictures, probably

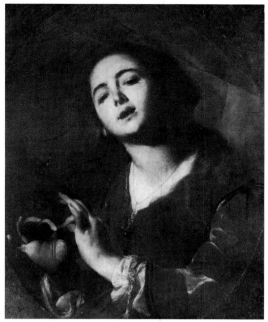

31

painted before the Uffizi and Harrach paintings and now both in a private collection in Milan. One is probably an early work dating from the end of the 1630s; it is in a poor state (ex Moratilla, Paris; Marini 1974²). The second dates from a few years later (ex Pagano in Suor Orsola Benincasa Coll., Naples). But neither of these youthful works can be the picture described by De Dominici, which he said measured 5 × 3 *palmi* (that is 132 × 127 cm), while the Milan and Naples versions measure respectively 99.8 × 154 and 71 × 97 cm. Moreover, the Valletta picture, which was 'closely imitative of the wonderful colouring of Peter Paul Rubens' (De Dominici), must have belonged to Cavallino's maturity when he was deeply influenced by Rubens.

The picture described by De Dominici is presumably lost, but this Uffizi version, like the poorly preserved one in the Harrach Collection (which has a pendant of *David Placating Saul* in the same collection) is one of Cavallino's masterpieces, of the same date or immediately after the *S. Cecilia* of 1645. He was deeply influenced by Van Dyck at this date; the warm, golden light permeates the whole scene, there are liquid zones of pure colour and a refined, restrained elegance in the compositions and the figures. The meeting between Esther and Ahasuerus becomes the occasion for a '*tacito dialogo interiore*' (Causa); the various sentiments are described with great delicacy within the rarefied atmosphere of the court scene. A copy of this painting was recorded by Ortolani (1922) in the Giglio Collection in Naples, while another replica formerly with the Direzione Generale delle Belle Arti, labelled as a work of the Venetian School (present where-

abouts unknown), was said by Zeri (letter of 25 Jan. 1962, Frick Library, New York) to be an autograph work by Cavallino.

N.S.

PROVENANCE
Agostino Conte Coll., Naples; Uffizi, Florence 1917

EXHIBITIONS
Florence 1922, no. 62; Naples 1938, pp. 66, 319

REFERENCES
Benesch 1926, p. 250; De Dominici 1742–45, III, p. 38; De Rinaldis 1917, pp. 179–86; De Rinaldis 1920, p. 16; Marini 1974², pp. 115–16; Ortolani 1922, p. 193; Sestieri 1920, pp. 188–97; Tzeutscher Lurie 1969, no. 4

31
The Singer

Oval, 75 × 64 cm
Capodimonte, Naples

This painting was first attributed to Cavallino by Longhi (1920); formerly it was given to the school of Pacecco de Rosa. The attribution to Cavallino was accepted by Sestieri (1920 and 1921), rejected in 1927 by De Rinaldis, who suggested it was from the 'School of Stanzione and Vaccaro', but finally accepted by Ortolani in 1938 and by all later critics. Bologna recognized it to be the pendant of the *Harpsichord Player* (Musée des Beaux-Arts, Lyons; see Rosenberg 1968, no. 4). The two ovals were then dated *c.* 1645, the date of the *S. Cecilia* (Cat. 28), but a more precise knowledge of Cavallino's later style makes it possible to place them in the late 1640s when the painterly quality of his early work was giving way to a classicism inspired by Mellin and Poussin. It is slightly earlier than the *Judith* in Stockholm (Cat. 36) and the *Expulsion of Heliodorus* in the Pushkin Museum, Moscow. The close connections of the *Harpsichord Player*, or rather *Clavichord Player*, and the present painting to works like those at Stockholm and Moscow, which belong to Cavallino's last years, was pointed out by Rosenberg. Causa sees in *The Singer* and other related works, such as the *St. Lawrence* (Museo Làzaro Galdeano, Madrid), the *St. Agatha* (Detroit Museum) and the *St. Catherine* (Cat. 32) the presence of persistent echoes of Artemisia Gentileschi, especially in the use of a dense impasto. He suggests a date a little before the *Judith* at Stockholm and other late works.

Cavallino had links with the French painters active in Rome who created a synthesis of the Venetian style and classical balance; Rosenberg pointed out close parallels between the work of Tassel (in Rome between 1634 and 1647) and the *Harpsichord Player*. Apart from the obvious connection with Mellin, and Poussin after 1640, Cavallino came into contact with Sébastien Bourdon (to whom the monogrammed *Expulsion of Heliodorus* in the Pushkin

Museum was long ascribed). Bourdon influenced the late work of both Cavallino and Falcone, and also Micco Spadaro after 1645.

N.S.

PROVENANCE
Unknown Neapolitan coll.;
Pinacoteca Nazionale, Naples at the beginning of this century

EXHIBITIONS
Naples 1954, no. 23; Paris 1965, no. 47;
Bucharest 1972; Naples 1973

REFERENCES
Causa 1957, p. 42; Causa 1972, p. 944;
De Rinaldis 1927, p. 149; Molajoli 1958, p. 56;
Rosenberg 1968, p. 152;
Sestierei 1920, p. 269; Sestierei 1921, pp. 188, 195

32
St. Catherine of Alexandria

72.2 × 59.2 cm
The Barber Institute of Fine Arts, The University of Birmingham

Close in style to the *St. Catherine* (Boymans-van Beuningen Museum, Rotterdam) in the tender chromatic passages and the dominant mother-of-pearl tone, and to the *Singer* (Cat. 31) in the facial type and its compact form, this *St. Catherine* is presumably a few years later than the *S. Cecilia in Ecstasy* of 1645 (Cat. 28) and belongs to the transitional phase from Cavallino's intensely painterly manner of the mid-1640s to his late style under the influence of the classicism of Mellin and Poussin.

N.S.

PROVENANCE
Henshaw Skinner Russell Coll.; Hazlitt Gallery, London;
Barber Institute 1966

EXHIBITIONS
Hazlitt Gallery, London 1966, no. 16

REFERENCES
Barber Institute Directors's Report 1966;
Causa 1972, p. 944

33
The Triumph of Amphitrite

148.5 × 203 cm
Hazlitt, Gooden and Fox, London
[*detail repr. in colour on p. 85*]

This is one of Cavallino's very rare large-scale compositions and a key work from his late style.

In this grand composition with its compact chromatic structure, its enveloping luminosity and its elegant classicizing arrangement of forms, as in his other paintings of the period after the painterliness which culminated in the *S. Cecilia* of 1645, Cavallino swings between his memories of Stanzione and Artemisia Gentileschi and his new interest in the neo-Venetian classicism of Poussin and Mellin.

When he illustrated biblical or literary episodes, the memory of the original sources was submerged by his anxiety to concentrate on to a small or medium-size canvas a world crowded with tender emotions. These he painted with an intensity perhaps only equalled in early Seicento poetry, or in the earliest secular plays. But painting on a large scale, with almost life-size figures, Cavallino had difficulty in avoiding the fascination of Stanzione's style; some elegant, formal motifs and the delicate colour derived from him. His chief influence is nonetheless Artemisia Gentileschi. The measured rhythm of the composition echoes Poussin.

Amphitrite, the wife of Poseidon (a sensual, languid Neapolitan *popolana*, who has much in common with Artemisia Gentileschi's female nudes) sits on an incredible knot of red coral growing out of a gigantic shell, drawn by a pair of dolphins, while four young tritons accompany the festal cortège with sounds of flute and conch; no doubt they were four stout fishermen, their heads wreathed in moss and seaweed, on the shore at Mergellina whom the

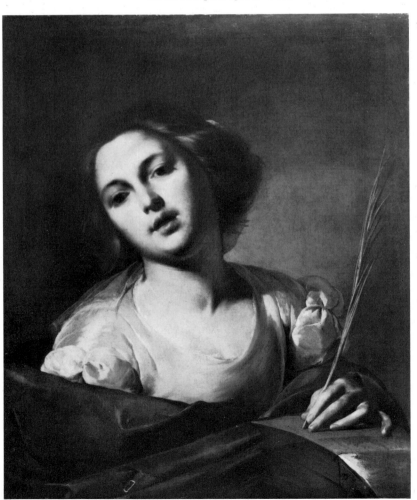

32

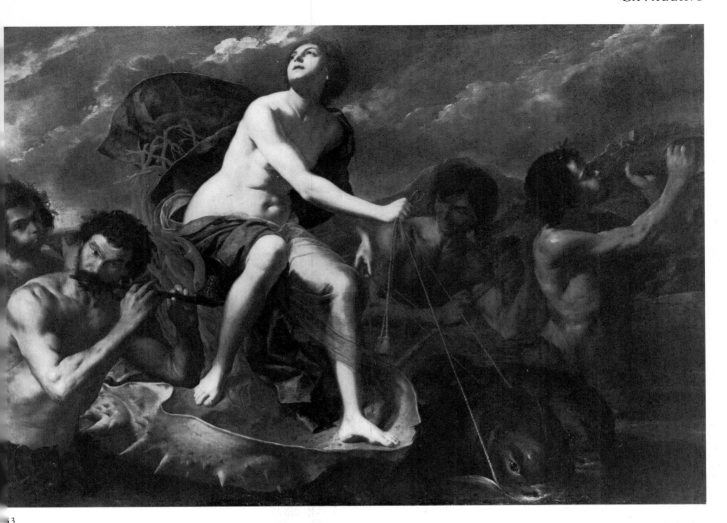

33

painter compelled to break off work to act as models for his picture.

Given the evident influence of Artemisia on this painting, it would be interesting to identify her picture of Galatea sitting on a crab, drawn by two dolphins and accompanied by five tritons measuring 8 × 10 *palmi* (212 × 264 cm) which is listed as no. 80 in the 1703 inventory of the 364 paintings in the house of Antonio Ruffo in Messina (Ruffo 1916). Given the similarity of subject matter and the large scale of both paintings, it is intriguing to speculate on other elements they may have shared.

The painting is unpublished and is exhibited here for the first time.

N.S.

34
The Finding of Moses

102 × 128 cm
Herzog Anton Ulrich-Museum, Brunswick
[*repr. in colour on p.* 81]

This is in the same museum as, and a companion to, *David and Abigail* (of which an earlier version is in the Castello Sforzesco, Milan): both were first listed as works of Mola and then of Jean Boulanger. Attributed to Cavallino by Voss in 1911, they date from the artist's last years, close to the tondos in Munich of *Erminia and the Shepherds* and *Tancred and Erminia* and slightly before the *Adoration of the Shepherds* (Cat. 35) from Cleveland. The elegant rhythm of the composition, the luminous atmosphere, and the firm plasticity of the figures, which almost anticipate Neapolitan polychrome porcelain figurines, are the results of the intense interest Cavallino showed after 1650 in the refined and cultured classicism of Poussin and the other French painters in Rome; but the general tone is that which would later inform the theatre of Metastasio.

The *Finding of Moses* (*Exodus*, ii), a fairly common subject in the seventeenth century, echoes the picture of the same subject by Orazio Gentileschi in the Prado (Tzeutschler Lurie 1968).

N.S.

PROVENANCE
In the collection of Herzog Anton Ulrich by 1710

REFERENCES
Causa 1966[1], pl. XII; Causa 1972, p. 944;
De Rinaldis 1917, p. 179; De Rinaldis 1929, pl. 43;
Milicua 1954, p. 68; Nugent 1930, p. 561;
Ortolani 1922, p. 192; Ortolani 1938, p. 66;
Tzuetschler Lurie 1969, p. 139; Voss 1911, pp. 249–50

35

Adoration of the Shepherds

126 × 148.3 cm
Monogrammed: on the ox's flank BC
Museum of Art, Cleveland, Ohio
[*repr. in colour on p. 81*]

Originally attributed to G. B. Castiglione, the
picture entered the Cleveland Museum in 1968
as the work of Cavallino. It is one of his last
works, and one of the few that are signed; the
others being *St. Peter* and *St. Paul* (Cat. 22, 23),
S. Cecilia in Ecstasy (Cat. 28), the *Pietà* in the
Church of the Purgatorio, Molfetta (in a chapel
built in 1649, although the painting must be
earlier), the Stockholm *Judith* (Cat. 36), the
Expulsion of Heliodorus (Pushkin Museum,
Moscow) and the *Shade of Samuel Invoked by
Saul* (American private coll.).

The painting is close in style to the Munich
tondos, the Brunswick biblical paintings (eg.
Cat. 34) and the series painted on copper in
Moscow and Fort Worth; they are all elegant
compositions, enveloped in a diaphanous light.
It was in these years that Cavallino was most
closely dependent on the luminous, tempered
classicism of the French painters active in Rome,
particularly in his small-scale works.

The painting is imbued by an atmosphere of
contained sentiment centred around the delicate
image of the Virgin (the last in a series of female
'portraits' which began in the 1640s). It is the
climax to the gradual process of classicist
revision which had begun around 1650; in this
painting the formal academic style is redeemed –
like pastoral poetry or a domestic story – by the
intimate tone with which the statuesque figures
are endowed.

N.S.

PROVENANCE
Marquis de Villette, Château de Villette, Oise;
Coll. J. B. Angiot, Paris;
sold as Castiglione at Hôtel Drouot, Paris March 1875;
private coll., Buenos Aires; F. Mont, New York;
Cleveland Museum of Art 1968

REFERENCES
Causa in *Storia di Napoli* 1972, p. 944;
Levey 1971, p. 85; Tzeutschler Lurie 1969, pp. 136–50;
Tzuetschler Lurie 1982, forthcoming publication

36

Judith with the Head of Holofernes

118 × 94 cm
Monogrammed: on the sword-hilt, BC
Nationalmuseum, Stockholm
[*repr. in colour on p. 79*]

Although it is monogrammed on the sword-hilt,
the painting was initially ascribed to Coriolano

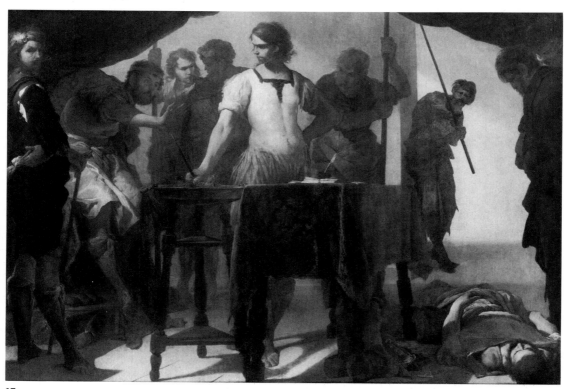

37

and later to G. B. Castiglione. It was attributed to Cavallino by Venturi and is an outstanding example of the painter's late style.

There are still traces of the influence of Artemisia Gentileschi and Massimo Stanzione, which suggests that this *Judith* dates from the beginning of his last phase, contemporary with the Capodimonte *St. Anthony* (an autograph version of this last painting – with many variations – appeared recently in a Christie's sale in New York). But the Old Testament heroine, 'an enchanting *popolana* dressed up as Judith' (Causa 1972) is painted in the style around 1650. The composition is more measured and balanced, forms are defined by means of light, homogenous colours are juxtaposed and give the picture a compactness that is entirely new in Cavallino's work. This is due to the classicizing influence of the French artists active in Rome in the 1630s who included Poussin, Mellin, Tassel and Sébastien Bourdon.

In this connection, there is a fine copy of this *Judith* in the Amiens Museum; it is from an old collection and was traditionally attributed to Biliverti (Rosenberg 1968).

N.S.

PROVENANCE
Given by Charles XV of Sweden to the Nationalmuseum 1864

REFERENCES
Causa 1966¹, pl. IX;
Causa in *Storia di Napoli*, 1972, V, II, p. 944;
Liebmann 1968, pp. 456–59;
Ortolani 1938, p. 66; Rosenberg 1968, p. 153, fig. 3;
Venturi 1921, p. 210

37*

Mucius Scaevola before Porsenna

Copper, 61.2 × 89.2 cm
The Kimbell Art Museum, Fort Worth, Texas

This illustrates a well-known episode from Livy from the war between the Romans and the Etruscans. Mucius Scaevola, a young Roman, offered to infiltrate the camp of the Etruscans besieging Rome and kill their king Porsenna. By mistake he killed a counsellor and, on being taken prisoner, he burnt his right hand which had failed him in his attempt. This so struck Porsenna that he released Mucius and, learning from him that there were 300 other Roman youths ready to kill him, he made peace with Rome.

The painting comes from an old collection in Madrid where, with two other paintings, it formed a series of biblical subjects painted on copper: these others depict Saul, who with the help of a witch from Endor questions the shade of Samuel (I *Samuel*, xxviii) and Jonah, who having been cast out by the whale preaches to the inhabitants of Nineveh the coming destruction of their city (*Jonah*, iii). These three paintings on copper, of identical dimensions, were all ascribed to Andrea Vaccaro, but while the attribution to the latter is correct for the painting of *Jonah*, *The Shade of Samuel Invoked by Saul* (American private collection) is monogrammed BC and *Mucius Scaevola before Porsenna* can also be confidently assigned to Cavallino.

Given the evident affinities of these two paintings on copper with the Munich tondos of *Erminia and the Shepherds* and *Tancred and Erminia*, the Old Testament scenes in Brunswick (Cat. 34) and the *Adoration of the Shepherds* from Cleveland (Cat. 35) in terms of the measured elegance of composition, the firm plastic definition of the figures and the compact and strongly-lit paint surface with almost mother-of-pearl tones, they can to be dated after 1650 at the time of the painter's most marked classicizing style.

This late dating is also confirmed by the identification of the figure of the counsellor on the right of Porsenna as a self-portrait of Cavallino when certainly no longer youthful; one would be inclined to say over 40, which suggests that the year of his presumed death, 1656, is wrong and should be moved to at least after 1660. In this connection it should be observed that, according to Causa (oral communication), self-portraits of Cavallino, at different ages, are also present in certain early works – the *Martyrdom of St. Bartholomew* (Capodimonte), the *Adoration of the Magi* (Vienna), the much-restored *David Placating Saul* of c. 1645 (Heim Gallery, London) and the *Meeting of St. Peter and St. Paul* (Corsini Gallery, Rome), which is datable to end of the 1640s.

Once we have established that these two paintings on copper belong to Cavallino's late phase, there follows the possibility that another painting from the same series was the *Expulsion of Heliodorus from the Temple* in the Pushkin Museum, Moscow, also on copper. This is of identical dimensions and also monogrammed BC; it was previously attributed to Sébastien Bourdon, but is now believed to be a late Cavallino (Rosenberg 1968; Leibmann 1968). It is worth remembering that De Dominici records the fact that Vaccaro often collaborated with Cavallino on commissions entrusted to him and that the latter had painted, among other things, a series of four paintings on copper with biblical scenes (of four *palmi*) for the collection of the Viceroy Don Pedro Antonio d'Aragòna in Madrid.

N.S.

REFERENCES
Pillsbury 1982, i–viii, fig. 5

Viviano Codazzi

BERGAMO 1604–ROME 1670

After a long period in Rome, Codazzi arrived in Naples in about 1634 (D'Addosio 1913). He was the foremost architectural landscape painter of his generation, developing the theme of landscape combined with architecture which Tassi had produced in many easel pictures, but adding much realistic detail. Codazzi must have known Tassi's *quadratura* work: in 1638 he painted the architecture for the *Pool of Bethesda* in Lanfranco's fresco in SS Apostoli (Celano 1692).

Codazzi's work for the Certosa di S. Martino (1936–1647) is fully documented; in 1647 he fled to Rome to escape the Masaniello revolt, leaving his work unfinished, which led to a long dispute with the monks over payment (Faraglia 1885). In the sacristy of S. Martino, Codazzi painted a colonnade in perspective for the *Crucifixion* of Cavaliere d'Arpino and a colonnade with staircase for Stanzione's *Ecce Homo*. According to the documents, the designs for the architecture painted by Codazzi were provided by the architect Cosimo Fanzago, a close friend of his (both came from Bergamo). In Naples Codazzi worked in close collaboration

with the most important painters of the time; for Artemisia Gentileschi he painted the architecture in *S. Gennaro in the Arena* (Duomo, Pozzuoli). His well-documented collaboration with Micco Spadaro was particularly successful; the results of this collaboration are listed in the inventories of many seventeenth-century Neapolitan private collections and some examples are now in the galleries at Besançon, Madrid and Dresden.

M.R.N.

REFERENCES
Celano 1692 (ed. 1856–60), I, p. 555;
Faraglia 1885, pp. 435–54; D'Addosio 1913, p. 46

38
Adoration of the Shepherds

124 × 156 cm
Sarah Campbell Blaffer Foundation

The collaboration between Viviano Codazzi and Domenico Gargiulo is reported by De Dominici and confirmed by a series of pictures in which one can discern two hands. Two of these are dated: the *Neapolitan Villa* (Musée des Arts, Besançon) is of 1641, and the *Vicaria Prison* (private coll., Naples) bears the date 1643. This *Adoration of the Shepherds* belongs

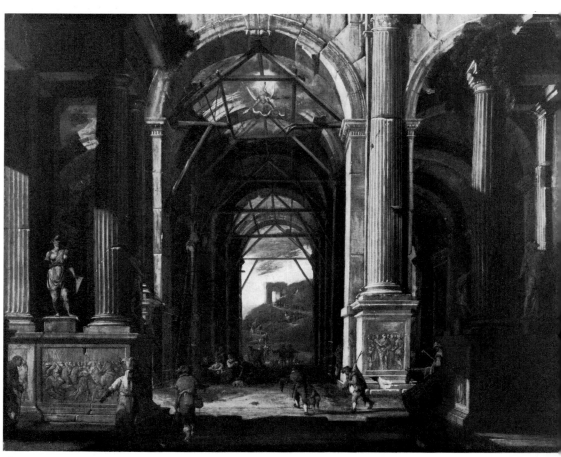

38

to the first period of collaboration between the two painters around 1638–43, when Codazzi chose Micco Spadaro to supply small figures for his architectural views.

The dominant element in this picture is the imposing architectural setting by Codazzi, based, according to Spinosa (London 1976), on the old Royal Palace of Naples before it was rebuilt by Vanvitelli. The open central vault with its wooden scaffolding and the classical ruins are elements which testify to Codazzi's Roman training in the circle of the *Bamboccianti*, particularly with Breenbergh, Poelenburgh and A. Both, who set their genre scenes within views of the ruins of ancient Rome. Domenico Gargiulo added the small figures, the landscape background, the antique statues and the bas-reliefs in monochrome. In other paintings of the same subject – the *Adoration of the Shepherds* (Museo di S. Martino, Naples) and *Adoration of the Shepherds* (private coll., Bologna) – Micco Spadaro uses very similar architectural elements, showing that he had learnt much about painting architectural views from Codazzi.

B.D.

EXHIBITIONS
London 1976, p. 35, no. 11

Antonio De Bellis

ACTIVE NAPLES, MID-SEVENTEENTH CENTURY

De Dominici, who counted De Bellis among the best of Stanzione's pupils, thought that he had died of the plague in 1656, aged about 34. On this basis (there is no documentary evidence) his birth can be placed between 1621 and 1623, which agrees with what we know of his background and stylistic development.

De Dominici believed he was working on painting the stories of the life of S. Carlo in the church of S. Carlo alle Mortelle when struck down by the plague, and it is clear that the cycle is incomplete. There are three autograph paintings; *S. Carlo Giving Communion to the Plague Victims*, *S. Carlo Visiting the Sick* and *S. Carlo Entrusting Canon Cesare Speciano with Gold from his Neapolitan Estates to Feed the Hungry*. The chancel paintings are autograph but unfinished: *S. Carlo Present at the Sermon*, and *S. Carlo Inaugurating the Rule*. *Girolamo Donato Farina, of the Order of the Umiliati, Writing the Life of S. Carlo* is probably not by De Bellis, and the two canvases with the *Miracle of S. Carlo Appearing to his Mother* and the *Birth of S. Carlo* are either repainted or by another hand; the *Miracle of the Possessed*

Woman is only half finished. These are Causa's observations, and it is to be hoped that the whole cycle may be restored to make a more detailed judgement possible. It would seem unlikely that De Bellis should have painted *S. Carlo Giving Communion to the Plague Victims* and *S. Carlo Visiting the Sick* while the plague was raging. It was however a theme that artists, particularly from Lombardy, had been using for half a century to illustrate the life of S. Carlo Borromeo, even though here the characters have an immediacy, as if they were taken from life.

De Dominici believed that De Bellis was influenced by Stanzione and Guercino, but this possibility has been rightly discounted by Causa, who discerns Ribera's influence, tempered by De Bellis' own, less violent style, which approaches that of Guarini. This is evident from the *Holy Family* in the church of the Madonna of Sunj on the island of Lopud off Ragusa, which is inscribed with the monogram ADB, which is certainly autograph, and in which the angels, the Madonna, and the touches of pink and yellow are reminiscent of the various Annunciations by Guarini. At Ragusa itself, in the church of the Dominican monastery, there is another monogrammed painting by De Bellis, the *Virgin in Glory with S. Biagio and St. Francis Interceding for the City*, where the yellow of the mitre laid aside is turned into gold, as it were through a sacrificial gesture. Stylistically, the work is still close to the paintings at S. Carlo alle Mortelle. The view of Ragusa and some topographical details date the work between late 1657 and the beginning of 1658.

De Bellis must have returned to Naples, since four pictures appear to post-date the Ragusa works and demonstrate that he knew the work of Giordano and Preti in the late 1650s. These are the *Scene of a Sacrifice* (Houston Museum of Fine Arts), the *Finding of Moses* (National Gallery, London), the *Drunkenness of Noah* (Cat. 39) and *Samson and Delilah* (private collection). It seems likely that De Bellis was active until the late 1650s.

G.D.V.

REFERENCES
Causa in *Storia di Napoli* 1972, V, II, p. 945, n. 117; De Dominici 1742–45, III, pp. 109–11; De Vito 1982, pp. 43–45

39
Drunkenness of Noah

158 × 210 cm
De Pietri Collection, Milan

'And Noah began to be an husbandman, and he planted a vine-yard. And he drank of the wine, and was drunken; and he was uncovered within his tent. And Ham . . . saw the nakedness of his father, and told his two brethren without. And

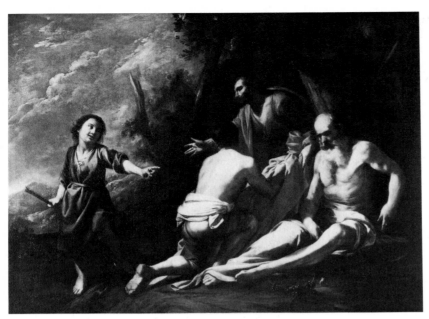

39

Shem and Japheth took a garment . . . and went backward, and covered the nakedness of their father; and their faces were backward, and they saw not their father's nakedness . . . And Noah . . . knew what his younger son had done unto him. And he said, "Cursed be Canaan; a servant of servants shall he be unto his brethren."' (*Genesis*, ix, 20–27.)

The subject, which Cavallino painted several times, is presented with moral overtones. The figure of Ham has the same morphology as Jesus in the *Holy Family* in Lopud and one must recognize in him a prefiguration of Christ (apart from the canonical purple of the robe) in an unusual role, as an example of human weakness. The rich, light colour scale and the fluidity of the outlines is hard to imagine without taking into account the work of Giordano in S. Agostino degli Scalzi, of Preti in Naples and the late work of Cavallino, which would suggest a date at the end of the 1650s.

G.D.V.

REFERENCES
De Vito 1982, p. 45

Giovanni Do

ACTIVE NAPLES FIRST HALF SEVENTEENTH CENTURY, DIED NAPLES 1656

We know little of the life of Giovanni Do. He was of Spanish origin, a pupil of Jeronimo Jacinto de Espinosa and was enrolled in the Colegio de Pintores of Valencia (Tramoyeres Blasco 1911); he was in Naples by 1626, the year of his marriage to Grazia, the sister of Pacecco de Rosa. The painter is called 'Spanish' in the marriage contract; his witnesses were Giovanni Battista Caracciolo and Jusepe Ribera (Salazar 1896). Other documents refer to events in the life of the artist and his children – baptismal and marriage certificates (Salazar 1895; Prota Giurleo 1951; Prota Giurleo 1953).

The first mention of paintings attributed to Giovanni Do occur in two eighteenth-century inventories. These unidentified paintings appear in the collection of the merchant family Van den Einden – 1688 Giordano inventory – and that of the Duca di Limatola – inventory and valuation (Ruotolo 1982; *Storia dell'Arte* 1979). In the first inventory a *St. Lawrence on the Gridiron with Other Figures* is listed and in the second 'four pictures . . . with the 4 Doctors of the Church and another picture of the same size showing St. Augustine'.

De Dominici names Do amongst the pupils of Ribera, stressing that Giovanni Do was 'so close an imitator of Ribera . . . that copies were taken for originals, and some histories were thought to be by the hand of Spagnoletto: especially some half-figures of philosophers and of St. Jerome . . .'. He adds that the artist 'finally working independently gave a pleasing tint to the flesh, obtained by a little charcoal black and lake, but delicately used . . .'; and he used this technique 'so long as he lived, as one sees in the fine picture of the *Nativity*, now in the Sacristy of the Pietà dei Turchini . . .'. Basing themselves on De Dominici, later Neapolitan writers attributed the Turchini painting to Do together with another of the same subject in the church of Gesù e Maria, Naples (Giannone 1773; Nobile 1855; Sigismondo 1788–89; Chiarini in Celano 1856–60). This painting seems to have disappeared at the end of the nineteenth century, when Galante (1872) said that the church was in a ruinous state and many pictures had been lost.

A *Martyrdom of St. Bartholomew*, attributed to Giovanni Do in the sale of the Tesorone Collection in 1919, seems also to be lost (Sale Catalogue Feb.–March 1919 no. 962). This picture was included in the 1977 exhibition, also attributed to Do. It came from Casa Carafa di Noja, and was said to be signed (Ortolani in Naples 1938, no. 84); in fact it was a copy of the *Martyrdom of St. Bartholomew* by Ribera in Palazzo Pitti, Florence, of which other replicas exist (cf. Spinosa and Pérez Sánchez 1978, nos. 34 and 34a).

The attribution of a *St. Jerome* (now lost) to Do proposed by Prota Giurleo (1951) is unacceptable, as is that of a *Sant'Onofrio*, given to Do in an eighteenth-century inventory of the Memoli-Capece Minutolo Collection. The second picture, identified as the *Sant'Onofrio* in the Corsini Gallery, Rome (Rome 1958) was ascribed by Longhi (1915) to Battistello

Caracciolo (cf. Causa 1972).

So in fact we have no securely attributed work of this painter, the imitator of Ribera, although his life is documented in Spanish and Neapolitan archives.

F.F.

REFERENCES
Causa in *Storia di Napoli* 1972, V, II, p. 973, n. 49;
Nobile 1855, I, p. 338;
De Dominici 1742–45, III, pp. 22–23;
Galante 1872, p. 407; Giannone ed. Morisani 1941, p. 105;
Longhi 1915, p. 124; Prota Giurleo 1951, pp. 13, 16;
Prota Giurleo 1953, p. 35; Naples 1938, p. 84;
Rome 1958, pp. 9–10; Ruotolo 1979, p. 36;
Ruotolo 1982, p. 38;
Salazar 1895, p. 187; Sigismondo 1788, p. 117;
Spinosa 1978, p. 97 nos. 34, 34a;
Tramoyeres Blasco 1911, p. 521

40

Adoration of the Shepherds

Attributed to Do
225 × 180 cm
Capodimonte, Naples

The attribution to Do is based on the evidence of De Dominici who mentions it in the sacristy of the church of the Pietà dei Turchini in 1742. Eighteenth and nineteenth-century Neapolitan sources followed De Dominici's attribution with the exception of D'Afflitto (1834) who ascribed it to Ribera and said that it was formerly in the Chapel of the Crocifisso. It was probably removed during the chapel's restoration in the second half of the seventeenth century.

Modern scholars consider Do to be very important for Neapolitan painting in the first half of the seventeenth century. Other pictures, mostly of the same subject and formerly considered to be either by Ribera or copies after him, have been compared to this *Adoration* and sometimes attributed to the same hand. The picture has been related to the *Adoration of the Shepherds*, signed and dated 1650, by Ribera in the Louvre (Galerie du Musée Napoléon 1804, cf. also Du Gué Trapier 1952); this comparison has been dismissed by Causa (Naples 1954), and he proposes that Do's painting is at least 20 years earlier than Ribera's *Adoration*. Causa believes Do to be the leader of the naturalistic trend in Naples in the 1630s, working in a refined, intellectual manner utterly at variance with his contemporaries Caracciolo and Ribera (Causa 1972).

But at the same time the Pietà dei Turchini *Adoration* is very close to another *Adoration* in the Academia de San Fernando, Madrid, attributed first to Ribera and then to Giordano (Causa in Naples 1954, Bologna forthcoming publication). Spinosa (1978 no. 433) hesitantly attributed a replica of the group of the San Fernando *Madonna and Child* in the Louvre (reserve coll.) to Do. Bologna (forthcoming publication) suggests that Cat. 40, which he dates *c.* 1623, must have been painted early in Do's career and is close to the work of painters in Valencia and Toledo in the early seventeenth century, particularly the painters P. Orrente and J. J. de Espinosa, artists who were still working in the Tuscan-based tradition of Counter-Reformation painting and yet were open to the influence of Caravaggio. The Virgin is comparable to the same figure in Juan van der Hamen's *Annunciation* (private coll., Madrid; cf. Pérez Sánchez, Rome Convegno 1973).

Bologna argues that there is no trace of the influence of Ribera; the figures, particularly the kneeling shepherd and the old woman, are less crudely naturalistic than Ribera's and the Virgin and Child are still almost Counter-Reformation in spirit, while other details recall Velasquez's work around 1618–20. According to Bologna, Do was later influenced by his compatriot Ribera, and this is evident in the *Adoration of the Shepherds* in Madrid, which has a Riberian composition still very close to the present work.

Spinosa ascribed another group of works, including the damaged *Adoration of the Shepherds* in Valencia Cathedral and one of the

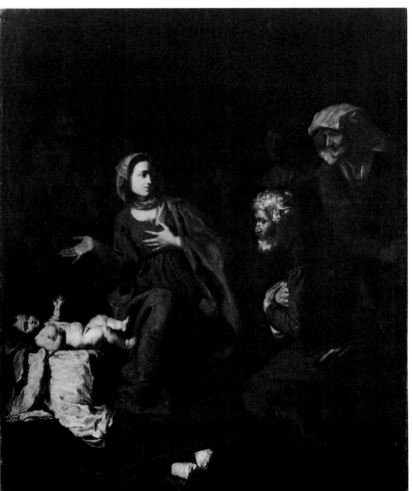

40

two versions of the same subject (Madrid) to Do (Spinosa 1978, nos. 393, 451). He hesitated in the ascription to Do of the other version in the Escorial and of an *Adoration of the Shepherds* in the Suermondt Museum, Aachen (Spinosa 1978, nos. 392, 373). The *Christ among the Doctors* (private coll.) published by Longhi as a 'possible work' by Do is a dubious attribution (Longhi 1969); it is close to a painting of the same subject, perhaps a copy from an original by Ribera, in the Kunsthistorisches Museum, Vienna.

Marini dated this picture after 1626 and identified Do with the Master of the Annunciations to the Shepherds (p. 190). He also adds other paintings to Do's oeuvre (Marini 1974).

During cleaning, Do's self-portrait, which we know also from the Madrid *Adoration*, came to light in the top right corner.

F.F.

PROVENANCE
Church of the Pietà dei Turchini, Naples, on deposit at Capodimonte since 1977

EXHIBITIONS
Naples 1954, no. 12; Bucharest 1972; Naples 1972

REFERENCES
Bologna, forthcoming publication on Filippo Vitale; Causa in *Storia di Napoli* 1972, V, II, pp. 928–29, 973; D'Afflitto 1834, II, p. 9; De Dominici 1742–45, III, pp. 22–23; Du Gué Trapier 1952, pp. 250–51; Longhi 1969, p. 48; Marini 1974², pp. 103–07; Naples 1954, p. 25; Perez Sanchez in Rome 1973, pp. 57–85; Spinosa 1978, nos. 373, 392, 393, 451

Domenico Zampieri, called

Domenichino

BOLOGNA 1581 – NAPLES 1641

Domenichino was regarded as the most important representative of the Carracci school active in Rome, and so it was natural that the *deputati* of the Cappella del Tesoro of Naples Cathedral should seek to engage him to complete the decoration of this most important shrine, where, among other relics, the phial containing the blood of S. Gennaro is preserved. In Rome, Domenichino had charge of the drawings from the Carracci studio, which were one of the most important links with Annibale and Agostino; Poussin was among many painters who studied them in the 1620s. When Domenichino left Rome for Naples in 1630, he entrusted this collection to the antiquarian Francesco Angeloni, with whom the painter maintained close links.

He had completed large decorative schemes in Rome, including the apse of S. Andrea della Valle, and the frescoes in Naples are in some ways an extension of his style there. The commission was, however, an extremely demanding one: Domenichino faced intense jealousy from Neapolitan painters, reminiscent of the situation that in 1622 had caused Guido Reni to decline the work after one of his assistants had been assaulted. Domenichino's inventive process was slow, some said plodding, and he was under constant pressure to complete the vast decoration; his employment did not allow him, apparently, to execute other commissions, although exceptions are known to have been made for the viceroy at that time, the Conde de Monterrey. Some contemporaries (eg. Baglione 1641) thought that the altarpieces in the chapel, amongst the largest ever painted on copper, surpassed all Domenichino's previous work; their condition now is almost completely illegible. The pressures on the artist were such that he fled to Rome, via Frascati, in 1634, leaving behind him his beautiful young wife Marsibilia, whom the viceroy held hostage against his eventual return (1635).

Apart from the evidence of the frescoes and of individual pupils like Francesco di Maria, it is difficult to assess fully Domenichino's stylistic impact in Naples, although it was considerable. In works outside the Cappella del Tesoro it is possible to see that he was experimenting in new artistic directions. The *Exequies of a Roman Emperor* in the Prado (Madrid 1970) can be regarded as an answer to the Spanish desire to illustrate scenes from Roman antiquity, which were also portrayed by Falcone and others in paintings doubtless destined for the Buen Retiro palace in Madrid. Domenichino almost certainly enlisted the help of Francesco Angeloni for the classical references in this picture.

A recently discovered altarpiece (signed and dated 1637) of the *Assumption with St. Nicholas of Bari* (acquired for the Metropolitan Museum by Mr and Mrs Charles Wrightsman) shows Domenichino moving towards the more baroque style of Pietro da Cortona, a reminder of the latter's success in Rome. Domenichino returned, exceptionally, to landscape painting, but the subjects of the few landscapes that he did at this period point to a deliberate return to the genre quality of those of Annibale in the Bolognese years.

His introspection was doubtless enhanced by Naples; he was already passionately interested in music, and he now sought to reconstruct ancient classical instruments and '*l'antica musica cromatica e enarmonica*' (Malvasia 1678).

C.W.

REFERENCES
Baglione in Rome 1949, pp. 381–85
Disertari 1966, pp. 5–23;
Perez Sanchez 1965, pp. 126, 129;
Malvasia 1678 -1841 ed.), II, p. 241;
Whitfield in London 1973, no. 29

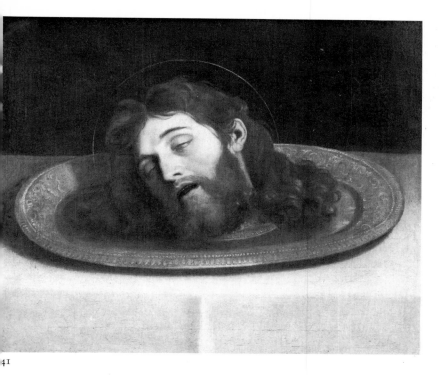

41

41

Head of St. John the Baptist

49 × 60 cm
Real Academia de San Fernando, Madrid

This is one of the few easel paintings by
Domenichino that date from his stay in Naples.
Its restrained naturalism is typical of his
approach to a subject whose brutality would
have been more emphasized by Neapolitan
painters, as it was by Caravaggio in his
spectacular *Head of Medusa*. This undoubtedly
tempered Ribera's choice of a more moderate
and profound realism in the 1630s, and this
painting is of obvious relevance to the latter's
representations (eg. Cat. 128) of the same theme.
Spear (1968) recognized a careful drawing from
life in the Windsor Castle collection as a study
for this painting.

C.W.

PROVENANCE
?Casa Boscoli Parma 1690; given to the Real Academia by
the Infante Don Francisco de Paula 1819

EXHIBITIONS
Madrid 1970, no. 64

REFERENCES
Campori 1870, p. 400; Perez-Sanchez 1965, p. 125;
Spear 1968, p. 126, pl. 19A

Aniello Falcone

NAPLES 1607–NAPLES ?1656

Falcone trained with Ribera, but must have left
his studio at an early date since De Dominici

separates his life from those of Ribera's other
pupils.

In 1641–42 he decorated the Sant'Agata
chapel in S. Paolo Maggiore, Naples; in both
these frescoes and the signed and dated *The Rest
on the Flight into Egypt* of 1641 (Cat. 43) his
connection with Romano-Bolognese classicism
is evident. But already at this date he must have
been famous as a painter of battle scenes (his
contemporaries called him the 'oracle' of this
genre), and it was these which attracted the
attention of the collector and dealer Gaspar
Roomer, who seems to have sold Falcone's work
throughout Europe.

Another indication of his international
reputation is his inclusion in the group of
famous artists commissioned by Philip IV of
Spain to paint a series of Roman historical
subjects for the Buen Retiro (Prado, Madrid).
Falcone's paintings for this series show the
influence of Castiglione, which is also evident in
his contemporary battle paintings.

The authenticity and dating of his many
battle pieces is difficult to establish; his work is
often confused with that of his pupil Andrea di
Lione. If we accept the date of 1631 read by
Villot on a painting in the Louvre in 1860, it
would make it the earliest of this genre. There is
another dated battle scene from later in his
career (1646) in a private collection (De Vito
1982).

It is still uncertain if Falcone also painted
still lifes; he is sometimes identified with the
Master of Palazzo San Gervasio. Although this
hypothesis is hard to accept, it is possible that
Falcone collaborated with other still-life
painters.

The frescoes of the *Life of St. Ignatius* in the
sacristy of the Gesù Nuovo, badly damaged in a
fire in 1963, can now be dated before 1652.

Throughout his life Falcone produced
drawings, many of which survive.

A.A.

REFERENCES
De Dominici 1742–45, III, pp. 70–87;
De Vito 1982, pp. 7–36;
Faraglia 1905, pp. 17–20

42

Battle of the Hebrews and the Amalekites

111 × 128.5 cm
Capodimonte, Naples

This painting is listed in the inventory San
Giorgio (1852) of the collections of the
Pinacoteca Borbonica, attributed to Aniello
Falcone. This was accepted by Chiarini (1856–

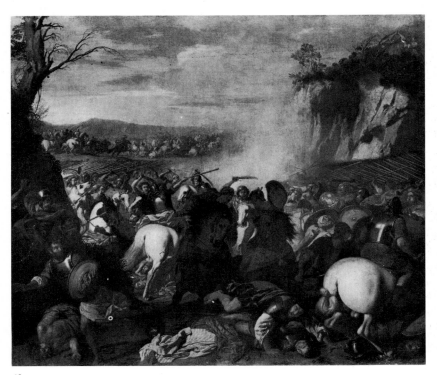

42

60) and all subsequent writers (Ortolani 1938; Scavizzi 1963) except for De Rinaldis (1911) who attributed it to Andrea di Lione.

Previously it was thought to represent an unspecified battle, but in fact it illustrates an episode from the Old Testament: the battle between the Hebrews and the Amalekites (*Exodus*, xvii, 8–13), which Joshua could win only if Moses kept his hand raised. When Moses grey weary 'Aaron and Hur stayed up his hands, the one on the one side, and the other on the other side; and his hands were steady until the going down of the sun. And Joshua discomfited Amalek and his people with the edge of the sword.'

Around 1650, Falcone illustrated the same subject in a series of frescoes of the story of Moses in the Villa Bisignano at Barra (Blunt 1969). This painting is one of the very few large scale examples of the 'many stories from the Old Testament' recorded by De Dominici.

These paintings are predominantly light in tone with brilliant colouring and incisive detail; in this work a golden evening light bathes the distant landscape. The foreground is occupied with minor characters; the main protagonists, including Moses, are relegated to the sides of the scene. Falcone is often compared with Callot, but differs from the French artist in failing to emphasize the uselessness and cruelty of war. The work dates from the mid-1630s.

A.A.

EXHIBITIONS
Athens 1962; Naples 1963, no. 32

REFERENCES
Blunt 1969, p. 215; Causa in *Storia di Napoli* 1972, fig. 351; Chiarini 1856–60, pp. 1, 838; De Rinaldis 1911, p. 419, no. 397; De Vito 1982, p. 8; Ortolani 1938, p. 92 Prota Giurleo 1951, p. 27; Scavizzi 1963, p. 32

43
The Rest on the Flight into Egypt

126 × 92 cm
Signed and dated: FALCONE 1641
Sacristy, Naples Cathedral
[*repr. in colour on p. 77*]

This painting, first recorded in the cathedral sacristy in the nineteenth century (Catalani 1845), is fundamental for a reconstruction of Falcone's stylistic development. Together with the *Battle Scene* (Pucci Coll.) and another privately owned painting (De Vito 1982), it is one of his few signed and dated works and one of his rare paintings of a religious subject, the others being the frescoes of the *Life of St. Ignatius* (Gesù) and the *Martyrdom of S. Gennaro* (ex Hirtsch Coll., Berlin). The *Death of St. Mary of Egypt*, formerly in the collection of Cavaliere Corona and now lost, is also reported to have been signed (Melchiorri 1837).

Stylistically, it falls between the naturalism still prevalent in the early 1640s in Naples and Caraccesque academicism (Saxl 1939–40). It is closer to Cozza than either Pacecco or Stanzione ever came (Ortolani 1938). The relationship between landscape and figures in particular recalls Romano-Bolognese classicism, specifically Poussin in the luminous open-air setting; his work was well-known at Naples at this date and was of great importance to artists looking beyond the classical repertory of the Bologna school.

A.A.

PROVENANCE
Gaspar Roomer, by whom given to Olimpia Piccolomini, Ferdinand van den Einden's wife; bequeathed to Cardinal Francesco Pignatelli 1708

EXHIBITIONS
Naples 1938, no. 91; Naples 1954, no. 29; Sarasota 1961, no. 17; Paris 1965, no. 133; Bucharest 1972; Naples 1972

REFERENCES
Catalani 1845, I, p. 39; Causa in *Storia di Napoli* 1972, p. 940; Celano ed. Chiarini 1856–60, I, p. 345; De Vito 1982, pp. 12–13; Galanti 1829, 1872 ed., p. 23; Loreto 1849, p. 110; Melchiorri 1837, p. 13; Ortolani 1938, p. 91; Alberto Pavone 1980, p. 96; Ruotolo 1982, pp. 6–7 Saxl 1939–40, p. 86, n. 2

44
St. Lucy Distributing Alms

72 × 84.5 cm
Capodimonte, Naples

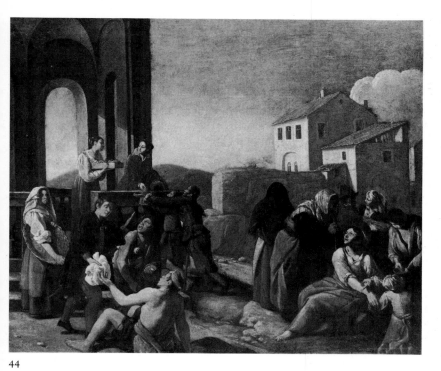

44

This picture was published by Longhi who suggested a date around 1630–40, soon after Velasquez's Italian journey in 1629–30 (Longhi 1950). But Causa considers it to be a late work, comparing it to the fresco of *St. Ignatius Distributing Alms* in the sacristy of the Gesù Nuovo which he dates after 1646 (Causa 1972, 1975).

Longhi (1950) stressed the Caravaggesque style evident in the open-air setting and the treatment of the religious theme as an everyday scene of alms-giving. Bologna (1955) pointed out the similarity of this picture to Francesco Guarino's work, especially in the monumental composition. He interpreted it as an illustration of the seventeenth-century attitude to charity, whereby poverty was considered to be indispensible in order to allow for the redemption of the rich through alms-giving.

The broad landscape is typical of Falcone, while the portico on the left is derived from Codazzi. But some similarities with the art of Le Nain has led Causa to repostulate the possibility of a journey to France which De Dominici reported that Falcone had made (Causa 1972, 1975).

While some critics have emphasized Falcone's links with Caravaggio (Briganti 1950; Kultren 1958; Moir 1967), Longhi (1950) believed him to be independent of such influence, and Causa (1975) suggested in discussing this work that Falcone actually deterred the spread of *Bambocciante* painting in Naples.

A.A.

PROVENANCE
Aldo Briganti Coll., Rome;
Sale Finarte, Rome, 16 May, 1966; bought by the Ministreo della Pubblica Istruzione for Capodimonte

EXHIBITIONS
Rome 1950, no. 51; Milan 1951, no. 56; Rome 1958, no. 66; Bucharest 1972; Naples 1972; Naples 1975–76, no. 20

REFERENCES
Bologna in Salerno 1955, pp. 57–58; Briganti in Rome 1950; Causa in *Storia di Napoli* 1972, V, II, p. 940; Causa in Naples 1975–6, p. 20; Kultren in Rome 1958, no. 66; Longhi 1950, p. 33; Moir 1967, pp. 171–72; Ottani Cavina in Bolaffi 1972–76, p. 285

Filippo Napoletano
(Filippo d'Angeli)

NAPLES *c.* 1590?–ROME 1629

Filippo Napoletano was born either at Rome (Baglione 1642) or at Naples (Mancini 1617–24) where he lived from 1600–14. There is little information about this artist during his formative years in Naples. He was involved with Carlo Sellitto but we can exclude the hypothesis that they collaborated together (Naples 1977). It is probable that Sellitto was the link between Napoletano and the band of Northerners then in Naples, such as the Fleming Luys Cruys, François de Nomé of Lorraine and Jakob Thoma, a follower of Elsheimer. To his youthful period belong the unpublished *Moonlit Landscape* (Pio Monte della Misericordia, Naples) with its echoes of Elsheimer; the *Conversion of St. Paul* and the *Crossing of the Red Sea* (ex Lucano Coll., Rome).

In 1617 Napoletano was called to Florence by Cosimo II. The years he spent as painter to the Grand Duke are the best documented in his life. The *Rustic Dance*, the *Fête Champêtre* and *Calvary* (Pitti) are amongst the many pictures made for the Medici in which Filippo developed a new type of landscape painting: realistic, on a large scale with a great sense of recession, rich in tonal effects and brilliant in colour (Chiarini 1972[1]). This new type of landscape painting greatly influenced Poelenburgh (Chiarini 1972[2]) and Callot, both at Florence at this date. Callot introduced Napoletano to engraving (Putaturo-Murano 1975) and his influence is particularly evident in the small figures in some of his paintings and engravings.

On the death of Cosimo II, after a short stay at Norcia (Casale etc. 1976), Filippo returned to Rome where he lived until his death in 1629 (Rinehart 1961). A second trip to Naples (Baglione 1642) can be dated between 1624 and 1626, although it is undocumented. Perhaps the two versions of the *Impruneta Fair* (Avati and De Conciliis Colls., Naples) belong to this date; they influenced Micco Spadaro. In Rome

Napoletano was Rector of the Academy of St. Luke (Longhi 1957) and worked for many noble families, in particular the Barberini, for whom he made a series of cartoons for tapestries (Aronberg Lavin, 1975). From documents we know that in the seventeenth century his paintings were in the collections of the Massimi, Chigi and Colonna at Rome and of various noble families in Florence, Venice, Bologna and Naples.

During his last years in Rome he painted the waterfalls at Tivoli from nature (Baglione 1642), which were important for later Italianate Dutch landscape painters such as Jan Both.

M.R.N.

REFERENCES
Aronberg Lavin 1975, p. 36;
Baglione 1642 (1935 ed.), p. 335; Chiarini 1972[1], pp. 18–34;
Chiarini 1972[2], pp. 203–12;
Longhi 1957[2], pp. 33–62;
Mancini 1617–24 (1956 ed.), I, p. 255;
Naples 1977, pp. 88–89;
Putaturo-Murano 1975, pp. 185–209;
Rinehart 1961, pp. 35–59

45
The Mill

Oil on copper, 30.5 × 23 cm
Inscribed: on verso in ink *Filippo Napoletano* and *no. 68 pal*; label inscribed *del Poggio a Cajano dalla Guardaroba 29 Oct. 1773*
Palazzo Pitti, Florence

This picture is documented in several Medici inventories. Longhi was first to note its existence in an early eighteenth-century inventory, but was unable to trace the painting itself (Longhi

45

1957). Earlier it is listed twice in 1666, in the inventory of the possessions of Cardinal Carlo de'Medici, for whom it was painted, and in the general inventory of Palazzo Pitti (Chiarini 1976). Later it was at Villa di Castello (A.S.F. 93 app. no. 675: copper with a 'landscape with a grotto having a mill at its foot') and in 1773, as the label states, at Poggio a Caiano (Florence 1969).

Chiarini used the painting to argue that Napoletano was of Northern extraction and not to be identified with the Neapolitan Filippo d'Angeli (Longhi 1957). Chiarini has identified many of Napoletano's works painted for the Medici; the painter's predilection for landscapes and for small format histories was congenial to Cosimo II and his court. In fact *The Mill* was painted for the Grand Duke's brother, Cardinal Carlo de' Medici, who began to take an interest in landscapes during Filippo's time in Florence. The cardinal, in addition to owning landscapes by Paul Brill, had nine paintings by Filippo Napoletano, of which the most important are the *Calvary* (Uffizi) and *The Mill*. Chiarini surmises that this picture was painted in Rome and sent to Florence, and suggests a date after 1621, the year in which the painter finally left the Medici court (Chiarini 1976).

This picture is unusual in its miniaturistic Northern technique and its small scale, rarer than may be supposed in his oeuvre. The unusual subject and its treatment have been correctly seen as an anticipation of the taste for the picturesque common amongst Italianate Dutch landscape painters such as Thomas Wijck (Roethlisberger 1975). Roethlisberger (*ibid.*) stressed the connection between this picture, for which he published the drawing (Uffizi), and a work by Wijck of the same subject (whereabouts unknown).

M.R.N.

EXHIBITIONS
Florence 1969, p. 24

REFERENCES
Chiarini 1972[1], pp. 18–34; Chiarini 1976, pp. 61–67;
Longhi 1957[2], pp. 32–62; Roethlisberger 1975, pp. 23–24;
Salerno 1977–82, pp. 206–7

46
Pastoral Scene

95 × 159 cm
Colnaghi & Co., London

When the death of Cosimo II de'Medici terminated Napoletano's highly successful Florentine interlude (Baglione 1642) he had already perfected the 'realistic landscape' of which he is considered the inventor, and of which this unpublished painting is a lively example.

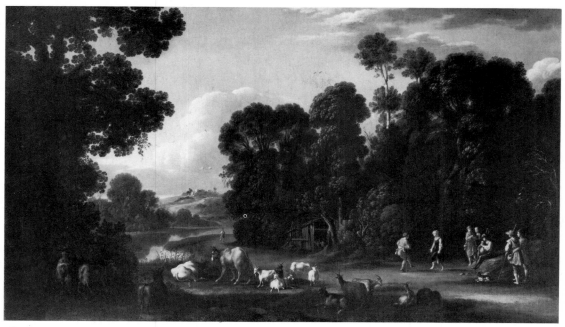

46

It was presumably painted almost immediately after his return to Rome, and it is of interest as one of the few pictures in which animals are prominently featured, although these were mentioned by early commentators. Mancini (1617–24) writes: '. . . he has done many pictures, and especially a large horse from the life, so that he has shown that he can do more than little things'. The two Uffizi paintings (Florence 1980, nos. 85, 86), while including a rich repertory of exotic animals, are still tied to Tempesta's mannerism. In this painting Filippo displays his extraordinary capacity to delineate materials: he highlights the fleeces with sharp realism and portrays the animals in natural attitudes, free from any Cinquecento affectations, opening the way for artists such as Asselijn and Wijck.

The landscape, which demonstrates his awareness of Elsheimer's work, is richly and cunningly articulated, the space emphasized by the extended oblong of the canvas, which Filippo used in other Florentine pictures – *Rustic Dance*, *Fête Champêtre* (both Uffizi) and *Landscape with a Pool* (B. Conti Coll., Rome), which is close to this work. Probably it was this aspect of Filippo Napoletano which Claude Lorrain studied during his formative years in Rome. From Napoletano he learnt to use water as a reflecting surface and how to render the tonal effects of light on foliage.

In this scene the clump of trees set at a diagonal (cf. Uffizi drawing no. 8588) is opened to show a group of peasants, dancing and making music. The pick-pocketing incident no longer has any trace of the Caravaggesque realism of a highway robbery, it is merely an amusing picturesque detail of the sort that must have pleased Cosimo de'Medici and the Roman nobility for whom Filippo worked. The small figures, close to those in the *Landscape with a Pool*, are less individualized than usual, and recall Poelenburgh, whom Filippo met in Florence (Chiarini 1972[1]) and with whom he may have collaborated in Rome.

M.R.N.

REFERENCES
Baglione 1642 (1935 ed.), p. 335;
Chiarini 1972[1], pp. 23, 203–12;
Mancini 1956, I, p. 255;
Florence 1980, nos. 85, 86, p. 134

Paolo Domenico Finoglia

ORTA DI ATELLA or NAPLES *c.* 1590–
CONVERSANO 1645

Finoglia is a complex artistic personality, stylistically in transition between late mannerism and Caravaggesque naturalism, although he was not a tenebrist. His great technical mastery and imaginative powers enabled him to make visually coherent images from these disparate elements. Very little is known of his early career; for this reason his early work is controversial (Buono 1978–79). Stanzione, Caracciolo and Ribera are seen as the most likely sources of Finoglia's style, although these influences superseded those of Ippolito Borghese and Belisario Corenzio (Causa 1972).

The ten lunettes of the *Founding Saints of Religious Orders* and the *Circumcision* of 1626

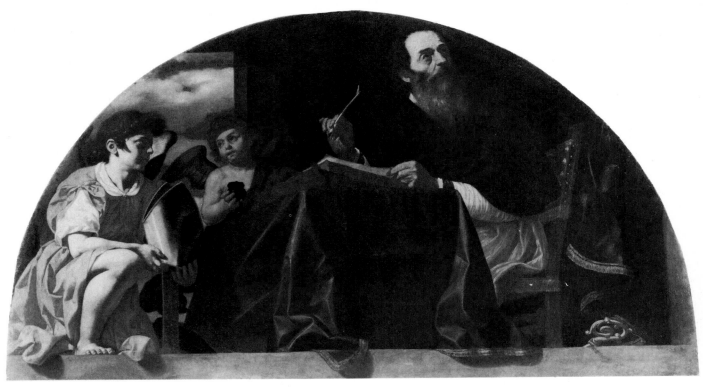

47

at the Certosa di S. Martino belong to the earliest period of Finoglia's career (Faraglia 1892). In the 1630s and 1640s he fell under the influence of Caracciolo, with whom he was on friendly terms: he worked alongside him in S. Martino and was godfather to one of his grandsons in 1632 (Salazar 1892). Finoglia's naturalism, which is fundamental to his style, is never violent or theatrical; objects are painted with a concrete sense of reality. It is known that he made copies after other artists' work and that he bought and sold paintings in partnership with Domenico Casolani and Tiberio Mazzucco.

Eighteenth-century Neapolitan historians (De Dominici, Giannone) recognized that Finoglia was influenced by Caracciolo, particularly by the latter's *Immaculate Conception* of 1607 (Cat. 5). Apart from the similarity of subject matter, Finoglia's two paintings in S. Lorenzo Maggiore (1629–30) are also close to this work in the arrangement of the figures, the lighting and the elaborate drapery.

From 1635 onwards Finoglia worked at Conversano (Marangelli 1979) and he stayed there until his death in 1645 (Marangelli 1967), occupying himself with commercial activities as well as painting (D'Elia 1970).

M.M.

REFERENCES
Buono 1978–79, pp. 91–103;
Causa in *Storia di Napoli* 1972, V, II, pp. 934–36;
D'Elia 1970, p. 13–33; Faraglia 1892, pp. 934–36;
Marangelli 1967, pp. 204, 209; Marangelli 1979, p. 2;
Salazar 1895, p. 187; Strazzullo 1955, p. 40

47, 48, 49 & 50

St. Augustine, St. Bernard, Elijah and St. Benedict

Each 130 × 200 cm
Sala del Capitolo, S. Martino, Naples
[*Cat. 48 repr. in colour on p. 74*]

These four lunettes form part of a series of ten in the Sala del Capitolo portraying the founders of religious orders: St. Bernard (Cistercians), St. Benedict (Benedictines), St. Augustine (Augustinians) and Elijah, who was considered the founder and protector of the Carmelites (Réau 1958). In the eighteenth century they were attributed to Tintoretto (Parrino) and to Corenzio (Sigismondo). De Dominici (1742–45) attributed them to Finoglia, and this is still the most convincing attribution, although undocumented.

Finoglia's early work is late mannerist in style, influenced by Corenzio (Causa 1973); these pictures in his mature style represent his greatest artistic achievement. There is great confidence in the manner in which the figures dominate their setting, some entirely on their own, others accompanied by angels. The shape of the canvases themselves determined a sitting or kneeling posture of the figures. Finoglia resisted the temptation to depend on the founding fathers' individual emblems to establish their individuality; these remarkable portraits of old men are shown in somewhat precarious poses, the light being both incisive and fleeting.

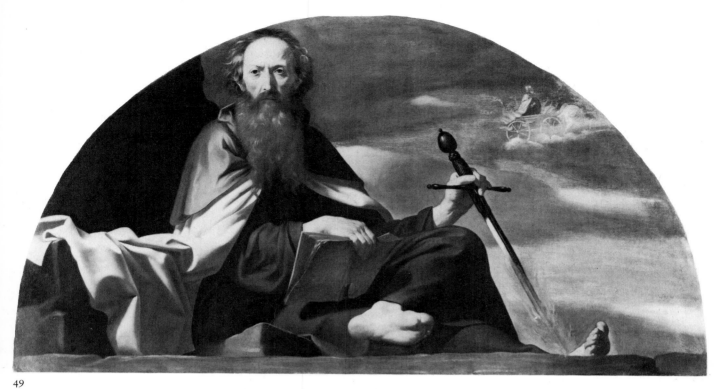

49

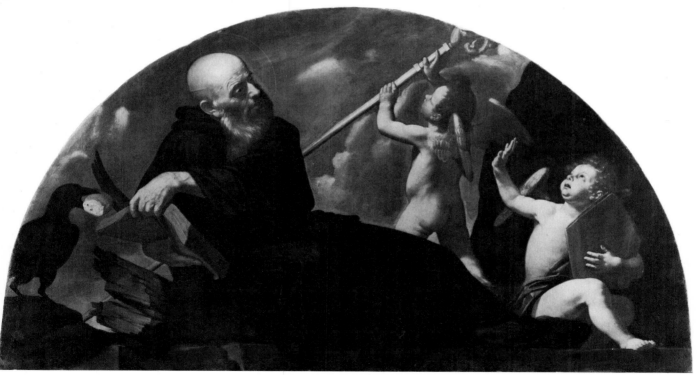

50

Caracciolo was evidently an important stylistic source, but the influence of Ribera is evident in the rendering of the furrowed and elongated faces. The early sources refer to the affinities that exist between these paintings and the 12 *Prophets* painted by Ribera for the spandrels of the nave arches in S. Martino, although in fact they post-date Finoglia's *Founding Fathers*, being painted in 1638 (Causa 1973). Nor does Finoglia seem to have been influenced by pietistic realism. The Carthusian friars painted by Antiveduto Gramatica around 1620 in the Chiesa dell'Eremo at Naples constitute the only artistic precedent for

Finoglia's lunettes. The *colori cangianti* of the drapery point to a period in the artist's maturity. The graphic design, the refined colours echoing Caracciolo and the coherent compositions struck Solimena, who influenced De Dominici's assessment of their qualities.

M.M.

REFERENCES
Bucharest 1972, pp. 49–50; Buono 1978–79, pp. 92–93;
Causa 1971, pp. 16–27;
Causa in *Storia di Napoli* 1972, V, II, pp. 934–35;
Causa 1973, p. 50; De Dominici 1742–45, III, pp. 115–16;
D'Orsi 1938, pp. 14–15; Lattuada 1980, p. 285;
Parrino 1751, p. 110; Réau 1958, III, p. 208;
Sigismondo 1789, III, p. 112

Luca Forte

1600/15–BEFORE 1670

Little is known about this painter, one of the earliest still-life specialists of Naples, but recently a number of works either signed or monogrammed by him have been identified. De Dominici (1742) commented on Forte's rather archaic style, 'his pictures as we see have little before or behind', and compared it unfavourably to the more modern ideas of Porpora. It seems probable that Forte was born in the first 15 years of the century, given that Porpora, who was his junior, was born in 1617. In 1639 Forte was witness to the wedding contract of Aniello Falcone (Prota Giurleo 1951) so, following local custom, he could not be younger than Aniello, whose own birth is documented in 1607 (De Vito 1982).

There remains the problem of Forte's training and of establishing a chronology for his works. The three signed pictures which Causa (1963) used as a basis for establishing his oeuvre (ex. Matthiesen Fine Art, London; Ringling Museum, Sarasota; Molinari Pradelli Coll., Cat. 52) are complex and rich in invention compared with *Still Life with Tuberose* (Cat. 51) which would seem to be an early work. Causa (1963) dates these three paintings of his mature phase to 1640–50 while Sterling (1959) dated them between 1630 and 1640. The Ringling Museum *Still Life* has, besides a monogram, a dedicatory inscription to Don Giuseppe Carafa, a Neapolitan nobleman whose tombstone in the church of S. Maria La Nova is dated 1647 (Sarasota 1961, no. 38). This date may act as an *ante quem*. The correspondence between Forte and the Messinese collector Antonio Ruffo also dates from 1640–50 (Ruffo 1916). Given the prices he demanded for his paintings, Forte seems to have been an established painter by then and may have begun his career 20 years before, around the year 1630.

At that date, there was a group of painters gathered around Falcone who constituted a sort of academy for life-study, to which Forte (witness to Falcone's marriage) must have belonged (De Vito 1982). In addition, a painting of flowers, fruit and figures by Luca Forte and Aniello Falcone is mentioned in an inventory of Palazzo Tarsia Spinelli (published as an appendix in Mormone 1962) together with other pictures by Forte and Falcone cited by Celano (1692). In his still-life paintings Forte combined elements taken from Roman painting with Spanish *bodegónes*.

A.T.

REFERENCES
Causa 1963, pp. 43–44; Celano 1692 (1972 ed.), pp. 61–63;
De Dominici 1742–45, III, p. 293; De Vito 1982, p. 9;
Mormone 1962, p. 222; Prota Giurleo 1951, p. 26;
Ruffo 1916, pp. 58–61; Sarasota 1961, no. 38;
Sterling 1959, pp. 69, 136, n. 124

51

Still Life with Tuberose and Crystal Goblet

77 × 101 cm
Monogrammed: in the vine tendrils *L.F.*
Galleria Nazionale Corsini, Rome (inv. 1930)

The picture was acquired by the Corsini Gallery in 1927, attributed to the school of Caravaggio. Di Carpegna said it was Neapolitan (Rome 1958) and Causa identified it as the work of Luca Forte and read the monogram (Causa 1962). The still life contains motifs still closely dependent on Caravaggio, characteristics which induced Sterling (1959) to propose that it was painted by a member of Crescenzi's circle.

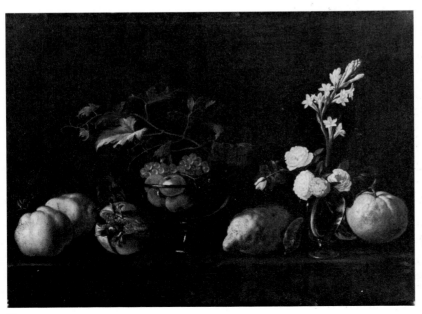

51

Bottari (1963) suggested that it was painted by Forte in Rome and that stylistically it comes after his early works which show the influence of Spanish art. But Causa (1962) believed it to be an early work, painted before Forte's style was fully formed. The objects are arranged almost on a single plane which echoes De Dominici's criticism that Forte's work lacked depth. The light defines the volume of the forms and at the same time silhouettes them sharply against a plain black background.

Some influence of the Roman circle of Bonzi, Crescenzi and Salini is evident and dilutes the Caravaggesque elements; from 1617, Giovanni Battista Crescenzi was living in Spain and through him Spanish influence seems to have filtered back to Naples. The severe simplicity of this composition is comparable to the clear presentation of paintings of Blas de Ledesma or Van der Hamen. The painting can be dated probably between 1625 and 1635, although Volpe (1981) has suggested a date around 1620. hypothesis of Spanish influence is accepted.

A.T.

PROVENANCE
Bought by the Corsini Gallery in 1927

EXHIBITIONS
Rome 1958, no. 22; Athens 1962–63, no. 15; Naples 1963, no. 23; Naples 1964, no. 54; Zurich 1964–65, no. 49; Rotterdam 1965, no. 49; Bucharest 1972

REFERENCES
Bottari 1963, p. 244; Causa 1962, p. 43; De Dominici 1742–45, III, p. 292; Volpe in Milan 1981, no. 3; Mitchell 1973, p. 114; Sterling 1959, p. 35

52
Still Life with Fruit and Flowers

64 × 78 cm
Signed: in the grapevine *Luca Forte*
Maestro Molinari Pradelli, Marano di Castenaso

This picture has been assigned to Forte's middle years (Causa 1962) and is later in date than the *Still Life with Tuberose and Crystal Goblet* (Cat. 51); its rather stylized composition, with the objects viewed frontally, is replaced by a more complex and articulated composition. The base on which the vase and the goblet stand is overlapped by objects jutting out beyond it, which belies De Dominici's judgement that Forte's pictures lacked depth compared to those of Porpora. This painting presages the change from realism to decorative painting in Neapolitan still-life painting. Yet Bottari (1963) thought that it might be Forte's first work, preceding his time in Rome, and Bologna (1968) discerned elements of Caravaggio and Caracciolo. However, compared to the Corsini picture (Cat. 51), the chiaroscuro is less violent and the colour is given more emphasis. The painting may be dated between 1640 and 1650.

A.T.

EXHIBITIONS
Naples 1964, no. 55; Zurich 1965, no. 50; Rotterdam 1965, no. 50; Bergamo 1968, pl. 40; Bucharest 1972

REFERENCES
Bottari 1963, p. 244; Causa 1962, p. 44; De Dominici 1742–45, III, p. 135; De Logu in Bergamo 1962, p. 191

53 & 54
Pair of Still Lifes of Flowers and Fruit

Each 79 × 52 cm
One signed: LUCAS FORTE F.
Cyril Humphris, London

These two pictures were published by Sestieri in 1972; previously they had been attributed to Caravaggio but recent cleaning revealed a signature on one of them. The signature is in capitals (mistranscribed by Sestieri as *Lucas Fort f.*) whereas the signature on Cat. 52 is in cursive script. Since Luca used the Spanish form of his name it has been suggested that he was of Spanish origin; the stylistic resemblance between his work and that of the Spaniard Blas de Ledesma has been pointed out (Hoogewerff 1923–24, Costantini 1930). The origins of Italian still-life painting still need further investigation; evidently the links with Spain were strong, but Sestieri (1972) has observed that the surname Forte is typically south Italian and since this is the only case in which the form *Lucas* is used, it may have been an attempt to render his name in Latin.

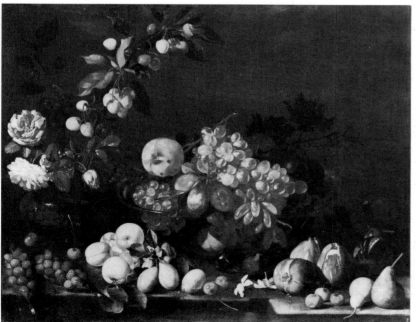

52

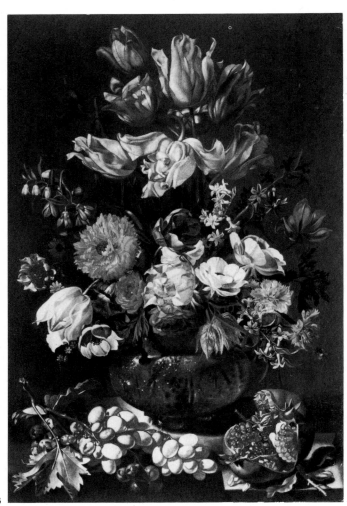

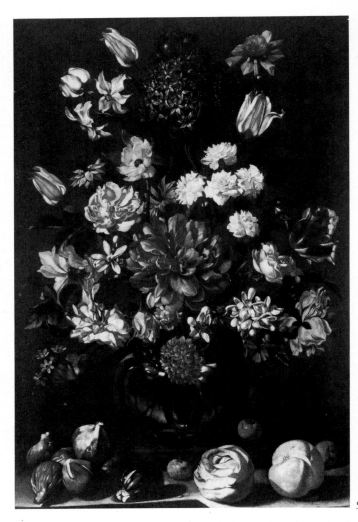

53

5.

Stylistically the paintings belong to a late phase in Forte's career and are similar to the work of Porpora, and perhaps also Giuseppe Ruoppolo. Although the motif of an opaque glass vase is derived from the Caravaggisti, the flowers are arranged in an extravagantly decorative manner covering most of the canvas, and the apple peel is elegantly curled around the fruit in demonstration of the artist's virtuosity.

A.T.

REFERENCES
Constantini 1930, I, p. 85; Hooegewerff 1923–24, p. 712; Sestieri 1972, pp. 376–80

Francesco Fracanzano

MONOPOLI 1612–NAPLES 1656?

The early life of this artist is still obscure; he was the son of Alessandro Fracanzano, a painter from Apulia. In 1622 he moved to Naples together with his brother Cesare, and entered Ribera's studio (De Dominici). In 1632 he married Giovanna, Salvator Rosa's only sister.

Bologna (1958) thought his early style evolved from the most naturalistic phase of Neapolitan painting. He dated a series of works to *c.* 1630–32, including the *Prodigal Son* (Capodimonte), another picture of the same subject (on deposit at Capodimonte from the Bari Museum; a third painting of the same subject is in the Bristol Museum), the *Christ among the Doctors* (Picture Gallery of the Gesù Nuovo, Naples), another painting of the same subject (Musée des Beaux-Arts, Nantes), the *Philosopher* (Hampton Court) the *Man Reading* (Museo Castromediano, Lecce) and the *Girl Looking at a Mirror* (Ralegh, North Carolina).

All these paintings are of half-length figures, densely painted on a generally dark ground, in a technique that is at times loose and at others more scumbled. Evidently there is a connection with Ribera and the generation of the 1630s. The type of composition and the highly individual technique recalls the work of another painter as well; the Master of the Annunciations (see p. 190). Causa (1972) has come to regard the connection between this artist and Francesco Fracanzano to be so close that he has limited the latter's output to a very few signed works and

attributed the rest of the pictures to the anonymous Master.

Although there is no record that Fracanzano returned to Apulia, D'Elia (1971) and other critics have attributed to him a number of works there including the beautiful paintings in S. Pasquale, Taranto.

The earliest works that are universally attributed to him are the well-known pictures of 1635 in S. Gregorio Armeno (Cat. 56, 57). The marvellous signed *St. Catherine of Alexandria* (Cat. 55) is close to these pictures in both colouring and style. Later works include the *Denial of St. Peter* (collection of Mme Boblot) and the signed *Triumph of Bacchus* (Capodimonte).

Fracanzano's work after 1640 has prompted comments about its 'involution', 'a return to Ribera', and 'classicism'. Perhaps Fracanzano's style at this time was going in two directions, on the one hand tending towards the painterly, and on the other aspiring to the discipline of the classical tradition, as is discernible particularly in the *Ecce Homo* (Morton B. Harris, New York), signed and dated 1647, and the *Death of St. Joseph*, (Trinità dei Pellegrini, Naples), dated 1652, which is stilted in composition, the drapery heavy and lifeless.

A signed *S. Onofrio and S. Paolo Eremita*, dated 1634, has recently come to light in S. Onofrio dei Vecchi, Naples.

A.S.

REFERENCES
Bologna 1958, pp. 17–19, 28;
Causa in *Storia di Napoli* 1972, V, II, pp. 933–34, n. 75;
De Dominici 1742–45 (1844 ed.), p. 238;
D'Elia 1971, pp. 117–30

55
St. Catherine of Alexandria

203 × 148 cm
Signed: on the book *fra'cesco frac*
Istituto Nazionale di Previdenza Sociale, Rome
[*repr. in colour on p. 84*]

This imposing, monumental image of St. Catherine, which for years was hidden away in an office of the Palazzo Sciarra in Rome, was published by the present writer in 1975 attributed to Francesco Guarino, although a 'surprising affinity to certain works by Francesco Fracanzano such as the *Triumph of Silenus*' (Capodimonte, Naples) was noted. Two alternative solutions were then considered: firstly, that the painting was a late work by Guarino, at a time when he was stylistically close to Fracanzano, or secondly that it was by Fracanzano, who was influenced in this particular case by Guarino. Since then it has become increasingly clear that the second solution is apparently the correct one.

The closest stylistic parallel and best comparison in Fracanzano's oeuvre is the large signed *Triumph of Silenus*: the figure of 'Bacchus' (?) on the right especially lends itself to comparison, as far as the facial type, the modelling of the flesh tones and, to some extent, the handling of the drapery are concerned. What the *St. Catherine* has in common with the Capodimonte *Triumph of Silenus*, with the other painting of the same subject in the Fogg Museum (Cambridge, Mass.) and with the pair of *St. Peter* and *St. Paul* at Barnard Castle, is the enormous (slightly overlife) size of the figures, the imposing monumentality and a certain *gigantismo*, which is in fact foreign to Guarino. Also the signature is comparable to those of Fracanzano (in the *Silenus* and the 1647 *Ecce Homo*, Morton B. Harris Coll.), while none of Guarino's paintings seem to be signed.

On the other hand, no other work by Fracanzano is as strongly influenced by Vouet (which links Fracanzano to Guarino, Stanzione and Artemisia Gentileschi) as the *St. Catherine*. The Riberesque handling of Fracanzano's usual style, the *tremendo impasto* of his brush and the stringy, rugged quality of his drapery which appear in works of such disparate dates as the paintings of 1635 in S. Gregorio Armeno and the 1647 *Ecce Homo*, are reduced to a minimum in the *St. Catherine*, where the highly polished golden tones of the drapery remind us of Artemisia Gentileschi even more than Stanzione and Guarino. The Capodimonte *Triumph of Silenus* is commonly dated considerably later than the S. Gregorio Armeno canvases of 1635 and one is inclined to believe that Fracanzano moved from the more naturalistic, Riberesque early style to calmer, more classical, academic compositions, but the stylistic evidence of the 1647 *Ecce Homo* stands in the way of such an interpretation of his development. Causa in fact saw in the two paintings of *Silenus* a return to the mode of Ribera.

E.S.

REFERENCES
Schleier 1975, pp. 27–33

56 & 57
St. Gregory of Armenia Thrown into the Well
A Miracle of St. Gregory of Armenia

Each 235 × 288.5 cm
Church of S. Gregorio Armeno, Naples

These pictures illustrate two episodes from the life of St. Gregory, the first Patriarch of Armenia; the first shows the saint thrown into a well full of wild beasts on the orders of King Tiridates, who was opposed to the Christian

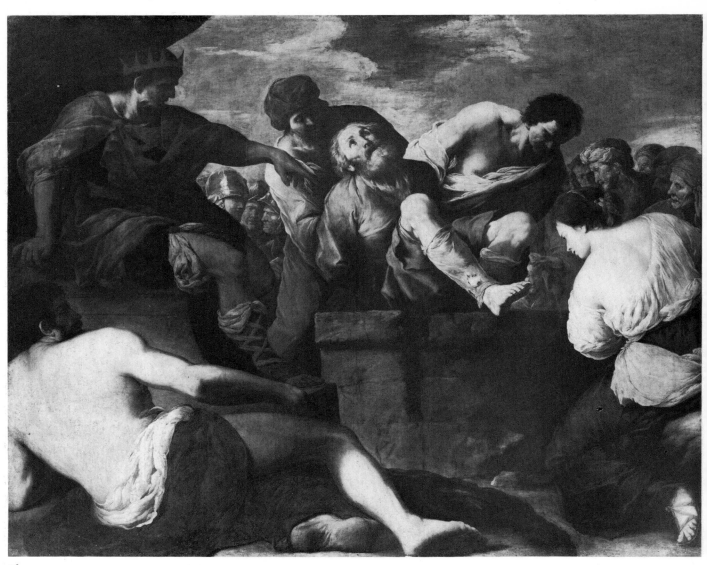

56

faith. The second shows the King afflicted by divine punishment and transformed into a wild boar, imploring St. Gregory for his help to regain his human form. Accounts of these two episodes from the life of the saint vary, as do the various paintings of the subject. Armenian emigrants brought the cult of St. Gregory of Armenia to Italy and he was particularly revered in Naples, where his remains were preserved in the church with a monastery attached named after him. The translation of his relics probably took place after the Emperor Leo III pronounced a decree against the use and veneration of holy images.

The two pictures are located on the lateral walls of the chapel dedicated to the saint in the church, which also has other paintings illustrating his life. Above the canvases are two lunettes portraying the martyrdom of St. Gregory and the altarpiece is of *St. Gregory among the Angels*.

The attribution of this series of paintings to Francesco Fracanzano has always been some-what controversial; while the altarpiece is now generally agreed to be by Francesco Di Maria, as are the frescoes in the vault of the chapel, critical opinion is still divided over Fracanzano's authorship of the lunettes above. Formerly they were given to his brother Cesare Fracanzano or considered to be a work of collaboration between the two. But doubts about Francesco's authorship of the two paintings exhibited here have now been virtually dispelled.

They are dated 1635, and were for a long time regarded as the artist's earliest works, but in fact they appear to be stylistically mature. Certainly these paintings are amongst the most important Neapolitan painting of the period. They have a Riberesque character; Causa (1972) also detected the influence of Caravaggists like Valentin de Boulogne and the Master of the Judgement of Solomon. Bologna (1958) thought

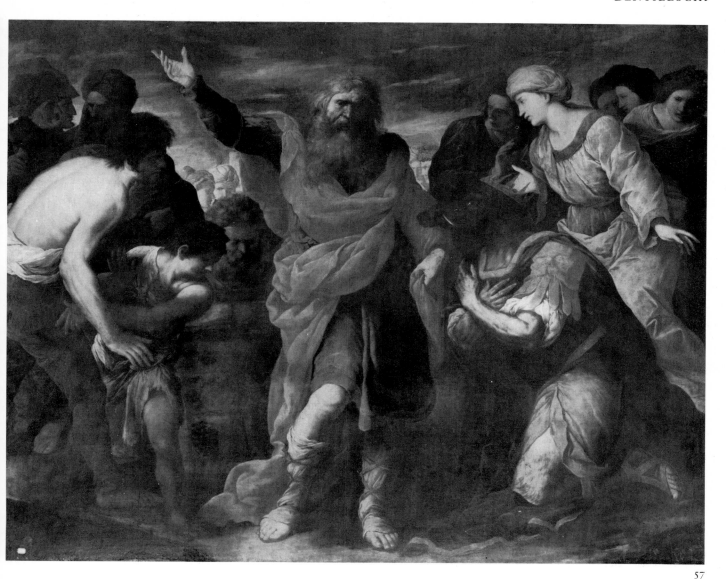

57

Artemisia Gentileschi

ROME 1593–NAPLES 1652/53

they belonged to a current that emerged in Naples between 1635 and 1640 that showed 'a pronounced and consistent move towards a more refined and tender manner, with an exquisitely painterly character', noting also a precocious awareness of the young Pietro da Cortona.

In both paintings the action takes place on two different planes; the chief protagonists, enveloped in massive robes, stand out boldly from the background, where the crowd of onlookers, their features barely indicated with broad, laden brushstrokes, seems to act as a chorus to the events.

A.S.

EXHIBITIONS
Naples 1963, nos. 35, 36

REFERENCES
Bologna 1958, pp. 17–19;
Causa in *Storia di Napoli* 1972, p. 933;
Galanti 1872, 1829 ed., p. 1502

Artemisia Gentileschi trained with her father Orazio in the early Seicento, when his style was at its most *tenebroso*. She was clearly very impressed with Caravaggio's work, particularly in themes like Judith and Holofernes which she continued to paint, with a number of variations, throughout her career. She had an artistic temperament that was very pronounced, and her abilities as an artist gave her an independence that was quite exceptional for a woman in her century.

Her career opened with the notorious trial of Agostino Tassi for her rape. Tassi was a kind of entrepreneur in the Roman art world and was able to arrange for a wide variety of painters to collaborate on decorations, so he came to be on familiar terms with a great number of the artists

living in the city, employing painters as varied as Gentileschi, Claude and Jan Miel. A braggart (he was nicknamed *lo smargiasso*), he took advantage of Artemisia, and was indicted by her father for rape. Orazio maintained at the trial that his daughter was only 15 years old at the time, and it has only relatively recently been demonstrated (Bissell 1968) that she was in fact 19. He also maintained that the violation occurred *più e più volte* (many times) and Tassi spent eight months in prison, although he was finally acquitted.

Artemisia married a Florentine a month after the trial ended, but her reputation was coloured by the libidinous nature of the story; her notoriety seems almost the counterpart to the fame of that heroine of Seicento feminism, Beatrice Cenci, abused by her father in the castle of La Petrella in the Abruzzi. Artemisia's marriage did not last; she lived in a state of independence rare for a woman at the time and she travelled considerably. Her stay in Florence ended in 1621 and she went to Genoa (where she worked again with her father), to Venice and at the end of the 1630s to London, where Orazio worked for eight years at the court of Charles I.

Artemisia settled in Naples as early as 1630, and apart from her journey to London from about 1638–1640/41, she appears to have lived there until her death. Neapolitan artists were, however, aware of her works even before 1630; in the decade up to that date she was in Rome, working in the circle of artists like Simon Vouet, who were doubtless drawn to her as one of the surviving representatives of the Caravaggesque tradition. As the fashion changed towards classicism in Rome, Artemisia, still working in a Caravaggesque vein, maintained links with foreigners in the capital. She went on painting Caravaggesque subjects, mainly for private clients, throughout her career, but it is interesting to note that when she did public commissions like the three large altarpieces for the cathedral at Pozzuoli, painted towards the end of the 1630s, she was more influenced by the Bolognese classicism that was obviously an important factor in Naples given the presence of Domenichino and Lanfranco. Her work was evidently sought by collectors all over Europe: the *Birth of St. John the Baptist* in the Prado was very probably painted for Philip IV's Buen Retiro Palace, along with Stanzione's *St. John the Baptist* series; she also painted a whole group of works for Don Antonio Ruffo (Ruffo 1916). Occasionally she collaborated with other painters, as in the *David and Bathsheba* (Columbus, Ohio) in which Micco Spadaro and Viviano Codazzi respectively painted the landscape and the architectural setting.

C.W.

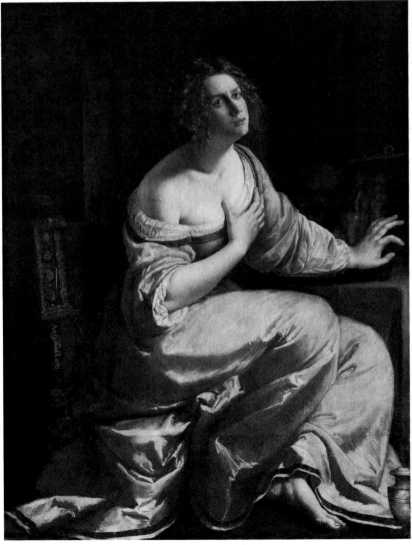

58

58

The Magdalen

146 × 109 cm
Galleria Palatina, Palazzo Pitti, Florence (inv. 142)
Signed: centre left on the chair ARTIMISIA LOMI and inscribed centre left on the chair OPTIMAM PARTEM ELEGIT

This is one of Artemisia's most successful works, dating from her period in Florence, which lasted from just after her marriage in 1612 until 1621. Ward Bissell (1968) has suggested that it was painted for Grand Duke Cosimo II (1590–1621), whose wife was Maddalena d'Austria. The form of the signature is one which Artemisia used in Florence only; her father's family name was Lomi and came from Florence, and the history of the picture itself suggests that it was painted there. It is possibly, as Ward Bissell has indicated, a work that Artemisia herself refers to in a letter of 10

February 1620, in which she promised to deliver to Cosimo II a painting for which she had already received a deposit of 50 *scudi* (Crinò 1954).

The wonderful passages in the drapery in this picture are among Artemisia's most subtle and rich; her style undoubtedly matured well in the Florentine artistic environment. The sensational naturalism that she had inherited from Caravaggio is overlaid with the attention to costume details and the qualities of materials that we see here; this was evidently fashionable in Florence, and it can be seen as an extension of the tradition of realism in which Santi di Tito had excelled, and in which Cristofano Allori and Lodovico Cardi, il Cigoli, were still active. It was evidently this observation of rich detail that particularly appealed to Artemisia's clients for her portraits, which Baldinucci among others commended, although remarkably few examples survive. It is interesting to note, in this context, that the overwhelming majority of Artemisia's paintings were done for private patrons, who were evidently interested in the quality of the representation more than the subject itself.

C.W.

EXHIBITIONS
Florence 1970, pp. 74–75; Los Angeles etc. 1976, no. 11
REFERENCES
Bissell 1968, p. 156, fig. 4; Crinò 1954, pp. 205–06

59
Self Portrait as 'La Pittura'

96.5 × 73.7 cm
Signed: AGE
Her Majesty The Queen

Artemisia refers to two self-portraits in correspondence with Cassiano del Pozzo in 1630 and 1637, and Ward Bissell (1968) has convincingly suggested that this is the later of the two works, the one which she had in her studio in Naples prior to her journey to England. The other work is now usually taken to be a painting in the Galleria Nazionale, Palazzo Corsini, Rome; this shows her painting a portrait that could be a portrait of Poussin, and for that reason alone it is tempting to think that it could have belonged to Dal Pozzo, even though there is no reference to such a work in the inventories of the collection (Brejon de Lavergnée 1973). The painting exhibited here, which can be traced back to the collection of Charles I, could have been sent to England in advance of her journey there towards the end of the 1630s, probably coinciding with the decline in her father's health (he died in London in 1639).

Sir Michael Levey has demonstrated (1962) that this is an allegory of painting, and follows the iconography suggested by Ripa, who named the gold chain with a mask pendant as one of the attributes suitable for such a personification. The allegory was obviously carefully thought out and was a suitable theme for a collector who would not appreciate her usual subject matter. It is quite different in nature to the illustrations from the Old Testament that were her favoured themes, and of course considerably different in character from the large altarpieces at Pozzuoli Cathedral that were probably also finished just before the artist left Naples for England. It is one of the most original portraits of the Seicento and a reminder of her fame in this genre, mentioned in particular by Baglione (1641), of which extremely few known examples have survived.

C.W.

PROVENANCE
Charles I; sold to Jackson 1651;
recovered for Charles II at the Restoration

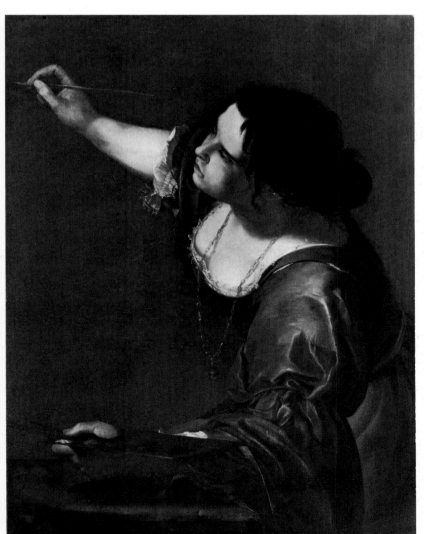

59

EXHIBITIONS
London 1946, no. 252; Naples 1954, p. 115;
London 1960, no. 48

REFERENCES
Baglione 1642, p. 360; Bissell 1968, pp. 153–68, fig. 15;
Levey 1962, vol. 104, pp. 79–80, fig. 37;
Levey 1964, pp. 81–82, no. 499, pl. 22;
Millar 1972, p. 186, no. 5; Voss 1924, p. 463;
Waagen 1854, II, p. 357

60

Judith and Holofernes

168 × 128 cm
Capodimonte, Naples

The subject of Judith and Holofernes is the one that Artemisia Gentileschi returned to most frequently, and was doubtless regarded as an echo of her Caravaggesque background. Her own life and experiences too led her to choose themes relating to famous women – those whose lives were threatened by men, like Lucretia, Susanna and Judith. Her earliest picture on the theme of Judith is the *Judith and her Maidservant* in the Pitti Palace, Florence, which was almost certainly painted in Rome before the famous lawsuit her father brought against Tassi and before her move to Florence, and so within a short time of Caravaggio's masterpieces like the *Judith Decapitating Holofernes* now in the Galleria Nazionale, Palazzo Barberini, Rome.

Although Artemisia protested in a letter written to Don Antonio Ruffo towards the end of her life (Ruffo 1919) that she never repeated the same composition twice, even down to the pose of a single hand, this rendering of *Judith and Holofernes* is essentially the same as that of the painting in the Uffizi. It was either painted in Naples, or brought to the city when Artemisia settled there in about 1630. It was undoubtedly a most successful image that had a great impact on Neapolitan painters and collectors, who appreciated both the sensational quality of the naturalism and the association of Artemisia's own life with the subject she portrayed. The success of this kind of painting, which was undoubtedly out of fashion in Rome, was probably one of the principal reasons why she settled in Naples where she had, we know, intended to stay only a short while.

C.W.

PROVENANCE
Saveria di Simone, Naples;
entered the collection of the Museo Nazionale 1827

REFERENCES
Bissell 1968, p. 158, fig. 10; De Rinaldis 1928, p. 111;
Molajoli 1957, p. 51

Luca Giordano

NAPLES 18 October 1634–NAPLES
3 January 1705

The son of Antonio Giordano, who was also a painter, Luca Giordano was first trained in the circle of Ribera. In about 1652, perhaps just after the death of Ribera, he first left Naples to study in Rome, Florence and Venice, paying particular attention to the work of Pietro da Cortona and the great masters of sixteenth-century Venice – Titian, Veronese and their followers. At Venice he won his first commissions: to paint altarpieces for the churches of S. Pietro in Castello, S. Maria del Pianto and S. Spirito.

He was back in Naples in 1653 and developed a baroque style based on what he had learnt on his travels, although he never entirely abandoned his links with Ribera's naturalistic style. This oscillation between two cultural traditions continued for a decade, during which time Giordano studied paintings in private collections in Naples by Rubens and Poussin. He

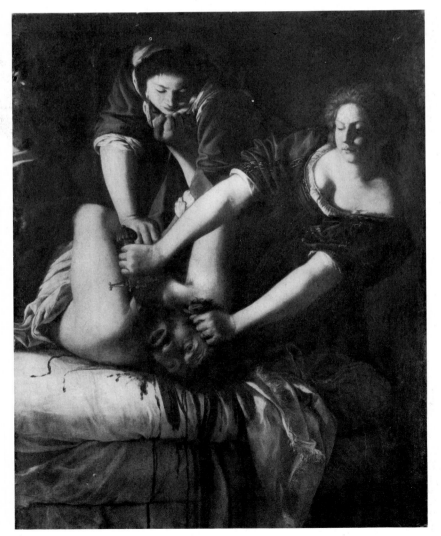

60

also drew close to the style of Mattia Preti, whose work he in turn influenced. In this period he showed his capacity to synthesize into a personal style what he had learnt from the Venetian masters. He was also extremely prolific and earned himself the nickname of *Luca fa presto*.

In 1665 he was in Florence again (working for the Medici amongst others) and later in Venice. His great fresco cycles in Naples date from some years after his return: the one in the Abbey of Montecassino, destroyed in the Second World War, dates from 1677–78, the cupola of S. Brigida, Naples is of 1678 and the *Life of S. Gregorio Armeno*, in the church of the same name at Naples, was painted in about 1678–79. By this time Giordano's fame was enormous both in Italy and abroad. On a visit to Florence in 1682 he painted the dome of the Cappella Corsini in the church of the Carmine, and began the *bozzetti* for the Library and the Gallery of Palazzo Medici-Riccardi which he completed (after a brief return visit to Naples) in 1685. These frescoes are probably the masterpiece of Giordano's maturity and mark a tremendous development both in his powers of narrative invention and in his style.

Giordano stayed in Naples until 1692, when he was summoned to Spain by Charles II. In the ten years he spent there he carried out grandiose decorative schemes in the Escorial, in the Palace of Buen Retiro, Madrid and in the sacristy of Toledo Cathedral. He also painted dozens of pictures for the court, for private patrons and for churches (San Antonio de los Portugueses, Madrid; Monastery of Nuestra Señora, Guadalupe). His tireless activity was considered to be almost miraculous.

After the death of Charles II, Giordano decided to go home; he left Spain in February 1702 and after a brief stop in Livorno returned to Naples. During the last years of his life he was still extremely prolific: he worked in the church of S. Maria Egiziaca at Forcella, painted the *Martyrdom of S. Gennaro* for S. Spirito dei Napoletani, Rome and decorated the Cappella del Tesoro in the Certosa di S. Martino, Naples, which was finished by April 1704. The *Meeting of S. Carlo Borromeo and S. Filippo Neri* in the Girolamini church, Naples, is also of 1704. At the time of his death Giordano was engaged on other projects, including the sacristy of S. Brigida, Naples which was completed by his pupils working from his *bozzetti*.

Throughout the various phases of his career Giordano exercised a vast influence on contemporary painters in Naples, Florence and Venice; his last works, which already show a change from the magniloquence of late baroque to the irridescent lightness of the Rococo, were greatly esteemed throughout the eighteenth century; his admirers included Fragonard. It is only recently that his drawings have also come to be appreciated.

O.F.

61

Carneades with the Bust of Paniscus

127 × 102 cm
Colnaghi & Co., London

In his early work Giordano not only echoed Ribera's style, but also copied some of his pictorial themes, including the half-length figures of philosophers. Sometimes these were imaginary portraits of real philosophers (eg. Democritus, Archimedes, Diogenes, etc.), but more often they were ideal figures of 'beggar philosophers' or 'scientist philosophers', this latter category including astrologers, alchemists, geographers and mathematicians. The prevalence of these images of philosophers in the Seicento, especially in Italy and Holland, would be more explicable if we knew who commissioned this type of painting. It may be that such pictures were bought by intellectuals to decorate their studies and libraries, where it was traditional to have portraits of philosophers and writers (Masson 1981).

In the first half of the Seicento in Naples the most prominent intellectual and cultural circles combined an interest in science with a neo-Stoic ethic based on the teachings of Diogenes, Seneca and Cato. Moreover, the study of physiognomy, of which Giovanni Battista della Porta was the principal Neapolitan exponent (his treatise *La Fisionomia dell' Huomo et la Celeste* was published at Padua in 1632) provided painters with a pretext to represent human character and 'sentiments'. Giordano was in touch with these intellectual circles and aware of their interests; it may be significant that in one pair of philosophers he portrayed himself and his father (Alte Pinakothek, Munich).

There are many paintings of 'philosophers' by Giordano; the *Democritus* (Kunsthalle, Hamburg); *Crates* (Galleria Nazionale d'Arte Antica, Rome), two *Philosophers* (Kunsthistorisches Museum, Vienna), another *Philosopher* in the Museo Nacional de Buenos Aires (Ferrari and Scavizzi 1966). Others were exhibited at the Heim Gallery, (London 1975, nos. 1–4). Later Giordano painted some dramatic 'philosophic' scenes, including the suicides of Cato and Seneca, and the death of Archimedes.

Carneades with the Bust of Paniscus belonged to a series of ten philosophers that were still together at the beginning of this century in the Carvalho Collection, Villandry, France, but later dispersed at an unknown date. It constituted the largest known series of philosophers by Giordano. Originally attributed

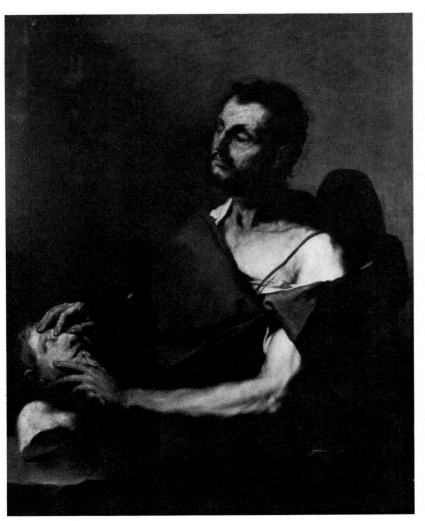

61

to Ribera (London 1913–14; Milward 1936), it
was Mayer (1923) who compared this painting
to Ribera's picture of the same subject in the
Prado, and concluded that it was the work of
Giordano, an attribution that has been
universally accepted.

Fitz Darby (1957) suggested this represented
the Greek philosopher Carneades who, after he
went blind, recognized the bust of Paniscus (the
young god Pan) by touch. This gives the painting
a double meaning, since it could also be read as
an allegory of the sense of touch, and this
ambiguity is quite in keeping with the Seicento
fashion of *concettismo*.

Griseri's (1961) dating of 1658–60 is
convincing; stylistically she sees it as belonging
to a moment of 'transition . . . from the
compactness of Caravaggesque naturalism to a
baroque painterly style'.

O.F.

PROVENANCE
Carvalho Collection, Villandry

REFERENCES
Ferrari and Scavizzi 1966, I, pp. 27–34; II, pp. 19–27;
Fitz Darby 1957, pp. 199–217; Griseri 1961, pp. 426–27;
London 1913–14; London 1975, nos. 1–4; Masson 1981;
Mayer 1923, pp. 78, 204; Milward 1926, pp. 13–17;

62

The Resurrection

187 × 205 cm
S. Maria del Buonconsiglio (Tempio dell'Incoronata),
Capodimonte, Naples

This painting has recently been given to the
gallery attached to the modern church of S.
Maria del Buonconsiglio. It is undocumented.

Causa was the first to call attention to it
(Causa 1972) and Grizzuti noted the relationship
between this composition and Caravaggio's
Resurrection painted in Naples between 1606
and 1608 for the Cappella Fenaroli in S. Anna
dei Lombardi, which was destroyed in the
earthquake of 1805. Cochin (1769) gave a
description of this lost work: '*C'est une
imagination singulière, le Christ n'est point en
l'air, & passe en marchant au travers des gardes;
ce qui donne une idée basse, & le fait rassembler
à un coupable qui s'échappe de ses gardes.
D'ailleurs le caractère de nature est d'un homme
maigre, & que a souffert. La composition du
côté de l'agencement pittoresque est fort belle,
& en est ferme & rassentie avec goût. Il est fort
noirci. On ignore le nom de l'auteur. Le morceau
est beau*'

But if the invention is Caravaggesque, we
cannot say that it is painted in Caravaggio's
style: the treatment is intensely colouristic and
there is a softness of forms which recalls the last
works of Ribera, such as the *Madonna in
Ecstasy* of 1634 (Academia de San Fernando,
Madrid), of which Giordano made a free copy in
about 1660 (Hispanic Society of America, New
York), or Ribera's *Miracle of S. Donato
d'Arezzo* of 1652 (Musée de Picardie, Amiens).
The picture belongs to a period in which
Giordano had returned to a study of Ribera's
work, but instead of concentrating on the
Spaniard's vigorous realism, as he had in his
youth, he now adopted Ribera's painterly
freedom. At this date, 1652–55, Giordano had
only just returned from a trip to Venice and
Rome where he had studied Pietro da Cortona's
frescoes in the Palazzo Barberini (there is a
direct quotation from him in the *Miracle of St.
Nicholas of Bari* in S. Brigida, Naples of 1655).
He was assimilating a variety of influences to
create a personal style (Spinosa in Bucharest
1972).

That he used Caravaggio's painting as a
prototype may have been due to the wish of the
unknown patron: it is also in tune with the
painter's development at a time when he was
looking back over 50 years of Italian painting.

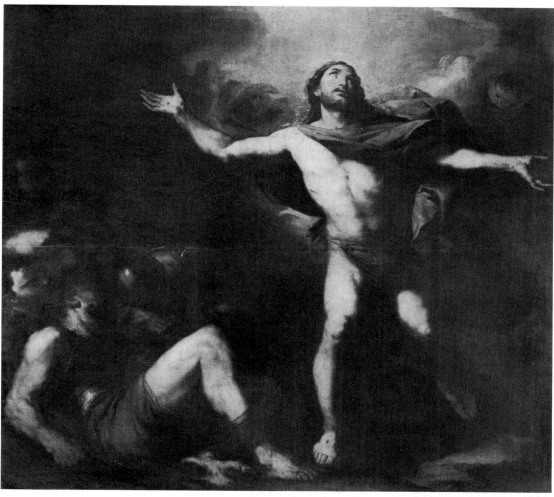

62

There is another autograph version of this painting in the Santuario di Monte Berico, Vicenza, formerly attributed to G. F. Cassana (Ivanoff 1933).

O.F.

EXHIBITIONS
Bucharest 1972

REFERENCES
Causa in *Storia di Napoli* 1972, p. 962, n. 6;
Cochin 1756, II, pp. 171–2; Ivanoff 1933, p. 322;
Marini 1974[1], p. 476; Marini 1974[2], pp. 136–7

63
The Entombment

211 × 160 cm
Detroit Institute of Arts, no. 72.434 (Founders Society Purchase, Robert H. Tannahill Foundation Fund)

This painting was published by the present writer (Ferrari 1975). The composition was known from a smaller version (197 × 159 cm) in the Galleria Nazionale d'Arte Antica in Rome (on loan to the Pinacoteca, Bari), previously believed to be autograph (D'Elia 1964; Ferrari

and Scavizzi 1966), but evidently a studio replica. The painting is undocumented.

Iconographically it departs both from traditional and Counter-Reformation representations of the subject (cf. Borromeo 1634) since it lacks the Virgin, the Magdalen and the other holy woman. Giordano had already painted the subject several times but always following traditional iconography. Two Entombments (Pinacoteca, Bologna; Landesmuseum, Oldenburg) are early works, still closely linked to Ribera's style and datable to around 1650–52. Two others (a signed work from the Museo del Sannio, Benevento, on deposit at Capodimonte; another at the Philbrook Art Center, Tulsa) date from after Giordano's return from Venice around 1653 and show the artist blending Ribera's naturalism with the more lively pictorial qualities of the Venetian masters. This painting shows a further development in this process, and can be dated between 1658 and 1662.

By this date Giordano had already painted some fully fledged baroque pictures, eg. *S. Tommaso da Villanova Distributing Alms*

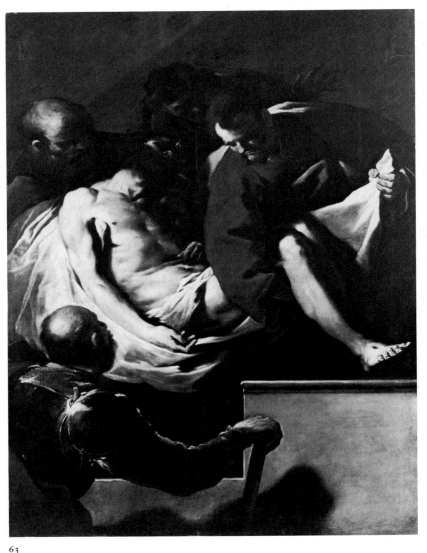

63

royal collection, although this is undocumented);
lot 70 in the sale of the Duchesse de Berry's collection at the
Hôtel Drouot, Paris 19 April 1865, sold for 460 francs;
bought on the English market 1972

REFERENCES
Ferrari 1975, pp. 24–32

64
S. Tommaso da Villanova Distributing Alms

315 × 235 cm
S. Agostino degli Scalzi, Naples
[*detail repr. in colour on p. 98*]

Tommaso da Villanova, a Spanish Augustinian monk (1486–1555) created Archibishop of Valencia in 1544, was instrumental in reforming his order according to the doctrines of the Council of Trent. He was canonized by Alexander VII on 1 November 1658.

His canonization was immediately celebrated by the Neapolitan Augustinians; they dedicated an altar to the new saint in their church (whose correct name is S. Maria della Verità), and it was for this altar, in the second chapel on the right, that Giordano was commissioned to paint the present picture. The Augustinians ordered another altarpiece from Giordano at the same time, to go in the chapel on the left of the crossing (the *Ecstasy of S. Nicola da Tolentino*, signed and dated *Giordanus F. 1658*).

These two paintings were greatly admired from the seventeenth century (Sarnelli 1688; Celano 1692). De Dominici said that this picture was painted 'in the manner of Titian', while in its companion 'Luca . . . imitated the manner of Paolo Veronese': he probably noticed that the figure of the naked beggar in the foreground of *S. Tommaso* is an exact quotation from Titian's *Martyrdom of S. Lawrence* in the Gesuiti, Venice.

In 1658 Giordano still had memories of his first trip to Venice; much of his work at this date shows his transformation of the style of the Venetian sixteenth-century masters into baroque terms. This is evident in the *Madonna of the Rosary* painted for the Church of the Solitaria (Capodimonte) and his two paintings for the church of the Ascensione at Chiaia, dated 1657 (*St. Michael Defeating the Rebel Angels*, *St. Anne and the Virgin*). The warm golden light and architectural setting of this picture are typical of Giordano's first 'neo-Venetian' period. Pallucchini (1981) sees the influence of Sebastiano Mazzoni in the two paintings of S. Agostino degli Scalzi.

O.F.

EXHIBITIONS
Naples 1938; Bucharest 1972

REFERENCES
Baldinucci 1681–95, p. 92; Bologna 1958, p. 35;

(Cat. 64; S. Agostino degli Scalzi). But other contemporary works (the *Archangel Michael* [Cat. 67]; Kunsthistorisches Museum, Vienna and the *Deposition*, Rodriguez Bauza Coll., Madrid) share the naturalism evident in this painting.

Christ's body creates a diagonal across the picture which recalls Caravaggio's *Deposition* painted for S. Maria in Vallicella, Rome (now in the Vatican). But the influence of the Venetians is also present; the rich light and colour, the freedom of the handling of the paint and the foreground figure on the left which recalls the late work of Titian. A comparison with contemporary works by Preti shows how the two artists reciprocally influenced one another.

O.F.

PROVENANCE
In the collection of the Duchesse de Berry at Palazzo Vendramin-Calergi, Venice 1844–64 (the Duchesse, née Maria Carolina di Borbone, was the daughter of Francesco I, King of the Two Sicilies, and Maria Clementina of Austria, so it is probable that the painting came from the Neapolitan

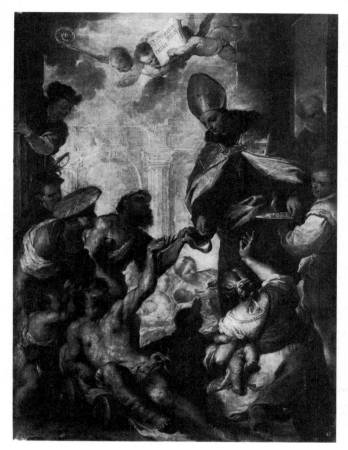

64

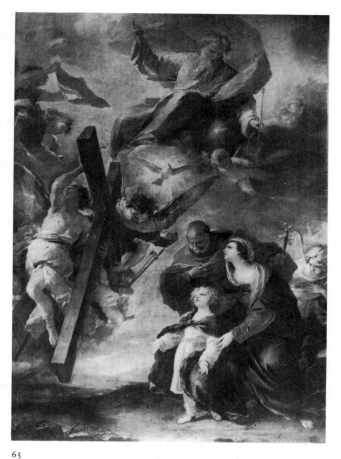

65

Causa 1957, p. 49; Celano 1692 (1970 ed.), p. 1713;
De Dominici 1742–45, III, pp. 399–400;
Ferrari and Scavizzi 1966, I, p. 47;
Ferrari in *Storia di Napoli* 1970, VI, p. 1248;
Griseri 1961, pp. 417–18; Petraccone 1919, pp. 81–83;
Sarnelli 1685, p. 443

65

The Holy Family with Symbols of the Passion

409 × 279 cm
Monogrammed and dated: bottom left LG 1660
SS Giuseppe e Teresa, Pontecorvo, Naples
[*detail repr. in colour on p. 99*]

The church of SS Giuseppe e Teresa was built in 1660, designed by Cosimo Fanzago and paid for by Doña Lucrezia de Cardona, wife of the Viceroy Gaspar de Bracamonte, Conde de Peñaranda, who in the same period had commissioned Giordano to paint two altar-pieces for S. Maria del Pianto (Cat. 66).

The church belongs to the Order of Discalced Carmelites, with which Giordano was frequently associated: in 1664 he painted the *Rest on the Flight into Egypt* and the *Virgin with St. Anne and St. Joachim* for S. Teresa at Chiaia, and some 20 years later the *Ecstasy of St. Teresa* for S. Teresa degli Scalzi.

The choice of subject was obviously determined by the Carmelites; it is typical of St. Teresa of Avila's mysticism and was occasionally painted by Counter-Reformation artists in Rome, sometimes paired with the *Rest of the Flight* (Mâle 1932). Giordano used the subject again in a nearly contemporary replica (Louvre, on loan to the Musée Municipal, St. Etienne) and a drawing possibly dating from his time in Spain from 1692–1702 (British Museum, London 1950-11-11-18). Other painted versions (Barcelona University; Prado Reserve Collection; Royal Palace, Aranjuez) and drawings (Uffizi no. 6707; Louvre no. 9627) are later workshop products.

Celano (1692) said that this was one of his first paintings; De Dominici (1743) remarked that it was painted 'in imitation of Paolo Veronese . . . a work which showed masterly brushwork and fine harmony of colour'. Giordano's baroque neo-Venetian style is immediately apparent, but the chromatic intensity and the grandiose movement in the composition, dominated by the diagonal of the Cross which is continued by the angel's wing and the mantle of God the Father, show how intelligently Giordano used the example of Rubens.

O.F.

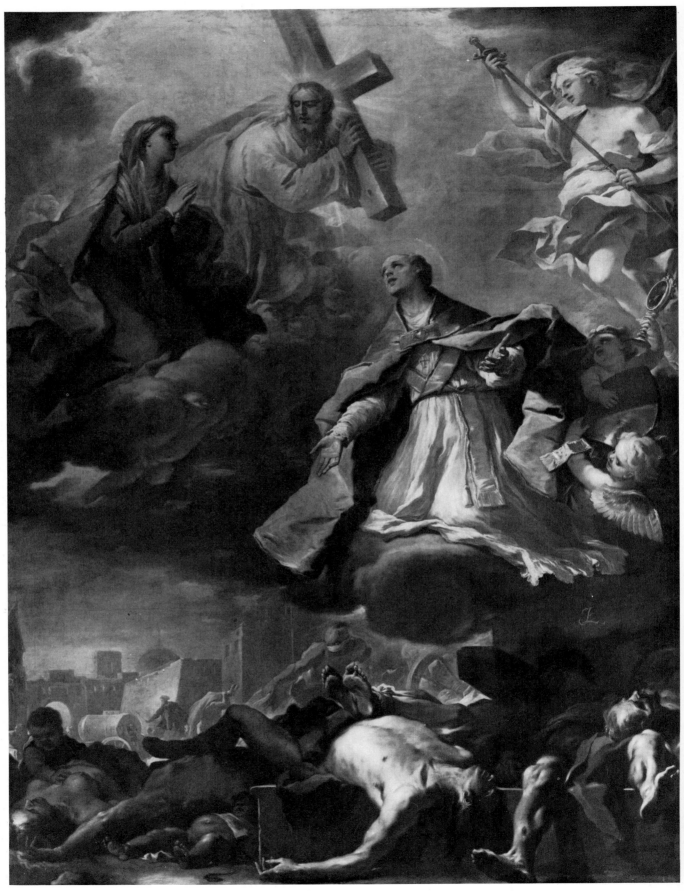

REFERENCES
Bologna 1958, p. 35; Celano 1692 (1790 ed.), p. 1615;
De Dominici 1742–45, III, p. 397; Ferrari 1966, p. 302;
Ferrari and Scavizzi 1966, I, p. 53; II, pp. 50–51;
Ferrari in *Storia di Napoli* 1970, VI, p. 1248;
Mâle 1932, pp. 329–31; Petraccone 1919, p. 54

66

S. Gennaro Frees Naples from the Plague

400 × 315 cm
Monogrammed: on right LF
S. Maria del Pianto, Naples

This picture, together with its pendant of the *Patron Saints of Naples Adoring the Crucifix*, was commissioned by the Viceroy, Conde de Peñaranda, for the church of S. Maria del Pianto. This was built at the instigation of the Company of S. Maria Verteceli over the *grotte degli sportiglioni* at Poggioreale in which many victims of the 1656 plague had been buried. For the same church Andrea Vaccaro painted the *Virgin Interceding for the Souls in Purgatory* (dated 1660). Both the church and its paintings were intended as an *ex voto* for the liberation of the city from the plague.

Don Gaspar de Bracamente, Conde de Peñaranda, was named as the patron by Celano (1692); De Dominici gives a lengthy account of the rivalry between Giordano and Vaccaro, each of whom wished to secure the right to have their own painting chosen for the high altar. According to De Dominici, *bozzetti* for all three pictures were submitted to a panel of artists resident in Rome which included Pietro da Cortona, Andrea Sacchi, Giacinto Brandi, Gaulli and Bernini. But this story would appear to be apocryphal.

De Dominici also says that Giordano's two paintings were painted at the same time as the *Madonna of the Rosary* for the Solitaria, which he dates 1657, but the Conde de Peñaranda only became viceroy in December 1658. The most likely dating is 1660–61; the paintings were in place at the time of the church's consecration in 1662 and Giordano was still receiving payments in 1665 (Strazzullo 1965).

The plague victims shown in the lower half of the composition were evidently inspired by Mattia Preti's frescoes on the gates of Naples (Cat. 100 and 101), but the over-riding stylistic influence is Rubens, as is evident in the brilliant colouring and light effects.

O.F.

REFERENCES
Baldinucci 1681–1975; Celano 1692 (1970 ed.) p. 1948;
De Dominici 1742–45, III, p. 399;
Ferrari and Scavizzi 1966, I, pp. 53–54; II, p. 52;
Ferrari in *Storia di Napoli* 1970, VI, pp. 1248–50;
Nappi 1980, pp. 34–35; Petraccone 1919, p. 56;
Strazzullo 1965, p. 224; Wethey 1967, pp. 678–86

67

St. Michael Vanquishing the Devil

198 × 147 cm
Signed: lower left *Giordano. F.*
Staatliche Museen Preussicher Kulturbesitz, Gemäldegalerie, West Berlin (property of the Kaiser-Friederich-Museums-Verein)
[*repr. in colour on p. 96*]

The painting was acquired in 1971 by the Kaiser-Friederich-Museums-Verein for the Gemaldegalerie Berlin shortly after it had emerged on the London art market. Its previous history is unknown. In that year it was published by the present writer who, following a suggestion by O. Ferrari, identified it with the picture by Giordano formerly on the high altar of S. Luigi di Palazzo in Naples. This picture had disappeared when the church was demolished in 1815–16; Giordano's frescoes of the ceiling of the choir, dated 1684, were destroyed, while the four altarpieces, painted in the eighteenth century by Corrado Giaquinto for the sacristy, came to light later (Pasadena; Detroit; Cambridge, Mass.; Montreal).

Subsequently, however, it became increasingly clear that 1684 was much too late a date for Giordano's Berlin picture and that consequently the identification with the high altarpiece from S. Luigi di Palazzo could not be maintained. A cautious revision of the previous dating, anticipating it by 15 years to *c.* 1670, was proposed by the present writer in 1979, but even that date seems too late and should be pushed back to *c.* 1663. Discrepancies and uncertainties in dating of this kind are not unique. The other very striking example in Giordano's oeuvre is the pair of paintings in Memphis, Tennessee (*Massacre of the Children of Niobe, Slaying of the Medusa*). Their dating varied from 1692–1702 (Longhi 1952) to the early 1680s (Milkovich 1964) and *c.* 1660 (Bologna 1958, Ferrari-Scavizzi 1966), which has now definitely been established as the correct date.

In 1684 Giordano had just returned to Naples from his sojourns in Florence (1680–81 and 1682–83) where he had frescoed the ceiling of the Galleria Medici-Riccardi and the dome of the Corsini chapel in S. Maria del Carmine. In these mature works the influence of Pietro da Cortona, which became increasingly noticeable from the end of the 1660s and beginning of the 1670s, reached its peak. Despite the air of baroque exuberance and hedonistic festiveness generated in *St. Michael Vanquishing the Devil* by the bright colours and the swift movement of the saint's body and his draperies, there are virtually no traces of Cortona's influence, which dominated his works from the 1670s onwards, with their fluffy, swelling (and swollen) forms. Also, the earlier paintings of Giordano's Cortonesque style, marked by a darker tonality

and somewhat stronger contrasts of light and shade, such as the two paintings in the Vienna Academy (Ferrari-Scavizzi, fig. 132–133), *Mars and Venus* in Sarasota (*ibid*. fig. 134), *Lucretia* in Schleissheim (*ibid*. fig. 128) and the two *Stories of Moses* in the Harrach collection, which are all datable to *c.* 1670, are quite different in style from this painting.

The style is marked by the extreme fluidity of brushwork and the contrast between the firm modelling of certain parts (arms and hands) and the lightness and transparent rendering of others (draperies). These stylistic characteristics correspond to what Ferrari (1966) described as 'la liquida scioltezza pittorica' and Causa (1954) as 'trasparenze appena velate de colore, ad una pittura fatta scorrevole e liquida, di tocco rapidissimo'. Their remarks were made in reference to the *Madonna of the Rosary* in S. Potito, which they date close to the two large canvases in S. Teresa a Chiaia, itself dated 1664.

And in fact the *St. Michael* seems to belong to this group of works painted between 1661 and 1664. The same fluidity can be found in the Capodimonte *Tarquin and Lucretia* (dated 1663), where the facial type of Tarquin, seen in profile, is the closest comparison to that of the St. Michael. The same translucid airiness is apparent in the large altarpiece from S. Maria del Pianto, *S. Gennaro Frees Naples from the Plague*, datable shortly before 1662 (Cat. 66). The presence of this altarpiece and the one from S. Giuseppe a Pontecorvo (dated 1660; Cat. 65) in this exhibition reveals the stylistic affinities and relative closeness of the two works, but also the differences between them and the quick development that took place in those few years. The modelling and the drapery style is less fluid, more calligraphic in the S. Giuseppe a Pontecorvo altarpiece, from which it is only a few steps back to the 1658 altarpieces in S. Agostino degli Scalzi (Cat. 64), the 1657 *Madonna of the Rosary* in Capodimonte and the altarpieces of 1657 in the Ascensione a Chiaia, one of which depicts the same theme as the Berlin picture, but in a completely different way. The Berlin picture should be placed closest to the *S. Gennaro* from S. Maria del Pianto and the 1663 Capodimonte *Tarquin and Lucretia*. To this group belongs also an unpublished *Temptation of St. Anthony* in a Swiss private collection, which is now on temporary loan to the Staatsgalerie, Stuttgart.

The size of the picture suggests that it was not placed on a high altar or on the altar of a transept of a church (such as those in S. Teresa a Chiaia), but rather on the altar of a side chapel. In its composition elements from two famous prototypes are blended together: from Guido Reni's altarpiece in S. Maria della Concezione in Rome, painted for Cardinal Antonio Barberini the Elder just before 1636, and from Raphael's painting for Francis I of France (Louvre), the composition of which Giordano could have known from engravings. These prototypes had had no influence at all on Giordano's earlier *St. Michael* in the Ascensione a Chiaia (1657). From Guido Reni's altarpiece Giordano derived the diagonal composition (with both the angel's wings cut by the edges of the picture), the pose of the archangel's head turned downwards towards the devil and the bright colour scheme (St. Michael's blue cuirass, red drapery and golden blond hair), while the motif of the archangel holding a lance with both arms stretched out to the left and the balletic or ice-skating pose of the legs (the right foot set on the devil's body and the left leg elegantly moved aside) are both derived from Raphael.

Giordano had used this particular pose of the legs in another, much larger St. Michael altarpiece (Vienna), datable to the mid-1650s and much more Riberesque in style. The colour scheme (blue cuirass, red drapery) is essentially the same, but much darker. The diagonal composition, which in the Berlin picture is taken from Guido Reni, and the dominance of the saint's figure, which fills almost the entire space, are absent in the Vienna picture, where the lower half is covered by the agonized bodies of the devils, modelled in a strong Riberesque chiaroscuro. In the Berlin picture the bodies of the devils still have some of the Riberesque chiaroscuro modelling, the agitated movements and drastic expressions of the Vienna picture, but they are painted in a much freer, more painterly fashion. Romanelli's altarpiece in S. Domenico, Pistoia (1640), the composition of which shows a surprisingly similar blend of elements from Raphael and Reni could have been seen by Giordano on his trip to or from Venice in the early 1650s.

E.S.

PROVENANCE
London Art Market, acquired by Kaiser-Fredrich-Museums-Verein for Gemäldegalerie Berlin 1971

EXHIBITIONS
Berlin 1971, pp. 15–17, no. 6 (Schleier)

REFERENCES
Gonzalez-Palacios 1979, p. 518;
Schleier 1971, pp. 517–18;
Schleier 1975, p. 170 and English ed., 1978, p. 176;
Schleier 1979, p. 84

68 & 69
Phineas and his Companions turned into Stone
The Death of Jezebel

Each 285 × 366 cm
Phineas; Matthiesen Fine Art Ltd., London
Jezebel; private collection
[*detail cat. 68 repr. in colour on p. 100*]

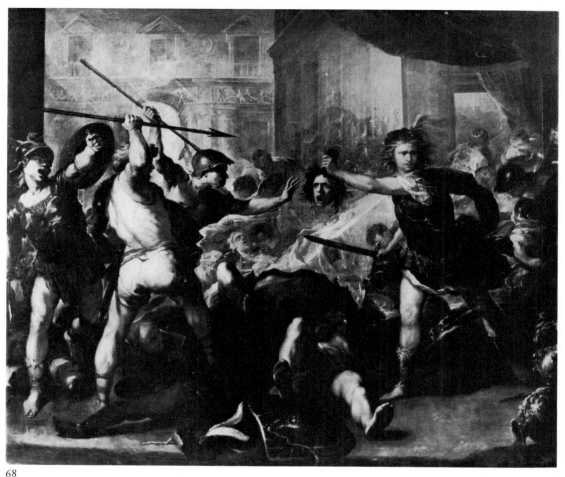

68

The subject of the first painting is taken from Ovid's *Metamorphoses*, v, 1–235: Phineas, to avenge the fact that Andromeda, formerly promised to him, had married Perseus, broke into their wedding feast with his companions. At first Perseus fought back, but fearing that he would be overwhelmed, he turned the intruders to stone by showing them the Gorgon's head.

The second painting illustrates an incident in the Old Testament (II *Kings*, IX, 30–37). On his triumphal entry into the city of Jezreel, Jehu, King of Israel orders Jezebel, widow of the evil King Ahab, to be killed. Her body was thrown from a tower window and devoured by dogs as Elijah had prophesied.

Both subjects illustrate the theme of punishment meted out for violence and lust. The two paintings can be identified with those recorded by Cochin (1769) and Ratti (1780) in the Palace of G. Balbi, Genoa, together with a third painting of the *Rape of the Sabines*. The same authors mention another version of *Perseus and Phineas* in the Palace of Marcello Durazzo (now Palazzo Reale), Genoa together with a picture of *Olindo and Sofronia* and a *Death of Seneca*. De Dominici, evidently misinformed, believed that there were four pictures in Palazzo Durazzo: a version of *Perseus and Phineas*, *Olindo and Sofronia*, the *Death of Seneca*, and the *Death of Jezebel*. This confusion between the two groups of pictures has only recently been resolved.

At present there are in the Palazzo Durazzo-Reale a *Perseus and Phineas* and an *Olindo and Sofronia*; the *Death of Seneca* has disappeared. These were commissioned by Eugenio Durazzo who had enlarged the palace after acquiring it from the Balbi family just before 1679. The recent discovery of these two pictures and their identification with those formerly in the palace of Giacomino Balbi (and since sold) makes it possible to correct an error of the present writer (Ferrari and Scavizzi 1966) that the Balbi paintings could be identified with a *Rape of the Sabines* (Palazzo Durazzo Adorno, Genoa) and yet another version of *Perseus and Phineas* then at the Heim Gallery (London 1975, nos. 7 and 12). This last painting is in any case smaller in scale (155 × 225 cm).

The two pictures in the Palazzo Durazzo-Reale and Cat. 68 and 69, all share a grandiose composition and can be dated around 1680. The

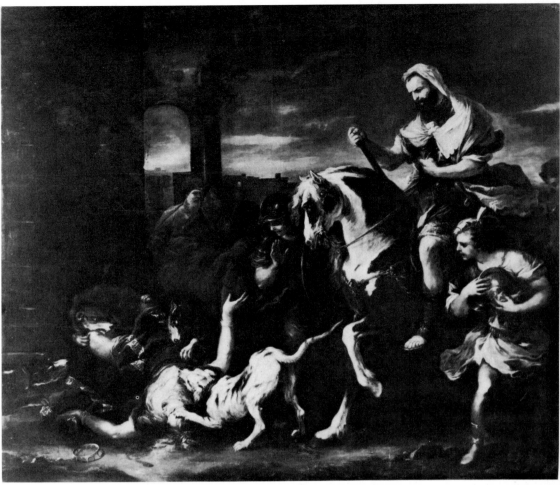

69

dates of 1702–04 (Griseri 1956) and *c.* 1655 (Torriti 1963) can be discounted.

The influence of the Venetian masters has long been recognized; Ratti (1780) remarked on the impact of Veronese on the Durazzo *Olindo and Sofronia.* But Giordano's style is more complex. De Dominici recalled that around 1665 the artist had gone to Florence (when his connection with the Rosso family began). Soon afterwards he returned to Venice; he painted the *Assumption* (dated 1677) for S. Maria della Salute (in Venice) after his return to Naples.

The journey had enabled him to study the work of Pietro da Cortona again and to gain a greater understanding of Maratta's synthesis of baroque and classicism. As a result he was able to construct large compositions with greater facility, and achieve a more balanced sense of colour. All this is evident in the frescoes in S. Gregorio Armeno, Naples of *c.* 1678–79, and in the *Vision of St. Francis* (Cleveland). This phase of Giordano's work, perhaps the happiest of his career, is crowned by the frescoes in the Library and Gallery of Palazzo Medici-Riccardi, Florence (1628–85).

O.F.

PROVENANCE
Palazzo Balbi, Genoa;
Christies sale, London 12 December 1980, nos. 4 and 5

REFERENCES
Cochin (2nd ed.) 1769, III, p. 270;
Ferrari and Scavizzi 1966, II, pp. 98, 118–19, 333;
Ratti, 1780, I, pp. 107–08

70

Homage to Velasquez†

205 × 182 cm
National Gallery, London (no. 1434)

The critical history of this picture is complicated: it was traditionally attributed to Velasquez, but in 1898 it was given to Giordano (de Beruete 1898). Justi rejected both these attributions and proposed that it was the work of a Spanish painter influenced by Velasquez, in particular by *Las Meniñas* (Justi 1903). Holmes (1925) suggested the authorship of Claudio Coello, and this was somewhat hesitantly accepted in the 1929 National Gallery Catalogue. Fiocco first proposed Francesco Maffei (1924), but reverted to Giordano (1929)

as did Mayer (letter in National Gallery files). The attribution to Giordano is now generally accepted.

The subject of the picture is equally problematic. Ortolani (1938) suggested its present title, referring both to its style and subject. Scavizzi suggested that the picture could be linked with an episode which occurred during Giordano's time in Spain, recorded by both Baldinucci (ed. Ferrari 1966) and De Dominici (1743). Apparently the Queen Maria Aña asked the painter to describe his wife's face and, to the marvel of all present, he rapidly sketched her portrait.

But here Giordano seems to have portrayed himself (the figure in the lower right hand corner is very similar to other self portraits), while the other figures are placed on a different plane, as if evoked by memory rather than their actual presence; amongst them it might be possible to identify Velasquez himself in the central figure in dark clothing wearing the Cross of the Order of Santiago. Perhaps it is a sort of *capriccio*, in which reality and imagination – or memory – are present together.

The picture probably dates from the beginning of Giordano's time in Spain; that it has previously been attributed to Spanish artists

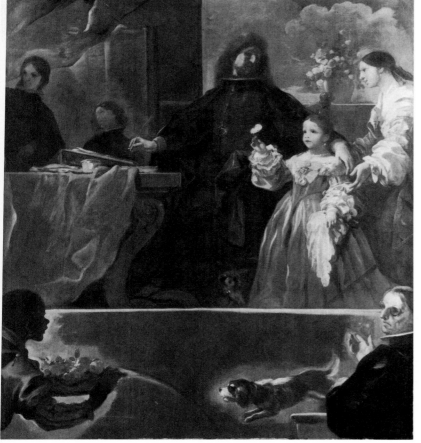

is a demonstration of his versatility in drawing inspiration from other painters' work without ever descending to banal imitation.

O.F.

PROVENANCE
Supposedly from the collection of Bernardo Yriarte (Spanish diplomat and Goya's friend) who died in Bordeaux in 1814; in London coll. Henry-Joseph Fradelle from 1845; on his death in 1865 passed to Sir E. Landseer who lent it to the Royal Academy in 1873; bought by Mr Crowley; in coll. of J. C. Crowley in 1894; bought by Lord Savile who gave it to the National Gallery in 1895

REFERENCES
Beruete 1898, pp. 187–88;
Ferrari and Scavizzi 1966, I, pp. 141–42; II, pp. 184–85;
Fiocco 1924, pp. 240, 245; Fiocco 1929, p. 88;
Holmes 1925, II, p. 296;
Justi 1903 (Italian translation 1959), pp. 791–93;
Levey 1971, pp. 113–14;
Ortolani in Naples 1938, pp. 182, 188

71
The Triumph of Judith

71 × 103.5 cm
Bowes Museum, Barnard Castle, Co. Durham

This picture is a *bozzetto* for part of the fresco of the same subject painted on the vault of the Cappella del Tesoro in the Certosa di S. Martino, Naples after Giordano's return from Spain, and certainly before April 1704. Its companion scene there is the *Discovery of the Corpse of Holofernes*; four biblical heroines are painted in the corners. The lunettes show the *Fall of Manna* and *Moses Striking the Rock*, the *Sacrifice of Abraham* and the *Burning Fiery Furnace*, and the apse lunette is frescoed with the *Brazen Serpent*.

The subject is taken from the book of *Judith* (Apocrypha, xiii, 10–16), which tells how Judith came to the camp of the Assyrian general Holofernes who was besieging the town of Bethulia, how she pretended to accept his advances and then beheaded him while in his tent. The *bozzetto* shows the victorious Judith displaying the severed head of Holofernes to the Assyrians.

There are two other *bozzetti* for the *Triumph of Judith* of similar dimensions in the St. Louis Museum of Art (76.3 × 102.2 cm); another *bozzetto* for one of the corner figures was at the Hazlitt Gallery (London 1967, no. 12). Two paintings in the Treccani Collection, Milan are only partially autograph and of indifferent quality; they derive from the fresco and are not preparatory *bozzetti*.

The Cappella del Tesoro at S. Martino is the happy conclusion to Giordano's long career. He still shows the ability to create a new manner with a strong sense of movement in the composition and colouring of liquid transparency. He anticipates the brilliant and

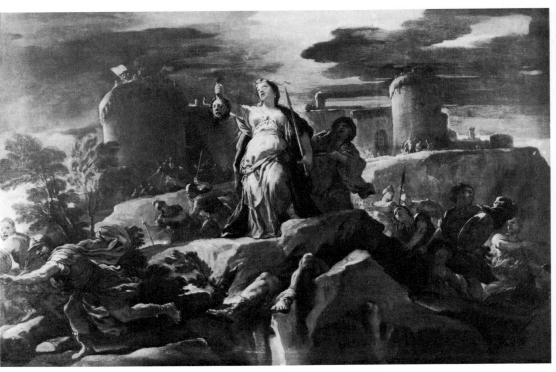

71

airy compositions of the rococo, and in fact many painters of the next century, both Neapolitans and foreigners, drew inspiration from these frescoes. According to De Dominici (1743), Francesco Solimena made the following comment on Giordano's masterpiece: 'Domenichino, Guido, Albani, and even Annibale Carracci himself, could, with a tremendous effort, be imitated; but the fury, the fire and the knowledge with which this battle was painted could not be imitated by any painter, however great, since it seemed all painted in one breath, and with a single sweep of the brush, so unified is it and so harmonious in the understanding of the whole'.

O.F.

PROVENANCE
Conde de Quinto, Madrid

EXHIBITIONS
Hatton Gallery, Newcastle 1960, no. 5;
London 1962, no. 143;
Bowes Museum 1962, no. 90

REFERENCES
Ferrari and Scavizzi 1966, II, p. 231;
Young 1970, pp. 100–01, no. 20

Antiveduto Gramatica

ROME *c.* 1570–ROME 1626

Antiveduto was born at or near Rome, of a noble family from Siena. Baglione (1641) gives us a characteristically charming anecdote about the origin of his name and birth; when his mother was pregnant with him, the Gramaticas were about to move from Siena to Rome. She was so impatient to get there that, against her husband's better judgement, they set out; after some days' travelling she went into labour and the child was born at a hostelry on the way. His father remarked that he had foreseen such a problem and so had the child baptized 'Antiveduto' in St. Peter's when they got to Rome.

The artist's early work reflects the contact he must have had in Siena with Barocci, Vanni and Salimbeni. He was of the same generation as Caravaggio who was working in his studio in 1594, perhaps on copies of other masters and devotional images. Gramatica had come back to Rome before Caravaggio arrived there and was accepted into the Accademia di San Luca in 1593; he eventually became *Principe* in 1624. Like his fellow-countryman Rutilio Manetti, he painted Caravaggesque subjects; a characteristic work of this kind is the *Theorbo Player* in the Galleria Sabauda, Turin. Another work that also had a traditional attribution to Caravaggio is the *Judith with the Head of Holofernes* (Derby Art Gallery) which was originally in Count Altamira's collection, together with a companion *Herodias Presenting the Head of John the Baptist to Herod.*

Gramatica in fact enjoyed the support of Caravaggio's patrons like Cardinal del Monte and Marchese Vincenzo Giustiniani; and Mancini, writing about 1620, mentions that he had done many private commissions and pictures for Spain. His work is not by any means

a slavish imitation of any of Caravaggio's genres; he clearly kept up with most of the artists who worked in this vein in Rome in the first quarter of the century, notably with Gentileschi, Borgianni and Vouet.

C.W.

REFERENCES
Baglione 1642, pp. 292–4;
Mancini ed. Marucchi & Salerno 1956–57, I, p. 245;
II, p. 146; Marino 1968, pp. 47–82; Nicolson 1979, p. 55

72

Death of St. Romuald

300 × 200 cm
Certosa dei Camaldoli, Naples
[*repr. in colour on p. 72*]

Mancini, writing in about 1620, praises Gramatica's chapel decorations, naming an altarpiece that he had recently completed for the Eremo dei Camoldoli at Frascati. It was doubtless as a result of this work, the *Dream of St. Romuald*, which remains Gramatica's best-known work, that the artist was called upon to paint the extensive series of canvases in the Eremo dei Camaldoli at Naples to which the present *Death of St. Romuald* belongs. Exactly when or how long Gramatica was in Naples is not documented, but the picture at Frascati is stylistically so close to the Neapolitan series that they cannot be far apart. It was the dream that inspired St. Romuald to declare that from that time forward, his Order should be dressed in white. The composition of Antiveduto's picture at Frascati must have inspired Andrea Sacchi when, in 1631, he painted his rendering of the theme for the Camaldolese Order in Rome (the painting is now in the Pinacoteca Vaticana); the subject naturally afforded poetic possibilities of variations of colour and tone, a Whistlerian symphony in white.

The *Death of St. Romuald* is the most out-standing of the extensive series of paintings done by Gramatica at the Certosa dei Camaldoli in Naples which include three more canvases on this scale (the *Last Judgement*, *Hell*, and *Paradise*), as well as smaller pictures of numerous martyr saints who had belonged to the Order. Some of these compositions reveal Gramatica's mannerist background, and indeed the design of the work exhibited here has affinities with late Cinquecento painting in its complicated grouping of numerous figures. The sensitivity of the tonality and light, however, shows how Gramatica could appreciate those qualities in Gentileschi's and Borgianni's work.

The apparent similarity with the work of Zurbaran is probably coincidental, although Gramatica certainly had Spanish connections. This characteristic is also, incidentally, a feature of Finoglia's series of lunettes painted for the Certosa di S. Martino (Cat. 47–50) which were undoubtedly influenced by Gramatica's work at the Certosa dei Camaldoli.

C.W.

EXHIBITIONS
Naples 1963, no. 29

REFERENCES
Bologna in Salerno 1955; Causa 1957;
Causa in *Storia di Napoli* 1972, V, II, p. 927;
Marino 1968, pp. 47–82

Francesco Guarino, or Guarini

S. AGATA, IRPINA 1611–GRAVINA or SOLOFRA 1654

Francesco Guarino worked in his birthplace Solofra, in Apulia and elsewhere in the south. In Naples he was patronized by the Orsini family of Gravina and Solofra. His style seems to have been formed on Stanzione's brief Caravaggesque phase, although naturalistic elements deriving from Caracciolo, Filippo Vitale and Roman Caravaggisti of the 1620s are also evident. The impact of Ribera was tremendous and Guarino was deeply involved with the painters of his circle.

His first significant works were painted for the Collegiata of Solofra between 1630 and 1635: *Christ in the Garden* (perhaps painted in collaboration with his father Giovanni Tommaso Guarino), the *Liberation of St Peter*, *Joseph's Dream*, and *Joseph Warned by the Angel*. Of the same date are *Christ in the Temple* and the *Circumcision*, which are more elaborate, akin to Francesco Fracanzano's style and also showing signs of the influence of Poussin's classicism.

The half-ruined *Annunciation to the Shepherds* (Collegiata, Solofra) was painted in the mid-1630s, slightly later than the first group of pictures, in it the influence of Velasquez, then on his first Italian journey, is apparent. Two paintings of the *Martyrdom of St. Agatha*, both in the parish church of S. Agata, Irpina, belong to the same date. Like almost all the Neapolitan school Guarino succumbed to the influence of Van Dyck and of the Venetians: his style is a synthesis of these influences blended with the classicism of Stanzione's maturity. To this period belong both the *Annunciation to Zacharias* of 1637 (Collegiata, Solofra), which draws freely on Stanzione's painting of the same subject in the Prado, and the *Immaculate Conception* of 1637 (Congrega dei Bianchi, Solofra).

The next group of paintings show the influence of Cavallino; they include the

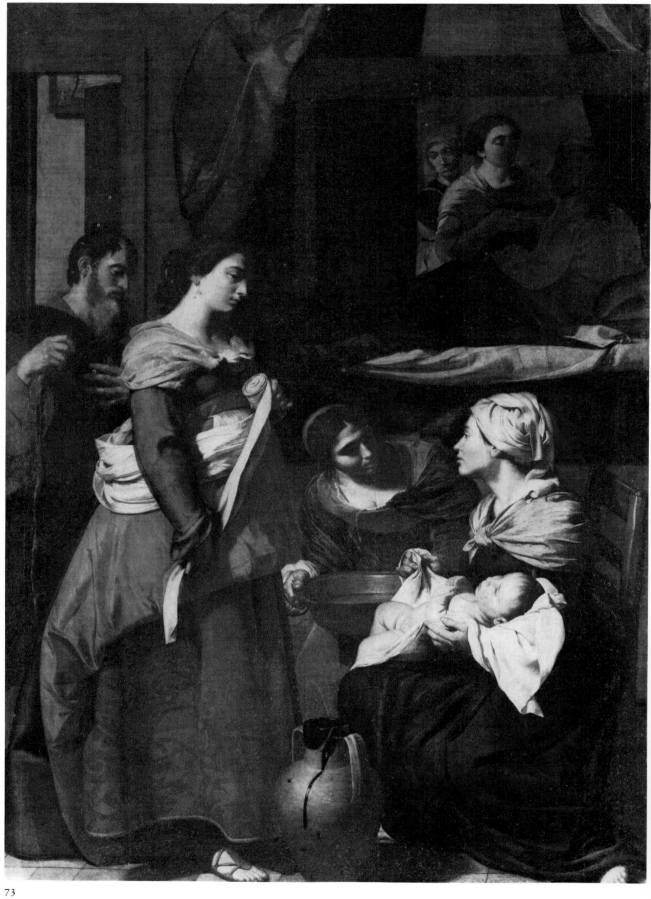

Annunciation of 1642 (Solofra) and the altarpiece of *St. Benedict* in S. Antonio Abate, Campobasso of 1643. It was at this time that Guarino perfected his own baroque style based on that of Stanzione, clearly visible in the two versions of the *Madonna of the Rosary* of 1644 (S. Domenico, Solofra) and 1645 (S. Maria di Materdomini, Nocera Inferiore) and in the two versions of the *Death of Joseph* (Solofra and S. Sossio di Serino) which are free versions of the painting of the same subject by Stanzione at S. Diego all'Ospedaletto, Naples. The *Madonna del Suffragio* at Gravina di Puglia is a late work.

In the mid-1640s Guarino was still enlarging his repertoire, assimilating the styles of Poussin, Domenichino and even Francesco Cozza, as can be seen in the *Baptism of Christ*, the *Assumption of the Virgin* and the *Christ with Angels*, all in the Collegiata at Solofra.

His brief career was ended (according to De Dominici) when he was involved in some jealous feud while working at the 'court' of Ferdinando Orsini at Gravina di Puglia. Although there is some doubt about the place and circumstances of his death, a document at Solofra gives the date: 13 July 1654.

R.L.

73
Birth of the Virgin

170 × 118 cm
Catello Collection, Naples

Traditionally ascribed to Stanzione, Ortolani recognized the picture as the work of Guarino (Naples 1938); it can be dated to the first half of the 1630s (Schleier 1975). Noting that this work had the same dimensions and a nineteenth-century frame identical to that of Guarino's *Visitation* (Berlin Museum), Schleier deduced that the two pictures had been together in the last century and that they might have formed part of a Marian series of paintings destined for the chapel of a church.

The style of the *Birth of the Virgin* is very close to the *Annunciation* in Solofra, dated 1642, and to *St. Benedict Freeing a Possessed Monk* (Church of St. Anthony Abbot, Campobasso), dated 1643 (Pace 1980). This last picture is typical of Guarino's mature style: in it he combines his earlier naturalism derived from Velasquez, evident in the *Annunciation* at Solofra, with a strongly classical idiom derived from Stanzione and Roman painting. The *Birth of the Virgin* is close to Velasquez's early style in the articulation of space and the inclusion of a still life with a water-pot in the foreground.

The clear rendering of the forms, the carefully organized composition and the brilliant colouring, derived from Stanzione and Ribera, are indicative of the mastery of Guarino's

mature style. He portrays working men and women with dignity and without recourse to rhetoric, and meticulously records their picturesque costumes (Cirillo Mastrocinque 1978).

R.L.

PROVENANCE
Scarfoglio Coll.; Matarazzo di Licosa Coll.

EXHIBITIONS
Naples 1938, p. 56; Bucharest 1972; Naples 1972

REFERENCES
Bolaffi 1974, VI, p. 205;
Bologna in Salerno 1955, p. 59;
Causa in *Storia di Napoli* 1972, pp. 931, 974;
Cirillo Mastrocinque 1978, p. 191; Pace 1980, p. 150;
Schleier, 1975, pp. 27–30

74†
The Madonna of the Rosary

350 × 230 cm
Inscribed and dated: on a cartello by St. Hyacinth, GIACINTI; on the paving *1644*; on the throne *1649*;
S. Domenico, Solofra

This great altarpiece is placed at the end of the left transept in S. Domenico, Solofra, annexed to the convent of the same name. Painted in 1644, it commemorates the start of the building of the convent at the instigation of Dorotea Orsini, ex-feudatory of Solofra, mother of Ferdinand Orsini and grandmother of Vincenzo Maria Orsini, the future Pope Benedict XIII. The construction was supervised by Dorotea, together with Fabrizio Sabelli, Bishop of Salerno from 1642–58 and Vincenzo Candido, General of the Dominican order and first prior of the monastery in 1646, the year in which the monks were installed (Lattuada 1981). All three are shown on the left of the painting. Innocent X, created pope in 1644, is also included; he was Sabelli's patron and raised him to the purple in 1647. The roses held by the cherubim allude to the Orsini roses which formed part of the family's coat-of-arms.

The painting was eulogized by Giovanni Canale, a marine poet in the Orsini circle (1694). It was probably Guarino's first important commission from the powerful family who were later his chief patrons: more than 28 works attributed to the artist are listed in the eighteenth-century inventories of the works of art then in their Neapolitan palace (Rubsamen 1980).

This is one of Guarino's most refined works; although influenced by Stanzione's *Madonna of the Rosary* (Capodimonte), it is saved from being a mere pastiche in Stanzione's style by the three portraits, amongst the most intense in early Seicento Neapolitan painting. The vivid rendering of this austere group of three of the foremost members of Solofra society is inserted into a picture which is still academic in style.

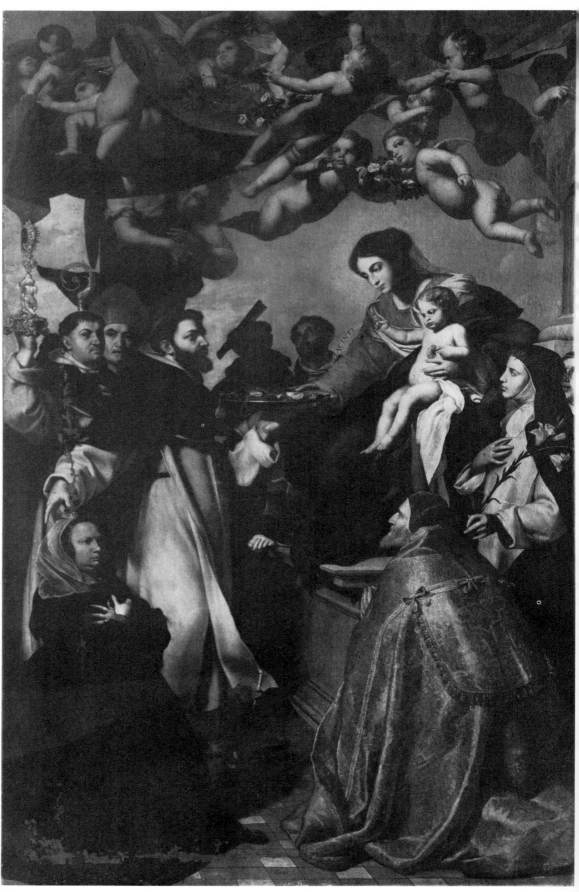

The restoration, which at the time of the Academy exhibition is still in progress, has brought several new elements to light. The date of 1644 is overpainted over the original, and a second date of 1649 has emerged on the throne, indicating in the restorers' view that Guarino worked on the picture again then, an interpretation supported also by the existence of two distinct layers of painting.

R.L.

EXHIBITIONS
Salerno 1955, no. 25

REFERENCES
Bologna 1955, p. 61, 83;
Causa in Storia di Napoli 1972, V, II, p. 931;
Lattuada 1981, forthcoming publication;
Pacelli 1979², p. 386; Rubsamen 1980, pp. 47–67, 95–117

74A

Liberation of St. Peter

163 × 223 cm
Collegiate Church of S. Michele Arcangelo, Solofra

One of the 21 canvases in this church, the subject

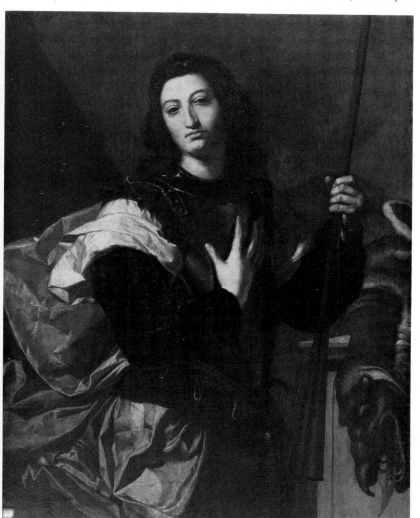

has only recently been correctly identified following recent restoration. It must be one of Guarino's earliest works, c. 1630–32, revealing a Caravaggesque naturalism close to the work of his teacher Stanzione in the 1610s and 1620s. This is consistent with the echo of Caracciolo's picture of the same subject (Cat. 7) and with the *Adoration of the Magi* (S. Martino).

The archaic nature of the composition is underlined by the derivation from Vitale's *Guardian Angel* (Cat. 162) of the diagonal stance of the angel. The hanging lamp derives from Honthorst. There does not appear to be any connection with the Master of the Annunciations, apart from the choice of humble subject-matter. The composition is more crowded than Stanzione's Caravaggesque works, and shows that Guarino's early style is a transition towards the innovations in Ribera's circle at the end of the 1620s.

R.L.

REFERENCES
Bologna, 1955, p. 58; Bossaglia, 1965, pp. 421–22; Bolaffi 1974, VI, pp. 204; Causa, 1957; Grieco, 1963, pp. 34–35, 94; Landolfi, 1852, p. 17; Lattuada, 1982, forthcoming publication

This painting was included in the exhibition when it became obvious that the restoration of the Madonna of the Rosary from Solofra would not be completed in time for the Royal Academy exhibition.

75

St. George

130.5 × 102 cm
Collection of the Banco di Napoli, Capodimonte

Formerly attributed to Bernardo Cavallino, *St. George* was given to Guarino by Molajoli (1951) and Bologna (1955). In 1953 Molajoli attributed it to a painter between Guarino and Finoglia, but later reverted to his attribution to Guarino.

This painting can be dated towards the end of the 1640s; its strongly graphic style and shrill colour are typical of Guarino's last works. The extreme psychological coldness of the painting demonstrates his move towards a classical style more rigorous than that of Stanzione's maturity.

It is possible that *St. George* is an allegorical portrait of a nobleman, like *St. Cecilia at the Harpsichord* (Capodimonte) which is traditionally said to be a portrait of Giovanna Frangipane della Tolfa, wife of Ferdinando Orsini (Landolfi 1852).

R.L.

PROVENANCE
Formerly in the Gualtieri-De Biase Coll.
EXHIBITIONS
Florence 1922, no. 259; Naples 1938, p. 319;
Florence 1954, p. 4; Bucharest 1972; Naples 1972
REFERENCES
Bologna in Salerno 1955, p. 60;
Causa in Storia Di Napoli 1972, V, II, pp. 931–32;
Lattuada 1982, forthcoming publication;
Landolfi 1852, pp. 26–27; Molajoli 1951, no. 33;
Molajoli 1953, pp. 28, 51

75

76
St. Agatha

87 × 71.5 cm
Capodimonte, Naples
(*repr. in colour on p. 78*)

This is perhaps the most famous work of the early Seicento in Naples. Dalbono (1871) cited it as one of Stanzione's masterpieces; it was first attributed to Guarino in 1957 by Bologna (reported by Causa 1957). The attribution has been generally accepted, the only dissenting voice being D'Argaville (1972) who returned it to Stanzione, remarking on its similarity to the *St. Agatha in Prison* (Capodimonte). The present writer retains the attribution to Guarino and dates the picture in the mid-1630s.

There are similarities between this work and the *Annunciation to the Shepherds* in the Collegiata at Solofra, where the shawl of the woman seated on the right, the shadows on her shoulders and, above all, the dazzling shirt of the shepherd lying on the ground are all close to the *St. Agatha*. The picture belongs to a compositional type of female half-length introduced to Naples by Vouet; Stanzione and all his circle were influenced by the French master, but after 1635 Stanzione himself turned to Reni for inspiration, while Guarino stayed loyal to the influence of Vouet; it was only in the 1640s that he approached Stanzione's style again in such works as the *Scene of Martyrdom* (Ponce Coll., Puerto Rico).

For these reasons a date around 1637 is suggested, the year of the *Immacolata* in the Congrega dei Bianchi. The paintings share the same method of defining the face by shadow, which plays such a spectacular part in the *St. Agatha*. The presentation of the subject is exceptional too, the fixed gaze of the saint looking out at the spectator detracting from the horror of the subject and St. Agatha's sanctity.

In the nineteenth century the Sicilian engraver Francesco Di Bartolo made an engraving of the painting with the inscription *Massimo Stanzione dip.* (an example is in the Castello Ursino Coll.), and it was to this engraving that Dalbono referred to in 1871. But this cannot be taken as documentary evidence that this is the work of Stanzione, only an indication that the painting was then considered to be by that master.

R.L.

PROVENANCE
Certosa di S. Martino, Naples

EXHIBITIONS
Florence 1922, no. 934; Naples 1938, pp. 43, 118; Rome 1956, pp. 224–25; Paris 1965, p. 159; Bucharest 1972; Naples 1972

REFERENCES
Bolaffi 1974, VI, p. 205; Causa 1957, p. 37; Dalbano 1871, p. 104; D'Arganville 1972, p. 809; Lattuada 1982, forthcoming publication; Libertini 1937, p. 156

Giovanni Lanfranco

PARMA 1582–ROME 1647

Lanfranco was first taught by Agostino Carracci in Parma (until 1597 and 1600–02). After Agostino's death in 1602, the Duke of Parma sent Lanfranco to Annibale Carracci's studio in Palazzo Farnese, Rome, and Lanfranco's first independent work was the decoration of the Camerino degli Eremiti in the Palazzina Farnese (1605). On Annibale's recommendation he entered the service of the Marchese Cardinal Sannesi and then worked for Cardinal Montalto, the powerful nephew of Sixtus V. Around 1610, still mainly influenced by Annibale, he also worked for the nephew of Pope Paul V, Cardinal Borghese (S. Gregorio, S. Sebastiano) and for the pope himself. On Annibale's death in 1609 he returned to Emilia and worked for two years in Piacenza, where he received numerous commissions for altarpieces. They show a radical, if temporary, stylistic change under the influence of Lodovico Carracci and Schedoni.

After his return to Rome in 1611, the artistic scene was dominated by Reni (until 1614) and Domenichino, and it took Lanfranco several years to establish himself. But by 1616 he was one of the chief painters at the Quirinal Palace (Sala Regia) and in 1619 Paul V gave him what would have been, had it not been cancelled after the Pope's sudden death, the largest public commission of the day: the decoration of the Benediction Loggia in St. Peter's.

By 1615–17 Lanfranco had abandoned his Lodovichian style; working in the circle of the Caravaggisti *nobilitati* like Sarceni, Gentileschi and Turchi and influenced by artists like Borgianni, he created a highly refined, elegant manner, working with subtle chiaroscuro and creating a new unity of space through atmospheric effects. It is this particular phase of his work that influenced not only Simon Vouet, but also Caracciolo, who arrived in Rome at that time. Lanfranco was then the most advanced artist there, and he might have retained his position if Paul V had not died in 1621. But Gregory XV's brief reign brought Guercino to Rome, and Domenichino into particular favour. Around 1620 Lanfranco's style began to change, becoming more robust, the figures beginning to expand dynamically into the space with more violent chiaroscuro contrasts. The most important works of this phase, a prelude to his fully mature baroque style, are the Sacchetti chapel in S. Giovanni dei Fiorentini (1623–24) and a number of stylistically related altarpieces.

The decoration of the Cappella del Sacramento in S. Paolo fuori le Mura and the fresco of the loggia vault in the Casino Borghese

(both 1624–25) lead on to Lanfranco's most important mature works, in which his dramatic baroque style became fully developed: the cupola fresco in S. Andrea della Valle, where Correggio's illusionism is transposed into the language of the baroque, and the altar fresco of the Navicella (1627–28) in St. Peter's. This was his most important papal commission from Urban VIII, together with the frescoes of the Cappella del Crocefisso in St. Peter's (1629–32) and the high altar of the Cappuccini.

But by now Lanfranco was eclipsed by the leading artists of the Barberini court – Bernini, Sacchi and Cortona. He received far fewer public commissions and consequently willingly accepted the invitation of the Jesuits in Naples to paint the huge cupola of the Gesù Nuovo (1634–36), thus following in the footsteps of his Bolognese colleague and rival Domenichino, who had gone to Naples in 1631. The Gesù Nuovo was the first of a series of vast commissions that made him, during the 15 years of his stay there, the most successful fresco painter in Naples; they included the nave vault, lunettes of the interior façade, lunettes of the presbytery at S. Martino (1637–39), frescoes throughout the church of SS Apostoli, excluding the cupola (1638–44), and the cupola fresco of the Cappella del Tesoro, in the Cathedral (1643), which Domenichino had failed to paint. He was also involved in the Spanish viceroy's commission of pictures with scenes from ancient Roman life (Cat. 78), for the Buen Retiro Palace in Madrid. Finally, he shared in the decoration of the cathedral at Pozzuoli (c. 1635–50; Cat. 77).

In 1646 Lanfranco returned to Rome, where he painted his last major work, in S. Carlo ai Catinari. In his Neapolitan works he developed his mature Roman style further and was stylistically ahead of his time. His work had a strong impact, not so much on his contemporaries, but on the painters after the plague of 1656: Giordano, Preti and, later on, Solimena. His direct followers were Giacinto Brandi in Rome and Giovanni Battista Beinaschi in Naples.

E.S.

77

Landing of St. Paul in Pozzuoli

306 × 203 cm
Museo Nazionale di S. Martino, Naples (on deposit from the Cathedral of Pozzuoli)

The painting belonged to a series of 11 paintings (by Lanfranco, Artemisia Gentileschi, Agostino Beltrano, Francesco Fracanzano, Massimo Stanzione and Paolo Finoglia) that decorated the walls of the choir and presbytery of the Cathedral of Pozzuoli until the church was destroyed by fire on 16–17 May 1964. The subject, the *Landing of St. Paul in Pozzuoli* on his way from Malta to Rome, is briefly told in the *Acts of the Apostles*, XXVIII, 13–14. The choice of this subject for a painting in the cathedral at Pozzuoli is self-explanatory; otherwise it is extremely rare.

In 1938 Ortolani dated the painting to the end of Lanfranco's Neapolitan period *c.* 1646 (Naples 1938), but D'Ambrosio's archival research (1973) has shown that it was painted between 1636 and 1640, at the same time as most of the other pictures in the choir; Beltrano's painting is dated 1640. After 1640 certain changes were made in the arrangement of the pictures. Two other paintings by Lanfranco and his studio (the *Martyrdom of SS Onesimus and Erasmus* and the *Capture of S. Artemas*, signed,

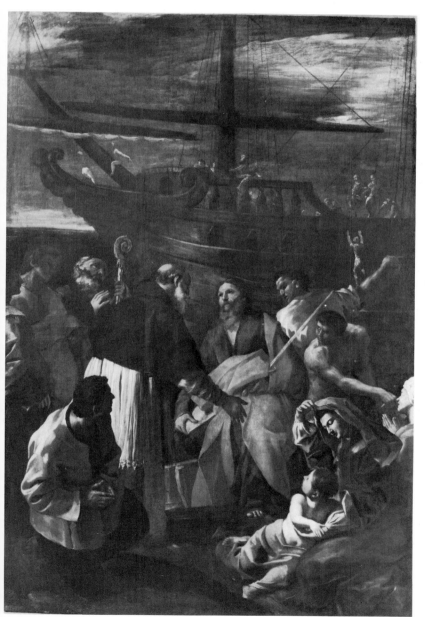

77

but executed by assistants from Lanfranco's designs) were hanging next to the *Landing of St. Paul* until 1964. Since they are not mentioned among the pictures described in the *Visita Pastorale* of 1640, they were apparently painted and placed in the choir after 1640. They are later in style than this painting.

The restructuring of the church was done on the initiative of the Bishop Martino de Leòn y Càrdenas (who reigned from 1631–50), in various phases from 1632–49. Lanfranco also frescoed the choir vault before 1640 and the dome of the sacrament chapel between 1640 and 1646. The choir fresco is briefly described in the 1640 *Visita*; a drawing in Capodimonte (no. 518) may relate to it. The frescoes which are mentioned by Scaramuccia (1674) apparently deteriorated and vanished very soon, as a passage in Passeri's biography of Lanfranco (before 1679) seems to imply. The *Landing of St. Paul* (or *Reception of St. Paul after his Landing*) is briefly mentioned by Lanfranco's other biographer, Gio. Pietro Bellori.

The painting has always been considered one of the most powerful and innovative pioneering works of Lanfranco's Neapolitan period, 'because of the originality of the contrasting light effects in the foreground, the picturesque quality of the ship in the background lowering its sails, and the bystanders, where Lanfranco displayed his virtuosity as a fresco painter'. (Ortolani 1938). The proportions of the figures, their elongated bodies and the facial types of the younger male figures; the rather warm palette with light red, yellow and white alternating with dark browns and greens, the sombre, broadly painted background (anticipating Salvator Rosa) and the chiaroscuro are all very close to the Roman history pictures painted for the Viceroy Conde de Monterrey (*c.* 1634–37, eg. Cat. 78) and the Brunswick *Finding of Moses* which is of the same date. The dramatic violence of the Roman histories is tempered here by the solemn character of the scene, but is still present in the figures of the two sailors behind St. Paul. The one dressed in red, seen from the back, is reminiscent of the executioner in the *Martyrdom of St. Paul* in SS Apostoli (1638–39). A preliminary chalk drawing for the naked sailor is preserved in Capodimonte (no. 314 verso; the recto for SS. Apostoli). Another chalk drawing, showing the figure in the same pose, but dressed, may also be related (no. 650 r.).

Except for a possible influence on some of Schönfeld's sombre works of the 1640s (and perhaps Vaccaro and to a certain extent Micco Spadaro), Lanfranco had little influence on most contemporary Neapolitan painters – Stanzione, Guarino, Finoglia, Ribera and the Fracanzanos – and only a marginal influence on Cavallino; nor was he influenced by them. It was only ten years after his death in 1647, and after the plague

of 1656, that Lanfranco's influence took effect on Giordano, Preti and Solimena.

E.S.

PROVENANCE
Pozzuoli Cathedral; on deposit at Museo di San Martino, Naples 1964
EXHIBITIONS
Naples 1938, p. 81 (Ortolani)
REFERENCES
Causa in Naples 1964, p. 5;
D'Ambrosio 1973, pp. 29–31; Longhi 1961, I, p. 263;
Passeri ed. Hess 1934, p. 158; Salerno 1958, p. 60;
Schleier 1965, p. 363; Schleier 1980, pp. 29–31

78

Roman Gladiators Fighting at a Banquet

232 × 355 cm
Museo del Prado, Madrid (no. 3091)
(*detail repr. in colour on p. 93*)

This painting is one of a group of six pictures by Lanfranco of scenes from ancient Roman life, which the Conde de Monterrey ordered, together with others from Roman and Neapolitan artists, for the decoration of the Buen Retiro Palace. Monterrey, brother-in-law of Philip IV's minister Olivares, was Spanish Ambassador to the Holy See in Rome 1628–31 and then Viceroy of Naples 1631–37. At least two shipments of paintings were sent by him to Madrid, one in November 1633 and another in October 1638, on his return to Spain.

Three other Roman painters worked on the series: Domenichino, his former pupil Camassei and Romanelli. Sacchi and Cortona were not involved. Bellori says that Domenichino painted his '*Exequies of a Roman Emperor*' after the artist had fled Naples, in 1634. The passage in Passeri makes it clear that Monterrey's commission to Domenichino dates from well before 1634, and that he was originally to paint several history paintings, but could only do one because of the pressure to finish the work on the Cappella del Tesoro in the Cathedral. The other firm date is given by Lanfranco's letter of 10 December 1637 to Ferrante Carli (Bottari, Ticozzi 1822), in which he informs his correspondent that the viceroy had ordered two more paintings from him for the King of Spain. Passeri's mention of the pictures is interwoven in his account of the commission to fresco the cupola of the Gesù Nuovo in Naples; in the correspondence Lanfranco's name appears only from early 1633 onwards (Bösel 1977), making it likely that Monterrey's commission dates from his time as viceroy, therefore *c.* 1633–34.

Lanfranco did at least six, and possibly seven paintings; they are somewhat different in size and must have been painted at intervals between 1634 and 1637. Only five autograph paintings were known to Pérez Sánchez (1970); the correct

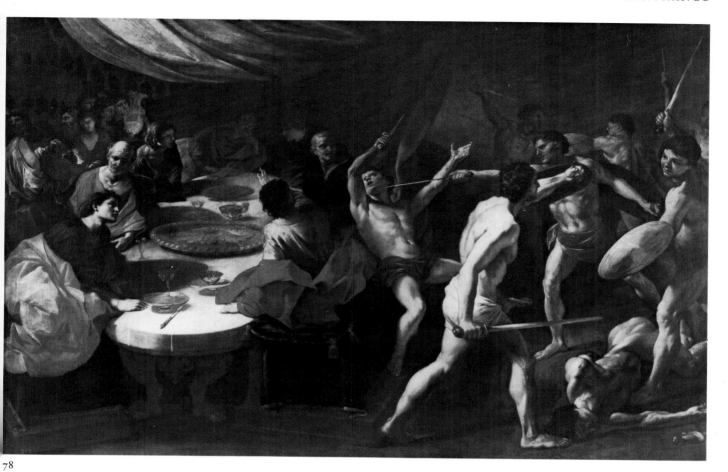

78

number, six, was given by Brown and Elliott
(1980) who believed the *Triumphal Scene* to be
lost, although in fact it had been retraced prior
to 1977 by Markus Burke and it corresponds
with the composition in Lanfranco's etching,
Bartsch 31. This unpublished work is now at the
Royal Palace of Aranjuez and is probably to be
identified with an entry in the Retiro inventory
of Charles II (1700–01), subsequently in the 1746
inventory of the Palace of San Ildefonso at La
Granja with another picture that was possibly a
seventh Roman history by Lanfranco.

The other paintings in the series, all in the
Prado, are as follows: *Exequies of a Roman
Emperor* (335 × 488 cm), *Roman Naumachia*
and *Sacrifice performed by a Roman Emperor*
(each 181 × 362 cm, the same dimensions as the
painting now at Aranjuez) and, finally, the
Allocution of a Roman General (230 × 362 cm),
which is the companion to the picture exhibited
here. These two paintings are of the same size as
Domenichino's *Exequies of a Roman Emperor*,
Romanelli's *Gladiators*, Camassei's *Lupercalian
Celebrations* and Stanzione's *Bacchanal*, the
only work by a Neapolitan painter in the series.
Another painting of *Gladiators*, formerly given
to Poussin and Perrier but now accepted as by .
Camassei, is of yet different dimensions. Which
of the six (or seven) Lanfrancos are the ones

mentioned in his letter of 1637 cannot be
established, although stylistic considerations
and their common dimensions suggest that they
may have been the picture shown here and the
Allocution of a Roman Emperor (Madrid 1970,
no. 108).

The commissions from Madrid for pictures of
Roman scenes continued well into the 1640s
and, after 1637–38, most of them were given to
Neapolitan artists. Vitzthum (1967) described
all the paintings in the series as one large
commission that was continued by the next
viceroy, the Duque Medina de las Torres (1637–
44). Brown and Elliott (1980), however, believe
that the orders from Madrid were for two
independent series of scenes from ancient
Roman life. Most or all of the paintings by
Roman artists, together with the one by
Stanzione, were probably commissioned in the
1630s, and this group varied in subject matter
and dimensions. The paintings by Neapolitan
artists probably mainly date from the first half
of the 1640s.

The Roman histories were not the only
decorations done for the Buen Retiro: there was
a series of scenes from the life of St. John the
Baptist by Stanzione and Artemisia Gentileschi
(c. 1634–35) and two series of anchorite
landscapes which were commissioned in Rome

by the Marquis of Castel Rodrigo, the Spanish Ambassador at the Holy See (1631–41) from Claude, Poussin, Both, Dughet, Lemaire and others.

E.S.

PROVENANCE
Palacio del Buen Retiro

EXHIBITIONS
Madrid 1970, no. 108

REFERENCES
Bellori 1672, (1976 ed.), p. 389, n. 2;
Brown and Elliott 1980, pp. 123–27;
Madrazo 1872, no. 282;
Perez Sanchez 1965, pp. 156–57, 159;
Perez Sanchez 1968, p. 34; Perez Sanchez 1970;
Schleier 1970, p. 344

79
The Dream of Joseph

178.8 × 216.5 cm
Viscount Coke, D.L.

The subject of the picture is drawn from the *Apocrypha*, in the Proto-evangelist Jacob. When Mary told Joseph that she was pregnant and that she did not know how this had happened, he was troubled and wished to send her away. An angel appeared to him in his sleep and told him that the child was conceived by the Holy Spirit, and that Mary would give birth to a son, to be named Jesus, who would redeem his people. Joseph awoke and gave thanks to God.

This unpublished picture is obviously a late work painted in Naples, probably in the early 1640s. As far as the present writer knows, it is the only authentic Lanfranco which has been in a British collection since before 1800. The figure of Joseph repeats almost exactly that of St. Peter in the picture of *Christ at Gethsemane with an Adoring Theatine Bishop*, one of the five canvases in the apse of SS Apostoli, Naples painted between 1638 and 1641. A preliminary drawing for this figure, carefully modelled in black and white chalk and squared in black chalk, is in Dusseldorf (13679 recto). It was probably made for the figure of St. Peter in the SS Apostoli painting and used again for the figure of Joseph in this picture. The subtle study of the face on the verso seems closer to the face of Joseph than to that of St. Peter.

It is tempting to relate *The Dream of Joseph* to the lost paintings from SS Annunziata, which were painted in 1641 in oil (on the wall or on canvas?) on the arches over the lateral arcades to the left and to the right of the high altar. They were destroyed in the fire of 1757, but they are described by both Passeri and Bellori and also by Celano, Cochin and others. On the left arch was shown the dream of Joseph concerning Mary's pregnancy, while over the right arch was the dream of Joseph before the flight to Egypt. Unfortunately preliminary drawings survive for only this latter scene (in Haarlem; Bean and Vitzthum 1961). But the coincidence of the dates of the SS Apostoli canvas and the lost SS Annunziata painting, 1641, makes our hypothesis more probable and would suggest a date of *c.* 1641 also for the Holkham picture.

E.S.

REFERENCES
Bean and Vitzthum 1961, p. 110, n. 4, figs 10–11

The Master of the Annunciations to the Shepherds

It is still not possible to identify this master, one of the most important in seventeenth-century Naples, since there is a total lack of documentary evidence; it is possible only to give a summary of current research.

The Annunciation to the Shepherds (City Art Gallery, Birmingham) was originally attributed to Velasquez. Mayer proposed the name of Bartolomeo Bassante, Ribera's best pupil according to the sources, whose work was sometimes confused with his master's (Mayer 1923). Longhi (1935) accepted the attribution of the Birmingham painting to Bassante and stressed the importance of his work in the context of Neapolitan painting, pointing out that in the wake of Caravaggio, gospel subjects were transformed into pastoral and peasant scenes, and that such subjects as the Nativity and the

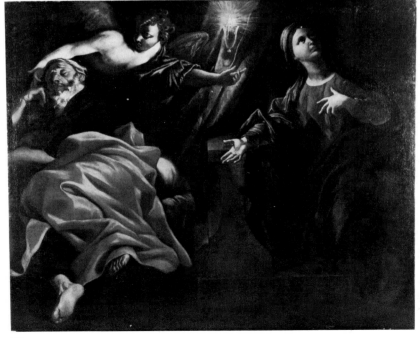

79

Annunciation to the Shepherds were chosen specifically for their pastoral content rather than their religious significance. In this way, the *Marriage of Jacob and Rachel* is painted as a *repas de paysans*.

Bologna named the painter of the Birmingham picture the Master of the Annunciation of the Shepherds, dated his works in the early 1630s and removed the Prado *Nativity*, which is signed Bassante, from his oeuvre (Bologna 1955 and 1958).

Following this Perera has added to the master's oeuvre the two versions of *St. Paul*, one in Brazil and the other in the Franciscan Convent of Ayu-Karem in Palestine, and Causa has attributed to him the two versions of the *Prodigal Son* at Capodimonte and *Jesus among the Doctors* in the Gesù Nuovo, indicating that this was the moment at which he was closest to the style of Fracanzano. Causa has also added to the oeuvre of Bassante, or Passante, working from the signed painting in the Prado.

Returning to the Master of the Annunciations, Causa suggested that he might be a painter of Spanish origin, possibly from Seville, because of the evident relationship between *Los Borrachos* and this painter's

shepherds. Attempts to identify him with Giovanni Do have not been convincing. Longhi continued to assert that there was only one master, Passante or Bassante, but shifted the dating of his work to the 1640s since Bassante was born in 1611 and was still in his father-in-law's studio in 1636 (of this painter we have no record). Bassante died in 1648.

Several paintings of biblical subjects, genre scenes, some half-length figures and some portraits of a style compatible with that of this anonymous master have still to be published.

G.D.V.

REFERENCES
Salerno 1955, p. 55; Bologna 1958, pp. 18, 30, 32;
Causa 1957, p. 37; Causa 1966[1], pp. 3–4;
Causa in *Storia di Napoli* V, II, pp. 930–31;
Longhi 1935, p. 1;
Longhi 1969, pp. 50–52; Mayer 1923, pp. 176–77;
Perera 1957, pp. 211–22; Perez Sanchez 1961, pp. 325–27;
Perez Sanchez 1965, pp. 372–75;
Sterling Maxwell 1848 (1891 ed.), IV, pp. 1, 575

80

Annunciation to the Shepherds

180 × 261.5 cm
Capodimonte, Naples

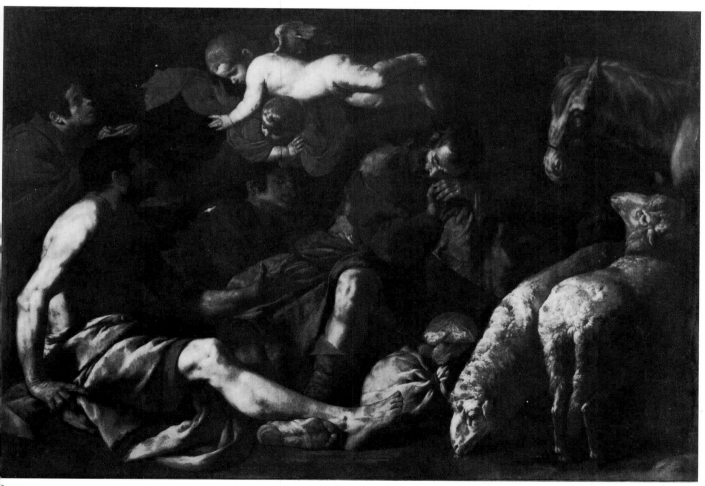

'And there were in the same country shepherds abiding in the field, keeping watch over their flock by night . . . and suddenly there was with the angel a multitude of the heavenly host praising God, and saying Glory to God in the highest, and on earth peace, good will toward men'. (*Luke*, II, 8–14.)

The consolatory theme justifies its frequent recurrence in Counter-Reformation iconography. Here the supernatural is almost entirely suppressed in favour of the earthly aspect, in which the presence of men and flocks together offers the opportunity for a realistic painting of humans and beasts observed from life. Significantly, the Angel of the Annunciation, usually included in the subject, is absent. The protagonists are markedly Iberian.

The light comes from a source practically parallel to the picture surface and, together with the use of clothing to emphasize or frame a figure (the red binding around a leg, the grey mantle), suggests a careful and deliberate handling similar to that in other works dating from early in this master's career. There are at least eight other versions of this subject apart from those in Birmingham and in Munich. Some are on a small scale (Chomont, Nantes) and their unfinished appearance suggests they may be preparatory studies for larger compositions.

G.D.V.

PROVENANCE
On deposit from the Museo di S. Martino

EXHIBITIONS
Naples 1963, pp. 50–61; Bucharest 1972; Naples 1972

REFERENCES
Bologna 1958, pp. 29–31; Causa 1957, p. 37;
Causa 1966[1], pp. 3–4;
Causa in *Storia di Napoli* 1972, V, II, p. 930;
Pacelli 1979[2], p. 379; Scavizzi 1963, p. 51

81

81

The Return of the Prodigal Son

102 × 126 cm
Capodimonte, Naples

Luke, XV, 21: 'And the son said unto him, Father, I have sinned against heaven, and in thy sight, and am no more worthy to be called thy son . . .'.

The story of the Prodigal Son is common in the seventeenth-century theatre, especially in the work of the Spaniard Lope de Vega; it recurs frequently in his *Autos*. Of Lope's interpretation it has been written: 'his naturalism seeks the essence of reality in the elementary and the simple, but at the depth where individual feeling is lost in the universal and collective', a conception which can apply equally to this painting, in which the contrasts in light and shadow create the intensity of the colours themselves, against a grey background which increases the depth of the image.

Causa has observed that the picture is close to the work of Fracanzano, to whom this picture had in the past been attributed. This is apparent in the rich colour, the negation of light and the adherence to neo-Venetian ideas then circulating in Naples.

G.D.V.

EXHIBITIONS
Bucharest 1972; Naples 1972

REFERENCES
Bologna 1958, p. 29 (as Fracanzano);
Causa in *Storia di Napoli* 1972, V, II, p. 976, n. 75

82

Genre Scene

78 × 101 cm
Museo di Roma, Palazzo Braschi (on deposit from the Capitoline Museums)

Against a naturalistic background centred around the figure of the shepherd, an academic note is sounded by the inclusion of the youth garlanded with flowers. The subject of the painting is almost a return from work in the fields. The painting is unpublished.

G.D.V.

PROVENANCE
De Horatiis Collection, Naples; Polak Collection; donated by Margaret Sussman Nicod 1958

REFERENCES
Nobile 1863, II, p. 104 (as Murillo)

83

Adoration of the Magi

127 × 180 cm
Matthiesen Fine Art Ltd., London

82

The broad and monumental composition, the tender intensity of the facial expressions, the fluid enveloping light and the delicacy of the paint point to a date around 1634–35. This is one of the largest pictures known from this anonymous hand. At this date, the two trends in Naples – the naturalism of Ribera and the Master of the Annunciations in the 1620s and the more classical style of Massimo Stanzione – both came into contact with the intense and luminous painterly styles of Van Dyck, Rubens and the Venetians, from which they took an enhanced quality of light and colour and a greater delicacy of expression.

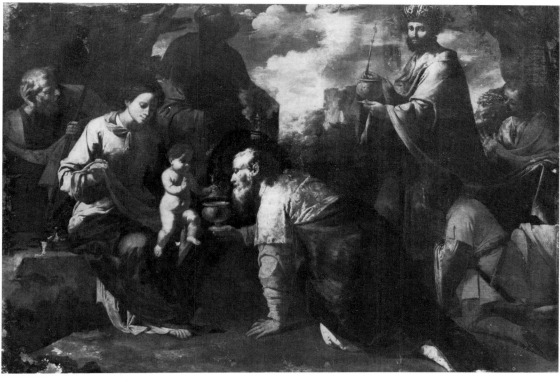

83

The chief exponent of this development was Ribera. But the most prominent representative of the naturalistic painters closer to Velasquez was the Master of the Annunciations, probably himself a native of Spain. This *Adoration*, exhibited for the first time, is later in date than the other Annunciations to the Shepherds in Capodimonte, the Stephens Collection, Brooklyn (N.Y.) and Birmingham (slightly later than the other two). Some compositional devices had already been used, either in the pictures already cited or in the *St. Simeon* (Museum of San Carlos, Mexico City; formerly ascribed to Ribera, perhaps datable *c.* 1630) and the *Girl with a Rose* (Cat. 84), where the portrait of the girl is the immediate precursor of the Madonna in the *Adoration of the Magi*.

This gradual change to a more soft and painterly style, away from his past naturalistic vigour, can be charted from the *Adoration of the Shepherds* in the Longhi Collection, Florence and the versions in the Museum of São Paulo in Brazil and the Pinacoteca, Rimini to the *Annunciation to the Shepherds* in the Falanga Collection, Naples (Bologna 1958). The Falanga picture was once attributed to Cavallino, who certainly painted its pendant of the *Flagellation* in the same collection. The last in the series is the *Adoration of the Magi* (ex Ruffo della Scaletta Coll., Rome).

There is a painting of a single Magus (Marsicola Coll., Rome) which could be a fragment of the ex-Ruffo picture (opinion of the present owner). In any case there is a close link between the turbaned king in the Marsicola picture and this *Adoration of the Magi*, not only because the Magus in the fragmentary canvas almost exactly reproduces the figure of the standing king on the right in this composition in reverse, but also because the two figures are close in colour, with the light vibrating on the damasked robes, and share a sensation of warm humanity in the rendering of the faces.

The links between the Master of the Annunciations and Cavallino seem strongest *c.* 1635–40 (which would suggest a date of *c.* 1637–38 for the octagon and the *Annunciation to the Shepherds* in the Falanga Collection) and it is evident that Cavallino had the present painting in mind when he painted his youthful *Adoration of the Magi* (Kunsthistorisches Museum, Vienna).

This picture, which is unpublished, is the pendant of the *Annunciation to the Shepherds* exhibited by Matthiesen (London 1981, no. 8).

N.S.

REFERENCES
Bologna 1958, p. 31

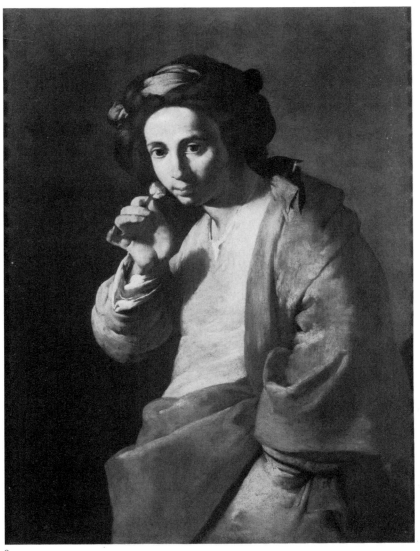

84

84

Girl with a Rose

103.5 × 78.5 cm
De Vito Collection, Naples

The subject may represent 'Smell'; there are Riberan precedents for a naturalistic presentation of the five senses and, given the same painter's pictures of a mandolin-player, who could be taken to represent 'Hearing', and a male figure at a mirror, who has been interpreted as 'Sight', the girl with the rose may well be a genuine portrait; the air of careless indifference, hand in pocket, and the look of bewilderment set the tone.

There is no doubt that this is one of the earliest works of this master, for whom as yet we have no established chronology; it is related to the ceiling of the Collegiata at Solofra, of the 1630s, especially if one compares the formal vigour with the somewhat slovenly way in which other themes are painted, such as some

biblical subjects and stories of Roman emperors. The picture is unpublished.

G.D.V.

PROVENANCE
Heim Gallery, London

85

The Birth of the Virgin

284 × 201 cm
S. Maria della Pace, Castellammare di Stabia
[*repr. in colour on p. 83*]

This unpublished painting was on the high altar of this church in 1842, recorded by Parisi and ascribed to Giulio Romano. It was transferred to the sacristy before the Second World War and recently has been moved again.

It is clearly by the same hand as the large group of paintings which have been built up around the two Annunciations to the Shepherds at Capodimonte and Birmingham. There are evident stylistic affinities between the Castellammare picture and the Capodimonte *Annunciation* (cf. the flying putti), and with the *Girl with a Rose* (Cat. 84) in the use of chiaroscuro and the strongly geometrical forms of the drapery.

The ample composition and the clear, bright colouring suggests it was painted after the 'crisis of painterliness' of 1633–34 which particularly affected the Neapolitan naturalistic painters including this anonymous master. But it cannot be later than the late 1630s or early 1640s since it displays not only strong naturalistic tendencies, but also has elements in common with paintings of the early 1640s by Cavallino, De Bellis and Nunzio Russo (first documented working in 1644), and even with Stanzione's picture of the same subject on the vault of S. Maria Regina Coeli, Naples, dated 1645.

This anonymous master was a dominating figure amongst the naturalistic painters in Naples between the late 1620s and the early 1640s, and this painting is important since it is his only known work recorded as being in a public building for a considerable length of time. Archival research is already underway to attempt to establish the date of the painting and the name of the artist.

The church of S. Maria della Pace formed part of the convent founded in 1542 and was entrusted to the reformed Carmelite nuns of the Theresian rule. After the suppression of the monasteries in 1860 the convent buildings were used for the local civil tribunal; the church was transformed into a parish church in 1937.

N.S.

REFERENCES
Parisi 1842, pp. 50–51

Master of Palazzo San Gervasio

86

Still Life with Fruit, Flowers and a Dove in Flight

170 × 245 cm
Municipio di Palazzo S. Gervasio, Potenza, on deposit from the D'Errico di Matera Collection.
[*repr. in colour on p. 101*]

The Master of Palazzo San Gervasio and Luca Forte were the first independent Neapolitans to respond to Caravaggio's still-life painting in Rome; the present picture is the most important example by this anonymous hand.

In 1938 the painting was attributed to Andrea Belvedere (Naples 1938), but Causa re-attributed it to Porpora at the outset of his career, while still influenced by his master Falcone (Causa 1951), a hypothesis accepted by Sterling (in Paris 1952), de Logu (1962) and, rather hesitantly, by Marabbottini (in Rome 1956). The attribution was retained in the 1957 exhibition and the Naples exhibition of 1964. But when placed alongside other pictures by Porpora, it seemed obvious that this was the work of a different master, almost certainly earlier than Porpora.

Bottari (1966) noted its connection with the still-life details included in two pictures by Aniello Falcone in the Prado: *The Concert* and the *Expulsion of the Money-changers from the Temple*, and suggested that the Master of Palazzo San Gervasio was Falcone himself.

Finally, Causa linked it to another group of pictures and suggested a chronology (Causa in *Storia di Napoli* 1972). The pictures were the *Still Life with Pigeons and Game* (Pinacoteca, Cremona), the still lifes in the Fleurville Collection, Paris and the Foletti Collection, Milan, the *Still Life with Fruit* (Novelli Coll., Naples and the De Young Memorial Museum in San Francisco).

Certain features of this master's style link him to the circle of Falcone between 1625 and 1635. Causa (*op. cit.*) also suggested that the anonymous master may have painted the still-life passages in Aniello Falcone's frescoes of 1641 and 1642 in the Cappella Firrao in S. Paolo Maggiore (Novelli 1976, no. 5).

The trio of Roman painters, Salini, Bonzi and the nobleman Giovan Battista Crescenzi, were working rather earlier. Recently there has been an unsubstantiated attempt to identify the author of the still life with Crescenzi (Marini in *Storia dell'Arte Italiana* 1981). Gregori's approach to the problem seems more likely to yield results and to establish the links between these still-life painters.

A.T.

EXHIBITIONS
Naples 1938, no. 2; Paris 1952, no. 69b;
Rome 1956, no. 233; Naples 1964, no. 57

REFERENCES
Bottari 1966, pp. 141–43; Causa 1951, pp. 30–36;
Causa in *Storia di Napoli* 1972, V, III, pp. 1004–05;
De Logu 1962, p. 190; Gregori 1973, p. 51;
Marini in *Storia dell'Arte Italiana* 1981, p. 392;
Rosci 1977, pp. 200, 233

Charles Mellin

NANCY c. 1597–ROME 1649

Mellin is first documented in southern Italy in 1634 when he was commissioned to paint the vault and walls of the abbey church of Montecassino (Caravita 1869–70). Nothing remains of this cycle, which was destroyed in the last war. It consisted of 15 paintings in stucco frames, was begun in 1636 and finished in 1637. These frescoes were one of the most important parts of the refurbishing of the abbey and Mellin's most important commission after that of 1631 for S. Luigi dei Francesi, Rome. Spinosa has noticed a painting of the *Sacrifice of Abel* in the refectory at Montecassino, signed and dated Rome, 1634, recorded by Caravita as in the abbey and previously thought lost. It may have been painted while he was working in the abbey.

Mellin was in Naples in 1643; on 16 April he signed a contract to paint the *Purification of the Virgin* for the high altar of the church of the Annunziata. This was finished in the first half of 1645 and valued by Stanzione, Ribera and Lanfranco; the artist was paid 600 ducats (D'Addosio 1883). The painting was destroyed by fire in 1757, but is recorded in a seventeenth-century etching of which copies exist (Thuillier); it is also described by Cochin in his travel notes of 1749. The picture was obviously influenced by Vouet's painting of the same subject 20 years earlier (S. Angelo, Segno) and by yet another *Purification* by Vouet now in the Louvre for the Jesuit house at Paris which Mellin certainly knew.

Mellin's Neapolitan work belongs to the classical movement promoted by Ascanio Filomarino, Archbishop of Naples from 1641. Filomarino probably met Mellin in Rome, where he developed his taste as a patron and collector in the circle of Francesco Barberini. Filomarino owned a *St. Peter with the Angel* by 'Monsù Carlo di Lorena' (Ruotolo 1977) now lost. It may be that other pictures in the collection admired as the work of Poussin by foreign visitors were in fact by Mellin (Wild 1967). The only known surviving works dating from his time in Naples are two paintings made for S. Maria Donnaregina Nuova: the *Immaculate Conception* dated 1646, and the *Annunciation* of 1647. In these Mellin adapts his

'pure' style to the local taste, particularly that of Stanzione. *St. Bartholomew* (Musée, Rodez) may also belong to this date. Mellin's stay in Naples ended abruptly; the revolt of Masaniello in 1647 led him to abandon the city and return to Rome.

I.M.

REFERENCES
Caravita 1869–70, III, pp. 257, 268–73;
Cochin 1756 (1763 ed.), I, p. 168;
D'Addosio 1883, pp. 100–01;
D'Addosio 1913, pp. 255–56;
Ruotolo 1977, pp. 71–82; Schleier 1976, pp. 837–44;
Thuillier 1981, p. 583–621;
Thuillier in Rome 1982, pp. 207–74;
Wild 1966, pp. 3–44

87
The Immaculate Conception

352 × 230 cm
Signed: CAROLUS MELLIN LOTARIN(GIUS)
Gallery of the Incoronata del Buonconsiglio,
Capodimonte, Naples

Painted for the church of S. Maria Donnaregina Nuova, recently discovered documents show that the painting was finished by 11 May 1646. On that date Carlo Mellino di Lorena declared that he had received from the Abbess Dianora Caracciolo '170 ducats in two installments . . . in payment for a picture of the *SS ma Concettione* made for a chapel of our church' (Archivio di Stato, Monasteri Soppressi 6453, vol. II, fol. 391; reported by A. Delfino). So the picture was finished about a year before the *Annunciation* inscribed 22 A 1647 ('A' = April) which was frequently moved around the church, as is evident from the guide books.

Although the document does not specify the chapel for which it was painted, we can guess that it was the first on the left, dedicated to the Virgin Immaculate; the painting was in this chapel until the last war when it was deposited in the Buon Consiglio. Celano (1692) mentions the *Immacolata* on the 'Gospel side'; that is, to the left of the presbytery, but most probably this was a temporary move. In 1687 the chapel of the Immacolata was granted by the nuns to the Carmignano family; presumably the chapel was decorated at this date and the picture moved into the presbytery.

Mellin depicts the theme of the Immaculate Conception as if he were working from the text of the *Litanie Lauretane*. The picture is crowded with Marian symbols, supported by angels, suspended in the sky and inserted in the landscape background. But the moon, the ship, the palm, and the *Hortus Conclusus* are painted not merely as symbols but incorporated into the landscape. The result is an original enumeration of the Virgin's attributes.

Neapolitan School

c. 1630–40

88

A Dead Soldier

104.8 × 167 cm
Inscribed: centre right '*A*'
National Gallery, London

This very poetic image, which even appears to be monogrammed, has baffled historians, to the extent that they are uncertain in which country, and even in which century, it was painted. There are good reasons, however, for supposing that it was painted in Naples in the 1630s; it was a moment at which the legacy of Caravaggesque naturalism was beginning to be transformed into a more philosophic and poetic idiom. It is not surprising that the image inspired Manet's *Dead Toreador* (National Gallery, Washington) for it is proto-Romantic as well as being a product of the literary world of emblems. These are the ingredients behind much of Salvator Rosa's art and this painting would seem to spring from the same culture as the one he started from.

As a subject, it is most unusual, except in its meaning, which is that of a *Vanitas*, a reminder of the transience of all things, conveyed not only by the very telling observation of a dead man, but also by the skulls, bubbles that are about to burst, light that has just been extinguished, branch that has lost its leaves and darkness that is about to fall. It is like a tailpiece, and was most likely a *sopraporta*, a reminder of the vanity of all the other images in the collection to which it originally belonged. These references are of course commonplace in Italian and northern art of the seventeenth century, but they are usually symbolized rather than rendered with the force of observation of this image.

The 1630s were undoubtedly a most fertile period for painting in Naples. There was a great deal of contact with Rome, especially as the Spanish rulers were impressed more by art from that centre rather than from Naples; ever since Caravaggio had descended on the city they had encouraged the best Roman painters to work for them. The theme of many of the decorations painted for the Buen Retiro Palace in Madrid was the ancient Roman world seen through the eyes of modern Roman painters. At the same time, there were pictures that had much less of a theme, like the great numbers of anchorite landscapes with single saints and, from the time of Caravaggio onwards, a tendency to pose the profounder philosophical questions that his objectivism put so forcibly.

It was this culture that brought forth Salvator Rosa, who as a painter sought out the philosophical not only in the macabre, but also

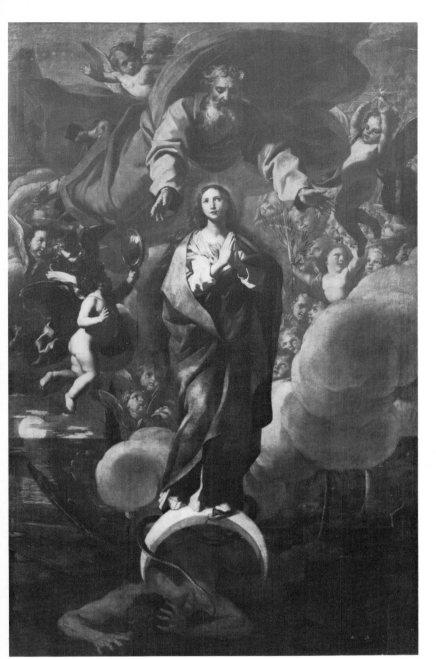

87

In Naples Mellin abandoned the broad, painterly style of his Roman work (Schleier 1976) and moved towards Poussin's baroque style and the fashionable neo-Venetian manner. This results in tighter modelling and a more rigorous composition close to the style of Domenichino, although darker in tone.

I.M.

PROVENANCE
S. Maria Donnaregina

EXHIBITIONS
Naples 1954, no. 30; Naples 1967, no. 23; Rome 1982

REFERENCES
Celano 1692 (1856 ed.), II, p. 646; Ortolani 1938, p. 83; Schleier 1976, p. 837; Thuillier 1981, p. 757; Thuillier 1981, p. 619; Wild 1980, pp. 202, 234

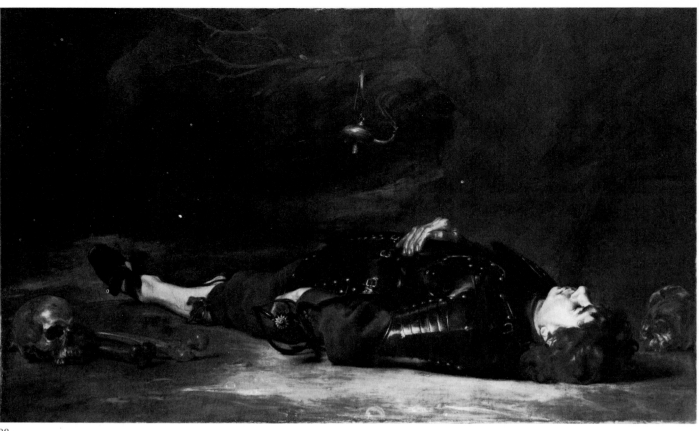

88

in the picturesque; and it is possible to imagine an image like the *Dead Soldier* coming from the extremely creative group of artists with whom he was associated in Naples, from Aniello Falcone and Andrea di Lione (surely it is not his 'A') to Castiglione, Stanzione, Fracanzano and Ribera. Older attributions to Spanish hands, including Velasquez, seem improbable, and the scale is inconsistent with an attribution to Cavallino. This is the imagery of the real world, descended from Caravaggio's *Death of the Virgin*, gradually to be transformed by Rosa into pictures of the unreal, the superstitious and the romantic.

C.W.

PROVENANCE
Said (1841) to have come from a Spanish Royal Palace; anon sale, Duparc de la Rue & Veuve Laforest, Paris, 20 Aug. & following days 1821, lot 104 (as by Velasquez); M. de Saint-Remy, his sale, Paris, 3 Feb. 1841, lot 16; Pourtalès-Gorgier Coll. 1841; his sale, 27 Mar. 1865, lot 205, when bought by the Gallery

REFERENCES
Levey 1971, p. 148 with bibliography

François de Nomé,
called Monsù Desiderio

METZ 1593–NAPLES *c.* 1640

Born in Metz, this painter came to Italy about 1602 and stayed in Rome, where he worked in the workshop of Balthasar Lawers, a follower of Brill and assistant of Tassi, until *c.* 1610 (Causa 1956). Later, he moved to Naples, where he probably stayed for the rest of his life. He worked on small to medium-scale pictures, almost always in collaboration with other artists, who would insert the figures into his architectural settings. His principal collaborator, mentioned in this capacity even by De Dominici, was the Greek-born Belisario Corenzio. He also worked with the Dutchman Jacob van Swanenburgh, who was in Naples from *c.* 1606–17. In fact it may be that many of the paintings at present given to François de Nomé are by Swanenburgh.

It is possible that he worked at the court of Cosimo II in Florence and some pictures suggest that he knew the work of Callot and the scenery painting of Giulio Parigi. This visit to Florence may have taken place around 1619, as there is a painting of that year which came originally from the Medici collections (Capece-Minutolo-Miranda Collection, Naples). A visit to Rome at the beginning of the 1630s is also a possibility, as there are echoes of the work of Tassi and Codazzi in pictures like the *Ruins and Arches* of 1634 (ex Allomello Coll., Rome), another painting of the same subject in the Ortolani Collection, Rome, where the date should

probably be read as 1637, and the *View of Roman Ruins*, formerly in the Mondolfo Collection, Rome.

Unfortunately the few dates that appear on his pictures are not always easy to read, and it is difficult to establish a chronology or even the date of his death. Dated works include the *Church Interior* formerly in the D'Urso Collection, Rome (1619), the *Marriage of the Virgin in a Cathedral Interior* (formerly private coll., Naples 1621), two of the paintings in the Harrach collection, Rohrau (1622) and the *Flight into Egypt* in the Musée des Arts Decoratifs, Paris (1624).

M.R.N.

REFERENCES
Causa 1956, p. 36; De Dominici 1742–45, II, p. 313; Seghers 1981, pp. 40–47

89
The Martyrdom of St. Catherine

95.8 × 126 cm
Dated: *1617 (or 1647)*
Southampton Art Gallery

The picture is by two different hands; Monsù Desiderio is the author of the architectural setting, while the figures are by a Neapolitan painter from the circle of Corenzio. This picture is particularly interesting as the date is difficult to read and may be interpreted either as 1617 or 1647. By coincidence, the picture which is closest to it in style, the *Destruction of Sodom* (Sanfelice di Bagnoli Coll., Naples), has a date that has been read as 1644, but can also be interpreted differently.

The figures in this picture are very close in style to those painted by the Corenzio circle at the beginning of the century. The artist evidently collaborated with Monsù in other paintings which form a substantial group of scenes of martyrdoms and episodes from the lives of the saints: two pictures in the Roseman Collection (Cleveland, Ohio), one in the Durand-Mathyssen Collection, Geneva, one in the Dreyfus Collection, Basle, another in the Anfuso Collection, Rome, another in the Weitzler Collection, New York and, lastly, a *Martyrdom of St. Ursula* whose whereabouts is unknown (Sluys 1961). Unfortunately, none of these works is dated, although it is likely that they were painted before de Nomé's stay in Florence (*c.* 1619). They do not show the influence of Callot evident in his later work and his employment of features such as animated sculpture, colonnades with ornate capitals and falling ruins is still rather tentative.

These are early works; during his stay in Florence de Nomé moved towards more animated and frenetic forms, where the statues take on the appearance of electrified ghosts, the capitals become whirlpools of matter and the ruins ever more wild and startling. The early works show Monsù's technique still at an experimental stage, with broad brushstrokes that almost seek to give the effect of relief through strong contrasts; later he was to achieve greater refinement.

So the most likely reading of the date is 1617, making this picture one of the artist's earliest works. His choice of martyrdoms as the subjects of these pictures doubtless had a formative influence on the work of the Maestro dei Martirii, who was active in Naples in the 1630s.

M.R.N.

PROVENANCE
Paris art market before 1939; Jeffress Gift 1948

EXHIBITIONS
London 1949, no. 2; Sarasota 1950, no. 59; Paris 1962, no. 68

REFERENCES
Causa 1956, p. 45; Scharf 1950, p. 21; Sluys 1961, p. 89, no. 58

Francesco De Rosa, called
Pacecco

NAPLES 1607–NAPLES 1656

A pupil of Massimo Stanzione according to the sources, Pacecco was also influenced by Filippo Vitale, who became his stepfather in 1612. So his formative years were dominated by two of the principal exponents of naturalistic painting in

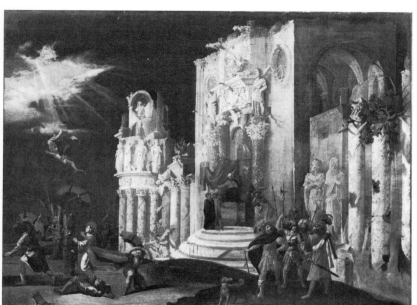

89

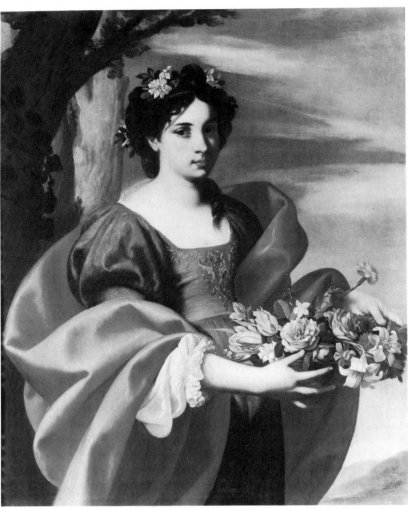

90

Naples, although the influence of Stanzione's classicism, with its echoes of Guido Reni, predominated and modified the Caravaggesque naturalism. Many of Pacecco's ideas were derived from Stanzione, although he made the shadows more transparent and the colours lighter. Thus, despite his naturalistic background, he became the chief representative of the classical Bolognese style and drew close to Domenichino, who was in Naples from 1631 onwards.

Few of his works are documented. His first dated picture is the *St. Nicholas of Bari* painted for S. Martino in 1636 in which the influence of Domenichino is evident. His eclectic mannerist background is apparent in some of his early works, like the *Flight into Egypt* (Capodimonte), while *Diana Bathing* (Palazzo Reale, Naples) has elements of classicism in the rendering of the nudes. Other works attributed to him at Capodimonte include a *Judgement of Paris*, *Rachel and Jacob* and *Susanna and the Elders*; the latter shows the influence of Artemisia Gentileschi in its naturalistic detail.

Apart from the many secular paintings

attributed to Pacecco in private collections and museums abroad, his works are in many churches in Naples. The *Annunciation* in S. Gregorio Armeno, which has an almost ostentatious elegance, is signed and dated 1644. The *Deposition* at Capodimonte, which is a successful composition with echoes of the painting by Filippo Vitale at Regina Coeli, must date from the years 1640–45. Vitale was also the inspiration for the pictures of the same subject in the Gesù Nuovo and in the church of the Nunziatella, the latter dating from 1646. The *St. Thomas Aquinas* in the church of S. Maria della Sanità is signed and dated 1652.

In his maturity Pacecco was also active in Apulia, but his style is tired and vulgarized. Nonetheless, the *Annunciation* in the parish church at Paolo shows, despite its rather vacuous composition, an exciting use of colour has an emotional appeal. The *St. Agnes* and in Palazzo Comunale, Francavilla, is a work which is equal in quality to the Neapolitan pictures in its refined sense of colour and the clarity of the surface effects.

L.R.

REFERENCES
Bologna in Naples 1955, pp. 61–2;
Causa in *Storia di Napoli* 1972, V, pp. 946–7, 988;
Dalbono 1871, p. 105; De Dominici 1742–45, pp. 101–4;
D'Elia in Bari 1964, pp. 169–70;
Pigler 1931, pp. 148–67; Ortolani 1938, pp. 52–55;
Pacelli 1979, no. 23;

90*
Flora

103.5 × 86 cm
Kunsthistorisches Museum, Gemäldegalerie, Vienna

This painting was first published in 1968, attributed to Pacecco. Although it does not appear in inventories of old Neapolitan collections, it was certainly a private commission; Pacecco was much in demand as a figure painter with the nobility (De Dominici). It is likely that it was one of a series of the four seasons.

This is certainly a portrait; the goddess has an air of dreamy calm, wrapped in an ample mantle whose heavy and swelling folds show Pacecco's delight in rendering such precious stuffs. It can be dated to *c.* 1645–50 and shows close affinities with Bolognese painting, particularly with Reni and Domenichino, in its clear colouring. Pacecco's early naturalistic training is revealed in details such as the shadow of the curl on the forehead and the play of chiaroscuro on the left cheek. The influence of Vouet is also apparent. The colour is lively and brilliant and the flowers rendered with great exactitude, but placed in a basket held in an improbable and unnatural manner. In contrast to the almost academic

precision of the figure, the background is barely suggested; on the left it is closed by trees, and on the right open to the sky.

L.R.

PROVENANCE
Bought by the Kunsthistorisches Museum, Vienna 1967

REFERENCES
De Dominici, 1742–45 III, p. 101–04

91*

Martyrdom of St. Lawrence

127 × 179 cm
Bob Jones University, Greenville, South Carolina

This painting is not mentioned in the source books, but has been attributed to Pacecco by Volpe, Gilbert, Zeri (all in 1963) and Longhi (1964) as written communications.

St. Lawrence was a Christian martyr born in Spain, an archdeacon to Sixtus II who was martyred in AD 258 by being roasted over a gridiron. In the painting he is being thrust onto the coals, while an old priest, in a last attempt to make him recant, offers him a small pagan idol. The martyrdom is not presented in a particularly tragic fashion and has an academic sense of detachment; the figure in the bottom left is smiling and so detracts from the sacred event.

Its obvious relationship to the work of Filippo Vitale, Pacecco's stepfather, would date it to

c. 1635–40, at which time Vitale was turning from naturalism to a more academic style. It also shows the influence of Stanzione.

The painting is close to other works by Pacecco, including the *Massacre of the Innocents* (Cat. 92) and *The Way to Calvary* (Museo del Sannio, Benevento). The restricted space, with large-scale figures in the foreground and those in the back painted in subdued colours, the gleaming helmets of the soldiers and the rich vestments of the priest perhaps show the influence of Artemisia Gentileschi, who had been in Naples before 1630.

L.R.

PROVENANCE
Julius Weitzner 1963

REFERENCES
Marrow 1978, pp. 2–11

92

The Massacre of the Innocents*

198 × 305 cm
Philadelphia Museum of Art

Formerly attributed to Stanzione, this painting was ascribed to Pacecco by Schleier and Brejon de Lavergnée. The subject was popular in the Seicento, given its combination of violence and religious subject matter (*Matthew*, ii, 16–18); it was made even more popular by the poem written by G. B. Marino, printed in 1632, which

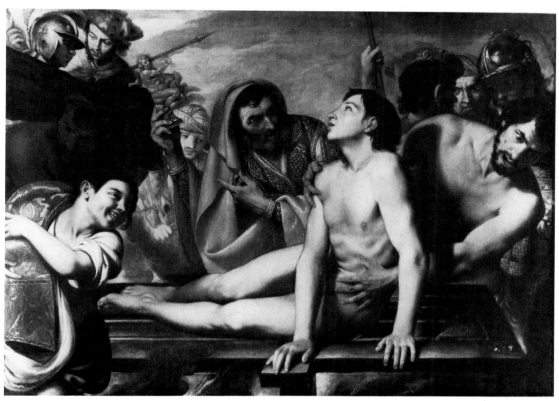

91

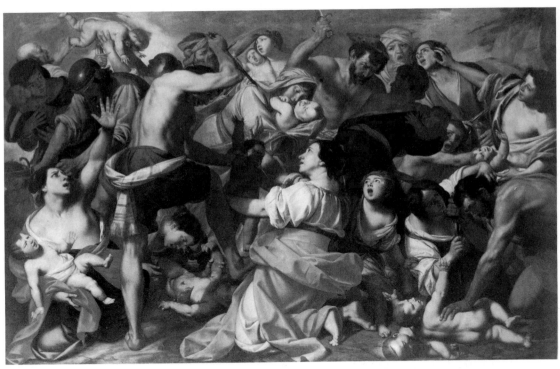

92

contrasted the violence of the soldiers to the impotent despair of the mothers.

The vast scale of the painting suggests that it must have been intended for a Neapolitan church. Dalbono says he saw a *Massacre of the Innocents* in the Casa Statella, Naples, attributed to Pacecco; it could perhaps have been this one. (Dalbono 1871). It can be dated to *c.* 1645–50 and shows baroque leanings in the crowd of foreground figures who seem to be confined in too narrow a space. The figures do not communicate the horror of the scene but seem posed, an academic approach typical of Pacecco at this date. The colour is brilliant and the details carefully rendered.

The painting is related to the *Martyrdom of St. Lawrence* (Cat. 91) and the *Way to Calvary* at the Museo del Sannio, Benevento (the central figure of the torturer is close to that in the present picture). Some details, such as the two dying babies in the right foreground and the turbanned woman, recall Guido Reni's *Massacre* (Bologna and Pinacoteca).

It is also related to Stanzione's *Massacre* (Cat. 157) in its colouring, the facial types of the woman and the crowd in the background. There was a copy of the painting formerly in the church of Ste Marguerite, Paris; a derivative version ascribed to Pacecco is in the gallery of the Incoronata del Buon Consiglio.

L.R.

REFERENCES
Dalbono 1871, p. 107; Marrow 1978, pp. 2–11

Onofrio Palumbo

ACTIVE MID-SEVENTEENTH CENTURY

Trained in the circle of Battistello Caracciolo, Onofrio Palumbo responded to the influence of Artemisia Gentileschi during her Neapolitan stay, and, above all, to Massimo Stanzione (De Dominici 1742–5; Galante 1872). His most famous work is *S. Gennaro Interceding for Naples* (Cat. 93) painted for the Arciconfraternità della SS Trinità dei Pellegrini at Naples together with *S. Filippo Neri Recommending his Brethren to the Trinity*. According to De Dominici there were works by Palumbo in both public buildings and private collections; however, his activity was apparently cut short when he became embroiled in a court case following a dispute with relatives. This not only turned him away from painting, but sent him mad.

Although this sad tale has the air of legend about it, it is still true that we know little of Palumbo's work and few pictures can be certainly attributed to him: the main altarpiece in the Neapolitan church of S. Maria Egiziaca at Pizzofalcone of the *Madonna and Child with St. Mary of Egypt and Augustine* (and the *Holy Family with St. Anne and St. Joachim* identified by Ortolani in Naples 1938), the two pictures of the *Annunciation* and the *Nativity* in the church of S. Maria della Salute (Bologna 1955) formerly attributed to Finoglia (D'Orsi) and Anteveduto Gramatica (Longhi), a

Crucifixion in Santa Maria Apparente (Causa in *Storia di Napoli*), the *Adoration of the Shepherds* in S. Maria del Sepolcro at Potenza, traditionally attributed to Jusepe Ribera (Causa, oral communication) and the *Immacolata with St. George and Saints* in the Neapolitan church of S. Giorgio a Pianura (Spinosa, oral communication). In these paintings Onofrio Palumbo's eclecticism embraces the work of Paolo Finoglia (whose influence seems to have preceded that of Stanzione and Artemisia Gentileschi), Andrea Vaccaro and Ribera.

F.P.

REFERENCES
Bologna in Naples 1955, p. 64;
Causa in *Storia di Napoli* 1972, V, pp. 975, 977, 987;
De Dominici 1742–45, II, p. 241; Galanti 1829, p. 360;
Ortolani in Naples 1938, p. 74

Onofrio Palumbo and Didier Barra

93
S. Gennaro Interceding for Naples

360 × 214 cm
Arciconfraternità della Santissima Trinità dei Pellegrini, Naples

In 1618 a number of altars in the arch-confraternity, one of the many religious foundations in Naples, were furnished and provided with paintings, amongst them one dedicated to S. Gennaro, commissioned by the Canon Giovanni Battista Saggese. All the pictures placed above the new altars are listed in a series of inventories dated between 1626 and 1630; by this time there was already a picture of S. Gennaro, the patron saint of Naples.

But it is only round 1652 that we learn of the canvas with *S. Gennaro Interceding for Naples*, painted by Onofrio Palumbo in collaboration with Didier Barra, a painter from Metz in Lorraine (see p. 108) who contributed the view of the city. From documents in the archconfraternity's archive (Carughi 1976) it emerges that shortly before 1652 Palumbo had painted another picture in the church, *S. Filippo Neri Recommending Brethren to the Trinity*, in honour of the Oratorian saint who had been named Protector of the Congregation in 1651 in emulation of the Roman archconfraternity of St. Philip Neri. Palumbo had therefore received two prestigious commissions within a short space of time. He rose to meet the challenge, as was indicated by an inventory of 1842 in which the 'large picture with S. Gennaro' was believed to be the 'work of the Cav. Massimo Stanzione', reckoned among the most important paintings in the church and given a much higher value than the others. Despite this misattribution in the nineteenth century, the picture was traditionally attributed to Palumbo in old Neapolitan guides.

Chiarini was uncertain of the saint's identity: 'there is a saint in bishop's vestments, i.e. S. Gennaro or as others say, S. Emidio, between pilasters, kneeling on the clouds, and accompanied by putti, who stretches his hands in supplication to Christ, Who in the glory of the Trinity has an angry look and seems about to hurl thunderbolts on the city of Naples depicted beneath. . .' (Celano [ed. Chiarini] 1859, Day VI).

The iconographical type of S. Gennaro must have been suggested to Palumbo by the painting of the *Apotheosis of S. Gennaro* in the Church of the Convent of the Discalced Augustines at Salamanca, painted by Ribera for the Conde di Monterrey, Viceroy of Naples between 1633 and 1634, probably together with the retable for the

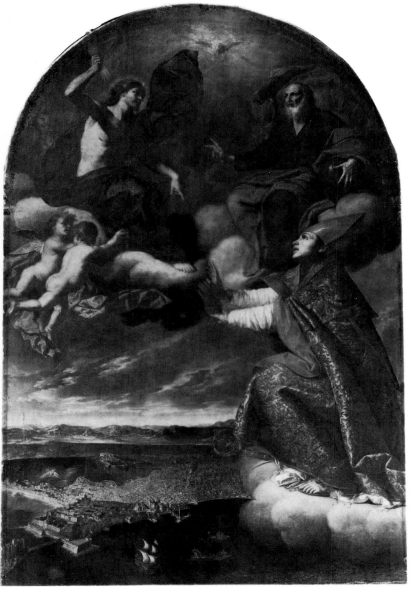

same convent. In fact, in that picture S. Gennaro is shown in the clouds protecting the city below; Ribera may have painted it after Naples escaped from the danger of the 1631 eruption of Vesuvius. At about the same time Andrea Vaccaro also did a painting with similar iconography (Prado, Madrid). Palumbo's variation on the theme was dictated by the need to incorporate the Trinity, in honour of the Archconfraternity which bore its name.

The picture is in the painter's mature style. The influence of Artemisia Gentileschi, Stanzione and Finoglia (Ortolani 1938; Causa 1972) have replaced the earlier influence of Caracciolo which De Dominici observed (1743).

F.P.

REFERENCES
Bologna in Naples 1955, p. 54;
Carughi 1976, pp. 119–21, 140–41; Causa 1956, pp. 35, 45;
Causa in *Storia di Napoli* 1972, V, II, p. 330;
Celano ed. Chiarini 1856–60, IV, pp. 808–09;
Ortolani in Naples 1938

Paolo Porpora

NAPLES 1617–NAPLES or ROME 1670/80

Although Porpora's work is one of the high points of Neapolitan still-life painting and we know something of his life from the sources, none of his paintings is documented. Only one flowerpiece in the collection of Prince Agostino Chigi, Rome, is signed (Causa 1972).

De Dominici remarks that Porpora's style is more modern than that of Forte, implying that Porpora was younger than Forte, a fact supported by a document which states that he was aged 15 and in the workshop of Giacomo Recco in 1632, which suggests that he was born in 1617 (Prota Giurleo 1953). De Dominici also says that he was a pupil of Aniello Falcone; it was this that led to the hypothesis, now discounted, that the Master of Palazzo San Gervasio might be identified with Porpora (Causa 1951). In fact, paintings considered to be his early works, such as *Flowers with a Crystal Goblet* (Cat. 95), are all similar stylistically to the works of the Master of Palazzo San Gervasio. Causa (1972) has rightly excluded the hypothesis of a closely Caravaggesque phase in Porpora's development; these paintings cannot be early works and must have been painted soon after his arrival in Rome.

He is documented as a member of the Accademia di S. Luca from 1656 or 1658; presumably he had arrived slightly earlier (Missirini 1823). At that date Rome was crowded with foreign artists; obviously Porpora worked very closely with Otto Marseus van Schrieck who arrived in Rome in 1652. It was under his influence that Porpora produced his idiosyncratic woodland scenes (Cat. 94). Porpora's decorative and baroque tendencies were strengthened by the influence of other northern artists: an example of this is the attribution of a flower painting either to Porpora or Karel van Vögelaer (ex Chigi Albani Zeri 1959; Causa 1972).

His later pictures (those in the Musée de Valence, Drôme), foreshadow such painters as Giuseppe Ruoppolo and Andrea Belvedere. But this influence does not prove that Porpora returned to Naples before his death, which must have occurred in the 1670s or 1680s. No works dating from the end of his life have yet been identified.

A.T.

REFERENCES
Causa in *Storia di Napoli* 1972, V, II, p. 1009;
De Dominici 1742–45, III, p. 293; Missirini 1823, p. 470;
Prota Giurleo 1953, p. 12; Zeri 1959, p. 280

94

Still Life with Roses, Partridges, Frogs, Owl and a Flamingo

74.5 × 98.5 cm
Musée du Louvre, Paris

This picture, formerly in the Wertheimer Collection in Paris, was presented to the Louvre in 1970.

De Mirimonde (1970) has attempted to decipher all the possible symbolism present in the composition. Using texts and iconographic traditions he interpreted the various elements (the butterfly, rose, owl, toad and flamingo) as allegories (the soul, love, death, sin and salvation). The concept is connected with the northern tradition of *Vanitas*, but seems

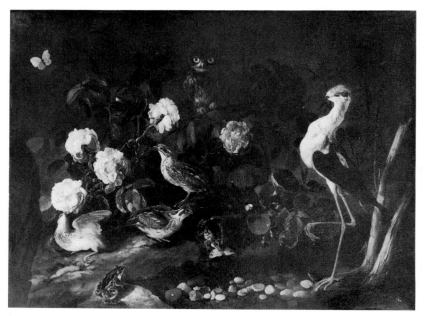

94

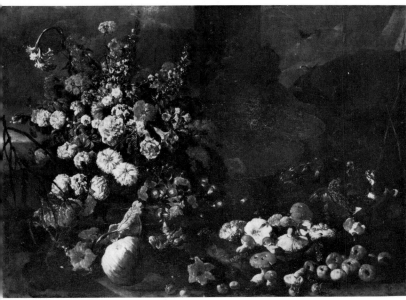

96

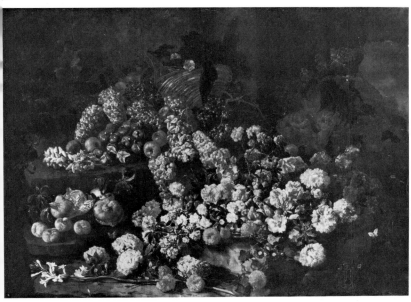

97

Compared to the other works by Porpora of this period, such as the two small pictures deposited at Capodimonte (Coll. Banco di Napoli), or those in the Bonello Collection Milan and the Camillo Guerra Collection, Naples (Volpe in Naples 1964), the Louvre picture is larger and more ample in composition.

A.T.

REFERENCES
Causa in *Storia di Napoli* 1972, V, III, p. 1010;
De Mirimonde 1970, pp. 145–54; Grimm 1977, p. 201;
Naples 1964, p. 44; Rosci 1977, p. 237

95
Flowers with a Crystal Goblet

150 × 116 cm
Capodimonte, Naples
[*repr. in colour on p.* 104]

This picture was first mentioned in an inventory of Capodimonte of 1930, attributed either to Brueghel or Belvedere. Its provenance is unknown. When Causa reconstructed Porpora's career (1951), he included it amongst the artist's autograph works, an attribution accepted by Molajoli (1957).

The picture is baroque in design: the flowers cover a large part of the surface, giving glimpses of distant space which presage the landscapes of Ruoppolo. Half a gourd, a crystal goblet and other flowers are arranged on the front plane; the observation of detail is minute and volume is defined by the play of light. The painting of the flowers betrays the analytical quality of Porpora's first master Giacomo Recco, although it is combined with a more sophisticated use of chiaroscuro.

Porpora's painting has neither the clarity of Luca Forte, nor the solid volumes of the Master of Palazzo San Gervasio; developing his style from a root common to these two painters, he produced an entirely idiosyncratic style. The painting can be dated to his first years in Rome.

A.T.

EXHIBITIONS
Sarasota 1961, no. 39; Athens 1962, no. 29;
Naples 1963, no. 49; Naples 1964, no. 58;
Zurich 1964–5, no. 53; Rotterdam 1965, no. 53;
Bordeaux 1978, no. 67; Bucharest 1972;
Munster, Baden Baden 1979–80, no. 132

REFERENCES
Causa 1951, p. 34;
Causa 1952, pp. 30–36; Causa 1957, p. 58;
Causa in *Storia di Napoli*, 1972, V, III, p. 1009;
De Logu 1962, p. 119; Mitchell 1973, p. 204;
Molajoli 1957, p. 58

96 & 97
Still Life with Fruit, Flowers and a Bas Relief
Still Life with Flowers, Fruit, Fungi and Birds

inapplicable to the climate of patronage in Naples or to Italy in general. Even if these subjects have traditions of this kind behind them, it seems likely that when the genre was introduced to Italy by northern painters (at the same time that private bestiaries were being formed) they were already reduced to the level of 'curiosities' and had lost their allegorical connotations.

Porpora adopted this particular genre of still life when he met Otto Marseus van Schrieck in Rome. Schrieck travelled to Florence together with other artists, including Matthias Withoos, and was in Rome from 1652–56 (Grimm 1977). The affinities of Porpora's work with that of these two Dutch painters who specialized in the pictures of undergrowth are remarkable.

Each 160 × 190 cm
Martinelli collection, Naples

These two unpublished paintings are very close, both in subject and composition, to the paintings by Porpora in the Musée de Valence (Drôme), and they can be dated to the same period in the 1660s, after his return from Rome (Causa 1972).

In spite of the crowded composition, which is exuberantly decorative and close to the contemporary work of Bruegel and Vogelaer, details are carefully painted from life. The various types of flowers are minutely observed as is the fruit cascading out of the basket; they are blended with other elements of northern origin: the fragment of bas relief, the birds, the butterflies and the glimpse of landscape.

Abandoning the rigidity of his earlier years when he was in close contact with Marseus, Porpora's style became more personal and established a precedent for a type of still-life painting later elaborated both at Rome and in Naples.

A.T.

PROVENANCE
Private collection, Florence

EXHIBITIONS
Turin 1975

REFERENCES
Causa in *Storia di Napoli* 1972, V, III, p. 1101

Mattia Preti,

called the Cavaliere Calabrese

TAVERNA, CATANZARO 1613–LA
VALLETTA, MALTA 1699

We have no knowledge of Preti's early training. De Dominici, his devoted biographer and the son of one of his pupils, says he left his native Taverna aged 17 to set up in Rome with his brother Gregorio who was also a painter.

In Rome in 1630 Preti came into contact with the work of Caravaggio, both directly from the master's paintings and through the work of his followers, in particular the French Caravaggisti, Valentin and Tournier, and the circle of painters faithful to the style of Manfredi. The numerous groups of musicians and card-players by Preti were painted under these influences (Municipio, Alba; Accademia Albertina, Turin; Galleria Doria Pamphili, Rome; Longhi Coll., Florence; Ashmolean Museum, Oxford; Hermitage, Leningrad). Religious subjects are rarer (Palazzo Rosso, Genoa; Brera, Milan).

The neo-Venetian painters in Rome (Mola, Testa and Poussin) were another source of inspiration; Preti adapted their style to different subject matter (*Bacchanal*, Raggi Coll., Rome; *Triumph of Silenus*, Musée de Tours). The fresco of the *The Charity of S. Carlo* in the church of S. Carlo ai Catinari dates from 1642 and is influenced by Andrea Sacchi. In that year Preti became a Knight of the Order of Jerusalem, and in 1650 he was received into the *virtuosi* of the Pantheon.

It is difficult to reconstruct Preti's movements in the 1640s. De Dominici says he went to Spain and Flanders and met Rubens there; it is more probable that he travelled in Italy to study the work of the Emilian painters Lanfranco, Domenichino and, above all, Guercino, whose influence was fundamental to his style. So, too, was Venetian art which was later imported to Naples by Luca Giordano. Between the end of 1650 and the middle of 1651 he worked on the frescoes of *Stories of S. Andrea* in the apse of S. Andrea della Valle in Rome, which demonstrate his assimilation of Emilian painting. From 1653 to early 1656 he was in Modena, frescoing the dome and apse of S. Biagio. He also painted frescoes in the Reliquary Chapel in the Duomo, now destroyed.

In 1656 he arrived in Naples. In a city stricken by plague, where the most important painters of the generation had died, Preti soon emerged as the only artist capable of giving new life to local painting. Reworking the Neapolitan Caravaggism of Battistello and Ribera, Preti created a style using light as the basis of the composition, and allowing forms to emerge from shadow; this is joined to an extraordinary versatility in his use of colour. In the four years he was in Naples he received many commissions: the frescoes on the city gates (1656–59, now destroyed; see Cat. 100, 101), those in the S. Domenico Soriano and numerous paintings for churches and collectors – the *Madonna of Constantinople*, dated 1656, for Sant'Agostino degli Scalzi, the *St. Sebastian* (Cat. 102) for S. Maria dei Sette Dolori, the *Banquets* at Capodimonte, the two versions of the *Prodigal Son* at Capodimonte (Cat. 99) and Palazzo Reale, the two canvases for the church of S. Lorenzo (documented 1660) and, above all, the important cycle of *Stories of the Life of S. Pietro Celestino and S. Caterina di Alessandria* for the vault of the nave in S. Pietro a Maiella, documented between 1657 and 1659 (De Conciliis, Lattuada 1979).

After a short stay at Valmontone near Rome between 1660 and 1661 when he frescoed the Palazzo Pamphili with allegories (a commission previously given to Mola), Preti settled in Malta for almost 40 years; he began with the grandiose cycle of *Stories of the Baptist* and *Illustrious Knights of Malta*, painted with a special preparation in oil directly on to the vault and apse of the Co-Cathedral of St. John in Valletta (1661–66).

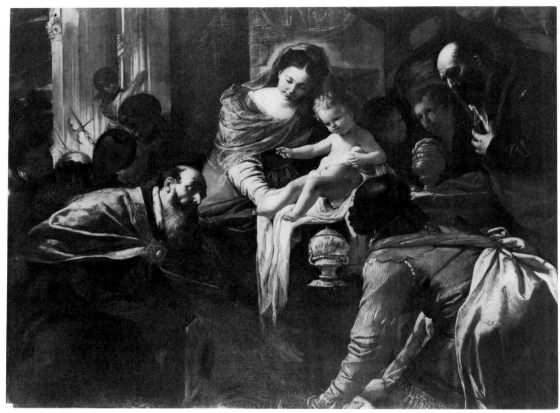

98

Preti's output was immense: there are many paintings still in Malta and others were sent to Italy (amongst the few documented works is the *S. Bernardino Preaching* now in the church of S. Domenico, Siena, painted in April 1674). It becomes increasingly difficult to date his work during this long period in Malta. Replicas incorporating variations, the repetition of details, the mastery of a calculated and adaptable style and increasing studio intervention all make it difficult to establish a chronology. But presumably his output suited the needs of his patrons. The paintings made for his birthplace, where Preti returned in 1672 after the death of his brother, have received greater attention and form a more coherent group.

M.U.

REFERENCES
De Conciliis and Lattuada 1979, pp. 294–301

98
Adoration of the Magi

171.9 × 229.6 cm
Viscount Coke, D.L.

This is a rare subject for Preti. It is unpublished although mentioned in guides to Holkham. Spike dated it *c.* 1653–55 (Spike 1979). The painting seems typical of this period of Preti's oeuvre: the Caravaggesque light is enriched with Venetian colour deriving from Titian and

Veronese, following the Roman fashion of the 1630s. To this is added a profound study of Emilian art, evident in the rendering of bodies and the broad, compact drapery comparable to the contemporary frescoes for the church of S. Biagio, Modena. It is the first sign of Preti's original style, matured by contact with differing schools, and is comparable with pictures such as the *Sophonisba* in the Galleria Pallavicini, Rome or the *Prodigal Son* in the Museum at Le Mans.

Light creates the composition, focussing attention on the young Madonna in her red robe with the Child in her arms. Some details emerge from the shadows and are treated with a hyper-realism: the ear and beard of the kneeling king on the left and the wrinkled brow of the king on the right. The faces of the young pages in the royal retinue set against the light is a formula which Preti frequently repeated (eg. Cat. 108).

M.U.

REFERENCES
Spike 1979[1], p. 21

99
Return of the Prodigal Son

255 × 368 cm
Capodimonte, Naples (inv. 84413)

The painting follows the gospel text closely (*Luke*, xv, 11–24); it was a subject dear to the painter and to his patrons in the 1650s. At least

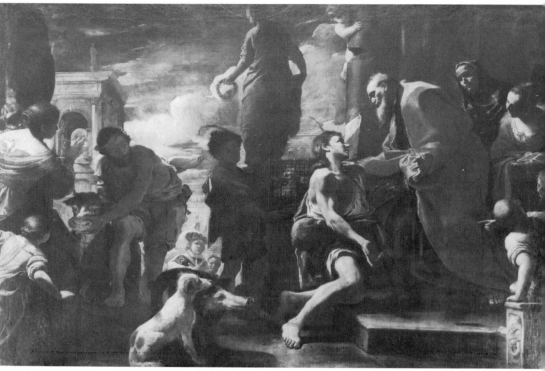

99

four versions of this subject seem to belong to this period: the picture in the Museum at Le Mans, dated to 1643 by Longhi and so amongst the earliest works mixing Caravaggism with Venetian elements, but more likely to date from somewhat later (Longhi 1943); the painting in the Pinacoteca of Reggio Calabria (ex Jerace Coll.) which is still very close to the one in Le Mans and dated by Carandente to the beginning of Preti's stay in Naples (London 1971); the present picture at Capodimonte and, finally, that in Palazzo Reale, Naples, both of which are traditionally ascribed to the Neapolitan period on the basis of style.

Some recently published documents allow us to date the Capodimonte picture more precisely, although they do not explicitly refer to the work. On 30 May 1656 Preti was paid 220 ducats for five pictures painted for the Duke of Maddaloni. On the basis of De Dominici's minute description, the Capodimonte picture has long been identified as one of the five that were in the collection of Duke Carafa dei Maddaloni (De Dominici, III, p. 373). And already on 25 April 1656 – as is shown by the payment slip – Preti had painted frescoes under the portal of Palazzo Maddaloni. So the painting dates from the beginning of his stay in Naples, and it was also because of this prestigious commission from one of the richest noble families that, after only a few months, Preti received the important commission for the votive frescoes on the city gates (Cat. 100 and 101).

The composition is particularly studied: the scene is divided in two by the great allegorical statue (the goddess Isis, according to De Rinaldis, but more probably a version of the Farnese *Flora*) and it is closed on either side by the groups of women who witness the encounter of the son with his old father. The richness and complexity of the architecture shows Preti's interest in Venetian painting, but it was only later in his Neapolitan career that he adopted Giordano's golden light. The predominant influence is still from Caravaggio: a violent chiaroscuro caused by strong shafts of light which break onto the scene accentuate the livid flesh and stress the intensely naturalistic passages, such as the muzzle of the ox or the animals in the foreground. A few notes of colour break the uniformity of tone: the red of the breeches of the servant who carries the calf, or the yellow of the father's ample mantle.

The bold foreshortening of the servant set against the light, and the prodigal son's knee emerging from the shadow are early examples of Preti's exploration of means of creating three-dimensionality by use of light and drawing, which was to culminate in the *St. Sebastian* in S. Maria dei Sette Dolori (Cat. 102) and in the first paintings for the vault of S. Pietro a Maiella.

M.U.

PROVENANCE
Duke of Carafa di Maddoloni in the seventeenth century; sold by F. A. Roberti to the Museo Borbonico 1819

EXHIBITIONS
La Valletta 1970, no. 389; Bucharest 1972; Naples 1973

REFERENCES
Carandente in London 1971, p. 5;
Causa in *Storia di Napoli* 1972, V, II, p. 954;
De Dominici 1742–45, III, p. 373;
Ferrari in *Storia di Napoli*, VI, 1970, p. 246;
Longhi 1943[1], p. 60, no. 86; Mitidieri 1913, p. 432;
Montalto 1920, pp. 104–05; Nappi 1980, p. 66, nos. 157–59

100 & 101

Two *bozzetti* for the votive frescoes for the plague of 1656

Each 127 × 75 cm
Capodimonte, Naples (inv. no. 84410, 84414)

These are *bozzetti* for the frescoes which the administrators of Naples, the *Eletti*, decided to have painted on the seven gates of the city to invoke divine protection during the terrible plague of 1656 which halved the population, killing more than 250,000.

Preti's commission is dated 27 November 1656 and followed numerous deliberations. The iconographical scheme was also fixed: on each gate the Madonna and Child and the Guardian Saints of the city were to be shown. Preti was required to make preparatory drawings to be submitted for approval to the *Eletti*. The last payment dates from April 1659, for a grand total of '1,500 ducats and 1 pound of ultramarine' (Capasso 1878); De Dominici's story that Preti

painted the plague frescoes for nothing, to expiate the murder of a sentinel on his arrival in Naples is untrue.

The frescoes, already ruined at the time of De Dominici, are now completely lost. There remain only these two *bozzetti*, one of which seems to belong to the fresco once over the Porta dello Spirito Santo (Causa) which was minutely described by De Dominici: between S. Gennaro, S. Francesco Saverio and S. Rosalia, the Immaculate Conception appeared and beneath was the angel sheathing his sword, an emblem of God's justice. Below were *monatti* (corpse-bearers) dragging bodies, and, among the victims, a mother with a baby at her breast. The iconography of the upper part of the second *bozzetto* is the same, though the angel's sword is unsheathed; at the bottom there is a cart loaded with bodies and in the background a view of the coast with the *molo* (pier) and lighthouse. The predominance of cold and livid tones, with few zones of warmer colour in the clothes of the victims, accentuates the atmosphere of despair and dissolution of these paintings, which are close in style to pictures from the beginning of Preti's stay in Naples such as the *Madonna of Constantinople* (dated 1656), the *St. Sebastian* (Cat. 102) and the *Holy Family* at Palazzo Reale in Naples.

The frescoes for the plague must have

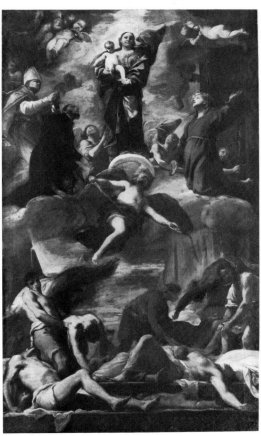

100

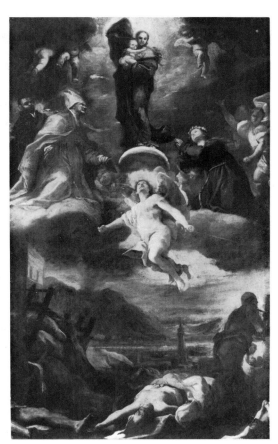

101

appeared as a positive manifesto for the baroque style in Naples (Ferrari 1970) which soon replaced the naturalistic and classicizing formulas of the first half of the century.

As often happened in his paintings, Preti used details of the composition more than once: this happened with the knot of bodies which reappeared in the background of the *Allegory of the Order* in the lunette at the entrance to the Co-Cathedral of St. John at La Valletta and in the later painting of the *Immacolata* in the church of the Beata Vergine di Sarria (Floriana, Malta) which also commemorated a terrible plague. In this painting the detail of the dying mother with her baby at her breast also recurs (Mariani 1929).

Giordano was influenced by these *bozzetti* when in 1660 he painted *S. Gennaro Frees Naples from the Plague* in the church of S. Maria del Pianto (Cat. 66) and in *St. Francis Interceding for the Plague-stricken* in the Conte Vitetti Collection, Rome (Ferrari and Scavizzi 1966).

Another *bozzetto*, perhaps the one for Porta Capuana, belonged to the collection of Don Nicola Farofalo according to De Dominici, but this has disappeared; in 1920 Montalto referred to a further bozzetto then on the art market (Montalto 1920).

M.U.

EXHIBITIONS
Florence 1922, no. 787; Paris 1965, nos. 88, 89;
La Valletta 1970, nos. 386, 387

REFERENCES
Capasso 1878, p. 603;
Causa in *Storia di Napoli* 1972, V, II, p. 993, no. 147;
De Dominici 1742–45, III, p. 334;
Ferrari in *Storia di Napoli* 1970, VI, II, p. 1244;
Ferrari and Scavizzi 1966, I, p. 54, III, fig. 95, 99;
Mariani 1929, pp. 41, 71; Montalto 1920, pp. 98–99;
Nappi 1980, p. 66, nos. 157–59

102

St. Sebastian

238 × 167 cm
Capodimonte, Naples
[*repr. in colour p. 97*]

The painting was commissioned by the nuns of the church of S. Sebastiano; but Preti's fame in Naples was so great that, according to De Dominici, Luca Giordano and his followers set about discrediting him in the eyes of the nuns. Once it was finished the work was turned down because it 'lacked nobility and beauty which belong to a noble body . . . the face was more that of a porter than of a Captain of Soldiers like St. Sebastian'. Preti, embittered by this rejection, is supposed to have given the painting to a gentleman who placed it in his family chapel in the church of S. Maria Ognibene, or dei Sette

Dolori, for the benefit of young men 'who wish to profit from perfect drawing and excellent representation from life' (De Dominici). The picture was in the church until a few years ago, when it was taken to the Capodimonte.

Datable *c.* 1657, at the beginning of Preti's stay in Naples, the overall silvery-grey tone, broken only by a few reddish touches on the elbows and knees of the saint (Causa 1972), is typical of this period. The plasticity of the twisted body is a '*capolavoro di figura isolata*' (Longhi 1913). It is a contemplative image showing the saint in the expectation of salvation; the drama of martyrdom is avoided. From his study of Caravaggio and his followers, Preti singled out the factor of light, but instead of using it for experimental and naturalistic purposes, he used it to construct forms by means of luminous planes, while the diagonal foreshortening of the saint's body gives vitality and movement to a fully baroque composition.

There is a preparatory drawing for the painting which is extremely close to the final composition (Geiger Coll., see Vitzthum 1971, pl. XXI); the version in the collection of Dr. Giuseppe Borghini at Piacenza is probably later in date (Pelaggi 1972). There are two other versions of *St. Sebastian* with some variations: one formerly in the Ferrara Dentice Collection at Naples, the other in the Perez Asensio Collection at Jerez de la Frontera (Pérez Sánchez 1965). The *St. Sebastian* in the Cathedral at Bovino and that in S. Stefano at Capri are probably old copies; the *St. Sebastian* at Warsaw (inv. no. 156197) and that in a private collection in Cadiz, formerly attributed to Ribera, are certainly copies.

The subject was repeated several times by Preti later in his career: one version is in S. Domenico a Taverna, documented in 1687 (Carandente 1966, pl. XX) and another in the church of the Beata Vergine di Sarria at Floriana, Malta (Mariani 1929, fig. 89), for which there is the preparatory drawing in the Scholz Collection (Sarasota 1961, fig. 63, identified by Ferrari 1962).

M.U.

PROVENANCE
Church of S. Maria Ognibene;
transferred to Capodimonte in 1974

EXHIBITIONS
La Valletta 1970, no. 390; Bucharest 1972;
Naples 1973.

REFERENCES
Carandente in Rome 1966, pl. XX, Causa 1952, pp. 201–12;
Causa in *Storia di Napoli* 1972, V, II, p. 954;
Dalbono 1903, p. 313; De Dominici 1742–45, III, p. 348;
De Rinaldis 1929, pp. 40–41; Ferrari 1962, p. 237;
Frangipane 1929, p. 74;
Longhi 1961, pp. 1171–75; Mariani 1929, fig 89;
Montalto 1920, pp. 97–113; 207–225; Pelaggi 1972, p. 51;
Perez Sanchez 1965, p. 421; Vitzthum 1971, p. 84

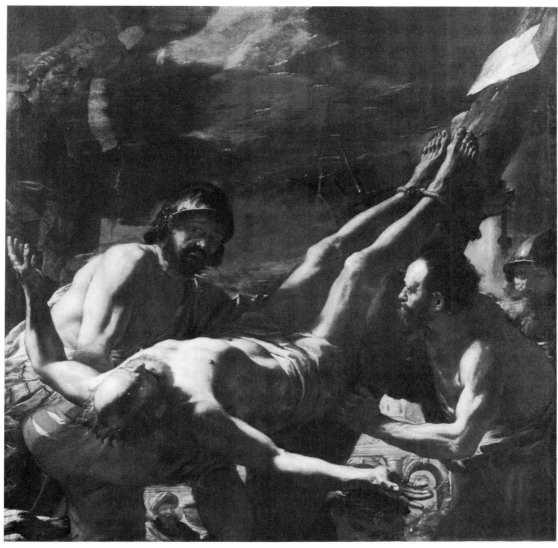

103

103†, 104* & 105*
Crucifixion of St. Peter

194.5 × 194.3 cm
Barber Institute of Fine Arts, The University of
Birmingham

The Decollation of St. Paul

179.6 × 184.3 cm
The Museum of Fine Arts, Houston

Martyrdom of St. Bartholomew

190.4 × 192.9 cm
The Currier Gallery of Art, Manchester, New
Hampshire

These three pictures have been identified by
Carandente as those described by De Dominici
in the house of the Marchese Ferdinand van den
Einden, a Flemish merchant resident in Naples
in the second half of the Seicento (London 1971).
His father Jan had, from the 1630s onwards,

been a business associate of Gasper Roomer,
another Flemish patron of the arts. Van den
Einden was deeply impressed by Preti's
Marriage at Cana painted for Roomer, and later
commissioned numerous works from the artist.

The recent publication of the complete
inventory of Ferdinand van den Einden's
possessions drawn up in 1688 by Luca Giordano
for the division of the inheritance between his
three daughters, shows that there were 11
paintings by Preti in the collection and
establishes the first change of ownership of these
three paintings. The *Crucifixion of St. Peter* was
valued at 200 ducats by Giordano, like the other
two martyrdoms. Through the daughter
Giovanna's marriage it entered the Colonna di
Stigliano Collection; the *Decollation of St. Paul*
passed into the Carafa di Belvedere Collection
through the marriage of Elisabetta to Carlo
Carafa; finally, the *Martyrdom of St.
Bartholomew* was left to the third sister who
was mentally handicapped (Ruotolo 1982).

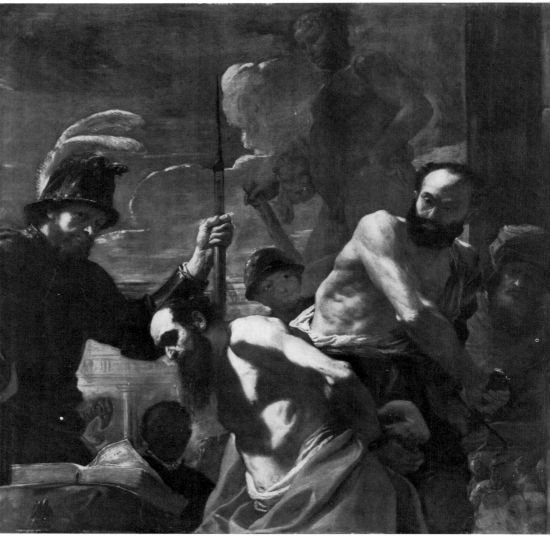

104

If Van den Einden preferred contemporary painters (in contrast to Roomer), the influence of his compatriot, a more experienced collector from whom he inherited nearly 100 paintings, must have played an important part in his choice; this is shown by these three scenes of martyrdom, painted with a type of realism which was dear to Roomer (Haskell 1963). Evidently Preti was influenced by Ribera's scenes of martyrdom (Princeton 1980) and adopted some of his dramatic sense, but not the Spaniard's naturalism. Ribera's *Martyrdom of St. Bartholomew* (Pitti) is significantly different from Preti's version of the same subject formerly in the Dragonetti Cappelli Collection, L'Aquila. De Dominici mentions many other martyrdoms painted for Neapolitan patrons; the picture formerly at L'Aquila, for instance, might be identified as the one painted for Don Antonio Caputo, since it includes numerous spectators as De Dominici mentioned (III).

Given their almost equal size (the slight variations are due to the canvases being trimmed later) and their stylistic similarity, it is obvious that the three pictures belong together. They were painted in the middle of Preti's stay in Naples. The compositions are similar, and they all are imbued with an imaginative verve which fills every corner of the scene (note the two turbaned heads which peep between the executioner's legs in the *Crucifixion*). The *Martyrdom of St. Bartholomew* was repeated by Preti several times: apart from the painting formerly in L'Aquila and the two versions in Dresden and the Corsini Gallery, Rome, (Longhi 1913), there is one in the Herberstein Collection in Slovenia which seems to be a late replica of the picture in Dresden, harsher in its use of chiaroscuro (Rizzi 1970). The version in the S. Casa dell'Annunziata in Naples seems to be a workshop copy of the Houston *Decollation* (Houston Museum of Fine Arts Bulletin 1970). There is a *Martyrdom of St. Peter* in the church of the Jesuits at La Valletta and another paired

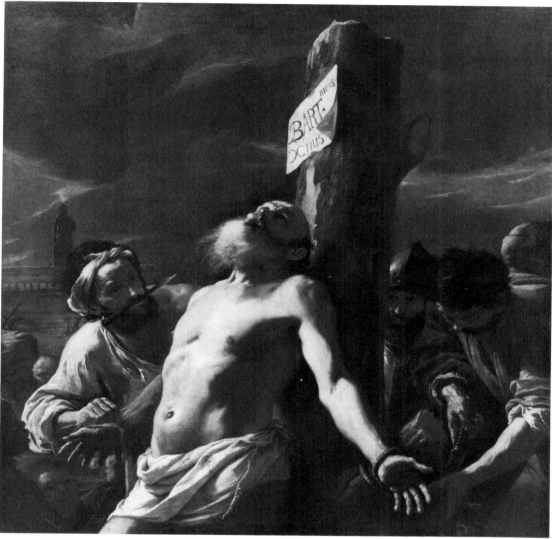

105

with one of *St. Paul* in the Cathedral of Medina
(La Valletta 1970).

M.U.

PROVENANCE
Crucifixion of St. Peter:
F. van den Einden Coll., Naples until 1688;
Colonna di Stigliano; private coll., Paris;
Heim Gallery, London
The Decollation of St. Paul:
F. van den Einden Coll., Naples until 1688;
Carafa di Belvedere Coll.
Martyrdom of St. Bartholomew:
F. van den Einden Coll., Naples until 1688;
Caterina van den Einden; subsequent history unknown;
Swiss private collection

EXHIBITIONS
Crucifixion of St. Peter:
London 1971, p. 6

REFERENCES
De Dominici 1742–45, III, pp. 340, 344;
Haskell 1963, pp. 207–8;
La Valletta 1970, pp. 82–83; Longhi 1961, p. 41;
Pelaggi 1972, pp. 64, 68; Princeton 1980, p. 94;
Rizzi 1970, pp. 20–23;
Ruotolo 1982, pp. 12, 26, 31, 35;
Sergi 1927, pp. 89, 91, 98; Wright 1972, pp. 3–10

106

Feast of Absalom

202 × 296 cm
Capodimonte, Naples

This is probably the picture seen by De
Dominici in the house of the Duke of S.
Severina, together with three others by Preti: a
David Playing the Harp before Saul, a *Madonna
and Child* and a *Belshazzar's Feast* to be
identified with the one now at Capodimonte.

Set under a portico, a favourite device of
Preti's in his numerous banquet scenes to create
particular effects of light and shade (De
Dominici), the picture shows Absalom
interrupting a banquet and ordering his
servants to kill his half-brother Amnon, eldest
son of King David, guilty of having ravished
Tamar, the young sister of Absalom (II, *Samuel*
xiii, 1–30).

Together with the *Belshazzar's Feast* at
Capodimonte the painting has been considered

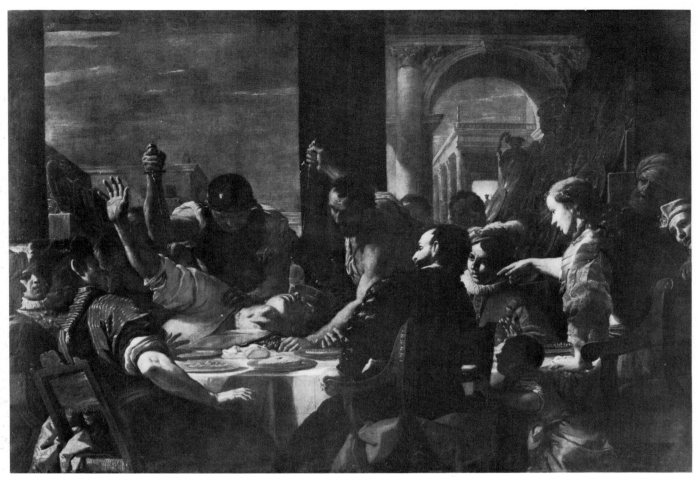

106

to be one of the most important works of Preti's Neapolitan period. Causa dated it to the last phase of the painter's short stay, when Luca Giordano was the new star of Neapolitan painting, between 1657 and 1658. This was Preti's reaction to the new style, a sort of compromise between the reliance on light effects still apparent in the use of chiaroscuro and the Venetian use of background architecture derived from Veronese (Causa 1952; Causa 1972).

Whitfield and Spike disagreed when publishing another version of the painting, now in the National Gallery in Ottawa, which they identified with the picture made for Don Antonio Caputo, Presidente della Sommaria, a great admirer of Preti (De Dominici III). Whitfield considered the Capodimonte picture to be later than that in Ottawa, which he dated to the beginning of Preti's stay in Malta (London 1975, no. 53). Spike dated the Ottawa version c. 1665 and considered it characteristic of the 'late baroque style' in its preference for profuse ornament and movements. On the basis of stylistic comparison with the *Conversion of St. Paul* in the Cappella di Francia in the Co-Cathedral of St. John in La Valletta, documented between 1667 and 1668, which

shares the same muted colouring as this picture, Spike moved the Capodimonte *Absolom* forward, dating it around 1668 (Spike 1979[1], Spike 1979[2]).

Compared with the Ottawa version, the picture in Naples has a more marked contrast in light which accentuates the drama of the scene. The swollen neck of Amnon, thrown back by the servants' daggers as his hand reaches up into the void almost as a signal of surrender, and the horror on the faces of the guests are the first elements of a theatricality which became central to Preti's work; his felicity in compositional invention was transformed in his later work into a more mannered, less original style.

The astonished face of Tamar is reminiscent of his early works while the slender statues that crown the portico, the wide spread of plate and the jug with a curved handle are motifs which he repeated many times, both on canvas and in his earlier fresco: a repertoire of motifs has taken over from imaginative freedom.

This painting was probably the inspiration for Gaspare Traversi's *Feast of Absolom* of 1752 in the Church of S. Paolo fuori le Mura, Rome (Moir 1967).

M.U.

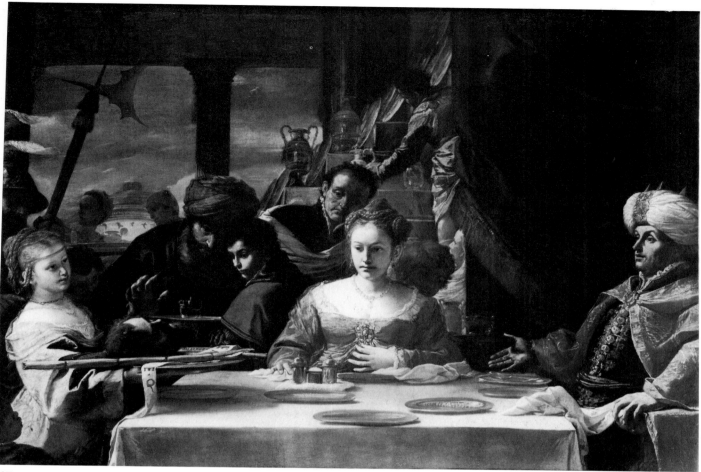

107

PROVENANCE
Duke of S. Saverino, Naples;
sold to Capodimonte by Cecilia Colonna, Princess of
Stigliano, 1907

EXHIBITIONS
La Valletta 1970, no. 391

REFERENCES
Bolaffi 1972–76, IX, p. 227;
Causa 1952, pp. 240–45;
Causa in *Storia di Napoli* V, II, p. 955;
De Dominici 1742–45, III, pp. 340, 372;
London 1975, no. 53;
Moir 1967 no. 80; Spike 1979[1], no. 16;
Spike 1979[2] no. 35

107*

The Feast of Herod

177.8 × 252.1 cm
The Toledo Museum of Art, Gift of Edward
Drummond Libbey
[*detail repr. in colour on p. 95*]

The death of John the Baptist, beheaded at the
command of Herodias who incited her daughter
Salome to ask King Herod for his life (*Matthew*
xiv, 1–12), is transformed by Preti into a scene
completely devoid of drama. The immediate
precedent for such a conception must have been
the *Feast of Herod* by Rubens (Cat. 138) which
was a work of fundamental importance for the
swing to the baroque in Naples. It entered the
collection of Gaspar Roomer around 1640. On
Roomer's death Rubens' *Feast of Herod* passed
with 90 other pictures by inheritance to
Ferdinand van den Einden, who in his turn
commissioned from Preti a *Feast of Herod* (De
Dominici, III). The 1688 inventory of Van den
Einden's pictures mentions both the Rubens and
the Preti (Ruotolo 1982).

Most critics have identified this picture with
the one painted for Van den Einden and date it
in Preti's Neapolitan period, close to the feasts
in Capodimonte and rather later than the Kassel
version. Only Spike proposes that it was painted
when Preti was in Modena and interprets his
work at that time as anticipation of the neo-
Venetian tendencies later to become
characteristic of Giordano (Spike 1978). Voss
believed the picture commissioned by Van den
Einden was that at Kassel (Weisbaden 1938,
no. 57), but this seems to be less complex in
composition and earlier than the Toledo
painting.

The studied scenography of the composition
and the careful arrangement of the various
elements – the richly dressed figure of Herod, in

which one can find traces of the theatricality already present in the Capodimonte feasts, the fall of the napkins on the table, the showy display of dishes, metalware and glass in the background, which recur in all Preti's banquet scenes – all support the idea that this is a work of his mature period.

M.U.

PROVENANCE
F. van den Einden Coll., Naples until 1688; Carafa di Belvedere Coll., Colonna di Stigliano Coll. until *c.* 1920; Professore Zoccoli, Palazzo Roccagiovane, Rome; M. and C. Sestieri, Rome 1960; Colnaghi & Co., London 1961

EXHIBITIONS
London 1961, no. 5; Detroit 1965, no. 151

REFERENCES
De Dominici 1742–45, III, p. 344; Ruotolo 1982, pp. 12–13, 28; Spike 1978, p. 498; Toledo 1976, p. 131; Wiesbaden 1938, no. 57

108
Almsgiving

171 × 123 cm
De Vito Collection, Naples

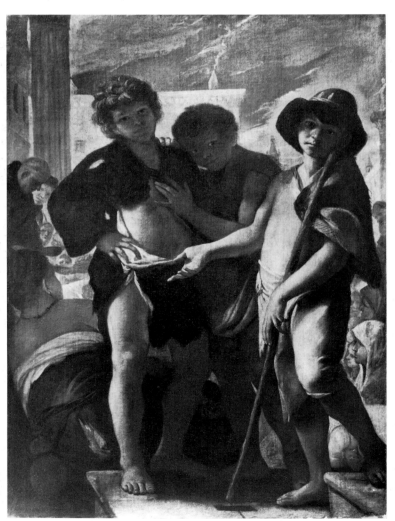

108

Wrongly attributed to Schedoni on the basis of its similarity to the *Almsgiving* in Capodimonte (London 1950, no. 9), this painting was attributed by Briganti to Preti in his Neapolitan period, as might be suggested by the costumes of the three 'pathetic *lazzaroni*' and by the style (Briganti 1951). The composition is of an originality unparalleled in Preti's work compared to the more traditional iconography of the *Almsgiving* formerly in the Connah Collection, Boston, which Longhi dates to *c.* 1640 (Longhi 1918), and this has led critics to think that the picture is a fragment cut from a larger composition, in spite of the fact that its dimensions are already large.

It is one of Preti's most successful pictures painted during his Neapolitan years. Inverting the traditional use of light by concentrating it all on the background of the picture, Preti found a new relationship between Caravaggesque luminism and Venetian Cinquecento painting: 'a Caravaggesque counterlight immersed in a Venetian *plein-air*' (Briganti 1951). In this respect the reciprocal influence between Preti and Giordano is important; (Giordano was already working in Santa Brigida [1655] and later in the Ascensione, Chiaia [1657] and S. Agostino degli Scalzi [1658], cf. Cat. 64). Both artists interpreted Veronese's spaciousness in baroque terms. In Preti, as in Giordano, a golden light illuminates the complex background architecture, dissolving its forms in atmosphere in a way unknown before in Naples.

The woman on the far right recalls her counterpart in the *Martyrdom of St. Philip* by Ribera (Prado). The detail of the child's face completely in shadow, from which his two great 'Neapolitan' eyes stand out, is an expedient which Preti often uses, as he had earlier in the young pages in the *Adoration of the Magi* at Holkham (Cat. 98). The figure of the monk in the left background has been identified as an illustration of a scene of the charity of St. Augustine (Marini 1974[2]).

M.U.

PROVENANCE
Major E. G. Burdon Coll.; Colnaghi & Co., London; David M. Koester; W. P. Chrysler Coll., New York

EXHIBITIONS
London 1950, no. 9; New York 1962, no. 22

REFERENCES
Briganti 1951, pp. 45–49; Causa 1952, pp. 201–12; Leli 1975, p. 78; Longhi 1958, p. 239; Marini 1974[2], p. 133; Nicolson 1979, p. 79; Refice, 1970 p. 87

109
Abraham Drives out Hagar and Ishmael

127 × 150 cm
Fraù Collection, Milan

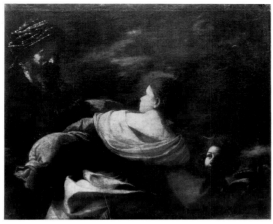

109

Abraham was compelled to drive out the
Egyptian slave Hagar, (the mother of his son
Ishmael), by his wife Sarah, the mother of Isaac,
so that Isaac should not have to share his
father's inheritance with Ishmael. The painting
shows the moment when, at dawn, Abraham
gave Hagar a piece of bread and a water-skin
and ordered them to depart (*Genesis*, xxi, 9–21).

According to De Dominici (III), Preti painted
this subject for Giuseppe d'Anna Reggio, a
customs official. Causa rejected Carandente's
dating of *c.* 1635–40 (La Valletta no. 383) and
dated the work to 1657–58, believing it was
painted in Naples (Causa 1972). Another *Hagar*
(Royal Palace, Madrid) is considered a youthful
work; it was formerly attributed to Guercino.

Whereas the Madrid version combines echoes
of Emilian classicism with the tenebrism of the
northern Caravaggisti which Preti saw in Rome
in the 1630s, the present picture shows a greater
attention to detail (Hagar's hair gathered on
her neck, and the beard and turban of Abraham for
instance), and clearly belongs to the Neapolitan
period. The motif of the woman seen from
behind with a mantle across her shoulders was
repeated both by Preti and other eighteenth-
century painters, including Mola and Giordano.

The *Hagar* in the Castle Schleissheim
Collection (Hohenzollern, 1980) is a youthful
work. More problematic is the painting in the
private apartments of Palazzo Doria Pamphili
which Longhi (1943) dated early, an opinion
which Faldi did not share (1957). Another *Hagar*
is at Miami (Marini 1976). Two drawings of this
subject, traditionally attributed to Preti are in
the Museum at Dusseldorf (Pelaggi 1972).

M.U.

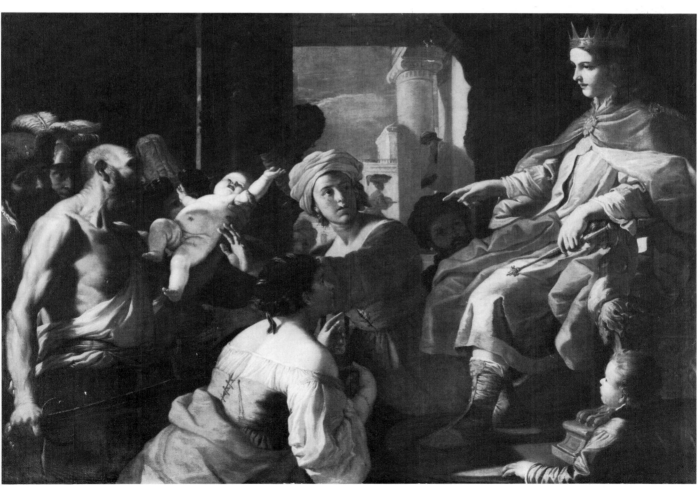

110

PROVENANCE
Gualtieri Coll., Naples; De Biase, Naples;
Galleria Manzoni, Milan

EXHIBITIONS
Florence 1922, no. 797; Milan 1967, no. 28;
La Valletta 1970, no. 383; Bucharest 1972

REFERENCES
Causa in *Storia di Napoli* 1972, pp. 991, 993;
De Dominici, 1742–45, III, p. 353; Faldi, 1957, p. 17;
Hohenzollern, 1980, p. 66; Longhi, 1943¹, p. 60;
Pelaggi, 1972, p. 67; Perez Sanchez, 1965, p. 418

110
The Judgement of Solomon

202 × 296 cm
Palazzo Serra di Cassano, Naples

The scene represents an episode from I *Kings*. A newborn child dies in the course of the night and his mother exchanges him with the child of a woman who has given birth at the same time. When the trick is discovered in the morning, Solomon is called in to give judgement. The king orders the baby to be cut in two to content both women: the reaction of the true mother shows what had really happened (I *Kings*, iii, 16–28).

This painting, previously unpublished, was cited by Montalto among the four works by Mattia Preti which formed part of the Serra di Cassano Collection: a *Hercules and Prometheus* and a *Hercules and Amphion*, now both in the Perrone Capano Collection and dated by Refice to Preti's late Neapolitan period but probably later (Refice 1970), *Christ and the Woman of Samaria* and the *Judgement of Solomon*. The last two are listed in the 1740 inventory of objects of art in Palazzo Serra, Naples, consulted by kind permission of the Duke, together with three other pictures by Mattia Preti, two generically termed Virgins and the last of 'two painted figures'.

Both the composition and the decorative intent of the picture – the mannered figure of the young king sitting on his high throne, wrapped in rich garments, the exotic costumes and hats – suggest a date after Preti's arrival in Malta, probably in the 1670s. At this stage in his career Preti could elaborate on his rich cultural experience with great technical skill and create a decorative style. That this accorded with the patrons' taste is shown by his vast output.

Caravaggesque luminosity (tempered by Guercino), memories of Ribera (the muscular figure of the executioner with his wrinkled brow), Emilian colour and Venetian backdrops all combine to form this style (Longhi 1913).

M.U.

REFERENCES
Longhi 1913, p. 41; Montalto 1920, pp. 100, 210;
Pelaggi 1972, p. 49; Refice 1970, p. 73;
Sergi 1927, p. 96

Giacomo Recco

NAPLES 1603 – NAPLES before 1653

Mentioned in passing by De Dominici as the father of the more celebrated Giuseppe, Giacomo Recco is one of the earliest Neapolitan still-life painters. He is grouped together with the mythical Ambrosiello Faro, Angelo Mariano and the better-known Luca Forte as a painter of 'flowers, fruit, fishes etc.' (Tutini 1898, 1899). In 1632 the young Paolo Porpora was apprenticed to Giacomo Recco (Prota Giurleo 1953). Around these scanty references a hypothetical career has been reconstructed for the last years of this Neapolitan flower painter.

The *Vase of Flowers* (Rivet Coll., Paris), probably dated 1626, and the two *Vases with Flowers* (Romano Coll., Rome), one of which is monogrammed G. R., were used as a nucleus from which to identify the work of Giacomo Recco (Causa 1961). Both the style and the probable date of 1626 would exclude the authorship of his son Giuseppe, who was born in 1634.

These rather formal, artificial arrangements of flowers in vases are typical of the sixteenth-century repertory and far removed from the realistic style instigated by Caravaggio. It is significant that Jan Brueghel was in Naples in 1590 and that mannerism was still fashionable in the mid-1620s. Two pictures with a *Vase of Flowers* apparently signed by Giovanni da Udine dated 1538 and 1553, have been recognized as seventeenth-century Neapolitan copies (Sterling 1952, Causa 1961); these have been compared to the *Vase with Flowers* (Cat. 111), also formerly attributed to Giovanni da Udine (Bologna 1968). Its attribution to Giacomo Recco (Causa 1961) is reinforced by its close connection with, for instance, the *Vase of Flowers* (Fleurville Coll., Paris), probably datable between the Rivet picture and the later ones in the Romano Collection. These three pictures are important to chart Recco's stylistic development. His combination of mannerist decoration and Flemish refinement produced an entirely original style.

A.T.

REFERENCES
Bologna in Bergamo 1968, pl. 1; Bottari 1961, pp. 354–61;
Causa 1961, pp. 344–53;
Prota Giurleo 1953, p. 13; Sterling 1952;
Tutini 1898, p. 191; Tutini 1899, p. 163

111

Vase of Flowers with the Arms of Cardinal Poli

76 × 60 cm
Pietro Lorenzelli Collection, Bergamo

Giovanni Battista Recco

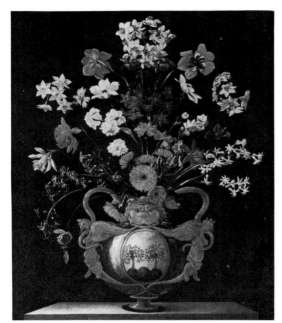

111

This picture was formerly attributed to Giovanni da Udine and dated *c.* 1555 on account of the mannerist decoration of the vase and its affinity to the frieze with still-life details painted by Giovanni da Udine in the Castle at Spilimbergo near Udine (Bologna 1968; Sterling 1952; Causa 1961). Two seventeenth-century Neapolitan copies of Giovanni da Udine's frieze were known to exist (Sterling 1952; Causa 1961), but Bologna commented on this picture's 'very high quality, which leaves far behind the tired and dimly lit copies'.

Causa (1972) first attributed the painting to Giacomo Recco. The light effects which silhouette the flowers (which are treated with a Flemish miniaturistic technique) derive from Caravaggio. It is close stylistically to Giacomo Recco's paintings in the Rivet and Romano Collections; this picture differs from the two other seventeenth-century copies in that Recco, although attached to the late mannerist style, has already fallen in with the spirit of the new age. Zeri identified the coat-of-arms as those of the Poli family of Cascia (Causa 1972). The Barberini bees are included because one of the Poli family, Fausto, was created a cardinal by Urban VIII in 1623. Since Fausto Poli died in 1653, the still life can be dated between 1623 and 1653.

A.T.

EXHIBITIONS
Zurich 1964, no. 5; Rotterdam 1965, no. 5; Bologna in Bergamo 1968, pl. 1

REFERENCES
Causa 1961, pp. 346, 353;
Causa in *Storia di Napoli*, V, III, 1972, p. 1003, n. 28;
Sterling 1952, pp. 36, 128, n. 66

Although Giovanni Recco appears in old inventories with the diminutive epithet of 'Titta', he was not mentioned by De Dominici and has only been rediscovered recently thanks to the work of Di Carpegna (1961), Bottari (1961) and De Logu (1962), to which Bologna (1968) and Causa (1972) later contributed. His dates are uncertain, but the rigorous naturalism of his style, influenced by Spanish developments in the first decades of the century, caused critics to place his birth about 1615–20 as opposed to 1630, which had tentatively been proposed by Di Carpegna. At first he was believed to be the elder brother of Giuseppe Recco, then the son of Giacomo (Di Carpegna 1961), but it seems likely that he was in fact the brother of Giacomo and the uncle of Giuseppe (Causa 1972).

Recco painted themes common in Spanish art – especially kitchen interiors – and he influenced the young Giuseppe Recco and Giovanni Battista Ruoppolo. He adhered to the style of Caravaggio more strongly than Luca Forte and the Master of Palazzo San Gervasio. His style approached that of the Spanish artists – Alejandro de Loarte, Juan van der Hamen, Juan and Francisco Zurbaran and the young Velasquez: this may be due either to Recco travelling to Spain at an early date or to the influence of Giovanni Quinsa and the presence of Spanish paintings on Naples.

Documentary evidence is scant. In the inventory drawn up in 1688 by Luca Giordano of the estate of the Flemish banker Ferdinand van den Einden, a large picture by 'Titta' Recco, measuring 10 × 8 *palmi*, of 'kitchenware in a larder with a cat wringing the neck of a heron' is listed (Ruotolo 1982). Despite its singular subject this work has not been identified. Two signed and dated paintings, the *Fish* (Mendola Coll., Catania 1653) and the *Larder* (ex Rappini Coll. 1654) make it possible to attribute to this phase of Recco's career two paintings: the *Fish and Oysters with Dish* in the Stockholm Gallery, formerly ascribed to Giovanni Battista Ruoppolo because of the presence of the monogram 'G.B.R.', and the canvas with *Dead Chickens and Eggs* (Rijksmuseum, Amsterdam), formerly attributed to Velasquez. There are not many certain works by 'Titta' Recco, although the *Kitchen Interior*, monogrammed 'G.B.R.' must be an early work (ex Astarita Coll., Naples; Di Carpegna 1961).

To his late period we may attribute the *Larder* (ex Molinari Pradelli Coll., now Lorenzelli; Bottari 1961; Bologna 1968) and the *Kitchen Interior with Game and a Live Turkey* (private

coll., Bologna; Bologna 1968) formerly thought to be by G. B. Ruoppolo because of the monogram 'G.B.R.' (Volpe in *Napoli* 1964; the same author has recently mistakenly reaffirmed his attribution to Ruoppolo, 1981). The *Still Life with Lemons* (Duca di Martina Coll., Naples) was attributed to Ruoppolo (Causa in Naples 1964), but since the signature is illegible the authorship is open to doubt (Bologna 1968; Causa 1972). The two still-life paintings with a goat's head at Capodimonte present great problems; if they are really by the same hand we must leave an interval of at least ten to fifteen years or more between the first (Cat. 112), which is violently naturalistic and Riberesque, and the second (Cat. 113), in which an incipient academicism in the composition suggests that it may date from the late 1650s.

R.M.

REFERENCES
Bologna in Bergamo 1968, pl. 42; Bordeaux 1978, pp. 115–16; Bottari 1961, pp. 354–61; Causa in *Storia di Napoli*, V, III, p. 1041; Di Carpegna 1961, pp. 123–32; Ruotolo 1982, p. 17; Volpe in Naples 1964, p. 17

112

Still Life with a Goat's Head

69 × 100 cm
Capodimonte, Naples

The attribution of this painting is controversial, but its quality and the extent to which it was imitated by other Neapolitan still-life painters in the first half of the Seicento make it an important work. The subject, with the gory head still bleeding beside the more conventional basket of eggs and the copper bowl on the left, is somewhat unusual; but there are examples of it in Spanish painting dating from the early years of the century.

The picture is permeated with a sense of Caravaggesque realism, rendered with a sureness of touch that recalls Ribera's maturity. This suggests an early date, around the 1640s, and rules out the attribution to Giovanni Battista Ruoppolo originally proposed by Causa (Naples 1964), for even in his early phase he never achieved such firm modelling of light or such intense images. Nor is Bologna's suggestion (1968) of the early Giuseppe Recco any more convincing, even though he makes the comparison with '. . . the well-known *Kitchen Interior* in Vienna, which is dated 1675, and with the other one which is also signed and dated 1680'.

Causa (1972) made the plausible suggestion that it is by Giovanni Battista Recco, close in date to the *Chickens and Eggs* in the Rijksmuseum, Amsterdam. There are many points of contact between this picture and Spanish still-life painting, and this corresponds with the Amsterdam work, which was originally attributed to Velasquez. In this painting 'Titta' Recco comes closest to Velasquez, to Alejandro de Loarte and Sanchéz Cotàn, although the attribution must remain somewhat tentative, as he is usually less pictorially imaginative and more meticulously descriptive. If it is by him, then it must date from at least 15 years prior to Cat. 113, which is a work of *c.* 1650. Causa's attribution has recently been supported by Volpe (Milan, 1981).

R.M.

PROVENANCE
Lombardi di Cumia Coll., Naples; acquired by the Capodimonte 1979

EXHIBITIONS
Naples 1964, no. 81; Zurich 1964; Rotterdam 1964

REFERENCES
Bologna in Bergamo, 1968, pl. 45; Causa in *Storia di Napoli* 1972, p. 1015; Tiberia in Rome 1982; Volpe in Milan 1981, pl. 5

113

Kitchen Still Life

128 × 183 cm
Capodimonte, Naples
[*repr. in colour p. 101*]

This is a painting dating from 'Titta' Recco's maturity, a little after 1650. It is one of his most successful compositions, comparable in its harmony with works such as those in the Mendola Collection, Catania, the Rijksmuseum, Amsterdam and the Nationalmuseum in Stockholm.

Causa first published this painting (1972). He then believed that the picture was a late work

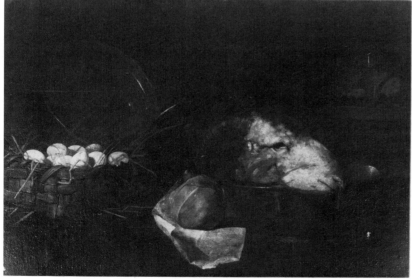

112

and, apart from Bologna (1976), subsequent writers have been in favour of Causa's attribution. However, Rosci's idea (1977) that this picture shows the influence of Flemish and Spanish still-life paintings seems to be exaggerated, except for the relationship with Juan van der Hamen, who was capable of this kind of geometric arrangement of elements in his most Italianate phase. But the straightforward quality of the painting and the use of chiaroscuro might point to some knowledge of Caravaggesque painting in Rome and of the first generation of Neapolitan still-life painters, like Luca Forte and the Master of Palazzo San Gervasio. These characteristics suggest some connection with Giuseppe Recco (the nephew of Giovanni Battista), who cannot however be regarded as the author of this painting.

The apparently casual disposition of the objects is in fact carefully selected and arranged. The objects are equidistant from each other and the great copper bowl and the Neapolitan majolica dish form the centre around which the composition is hinged. The feature of the goat's head, which is also present in Cat. 112, does not have the same dramatic quality here as in the latter painting; it is reduced to being merely an element in a carefully balanced composition.

R.M.

PROVENANCE
Baratti Coll., Naples, acquired 1973

EXHIBITIONS
Naples 1975; Bordeaux 1978

REFERENCES
Bologna 1976, p. 3; Causa 1972, p. 1041; Rosci 1977, p. 237

Giuseppe Recco

NAPLES 1634 – ALICANTE 1695

Giuseppe Recco came from a family of artists specializing in still-life painting. His father Giacomo was one of the first Neapolitan flower-painters and his uncle Giovanni Battista's work combined elements of both the Neapolitan and Spanish styles. Of the numerous children of Giuseppe Recco, Elena and Nicola Maria were both minor painters.

Giuseppe Recco began in the family tradition, painting naturalistic compositions of flowers, fish and kitchen interiors; only at the end of his life did he lean towards a more elaborate baroque decorative style. According to De Dominici (1742), he went to Lombardy when in his twenties. This has led some critics to discern the influence of Evaristo Baschenis of Bergamo. But there is no proof that Recco visited Lombardy and the influence of Baschenis may have filtered through to him via Bartolomeo Bettera. The only similarity between the work of Baschenis and Recco's mature work is in the subject matter.

From the beginning of his career, Recco dated and monogrammed many works (some are fully signed) and this allows us to follow the evolution of his style with ease. The *Bodegón with a Negro and Musical Instruments* of 1659 (Medinacoeli Coll., Madrid) shows his style moving away from that of Giacomo Recco towards that of Giovanni Battista Recco, and the *Bodegón with Copper Vessels and Fish* (Moret Coll.), formerly misattributed to his uncle Giovanni Battista (Bottari 1961), dates from 1664. The large unfinished *Still Life with Fruit, Flowers and Birds* is dated 1672 (Reserve Coll., Capodimonte); *Still Life with Fish* is of 1674 (Gaudioso Coll., Catania); and the *Kitchen* (Akademie Gallery, Vienna) is dated 1675 and is still dependent on Giovanni Battista Recco. The *Fish* (Uffizi, Florence) is dated 1691. In his last phase Recco was evidently influenced by the baroque still lifes of Giovanni Battista Ruoppolo and Abraham Brueghel, but he never abandoned the order and clarity of his own style. From about 1680 he signs his works EQUES (or EQS), that is to say *Cavaliere*; according to De Dominici (1742) he was a knight of the Order of Calatrava, although this has recently been denied (Pérez Sánchez 1965).

A small group of paintings dating from the artist's maturity stand apart from the rest of his work and re-open the problem of his relationship to Baschenis and Bettera. These are the *Still Life of the Five Senses* dated 1676 (Lorenzelli Coll., Bergamo), the *Flowers and Candied Fruit* dated 1680 and signed EQS R (Pesaro Museum), the *Still Life with Masks and Musical Instruments* (Boymans-Van Beuningen Museum, Rotterdam) signed *G. Recco* and the *Still Life with Glasses* (Warsaw Museum) signed *Gios Recco*. If we eliminate Bettera, who was five years younger than Recco, there remains the dependence on Baschenis, but he seems to have influenced the content rather than the style of Recco's pictures (Rosci 1971). Causa also detected in this group of paintings echoes of the compositions of foreign painters working in Rome – for instance, Francesco Fioravino the 'Maltese' and Meifren Conte of Marseille, who was there between 1651 and 1654.

There are several problems of attribution in Recco's career, arising partly from the confusion over the monogram *G R* used by Giacomo Recco, Giuseppe Recco and Giuseppe Ruoppolo. The two pictures of *Flowers* monogrammed *G R* are particularly problematic (ex Bloch Coll., now Lorenzelli); they were assigned first to the final period of Giacomo Recco (Causa 1961; Bologna 1968),

transferred to Giuseppe Recco's early period (Causa 1972), but more recently given back to Giacomo (Volpe 1981). The attribution to Recco of two pictures in the Garzilli College, Naples which was suggested by Bologna (1958), is uncertain. It was recently contested by Volpe (1981).

Invited to Spain by Charles II, Recco died at Alicante shortly after his arrival. His last paintings are a *Death of St. Joseph* and an *Assumption*, both in the Arenaza College, his only religious paintings.

R.M.

REFERENCES
Bologna 1958, p. 67; Bologna 1968, pl. 24;
Bottari 1961, p. 356; Causa 1961, p. 369, n. 156 b;
Causa in *Storia di Napoli*, V, III, 1972, p. 1123;
De Dominici 1742–45, p. 295–6; Perez Sanchez 1965, p. 424;
Volpe in Milan 1981

114
Still Life with Fruit and Flowers

255 × 301 cm
Capodimonte, Naples

This is one of the best examples of a flowerpiece in Giuseppe Recco's mature style. It came from the d'Avalos collection in Naples with another picture of similar subject and size (Naples 1964, no. 93) and was attributed to Giovanni Battista Ruoppolo, an attribution which was retained in the inventories of Capodimonte (De Rinaldis 1928; Causa in Naples 1964, no. 86). Its presumed companion piece was attributed to two painters, the centre to Giuseppe Ruoppolo and the landscape and architecture to Abraham Brueghel (De Logu 1962).

Recently this painting has been attributed to Giuseppe Recco at a time when he was deeply influenced by Giovanni Battista Ruoppolo (Causa 1972). The firm rendering of the individual elements derives from Giuseppe Recco, even if the theatrical composition shows the baroque tendencies of Brueghel and G. B. Ruoppolo. We can exclude the idea that the two pictures from the d'Avalos collection were pendants: the *Flowers and Fruit* (Naples 1964, no. 93) has none of the stylistic vigour of this picture and would appear to be at least ten years later in date – even the attribution to Giuseppe Ruoppolo and Abraham Brueghel no longer seems satisfactory. Moreover this picture has a strip of landscape painted by another hand, added on the left at a later date in order to match the scale of the other picture.

Stylistically this *Fruit and Flowers* is close to the *Watermelon, Silver Dish and Parrot* (Capodimonte), to an unfinished painting *Flowers, Fruit and Birds* of 1672 (Reserve Coll., Capodimonte) and to the *Still Life with Fruit* in the Molinari Pradelli Collection (no. 73 in the 1964 exhibition). Another example of Giuseppe

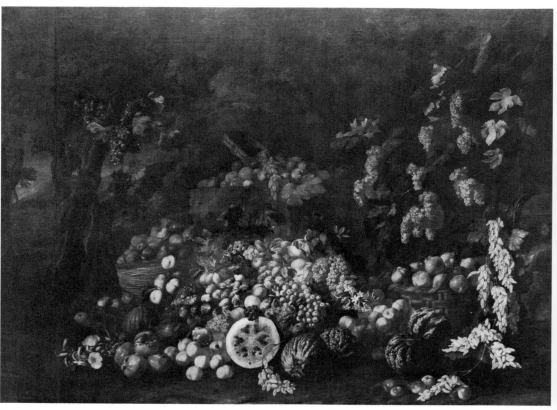

114

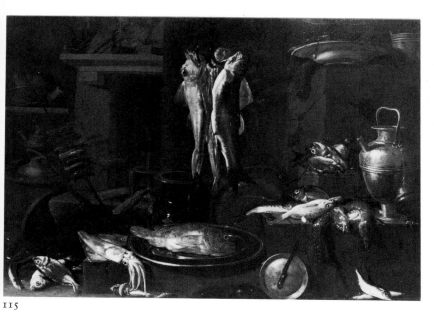

115

Recco's large-scale flower paintings is the monumental canvas with *Flowers and Game* in the Palazzo di Montecitorio, Rome, with a Neapolitan provenance, similar in size and shape to the Capodimonte picture and also with a landscape background. In the Roman painting the introduction of archaeological and romantic motifs shows the more direct influence of Abraham Brueghel.

A fuller account of Giuseppe Recco is given by Bologna (1958; 1968), Causa (1972) and Volpe (1981, no. 4).

R.M.

PROVENANCE
D'Avalos Collection, Naples; transferred to Capodimonte 1882

EXHIBITIONS
Naples 1938; Naples, Zurich, Rotterdam 1964

REFERENCES
Bologna 1958, pp. 67, 120;
Bologna in Bergamo 1968, pl. 45;
Causa in *Storia di Napoli* 1972, p. 1049;
De Logu 1962, p. 131; De Rinaldis 1928, pp. 277–78;
Molajoli 1964, p. 55; Ortolani 1938, p. 112
Volpe in Milan 1981, no. 4

115

Still Life with Fish

121.5 × 175 cm
Signed: lower left *G. . .ᵉ Recco F.*
Matthiesen Fine Art Ltd., London

This kitchen interior is characteristic of Giuseppe Recco's work; he was well-known for specializing in fish still lifes. The composition here is still similar to those of his uncle Giovanni Battista, as may be seen from a comparison with the latter's work (Cat. 112, 113); this points to a date relatively early in his career, perhaps around 1660. It is comparable to the monogrammed picture of *Fish on the Shore* at

Capodimonte, which must be a somewhat later work, and with the large *Kitchen Interior* in the Kunsthistorisches Museum, Vienna which is dated 1675.

Still a typical Neapolitan subject, the fresh fish recalls the gift that Masaniello, who was a *pescivendolo* (fish-seller), is known to have sent to the viceroy in the early days of the insurrection a decade or so earlier.

C.W.

EXHIBITIONS
London 1981, no. 14

116 & 117

Flowerpiece
Companion Flowerpiece

Each 258 × 206 cm
Signed: EQUES RECCUS F 1683
Governors of the Burghley House Preservation Trust
[*Cat. 117 repr. in colour on p. 103*]

These are two outstanding paintings from Giuseppe Recco's late period. They were completely overlooked until recently, but are fully documented as well as being signed and dated. The earliest mention of them is in D'Addosio (1912) who published a record of a payment made to the artist on 10 May 1684 for these two pictures. The agent of the Marquess of Exeter, George Davies, paid Giuseppe Recco 66 ducats, to be made up to 100 as a down payment for two flower paintings, each measuring 10 × 8 *palmi*; the full fee was to be 400 ducats, an extremely high price for paintings of this sort. Recently De Vito (1982) connected these payments with the pictures from Burghley House. Lord Exeter's contact with the painter did not stop there; on 8 October 1685 Giuseppe Recco was paid 385 ducats through Davies for two large paintings of fish and four small ones, two of fish and two of game (D'Addosio).

The paintings show Recco's art in its most mature phase, incorporating the most recent developments in European still-life painting; the richness of design and colouring recalls the work of J. B. Monnoyer. The great vases are decorated with mythological reliefs. One illustrates the story of Perseus and Andromeda, while the other shows two episodes: a battle of Lapiths and Centaurs and two nude men battling with a great serpent who bites off one of their heads. It does not appear to correspond with any of the labours of Hercules, nor does it appear related either to the story of Laocoön or to the serpent in the story of the Creation of Man.

In these paintings, Recco collaborated with another unknown painter, who was probably responsible for the reliefs and the two female figures in one of them. This collaboration

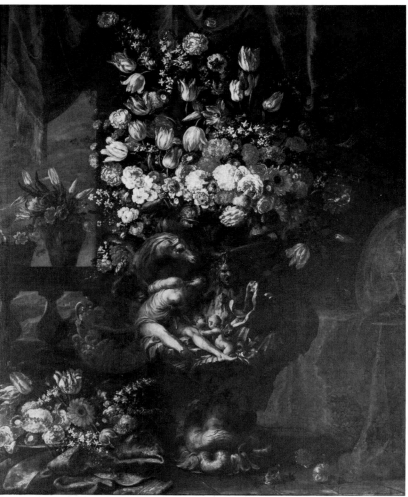

116

between a still-life painter and a figure-painter is not uncommon in Neapolitan painting of the Seicento. In this instance it would seem that the artist involved belonged to the circle of the young Francesco Solimena and was particularly influenced by his frescoes in S. Giorgio at Salerno and in S. Maria Donnaregina in Naples.

R.M.

REFERENCES
D'Addosio 1912, p. 493; De Vito 1982, p. 10

Guido Reni

BOLOGNA 1575–BOLOGNA 1642

Reni is recorded as having been in Naples twice, in 1612 and again in 1621–22, but the great esteem in which his art was held by Spanish patrons and Neapolitan artists alike meant that many works other than those actually painted in the city are relevant when considering his impact there. In 1619 negotiations were under way for him to execute the fresco decoration of the

Cappella del Tesoro in Naples Cathedral, perhaps the most important commission in the city that was debated for a whole generation. Reni brought with him his assistants Gessi and Sementi to help him with the work, but the exact circumstances of his departure before he had even started it are unclear; it was not until a decade later that Domenichino was enticed from Rome to execute the work.

The importance of Guido Reni's art to the Spanish patrons is a little easier to gauge from the larger number of works attributed to the artist still in Spanish collections. It is difficult, however, to be certain about the precise date of most of these works; Reni was enthusiastically pursued to Rome by several successive viceroys and Spanish ambassadors whom he treated in a characteristically cavalier fashion. It is possible that one of the works that ensured his enduring popularity in Spain was the *Atalanta and Hippomenes* of which there are autograph versions at Capodimonte and the Prado. The second version has the earliest recorded history – it was in the Spanish Royal Collection by 1666 – and it could well be that the other version was commissioned, perhaps during or following Reni's first stay in Naples, in order to retain this extremely successful image in a Neapolitan collection.

In the 1620s the Spanish patrons redoubled their efforts to secure works by Reni for the Crown; possibly the single most important painting sent over there was the *Immaculate Conception* (Metropolitan Museum, New York), which was painted *c.* 1627 for the Infanta of Spain, through the Spanish Ambassador in Rome, in order to hang in Seville Cathedral. The great *Rape of Helen* in the Louvre was originally painted for Philip IV, although when it was eventually completed in 1631 it went to France. Also never delivered to Spain was an 'immense canvas', as Malvasia describes it, with the story of Latona, which was never completed. Evidently, many of Reni's paintings, even ones as large as the *Nativity* painted for the high altar of the Certosa of S. Martino (which is a late work very similar in style to the large picture of the same subject in the National Gallery, London) were not painted in their eventual locations.

Stylistically, it was the combination of Reni's painterly virtuosity and the balance of his design that had such a lasting impact in Naples. Once again, it is tempting to see the *Atalanta and Hippomenes* as the composition that set in train this enthusiasm; a work whose chiaroscuro is not distant from that of Caravaggio, but in which the representation is permeated with a tender realism that would be taken up by Stanzione and Cavallino, Falcone and Vaccaro. Clearly some of these painters were aware of many more of Reni's works than those that were

in Neapolitan collections and the general fashion for Bolognese painting, particularly in the 1630s, meant that some of them must have travelled to Bologna to see his pictures there.

C.W.

118
The Meeting of Christ with St. John the Baptist

198 × 148 cm
Sacristy, Church of the Girolamini, Naples
[*repr. in colour on p. 73*]

This remarkable and little-known masterpiece has been in the church of the Girolamini, S. Filippo Neri, since it was delivered and framed *in situ* by a marvellous contemporary polychrome marble surround. It was commissioned by Domenico Lercari, who left his entire inheritance to the Philippine fathers, and it used to be thought that it dated from the time when Reni came to Naples to paint the Cappella del Tesoro, around 1622. In reality the documents unearthed by Borrelli (1968) show that although Lercari had paid for three pictures from Reni and Gessi, these had still not been delivered at the time of his death and the Congregazione had some difficulty in securing their delivery. It would appear that the present picture had arrived by 1628–33, while one of Gessi's pictures was delivered only in 1646–48.

The picture is a miraculous example of Reni's mature style, an evolution of the kind of composition represented by the Capodimonte *Atalanta and Hippomenes* with which the two figures in this picture invite comparison. Their juxtaposition is perfectly balanced and the rendering of the flesh tones is of the utmost delicacy and naturalism, belying the artificiality of their poses. The subtlety of the tonal variations is eloquent testimony to the enormous impact that Reni's art had in Naples, particularly in the 1620s and 1630s. It is by far the most poetic of the three pictures by Reni at the Girolamini, the others being a *Flight into Egypt* and a *St. Francis in Ecstasy*. One at least of these may have been completed before 1622, as the three outstanding pictures due to Lercari at the time of his death included a S. Domenico and another whose subject had been forgotten, but turned out to be St. Jerome.

The subject of the picture is unusual; another version in which Reni used simply the heads of Christ and St. John, is in the National Gallery, London (no. 191). The representation of St. John is of course reminiscent of paintings like Reni's *St. John the Baptist in the Wilderness* in Dulwich, or the *St. John the Baptist* in the Galleria Sabauda, Turin; it would seem that Reni used the same model in all these pictures.

C.W.

EXHIBITIONS
Bologna 1954, no. 21
REFERENCES
Baccheschi 1971, no. 112;
Borelli 1968, pp. 41, 50–51, 64–65;
Cochin 1756, I, p. 251; Passeri ed. Hess 1934, p. 33;
Kurz 1971, p. 217; Lalande 1769, VI, p. 264;
Middione 1982; Oretti 1760–80, IV, p. 276;
Richard 1769, p. 151

Jusepe De Ribera,
called Spagnoletto

JATIVA (VALENCIA) 1591–NAPLES 1652

Ribera was born and trained in Spain, but the hypothesis that he was apprenticed to Francesco Ribalta is undocumented and no paintings survive from this period. Seventeenth-century sources state that he was in Lombardy and at Parma around 1610–12, a hypothesis made probable by the political, cultural and spiritual ties between Lombardy, Emilia and Spain at this date. At Parma, where he was in the service of Prince Ranuccio Farnese, he was able to study the painting of the Cinquecento, from Correggio to Carracci. During this period he painted a *St. Martin* in S. Andrea which was recorded by Ludovico Carracci, but has since been lost. In 1615, he is documented as being in Rome where he came into contact with the circle of northern Caravaggisti and painted works of great originality, such as the series of the *Five Senses* mentioned by Mancini.

In 1616 he left for Naples, probably in the suite of the Viceroy Conde de Osuña. There he married Caterina, daughter of the painter Giovanni Battista Azzolino. After this, he was to leave Naples rarely, except for short trips to Rome, to receive the Cross of a Cavaliere of the Order of Christ in St. Peter's on one occasion, and to northern Italy, in the retinue of the Infanta Maria.

In Naples, under the protection of the Spanish viceroys, who commissioned many works from him, Ribera quickly gained a prominent position in the artistic community and worked for the local aristocracy and some of the most powerful religious orders. Some of his works were sent back to Spain. The *Apostles* (Picture Gallery, Girolamini), the *SS Peter and Paul* (Strasbourg), and *The Penitent St. Peter* (Marsicola Coll., Rome) are all close in style to the *Five Senses* and probably date either from the end of his time in Rome or his first years in Naples. In the years 1616–23 his activity is documented by engravings and drawings which show his interest in graphics, both as a medium of expression and as a means of deepening his study of nature.

From 1626, the year of the *Drunken Silenus*,

his development can be closely followed in the many signed and dated works. These chart his development from the crude realism culminating in the *Martyrdom of St. Bartholomew* of *c.* 1630 (Pitti Palace), which reflects the culture of the Spanish Counter-Reformation mystics, particularly the Jesuits, towards a gentler naturalism. This phase owes much to the influence of Velasquez whom he met in 1630. From it date the series of *Apostles*, (*S. Rocco, St. James*) and the *Philosophers* (*Archimedes*), all in the Prado, and the Old Testament characters (*Jacob* in the Escorial) in which Ribera creates a more intimate realism.

By 1634 he had fallen under the influence of Van Dyck and the fashion of neo-Venetian painting which originated in Rome (*S. Zaccaria*, Rouen; *St. Gregory's Mass*, Amiens). His heightened sensibility to light and colour culminates in the dynamic baroque paintings of 1637–38 (*Venus and Adonis*, Corsini Gallery Rome; *Jacob and Isaac*, Prado, Madrid). In 1637–38 he was also painting for the Certosa di

S. Martino a series which included the *Pietà, Moses, Elijah*, and the *Prophets* in the lunettes of the lateral chapels.

From 1640–46 his activity was slowed down by an illness which forced him to make increasing use of pupils and collaborators; works of this date may be signed and dated by Ribera but show obvious signs of studio intervention. However the *Penitent Magdalen* in the Prado, the *Cripple* in the Louvre and the Capodimonte *St. Bruno* all contain autograph elements. *S. Gennaro Emerges Unharmed from the Furnace*, painted on copper, was made for the Saint's chapel in the Duomo in 1646.

His last works show increasing psychological understanding of his characters; the compositions are monumental and bathed in a warm, golden light, obviously deriving from Venetian painting. To this period belong works of extreme refinement such as the *Mystic Marriage of St. Catherine* (Metropolitan Museum, New York) and the serene *Adoration of the Shepherds* (Louvre, Paris). One of his last works is the *Communion of the Apostles* in S. Martino, commissioned in 1637–38, but dated 1651.

There are few autograph portraits; they include *Maddalena Ventura degli Abruzzi* (Fundación Duque de Lerma, Toledo), a *Jesuit Missionary* (Poldi Pezzoli, Milano), a *Knight of the Order of Santiago* (Meadows Museum, Dallas) and *Don Juan of Austria on Horseback* (Royal Palace, Madrid).

Ribera died in Naples on 5 September 1652 after more than 30 years of uninterrupted activity. His example was fundamental in forming the style of the many Neapolitan painters who trained in his workshop, but went on to paint in widely divergent manners.

D.M.P.

119
Taste

113.5 × 87.5 cm
Wadsworth Atheneum, Hartford, Conn., The Ella Gallup Sumner and Mary Catlin Sumner Collection

Longhi (1966) identified this picture on the basis of a series of five seventeenth-century copies then on the Paris art market, as one of the sequence of *Five Senses* mentioned by Mancini (1614–20/21), painted by Ribera in Rome before he went to Naples in 1616. Previously it had been variously attributed to P. Novelli, Velasquez and Puga.

It shows a man sitting at table before a dish of squid, with a glass of wine in his right hand; on the table is a still life of bread, cheese and olives. The background is dissected by a diagonal band of shadow in the manner of Caravaggio. Its composition and style link it to two other

119

pictures: *Touch* (Norton Simon Foundation, Los Angeles) and *Sight* (Museum of San Carlo, Mexico City); *Smell* and *Hearing* exist only as copies. Unlike earlier northern mannerists' allegorical interpretations of this subject, Ribera's treatment is sharply naturalistic, one of his first successful attempts at following the example of Caravaggio which preoccupied so many of the northern artists active in Rome in 1610. The composition, and the treatment of the hands is close to the *St. Sebastian* and *St. Jerome* in the Collegiate Church of Osuña (Pérez Sánchez 1978). Ribera interprets the teaching of St. Ignatius Loyola, using the five senses to explain the Holy Mysteries (Felton 1971).

There are numerous copies (Hermitage, Leningrad; Europahaus, Vienna [Felton 1971]; Prado reserve coll.; private coll., Madrid [Pérez-Sánchez 1978]; Rossi Coll., Forlí; Casa Pampini, Florence [Longhi 1966]; Dorotheum, in Vienna auction 1966 attributed to 'Baburen after Ribera' [Longhi 1966]). Another copy noted by Soria in the store of the Accademia di San Fernando, Madrid has disappeared.

D.M.P.

PROVENANCE
Coll. Prince Youssoupov, Moscow;
Duveen Coll., New York;
acquired by the Ella Gallup Sumner and Mary Catlin Sumner Collection 1963 and given to the Wadsworth Atheneum (attrib. to P. Novelli)

EXHIBITIONS
Cleveland 1971, pp. 149–53

REFERENCES
Felton 1971, p. 174; Konecny 1973, pp. 285, 85–91; Longhi 1966, pp. 74–78; Mancini 1614–20/21 (1956–57 ed.) I, p. 25; Mayer 1929, pp. 261–62; Perez Sanchez 1978; Schleier 1968, pp. 79–80; Spinosa 1978, p. 91, no. 2

120

Drunken Silenus

181 × 229 cm
Inscribed lower left: *Josephus de Ribera, Hispanus, Valentin/ et academicus Romanus faciebat/partenope . .6. .*
Capodimonte, Naples
[*repr. in colour on p. 87*]

This is the earliest of Ribera's paintings signed and dated with the title *Academicus Romanus*; the inscription is on a cartello held in the teeth of a serpent, which symbolizes variously the other world, death, fame, prudence or wisdom. In the guise of wisdom the serpent might allude to the duality of Silenus, often compared to Socrates, known both for his wisdom and his vulgarity.

On the evidence of Palomino (1724) this painting belonged to the merchant collector Gaspar Roomer and is probably the *Silenus* seen by Sandrart in Roomer's villa at Monteoliveto; however, Capaccio does not mention it in the account of his visit in 1630 (Capaccio 1634). On the death of Roomer his estate was divided amongst pious institutions, friends and members of his family: part passed to Ferdinand van den Einden, the son of his partner, who in his turn left his collection to be divided between his three daughters. Giovanna, wife of Giuliano Colonna, inherited a series of pictures – some of them from Roomer's collection – which Luca Giordano catalogued on 17 November 1688 (Ceci 1920; Colonna 1895). In his list is a *Bacchus* by Ribera which might be this picture, despite the different title and its larger dimensions (Ruotolo 1982).

The picture shows Silenus, who had brought up Dionysus as a child and later became his travelling companion. He is traditionally shown as an obese, epicene old man, so fat that he was unable to stand; consequently he followed Dionysus on a donkey supported by young satyrs. The presence of the shell, the tortoise (a symbol of laziness) and the shepherd's staff – attributes of Pan and not Silenus – have led to the conjecture that the satyr supporting Silenus's head is Pan himself, included with the other mythological figures to create a bacchanal.

The source has been identified in a design by Annibale Carracci for a silver dish in the Palazzo Farnese collection (Du Gué Trapier 1952), but it is more likely that Ribera worked from either a Hellenistic relief or a contemporary print of an antique monument (details of classical sculpture are included in his paintings). Recently the work has also been related to a drawing attributed to Giulio Romano (Sacramento, California) of *Silenus and the Grape-gatherers*: both figures of Silenus are in a similar pose and of the same type.

The realistic treatment and the artist's transformation of the subject into a genre scene redolent of grotesque irony is characteristic of this period. The paint is thick, the brush strokes loaded, the colour stressing the tactile qualities of the skin. The head of the female figure in the upper right corner is repeated in various Magdalens; *The Crucifixion* (Collegiata, Osuña), *Lamentation* (National Gallery, London) – a dubious work – and *Pietà* (Certosa di S. Martino, Naples).

Ribera made an engraving of this painting in 1628 (British Museum, London) with some variations – the tortoise, the shell and the serpent are eliminated, Pan's reed-pipe and two putti are added and the background is transformed into a spacious landscape. A late seventeenth-century painted copy of the engraving is in the Corsini Gallery, Rome, another engraving in the Museum of Fine Arts, Philadelphia and an etching in the collection of the Duke of Northumberland. In the Museo di S. Martino, there is an engraving which includes the right arm of Silenus holding a cup.

D.M.P.

PROVENANCE
Palazzo of the Prince of Francavilla, Naples (late eighteenth century);
Palermo 1802; Naples 1806

EXHIBITIONS
Florence 1922, no. 817

REFERENCES
Capaccio 1634, p. 863; Ceci 1920, pp. 160–65;
Chenault Porter 1979, pp. 41–54;
Colonna 1895, pp. 29–30; Du Gué Trapier 1952, pp. 36–39;
Parks 1954, pp. 4–5; Ruotolo 1982, p. 15;
Spinosa 1978, p. 95, no. 28

121

St. Jerome and the Angel of the Judgement

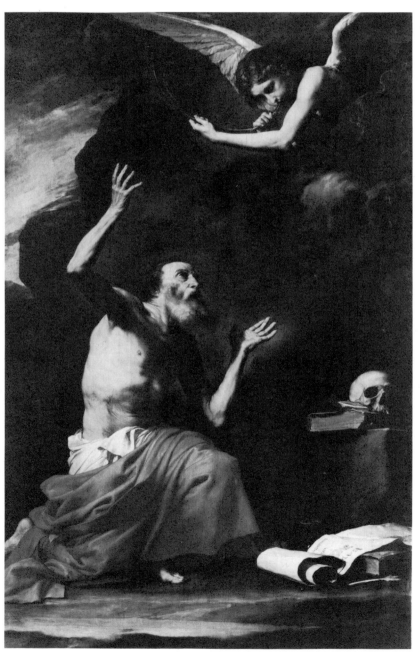

121

266 × 166 cm
Signed and dated: *Jusephus de Ribera/Hispanus Valentin/Setaben. .Partenope/F.1626*
Capodimonte, Naples

Originally in the church of the SS Trinità delle Monache, the painting was already in the Museo Nazionale di Napoli in 1813, in which year the church was inspected and a list of works still in suppressed monasteries was drawn up.

St. Jerome falls to his knees at the sound of the trumpet and raises his hands to heaven. Of it De Dominici wrote: 'Apart from the pose and the fine mass of the figure, it is admirable for the texture of the nude, showing the aged saint withered by his years, macerated by penance and extenuated by his fasting, with his skin clinging to the bones and wrinkled in all the joints of the body, and especially so on the soft part of the flanks, so that it is easier for the eye to take it in than for the pen to describe it: so wonderfully is this picture painted, and so excellently conceived'.

The construction is typical of Ribera: the pyramidal figure of the saint, set at a diagonal to the angel, is placed opposite a splendid still life, analysed with Spanish realism but lit in the manner of Caravaggio. The composition is simple, like the slightly earlier *St. Jerome* at Leningrad. Here the tonal gradations and the use of half-lights and shadows is more sophisticated, surpassing the earlier tenebrist formula of the first works, painted in Naples between 1615 and 1623 (Felton 1971). The flat figure in the Leningrad picture has given way to a three-dimensional image approaching a work of sculpture (De Rinaldis 1928). The brushwork is vigorous, creating a rich impasto like that in the *Drunken Silenus*; here the colour is more important, evident in the contrast of red and white in the saint's drapery. The plain dark background of the Leningrad *St. Jerome* is replaced by a bright sky; in a spacious grotto the angel appears, wrapped in clouds. There is an obvious desire to achieve spatial depth.

A transitional work between the earlier *St. Jerome* and the present work is the engraving of the same subject in the Hispanic Society of America (Spinosa 1978). There is a seventeenth-century copy in Acerra Cathedral and another late seventeenth-century copy in the Brunner Collection, Paris (written note; Witt Library).

D.M.P.

PROVENANCE
SS Trinità delle Monache;
in the Museo Napoleonico by 1813;
later transferred to the Museo Borbonico

EXHIBITIONS
Bordeaux 1955, no. 47

REFERENCES
De Dominici 1742–45, III (1979 ed), p. 11;
De Rinaldis 1928, p. 263, no. 312; Felton 1971, p. 188;
Spinosa 1978, p. 96, no. 30

122
Pietà

264 × 170 cm
Signed and dated: *Jusepe de Ribera español/F.1637*
Church of the Certosa di S. Martino, Naples
[*repr. in colour on p. 90*]

The picture was painted in the period from which we have the greatest number of signed and dated works by Ribera, when there were many assistants and collaborators in his studio. It was commissioned by Padre Giovanni Battista Pisante, the prior of the Certosa; Ribera received 400 ducats for it on 3 October 1637 and it was hung in the Sacrestia Nuova. The early biographers said that it was painted in competition with Massimo Stanzione, although the latter completed his painting of the same subject for S. Martino a year later.

Ribera's aim at this date was to achieve a refined and elegant painterly style in emulation of Van Dyck. The elaborate theatricality of the group, the brightness of the figures in contrast with the dark background and the use of soft and delicate tones (although painted in rich impasto) are part of his attempt to endow the protagonists with a profound humanity. The intensity of his vision of the Pietà, in the spirit of the devotional practices of Ignatius Loyola, draws the spectator into the religious drama (Felton 1971). Pérez Sánchez (Seville 1973) noted that the figure of the Virgin is repeated in the painting of the same subject in the Academia de San Fernando, Madrid. An early version of the composition may be the *Pietà* in the National Gallery, London (no. 235), which is not considered autograph by some critics.

The success of this painting was extraordinary, and it was frequently enthusiastically praised by foreigners visiting Naples. One eighteenth-century visitor wrote '. . . in this *Pietà* Spagnoletto has excelled himself, to the extent that connoisseurs value this work more highly than all the riches enclosed in the cupboards of this room. No praise suffices; words fail to describe it' (François 1775–76, ed. 1794). Many copies were made after it (Staatsgalerie, Stuttgart [formerly given to Luca Giordano]; S. Angelo a Nilo, Naples; Musée des Beaux-Arts, Dijon; Hermitage, reserve coll. [attributed to Giordano]; information from Spinosa). A preparatory drawing for the figure of Christ supported by St. John is in the Gabinetto Nazionale dei Disegni e Stampe in Rome; formery attributed to Salvator Rosa, Vitzthum gave it to Ribera. An engraving of this picture after a drawing by Fragonard is published in the *Voyage Pittoresque* of Richard (1781–86) and a drawing by Hubert Robert is in the Encil Collection, Vienna (Paris-Geneva 1978).

D.M.P.

EXHIBITIONS
Rome 1956, no. 247; Naples 1963, p. 56

REFERENCES
Camesasca 1973, no. 11;
Chiarini 1856–60, IV, pp. 686, 723–24;
De Dominici 1742–45, III, pp. 13–14;
D'Afflitto 1834, II, p. 87; Dalbono 1903, p. 332;
D'Aloe 1853, p. 115;
Du Gué Trapier 1952, pp. 150, 153, 162, 270;
Faraglia 1892, XVII, p. 670;
Felton 1971, I, pp. 257–58; Galante 1872, p. 417;
Galanti 1742, p. 59; Mayer 1908, pp. 104–07;
Nobile 1855, p. 306;
Parrino 1725, p. 107;
Perez Sanchez in Seville 1973, no. 85;
Sarnelli 1685, p. 324

123
Apollo and Marsyas

176 × 227 cm
Inscribed: *Jusepe de Ribera español valenciano/F.1637*
Museo Nazionale di S. Martino, Naples
[*repr. in colour on p. 86*]

Marsyas claimed to be the inventor of the flute; he had in fact stolen it from Minerva, its real inventor, who had thrown it away. Marsyas challenged Apollo to a musical contest, with the condition that the winner should have absolute power over his rival. Apollo won, tied Marsyas to a tree and flayed him.

The picture is dated 1637 and so cannot be the *Apollo and Marsyas* among the many Ribera pictures seen by Capaccio during his 1630 visit to the gallery of the Flemish merchant Gaspar Roomer. The composition is based on crossed diagonals, with Apollo's right knee at their centre. The drama is created through the colour, which reaches its greatest intensity in the god's cyclamen mantle, while the composition is balanced by the tree-trunk on the left and the three satyrs on the right. The figure of Marsyas can be related to the giants *Ixion* and *Tityos* of 1632 in the Prado (Spinosa 1978, nos. 75 and 76).

The refined colour and rich lighting, the formal and pictorial elegance, the psychological and dramatic expression supersede Ribera's love of the grotesque and the rather loose compositions of the 1620s. This is the period in which the artist, having abandoned his moralizing, Counter-Reformation mysticism, turned to mythological subjects and produced baroque compositions in which the influence of Van Dyck is evident. This was prompted by the presence in Naples of Pietro Novelli in 1632 and Castiglione in 1635, and the arrival of paintings by Van Dyck himself, sent from Palermo and Genoa. The influence of the Roman neo-Venetian style changed Neapolitan naturalistic painters from imitating Caravaggio's manner to the baroque.

There is an autograph version of this picture in the Musées Royaux des Beaux-Arts, Brussels

and another in the Ringling Museum, Sarasota (Suida 1949), attributed to an Italian follower of Ribera. A preparatory drawing (ex Corsini Coll.) is in the Gabinetto Nazionale dei Disegni e Stampe, Rome, and a copy with some variations, by Luca Giordano, is in the Museo Nazionale di S. Martino, Naples.

D.M.P.

PROVENANCE
Avalos del Vasto Collection

EXHIBITIONS
Rome 1956, p. 246; Naples 1963, p. 56, pl. XLVIII; Bucharest 1972

REFERENCES
Bologna 1952, II, pp. 47–56; Camesasca 1973, no. 12; Capaccio 1634, p. 863; Du Gué Trapier 1952, pp. 133–35; Felton 1971, I, pp. 235–36; Mayer 1908, pp. 100–02; Spinosa 1978, no. 103

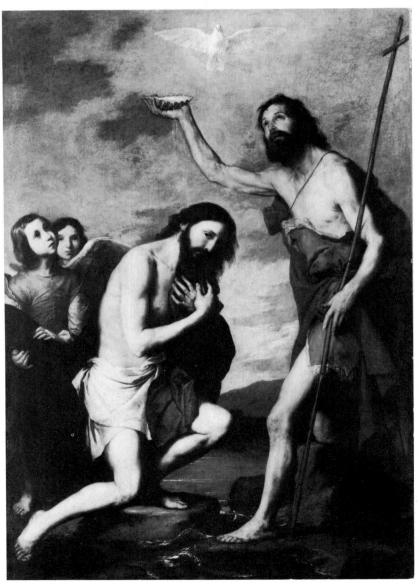

124

124 & 125
Moses
Elijah

Each 168 × 97 cm
Both signed and dated at foot: *Jusepe de Ribera español/F.1638*
Church of the Certosa di S. Martino, Naples
[*repr. in colour on pp. 124 and p. 125*]

In 1638 Giovanni Battista Pisante, Prior of the Certosa di S. Martino, commissioned a number of works from Ribera to decorate the church, among them *Moses* and *Elijah* for the entrance wall and 12 prophets to fit the spandrels of the arches along the nave on each side. These were begun in 1638 and were completed in 1643; the imposing figures of *Moses* and *Elijah*, for which Ribera received 50 ducats apiece, were begun first and completed the same year.

The simple compositions are combined with an intensity of expression and a vigorous naturalism, paralleling the architecture of S. Martino itself, designed by Cosimo Fanzago, who was at the period working on the great cloister of the Certosa (Spinosa 1978).

A replica, which has been regarded alternatively as autograph and as a workshop production, ascribed to Francesco Fracanzano and then to Giovanni Ricca (information from Bologna) belongs to Victor Spark in New York. A derivation from the Spark picture, to be attributed to Fracanzano, is in the Pinacoteca d'Errico at Matera.

D.M.P.

REFERENCES
Celano 1646 (1856–60 ed.), IV, pp. 684, 702; D'Afflitto 1834, II, p. 78; D'Aloe 1853, p. 111; De Simone 1845, I, pp. 16–17; Du Gué Trapier 1952, pp. 161–62; Felton 1971, I, pp. 275–76; Fitz Darby 1942, p. 47; Galante 1872, p. 414; Galanti 1742, p. 58; Nobile 1855, I, p. 303; Romanelli 1815, p. 124; Sarnelli 1697, p. 316; Spinosa 1978, no. 136–37

126
Jacob's Dream

179 × 233 cm
Signed and dated: on the stone to the right *Jusepe de Ribera, español. F./1639*
Museo del Prado, Madrid
[*repr. in colour on p. 91*]

The episode of Jacob's dream (*Genesis*, XXVIII, 10–22) was often used by baroque artists as a prefiguration of the coming of Christ; the dream also foretells Christ's promise to Nathaniel (*John*, I, 51) that the heavens would open to allow angels to pass through (Du Gué Trapier 1952).

The date of the picture has also been read as 1626. It is an exceptionally lyrical treatment of

the subject, painted with fluid brushstrokes and liquid colours. A luminous sky occupies half the picture; the light falling from the top left strikes the body of Jacob and casts transparent shadows on the ground. The golden tone of Jacob's face reflects his dream and the angels are ethereal and insubstantial. Subtle chromatic effects are combined with a naturalistic presentation of a supernatural event. The cruciform composition gives equal importance to the body of the sleeper and the old tree-trunk. There is some resemblance between Jacob and the shepherd on the right in the *Death of Adonis* (Cleveland), a picture that has been attributed alternatively to Ribera and De Bellis (Chenault 1971).

D.M.P.

PROVENANCE
Elisabetta Farnese (in the Royal Collection at La Granja attributed to Murillo);
Academia de San Fernando, Madrid 1746;
entered the Prado in 1827

EXHIBITIONS
Geneva 1939, no. 73

REFERENCES
Camescasca 1973, no. 13; Chenault 1971, p. 73;
Du Gué Trapier 1952, pp. 162–65; Felton 1971, I, pp. 280–81;
Mayer 1908, pp. 141–43;
Spinosa 1978, no. 150

127

Baptism of Christ

235 × 160 cm
Signed: lower right *Jusepe de Ribera español/.F.1643*
Musée des Beaux-Arts, Nancy

This picture comes from the church of the Monastery of S. Pascual in Madrid, where it is mentioned by the sources along with a *Martyrdom of St. Sebastian* of similar size and in the same chapel (taken to be the one formerly in the Berlin Museum, destroyed in the war). The composition is masterful; St. John occupies

almost all the upper right-hand zone while the figure of Christ creates a diagonal that runs from his right foot through both heads. It is dated 1643, when the precarious state of Ribera's health forced him to use numerous assistants.

The realism and the psychological characterization of the protagonists are typical of Ribera throughout his career. The horizon is low, the landscape barely indicated and the large area of sky is bathed with a clear diffuse light similar to that in the contemporary painting of the *Cripple* (Paris, Louvre). The elongation of the forms is similar to other works of the period, such as *S. Gennaro Emerges from the Furnace* (Cappella del Tesoro, Naples), the *St. Francis* (S. Francesco, Aversa) and the *Crucifixion* (Palacio de la Deputaciòn, Vitoria).

This characteristic, also found in Zurbaran's work, confirms the probable links between these two Spanish painters at this date (Spinosa 1978). Felton compares the *Baptism* to the *Ecce Homo* (Bob Jones University, Greenville) and, in particular, the *Vision of St. Bruno* (Weimar), both for the sharp contrast of light and shadow on the face of Christ and for the importance of the gestures in the compositions (Felton 1971).

D.M.P.

PROVENANCE
Church of the Monastery of San Pascual, Madrid;
sale at Salamanca, no. 8, 1867;
Roxard de Lasalle sale 1875;
given to the Musée des Beaux-Arts 1881

EXHIBITIONS
Paris 1963, no. 73

REFERENCES
Harris 1963, pp. 321–25;
Felton 1971, I, p. 298; Mantz 1881, p. 250;
Mayer 1908, p. 190; Palomino 1796, III, p. 465;
Ponz 1776 (1793 ed.), V, p. 39; Spinosa 1978, no. 181

128

Head of St. John the Baptist

66 × 78 cm
Signed: bottom centre *Jusepe de Ribera español/F.1646*
Museo Civico Gaetano Filangieri, Naples

The severed head of the Baptist is shown on a dish surrounded by a white cloth, a knife and a red cross, the symbol of St. John. The treatment of the subject is not horrific; death is indicated only in the grey flesh tone and the traces of blood on the cloth. The strongly modelled head stands out against the dark background, painted with an impasto that recalls that of the head of Christ in the Prado *Trinity* (Du Gué Trapier 1952). An earlier painting of this subject in the Academia de San Fernando, Madrid, shows the head reversed; it is not of such outstanding quality and the lighting is less confident.

The subject was also painted by Domenichino during his stay in Naples (Cat. 41). The date,

128

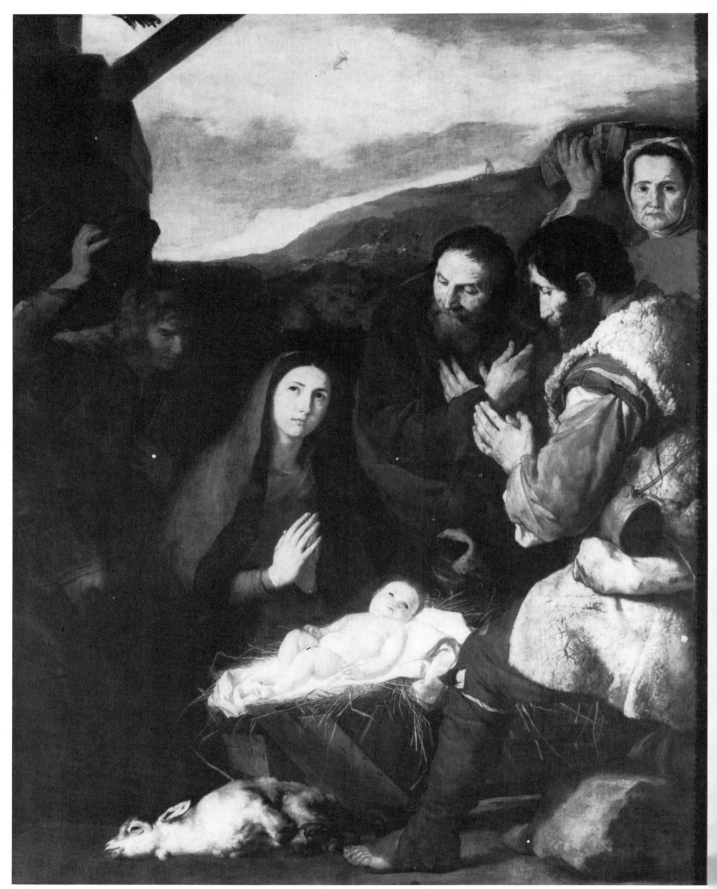

which before restoration was read as 1647, gave rise to the suggestion that Ribera had used one of the heads of the executed leaders of the Masaniello revolt for this image. An autograph version of the picture, with slight variations and more modest in quality, was formerly with Algranti, Milan.

D.M.P.

EXHIBITIONS
Bucharest 1972

REFERENCES
Acton 1961, p. 28; Du Gué Trapier 1952, pp. 194–95; Felton 1971, I, pp. 312–13; Filangieri 1888, p. 328, no. 1455; Filangieri 1891, p. 342; Frizzoni 1889, p. 299; Rolfs 1910, pp. 303–04; Spinosa 1978, no. 191

129

Adoration of the Shepherds

239 × 181 cm
Inscribed on the stone on the right: *Jusepe de Ribera español/Accademico Romano/F.1650*
Musée du Louvre, Paris

The painting dates from the time of Velasquez's second visit to Naples (1649–50); Ribera had not abandoned his realism and there are still some echoes of Guido Reni. The composition is calm and balanced, the forms simple and severe, with the Christ Child at the centre. Ribera concentrates on a luminous and intimate representation with brilliant and refined colour harmonies.

A studio replica with some variations, oblong in format, is in the Cathedral at Castellammare di Stabia. Another later version is in the parish church of Manneville in France.

D.M.P.

PROVENANCE
Duca della Regina, Naples;
given by Ferdinando IV di Borbone to the French Government in exchange for the paintings taken by the Napoleonic army from S. Luigi dei Francesi, Rome, 1802; assigned by Napoleon to the Musée du Louvre

EXHIBITIONS
Paris 1963, p. 197

REFERENCES
Blumer 1936, p. 325; Camesasca 1973, no. 19; Du Gué Trapier 1952, p. 210; Felton 1971, II, p. 386; Hautecoeur 1926, II, p. 162, no. 1721; Lòpez-Rey 1963, p. 335; Mayer 1908, pp. 149–51; Spinosa 1978, no. 201

130

St. Mary of Egypt

88 × 71 cm
Signed and dated: bottom left *Jusepe de Ribera español/F.1651*
Museo Civico Gaetano Filangieri, Naples
[*repr. in colour on p. 92*]

Traditionally the saint was thought to be a likeness of Ribera's daughter, who was said to have had an affair with Don Juan of Austria, the illegitimate son of Philip IV who had been sent to Naples to crush the anti-Spanish revolt, but this story is unfounded. St. Mary of Egypt, a penitent and hermit who died in AD 421, was usually portrayed bearing a loaf and accompanied by a lion. Here the young saint is shown in three-quarter length, her dark eyes red with weeping and raised to heaven, and her hands joined together in prayer, against a dark background cut diagonally by the light. In front of her, on a table, are three pieces of bread and a skull.

Although in his last years Ribera reverted to religious subjects, particularly saints in penance or ecstasy, he did not return to the vigorous naturalism of his youth. The rendering of physical reality and attention to every distinguishing element is now enveloped in a warm tone both in the light and dark passages. Realism and the painterly qualities of Van Dyck are united in this gentle and very human image, which is stylistically close to the *St. Sebastian* and the *St. Jerome* in Capodimonte.

A late seventeenth-century copy is in the Muzeul de Arta in Bucharest.

D.M.P.

PROVENANCE
Duca della Miranda, Naples

EXHIBITIONS
Florence 1911, no. 43; Florence 1922, no. 820; Naples 1954, no. 22; Bucharest 1972

REFERENCES
Ceci 1894, pp. 65–67; Filangieri 1888, p. 308; Filangieri 1891, p. 342; Frizzoni 1889, p. 299; Rolfs 1910, p. 305; Spinosa 1978, no. 206

Salvator Rosa

NAPLES 1615–FLORENCE 1673

Salvator Rosa is one of the most familiar names from Seicento Naples for an Anglo-Saxon audience. It is not an understatement to say that most of his paintings were by the end of the eighteenth century English collections, for which his individuality and latent romanticism had an irresistible attraction.

The background to Rosa's development in Naples and Rome was extremely varied and it says something of taste in Naples in the 1630s that this should have been so. His sister had married Francesco Fracanzano, he studied with Falcone, he admired Castiglione and Ribera and was even more envious of the intellectual heights reached by Poussin. It is possible to recognize the formative influences these painters had upon his style, while at the same time his individuality and virtuosity come through in even the slightest sketch or *figurina*.

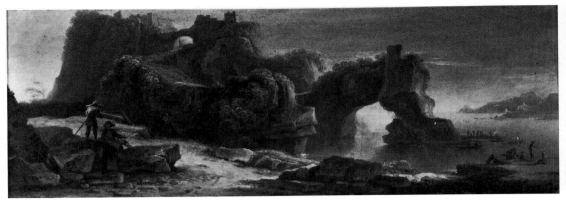

131

A character larger than life, poet, actor, musician, the extravagance of Rosa's personality was associated with his native background, just as the desolate landscape, the coastal view, the battle scene and the *banditti* were always associated with Naples and southern Italy by his patrons and had been transformed into legend by the eighteenth century. For Lady Morgan, he came 'fresh from the stupendous altitudes of the Abruzzi, with all their mightiness impressed on his mind'. Even for Roman and Florentine eyes the scenery of the South was as strange and new as Jan Brueghel's Alpine views had been 50 years earlier – and that was a genre that the latter started during a visit to Rome.

It was no accident that Rosa started his career painting decorative subjects, landscapes among them; the measure of his success was that he was obliged to continue with them even when his artistic inclination was towards more profound themes and philosophical meanings. He played

an important role in establishing the artistic independence of the painter, a stance first adopted by Caravaggio. His scenes of witchcraft and the occult are further instances of an attitude that is only initially as naturalistic as that of Caravaggio, but a spirit of naturalism is nevertheless revealed by his decision to put a painting of a rock on exhibition at the Pantheon.

C.W.

131

Landscape with a Natural Arch

15 × 44 cm
Signed: *Salvator Rosa*
Galleria Palatina, Palazzo Pitti, Florence (1890 inv. 1325)

This is an early landscape by Rosa, with an echo of a real landscape; it has been suggested that the natural arch was based on the one at Nisida.

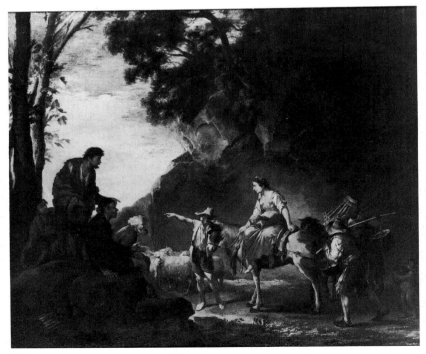

132

The oblong proportions of the picture suggest that it was originally a *sopraporta* and it shows Rosa already exploiting the picturesque elements in his native scenery. Like Tassi and Filippo Napoletano, Rosa often chose marine subjects for his landscapes. But he was never a *quadratura* painter and he does not give his landscapes any architectural framework.

This type of view was already established in Rome as a genre on its own, as can be seen from Filippo Napoletano's frescoes in Palazzo Rospigliosi, which date from 1623–27 (Pugliatti 1977) and which include one with a view of a natural arch comparable to the present picture. Rosa, however, never painted in fresco, and the landscapes he produced, although often obviously part of a decorative scheme, increasingly had the independence of gallery works, a role that the admiration of later generations would emphasize.

C.W.

PROVENANCE
Principe Ferdinando de Medici, at Palazzo Pitti in 1713

REFERENCES
Ozzola 1980, p. 106; Pugliatti 1977, fig. 127; Rusconi 1937, p. 237; Salerno 1963, p. 142; Salerno 1975, no. 52

132

Landscape with Travellers asking the Way

143.5 × 170.2 cm
Signed: lower left *Salvator Rosa*
Matthiesen Fine Art Ltd., London

The painting must be from a relatively early moment in Rosa's career, around the time he left Naples in 1638–39. There is still a pronounced influence of Falcone, with whom he studied, but the colouring is also Castiglionesque and the subject matter echoes that of Swanevelt and Both. Swanevelt did some of the paintings for the extensive decorations commissioned for the Buen Retiro Palace in Madrid in the mid-1630s, and this picture is yet another example of the considerable influence this great collective scheme had on artists both in Rome and in Naples. The scale of the works and the nature of the subjects were surely responsible, among other things, for the increase in the popularity of a wide range of landscape genres. The cross-fertilization that occurred in the decade of the 1630s is a fascinating pattern, as the obsessive originality that coloured Rosa's personality itself illustrates.

Salerno (1976) suggested that Nicolaes Berchem could have seen this picture during his journey to Italy *c.* 1640, and certainly the figure with hand outstretched is echoed in many such gestures in Berchem's work: it becomes a powerful characterization of Italian life. It is also, of course, painted with the consciousness of that most celebrated naturalistic image, Caravaggio's *Calling of Matthew* in S. Luigi dei Francesi, which underlines the real roots of *Bambocciante* painting in Rome.

C.W.

PROVENANCE
Sir. H. Carr Ibbetson, Bt., Denton Park, Yorkshire 1760; remained in the house until sold by Mrs Arthur Hill, 1975

EXHIBITIONS
London 1981, no. 10

REFERENCES
Morgan 1824, II, p. 370; Salerno 1976, II, p. 547; Zeri in *Storia d'Italia*, VI, 1976, fig. 71

133

Landscape with *Banditti*

70 × 76.2 cm
Monogrammed: SR
Lord Sackville, Knole

Rosa's name was in the eighteenth century almost synonymous with *banditti*; they were indeed a subject that inspired his romantic imagination as much as it fired that of Lady Morgan, his biographer, who knew this painting. She believed he had been a captive of the *banditti* of the Abruzzi, and quoted an anonymous author in the *Encyclopedia Britannica*. 'We are told that he spent the early part of his life in a troop of *banditti*, and that the rocky desolate scenes in which he was accustomed to take refuge, furnished him with those romantic ideas in landscape. . .'. For Lady Morgan these were the condottieri of the recent past, and there is no doubt that Rosa too

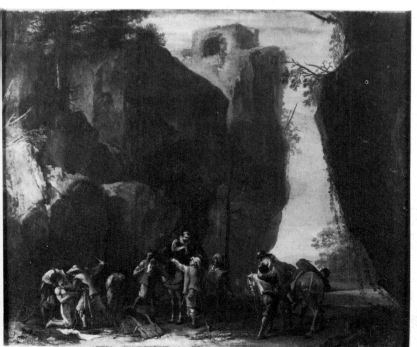

133

realized their romantic appeal, being not so much concerned with truth to life as with the legend of the south.

Even before Rosa moved from Naples, he evidently had many contacts with the Roman artistic world and the form of this composition is strongly reminiscent of the work of the *Bamboccianti*, particularly that of Pieter van Laer. Salerno (1973) dates this painting to between 1638 and early 1639.

C.W.

PROVENANCE
Thomas Jenkins; acquired from him by third Earl of Dorset; and by family descent

REFERENCES
Morgan 1824, II, p. 370; Salerno 1973, no. 17

134
Battle Scene

53 × 62 cm
Monogrammed and dated: 1637, S.R
William Mostyn-Owen Esq., London

This is the earliest dated work by Salvator Rosa and is strongly reminiscent of the battle scenes of his teacher, Aniello Falcone (cf. Cat. 42). This was a genre to which Rosa contributed many works, both major and minor. It is interesting indeed to see the variety of subjects that came to be accepted in the Seicento; the battle pictures do not seem to have been inspired by a particular campaign, or by the army of one country rather than another; at best they would seem to represent the Christian fighting the infidel. It was essentially a decorative genre, as with most of Rosa's work.

This painting was probably originally one of a pair, as is suggested by the diagonal emphasis of the composition. As opposed to the very crisp outlines preferred by Falcone, Rosa was influenced here by the more open brushwork and colouring of Castiglione, who had arrived in Naples in 1635; he also dramatized the theme with greater characterization and expression.

C.W.

PROVENANCE
Acquired from Colnaghi's by the present owner, 1958

EXHIBITIONS
Barnard Castle 1962, no. 44; London 1973, no. 2

REFERENCES
Mahoney 1964, p. 59; Salerno 1963, pp. 30, 92, 114; Salerno 1975, no. 7

135
Harbour Scene

143 × 176 cm
Monogrammed: SR
Galleria Estense, Modena

This large and impressive canvas is one of a pair of pictures which are known to date from 1640; the coat of arms of the patron, the Duke of Modena, appears above the archway on the right. The companion picture is a *Landscape with Erminia* and Rosa exploited to the full the contrast between a marine view and a landscape subject.

In these paintings he shows an awareness of the widest range of decorative landscape painting in Rome and Naples; the shipping recalls Brill and Tassi, the ruins Breenbergh and Poelenburgh and the figures seem to derive from Filippo Napoletano, while some of the passages in the landscape have a quality akin to that of Micco Spadaro, for instance, in the fresco lunettes in the choir at S. Martino. The

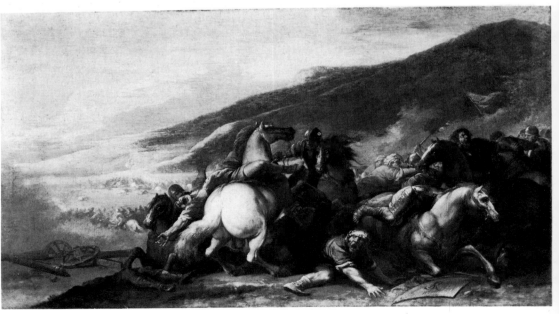

134

companion *Landscape with Erminia* is a signal tribute to Claude. Already, what had started out as a decorative genre, exploiting the contrast between land and marine views in much the same way as Claude was concerned with the theme of comparison between 'Morning' and 'Evening', gains greater artistic independence by means of Rosa's extreme virtuosity.

There is no doubt that the setting was regarded from the start as the coast near Naples and the artist used all his skill to enhance the picturesque elements of the scenery, which came to characterize the southern landscape for many generations to come.

C.W.

PROVENANCE
Commissioned by Francesco Mantovani for the Duke of Modena 1640; despatched to him 1 Sep. 1640

EXHIBITIONS
Naples 1938, p. 324; Rome 1956, no. 252; London 1973, no. 6 with full bibliography

REFERENCES
Buscaroli 1935, p. 302; Ozzola 1908, pp. 84, 255; Salerno 1963, pp. 34–35, 37, 107, pl. 1; Salerno 1975, no. 26

136

A Philosopher

136 × 99 cm
Colnaghi and Co., London

This unpublished picture is an outstanding example of Rosa's work. It was inspired by Ribera's paintings on the same theme, which were particularly successful in Naples, and which also prompted the young Luca Giordano to paint in this vein (see Cat. 61). The representation of philosophers in fact enjoyed a wide popularity in Europe during the seventeenth century; one has only to recall Rembrandt's *Aristotle Contemplating the Bust of Homer*, which was painted for Don Antonio Ruffo, the famous collector in Messina, to realize that the subject was commonplace both in the north and south. Little is known, however, of the actual significance of the series of philosophers to the collections to which they originally belonged.

It is interesting to see Rosa turning early in his career to a theme that is more contemplative and profound than the landscapes at which he excelled. This picture is comparable with the *Philosopher* at Kedleston Hall (Viscount Scarsdale Coll.) of similar dimensions, in which Salerno (1975) sees an echo of Ribera. Like the latter painting, this also recalls the portrait of Giovanni Battista Ricciardi in the Metropolitan Museum and, indeed, many of Rosa's male portraits, particularly the self-portraits, have a reflective content that evolves from this moment in his development.

C.W.

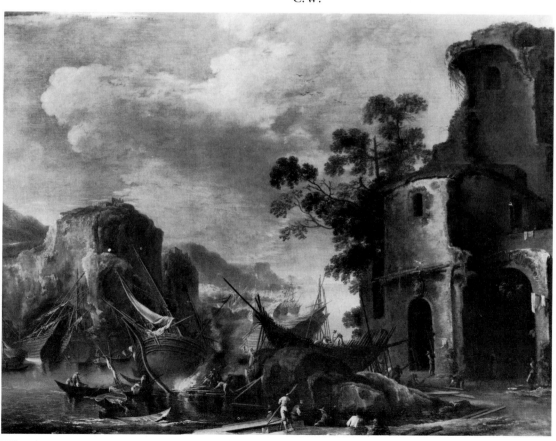

135

136

PROVENANCE
Prince Poniatowsky, Paris (19th century label on reverse of stretcher)

137

137
Mr Altham as a Hermit

235 × 162.5 cm
National Trust, Kingston Lacy

This is one of Rosa's most ambitious allegorical portraits and one of the very few pictures known to have been painted by him for an English patron. The sitter is Sir James Altham, who was born in 1614 and knighted in 1661; he is said to have been a painter and a pupil of Rosa's in Rome, as was another Englishman, Henry Cooke, who died in 1700. There are pictures listed as works by Altham in the 1783 catalogue of the Colonna Collection, and Sir Ellis Waterhouse has suggested that he is possibly the author of the picture of the *Decollation of the Baptist* in one of the oratories in the church of S. Tomaso di Canterbury in Rome.

Mr Altham is shown trampling on the works of Epicurus, which are labelled *Post mortem nulla voluptas* ('There is no pleasure after death'), while he gazes improvingly on a skull, a copy of the gospels and a paper which reads *Post mortem summa voluptas* ('The greatest pleasure is after death'). R. W. Wallace (1968) has shown that the bas-relief on the plinth, which shows Father Time gnawing the Belvedere torso, is taken from an engraving by François Perrier published in 1638 and that the thistle in the foreground is also a symbol of vanity, as any puff of wind can blow away its flowers, like man's hopes.

The painting is traditionally said to have been painted in Naples in 1665 and sent from there to Sir John Bankes; it is possible that the family papers at Kingston Lacy may eventually yield more about the circumstances of its execution. It was probably one of the earliest of Rosa's paintings to come to England, in itself a fact of some importance considering his enormous popularity in this country in the eighteenth century. The symbolic imagery is what Rosa most enjoyed painting and he must have been gratified to find such a responsive patron and pupil in Altham. It cannot be a coincidence that the Earl of Shaftesbury also chose a Neapolitan painter, Paolo de Matteis, to lend substance to his own philosophizing a generation later in the *Choice of Hercules* (recently acquired by the Ashmolean Museum, Oxford, from St. Giles House, only a few miles away from Kingston Lacy).

C.W.

PROVENANCE
Sir John Bankes; thence by descent at Kingston Lacy

EXHIBITIONS
London 1960, no. 15

REFERENCES
Salerno 1963, p. 10, 123; Salerno 1975, no. 118; Wallace 1968, pp. 21–32; Waterhouse 1960, pp. 54–58

Sir Peter Paul Rubens

SIEGEN 1577–ANTWERP 1640

There is no record that Rubens visited Naples, but his reputation, and perhaps some of his works also, preceded the arrival of the *Feast of Herod* in Gaspar Roomer's collection around 1640. Rubens came to Italy in 1600 and, apart from a journey to Spain in 1603–04, he remained in the country until 1608. Having started in the employ of the Gonzaga in Mantua, he visited Rome and his most important patrons during the second part of his stay in Italy were Genoese. Rome and Genoa were the two Mediterranean centres with which Naples had most active trading links; but, above all, Neapolitan painters were encouraged to look outside their native tradition and many of the artists whom they admired were directly influenced by Rubens' work. The full magnificence of Rubensian composition is perhaps not realized at Naples until Preti and Giordano, but the impact of his work is transparent in earlier paintings like Ribera's *Drunken Silenus* of 1626 (Cat. 120) and implicit in Artemisia Gentileschi's work generally.

Neapolitan painters would recall that Rubens had bought Caravaggio's *Death of the Virgin* for the Duke of Mantua after the Carmelites at S. Maria della Scala in Rome had rejected it on account of its scandalous subject matter; his part in the affair must have been well-known to everyone, especially following the public exhibition of the painting for a week prior to its leaving Rome in 1607. His enthusiasm for Caravaggio was demonstrated again when he had the opportunity to acquire another of his masterpieces, the great *Madonna of the Rosary* which Louis Finson had brought home to Flanders from Naples; Rubens secured it for the Dominican church of St. Paul in Antwerp.

Van Dyck travelled to Sicily, and in all probability stopped off briefly in Naples; Rubens's fame was European in scale, but in Naples there can have been few, if any, of his works to illustrate on what his reputation was based. This must have made the impact of his *Feast of Herod* all the more sensational.

C.W.

138†
Feast of Herod

208 × 264 cm
National Gallery of Scotland, Edinburgh
[*detail repr. in colour on p. 94*]

The picture belonged to, and was probably commissioned by the great Flemish merchant and collector Gaspar Roomer, and arrived in Naples around 1640. The sensation it created there is reported by De Dominici, who mentions it both in his life of Mattia Preti and in that of Cavallino 'who came to see this much talked-of work, and he found it so beautiful that, captivated by the magic of its brilliant and life-like colouring laid on with such consummate skill, he determined to imitate it himself'.

Its example was of great significance in Naples for a whole generation of painters from Cavallino onwards, both before and after the plague of 1656. The theme of the violent banquet, laden with sensation, dramatic colour and rich naturalism, was immediately adopted and became an intrinsically Neapolitan subject. Two such works in this exhibition that are probably contemporary with the arrival of Rubens' masterpiece are Lanfranco's *Roman Gladiators Fighting at a Banquet* (Cat. 78) and Cavallino's *The Feast of Absalom* (Cat. 25). The relevance of the picture is self-evident in the case of later works like Mattia Preti's *The Feast of Herod* (Cat. 107) painted for Roomer's son-in-law, Ferdinand van den Einden, and of Luca Giordano's style.

Roomer's taste, which we know from other paintings in his collection (Ruotolo 1982), can be identified so closely with this painting that it would seem most likely that he did indeed commission it directly from Rubens himself. One can imagine his appreciation of Rubens's depiction of Herodias' sacrilegious gesture in prodding the Baptist's tongue with her fork, taking her revenge for St. John's invective in life; if he owned works like Ribera's *Drunken Silenus* (Cat. 120) and *Apollo and Marsyas* (Cat. 123), then he was much taken with sensation in pictorial representation. His vast collection of more than 1,500 paintings must have been very influential in forming taste, particularly as there were few old masters among them. Unlike Cardinal Ascanio Filomarino, the Archbishop of Naples who had arrived with a large collection of pictures reflecting essentially Roman taste, Roomer seems to have favoured Flemish and Neapolitan masters on their own merits. His son-in-law shared his taste, inheriting the Rubens among other pictures, and Roomer was surely as extrovert with his artistic inclinations as the pictures in his collection themselves suggest.

The question of the dating of this work is discussed by both Burchard (1953) and Held (1954), the one suggesting a date around 1633, the other a date closer to 1638. The painting was not well-known to Rubens scholars even after it left Naples in 1830, despite the existence of a related engraving by Schelte à Bolswert, various copies and versions and a drawing prepared for the engraver formerly in the collection of Sir Thomas Lawrence, PRA. In the nineteenth century, it came to England and then to

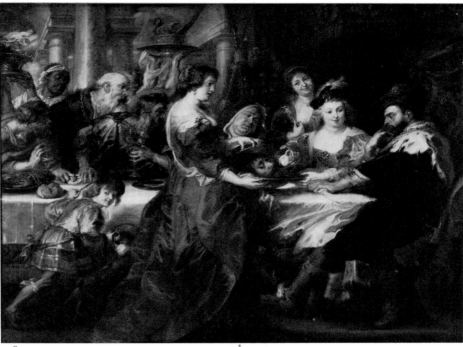

138

Scotland, and it was lent to the Royal Academy in 1878 and 1893. This is the first exhibition to which it has been lent since then.

The dimensions given in the Van den Einden inventory (Ruotolo 1982) confirm that the Edinburgh picture was originally larger, 9 × 11 *palmi*. (The present dimensions correspond to about 8 × 10 *palmi*.)

C.W.

PROVENANCE
Gaspar de Roomer (died 1674);
his son-in-law, Ferdinand van den Einden;
his son-in-law, Principe di Belvedere-Carafa;
acquired by John Campbell, Earl of Ormelie (later Marquess of Breadalbane) in Naples in 1830;
his brother-in-law, Sir John Pringle;
his daughter, who married Major Robert Baillie-Hamilton;
acquired by William Hesketh Lever, afterwards Viscount Leverhulme at Christie's sale, 6 July 1917;
Lady Lever Art Gallery, Port Sunlight until 1958

EXHIBITIONS
London 1878, no. 168; London 1893, no. 128

REFERENCES
Burchard 1953, pp. 383–87; Celano 1692, III, p. 132;
De Dominici 1742–45, III, pp. 35, 344;
Haskell 1963, pp. 206–07;
Jaffé 1977, p. 102;
Thompson and Brigstocke 1970, pp. 84–85

Giovanni Battista Ruoppolo

NAPLES 1629–NAPLES 1693

Giovanni Battista Ruoppolo was the foremost still-life painter in seventeenth-century Naples and uncle of the genre-painter Giuseppe Ruoppolo. De Dominici (1742–45) dedicated a whole life to him and evidently knew his work well; his career has been clarified by the discovery of the dates of his birth and death (Prota Giurleo 1953) and by the subsequent elimination from his oeuvre of some works that are now attributed to the older Giovanni Battista Recco, the confusion having arisen because their initials and monograms – GBR – were the same. Three such works are now given to Recco: *Fish and Oysters with a Dish* (Stockholm Museum, monogrammed and dated 1653), *Larder with Game and a Turkey* (private coll., Bologna, monogrammed) and *Still Life with a Goat's Head* (formerly Lombardo di Cumia Coll., now Capodimonte).

Giovanni Battista Ruoppolo was the son of the maiolica-worker Francesco; his brother Carlo was also a picture and maiolica painter. This background, together with Giovanni Battista's marriage to Teresa Congiusto, daughter of the maiolica-worker Bernardo, has given rise to the unacceptable hypothesis that he was initially a porcelain painter (Prota Giurleo 1953).

Ruoppolo, together with Giuseppe Recco, was well-represented in the major Neapolitan picture-galleries of the time; the best clients for still-life painters were almost invariably members of the aristocracy or intellectuals. On 30 August 1673 'G. B. Ruoppolo' was paid 60 ducats for completing some work for Ferdinand van den Einden, the Flemish banker and patron of the arts. And in the 1688 inventory of Van den Einden's collection drawn up by Luca Giordano,

we find various paintings by G. B. Ruoppolo, one depicting 'Game, a Kid and a Goose' measuring 6 × 8 *palmi* and another of 7 × 5 *palmi* of 'kitchen ware and a pile of loaves' (Ruotolo 1982). Van den Einden died in 1674 which provides a *terminus ante quem* for the pictures. Unfortunately, none of these paintings has been so far identified.

Ruoppolo's first works may be dated from the early 1650s, following in the wake of the naturalism of Luca Forte, of early Paolo Porpora and Giovanni Battista Recco. The most important picture is the *Still Life with Celery and Guelder Roses* (Cat. 139), which is followed by a series of pictures (cf. Cat. 140) datable before 1661, a date that seems legible at the foot of the *Still Life* (ex Zauli Naldi Coll., now Lorenzelli Coll.). During the 1660s Ruoppolo changed his repertory, in some cases adopting subjects more typical of Giuseppe Recco, such as the signed *Fish on the Shore* (Museo di S. Martino, Naples) which possesses an immediacy of vision and a spontaneity of colour typical of his second phase.

In the 1660s and the 1670s he veered towards a more baroque style under the influence of the Roman painters, Michelangelo Campidoglio and Mario Nuzzi, called Mario dei Fiori. In 1675 Abraham Brueghel of Antwerp (son of Jan Brueghel the Younger), a competent exponent of a facile and repetitive baroque style had settled in Naples. Even in this decorative phase Ruoppolo preserved his naturalistic and objective vision. This is evident in the *Still Life with Fish and Grapes* in the Museum of Lofstede, Sweden, the compositions of *Grapes* in the Museo Correale, Sorrento and in the Musée des Arts Décoratifs, Paris, and the *Fruit and Vegetables* in the Gava Collection, Naples. In the works of Ruoppolo's final phase, the lavish arrangements of vegetables and fruits of the sea show that his interest was now directed to purely decorative ends.

R.M.

REFERENCES
Prota Giurleo 1953;
Ruotolo 1982, p. 29

139

Still Life with Celery and Guelder Roses

108 × 87 cm
Signed: *G B Ruoplo*
Ashmolean Museum, Oxford

This is one of the very first works of Ruoppolo and one of the few to be signed; it probably dates from the early 1650s. At this time Ruoppolo was working in the Neapolitan naturalistic tradition, focussing attention on the objects by setting them against a dark background; this derives from the *luminismo* of Caracciolo and the early works of Massimo Stanzione. Ruoppolo was following the painters with whom he probably studied: Luca Forte, Paolo Porpora and Giovanni Battista Recco.

The *Still Life with Vegetables and Loaves* (Cat. 140), formerly given to Giuseppe Ruoppolo, must date from shortly after this work, as does the *Still Life with a Vase of Flowers* also at Capodimonte (attributed to G. B. Ruoppolo by Causa 1954, formerly given to another artist by De Logu 1962). Recently a *Kitchen with Fruit, Fish and Game* (Colnaghi & Co.) and a *Still Life with Vegetables* (Arcade Gallery, London 1956) which is still close to the Oxford painting have been added to his oeuvre (Causa 1972; Volpe 1981). Another picture is in Vassar College Art Gallery, Poughkeepsie (Bologna 1968). Finally, there is a *Still Life* formerly attributed to G. Ruoppolo (Naples 1964; ex Zauli Naldi Coll. now Lorenzelli) and the *Still Life with Cherries* (Ciollaro Galante Coll., Naples), attributed first to an anonymous Neapolitan painter (Naples 1964, 56) and later to G. B. Ruoppolo (Bologna 1968; Causa 1972). All these paintings must date from before 1661.

R.M.

PROVENANCE
Tomas Harris; H. Mackowsky, presented to the Museum by the N.A.C.F. in 1934

EXHIBITIONS
London 1938, no. 222; Barnard Castle 1962, no. 30; Naples 1964, no. 98; Liverpool 1968, no. 77

REFERENCES
Bologna in Bergamo 1968, pl. 44;
Causa in *Storia di Napoli* 1972, p. 1017;
De Logu 1962, pp. 126, 192; Mitchell 1973, p. 222;
Roscí 1977, p. 211; Volpe in Milan 1981, pl. 5

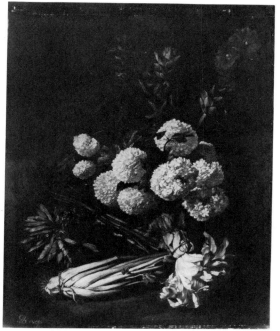

139

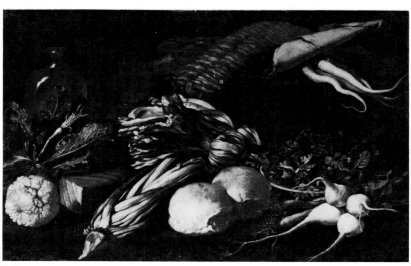

140

Johann Heinrich Schönfeld

BIBERACH AN DER RISS 1609–AUGSBURG 1683

140
Still Life with Vegetables and Loaves

97.5 × 130.5 cm
Capodimonte, Naples

This is an important early work of Ruoppolo's, stylistically still within the naturalistic tradition of Neapolitan still life. There are echoes of Luca Forte and of Giovanni Battista Recco and it is close to the early work of Giuseppe Recco. The composition revolves around the play of light and shadow; the loaves, bacon and dried figs are depicted with care for the integrity of each object; it is very different to the decorative quality of Ruoppolo's later baroque style.

The painting dates from the late 1650s, a little later than the *Still Life with Celery and Guelder Roses* (Cat. 139) and a little before the *Still Life* of 1661. This picture was formerly given to Giuseppe Ruoppolo (Causa in Naples 1960, p. 76; De Logu 1962); later Causa changed the attribution to Giovanni Battista Ruoppolo (Causa in Naples 1964). Volpe (in Milan 1981, no. 5) has proposed a date of *c.* 1680 for this work, comparing it to a *Kitchen with Fruit, Fish and Game* (art market) and positing the existence of a dual style in Ruoppolo – restrained and realistic for pictures of fish and kitchens, decorative and fanciful for compositions of flowers and fruit. However, this seems unlikely.

R.M.

EXHIBITIONS
Naples, Zurich, Rotterdam 1964, no. 80

REFERENCES
Bologna in Bergamo 1968, no. 44;
Causa in Naples 1960, p. 76;
Causa in *Storia di Napoli* 1972, V, p. 1017;
De Logu 1962, p. 192; Volpe in Milan 1981, no. 5

Trained in southern Germany in a late mannerist style, Schönfeld went to Italy, travelling via Switzerland and possibly France (Pée 1968). He arrived in Rome in 1633 (Schleier 1967) and joined the group of northern painters in the Schilderbent, which included Poelenburgh, Swanevelt and Jan Both. The influence of Poussin and Claude Lorrain is evident in Schönfeld's classicizing, Arcadian landscapes and the grouping of the figures either in a frieze or in a semicircle.

When he moved to Naples in the second half of the 1630s, he was already a fully mature painter. The pictures done around 1640 are certainly among the best of his early period and portray Old Testament themes (*Triumph of David*, Staatliche Kunsthalle, Karlsruhe), scenes from ancient history (*Rape of the Sabines*, Hermitage, Leningrad) and mythological scenes (*Triumph of Bacchus*, Capodimonte). These pictures reveal his debt to Poussin and to northern mannerism, and his approach towards the painters in the circle of Aniello Falcone and particularly Micco Spadaro. It was this group that gained most from Schönfeld's presence in Naples (Voss 1964; Pée 1971). The broad layered composition and the elongated figures derive from prints by Callot, a source used also by Micco Spadaro.

His first Neapolitan paintings have lost their Roman character, which is replaced by Neapolitan themes and style (as in the *Triumph of Venus*, Gemäldegalerie, Berlin). In his last years in Naples, between 1643–4 and 1649, Schönfeld was attracted by the religious art of Andrea Vaccaro and Bernardo Cavallino, and to this period belong some pictures with large-scale figures, dark tones and concentrated light (*Death of Rosalia*, Augsburg; *Death of Mary Magdalen*, Schweinfurt; Pée 1967). In these pictures he abandons the crowded compositions and the typical theatricality of his earlier Neapolitan style. With the *Ecce Homo* in the Alte Pinakothek, Munich, datable to the end of the 1640s, Schönfeld abandoned a formal Neapolitan style in favour of new compositional freedom. The colours are once again lighter and more luminous, evidence of the Venetian influence fashionable in Rome and at Naples from the 1630s, though his links with Cavallino remain.

Schönfeld left Naples in about 1649 and, travelling via Rome and perhaps Venice (Schleier 1967), returned to Germany for good. In his later works there are still traces of his

Italian period (eg. of Salvator Rosa in his landscapes) and one can even see some echoes of Ribera (*Martyrdom of St. Bartholomew*, Stuttgart; *St. Jerome*, Augsburg), a painter who did not appear to influence him during his stay in Naples.

B.D.

141

Gideon Reviews his Troops

99 × 179 cm
Signed: *H. Schonfeldt fecit*
Kunsthistorisches Museum, Gemäldegalerie, Vienna (inv. 1143)

The painting represents an episode from the Old Testament (*Judges*, VII, 5–11). Gideon was chosen by God to free the people of Israel from the tyranny of the Midianites. As too many volunteers came forward, Gideon adopted a subterfuge to reduce their number; he asked them to drink at the River Jordan and those who 'lapped, putting their hand to their mouth' were chosen out of the multitude.

Pée (1971) dated the painting around 1636, towards the end of Schönfeld's period in Rome, because of the Colosseum-like building and a stylistic affinity with Poussin and A. Tempesta. Voss (1927) and Neumann (1966) however observed that it has stylistic features that are to be associated with Naples, and dated it towards the beginning of the 1640s.

The picture has a number of Neapolitan characteristics and is reminiscent of Micco Spadaro, a painter who was evidently close to Schönfeld during the latter's stay in Naples. The elongated figures, which are no longer disposed according to any classical canon, their movements and the naturalistic detail are close to the art of Micco Spadaro, or at least to that of the painters grouped around Aniello Falcone.

The composition, which must have been based on Callot's *Martyrdom of St. Sebastian* (Pée 1971), is constructed around the mass of figures parted by the diagonal opening in the centre, closed by another crowd of soldiery in the background. Schönfeld employed this type of composition in other paintings of this period, such as *Jacob and Esau* (also in the Kunsthistorisches Museum), the *Battle of Jacob and the Amorites* (Castle, Prague) and the *Scene with a Naked King by a Stream* (Sanminiatelli-Odescalchi Coll., Rome).

There are a number of versions of this composition: at Sanssouci, Potsdam, in the Sanminiatelli-Odescalchi Collection, Rome, in the Kremsier Museum, Czechoslovakia (signed and dated 1653) and in the Stadtisches Bodensee Museum, Friedrichshafen. The present work must however be the prototype (cf. Berlin 1966). Two early copies of the compositions are listed by Pée.

B.D.

PROVENANCE
In the collection at Prague Castle by 1663;
in the inventories of 1685, 1718 and 1737;
acquired for the Imperial Collection in Vienna in the second half of the eighteenth century

EXHIBITIONS
Zurich 1956, no. 231; Berlin 1966, no. 91;
Ulm 1967, no. 19

REFERENCES
Pée 1971, pp. 26, 101–02, pl. 22, 24

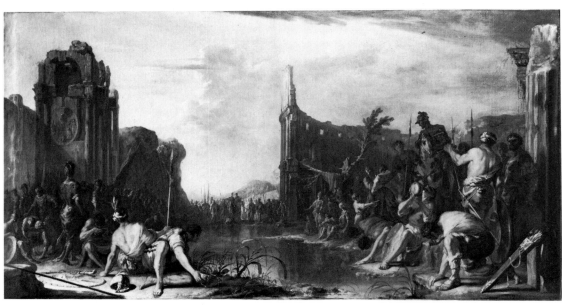

141

Carlo Sellitto

NAPLES 1581–NAPLES 1614

The son of Sebastiano, a painter and gilder from Montemurro in Basilicata, and of his Neapolitan wife, Lucente de Senna, Carlo Sellitto was born in Naples in 1581. After a period of apprenticeship to the Piedmontese painter Giovanni Antonio Ardito, c. 1591 he entered the workshop of the Flemish painter Loise Croys, recently arrived from Rome, which was also frequented by François de Nomé of Lorraine and the landscape-painter Filippo Napoletano. In 1607, Sellito, who was betrothed to Claudia, the daughter of his Flemish master, established himself as an independent painter with his own workshop, where Filippo Napoletano, Francesco Abbenante and Giovan Matteo Arciero also worked at the start (Prota Giurleo 1952).

Sellitto quickly became famous, especially as a portraitist; his first commissions and payments for paintings date from 1607, but most of the works have not survived. Amongst these pictures was a *St. Michael Archangel* for Onorio di Galatina. In 1608 Sellitto received payments from Pietro and Giovanni Domenico Cortone for one of two pictures they had commissioned with stories of St. Peter, destined for the church of Monteoliveto in Naples. Around 1611–12 he painted the *S. Carlo Borromeo* in the church of S. Aniello at Caponapoli (now at Capodimonte) and, shortly afterwards, the *Adoration of the Shepherds* for S. Maria del Popolo agli Incurabili.

In 1612 he became godparent to the eldest son of Filippo Vitale, together with Andrea Vaccaro's mother. Having broken off his engagement to Claudia Croys, he married Porzia Perrone of Montemurro in 1613; the *S. Cecilia* for S. Maria della Solitaria, Naples (now at Capodimonte) was finished in the same year, and can be regarded as one of his last works. Also in 1613 he was commissioned to paint the *Liberation of St. Peter* for the Pio Monte della Misericordia, a commission which passed, after his premature death, to Caracciolo. In August of the same year he received a payment on account of 20 ducats for the *Crucifixion* destined for the Marchese di Missanello's chapel in the church of S. Maria di Portonova. Before his death in October 1614, Sellitto left two paintings to churches: the *Vision of S. Candida* to S. Angelo a Nilo, and *St. Anthony of Padua* (which is unfinished) to S. Nicola alla Dogana, now in the church of the Incoronata at Capodimonte. In these Sellitto shows his allegiance to late Neapolitan mannerism, especially to Giovan Bernardo Azzolino and Fabrizio Santafede, although he was not insensitive to the new forms that Caravaggio introduced in Naples at the time.

In his will, drawn up by the notary Francesco Borello, Carlo Sellitto made his elder brother, Francesco Antonio, his sole heir and named as his executors Gian Carlo de Mondellis and Francesco Antonio Ametrano, who had been a patron. The latter drew up the inventory of his possessions, which included the pictures remaining in the workshop (the so-called *lista delli quadri de bascio*: 'list of pictures down below'). After the departure of Francesco Antonio Sellitto for Montemurro, Ametrano had the task of selling the pictures; before that Geronimo del Rosso had collected payments for works which Sellitto had finished. In 1616, two years after his death, his executors were still receiving payments for portraits and religious and genre paintings.

F.P.

REFERENCES
Naples 1977, *passim*

142

S. Cecilia

250 × 183 cm
Capodimonte, Naples (inv. 313)
[*detail repr. in colour on p. 74*]

The picture is attributed to Sellitto in two eighteenth-century sources (Parrino 1751, Sigismondo 1788) while it was still in the church of S. Maria della Solitaria in Naples for which it was painted. But De Dominici (1742–45), followed by others, described it instead as an early work by Caracciolo. Beside late mannerist traits, there are elements derived from Caravaggio, such as the chiaroscuro and the quality of the brushwork. Subsequently, the painting was thought to be by Vaccaro, then by Giovanni Matteo Arciero, who is still a shadowy figure.

A group of works with Caravaggesque characteristics was attributed to Sellitto, including the *Scenes from the Life of St. Peter* in the church of Monteoliveto, the *Nativity* in S. Maria del Popolo agli Incurabili and the *S. Carlo Borromeo* formerly in S. Aniello a Caponapoli, which Causa (1972) has described as 'one of the greatest works of the whole Seicento in Naples'. His authorship of the present painting was established by the discovery of documents (Prohaska 1975; Naples 1977). It was discovered from an inscription in the chapel of S. Cecilia in the church of S. Maria della Solitaria (De Lellis 1654–1689) that the painting had been consecrated in 1613, and newly found documents have made it possible to identify the

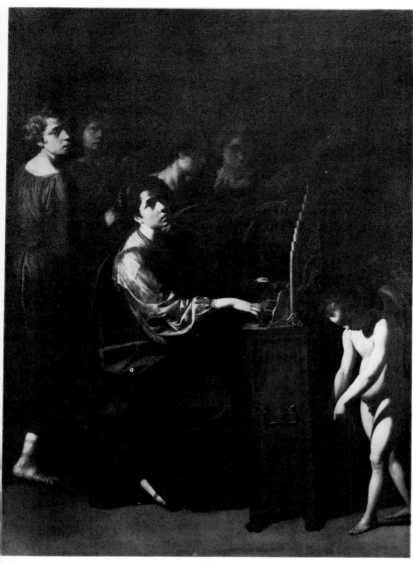

142

REFERENCES
Causa in *Storia di Napoli* 1972, V, pp. 921–22;
De Dominici 1742–45, II, p. 279;
De Lellis 1666–68, IV, p. 131f.;
De Rinaldis 1928, pp. 45–46, pl. 49;
Ferrari 1969, p. 217; Filangieri 1891, V, p. 95;
Longhi 1943[1], I, p. 44, n. 30;
Longhi 1915 (1961 ed.), I, pp. 191, 209;
Moir 1967, I, p. 166, n. 40, II, fig. 210;
Molajoli 1964, II, p. 52; Molajoli 1957, p. 3;
Naples 1977, *passim*; Parrino 1725, 1751 ed., p. 67;
Prohaska 1975, p. 8f.; Prohaska 1978, pp. 263–64;
Sigismondo 1788, II, p. 311; Stoughton 1977, pp. 367–68

Francesco Solimena

CANALE DI SERINO 1657–BARRA DI NAPOLI 1747

Solimena was trained in the provincial workshop of his father Angelo, where he absorbed the southern naturalistic tradition and was especially influenced by Francesco Guarino. This initial phase is represented by the *Vision of St. Cyril of Alexandria* (S. Domenico, Solofra), a work on which he collaborated with his father.

He arrived in Naples in 1674 (De Dominici 1742) and fell under the influence of the Neapolitan work of Lanfranco and Preti. In 1675–77 he again collaborated with his father, this time on the fresco of *Paradise* in the cupola of the Chapel of the Rosary in Nocera Cathedral. He reached his maturity in the frescoes of 1680 in S. Giorgio, Salerno, with *Stories of the Saints Tecla, Archelas and Susanna.* Although there are echoes of Luca Giordano's slightly earlier frescoes in S. Gregorio Armeno, Solimena's solid forms and firm constructions offer an alternative to the animated compositions and the dissolving light and tones of Giordano; he also adopts some compositional devices from Pietro da Cortona. The lost picture from Montecassino (1681) and the frescoes for S. Giorgio ai Mannesi were in this style.

During the 1680s Solimena found his own style in which naturalism and the influence of Preti and Lanfranco were merged with the baroque. The two altarpieces for S. Nicola alla Carità, one dating from after 1681 and the other *c.* 1684, and the frescoes in S. Maria Donnaregina Nuova, also of 1684, are all from this period. These works impressed Giordano after his return from Florence in 1683, when he reassumed his place as the foremost painter in Naples during the viceregency of the Marchese del Carpio. While Giordano dominated Neapolitan painting, Solimena was momentarily relegated to second place. This he quickly overcame and reached the height of his powers with the frescoes of 1690 for the sacristy of S. Paolo Maggiore. In this cycle Solimena equalled Giordano in the allegories on the vault

patron as the organist and composer Giovanni Maria Trabaci, governor of the congregation. It was also discovered that the chapel had been dedicated to musicians.

Since this painting can be firmly dated 1613, other pictures attributed to Sellitto have been related to it, of which the somewhat earlier *S. Carlo Borromeo*, now at Capodimonte, is the closest in style. Both the quality of the design and the light effects seem to be very close to this work, although here Sellitto seems to have developed further in pictorial technique and the use of chiaroscuro, and also reveals a certain interest in the art of Guido Reni.

F.P.

PROVENANCE
S. Maria della Solitaria, Naples

EXHIBITIONS
Naples 1977

and surpassed him in the *Conversion of St. Paul* and in the *Fall of Simon Magus*. These frescoes, and his reworking of themes of Preti's after 1690, were inspired by the ideal of 'naturalness' derived from the literary society *Arcadia*, to which Solimena belonged.

His work from the second half of the 1690s, of which the *St. Christopher* of Monteoliveto and the *Adoration of the Shepherds* (one of six canvases for S. Maria Donnalbina painted between 1699 and 1701) are typical examples, kept to the purist canon. His trip to Rome in 1700 and his direct contact with the classicism of Maratta reinforced this tendency. By the beginning of the new century Solimena was one of the great international painters, in demand at many of the European courts. He developed a subtly academic formula which suited the courtly taste for lofty classicism. In his last paintings he showed, almost by way of reaction against his own and his followers' academic style, a happy return to his baroque enthusiasm, once more echoing Preti. His *SS Trinità with Saints* of 1741, for La Granja near Segovia, is one of the most captivating paintings of this period.

I.M.

REFERENCES
Bologna 1958, *passim* with full bibliography;
Bologna 1962, pp. 1–12;
Bologna 1979, pp. 53–67;
De Dominici 1742–45, III, pp. 579–638;
De Maio in *Storia di Napoli* 1970, VI, I, pp. 609–749;
Ferrari in *Storia di Napoli* 1970, VI, II, pp. 1223–363;
Levey 1973, pp. 385–90; Paris 1960;
Spinosa 1975, pp. 359–63; Spinosa 1979, pp. 211–20

143
Madonna of the Rosary

247 × 168 cm
Staatliche Museen Preussischer Kulturbesitz,
Gemäldegalerie, West Berlin

When the picture was acquired by the Berlin Gallery on the London market in 1971, a date of c. 1708–10 was suggested, and it was tentatively identified with a painting that Cochin (1756) and Ratti (1780) saw in Palazzo Carrega, Genoa. It was soon apparent that the painting dated from much earlier, around 1680–82 (Oertel 1972; Schleier 1975). The Carrega painting also turned out to have been much smaller, a *sopraporta* originally from a room adjacent to the Galleria (untraced: Schleier 1978).

The Berlin picture must have originally been an altarpiece in a chapel dedicated to the Madonna of the Rosary, probably in a Dominican church. Ferrari's alternative suggestion (London, 1971) that it is the picture in the Dominican church at Sessa Aurunca, northern Campania referred to by De Dominici

(1742–45) is plausible, although two surviving *bozzetti* that have been related to the missing altarpiece (Bologna 1958) are quite different and are datable to c. 1720. De Dominici had apparently not seen the altarpiece himself, perhaps because it was no longer in the church, which is now virtually destroyed.

Stylistically, the picture belongs to a group of early works done between 1680 and 1684, characterized by rich impasto, free handling, swelling forms, bright colours, an accentuated, nervous chiaroscuro and by rather free, unstable, dense and sometimes overloaded compositions. This group of paintings includes the frescoes at S. Giorgio, Salerno (1680), the destroyed altarpiece formerly at Montecassino, the two altarpieces in S. Nicola alla Carità in Naples, the frescoes at S. Maria Donnaregina Nuova (1681–84) and a number of others. In these paintings Solimena was influenced by Pietro da Cortona and Luca Giordano.

X-ray photographs of the present picture show that the red drapery at top left was originally supported by the right arm of an angel, to whom the extraneous piece of green drapery belonged, comparable to the analogous angel in the S. Nicola alla Carità altarpiece. The angel held a garland of roses in his left hand over the Madonna's head, while a smaller putto to the right also supported the drapery. Solimena painted out these figures to make the overcrowded composition clearer and to strengthen its diagonal slant. The S. Nicola alla Carità composition has a similar spatial clarity. De Dominici refers to the impact of Lanfranco's altarpiece of the *Madonna of the Rosary*, painted for S. Martino and now in the Church of the Rosary at Afragola, on both these pictures; in it Lanfranco introduced an unusual iconography, with the Madonna with angels and only two saints. Since the establishment of the Feast of the Rosary in 1573 to celebrate the victory of Lepanto, the Madonna was usually represented with a multitude of saints and worshippers, who accompany the two major saints (usually St. Dominic and St. Catherine of Siena).

E.S.

PROVENANCE
London Art Market; Heim Gallery 1971

EXHIBITIONS
London 1971, no. 10; Berlin 1971, no. 10

REFERENCES
Ferrari in London 1971, no. 10 with further references;
Nicolson 1971, p. 346; Oertel 1972, p. 244;
Schleier 1975, pp. 406–07; Schleier 1978, p. 416

144
S. Rosalia

100 × 74 cm
Pisani Collection, Naples

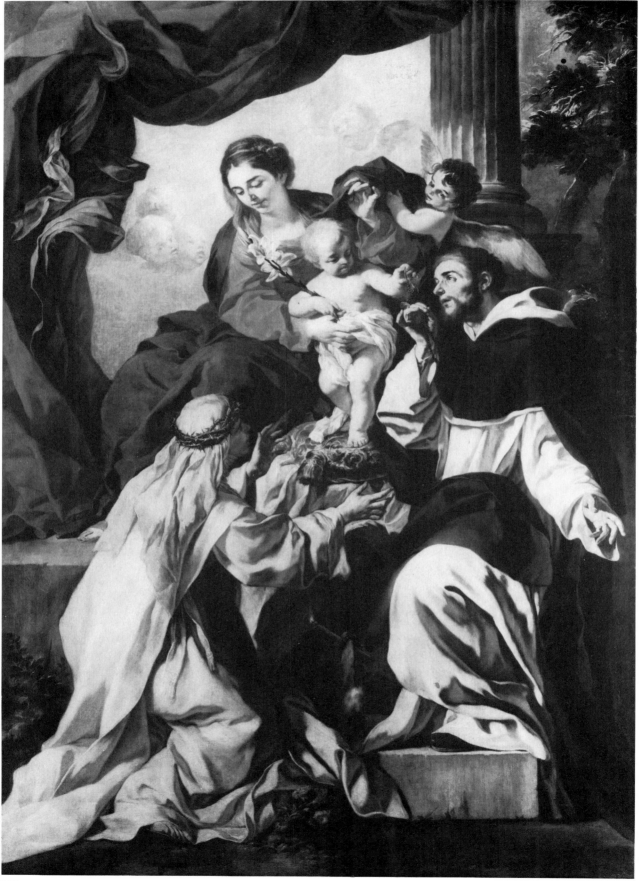

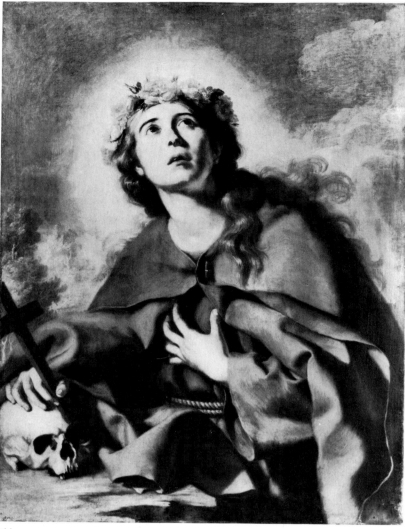

144

crowning S. Rosalia.

Francesco Solimena's frescoes in the S. Giorgio, Salerno contain, in the third compartment, a still life with a skull identical to the one in this painting. This portrayal of the hermit saint communing with God is connected with the neo-mystical movement emphasizing private communion with God and purity of faith, urged by Miguel de Molinos in his *Guia Espiritual*, the first Italian translation of which was published in Naples in 1675 (De Maio 1970). The Neapolitans were profoundly influenced by the meditative movement promoted by the Theresian and Alcantarine reform and by the quietism of Molinos himself. This contrasted strongly with the optimistic baroque vision of the glorification of the saints and is reflected in Solimena's deliberately prosaic images of saints painted between 1680 and 1684 (Ferrari 1970). There is a workshop copy of this picture in a private collection at Bologna.

I.M.

PROVENANCE
Mrs F. H. Drey, London

EXHIBITIONS
Paris 1960, no. 28

REFERENCES
Bologna 1962, p. 53; Bologna 1962, pp. 4–6

Domenico Gargiulo, called
Micco Spadaro

NAPLES 1609/10–NAPLES 1675

Micco Spadaro, born at Naples in 1609 or 1610 (Ceci 1905), spent all his life in his native city and probably died there in 1675 (Baldinucci 1681). The nickname Spadaro came from the trade of his father, who was a swordsmith. Micco began his career around 1628 when he entered the workshop of Aniello Falcone, frequented at the time by C. Coppola, Andrea di Lione and Salvator Rosa. He was also much influenced by the prints of Callot and Stefano della Bella; in all his works we find elongated figures with small heads and crowded compositions derived from Callot.

In Falcone's workshop he was closest to Rosa, with whom he began to paint landscapes from nature (De Dominici 1742). The figures in these views, such as those in the genre scenes (ex Fondi Coll., Naples) signed and dated 1636, have affinities with those in pictures by the Roman *Bamboccianti*. This suggests that Spadaro made a trip to Rome in the mid-1630s when he might have seen the work of Cerquozzi, Sweerts and Miel, the landscape decorations by Filippo Napoletano and Paul Brill in Palazzo

Bologna attributed this painting to Solimena and dated it a little before the 1680 frescoes for S. Giorgio, Salerno. He suggested that it may have been an experimental commission from the Benedictine nuns of that church, before he was entrusted with the frescoes.

The style is still influenced by Guarino's naturalism, as assimilated by Solimena from his father Angelo – a synthesis that is evident in Angelo's *St. Francis Asking Indulgence for the Porziuncola* (S. Lorenzo, Salerno). Francesco takes from the Salerno painting the facial types, the firm rendering of the saint's hands and the tactile quality of the habit and cord belt. But in the present picture this underlying naturalism is disturbed by 'a powerfully baroque impulse which, based on Lanfranco, embraces the tumultuous excitement of Luca Giordano's style in the decade 1650–60' (Bologna 1962–63). Angelo Solimena reacts similarly in the *S. Rosa* (S. Giovanni Battista, Angri), dated 1679; over the head of the saint the Child suspends a crown of flowers very like the garland of roses

Pallavicini-Rospigliosi and those by Agostino Tassi in the Quirinal Palace. There were also landscape paintings in Naples, such as the lunettes by Brill in the atrium of S. Maria Reginacoeli and those by Caracciolo in S. Diego all'Ospedaletto. Moreover private collectors, especially the Flemish merchants Van den Einden and Roomer, were already collecting landscapes by Flemish painters at the beginning of the century (Ruotolo 1973).

The arrival of Filippo Napoletano in Naples in 1627–28 had a great effect on Spadaro. Under his influence, Micco began to paint views of the coast and of the Neapolitan countryside in the open air.

From 1635–47 he often painted the figures in the architectural views of the Bergamo painter Viviano Codazzi, active in Naples during those years (*Villa Napoletana*, Musée des Arts, Besançon, dated 1641; *Adoration of the Shepherds*, Sarah Campbell Blaffer Foundation, Cat. 38).

In 1638 he was commissioned by the Certosa di S. Martino to fresco the choir of the Frati Conversi with biblical scenes and Carthusian legends as feigned tapestries with architectural painted surrounds. The lunette over the entrance, *Moses Striking the Rock* (the *bozzetto* is in Capodimonte) shows the influence of Schönfeld, who had just arrived in Naples. This is noticeable in Micco's pictures of biblical stories (*Elijah's Sacrifice on Mt. Carmel*, Cat. 149) and martyrdoms (*St. Sebastian*, Capodimonte) of the 1640s. In 1642 Gargiulo was commissioned by the Carthusians of S. Martino to fresco the prior's apartment: payments for the work date from 1642–47. Most

of the decoration consists of landscapes, which show the painter's adoption of the canons of northern landscape, particularly of Swanevelt and Dughet.

The *Revolt of Masaniello*, (Museo di S. Martino) the *Piazza Mercatello in the Plague of 1656* (Cat. 150), and the *Eruption of Vesuvius* (Cat. 151), all set in recognizable views of the city, were probably painted in the second half of the 1650s and represent Spadaro's activity as a chronicler of Neapolitan history. After the plague of 1656 he left the Certosa di S. Martino. De Dominici says that from 1657 he frequented the shop of Aniello Mele, a picture-dealer, which served as a meeting-place for Andrea Vaccaro, Luca Giordano, Giovanni Battista Ruoppolo and Carlo Coppola. The influence of Giordano and Venetian painting make it likely that the *Baptist Preaching* (private coll., Naples) and the *Circumcision* (private coll., Bologna) belong to this date. Amongst the rare works with large-scale figures is the *Last Supper* in the church of S. Maria della Sapienza, Naples (1641), still in the Neapolitan naturalistic tradition. Another large-scale figure composition is the *Madonna and Child with SS John and Paul* in S. Maria Donnaromita, Naples, in which the influence of Cavallino is discernible; it can be dated in the late 1640s.

His late work has still to be identified; according to De Dominici he continued to paint small pictures with great success.

B.D.

REFERENCES
Baldinucci 1681, (1975 ed.), VI, p. 382; Ceci 1905, p. 66; De Dominici 1742–45, III, p. 209; Ruotolo 1973, XII, pp. 145–53

145
Adoration of the Shepherds

74 × 99 cm
Matthiesen Fine Art Ltd., London

Gargiulo painted several versions of the *Adorations of the Shepherds*; those closest to this picture are the painting in the Molinari-Pradelli Collection, Marano di Castenaso, Bologna and the one in the Museo di S. Martino at Naples, which repeats the composition in reverse, with the Holy Family moved to one side, and includes the classical ruins, the flying putti, the bound limb and a wicker basket.

The insertion of the Nativity in a setting dominated by classical architecture would suggest that Gargiulo was familiar with paintings of similar subjects by Poussin, such as the *Adoration of the Magi* (Staatliche Kunstsammlungen, Dresden) and the *Adoration of the Shepherds* (National Gallery, London), which date from the 1630s. The picture also shows characteristics that suggest the influence

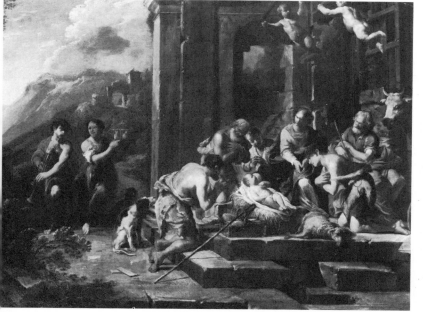

145

of Cavallino's later works, such as the two tondi illustrating subjects from Tasso in Munich, the Cleveland *Adoration of the Shepherds* (Cat. 35) and the *Mucius Scaevola* (Cat. 37). The use of a denser, more compact brushwork, similar to that of the late Cavallino, is unusual in Spadaro's work and suggests that the picture can be dated after 1650–55, but before the development of his later baroque style of *c*. 1660. Pentimenti show that the figures of St. Joseph and the Madonna were originally further to the left. The work is unpublished.

B.D.

146 & 147
Landscape with SS Anthony and Paul
Landscape with S. Onofrio

SS Anthony and Paul 62 × 76 cm
S. Onofrio 62 × 74.5 cm
Capodimonte, Naples

In 1642 the monks of the Certosa di S. Martino commissioned Spadaro to fresco the rooms in the prior's apartment. The work is documented by payments from 1642–46.

These two landscapes are preliminary studies for the lunettes in the first room. They come from the Certosa and are first listed in the Arditi Inventory of the Museo Nazionale (1806, nos. 905 and 906). In one picture S. Onofrio is seated on a rock by a stream with a seascape and a small port in the distance; in the other picture St. Paul and St. Anthony are placed in the extreme left.

The hermits in these pictures are incidental to the real subject, which is the landscape. The woodland studies, with broken tree-trunks, twisted trees and lush vegetation, draw on early seventeenth-century northern landscapes which

Gargiulo certainly knew. Particularly in these two pictures, we can find affinity with the 'romantic' landscapes of Salvator Rosa who often painted scenes of forests with twisted tree-trunks like these, although Spadaro uses a quite different palette based on light, melting colours.

The wide view opening into the distance shows the influence of Filippo Napoletano, as well as Swanevelt and Gaspard Dughet, on this type of landscape. Indeed, Dughet's frescoes in S. Martino ai Monti, Rome (1638–42) are very similar both to the lunettes in the prior's apartments and to these two *bozzetti*.

B.D.

PROVENANCE
Certosa di S. Martino, transferred to Capodimonte 1906

EXHIBITIONS
Naples 1947, p. 32

REFERENCES
Bologna 1962; Causa in *Storia di Napoli* 1972, p. 985, n. 122; Ceci 1905, p. 106; De Rinaldis 1928–29, p. 105; Ortolani 1970, p. 110

148
Bacchanal

69 × 103.5 cm
Monogrammed: *D.G.*
De Vito Collection, Naples

This work must have been painted for one of the many private collectors who ordered pictures from Micco Spadaro (De Dominici). Bacchus is shown seated on a barrel drawn by two goats, led by three fauns.

The painting, which can be dated towards the end of the 1650s, is one of the artist's rare mythologies. He shows a familiarity with Roman classicism, particularly with Poussin's style at the date at which Titian made such an

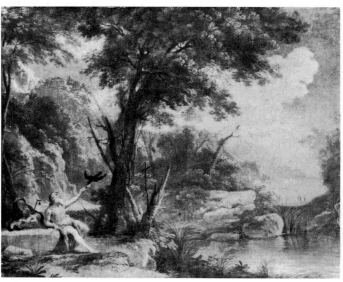

146

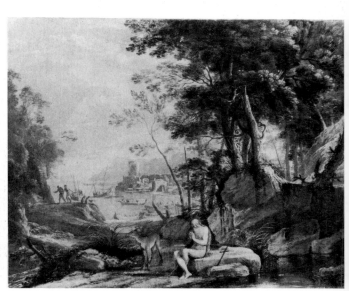

147

The absence of dated works makes it difficult to establish the place of the picture in Spadaro's career, but it is relatively late, given the baroque composition based on four diagonals crossing at the centre (obviously derived from Cortona). This can be accounted for by Spadaro's contact with Luca Giordano around 1657–60.

B.D.

REFERENCES
Blunt 1958, pp. 76–86; Ruotolo 1977, pp. 71–82

149
Elijah's Sacrifice on Mount Carmel

136 × 183 cm
Monogrammed: *DG*
Colnaghi & Co., London

The subject is taken from I *Kings*, xviii, 40. Jezebel, wife of Ahab, had introduced the cult of Baal to the court. The prophet Elijah called on the priests of the cult to testify to the power of the new divinity. Two altars were erected on Mount Carmel, one dedicated to Baal and the

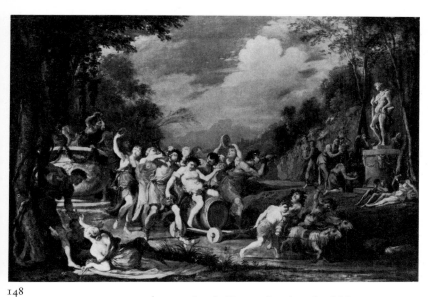

148

impression in Rome. Spadaro had felt Poussin's influence in Naples where paintings, drawings and prints after the Frenchman's work circulated at an early date (Blunt 1958; Ruotolo 1977).

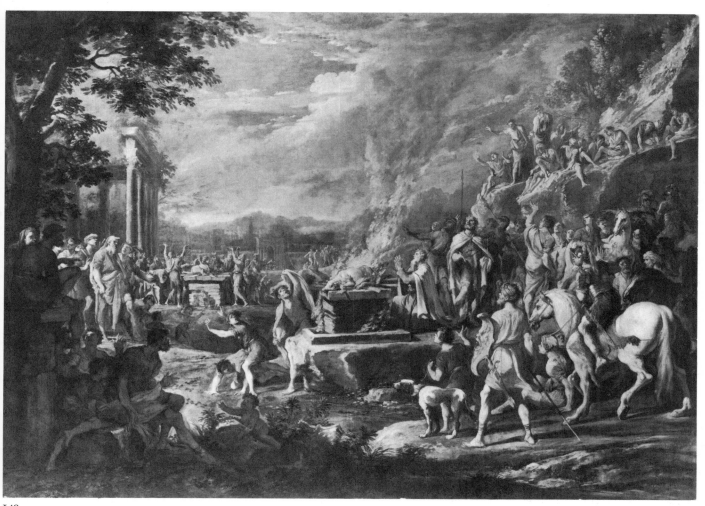

149

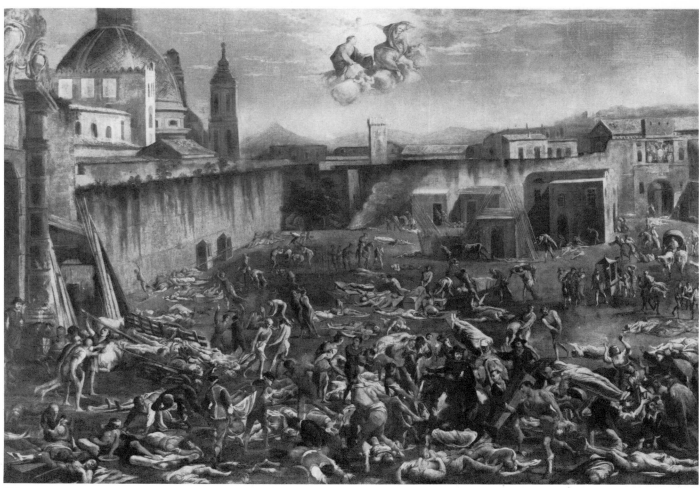

150

other to the God of the Hebrews; the followers of the two cults invoked their gods to accept the sacrificial calves. Only the God of the Hebrews responded and his fire consumed the animal; the followers of Baal 'cried aloud, and cut themselves after their manner with knives and lancets, till the blood gushed out upon them'.

The composition, with small figures diminishing into the distance, painted in near-monochrome, is derived from the engravings of J. Callot, whose work inspired Gargiulo's crowded compositions. But the attempt to compose on diagonals may indicate a certain sympathy for baroque figurative compositions. The influence of J. H. Schönfeld, in Naples from c. 1640 to c. 1649 is fundamental: the concentration of the figures on the edges of the picture with an open central view recalls Schönfeld's *Gideon with his Army* in the Potsdam Museum and the *Meeting of Jacob and Esau* in the Kunsthistorisches Museum, Vienna, both painted in Naples in the mid-1640s.

This picture belongs to the second half of the 1640s, when Gargiulo had already assimilated elements taken from Schönfeld, Callot and Poussin. Other pictures of similar date are the *Martyrdom of Sant'Andrea* (Ritiro dell'Addolorata, Portici), the *Martyrdom of St. Agatha* (private coll., Naples) and the *Martyrdom of S. Sebastiano* (Capodimonte, Naples).

B.D.

PROVENANCE
Sgambati Coll., Naples

REFERENCES
Ortolani in Naples 1938, p. 95; Ortolani 1970, p. 111

150

Piazza Mercatello in Naples during the Plague of 1656

125 × 177 cm
Museo Nazionale di S. Martino, Naples

This picture, perhaps painted for Cavaliere Don Antonio Piscicelli (De Dominici 1742), cannot date from much later than the event it portrays. The plague of 1656 decimated the population of Naples and many artists died, including Falcone, Stanzione, Do and Pacecco de Rosa. In the painting Gargiulo records an historical episode

with a chronicler's exactitude; the piazza has been identified as the Piazza Mercatello, outside the city walls (now called Piazza Dante), before it was altered by Vanvitelli. On the left is the Port'Alba, through which emerges a man on horseback who has been identified as Gargiulo himself (Rolfs 1910). In the background on the right is the gate of the Spirito Santo (now destroyed) which led into Via Toledo; behind the walls rises the dome of S. Sebastiano, which collapsed in 1939. Aloft on a cloud the Madonna intercedes with God that the terrible plague may cease.

Because of its location outside the walls the Piazza Mercatello was used as a collecting point for the corpses of plague victims. The dead were piled up and carried away by Turkish slaves and convicts who used long pitchforks.

The architecture in the upper half of the painting was certainly painted by Gargiulo, since Codazzi, his assiduous architectural collaborator, left Naples in 1647 and this picture obviously dates from after 1656. The figures with small heads show the influence of Callot and Stefano della Bella. The rapidity of the brushwork gives the figures an impressionist quality, increased by the grey tones.

Among the corpses in the foreground there is a woman with a living child at her breast. This appears earlier in a print by Marcantonio Raimondi (cf. *The Sickly Child* reproduced by Petrucci 1938) and was repeated by Mattia Preti in one of his *bozzetti* for the frescoes painted after the plague on the city gates (Cat. 100, 101).

In the *Thanksgiving after the Plague* (Museo di S. Martino), the Piazza Mercatello piled with corpses is included in the view of Naples from the Certosa. Together with the *Revolt of Masaniello* and the *Eruption of Vesuvius* this painting may be part of a single commission to Gargiulo to document three dramatic events in Seicento Neapolitan history: they are close stylistically and their measurements are identical.

B.D.

PROVENANCE
Casa Piscicelli, Naples;
sold to the Bourbon government 1829;
listed in the Sangiorgio Inventory of the Museo Nazionale di Napoli 1852;
moved to San Martino during the rearrangement of Neapolitan galleries 1945

REFERENCES
Causa 1946, p. 3; Causa 1956, p. 15;
Causa in *Storia di Napoli* 1972, V, II, p. 985;
Ceci 1905, p. 105; de Dominici 1742–45, p. 197;
de Renzi 1867, p. 396; De Rinaldis 1912, p. 238;
Ortolani 1970, p. 111; Petrucci 1938, pp. 403–19;
Rolfs 1910, p. 327

151

Eruption of Vesuvius

126 × 177 cm
Monogrammed: *DG*
Baron Giuseppe Carelli Collection, Naples

This painting may have been made for Cavaliere Antonio Piscicelli at the same time as another of

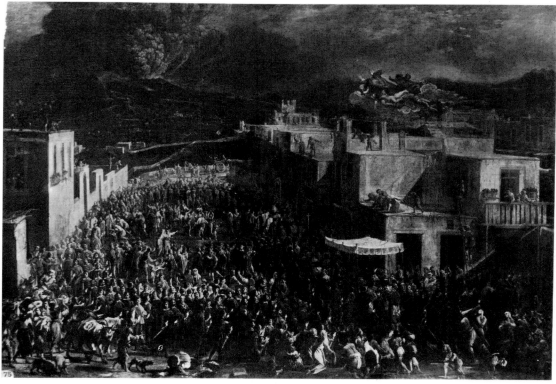

151

the same subject sent to Spain by Stefano Carriglio (De Dominici 1742). We only know the Neapolitan picture; the Spanish version is lost. It shows the procession of 17 January 1631 to invoke S. Gennaro's protection against the eruption of Vesuvius. Beneath the canopy is a reliquary bust of the saint and a priest, who carries the phials containing the martyr's blood. The city authorities, the viceroy and Cardinal Buoncompagni surrounded by a crowd are shown in a piazza evidently painted from life, with people on the balconies and terraces. On the left in the background, Vesuvius is erupting, while on the right above a cloud, S. Gennaro accompanied by putti raises his arms to halt the lava and fire.

The picture was painted many years after the event, but Spadaro certainly used old sketches and drawings of the procession and painted the piazza on the spot. Its style and vast scale, comparable to *Masaniello's Revolt* (Cat. 150) and *Piazza Mercatello during the Plague of 1656* suggest that it dates from 1655–60. The impressionistic painting of the figures, together with the pervading warm light and the framing of the scene as a view in the modern sense, are typical of Spadaro's mature style. Scipione Compagni, a contemporary of Micco, also painted this same event. In his *Eruption of Vesuvius* of 1635–40 (Kunsthistorisches Museum, Vienna; a larger version is in the Costantini Coll., Rome) the focus of attention is Vesuvius. In Gargiulo's picture all the interest is concentrated on the procession and the incidents of city life.

B.D.

PROVENANCE
Carafa di Noja Coll.;
Carlo Capece Galeota, Duca della Regina (Ceci 1905); inherited in 1920 by the present owner

EXHIBITIONS
Naples 1938, p. 95

REFERENCES
See Cat. 150

Giovanni Battista Spinelli

ACTIVE IN NAPLES *c.* 1630–*c.* 1650

The only information we have about the life of this Neapolitan painter is from De Dominici, not always a reliable source, who says he was the pupil and collaborator of Massimo Stanzione, with whom he painted a *Christ Disputing in the Temple* (lost) for the church of the Annunziata in Naples. Later, abandoning his career as a painter, he interested himself in alchemy. It is said that it was as a result of an accident in an alchemy experiment that he died prematurely in 1647.

Faced with the scant knowledge of his life, it has only recently been possible to trace a preliminary outline of Spinelli's painting career as documented by an inadequate series of autograph works and by a considerable number of drawings, some of them signed, in various European museums and collections (Capodimonte, Naples; Uffizi, Florence; Nationalmuseum, Stockholm). Longhi's essay on Spinelli is the basis of this reconstruction (Longhi 1969); recently there have been contributions by Borea, Schleier, Causa, Abbate and the present writer.

On the basis of Vitzthum's studies of his drawings and of his identified paintings, it seems that his artistic formation, which must have been in the late 1620s, was deeply influenced by his knowledge of a large number of prints by northern artists of the sixteenth and seventeenth centuries, including Dürer, Lucas van Leyden, Aldegrever, Goltzius, Matham, de Gheyn, Bellange and Callot. In addition he reverted to the style and composition of late Neapolitan mannerists, particularly that of Francesco Curia. These influences were basic to his style throughout his career, but on to it were grafted reflections of Caracciolo's late work evident in *St. Stephen* (private coll., Naples; 1630).

There followed a return to a style derived from northern prints and late mannerist models (*Lot and his Daughters*, Cat. 153), which was paralleled by the work of Pietro Testa in Rome. Sometimes the slight influence of Ribera's recent paintings is apparent as, for instance, in the *Prophet* (private coll., Naples), reminiscent of the *Elijah* and *Moses* by Ribera (Cat. 124, 125), datable to the late 1630s. At the beginning of the 1640s he was momentarily influenced by the naturalism of the Master of the Annunciations (e.g. the *Nativity*, National Gallery, London).

In his late works there are also echoes of Cavallino's contemporary work, namely the *Christ and the Woman of Samaria* (Francesco Romano, Florence), the *Madonna and Child* (Carola Coll., Naples), and the *Departure of Tobias* (Abbey of Montecassino), formerly attributed to Stanzione. This work marks the beginning of a phase in which, without abandoning his youthful style derived from northern art and late mannerism, Spinelli gradually adopted elements of form and composition from Massimo Stanzione in, for example, the *Stories of the Baptist c.* 1633–34 (Prado) and in his later work which culminated in the decoration of the Chapel of the Baptist (1624–44) in the Church of the Certosa di S. Marti

N.S.

REFERENCES
Longhi 1969, pp. 42–48

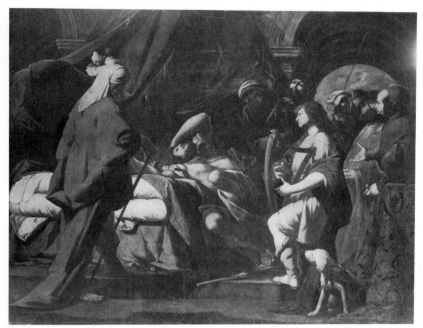

152

the latter also by Schleier) and saw the two paintings as a reaction against naturalism and classicism, and against Massimo Stanzione. This is confirmed by comparison with other recently discovered pictures by Spinelli (Spinosa 1982) and in turn suggests a later dating for the two paintings in the Uffizi. It now seems probable that they were painted in the mid-1640s, earlier than the paintings in the Duomo di Castellammare di Stabia and the Barberini Collection, Naples, which can hardly be dated earlier than the end of the 1640s or the early 1650s. Schleier, on an indication from Eduard Safarik, has published another autograph version of *David and Saul* (with some variations) which had been said by Longhi to be a lost work. This picture, now in the National Gallery of Prague, could be the preparatory model for the larger painting now in the Uffizi.

N.S.

PROVENANCE
Private coll., Florence; presented to R. Longhi 1967; acquired by the Italian State for the Uffizi 1970.

EXHIBITIONS
Florence 1970, no. 75

REFERENCES
Longhi 1969, pp. 42–48; Schleier 1971, p. 101; Spinosa 1982

152
David Placating Saul

253 × 309 cm
Uffizi, Florence (inv. no. 9467)

This painting and its pendant of *David's Triumph celebrated by the Hebrew Maidens* (Uffizi, inv. no. 9468), for which there is a preparatory drawing also in the Uffizi (inv. no. F. 8897), come from the same noble Florentine collection as the *St. Stephen* (private coll., Naples). The compositions illustrate two episodes in the Old Testament (I, *Samuel*, xvi and xvii) – the young David soothing the anguished Saul by playing on the harp and the triumph of David after his victory over Goliath. Longhi published the three paintings in 1969 as the work of G. B. Spinelli on the basis of iconographic and stylistic similarities with the drawings, including the *David Triumphant* (in the Uffizi) and the *Nativity* (National Gallery, London, inv. no. 1157) which Longhi had already transferred from Cavallino to the young Spinelli.

Longhi considered them to be mature works linked stylistically and chronologically with the *Stories of St. John the Baptist* painted by Stanzione c. 1633–34 (Prado), especially in the breadth of their composition and the similarities in form. He also pointed out their dependence on northern engravings and drawings of the sixteenth and seventeenth centuries and on the style of the Neapolitan late mannerist Francesco Curia. Borea wrongly insisted on the paintings' marked naturalism outside the Caravaggesque main stream (Florence 1970, no. 75).

Causa proposed a possibile connection with the work of Saraceni and Testa (suggested for

153
Lot and his Daughters

154 × 210 cm
Pisani Collection, Naples
[*repr. in colour on p. 76*]

This picture illustrates *Genesis*, xix: Lot, son of Abraham, fleeing from the flames of Sodom, is beguiled unknowingly into an incestuous relationship with his two daughters who, anxious to perpetuate their race, had embraced their father after they had made him drunk.

First published in 1972 (Causa), at a time when knowledge of Spinelli was confined mainly to his graphic work and to the few pictures ascribed to him by Longhi in 1969, the picture was then dated to the final years of his career, c. 1647. This dating was also based on the extraordinary still life of grapes and pomegranates inserted in the painting which Causa attributed to Luca Forte at the end of his life. But while this attribution for the still life seems fairly convincing (another still-life insertion by Luca Forte is in the *St. Stephen* by Spinelli published by Longhi when it was still in Florence), it seems to date the picture at least ten years earlier. The detail of the grapes with their long racemes and of the pomegranates is closer, as Causa agrees (oral communication), to the monogrammed still life by Luca Forte in the Corsini Gallery, Rome, dated to 1630 or shortly after, than to Forte's other compositions of the

years 1645–50. These later paintings are more baroque in style. *Lot and his Daughters* would seem to belong to a period at least ten years earlier than the pictures at Montecassino, and in the Uffizi and the Duomo of Castellammare di Stabia.

The composition, unlike later works, is not yet affected by Stanzione's style and depends strongly on late mannerism, which produces a contorted, anti-naturalistic monumentality. Even the strongly plastic quality of the forms, defined by sharp outlines and profiles rather than by chiaroscuro, and the *contrapposto* are derived from Spinelli's drawings based on northern engravings. The result is that even the echoes of Caracciolo (more evident in the *St. Stephen* which, for this reason, would seem to be a few years earlier) are subjugated to late mannerist ideals of bewitching pictorial beauty. The use of dark tones deriving from Caracciolo date the picture before 1640; after that date his work shows the influence of Massimo Stanzione.

N.S.

PROVENANCE
Neapolitan coll.; Moratilla Coll., Paris

EXHIBITIONS
Bucharest 1973; Naples 1973

REFERENCES
Causa in *Storia di Napoli*, V, II, 1972, p. 926; Marini 1974², pp. 97–98

Massimo Stanzione

ORTA DI ATELLA 1585? – NAPLES 1656

The only information on the birth and training of Massimo Stanzione comes from De Dominici and this has still to be verified. He wrote that Stanzione was born in 1585 and began to paint comparatively late in life; he first entered Santafede's studio and subsequently that of Battistello.

Stanzione was certainly an established painter by 1617 when G. B. Basile wrote and dedicated a madrigal to him in which he praised a painting of *Venus and Cupid* and described three of his other paintings – the *Fight between Achilles and Hector*, *Hero and Leander* and the *Gigantomachia* (Basile 1617) – in an ode. In October of the same year he is documented as being in Rome, where he worked in S. Maria della Scala until April 1618, together with established painters such as Cavalier d'Arpino, Roncalli, Saraceni and Honthorst (Borsook 1954). It is likely that Stanzione studied the work of the Carracci at this time, as De Dominici states, and was influenced by the Caravaggisti,

particularly Vouet. Unfortunately there are no works surviving from this date, since the painting for S. Maria della Scala is lost and the *Presentation in the Temple* of Giugliano, Naples, is reduced to little more than a fragment.

He was in Rome again from 1625–30 (Novelli Radici 1974) and the *Pietà* (Corsini Gallery), previously attributed to Battistello until restoration work revealed Stanzione's signature EQUES MS, is in his mature style. Although there is some doubt whether Stanzione actually received the title of *Cavaliere*, the signature of EQUES with which he almost invariably signed his works attests to his desire for status.

After Stanzione's return to Naples in 1630, carrying a letter of introduction to the monks of the Certosa di S. Martino, it is possible to follow his development from his youthful Caravaggesque phase (the *Martyrdom of St. Agatha*, reserve coll. Capodimonte; *St. Bruno Giving the Rule*, Certosa di S. Martino and the *Madonna with the Souls in Puragory* in the Church of the Purgatorio, Arco) through a gradual conversion to Bolognese classicism, close to that of Reni and Domenichino, as encouraged by Cardinal Filomarino. Stanzione's contact with Artemisia Gentileschi, who was in Naples around 1630, was also decisive for him; her influence is evident both in his use of colour and his lighting effects (Longhi 1916). The reason for Stanzione's extraordinary success lies in his easy eclecticism, enabling him to create a personal style from a variety of sources. Whereas his early work is mostly secular – portraits or mythologies – his mature work is largely religious.

After 1630, Stanzione worked almost uninterruptedly for the most important Neapolitan churches. In the early 1630s he decorated the Chapel of S. Bruno in the Certosa di S. Martino, in 1633 he painted for the vault of the church of SS Marcellino e Festo, in 1638 the *Pietà* and in 1639 the *Last Supper* (both for the Certosa). In the following years he carried out the decoration of the vault in the apse of the Gesù Nuovo (1640), the lost painting of the *Marriage of Cana* (1640–42) for the church of the Annunziata (the *bozzetto* for which is in the Pinacoteca dei Girolamini in Naples) and the decoration of the vault in the Church of S. Paolo Maggiore (1643–44). In 1644 he painted the *Ecce Homo* with an architectural framework by Codazzi and the *Madonna with St. Hugo and St. Anselm*, and decorated the chapel of St. John the Baptist for the Certosa di S. Martino, which was completed in 1651. These are all very decorative and rich in colour, although at times the compositions are rather mechanical. But Stanzione's openness to new stimuli continued and his works, such as the *Annunciation* at Marcianise, signed and dated 1655, and the

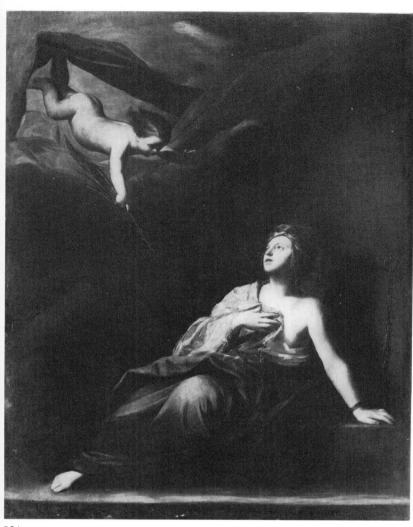

154

appears to the saint with the palm of martyrdom. This picture is generally recognized as an early work, painted in the early 1630s just after Stanzione's return to Naples.

Stylistically it is close to the *Martyrdom of St. Agatha* (reserve coll., Capodimonte) and to the *Madonna with the Souls of Purgatory* in the church of the Purgatorio ad Arco. The solid forms in the *St. Agatha in Prison* derive from Caracciolo; against a dark background, the shaft of light coming from high on the left both defines the volume of the forms and introduces delicate shimmers of light on the drapery and the chains on the right. Stanzione displays an extraordinary sensibility to colour in the painting of the precious material of the mantle and the turban of the saint. The pose of the saint, with her face turned to the heavens in accordance with Counter-Reformation taste, also shows that even in the early 1630s Stanzione had begun to rework the lesson of Caravaggio in an academic way, which was to be the basis of his subsequent success.

L.G.

PROVENANCE
Bought from Avvocato Michele Ridola by the Museo Nazionale 1912

EXHIBITIONS
Athens 1962, pp. 76–77; Naples 1963; Paris 1965, p. 235; Bucharest 1972

REFERENCES
Causa 1966[1], pl. V;
Causa in *Storia di Napoli*, 1972, V, II, p. 938

155
St. John the Baptist

182 × 152 cm
Signed: lower centre *Eques Mass. F.*
De Vito Collection, Naples

The youthful St. John in the wilderness was a very common subject in Neapolitan seventeenth-century painting. This is an early work, to be dated immediately after Stanzione's second stay in Rome (1625–30). It is very close to *St. Agatha in Prison* (Cat. 154) which is perhaps a year or two earlier: the lighting is very similar in both paintings.

In this work we can recognize some of Stanzione's sources: the pose of the saint is that of an academy nude and the sharp separation of light and shade derives from Caravaggio. The presence of such elements as the fleece around the saint's loins and the highly naturalistic lamb show Stanzione's awareness of the work of Ribera in the 1630s.

There is a seventeenth-century copy of this picture in the Albergo dei Poveri, Naples.

L.G.

PROVENANCE
Finarte Sale Milan, April 1973, no. 62.

Visitation in the Gesù Nuovo, show the influence of the new baroque style.

After 1655 we lose trace of Stanzione, which gives credence to De Dominici's assertion that he died in the great plague of 1656. Several nineteenth-century sources however cite a picture which is still in S. Pietro in Vinculi as signed and dated 1658, although the lower half is ruined (De Vito 1982).

L.G.

REFERENCES
De Vito 1982, pp. 64–65; Basile 1617, p. 49; Longhi 1916[2], p. 308; Borsook 1954, p. 271; Novelli 1974, pp. 99–100

154
St. Agatha in Prison

231.5 × 180 cm
Capodimonte, Naples

Saint Agatha, a virgin of Catania, was subjected to torture during which her breasts were torn off; later she died in prison. Here the angel

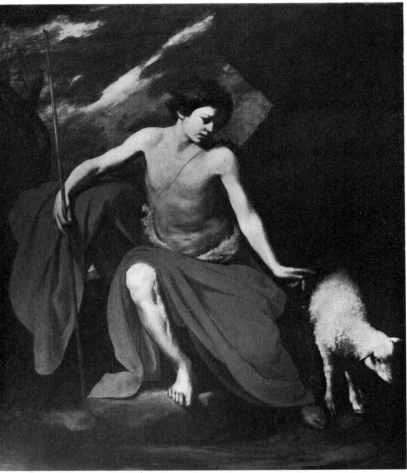

155

Sánchez argued that the series was painted after 1634 because of the inclusion of a picture by Artemisia Gentileschi, who came to Naples in that year. But in fact she first came to Naples in 1630, the date at which Stanzione returned from his second stay in Rome. The group of paintings is markedly Caravaggesque in feeling and may be dated in the early 1630s.

The influence of Artemisia Gentileschi is evident in the meticulous and luminous passages in the drapery and the armour of the figure on the right. De Dominici recalls that Stanzione greatly admired her work 'and having become friendly with her went to watch her paint every day'; it is reasonable to assume that they collaborated closely on this series. The *Decollation of St. John the Baptist* is the most Caravaggesque of the series, inspired by Caravaggio's painting of the same subject at La Valletta, Malta and by that of Honthorst which Stanzione saw in Rome when he was working on the church of S. Maria della Scala (Moir 1967; Causa 1972).

There is a copy of the picture by Andrea Vaccaro in the Bowes Museum at Barnard Castle (Soria 1961; Salerno 1955, no. 56).

L.G.

PROVENANCE
Buen Retiro Palace in 1656–59 (Diaz del Valle 1956–59 [ed. Sanchez Canton, 1933]); later recorded in the Chapel of the Royal Palace in Madrid (Ponz 1947)

EXHIBITIONS
Madrid 1970, p. 536, no. 83

REFERENCES
Causa 1957, p. 31;
Causa in *Storia di Napoli* 1972, V, II, p. 937;
Ceci in Thieme Becker 1937, p. 473;
De Rinaldis 1920, p. 45;
Diaz del Valle 1656–59 (1933 ed.), p. 339;
Moir 1967, I, pp. 167–68; Nugent 1930, p. 76;
Perez Sanchez 1965, pp. 452–54; Ponz 1947, pp. 772–74;
Salerno in Naples 1955, p. 56; Tormo 1924, p. 12

156
Decollation of St. John the Baptist

184 × 258 cm
Museo del Prado, Madrid
[*repr. in colour on p. 75*]

This painting, together with three others by Stanzione – *The Annunciation to Zacharias, The Baptist Taking Leave of his Parents* (signed) and the *Baptist Preaching in the Wilderness* – and one by Artemisia Gentileschi, *The Birth of St. John*, all of which are in the Prado, Madrid, form part of a series of stories of the Baptist; it is probable that they decorated a chapel dedicated to the saint, and the altarpiece, now lost, could well have been the *Baptism of Christ* (Tormo 1924). Another such series by Stanzione is in the chapel devoted to St. John the Baptist at S. Martino, and dates from the mid-1640s.

This group in the Prado has been assigned to widely discrepant dates: Bologna (Naples 1955) thought that they were early works painted before 1630, a dating accepted by Causa (1957) and Moir (1967), Pérez Sánchez (Madrid 1965 and 1970) placed them in the mid-1630s, which Causa has recently accepted (1972) while De Rinaldis (1920) dated them *c.* 1640. Pérez

157
Massacre of the Innocents

127 × 153 cm
Graf Harrach'sche Familiensammlung, Schloss Rohrau
[*repr. in colour on p. 75*]

Ortolani believed this painting was influenced by Caracciolo (Naples 1938) and Causa thought it was a youthful work (Naples 1954). Heinz dates it later, *c.* 1640, pointing out that the composition derives from Poussin's work around 1630 (Heinz 1960). The picture reflects the earlier paintings of Guido Reni at Bologna (Moir 1967) and Poussin (Chantilly), datable to *c.* 1630, in which the biblical episode is represented with the same drama conveyed by the reaction of a few protagonists.

The composition is dominated by the violent diagonal formed by the figure of the executioner

and is lit sharply from the left. Evidently Stanzione was attracted to the dramatic possibilities of the subject which he accentuated by placing the figures on two levels. This use of chiaroscuro suggests that the painting dates from Stanzione's most Caravaggesque phase in the first half of the 1630s. Moir observed that some of the physical types and expressions derive from Reni's *Massacre of the Innocents* (Moir 1967).

The success of this painting is apparent from the many replicas of it, both autograph and studio production; one at the Confraternity of the Trinità dei Pellegrini, Naples, one on deposit at Capodimonte, another version at Bruchental which shows signs of greater studio participation, one in a Neapolitan private collection and, finally, one which has recently appeared on the art market (Finarte, Rome, November 1980, no. 119). A copy by Andrea Vaccaro was formerly in the Von Bissing Collection, Munich. A drawing of the same subject (Scholz Coll., New York) shows only the figure of the executioner.

L.G.

EXHIBITIONS
Naples 1938, p. 40: Naples 1954, p. 50

REFERENCES
Gruss 1856, p. 82; Nasse 1911, p. 133;
Ritschl 1926, pp. 101–02; Heinz 1960, p. 74;
Moir 1967, I, p. 170; II, p. 107; Marrow 1978, p. 7

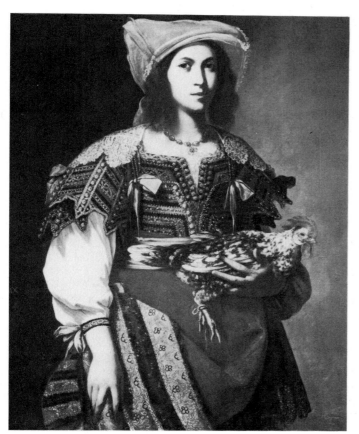

158

158

Portrait of a Woman

118.7 × 97.2 cm
Monogrammed: on left EQ. MAX.
Fine Arts Museums of San Francisco
[*repr. in colour on back cover*]

De Dominici tells how Stanzione began his career as a portrait painter by painting the portrait of his uncle on his deathbed and how he entered the workshop of Santafede where he portrayed a large number of Neapolitan noblemen. Stanzione produced many portraits from the beginning of his career, as documents of 1615, 1620 and 1622 show (D'Addosio 1913; Rassegna Economica del Banco di Napoli 1940). Other portraits are mentioned by Basile (1627) in inventories. Almost all Stanzione's secular work mentioned in the literature has yet to be identified, and only a few portraits have been ascribed to him: the presumed self-portrait at Barletta (Naples 1938, no. 43), the portrait of the Conde di Oñate at the Istituto Valencia de Don Juan di Madrid (Pérez Sánchez 1965, p. 456), the monogrammed portrait of a woman now on the London market and that of Jerome Bankes (Cat. 160). This *Portrait of a Woman* in San Francisco, a magnificent specimen of Stanzione's portraiture, shows a woman in peasant clothes, probably a noblewoman dressed in popular costume while the cock might be either a symbol of jealousy or a name-day allusion.

The picture can be dated in the mid-1630s; besides the evident influence of Caravaggio, especially in the light and shade that cuts across the woman's face, there is a sensitivity to colour unusual in Stanzione's works. The influence of Artemisia Gentileschi, which led him towards a more classicizing style is here interpreted in the light of the new wave of painterliness which struck Naples in the mid-1630s.

L.G.

PROVENANCE
Hispanic Society of America, New York;
on deposit at the De Young Memorial Museum, Fine Arts Museums of San Francisco since 1941.

EXHIBITIONS
Sarasota 1961, no 9

REFERENCES
Causa 1966[1]; Causa in *Storia di Napoli*, V, II, 1972;
D'Addosio 1913, p. 511;
Ferrari 1962, p. 236; Heil 1942, pp. 11–13;
Naples 1938, p. 43; Perez Sanchez 1965, p. 456

159

Pietà

240 × 320 cm
Signed: on the right EQ. MAX.
Certosa di S. Martino, Naples

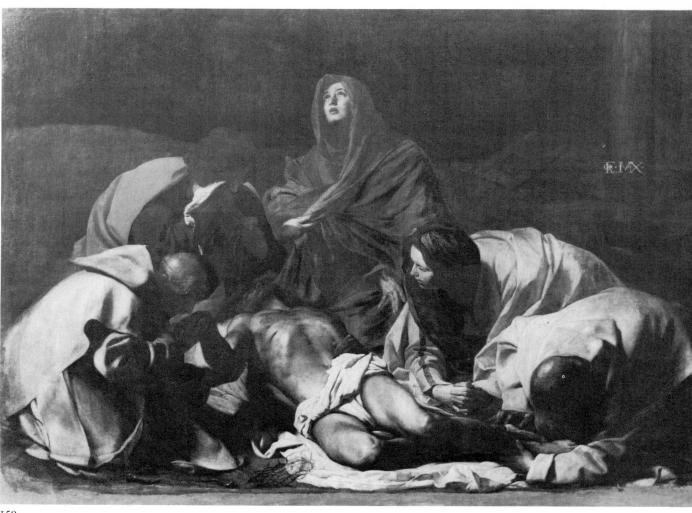

159

The *Pietà* has always been considered to be Massimo Stanzione's masterpiece; it was paid for in 1638 (Faraglia 1892). De Dominici tells many apocryphal anecdotes about this painting: in the life of Ribera he relates that the monks of the Certosa initially gave Stanzione the commission to paint the high altarpiece for the Cappella del Tesoro, but were persuaded by Ribera that the two painters should paint an altarpiece in competition with each other and Ribera's was chosen. And in the life of Stanzione, de Dominici tells how Ribera, jealous of the beauty of Massimo's *Pietà*, persuaded the monks to wash it with 'corrosive liquid', in order to spoil it (De Dominici, 1742–45). But these stories no longer seem credible: the document for the payment speaks clearly of a large picture of the *Pietà* over the door of the church (Faraglia 1892) and the dimensions of Stanzione's picture fit the high altar exactly, unlike Ribera's painting which is too wide. As for the story about the 'corrosive liquid', it is most improbable that Ribera, at the height of his success, should have feared comparison with Stanzione; in fact, Massimo's *Pietà* seems to

have suffered from the bitumen used in the priming (Causa 1973).

This painting, together with the *Last Supper* in the choir of the Certosa di S. Martino (1639) and the decoration of the vault of the apse of the Gesù Nuovo (1639–40), belongs to Stanzione's middle period, when his style was becoming progressively more classical, for which he was dubbed 'the Guido of Naples'.

His youthful Caravaggism, still evident in the figures of the two friars, their habits lit by a shaft of light, and in the volumetric solidity of Christ's body, is incorporated into a classically balanced composition achieved through the measured gestures which create the space around the body of Christ. The refinement of the colouring of some details, especially the mantle of the Magdalen, is derived from Artemisia Gentileschi (Bologna 1958).

At this period Stanzione was extremely eclectic, but the extraordinary success of the *Pietà* was due to the sincerity and directness of its religious appeal: 'Stanzione was consciously creating something new and different, no longer treating the subject as a religious drama . . . but

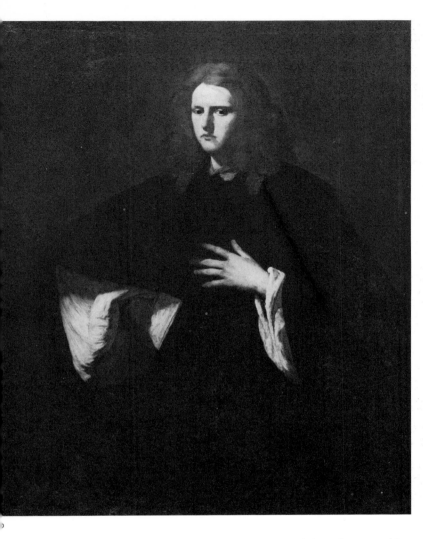

in human terms, familiar and directly accessible . . .'. (Causa 1973).

L.G.

EXHIBITIONS
Florence 1922, p. 171; Bucharest 1972

REFERENCES
Bologna 1958, p. 17; Causa 1973, pp. 61–63;
Celano 1692 (1970 ed.) pp. 1604, 1643;
De Dominici 1742–45, III, pp. 13, 53; Faraglia 1892, p. 666;
Sarnelli 1685, p. 323; Schwanenberg 1937, pp. 39, 43–44, 67

160

Portrait of Jerome Bankes

126.5 × 103 cm
National Trust, Kingston Lacy, Dorset

Jerome Bankes was the third son of the lawyer Sir John Bankes and Lady Mary Hawtreys; he matriculated in 1653 at Queen's College, Oxford. Together with his cousin, Mr Altham, Bankes travelled to Italy and visited Naples, but the exact date of this journey is unknown.

Salvator Rosa painted Altham dressed as a hermit, probably in Rome in 1665 (Cat. 137),

but this does not help to date the present picture (Waterhouse 1960). This portrait is usually dated around 1655 in Stanzione's last period, (London 1956–57; Waterhouse, 1960). Compared to the earlier portrait of a woman in San Francisco, which still contains naturalistic touches, the Bankes portrait shows that Stanzione had assimilated elements of Van Dyck's style, such as the elongation of the figure and the emphasis on the hands and head.

The composition follows the seventeenth-century formula for official portraits; the sitter is shown in three-quarters length. De Dominici states that there were many pictures by Stanzione in English collections.

L.G.

PROVENANCE
Jerome Bankes and by descent

EXHIBITIONS
London 1956–57, no. 160

REFERENCES
Waterhouse 1960, p. 58

Andrea Vaccaro

NAPLES 1605 – NAPLES 1670

Andrea Vaccaro's father encouraged him to study literature, but he himself wished to be a painter and initially trained with the late mannerist Girolamo Imparato. Soon he was attached to the early Caravaggisti: Carlo Sellitto and Caracciolo. His copy of Caravaggio's *The Flagellation* for S. Domenico in the same church is an early work, as is *St. Sebastian* (Cat. 161) and *David with the Head of Goliath* (Longhi Coll., Florence); in these paintings the chiaroscuro still has an academic rigour.

Later, influenced by Massimo Stanzione, he came into contact with the Bolognese, particularly Guido Reni. Vaccaro's eclecticism embraced the style of Van Dyck, and this was reinforced by the presence of Novelli in Naples after 1630. The art of Reni and Van Dyck influenced him throughout his career, the former providing the prototypes for his innumerable pietistic images of saints, (the *Magdalen* of 1636 in S. Martino, Naples, *S. Rosalia* in the Prado, Madrid and the *Stigmatization of St. Francis* in the Duomo, Pozzuoli) and the latter enriching his colour scale with browns and purples.

In spite of his interest in colour, which was also influenced by Ribera, Vaccaro never succeeded in freeing himself from a certain academic stiffness even present in his best works (*Madonna and Saints*, S. Maria delle Grazie a Caponapoli, Naples; *Storia di S. Ugo*, S. Martino, Naples 1652). Perhaps his best work was done between 1635 and 1645 when he was in contact with Bernardo Cavallino, from whom

he derived a certain refinement. Examples of his work at this stage are the *Death of Joseph* (S. Maria del Purgatorio ad Arco, Naples; Capodimonte), *Erminia and the Shepherds* and *Abraham and the Angels* (private coll., Naples). His altarpieces are monotonously academic in style, though this is often mitigated by passages of great pictorial beauty.

In his last works Vaccaro seems to echo the great baroque compositions (S. Maria del Pianto, Naples), although he was still tied to well-tried formulas which ensured for him great success, especially in the years between the death of Stanzione and the establishment of Luca Giordano. From 1665 he was Rector of the Academy of Neapolitan Painters.

There are many works by Vaccaro in south Italy, in churches in the Campania, Apulia and Calabria, as well as Naples itself. A large group of his pictures is also in Spain (Prado, Madrid and private colls.; Pérez Sánchez 1965).

M.R.N.

REFERENCES
Pérez Sánchez 1965, pp. 361–76

161

St. Sebastian

203 × 130 cm
Capodimonte, Naples

The painting came from the Confraternità di SS Anna e Luca, and was in the church of S. Giovanni Battista delle Monacle from 1666 until 1680.

It may have been one of the lateral pictures in a minor chapel; its provenance is unknown. Although not one of Vaccaro's best works, it demonstrates how he arrived at the eclectic formula which was to make his name in Naples.

The naturalistic details of the saint's hands and the use of chiaroscuro does not hide the debt to Reni, both in the figure and in the expression of pathos. After his early Caravaggism, Vaccaro studied Reni (De Dominici) whose classicism remained fundamental to his style. Reni's influence is most obvious in his single figures of saints, whether half or full-length. In this case it is probable that he used as models Reni's two versions of *St. Sebastian*, one in the Louvre and the other in Palazzo Rosso, Genoa.

Ortolani (in Naples 1938) linked this work with two pictures of episodes of the Passion in the Rebuffat Collection. In all these paintings Vaccaro approaches Reni's luminism, and this reached a high point in the altarpiece in S. Maria delle Grazie at Caponapoli. Vaccaro already knew Ribera's work (eg. the series for the Collegiata at Osuña) and he now adopted the intense naturalism and rich chiaroscuro effects of the Master of the Annunciations. These influences evidently undermined Vaccaro's classicism, and by the late 1620s he was attempting to synthesize realism with his earlier style. The results were not entirely successful, as is apparent in this painting. Later he was influenced by Van Dyck and reached a mature style in the 1630s and 1640s.

M.R.N.

PROVENANCE
S. Giovanni delle Monache, Naples; from 1680 in an oratory in the sacristy of the Gesù Nuovo, where it remained until the suppression of the monastery

REFERENCES
Ceci 1898, pp. 8–13;
De Dominici 1742–45, III, p. 137;
Ortolani in Naples 1938, p. 49

161

Filippo Vitale

NAPLES OR CAPUA 1589–NAPLES 1650

Filippo Vitale is barely mentioned by early writers, Celano alone refers to a painting by him, then in the collection of Principe Tarsia. Documents published by Strazzullo (1955) have made it possible to identify Vitale's links with contemporary artists. In 1612 he married Caterina di Mauro, the widow of Tommaso de Rosa, so becoming the stepfather of Pacecco de Rosa and of Dianella (or Annella, as De Dominici calls her); in 1613 Carlo Sellitto was godfather to his son Carlo; in 1629 his step-daughters Dianella and Maria Grazia married respectively the painters Agostino Beltrano and Giovanni Do, while in 1639 his own daughter Orsola married Aniello Falcone.

Despite these bibliographical details, only one signed work, the *Pietà* in Regina Coeli, and one monogrammed work, the *Guardian Angel* (Cat. 162), survive. These are the basis around which Vitale's painting career must be constructed. The identification of the *St. Francis at Prayer* at S. Maria di Monteoliveto as a picture of the same subject documented as having been painted by Vitale in 1613 is doubtful, and the *Holy Family* at S. Maria delle Grazie in Caponapoli is equally uncertain. Bologna has constructed the most convincing oeuvre which, apart from the two signed pictures, includes the *St. Nicholas with S. Gennaro and S. Severo* (S. Nicola alle Sacramentine, Naples), the *Liberation of St. Peter* (Musée des Beaux-Arts, Nantes), the *Charity* (private coll., Turin), the *St. Sebastian* (National Gallery of Ireland, Dublin) and the *Martyrdom of St. Sebastian* (S. Maria degli Angeli alle Croci, Naples) which is a copy of an original by Vitale, possibly identifiable with a picture of the same subject attributed to a 'follower of Caravaggio' at auction (Christie's sale, Villa d'Este, 31 March–1 June 1971).

This is not a very extensive list of works, but enough to reveal an early Caravaggesque formation (documents show that he was already active as early as 1613) in close contact with Sellitto, which suggests that he may have been the 'Signor Filippo' referred to in the latter's will of 1614 (Causa 1972). The paintings in the ceiling of the church of the Annunziata at Capua, which were at one time dated 1618, show that Vitale's development was parallel to Caracciolo's, derived ultimately from Sellitto.

The church was extensively damaged in the last war, and of the canvases attributed to Vitale only the *Pentecost* (much repainted), the *Circumcision* and the *Annunciation* are legible. *The Liberation of St. Peter* at Nantes and the *St. Nicholas with S. Gennaro and S. Severo* at S. Nicola alle Sacramentine must also date from the second decade of the century; the latter, particularly in the figure of the Madonna in Glory, reveals Vitale's close study of Caravaggio.

Bologna (1977–78) identifies a group of works (among which the *St. Jerome* in S. Maria dei Sette Dolori is perhaps the most significant) that reveal Vitale's interest in Ribera's work around 1620. Vitale's naturalistic style culminates around 1630 in the *Guardian Angel* (Cat. 162), but later, influenced by Domenichino and Van Dyck, became more academic.

P.G.

162

The Guardian Angel

340 × 210 cm
Monogrammed: FV
Pietà dei Turchini, Naples

The picture shows the rare subject of the Guardian Angel protecting a child (symbolizing the soul) from the temptations of the Devil and sin. The theme, which has a precedent in the older story of Tobias and the Angel, gained popularity at the end of the sixteenth and beginning of the seventeenth centuries, especially with the Oratorians and the Jesuits.

The subject was exceptionally popular in Naples from the beginning of the seventeenth century onwards, both with late mannerist artists such as G. B. Azzolino (at S. Maria degli Angeli, Pizzofalcone) and G. Balducci (at the Girolamini, Naples), and with Caravaggesque painters like Sellitto (the picture referred to in the *Lista delli quadri de bascio*) and Vaccaro (the work attributed to him at S. Pietro ad Aram). So there were a number of precedents to which Vitale could turn for inspiration.

This work, which is mentioned as being in the Church of the Pietà dei Turchini in old guidebooks, attributed either to Annella de Rosa (Chiarini, Galante) or to Giuseppe Marullo (De Dominici, D'Afflitto), has more recently come to be regarded as one of the most important pictures around which to reconstruct Filippo Vitale's work. Bologna (in Naples 1955) attributed it to the artist on the basis of the monogram revealed during restoration.

The picture probably dates from the beginning of the 1630s, the years of Vitale's maturity. Compared with earlier pictures like the *Liberation of St. Peter* at Nantes or the *St. Nicholas with S. Gennaro and S. Severo*, which are both more strictly Caravaggesque, the influence of Ribera's naturalism around 1616 is also evident. (cf. *Taste*, Cat. 119 and the Girolamini *Apostles*). But Vitale's assimilation of Ribera's style is contained within his own tenacious pursuit of concrete reality; light is

Simon Vouet

PARIS 1590–PARIS 1649

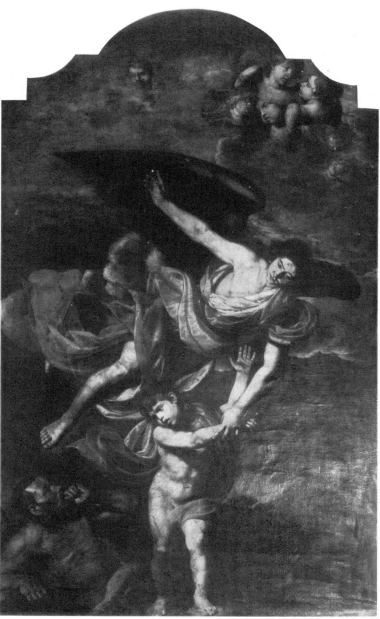

162

Simon Vouet was born in Paris and studied there under his father Laurent. Nothing remains of his early work. He may have started as a portrait painter; early commentators say that he went to London at an early age (*c.* 1605?), later to Constantinople (*c.* 1611–12) and then to Venice (1612–13). He probably arrived in Rome between 1613 and 1614, but he is first documented there in 1615; here he lived almost uninterruptedly till 1627, the year of his return to France. In 1620–21 he went to Genoa to work for the Doria family but by 1622 he was in Rome again. On his return journey he may have stayed in other towns: Milan, Piacenza, Parma, Bologna and Florence (in his letters he mentions his wish to see these places).

At Rome he emerged as the leader of the French colony; he was the head of the Academy of St. Luke from 1624, he won prestigious commissions in Rome and elsewhere and he had important protectors and admirers. His works were highly esteemed and included in the most notable collections of the day. He revisited Venice in 1627, before travelling to Paris, where he had been recalled by King Louis XIII.

Vouet's 15 years in Italy saw a rapid development in his art. Between 1614 and 1620 he moved away from the Caravaggism he had absorbed through Bartolomeo Manfredi and studied the work of Orazio Borgianni and Carlo Saraceni. After his period in Genoa he was influenced by both Orazio and Artemisia Gentileschi and by the Bolognese classicists, especially Lanfranco. Through Lanfranco's influence Vouet gradually reached a lighter, more decorative and baroque style which was to be fully developed in his French period.

There is no record of Vouet's presence in Naples and recent criticism has tended to reject the idea of such a visit. In fact the inscriptions on the two paintings made for Naples – the *Circumcision* (Cat. 164) and *St. Bruno Receiving the Rule* (Cat. 163) – record that he painted them in Rome. These works won great acclaim in Naples for their modernity and originality and had considerable influence on the local Caravaggisti. They not only contributed to a modification of tenebrism, but also prepared the ground for the acceptance of Artemisia Gentileschi's work and, later, the baroque style. The link between Vouet and Stanzione may have been formed when Stanzione collaborated in the decoration of the church of S. Lorenzo in Lucina during his second stay in Rome (Rome 1973–74). Prohaska has observed parallels between Vouet's work of 1622–25 and that of Battistello Caracciolo (Prohaska 1978).

employed to give relief and substance to the forms, rather than to fragment and dissipate them as it does in Ribera's work.

P.G.

EXHIBITIONS
Naples 1955, p. 64, no. 2

REFERENCES
Bolaffi 1972–76, XI, p. 352;
Bologna 1977–78 (in course of publication);
Causa in *Storia di Napoli* 1972, V, II, p. 992;
Chiarini 1856–60, (1970 ed.), p. 1468 (as Annella de Rosa);
D'Afflitto 1834, II, p. 9 (as Marullo);
Dalbono 1875, p. 270 (as Marullo);
De Dominici 1742–45, II, p. 107 (as Marrullo);
Galante 1872, p. 336; Pacelli 1978², p. 424;
Nicolson 1979, p. 108

Finoglia's work before 1630 may also have influenced Vouet.

Celano (1692) mentioned pictures by Vouet in contemporary Neapolitan collections: in that of the Prince Bisiginano of the Sanseverino family and in the collections of Alfonso Sancez and Cardinal Filomarino (cf. Dargent and Thuillier 1965). Cochin (1756) admired a series of 'Angels Bearing the Instruments of the Passion' in the Palace of Prince della Rocca. Crelly (1962) identified two of these angels as those now in Capodimonte; two others are at Minneapolis (Minneapolis 1970, nos. 87A and B).

F.F.

REFERENCES
Celano 1692 (1970 ed.), pp. 890, 1234;
Cochin 1756, I, p. 191;
Crelly 1962, pp. 184–85; Dargent and Thuiller 1965, p. 59;
Minneapolis 1970, p. 166;
Prohaska 1978, pp. 245–46, nos. 324, 325;
Rome 1973–74, pp. 200–01

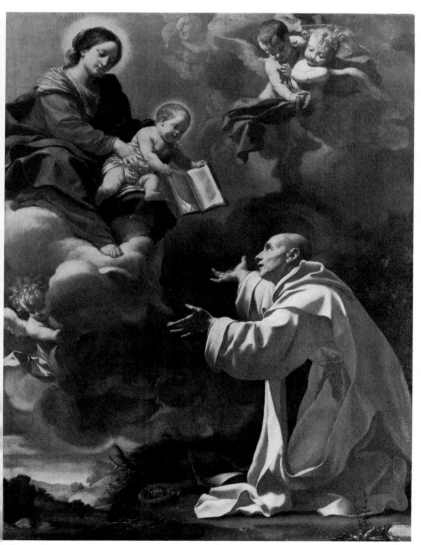

163

163

St. Bruno Receiving the Rule of the Carthusian Order

255 × 165 cm
Signed and dated: on a stone in the lower right corner
Simon Couet / Parisien pin . . . / Romae 162..
Chapter House, Certosa di S. Martino, Naples

St. Bruno of Cologne, founder of the Carthusian Order (d. 1101) is shown receiving the rule of the order from the Christ Child. The picture is recorded by Celano (1692); in the seventeenth and eighteenth centuries it was attributed to a Frenchman, *Monsù Monguet*, or *Monguer*, (Sarnelli 1697; Sigismondo 1788; D'Afflitto 1834), but by the nineteenth century was correctly given to Simon Vouet (Tafuri 1854; Chiarini 1856–60; Galante 1872).

The last digit of the date is practically illegible, but a number of scholars read it as 1620, at the end of Vouet's first stay in Rome. Alternatively, it could have been painted after his visit to Genoa in 1620–21 and others have suggested a date of 1623–27. But Demonts (1913) suggested that it was painted in Rome for Cardinal Barberini, later Pope Urban VIII, who revered his predecessor Urban II, the pupil and protector of St. Bruno, and consequently favoured the Certosa di S. Martino at Naples.

Although it still shows some reminiscences of Caravaggio and links with the Carracci and Guercino in its 'official and ceremonial character' (Crelly 1962), it is far removed from Vouet's early works inspired by Manfredi. Briganti (1962) believed this change took place between 1610–20 and that it was due to the influence of Lanfranco's *Vision of St. Theresa* of 1613 (Capolecase) with its revolutionary diagonal composition. Reni's frescoes in the Cappella Paolina, S. Maria Maggiore and Lanfranco's *Virgin Appearing to S. Lorenzo* of 1617 (Palazzo del Quirinale) also contributed to Vouet's development of a fully baroque, anti-classical style.

Blunt (1953) relates the *St. Bruno* to the picture commissioned in 1624 for St. Peter's, Rome (the *bozzetto* and some fragments survive) and discerns early signs of Vouet's baroque manner, still tempered by Bolognese classicism, a view accepted by most recent critics. So the work can probably be dated between 1624 and 1626; it could have been commissioned at this time when Finoglia and Caracciolo were all working in the Certosa di San Martino, decorating the Chapter House.

A copy of this picture, formerly in the Incoronata, Naples (now reserve coll., Capodimonte, inv. I C 1373), appears after 1821 in the inventories of the Museo Borbonico in the Palazzo Reale of Naples with the improbable attribution to Paolo Finoglia (De Rinaldis 1911).

F.F.

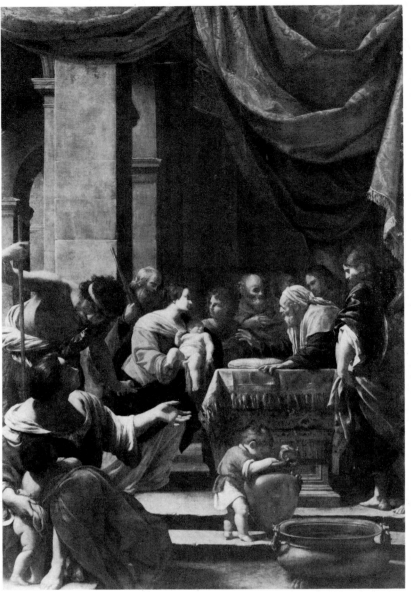

164

EXHIBITIONS
Naples 1963, no. 73; Naples 1967, no. 14

REFERENCES
Blunt 1953 (1970 ed.), pp. 147–49;
Celano 1692 ed. Chiarini (1970 ed.), p. 1605;
Crelly 1962, p. 27, no. 78; D'Afflitto 1834, II, p. 84;
Demonts 1913, pp. 310–11;
Sarnelli 1685; Sigismondo 1788–89, I, p. 279

164

The Circumcision

293 × 193.5 cm
Signed and dated: on the altar base SIMON VOUET
PARISIEN / F. ROMAE MDCXXII
Capodimonte, Naples

This picture was first noted by Catalani (1845)
who suggested it was by Procaccini, an
attribution accepted by Galante (1872). Ortolani

(Naples 1938) pointed out Vouet's signature and
the date, which he read as 1626. Like the *St.
Bruno Receiving the Rule of the Carthusian
Order* (Cat. 163), the picture was painted in
Rome and sent to Naples. They are both
important, not only within the context of
Vouet's career, but also for their influence on
Neapolitan painting of the second quarter of the
seventeenth century.

In neither painting is the date clearly legible:
that of *The Circumcision* has been read as 1622
or 1623, that of *St. Bruno* between 1620 and
1626. *The Circumcision* dates from after Vouet's
stay in Genoa 1620–21 and fits stylistically
between the *Crucifixion* in S. Ambrogio, Genoa
(probably 1621), the *Birth of the Virgin* in S.
Francesco a Ripa (Vouet's first Roman public
commission, perhaps before 1622) and the cycle
in the Cappella Alaleoni in S. Lorenzo in Lucina,
Rome (documented as 1623–24). The
Circumcision is close to another group of works,
in particular to the *St. Sebastian Tended by St.
Irene* (Condorelli Coll., Rome) and the
Sophonisba (Kassel, Schleier 1971).

In this painting Vouet has abandoned his
early Caravaggism, already modified in his
Roman pictures, and taken his inspiration from
Lanfranco and both Orazio and Artemisia
Gentileschi, whom he had met in Genoa.
Schleier (1967, 1971; Rome 1973–74) notes that
in the 1620s Vouet echoes Lanfranco's elegant,
classicizing style of 1615–20, not his baroque of
the 1620s. The *Circumcision* preludes Vouet's
baroque phase: the colours are light and
luminous, the composition open and theatrical,
the sacred event is rendered with a new narrative
verve, and the figures are more ample (Prohaska
1978).

The painting was studied in Naples by those
artists who, like Vouet, 'were modifying the first
frenzy of their Caravaggism' (Longhi 1935) and
perhaps contributed to Artemisia Gentileschi's
success in Naples where she was working from
1630–48; she did much to popularize Vouet's
style.

The *Circumcision* is often related to a
painting of the same subject by Paolo Finoglia
(1626) in the Certosa di S. Martino, Naples
(Demonts 1913; Novelli 1974).

F.F.

PROVENANCE
Church of Sant'Arcangelo a Segno, Naples, deposited
Capodimonte 1977

EXHIBITIONS
Naples 1938; Naples 1954, no. 8; Naples 1963, no. 74;
Naples 1967, no. 15

REFERENCES
Catalani 1845–53, I, p. 120; Crelly 1962, pp. 36, 184, no. 79;
Dargent and Thuillier 1965, pp. 29–30, 42–44;
Demonts 1913, pp. 309–46; Galante 1872, p. 169;
Longhi 1935; Novelli 1974, p. 79, no. 8;
Prohaska 1978, p. 246, n. 324;
Schleier 1971, pp. 65–69

Other Painters in Naples in the Seicento

Bartolomeo Bassante or Passante

BRINDISI 1618–NAPLES 1656

Bassante came to Naples at an early age in about 1628; in 1636 he married Angela Formichella, the niece of Pietro Beato, with whom he was living.

His best-known picture, signed *Bartolomeo Bassante*, is the *Adoration of the Shepherds* (Prado) which is close in style to Cavallino. Other signed or monogrammed pictures include the *Mystic Marriage of St. Catherine* (private coll., Naples), *S. Onofrio* (Pinacoteca d'Errico, Matera), which is a copy of a Ribera signed and dated 1637 (Hermitage, Leningrad), and an *Adoration of the Magi* (University of Santa Barbara, Cal.) which bears the monogram '*B*' and is perhaps a very late work. The *Holy Family* (Causa Coll., Naples) and the *St. Sebastian Tended by the Holy Women* (University of California) both contain a female figure repeated from the *Mystic Marriage of St. Catherine*; they are probably all close in date. The *St. Catherine of Alexandria* (Einaudi Coll., Turin) is attributed to him. Bologna also attributed to him the *Triumph of David* (Diodati Coll., Naples), *Lot and his Daughters* Briganti Coll., Rome) and the *Sacrifice of Abraham* (Kress Coll., Houston Museum), but these two paintings are now more convincingly given to De Bellis (De Vito 1982).

Bassante probably trained around 1635–40, presumably with the painter Pietro Beato, and was in close contact with De Bellis, Stanzione and Cavallino. The reconstruction of Bassante's artistic personality has always presented difficulties. In 1935 Longhi attributed to him the group of pictures of outstanding quality that are now given to the anonymous Master of the Annunciations to the Shepherds. The attribution was, however, later rejected by Bologna (1958) and Causa (1972).

The confusion is probably in part due to De Dominici's description of the artist; he said he died young of the plague in 1656 and that he was a faithful pupil of Ribera's, often making copies for him, particularly of paintings to be sent abroad. 'He is so close to Ribera's work, that one has to know their styles very well to distinguish them; for in composition, and in the movement of the figures, he is very similar to the Master himself, as also in the marvellous impasto. . .'. This characterization seems to correspond better to the work of the Master of the Annunciations to the Shepherds. The only work of Bassante's specifically mentioned by De Dominici was the *Birth of Christ* in S. Giacomo degli Spagnoli, which has disappeared.

A.S.

Giovanni Battista Beinaschi

FOSSANO 1636–NAPLES 1688

Beinaschi was born in Piedmont and trained in Rome, where he probably arrived between 1650 and 1655. While De Dominici (1742–45) stated that he was the pupil of Lanfranco – an impossibility since he died in 1647 – Pascoli (1730) suggested that Pietro dal Pò was his master. Pietro had been Lanfranco's chief assistant in 1644–46 when he was working in the church of SS Apostoli in Naples and had followed Lanfranco to Rome in 1647. De Dominici says that Beinaschi also studied Correggio in Parma.

In 1664 he went to Naples; at this date the most important patrons were the religious confraternities rather than the court or the nobility. The frescoes of the *Stories of S. Nicola* in S. Nicola alla Dogana (now demolished) dated from 1664; some pen drawings for these are known (Louvre; Graphische Sammlung, Munich; Albertina, Vienna). These are the earliest of Beinaschi's many drawings, which were mistaken for the work of Lanfranco at an early date (De Dominici 1742–45). As a draughtsman he is 'full of fire and vivacity' (Vitzthum 1961); his style is characterized by a flowing outline and broad shading with long, widely-spaced pencil strokes, fully baroque in manner.

Around 1670, he frescoed the vault of the church of S. Maria degli Angeli at Pizzofalcone with *Stories of the Virgin* for the Theatine Fathers. Here there are quotations from Lanfranco, but the main source of inspiration is Correggio, purified of any profane or sensual connotation. At the end of his first stay in Naples he frescoed some of the chapels in S. Maria la Nova.

From 1676–79 he was in Rome, where he is documented working under the direction of Brandi on the allegorical frescoes in the chapel of St. Barnabas in S. Carlo al Corso.

Beinaschi returned to Naples at the end of 1679 and, together with his pupil Orazio Frezza, began his most famous work in 1680: the cupola of SS Apostoli, the laboured execution of which is fully documented (Prota Giurleo 1957; Strazzullo 1959). The overwhelming influence of Lanfranco is apparent in the fresco of *Paradise* (a subject that Lanfranco had painted twice; Bologna 1958). In fact Luca Giordano was also deeply influenced by Lanfranco, so Beinaschi's taste should not be judged to be reactionary (Ferrari 1970).

Afterwards Beinaschi adopted warmer colours and a softer manner. His last works were painted for the Oratory of St. Philip Neri, for the church of the Gesù Nuovo and for the complex of S. Maria delle Grazie at Caponapoli. He died on 28 September 1688 and was buried in S. Maria delle Grazie, where the friars erected a tablet in his memory.

A.A.

REFERENCES
De Dominici 1742–45, III, p. 277:;
Ferrari in *Storia di Napoli*, VI, II, pp. 1, 223–345;
Minicuci in Bolaffi, I, 1972, pp. 442–45;
Pascoli 1730, II, pp. 223–34;
Bean and Vitzthum 1961, pp. 106–22

Agostino Beltrano

NAPLES 1607–NAPLES 1656 OR 1665

Beltrano was regarded by De Dominici (1742–45) as one of Stanzione's most gifted pupils. For long critics have repeated the calumny that he was guilty of murdering his wife. During the 1630s he married the painter Annella de Rosa, and by complicated family connections was related to Andrea Vaccaro, Pacecco de Rosa, Filippo Vitale, and Aniello Falcone. But the most pronounced influence on his style is that of Stanzione. He was particularly successful with female figures, especially Madonnas, and liked to include garlands of flowers in his works, inserting them, for instance, in *St. Jerome* and *S. Nicola da Tolentino* in S. Agostino degli Scalzi and in the *S. Gaetano* in SS Apostoli.

Recently the *Martyrdom of SS Procolo and Gennaro* in the Cathedral at Pozzuoli, where Beltrano's *Miracle of S. Alessandro*, *Last Supper* and *St. Martin and the Beggar* were prior to their destruction in 1963, has been attributed to him. The painting was previously attributed to the German painter Schönfeld (Naples 1938; Bologna 1958) who was also influenced by Stanzione. The landscape backgrounds of *Lot and his Daughters* (private coll., Naples), *Jacob*

and Rachel at the Well (Musée de Besançon) and the *Sacrifice of Isaac* (Residenzgalerie, Salzburg), have been associated with those of Poussin (Novelli 1974). The equestrian portrait of *Leonardo di Tocco*, in the Pio Monte della Misericordia, is an unusual work of Beltrano's, painted in a Hispano-Flemish court portrait style (Causa 1970).

M.M.

REFERENCES
Bologna 1958, p. 33; Causa 1970, p. 89;
De Dominici 1742–45, III, pp. 111–12;
Naples 1938, p. 81; Novelli 1974, pp. 67–82

Paul Brill

ANTWERP 1554–ROME 1626

Paul Brill joined his brother Matthew, who was already an established landscape painter, in Rome during the papacy of Gregory XII (1572–85). He worked first in a Flemish manner, characterized by strong colour contrasts and small scale, and was gradually won over to the new Carracesque landscape style.

He is first recorded as a member of the Accademia di San Luca in 1582 (Hoogewerff 1913) and remained in Italy for the rest of his life. That he was active in Naples, as stated by Galante (1872), is now generally accepted; a drawing of Garigliano may be regarded as almost documentary proof that the artist travelled to the south of Italy (Bodart 1970).

Works attributed to Paul Brill include a cycle of frescoes in the portico of the church of the convent of Regina Celi (a series of landscapes, and a *Madonna della Misericordia*) and a painting of the *Stigmatization of St. Francis* inside the same church. He left a host of easel paintings in Naples; in addition an extensive series of fresco decorations, hitherto overlooked, can also be attributed to him. These are the landscapes and grotesques in the cloister of the Ospedale degli Incurabili; they are by various artists, but one of the two principal hands is undoubtedly that of Paul Brill.

These frescoes, still imbued with mannerist sentiment, seem to follow on from his Roman frescoes for the Scala Santa (1589) and in S. Cecilia in Trastevere (1599); they can be dated around 1602 (Causa 1957), probably slightly before the *Martyrdom of St. Clement* in the Vatican. Both the landscapes and the grotesques had a great impact in Naples, and many imitations exist.

M.R.N.

REFERENCES
Bodart 1970, II, p. 221; Causa 1957, p. 51;
Galante 1872, p. 90; Hoogewerff 1913, II, p. 88

Giovanni Benedetto Castiglione

GENOA 1609–MANTUA 1710

After an early apprenticeship to G. B. Paggi, Giovanni Benedetto Castiglione, called Grechetto, completed his training at Genoa with Sinibaldo Scorza, who worked there at the end of his life between 1627 and 1631.

Already Castiglione showed a interest in painting animals and still lifes, continuing the Genoese tradition that had been started by Bassano and reinforced by the group of Flemish artists headed by the brothers de Wael and by Jan Roos (Algeri 1979). Castiglione is documented as being in Rome from 1632–34, when he was registered in the rolls of the parish of S. Andrea delle Fratte (Percy 1967) and was a member of the Accademia di San Luca (Piacentini 1939). At this time Castiglione, still under the influence of Rubens and Van Dyck, whose work he had seen in Genoa, came into contact with the artistic milieu of Rome, at that time split between the baroque style of Bernini and Pietro da Cortona, and the classicism of Poussin. Together with Claude Lorrain, Poussin established the fashion for classical landscape painting which was partially adopted by Castiglione and translated by him into a more realistic form, closer to the work of Peter van Laer and the *Bamboccianti* (Costa Calcagno 1971).

Castiglione became indirectly involved in a trial arising from a brawl between some painters in Rome. The testimony of the Genoese Greppi shows that on 20 February 1635 Castiglione was no longer in Rome, but living at Naples, as a result of which he was acquitted of any blame (Bertolotti 1884; Meroni 1978). This contemporary evidence, supported by the early biographers (Soprani 1674; Baldinucci 1681; Soprani Ratti 1768), is proof of Castiglione's presence in Naples, although the length of his stay is unknown.

Castiglione's influence on Neapolitan painters, especially on such *petits maîtres* as Andrea di Lione, Niccolò di Simone and Aniello Falcone, makes it likely that originally many works of his existed in Naples (Blunt 1939–40; Percy 1967). Amongst the pictures still there is a *Jacob and Rebecca* (Museo di S. Martino) of which there is a copy in the Corsini Gallery, Rome (Bologna 1958; Delogu 1928). It originally came from the collection of the Real Museo Borbonico, although it is impossible to say how it reached Naples (Scavizzi 1970). The same applies to the *Woman with Child and Still Life* (Naples University; De Rinaldis 1911), which was already attributed to Castiglione in nineteenth-century inventories. Details such as the dish of fruit, the damask cloth and the delicate colouring of flowers derive from Flemish models, and Castiglione may have indirectly contributed to the Neapolitan still-life tradition (Genoa 1969).

Two other paintings by Castiglione have been in Naples for an indeterminate length of time: *Orpheus among the Animals* and the *Exodus of the Israelites from Egypt* (Bologna 1958). In these the painter dwells on the minute depiction of animals, metal objects and the landscape, which influenced Neapolitan painters like Aniello Falcone and in particular his pupil Andrea di Lione. The *Annunciation to the Shepherds* (Birmingham City Art Gallery) must be of around the same date; it is close to the two last pictures in the airy presentation of the scene and in the lively nature of the composition (Costa Calcagno 1971).

It is still uncertain which of these works Castiglione painted in Naples, what contacts he may have had with Genoese patrons in the city (the most prominent being Marcantonio Doria; Bologna 1980) and which drawings belong to this phase of his career (Newcombe 1981). Later, Castiglione worked in Genoa, Rome, Venice and Mantua, where he died in 1633 (Hess 1934); certainly before 1635, the date on his tomb in Mantua Cathedral.

G.C.A.

REFERENCES
Algeri in Dizionario Biografico 1979; Bertolotti 1884; Blunt 1939–40, pp. 142–47; Blunt 1954; Bologna 1958; Costa Calcagno in Genoa 1971; Delogu 1928; Genoa 1969; Hess 1934; Meroni 1978; Pacelli and Bologna 1980, pp. 24–44; Percy 1967, pp. 672–77; Piacentini 1939, p. 160;

Scipione Compagni

NAPLES *c.* 1610–NAPLES 1650(?)

The reconstruction of Scipione Compagni's career is based almost exclusively on De Dominici (1742), who says he was a pupil of Falcone and friend of Rosa, who accompanied him on a trip to Rome. When Rosa left for Florence, Compagni returned to Naples where he became a painter of land and seascapes 'with figures very different from Rosa', as his biographer says, continuing, 'he has painted much from nature, depicting beautiful and strange trees'. This information allows us to surmise that he was born *c.* 1610–15 which is confirmed by documented payments for work in 1641 (D'Addosio 1913) and by a signed and dated painting of 1642 (Corsini Gallery, Rome).

There are two signed paintings in the Kunsthistorisches Museum, Vienna; the *Martyrdom*

of *S. Gennaro* and the *Eruption of Vesuvius in 1631*. These works have an anecdotal quality deriving from Filippo Napoletano, whose works Compagni probably saw in Rome and Naples, and they share characteristics with the Master of the Martyrdoms. Unfortunately many of the works that were sent to Spain, listed in old inventories, are not identifiable (Pérez Sánchez 1965). Despite this scant information, it has been suggested that Compagni can be identified as the author of the pictures initially attributed to Filippo Napoletano (Salerno 1970). But these paintings can be dated to the first decade of the century and Compagni's probable date of birth would exclude his authorship (Longhi 1957).

M.R.N.

REFERENCES
D'Addosio 1913, p. 46; De Dominici 1742, III, pp. 252–53; Longhi 1957², pp. 33–62; Perez Sanchez 1965, pp. 384–6; Salerno 1970, p. 139

Carlo Coppola

ACTIVE IN NAPLES 1640–1660

According to De Dominici, Coppola was one of the many disciples of Aniello Falcone. A number of his battle scenes show that he was quite close to Falcone in his use of warm, dark tones and closely-packed groups of figures, to the extent that many of his pictures may now pass under an attribution to Falcone. Our scant knowledge of Coppola is illustrated by the confusion that still exists between his work and that of the Apulian painter Giovanni Andrea Coppola (Ortolani 1938) who belongs to the Romano Emilian school (Uffizi 1979).

According to De Dominici, Coppola studied with Micco Spadaro and certainly he imitated his work; he shares his interest in illustrating scenes from everyday life, but emphasizes the architecture and landscape views (Causa 1972). Two of his pictures at the Museo di S. Martino, *The Surrender of Naples to Don John of Austria in 1648* (inv. no. 14566) and *Piazza del Mercato at the time of the Plague in 1656* (inv. no. 34061), show his interest in architectural perspective. The distinct shadows and dark ground seem to echo Falcone, while the sketchiness of the tiny figures and the touches of red and yellow recall similar features in Micco Spadaro's work, although with less fluency and luminosity.

Coppola is also referred to in the earlier sources as a landscape painter (Ceci 1899) and the canvas of *Joseph and his Brothers* (Museo Diocesano, Salerno), which is signed with a monogram of linked Cs, is an exercise in this genre. It echoes both Spadaro and the kind of pastoral subject that became popular in Naples after the arrival of Castiglione (about 1635).

Three still lifes have recently been attributed to Coppola (Bologna 1968); the *Vegetables and Flowers* (Capodimonte, inv. I.C. 635) previously attributed to G. B. Ruoppolo, *Fruit and Vegetables* (private collection) and *Fruit and Flowers* (Coppola Coll., Alezio, Lecce). This latter attribution has been rejected by Causa on the grounds of a different reading of the monogram it bears (G.C. instead of G.C.) and also on stylistic grounds.

I.C.

REFERENCES
Bologna in Bergamo 1968;
Causa in *Storia di Napoli* 1972, V, II, pp. 1116–43;
Ceci 1899 p. 165;
De Dominici 1742–45, III, p. 8;
Ortolani in Naples 1938, p. 322

Paolo De Matteis

PIANO DEL CILENTO 1662–NAPLES 1728

De Matteis came to Naples at an early age and was influenced by Giordano; his style was formed by a visit to Rome at the end of the 1670s. There he was protected by the Marchese de Carpio, Spanish ambassador to Rome, who introduced him to the city's artistic circles, dominated at that time by Carlo Maratta and Luigi Garzi, Director of the Accademia di San Luca. De Matteis was an assiduous attendant of sessions at the Accademia, where the rivalry between the classicists and the adherents of the Baroque was raging; he modelled himself on Maratta who synthesized the two styles. This synthesis is apparent in De Matteis' first known work, an *Allegory of the Arts* from the 1680s (Getty Coll., Malibu).

When he returned to Naples, probably with the Marchese del Carpio who became viceroy in January 1683, De Matteis adopted Giordano's classical style. This can be seen in the altarpiece of *S. Nicola* of 1695 (Duomo Naples) and in his various pictorial cycles (the frescoes in the Theatine church of S. Maria degli Angeli, Pizzofalcone and in the Jesuit church of S. Ferdinando; the pictures sent to Spain for the Jesuit college of Madrid and to the church of the Clarissan nuns of Cocentaina). His work in the 1690s is of particular interest in its mixture of elements derived from Maratta with others taken from Giordano. At this date, he was an important influence for Solimena. With the decoration of the vault of the pharmacy of S. Martino in 1699, which echoed Garzi's fresco in S. Caterina a Formiello of 1695–97, De Matteis moved towards a style of Arcadian rococo.

His modernity earned him an invitation to Paris from the Comte d'Estrées, where he stayed from 1702–05, painting for the court and the

upper bourgeoisie, although no works from this period are known.

Returning to Naples, he obtained prestigious commissions from such patrons as Comte Daun, Lord Shaftesbury and Eugenio di Savoia, and continued to decorate Neapolitan palaces and churches, alternating between the rococo manner and a more elaborate style which grew increasingly academic.

I.M.

Giacomo Farelli

ROME 1624–NAPLES 1706

Born at Rome in 1624, Farelli initially studied the classics and literature. His interest in painting dates from after his move to Naples, when he entered the workshop of Andrea Vaccaro. From his first works, such as the *St. Anthony of Padua* in the Trinità dei Pellegrini, the *Resurrection* in the parish church of Secondigliano and the *S. Brigida* in the church of that name in Naples, Farelli showed himself to be responsive to the influences of Vaccaro, Cesare Fracanzano and Francesco di Maria, 'because of their common desire to bring down Luca Giordano' (De Dominici 1742–45).

But the style fostered by Giordano soon influenced Farelli too, and he began to make his pictures more precious, giving 'nobility to his new manner, using sweet colours, full of softness' (De Dominici). In the paintings in S. Maria Maggiore, Farelli seems to oscillate between the old masters and Giordano's new style, and in the painting for S. Maria delle Anime del Purgatorio he reveals clear affinities with Giordano (Gallichi Schwenn 1961). Similar characteristics recur in the canvases painted later for S. Maria Egiziaca and S. Giuseppe dei Ruffo. In its best moments his work attains a happy equilibrium between mannerist compositions and a modern pictorial style. While Francesco Di Maria either rejected the novelties of Preti and Giordano, or tried to interpret them in traditional forms, Giacomo Farelli aimed at a compromise between old and new.

His fame spread beyond the confines of Naples and between 1661 and 1663 he won commissions first in the Abruzzi (S. Giovanni Evangelista a Sulmona, S. Filippo at L'Aquila and the Palazzo of the Duchi di Atri; Bologna 1958) and then at Pisa, from the Grand Duke Ferdinand II. On his return from Pisa in 1664, Farelli frescoed the vault of the chapel of the Madonna in the sacristy of the Cappella del Tesoro in Naples Cathedral, and in 1667 he worked on the paintings for the large chapel dedicated to St. Anne in the Pietà dei Turchini,

for which 'he won praise not only from all our painters, but even from Luca Giordano himself and Francesco Solimena' (De Dominici).

Farelli's powers of invention gradually diminished, so much so that in 1671 he copied the figures of those struck down by plague in the SS Apostoli frescoes from the cartoon that he had used for the dead Turkish warriors in the *Sardinian Campaign* at Pisa, while the putti seem to derive from the drawings for the pictures at the Pietà dei Turchini (Ferrari 1970). The lively picture with the *Redemption of Slaves* (1672) in the church of the Redenzione dei Cattivi, and the two powerful paintings in the choir of S. Giuseppe a Chiaia, on either side of one by Di Maria, belong to the same date.

Farelli died on 26 June, 1706, aged 82, and was buried in the Real Congregazione of the Madonna dei Sette Dolori.

G.C.A.

Domenico Fiasella

SARZANA 1589–GENOA 1669

Born at Sarzana on 12 August 1589 (Soprani 1674; Sforza 1874), Domenico Fiasella was encouraged to paint by his father Giovanni Francesco, a goldsmith and silversmith, and only later (c. 1600) moved to Genoa, where he studied with Lomi and Paggi. During his stay in Rome (from 1607) he met Tuscan painters active there, such as the Sienese painters Gramatica and Manetti, Cavarozzi from Viterbo and the Pisan Gentileschi, who served as his models after his return to Sarzana (1616) and during his later years in Genoa (from 1617). Longhi (1943) attributed a *Baptism of Christ* for the church of S. Giorgio dei Genovesi to the youthful Fiasella in his Roman period, and Bologna (1980) dates the *S. Ivo receiving Supplications* in SS Apostoli, Naples, to the same period.

Although there is no proof of Fiasella's presence in Naples, the small group of intensely Caravaggesque paintings attributed to him and the fact that the Genoese patron Marcantonio Doria (d. 1651) was also in the city, makes it probable that Fiasella had close links with Caravaggio's Neapolitan followers. In this connection, Bologna compares the intense naturalism of the supplicants in *S. Ivo* with similar figures in the works of Carlo Sellitto and his follower Filippo Vitale. Bologna proposed a date of around 1615 for *S. Ivo* and suggested that the painter was Genoese, not far from Fiasella himself. *St. Cyril of Alexandria*, also in the same church and attributed in the sources to Carlo Rosa, is now generally recognized as the work of Fiasella and dated c. 1620, in the period when he had links with the Doria family of Genoa.

In the church of S. Giorgio dei Genovesi in Naples there are two works attributed to Fiasella, the *Madonna in Glory* including a bird's eye view of Genoa, and a *Crucifixion* (Causa 1954) of the same date as the *Martyrdom of St. Ursula* in S. Anna, Genoa (after 1623; Bologna 1980).

G.C.A.

REFERENCES
Causa in Naples 1954; Longhi 1943[1], pp. 53–54; Pacelli and Bologna 1980, pp. 24–44; Sforza 1874; Soprani 1674

Louis Finson

BRUGES *c.* 1580–AMSTERDAM 1617

Louis Finson, a pupil of his father Jacques, who was a painter-decorator in Bruges, was one of Caravaggio's earliest imitators and particularly copied his Neapolitan works (Causa 1972). He is documented in Naples in 1612, but was already there between 1605 and 1613 (Bodart 1970). At this time he saw the work of Caravaggio at first hand and made contact with painters like Abraham Vinck (in Naples 1600–1606, later his executor) and Martin Faber (in Naples 1611–14, later Finson's companion in Provence).

Two Annunciations by Finson are dated; one is signed and dated 1612, and came from the suppressed Dominican monastery of S. Tommaso d'Aquino; the second, now in the Aubanel collection at Avignon, is inscribed 'LUDOVICUS / FINSONIUS FECIT IN NEAPOLI / AN. 1. 6. 12. Painted in Naples it was exported, perhaps by Finson himself. His Annunciations were popular in Provence; on 3 August 1613 he was commissioned to provide '*une annonciade pour la chapelle de la chambre*' for the Parlement d'Aix (Isarlo 1941).

The Capodimonte *Annunciation* fuses various Caravaggesque elements with sixteenth-century mannerist traits: the angels are reminiscent of parts of *The Seven Acts of Mercy* (Scavizzi in Naples 1963). The *Resurrection* in the church of S. Jean de Malte at Aix-en-Provence, dated 1610, is also inspired by Caravaggio, perhaps by his lost work in S. Anna dei Lombardi, Naples (Naples 1951). The *Resurrection* could have been painted in Naples and then exported to Provence, where the coat-of-arms of the Gaillard family was added (Bodart 1970).

Spear (Cleveland 1971) relates a half-length of *S. Gennaro* (Morton B. Harris Coll., New York), datable 1612, to his Neapolitan works. This has stylistic affinities with two versions of the *Magdalen*, probably copies after Caravaggio (Musée des Beaux-Arts, Marseille; private coll., St. Rémy de Provence), and with the *Portrait of a Man* (Accademia di S. Luca, Rome; dated 1613). This group of works was probably also painted in Naples. Finson later worked at Arles and Marseille; around 1616 he established himself in Amsterdam where he died in 1617. From his will, drawn up on 19 September 1617, we know that in partnership with the Hamburg painter Abraham Vinck he owned two paintings by Caravaggio, the *Madonna of the Rosary* (Vienna, Kunsthistorisches Museum) and a *Judith with the Head of Holofernes* (perhaps a lost original painted by Caravaggio in Naples). After Finson's death this passed to Vinck (Bredius 1902, 1918).

G.C.A.

REFERENCES
Bredius 1902, p. 34; Bredius 1918, p. 177; Bodart 1970, pp. 10–16, 73; Causa in *Storia di Napoli* 1972, V, II, p. 964; Cleveland 1971, p. 93; Aix-en-Provence 1941, pp. 126–27; Scavizzi in Naples 1963, pp. 32–33

Cesare Fracanzano

BISCEGLIE *c.* 1605–BARLETTA 1651

The elder brother of the more gifted Francesco, Cesare Fracanzano was apprenticed to his father Alessandro in Apulia and was active in Naples for most of his career. His earliest work echoes the mannerist art of Santafede, Imparato and Borghese (D'Elia 1964). In 1622 he went with his brother to Naples, where, as De Dominici recounts, they worked in the workshop of Ribera. Of his early works, the *St. John the Baptist* at Capodimonte shows Ribera's influence in its dense, mellow colouring reduced to a limited chromatic scale. But Ribera's influence was superficial, as was that of the newly introduced styles of Rome and Venice. Causa (1972) labelled Cesare a 'mediocre artist', still tied to mannerism and academic by inclination.

His works are poorly documented: there are few signed pictures (among them are the *Two Wrestlers* in the Prado, the *Miracle of the Blind Man* and the *Pietà* now at Casamocciola). Bologna has attributed to Cesare other works which he believes were painted in Naples and D'Elia has added others that were painted in Apulia. Despite the attempt of these two scholars, and of Ortolani before them, to reconstruct his development, there remain considerable problems of attribution. Bologna ascribes to Cesare a series of paintings: the *Trinity with SS John the Baptist and John the Evangelist* in the Cathedral of Castellammare, the *Archangel Michael* at S. Martino (dated by Causa to before 1631) and the *Christ at the Column Comforted by Angels* in the Pinacoteca

of the Girolamini, Naples, emphasizing the impact of Van Dyck who visited the town in 1635. In these works, the light and colour is more diffused and brilliant, the tone warm and golden. Documentary evidence shows that Cesare was at Barletta between 1633 and 1635, which dates these pictures after 1639, when Cesare returned to Naples. The frescoes in the nuns' choir at S. Maria della Sapienza, datable to around 1640, show the impact of Lanfranco. *St. Francis Xavier* in the Gesù Vecchio, referred to by most of the old guide-books, dates from 1641 (Strazzullo 1955). Amongst his last works is the *Annunciation to the Shepherds* from the cathedral at Pozzuoli, now in the Museo di S. Martino, and the frescoes in the church of SS Cosmas and Damian at Conversano, datable to *c.* 1650, which show marked affinities with those in the church of the Sapienza.

A.S.

REFERENCES
Bologna 1955, pp. 66–68;
Causa in *Storia di Napoli* 1972, V, II, pp. 949–50;
D'Elia in Bari 1964, pp. 159–161;
Ortolani in Naples 1938, pp. 67–69

Francesco Di Maria

NAPLES 1623–NAPLES 1690

Di Maria was probably born before 1623, the date given by De Dominici, and was trained by his father (Ceci 1899). An eclectic, his early style was based on Santafede's mannerism and Caracciolo's Caraccesque phase. Later he became a follower of Domenichino and visited Rome where he came into contact with Pietro dal Pò, Andrea Sacchi, Poussin and Salvator Rosa. He also studied the old masters. He was influenced by Mellin (in Naples 1643–47) and by Vouet whose work he could see in Cardinal Filomarino's collection. Sometimes his art approached the work of Mattia Preti in its dark tones while in other pictures he looked to Raphael for inspiration; elsewhere he mixed late mannerist elements with more contemporary traits, echoing Lanfranco and Rosa. Finally, he sometimes worked in the style of other masters, as is the case of the altarpiece of *S. Gregorio Armeno* in the church of the same name in Naples, which was long thought to be by Francesco Fracanzano and was reattributed to Di Maria by Longhi (1969).

Amongst his pupils were such painters as Francesco Solimena and Giacomo dal Pò, although they did not stay for long. He was a prolific draughtsman and his portraits sometimes rival those of Giordano.

Amongst his early works are a *St. Anne* in the Girolamini and a *Pietà* in S. Agostino degli

Scalzi. The *Visitation* and the *Rest on the Flight* for S. Maria La Nova are *c.* 1647. The *Calvary* and the *Ecstasy of St. Teresa of Avila* in the church of S. Giuseppe at Pontecorvo (both signed) date from 1660–64, and were followed by *SS Peter and Paul* (*c.* 1667) in the church of Monteverginelle. Then came the *S. Gregorio Armeno* already referred to; De Dominici believed it to be contemporary with the signed frescoes of *Stories of the Life of St. Gregory* in the same church. In 1668 he painted *Carlo II Adoring Christ at the Elevation of the Sacrament* which is now lost (Cronistoria, f. 133). A signed *Apotheosis of St. Anne* was painted around 1673 for S. Giuseppe a Chiaia, together with a *Holy Family* now on the high altar. The *Holy Family with St. Francis* in the Capuchin monastery at Nola is almost contemporary. The signed *Madonna with Dominican Saints* in the Dominican church at Dubrovnik dates from a year or two earlier; it was published by Prijatelj (1975) with another picture also attributed to Di Maria, which is a school work. Probably early in 1680 he was commissioned to fresco S. Luigi di Palazzo (lost); some of the work was given to Farelli and finished by Di Maria in 1688. Between 1680 and 1685 he painted a *Fall of the Giants*, an *Argus and Io* and another unidentified subject for Lord Exeter (D'Addosio 1913). These paintings are apparently no longer at Burghley House; some unpublished documents suggest that there is a large group of Di Maria's paintings in Great Britain that have yet to be identified.

In 1688 Di Maria was commissioned to paint four large paintings for the church of S. Anna dei Lombardi of the *Life of the Blessed Bernardo Tolomei*, only two of which were painted (Celano 1694). Another signed painting of the same subject is at Monteoliveto Maggiore, Siena (Brogi 1897). An inventory of 1706 of the property of the Carafa di Belvedere (Archivio di Stato, Naples, Fondo Notai) attributed several paintings to Di Maria; an *Allegory of Faith* (3 × 4 *palmi*), a *Battle of Hercules with the Amazons* (8 × 11 *palmi*) and a *Seneca Cutting his Veins* (5 × 7 *palmi*). The latter is a subject also recorded by De Dominici, and the Valletta family owned a *bozzetto* of the scene. His biographer mentions portraits which have been lost, as are the paintings that Lanzi saw sold 'at a high price and well-thought of by experts' as the work of Domenichino. The frescoes on the staircase and *piano nobile* of Palazzo Maddaloni no longer exist, nor those in the *scodella* of the Sedile di Nilo (De Dominici).

C.F.

REFERENCES
Brogi 1897; Ceci 1899, p. 164; Celano 1692, p. 185;
D'Addosio 1913, pp. 251–52;
De Dominici 1742–45, III, pp. 302–07;
Longhi 1969, p. 49

Niccolò De Simone

There is no record of the birth or death of this painter. According to De Dominici he made long trips to Spain and Portugal in his youth. He is first documented in Naples in 1636 (payment for a lost picture), but it is not clear whether he stayed there continuously until 1655, when he signed the altarpiece for the church of S. Maria Antesecula (destroyed in the last war; cf. Naples 1938). In documents of 1644 and 1653, his name is accompanied by the epithet 'Fleming' with the addition of Lo Zet or Loket, which may denote his northern origin (Filangieri 1884).

In the signed pictures of the *Beheading of S. Gennaro* (Quadreria del Pio Monte della Misericordia, Naples) and the *Martyrdom of S. Gennaro* (Museo di San Martino) Genoese and northern influences are apparent together with a predilection for Castiglione's style. The two pictures in the church of SS Severino e Sossio (*Moses Striking the Rock* and *Aaron Changing the Water of the Nile to Blood*), recently attributed to De Simone (Novelli 1978), are close in style to Andrea di Lione; both painters borrow from Pietro da Cortona while their naturalism derives from Ribera. This led to the pictures' former attribution to Francesco Fracanzano.

In his mature works De Simone approaches the style of Massimo Stanzione (Dalbono 1871; Rolfs 1910; Causa 1954) as can be seen in some of the frescoes in Cappella Cacace in S. Lorenzo, Naples (dated 1653), in the female saints (*S. Martire*, Museo di Capodimonte, Naples) and in the Madonnas (*Madonna and Child*, private coll., Avellino). The *Martyrdom of S. Potito* in the church of that name in Naples, signed and dated 1654, although close to Stanzione is also influenced by Artemisia Gentileschi.

B.D.

REFERENCES
D'Albono 1871, p. 114; De Dominici 1742, II, p. 243; Causa in Naples 1964, p. 44; Filangieri 1884, II, p. 165; Naples 1938, p. 84; Novelli 1978, pp. 21–28; Rolfs 1910, p. 282

Pietro Novelli, called

Monrealese

MONREALE 1603–PALERMO 1647

After training in Monreale with his father Pietro Antonio, a mosaic-worker and painter, Pietro Novelli set up in Palermo in 1618. His apprenticeship with Vito Carrera made him aware of the Venetian school of painting. He joined the circle of Van Dyck, who was in Palermo in 1624 and who, late in 1627, despatched the *Madonna of the Rosary* from Genoa to the Oratory of that name in Palermo. Novelli's *Coronation of the Virgin*, painted in 1630 to decorate the vault of this same chapel, shows him completely under the influence of Van Dyck, but other Flemish painters active in Palermo, including Guglielmo Walsgart and Jan Brueghel II, also had some influence on him.

Around 1631–33 he travelled to the mainland; he certainly visited Rome and Naples (Gallo 1828), although these visits are undocumented. His presence in Naples, almost ten years after Van Dyck's visit to Palermo, renewed interest in the Fleming's work. Bologna (1958) believes that the *Miracle of S. Francesco Saverio* in the Casa Professa of the Gesù Nuovo, which has strong affinities with the work of Andrea Vaccaro, was painted in Naples. There are several points of contact between Novelli's work and that of Vaccaro, whose *Resurrection of Lazarus* (Leonetti Coll., Naples) is very close to Novelli, but imbued with a strong Neapolitan character.

The connection between Novelli and Ribera has still to be assessed; in the first half of the 1630s Ribera abandoned his harsh realism in favour of a new interest in light and colour. Novelli's style in turn was influenced by his encounter with Neapolitan naturalism, as can be seen in his work after his return to Sicily; in the *St. Benedict Distributing the Rule* (1635) for the Benedictine monastery at Monreale, there are echoes of Stanzione, Ribera and Artemisia Gentileschi, bound together in a warm Vandyckian atmosphere. The half-length figure of *St. Paul* (Capodimonte) painted in Sicily, is very close to Ribera. In the *Judith* in Palazzo Reale, Naples, also painted in Sicily, the overthrown body of Holofernes, which occupies the depth of the painting, is reminiscent of Ribera's various versions of the martyrdom of St. Bartholomew, although there is also a hint of academicism.

I.M.

REFERENCES
Bologna 1958, pp. 19–20; Gallo 1828, p. 12

Nicolas Poussin

LES ANDELYS 1594–ROME 1665

The influence of Poussin on the development of Neapolitan painting in the seventeenth century has long been acknowledged by critics. Poussin arrived in Rome in 1624 and his first contact with Roman patrons was through the intervention of the poet Giovanni Battista Marino, who had been his protector in Paris. New documents have provided more information about Marino's visit to Naples in 1625, a visit which was cut short by the poet's

sudden death (Fulco 1978). From an inventory of his possessions it appears that although a large part of his art collection remained at the Casa Crescenzi in Rome, he had taken many things with him to Naples. These included drawings and some pictures which were left to the nobleman Giovan Battista Manso, who deposited them in his charitable foundation, the Monte Manso. It is probable that there were some drawings by Poussin in the collection, since Marino had already asked for some from him in France (Castello 1955; Thuillier and Vitzthum 1962).

Poussin was in contact with Neapolitan patrons even after Marino's death. Félibien (1685) cited the *Worship of the Golden Calf*, painted for a Neapolitan nobleman, of which a fragment arrived in Rome after Masaniello's revolt in 1647. It is thought that this fragment can be identified with the *Two Female Heads* in an English private collection (Blunt 1947). Celano names Poussin ('Monsu Pusino', 'Nicolò Pusino' and 'Pusini') as the author of three pictures in the collection of Cardinal Filomarino and also of paintings in the collections of the brothers Garofalo and of Giovanni van den Einden (Celano 1692). The three Filomarino paintings came to Naples in 1641 when the Cardinal, having been created Archbishop of Naples by Urban VIII, returned to the city from which he had been absent for many years with the famous collection he had formed while in Rome, where he had been a member of the classically inclined group centred around the Barberini family.

The Filomarino-Della Torre inventory lists works by Poussin including an *Annunciation*, a *Rest on the Flight* and a *Healing of the Blind Man* (Ruotolo 1977). The first two are described by Cochin (1769); engravings after them were made by Fragonard in the *Voyage Pittoresque* (De Saint Non). Blunt suggested that the *Annunciation* could be identified with that in the Musée de Chantilly (also attributed to Charles Mellin), and the *Rest on the Flight* with one in the Heineman Collection, New York (Blunt 1958). But the inventory measurements for the pictures, although approximate, make this impossible; Ruotolo (op. cit.) surmised that the Heineman picture, of which there is a seventeenth-century copy at Capodimonte (inv. no. 924), may be the one attributed to Poussin in the Van den Einden inventory of 1688. It is evident that the influence exerted by Poussin on Neapolitan artists should not be explained exclusively in terms of indirect influences such as Castiglione's visit to Naples in 1635.

Echoes of Poussin's style are present in Stanzione's paintings of 1634 in the Prado, and direct quotations from Poussin appear in the work of Guarino and De Bellis (Causa 1972). An example of this can be seen in the kneeling figure viewed from behind in Poussin's *Apparition of the Virgin to St. James* (Louvre) and the almost identical figure in De Bellis' *Sacrificial Scene* (Museum of Fine Arts, Houston).

A.T.

REFERENCES
Blunt 1947, p. 266; Blunt 1958, pp. 76–85; Castello 1955, pp. 296–317; Causa in *Storia di Napoli*, V, II, p. 937; Celano 1692, (1970 ed.), II, pp. 1234, 1240; III, p. 1443; De Saint Non 1781–85, 1829 ed., p. 201; Félibien 1685, IV; Fulco 1978, pp. 84–99; Ruotolo 1977, p. 74; Thuillier 1962, p. 265

Carlo Rosa

GIOVINAZZO 1613–BITONTO 1678

Carlo Rosa was born at Giovinazzo to a family from Bitonto (Castellano 1978) and was apprenticed to his father Messenzio, a painter who worked for noble families and rich clergy in the town (D'Elia 1979). Between 1636 and 1641 he was in Naples in Massimo Stanzione's shop, making journeys to Rome to study Raphael, the Carracci and the *bella tinta* of Guido Reni.

While in Naples, he was patronized by the Bishop of Bitonto, Fabrizio Carafa, who had long been friendly with the Rosa family, and by Isabella Carafa, abbess of the convent of the Sapienza and patron of SS Apostoli (Castellano 1974). In these two buildings there are still works by Rosa, painted under the influence of Massimo Stanzione and close to the style of Novelli and Fiasella (Causa 1972). The *Christ Healing the Epileptic* (c. 1640) in the church of S. Maria della Sapienza, where it is traditionally attributed to Stanzione, is in fact a documented work by Carlo Rosa. The *Christ Blessing the Children* (Metropolitan Museum, New York), formerly attributed to Alonso Cano or Pacecco de Rosa, belongs to the same date (Bologna 1958). De Dominici ascribes to Carlo Rosa 'two or three pictures for the church of SS Apostoli of the Theatine Fathers', and mentions a *S. Carlo Borromeo* 'painted with great mastery' and a *S. Gregorio Taumaturgo*. This saint has been more correctly identified as *St. Cyril of Alexandria* (Bologna 1958), to whom St. John the Evangelist is pointing out the Madonna; it is almost certainly by Domenico Fiasella.

After leaving Naples Carlo Rosa worked for over 30 years in Apulia, where artists were still tied to a moribund mannerism. Here he practised as an architect and built some churches (Mongiello 1979). He died at Bitonto on 12 September 1678 and is buried in the family chapel of St. Philip Neri in the church of the Crocefisso, which he had himself designed in 1666 (Castellano 1971).

G.C.A.

REFERENCES
Bologna 1958, p. 33; Castellano 1971, pp. 37–46;
Castellano 1974, p. 69–71; Castellano 1978, pp. 273–75;
Causa in *Storia di Napoli* 1972, V, II, p. 945;
De Dominici 1742–45 (1846 ed.), III, pp. 284–85;
D'Elia 1979, p. 186; Mongiello 1979, *passim*

Nunzio Rossi

c. 1626–PALERMO 1645/50

The first mention of Rossi comes from the Bolognese writer Masini (1650) who said he painted the *Nativity* in the Certosa of Bologna at the age of 18. He was paid for this work in 1644 (Crespi 1772); from it survive the *Four Evangelists* and the *Nativity*, signed and dated 1644, which were moved to the Chiostro delle Madonne in 1836. Since there is no reason to doubt the painter's age as given by a reliable contemporary source, we can put his birth around 1626.

It seems probable that he returned to Naples in 1645 and had hardly started on the frescoes in the tribune of S. Pietro a Maiella, which Celano says he painted at the age of 20 (adding that he died shortly afterwards) before he was called to Messina, leaving the frescoes in Naples incomplete. In 1646 he frescoed some rooms in the Palazzo Bagnara, Messina for the Ruffo family, which were finished by September of that year. Between 1646 and 1649 four *Bacchanals* by Rossi entered the Ruffo collections and by 1655 the list included five others, as well as an *Apollo and Marsyas*. At Messina he painted *Angels playing Musical Instruments* over the door of the Madre Chiesa, a *St. Peter and St. Paul with the Madonna in Glory* in the church of the Padri Crociferi, which included a view of part of Messina, another *Virgin and Child with St. Peter and St. Paul* in the church of St. Helen and Constantine and yet another picture of the same subject, which was still in the local picture gallery in 1902. According to Messinese sources Rossi went on to Palermo, where he painted many pictures and where he seems to have died.

G.D.V.

REFERENCES
Celano 1692, I, II, p. 143; Crespi 1772, p. 13ff;
De Vito 1982, pp. 73–75; Novelli Radice 1980, pp. 185–98;
Ruffo 1916, pp. 21, 237; 1919–20, p. 177

Giuseppe Ruoppolo

DIED NAPLES 1710

According to De Dominici, Giuseppe was the nephew of the more famous Giovanni Battista Ruoppolo, from whom he inherited an exuberant baroque style and rich impasto. The lack of biographical data and the confusion arising from the monogram GR used by his contemporary Giuseppe Recco have made it difficult to reconstruct his career.

Causa (1964) proposed that there were two painters, one a modest character who signed his works G R U and was active slightly later than the other. His earliest picture is in the Corsini Gallery, Rome but there are many of his works on the art market and in private collections.

The second painter is of greater importance. He signs himself *G Ruoplo* on a *Still Life with Fruit* (Kunsthalle, Hamburg) and *Giuseppe Roppoli* on a *Still Life with Peaches and Fruit* (ex Astarita Coll., Naples). To this second artist, who is probably the Giuseppe Ruoppolo mentioned by De Dominici, we can perhaps attribute the *Still Life with Citrus Fruits and Copper Pail* (Molinari Pradelli Coll.), the *Still Life with Pie and Limes* (Museo Duca di Martina, Naples) signed *Gius R* and the fruit in the big *Still Life* in Capodimonte (the flowers and the landscape are evidently the work of Abraham Brueghel *c.* 1675). To these Bologna (1968) has added a group of four pictures, one of them signed *Giuseppe Roppoli*, in which Giuseppe Recco's early manner has been assimilated into a baroque style.

Various works formerly attributed to Giuseppe Ruoppolo have now been given to other artists (Borea 1964; Bologna 1968; Causa 1972; Volpe 1981). For instance, the *Still Life* (ex Zauli Naldi Coll.) is an early work of Giovanni Battista Ruoppolo and the *Still Life with Loaves, Tart and Ice-Box* (Molinari Pradelli Coll.) has been convincingly attributed to Giuseppe Recco.

In his late works Giuseppe Ruoppolo's repertory of flowers, fruit and kitchen interiors fall into still, repetitive formulas.

R.M.

REFERENCES
Bologna 1968;
Causa in *Storia di Napoli* 1972, V, III, p. 1116, n. 69;
De Dominici 1742–45, III, p. 565; Naples 1964, pp. 53–56;
Volpe 1981, pl. 6

Angelo Solimena

CANALE DI SERINO 1629–1716

The father of the more famous Francesco Solimena, Angelo was a pupil of Francesco Guarino and one of the last naturalistic painters of southern Italy. Little is known of his life; his only work mentioned in source books is a *Madonna and Child with St. John and St. Gregory* formerly in S. Maria delle Grazie ai Mannesi in Naples, now lost.

Bologna suggested that he began as a rather conservative provincial painter working in a naturalistic vein at a time when most Neapolitan painters were swept up by the baroque style. One of his earliest pictures is the *Pentecost* at S. Michele, Solofra, which is dated 1654 and still close to Guarino, to Caracciolo in its metallic tonality and to Ribera in its realism.

Around 1660 Angelo must have moved to Nocera, where in 1664 he painted the *Deposition* in the church of S. Matteo, which is still deeply naturalistic. The *Madonna and Saints* in the church of the Purgatorio at Gravina (1667) which derives from Stanzione, shows a new interest in light, which he developed in his later work. In the *Madonna of the Purification* of 1671 in the parish church at S. Egidio Montalbino despite the naturalism, the influence of Mattia Preti is evident in the rich colour and diffused light. The frescoes in S. Giorgio, Salerno date from about 1674 (those of the choir are signed and dated 1675) and although ruined by poor restoration, show that he was aware of Lanfranco's work in SS Apostoli, Naples.

He visited Naples, perhaps in 1674, and fell under the influence of Cesare Fracanzano. The *Vision of St. Cyril of Alexandria* at S. Domenico, Solofra, which was painted in collaboration with his son Francesco, shows a new freedom of execution and warm colouring that reflects the impact of Luca Giordano.

Angelo later worked at Sarno, where he painted the vault and some other pictures in the cathedral in 1698. Partly as a result of the directions imposed by Cardinal Orsini, Archbishop of Benevento, he painted in the approved Counter-Reformation style. This classicizing tendency is evident in his last known work, a *Madonna and Child with St. Matthew and St. Peter* in Nocera of 1706, based on a prototype by Carlo Maratta and influenced by his son Francesco.

L.R.

REFERENCES
Alberto Pavone 1980, with full bibliography
Bologna 1962, pp. 1–12;

Matthias Stomer

AMERSFOORT 1600–SICILY AFTER 1650

Stomer is documented in Rome in 1630–32, but the date of his arrival and his previous experience are unknown. His style shows signs of the influence of Honthorst. But since we must exclude the hypothesis of an encounter between Stomer, still under 20 years old, and Honthorst before he left Rome in 1620, it has been suggested that he was trained in Utrecht, probably after Honthorst's return (London

1960). Stomer died around 1650 in Sicily; his only signed and dated picture (1641) was formerly in the church of the Agostiniani of S. Isidoro Agricola at Caccamo, near Palermo; recently it was stolen.

Presumably this Flemish artist was in Naples in the 1620s between his years in Rome and those in Sicily. Celano (1710) and De Dominici (1742) say that he painted pictures in the church of the Capuchins of S. Efremo Nuovo. Two of these were seen there by Sigismondo in 1789: a *Christ at the Column Crowned with Thorns* and a *Crucifixion with Weeping Angels*, while Chiarini in 1860 lists a *St. Francis in Ecstasy before the Child Jesus*, a *St. Anthony of Padua*, a *Christ at the Column* and a *Crowning with Thorns* in the same church. These reports, used by Nicolson in his reconstruction of Stomer's work (Nicolson 1977), do not help to identify any of the pictures now in Naples with the pictures in S. Efremo, a church which was turned into a penitentiary in 1860. Two pictures which were certainly painted in Naples are the *S. Onofrio* or *S. Canuto Re* and the *St. Sebastian* in the Pinacoteca dei Girolamini which show a synthesis of Honthorst's tenebrism with the contemporary style of Ribera.

While the only Neapolitan to be influenced by Stomer is Vaccaro (Causa 1972), his mature works, all painted in Sicily, show that Stomer was influenced by the Neapolitan naturalistic style. This development from a northern clarity to southern realism is characterized by Nicolson (1977) who isolated many paintings of Stomer's which he believed were painted in Naples and were stylistically different from the Sicilian ones. The pictures in Capodimonte, including the *Christ at Emmaus*, the *Holy Family with St. John*, two versions of the *Adoration of the Shepherds* (on deposit with the Museo Provinciale del Sannio, Benevento and the Museo Filangieri, Naples) and the *Liberation of St. Peter* (on deposit with the Pinacoteca Provinciale, Bari), all fall within Stomer's Neapolitan years from 1633–39. The large picture of the *Death of Seneca* (Capodimonte) is more difficult to date; Nicolson discerned references to Sicilian works and a more exuberantly baroque style.

A.T.

REFERENCES
Causa in *Storia di Napoli* 1972, V, II, p. 964, n. 8;
Celano 1692 (1970 ed.), p. 1710; De Dominici 1742, p. 155;
London 1960, p. 21; Nicolson 1977, pp. 230–45;
Sigismondo 1788, III, pp. 94–95

Hendrick Van Somer

AMSTERDAM 1607 OR 1615–AMSTERDAM
1684

The accounts of this Dutch painter, who worked
in both Amsterdam and Naples, are confused.
His baptismal certificate shows that he was the
son of Barent or Bernard van Somer, and was
born on 23 July 1615. This conflicts with what
the painter himself apparently declared when he
was a witness at the marriage of Viviano
Codazzi, when he stated that he was the son of
one *q.m Gil*, 29 years old, and that he had lived
in Naples for 12 years (Prota Giurleo 1953),
which would suggest that he was born in 1607
and came to Naples in 1624. The discrepancies
suggest that one or other of the documents was
mis-transcribed, or else that there were two
painters of the same name, possibly cousins, the
one the son of Barent (who had married the
daughter of the Brussels painter Art Mytens in
1601) and the other the son of Gil.

De Dominici says that Van Somer first
attended Ribera's studio, but later drew closer
to Reni's style. He qualified this rather
conflicting information, writing 'Errico
Fiammingo was a pupil of Ribera's, but I do not
know how he can be the follower of Guido Reni
who followed the latter's hand so closely, that
some of his Apostles were thought to be by the
Master himself, and even deceived
connoisseurs. . .'. The pictures attributed to him
show a close dependence on Ribera and the *St.
Jerome* (Borghese Gallery, Rome) bore Ribera's
signature (and was acquired as such), but
cleaning revealed the authentic signature *Errico
Semer F. 1652*. De Dominici's other story, that
Van Somer became a follower of Reni to the
extent that he went to work with him in
Bologna, seems less likely; no journeys to
Bologna are recorded and there are no works
that would illustrate a close connection with
Reni. There are references to genre paintings by
him and early Dutch inventories mention

landscapes and animal pictures (now lost),
probably painted after his return to Holland,
c. 1652. Hoogewerff (1943) attempted to
reconstruct his oeuvre working from the
Bologna are recorded and there are no works
(Spada Gallery, Rome), *c.* 1650, the *St. John the
Evangelist* (Pinacoteca Sabauda, Turin), more
tentatively the *Martyrdom of St. Lawrence* in
the Pinacoteca Vaticana and, finally, a still life
with a *Vanitas* in a private collection in
Amsterdam.

Of Van Somer's work in Naples, it has been
established that he was paid in 1641 for a
Baptism of Christ in the church of S. Maria della
Sapienza, which is close to Stanzione in style
(Bonazzi 1888). Causa (1970, 1972) added to his
oeuvre the *St. Jerome* (Banco di Napoli Coll., on
loan to Capodimonte), which he suggested
dated from after 1652 on account of his baroque
forms. However, several documents attest to the
painter's return to Holland in 1652.

Causa also attributed to Van Somer the *St.
Jerome disputing with the Jews* in the
Accademia di S. Luca in Rome and a further two
St. Jeromes, one belonging to the National
Museum at La Valletta, on loan to the Palazzo
Magistrale, and another at La Notabile in Malta
(J. Cauchi Coll.). He also suggested that the
painter may have travelled to Sicily, and
suggested that there were affinities between his
work and that of Stomer. Other works
attributed to him include two ovals of the *Virgin
Mourning* and *Ecce Homo* (Causa Coll.), and
the *St. Jerome* in the Girolamini collection,
which is quite close to the Borghese picture and
may be the work mentioned by Chiarini (1692)
among those in the Sacristy of the Girolamini as
'a hermit Saint, by Errico Francingo. . .'.

A.S.

REFERENCES
Bonazzi 1888, p. 126; Causa 1970, p. 104;
Causa in *Storia di Napoli* 1972, V, II, p. 965, n. 8;
Chiarini 1692 (1972 ed.), p. 772;
De Dominici 1742–45, III, p. 23;
Hoogewerff 1943, pp. 158–72; Prota Giurleo 1953, p. 77

Chronology

1601	Foundation of Pio Monte della Misericordia
1606–7	Caravaggio's first visit to Naples; *The Seven Acts of Mercy* and *The Flagellation*
1607	*Immaculate Conception* Caracciolo
1609–10	Caravaggio's second visit to Naples
1610	Death of Caravaggio at Porto Ercole
1610–16	Viceregency of Conde de Lemos, important social reformer
1611–12	Reni's first visit to Naples
1616	Arrival of Ribera in Naples
1618–48	Thirty Years' War
1620–22	Social unrest and risings due to economic difficulties
1621–22	Reni's second visit to Naples, negotiating for commission to decorate Cappella del Tesoro
1622	*Circumcision* Vouet
1623–44	Papacy of Urban VIII, important patron of the arts
1623–56	Cosimo Fanzago director of building at Certosa de S. Martino
1624	Van Dyck's visit to Palermo
1625	Death of poet Giovanni Battista Marino, court poet to the viceroys
1626	*Drunken Silenus* Ribera
1626–30	Artemisia Gentileschi's arrival in Naples
1629–30	Velazquez's first visit to Italy and to Naples
1631	Arrival of Domenichino in Naples to paint the Cappella de Tesoro
1631	Eruption of Vesuvius
1631–37	Viceregency of Manuel de Guzman, Conde de Monterrey, important patron of the arts; commissions to Roman and Neapolitan artists to decorate Buen Retiro Palace, Madrid
by 1634	Gaspar Roomer, Flemish merchant, living in Naples, collecting contemporary painting
1634	Arrival of Lanfranco in Naples
1635	Castiglione's visit to Naples
1637	*Pietà* Ribera
1638	*Pietà* Stanzione
1638–47	Deterioration of economic climate, due to drain on resources resulting from Spanish involvement in Thirty Years' War
c. 1639	Departure of Salvator Rosa from Naples
c. 1640	Arrival of Rubens' *Feast of Herod* in Gaspar Roomer's collection
1641	Death of Domenichino
1641–67	Archbishopric of Cardinal Ascanio Filomarino, important patron of arts; arrives in Naples with important collection of paintings from Rome
1642	Death of Reni; arrival of his *Adoration of the Shepherds* in Naples
1645	*S. Cecilia* Cavallino
c. 1646	Don Antonio Ruffo of Messina begins collecting contemporary painting
1647	Death of Lanfranco
1647–48	Masaniello's Revolt, fired by reimposition of tax on fruit
1649–50	Velasquez's second visit to Italy and to Naples
1650	French offensive at Portolongone; successfully repulsed
1652	Death of Artemisia Gentileschi
1652–53	Giordano travels to Rome and northern Italy
1654	French offensive at Castellammare led by Duc de Guise
1656	Plague, death of between a third and a half of population of Naples
1656–60	Preti's visit to Naples
1674	Arrival of Solimena in Naples
1674	Death of Gaspar Roomer; bequeaths collection in part to Ferdinand Van den Einden, son of business partner and collector of paintings
1674–78	French occupation of Messina
1683–87	Viceregency of Marchese del Carpio, important collector and social reformer; decisive campaign against brigands in the Kingdom of Two Sicilies
1688	Major earthquake; damages many buildings in city centre
1705	Death of Giordano
1707	Beginning of Austrian rule

Viceroys of Naples

1595–1599	Enrique de Guzman, Conde de Olivares
1599–1601	Fernando de Castro, Conde de Lemos
1601–1603	Francisco de Castro (Regent)
1603–1610	Juan Alonso Pimentel, Condé de Benavente
1610–1616	Pedro Fernández de Castro, Conde de Lemos
1616–1620	Pedro Girón, Duque de Osuna
1620	Cardinal Borja
1620–1622	Cardinal Zapata (Deputy)
1622–1629	Antonio Alvarez de Toledo, Duque de Alba
1629–1631	Fernando Afám de Ribera, Duque de Alcalá
1631–1637	Manuel de Guzmán, Conde de Monterrey
1637–1644	Ramiro de Guzmán, Duque de Medina de las Torres
1644–1646	Juan Alfonso Enríquez de Ribera, Almirante de Castilla
1646–1648	Rodrigo Ponce de León, Duque de los Arcos
1648	Don Juan of Austria
1648–1653	Inigo Vélez de Guevara y Tassis, Conde de Onate
1653–1658	García de Avellaneda y Haro, Conde de Castrillo
1658–1664	Gaspar de Bracamonte, Conde de Peñaranda
1664–1666	Pascual, Cardinal of Aragón
1666–1672	Pedro Antonio de Aragón
1672–1675	Antonio Alvarez, Marqués de Astorga
1675–1683	Marqués de los Vélez
1683–1687	Gaspar de Haro, Marqués del Carpio
1687–1695	Fernando de Benavides, Conde de San Esteban
1695–1700	Luis de la Cerda, Duque de Medinaceli

Kings of Spain 1600–1700

Philip III (1598–1621)
Philip IV (1621–65)
Charles II (1665–1700)

Bibliography

The following works are listed under the authors' surnames, or in the case of catalogues under the location of the exhibition, arranged alphabetically. Under each author's name the titles appear in chronological order.

Acton 1961
F. ACTON, *Il Museo Civico Gaetano Filangieri di Napoli*
Naples, 1961.

Aix-en-Provence 1941
Caravage et le caravagisme européen, exhibition catalogue
ed. G. Isarlo, Aix-en-Provence, 1941.

Alberto-Pavone 1980
M. ALBERTO-PAVONE, *Angelo Solimena*, Salerno, 1980

Argan 1956
G. C. ARGAN, 'Il 'realismo' nella poetica del Caravaggio',
Scritti di Storia dell'Arte in onore di Lionello Venturi, Rome,
1956, II, p. 24–41; reprinted in *Studi e note dal Bramante al
Canova*, Rome, 1970.

Argenville 1745
A. J. D'ARGENVILLE, *Abrégé de la Vie des plus fameux
Peintres*, Paris, 1745.

Aronberg Lavin 1975
M. ARONBERG LAVIN, *Seventeenth Century Barberini
Documents and Inventories of Art*, New York, 1975.

Athens 1962–63
Caravaggio and his School, exhibition catalogue, Athens,
1962–63.

Baccheschi 1971
E. BACCHESCHI, *L'Opera completa di Guido Reni*, Milan,
1971.

Back-Vega 1958
E. AND C. BACK-VEGA, 'A Lost Masterpiece by
Caravaggio', *Art Bulletin*, XL, 1958, p. 65–66.

Baglione 1642
G. BAGLIONE, *Le Vite de' Pittori, Scultori et Architetti, dal
Pontificato di Gregorio XIII del 1572 in fino a' tempi di Papa
Urbano Ottavo nel 1642 . . .*, Rome, 1642.

Baldinucci 1681, 1975
F. BALDINUCCI, 'Notizie de'Pittori, Scultori e Architetti che
dall'anno 1640 sino al presente giorno hanno operato
lodevolmente nella città e Regno di Napoli', *Notizie dei
professori del disegno da Cimabue in quà*, ed. F. Ranalli,
appendix by P. Barocchi, 1681–1728; reprinted in Florence,
1975.

Bardon 1978
F. BARDON, *Caravage ou l'experience de la matière*,
Paris, 1978.

Bari 1964
Mostra dell'Arte in Puglia dal tardo Antico al Rococo,
Bari, 1964, catalogue ed. M. D'Elia.

Barnard Castle 1962
Neapolitan Baroque and Rococo Painting, exhibition
catalogue ed. T. Ellis, Bowes Museum, Barnard Castle, 1962.

Baroni 1951
C. BARONI, *Tutta la pittura del Caravaggio*, Milan, 1951.

Basile 1617
G. BASILE, *De' Madrigali e delle Ode del Cavalier
Giovanni Battista Basile*, Naples, 1617.

Baumgart 1955
F. BAUMGART, *Caravaggio: Kunst und Wirklichkeit*,
Berlin, 1955.

Bean and Vitzthum 1961
J. BEAN AND W. VITZTHUM, 'Disegni del Lanfranco e del
Beinaschi', *Bollettino d'arte*, XXXXVI, 1961, p. 102–22.

Bellori 1672
G. P. BELLORI, *Le Vite de' Pittori, Scultori ed Architetti
moderni*, Rome, 1672.

Benesch 1924
O. BENESCH, 'Maulertsch. Zu den Quellen seines
malerischen Stils', *Städel-Jahrbuch*, III–IV, 1924, p.
107–76.

Benesch 1926
O. BENESCH, 'Zu Bernardo Cavallinos Werdegang'
Jahrbuch der Kunsthistorisches Sammlungen in Wien, 1926,
p. 245–54.

Berenson 1951
B. BERENSON, *Del Caravaggio, delle sue incongruenze e
della sua fama*, Florence, 1951.

Bergamo 1962
Natura Morta italiana, exhibition catalogue, ed. G. De
Logu, Lorenzelli Gallery, Bergamo 1962.

Bergamo 1968
Natura in Posa. Aspetti dell'antica natura morta italiana,
exhibition catalogue ed. F. Bologna, Bergamo, 1968.

Berlin 1966
Deutsche Maler und Zeichner des 17 Jahrhunderts,
exhibition catalogue Berlin, 1966.

Berlin 1971
Neuerwerbung Gemäldegalerie Berlin, exhibition
catalogue ed. E. Schleier, Berlin, 1971

Berne-Joffroy 1959
BERNE-JOFFROY, *Le dossier Caravage*, Paris, 1959.

Bertolotti 1881
A. BERTOLOTTI, *Artisti lombardi a Roma nei secoli XV,
XVI e XVII, studi e ricerche negli archivi romani*, Milan,
1881.

Bertolotti 1884
A. BERTOLOTTI, *Artisti subalpini in Roma*, Modena, 1884.

Beruete 1898
A. DE BERUETE, *Velasquez*, Pariss, 1898.

Besançon 1982
Peintures napolitaines, exhibition catalogue, ed. A. Brejon
de Lavergnée, Besançon, 1982.

Bissell 1968
R. W. BISSELL, 'Artemisia Gentileschi – A new
documented chronology', *Art Bulletin*, L, 1968. p. 153–68.

Blumer 1936
M. BLUMER, 'Catalogue des peintures transportées d'Italie
en France de 1796 à 1814', *Bulletin de la Société de l'Histoire
de l'Art Français*, 26, 1936, p. 244–348.

Blunt 1939–40
A. BLUNT, 'A Poussin-Castiglione Problem', *Journal of the
Warburg and Courtauld Institutes*, III, 1939–40, p. 142–47.

Blunt 1947
A. BLUNT, 'Poussin Studies II: Three early Works',
Burlington Magazine, LXXXIX, 1947, p. 26–73.

Blunt 1953
A. BLUNT, *Art and Architecture in France, 1500–1700*, Harmondsworth, 1953, 2nd ed., 1970.

Blunt 1954
A. BLUNT, *The Drawings of G. B. Castiglione and Stefaanano della Bella at Windsor Castle*, London, 1954.

Blunt 1958
A. BLUNT, 'Poussin Studies VII: Poussins in Neapolitan and Sicilian Collections', *Burlington Magazine*, C, 1958, 1952, p. 47–56.

Blunt 1969
A. BLUNT, 'A frescoed ceiling by Aniello Falcone', *Burlington Magazine*, CXI, 1969, p. 215.

Bodart 1966
D. BODART, 'Intorno al Caravaggio: la Maddalena del 1606', *Palatino*, 1966, p. 118–26.

Bodart 1970
D. BODART, *Louis Finson*, Brussels, 1970.

Bolaffi 1972–76
Dizionario enciclopedico Bolaffi dei Pittori e degli Incisori italiani dal XI al XX secolo, Turin, 1972–76.

Bologna 1952
F. BOLOGNA, 'A proposito dei Ribera del Museo di Bruxelles', *Bulletin des Musées Royaux de Belgique*, I–II, 1952, p. 47–56.

Bologna 1958
F. BOLOGNA, *Francesco Solimena*, Naples, 1958.

Bologna 1960
F. BOLOGNA, 'Altre aggiunte a Battistello Caracciolo' *Paragone* CXXIX, 1960, pp. 45–51.

Bologna 1962
F. BOLOGNA, 'Aggiunte a Francesco Solimena I: La giovinezza e la formazione (1674–84)', *Napoli Nobilissima*, 1962–63, p. 1–12.

Bologna 1974
F. BOLOGNA, 'Il Caravaggio nella cultura e nella società del suo tempo', *Caravaggio e i caravaggeschi*, Acts of the 1973 colloquium, Accademia dei Lincei Quaderno No. 205, Rome, 1974.

Bologna 1976
F. BOLOGNA, 'Le acquisizioni '60–'75 nei Musei napoletani', *Il Mattino*, 1976.

Bologna 1979
F. BOLOGNA, 'Solimena al Palazzo reale di Napoli per le nozze di Carlo di Borbone', *Prospettiva*, XVI, 1979, p. 53–67.

Bologna 1980, see Pacelli and Bologna 1980

Bonazzi 1888
F. BONAZZI, 'Dei veri autori di alcuni dipinti della chiesa di S. Maria della Sapienza in Napoli', *Archivio Storico per le Provincie Napoletane*, XIII, 1888, pp. 119–49.

Bordeaux 1955
L'Age d'or espagnol, exhibition catalogue, Bordeaux, 1955.

Bordeaux 1978
La Nature Morte de Bruegel à Soutine, exhibition catalogue, Galerie des Beaux-Arts, Bordeaux, 1978.

Borea 1974
E. BOREA, 'Caravaggio e la Spagna: osservazioni su una mostra a Siviglia', *Bollettino d'Arte*, LIX, 1974, p. 43–52.

Borenius 1931
T. BORENIUS 'The Kaleidoscope of Taste', *The Studio*, 1931, p. 229.

Borla 1967
S. BORLA, 'L'ultimo percorso del Caravaggio', *Antichità Viva*, VI, 4, 1967, p. 3–14.

Borsook 1954
E. BORSOOK, 'Documents concerning the Artistic Associates of Santa Maria della Scala in Rome', *Burlington Magazine*, XCVI, 1954, p. 270–75.

Bossaglia 1965
R. BOSSAGLIA, F. Guariano in *Le Musei Enciclopedia di tutte le arti*, Novara 1965, V, p. 421–22.

S. BOTTARI, 'Appunti sui Recco', *Arte Antica e Moderna*, 13–16, p. 354–61.

Bottari 1963
S. BOTTARI, 'Una traccia per Luca Forte e il primo tempo della "natura morta" a Napoli', *Arte Antica e Moderna*, XXIII, 1963, p. 224, p. 242–46.

Bottari 1966
S. BOTTARI, *Caravaggio*, Florence, 1966

Bottari-Ticozzi 1822–25
G. BOTTARI, S. TICOZZI, *Raccolta di lettere sulla pittura, scultura ed architettura*, Milan, 1822–25.

Bredius 1886
A. BREDIUS, N. DE ROEVER, 'Pieter Lastman en François Venant', *Illand*, IV, 1886, p. 1–23.

Bredius 1902
A. BREDIUS, Le peintre Louis Finson', *Annales internationales d'histoire*, Congrès de Paris 1900, Paris 1902.

Bredius 1918
A. BREDIUS, 'Iets over de schilders Loujs, David en Pieter Finson', *Oud Holland*, XXXVI, 1918.

Brejon de Lavergnée 1982
A. BREJON DE LAVERGNEE, 'Nouvelles peintures d'Andrea di Lione; essai de répertoire des oeuvres', *Miscellanea Zeri*, forthcoming publication.

Brejon de Lavergnée and Dorival 1979
A. BREJON DE LAVERGNEE, B. DORIVAL, *La Peinture italienne du dix-septième siècle*, Geneva 1979.

Briganti 1951
G. BRIGANTI, 'Mattia Preti, i seicentofile e gli snobs', *Paragone*, XV, 1951, p. 45–49.

Brigstocke 1980
H. BRIGSTOCKE, 'Castiglione: two recently discovered paintings' *Burlington Magazine*, CXXII, 1980, p. 292–98.

Brown 1978
J. BROWN, *Images and Ideas in Seventeenth-Century Spanish Painting*, Princeton, 1978.

Brown and Elliott 1980
J. BROWN, J. ELLIOTT, *A Palace for a King, The Buen Retiro and the Court of Philip IV*, New Haven and London, 1980.

Bucharest 1969
Desene Napolitane Secolele XVII–XVIII, exhibition catalogue ed. W. Vitzthum, Bucharest, 1969.

Bucharest 1972
Seculul de aur al picturii napolitane, exhibition catalogue ed. R. Causa and N. Spinosa, Bucharest, 1972.

Buono 1978–79
R. BUONO, 'Nota bibliografica su Paolo Finoglia' in *Ricerche sul sei- sepecento in Puglia*, Bari, 1978–79, p. 91–103.

Burchard 1953
L. BURCHARD, 'Rubens' 'Feast of Herod" at Port Sunlight', *Burlington Magazine*, XCV, 1953, 33–87.

Buscaroli 1935
R. BUSCAROLI, *La Pittura di Paesaggio in Italia*, Bologna, 1935.

Buschbeck 1931
E. BUSCHBECK, *Kunsthistorisches Museum in Wien, Führer durch die Gemäldegalerie*, Vienna, 1931.

Calvesi 1954
M. CALVESI, 'Simone Peterzano, maestro del Caravaggio', *Bolletino d'Art*, XXXIX, 1954, p. 114–33.

Calvesi 1965
R. CALVESI, 'Caravaggio', in *Le Muse, Enciclopedia di tutte le Arti*, Novara, 1965.

Calvesi 1971
M. CALVESI, 'Caravaggio o la ricerca della salvazione',
Storia dell' Arte, 9–10, 1971, p. 93–141.

Camera 1881
M. CAMERA, *Memorie storico-diplomatiche dell'antica
citta e Ducato di Amalfi*, 2 vols, Salerno, 1811.

Camesasca 1973
E. CAMESASCA, *Ribera el Españoleto*, Barcelona, 1973.

Campori 1870
G. CAMPORI, *Raccolta di catalogi ed inventari inediti*,
Modena, 1870.

Canova 1779–80
A. CANOVA, *Quaderni di viaggio*, ed. E. Bassi,
Venice/Rome, 1959.

Capaccio 1634
G. CAPACCIO, *Il Forastiero*, Naples, 1634.

Capasso 1878
B. CAPASSO, 'Sull'aneddoto riguardante gli affreschi del
Cavaliere Calabrese sopra le porte de Napoli', *Archivio
Storico per le Provincie Napoletane*, III, 1878, p. 597–605.

Carandente 1966
G. CARANDENTE, *Mattia Preti a Taverna*, Rome, 1966

Caravita 1869–70
A. CARAVITA, *I Codici e le Arti a Montecassino*,
Montecassino, 1869–70.

Carita 1951
R. CARITA, 'Un Battistello ritrovato', *Paragone*, XIX, 1951,
p. 50–54.

Carritt 1972
D. CARRITT, 'Pictures from Gosford House', *Burlington
Magazine*, XC, 1957, p. 343–44.

Carughi 1976
U. CARUGHI, *L'Arcionfraternità della SS Trinita dei
Pellegrini in Napoli*, Naples, 1976.

Cassandro 1932
M. CASSANDRO, *Cesare Fracanzano e il suo tempo*, 1932.

Castellano 1971
A. CASTELLANO, 'Documenti biografici del pittore Carlo
Rosa' *Studi Bitontini*, V, 1971, p. 37–46.

Castellano 1974
A. CASTELLANO, 'Carlo Rosa pittore bitontino', *Bitontum*,
VI, 1974, p. 69–71.

Castellano 1978
A. CASTELLANO, 'La fede battesimale di Carlo Rosa',
Archivio Storico Pugliese, XXXI, 1978, p. 273–75.

Castello 1955
J. CASTELLO, 'Poussin's Drawings for Marino and the new
Classicism: I Ovid's *Metamorphoses*', *Journal of the
Warburg and Courtauld Institutes*, XVIII, 1955, p. 296–317.

Catalani 1845–53
L. CATALANI, *Le Chiese de Napoli*, Naples 1845–53.

Causa 1946
R CAUSA, 'Appunti sulla formazione di Micco Spadaro', *Il
Sagittario*, 1946, p. 2–6.

Causa 1950
R. CAUSA, 'Aggiunte a Battistello', *Paragone*, IX 1950,
p. 2–45.

Causa 1951
R. CAUSA, 'Paolo Porpora e il primo tempo della "natura
morta" napoleta', *Paragone*, XV, 1951, p. 30–36.

Causa 1952
R. CAUSA, 'Per Mattia Preti: il tempo di Modena e il
soggiorno a Napoli', *Emporium*, 1952, p. 201–12.

Causa 1956
R. CAUSA, 'François de Nomé detto Monsù Desiderio',
Paragone, LXXV, 1956, p. 30–46.

Causa 1957
R. CAUSA, *Pittura napoletana dal XV al XIX secolo*,
Bergamo, 1957.

Causa 1961
R. CAUSA, 'Un avvio per Giacomo Recco', *Arte Antica e
Moderna*, 1961, p. 346ff.

Causa 1962, 1963
R. CAUSA, 'Luca Forte e il primo tempo della "natura
morta" a Napoli', *Paragone*, 1962, CVL, p. 41–48.

Causa 1966[1]
R. CAUSA, *I seguaci del Caravaggio a Napoli*, Milan, 1966.

Causa 1966[2]
R. CAUSA, *Caravaggio*, Maestri del colore, Milan 1966.

Causa 1970
R. CAUSA, *Opere d'arte nel Pio Monte della Misericordia a
Napoli*, Naples, 1970.

Causa 1971
R. CAUSA, 'Musei Napoletani: Restauri a San Martino',
Arte Illustrata, IV, 1971, p. 16–27.

Causa 1972
R. CAUSA, *La Pittura del Seicento a Napoli dal
Naturalismo al Barocco; II La Natura Morta a Napoli nel
sei a settecento*, reprint from *Storia di Napoli*, Naples 1972.

Causa 1973
R. CAUSA, *L'Arte nella Certosa di San Martino*, Naples,
1973.

Causa Picone 1974
M. CAUSA PICONE, *Disegni della Società Napoletana di
Storia Patria*, Naples, 1974.

Céan Bermùdez 1800
J. CEAN BERMUDEZ, *Diccionario historico de los mas
illustres professores de las bellas artes en España*, Madrid,
1800.

Ceci 1894
G. CECI, 'La figlia dello Spagnoletto', *Napoli Nobilissima*,
1894, p. 65–67.

Ceci 1898
G. CECI, 'La corporazione dei pittori', *Napoli Nobilissima*,
VII, p. 57f.

Ceci 1899
G. CECI, 'Scrittori della Storia dell'arte Napoletana
anteriori al De Dominici', *Napoli Nobilissima*, VIII, 1899,
p. 163–68.

Ceci 1905
G. CECI, 'Domenico Gargiulo, detto Micco Spadaro',
Napoli Nobilissima, 1905, p. 65–8, 104–08.

Ceci 1920
G. CECI, 'Un mercante mecenate del secolo XVII. Gaspare
Roomer', *Napoli Nobilissima*, N.S., I, 1920, p. 160–64.

Ceci 1937
G. CECI, *Bibliografia per la Storia delle arti figurative nell'
Italia Meridionale*, Naples, 1937.

Celano 1692
C. CELANO, *Notizie del Bello, dell'Antico e del Curioso
della città di Napoli*, 1692, ed. G Chiarini, Naples 1856–60,
reprinted Naples 1970.

Chenault 1971
J. CHENAULT, 'Ribera, Ovid and Marino: "Death of
Adonis"', *Paragone*, CCLIX, 1971, p. 73.

Chenault Porter 1979
J. CHENAULT PORTER, 'Ribera's Assimilation of a Silenus',
Paragone, CCCLV, 1979, p. 41–54.

Chennevières-Pointel 1847
P. DE CHENNEVIERES-POINTEL, *Recherches sur la vie et
les ouvrages de quelques peintres provincaux de l'ancienne
France*, Paris, 1847.

Chiarini 1856–60
G. CHIARINI, *Aggiunzioni a C. Celano, Notizie del Bello,
dell'Antico e del Curioso della città di Napoli*, Naples,
1856–60.

Chiarini 1972[1]
M. CHIARINI, 'Filippo Napoletano, Poelenburgh e
Breenbergh el la nascita del paesaggio realistico in Italia',
Paragone, CCLXIX, 1972, p. 18–34.

Chiarini 1972[2]
M. CHIARINI, Ipotesi sugli inizi di Corneliis van Poelenburgh',, *Kunsthistorisches Jarboeck*, XXIII, 1972, p. 33–62.

Chiarini 1976
M. CHIARINI, 'Filippo Napoletano e il Cardinale Carlo de' Medici', *Paragone*, CCCXIII, 1976, p, 61–67.

Chimirri and Frangipane 1915
B. CHIMIRRI, A. FRANGIPANE, *Mattia Preti*, Milan 1915.

Cinotti 1971
M. CINOTTI and G. A. DELL'ACQUA, *Il Caravaggio e le sue grandi opere di San Luigi dei Francesi*, Milan, 1971.

Cinotti 1973
M. CINOTTI, *Immagine del Caravaggio*, catalogue of travelling exhibition, 1973.

Cirillo Mastrocinque 1978
A. CIROLLO MASTROCINQUE, *Usi e costumi popolari a Napoli nel Seicento*, Naples, 1978.

Cleveland 1971
Caravaggio and his Followers, exhibition catalogue ed. E. Spear, Cleveland, 1971.

Cochin 1763
N. COCHIN, *Voyage d'Italie, ou Recueil de notes sur les ouvrages d'Architecture, de Peinture et de Sculpture que l'on voit dans le principales villes d'Italie (1749–51)*, Paris, 1763.

Colonna 1895
F. COLONNA DI STIGLIANO, 'Inventario dei quadri di Casa Colonna, fatto da Luca Giordano', *Napoli Nobilissima*, IV, 1895, p. 29–32.

Commodo Izzo 1951
M. COMMODO IZZO, *Andrea Vaccaro Pittore*, Naples, 1951.

Coniglio 1967
C. CONIGLIO, *I Vicerè Spagnuoli di Napoli*, Naples, 1967.

Constantini 1930
V. CONSTANTINI, *La pittura italiana del 600*, Milan 1930.

Crelly 1962
W. CRELLY, *The Paintings of Simon Vouet*, New Haven and London 1962.

Crinò 1954
A. CRINO, 'Due Lettere autografe di Orazio e di Artemisia Gentileschi de Lomi', *Rivista d'Arte*, XXIX, 1954, p. 203–06.

D'Addosio 1883
G. D'ADDOSIO, *Origine, vicende storiche e progressi della Real S. Casa dell'Annunziata di Napoli*, Naples, 1883.

D'Addosio 1912, 1913
G. D'ADDOSIO, 'Documenti inediti di Artisti Napoletani del XVI e XVII secolo', *Archivio Storico per le Provincie Napoletane*, XXXVII, 1912, p. 593–616; XXXVIII, 1913, p. 36–72, 232–59, 483–524, 578–610.

D'Afflitto 1834
D. D'AFFLITTO, *Guida per i curiose e i viaggiatori che vengono alla città di Napoli*, Naples, 1834.

Dalbono 1871
C. DALBONO, *Massimo, i suoi tempi, la sua scuola*, Naples 1871.

Dalbano 1875
C. DALBONO, *Nuova guida di Napoli e dintorni*, Naples, 1875.

Dalbono 1878
C. DALBONO, *Ritorni sull'arte antica napolitana*, Naples 1878.

Dalbono 1903
C. DALBONO, *Guida di Napoli e dintorni*, Naples, 1903.

D'Aloe 1853
S. D'ALOE, *Naples, ses monuments et ses curiosités*, Naples, 1853.

D'Ambrosio 1973
A. D'AMBROSIO, *Il Duomo di Pozzuoli, storia e documenti inediti*, Pozzuoli, 1973

D'Argaville 1972
B. D'ARGAVILLE, 'Neapolitan Seicento Painting; Additions and Revisions' *Burlington Magazine*, CXIV, 1972, p. 809.

Dargent and Thuillier 1965
G. DARGENT and J. THUILLIER, 'Simon Vouet en Italie', *Saggi e memorie di Storia dell'Arte*. IV, 1965.

De Concilis and Lattuada 1979
D. DE CONCILIS, R. LATTUADA, 'Unpublished documents for Mattia Preti's paintings in S. Pietro a Majella in Naples', *Burlington Magazine*, CXXI, 1979, p. 294–301.

De Dominici 1742–45
B. DE DOMINICI, *Vite dei Pittori, Scultori ed Architetti Napoletani*, Naples, 172–45.

D'Elia 1970
M. D'ELIA, 'Paolo Finoglia a conversano', *Pittori del Guercio*, Quaderni di Terra di Bari, 1970, p. 13–33.

D'Elia 1971
M. D'ELIA, 'Sulle orme dei Francanzano in Puglia', in *Studi di Storia pugliese in onore di N. Vacca*, 1971.

D'Elia 1979
M. D'ELIA, 'Per la pittura del 600 in Puglia. considerazioni sul Carlo Rosa', *Cultura e società a Bitonto nel Sec. XVII*, Bitonto, 1979.

De Frede 1951
B. DE FREDE, 'Bollettino Bibliografico per la Storia de Mezzogiorno d'Italia 1939–60', *Archivio Storico er le Province Napoletane*, LXXI, Naples, p. 215–350.

De Lellis 1666–68
C. DE LELLIS, *Aggiunta alla Napoli Sacra del C. D'Engenio*, Naples, ed. F. Aceto, Naples, 1977.

Dell'Acqua 1971
G. DELL'ACQUA, *Il Caravaggio e le sue grandi opere da San Luigi dei Francesi*, appendix by M. Cinotti, Milan, 1971.

De Logu 1928
G. DE LOGU, *Giovan Benedetto Castiglione*, Bologna, 1928.

De Logu 1931
G. DE LOGU, *La Pittura Italiana del'600*, Florence 1931.

De Logu 1937
G. DE LOGU, 'La Galleria Harrach a Vienna', *Emporium*, 1937, p. 405–14.

De Logu 1962
G. DE LOGU, *La Natura Morta Italiana*, Bergamo, 1962.

De Mirimonde 1970
A.-P. DE MIRIMONDE, 'Une nature morte énigmatique de Paolo Porpora au Musée du Louvre', *Le Revue du Louvre*, III, 1970, p. 145—4.

Demonts 1913
L. DEMONTS, 'Essai sur la formation de Simon Vouet en Italie (1612–1627)', *Bulletin de la Société de l'Histoire de l'Art Français*, 1913, p. 309–48.

De Renzi 1867
S. DE RENZI, *Napoli nell'anno 1656*, Naples, 1867.

De Rinaldis 1912
A. DE RINALDIS, 'Note sulla pittura napoletana del' 600', *Ausonia*, VII, 1912, p. 221–50.

De Rinaldis 1917
A. DE RINALDIS, 'Bernardo Cavallino e alcuni suoi nuovi quadri', *Rassegna d'Arte*, XVII, 1917, p. 179–86.

De Rinaldis 1920
A. DE RINALDIS, 'Massimo Stanzione al Prado', *Napoli Nobilissima*, XVI, 1920, p. 44–46.

De Rinaldis 1921
A. DE RINALDIS, Cavallino, Rome, 1921.

De Rinaldis 1928
A. DE RINALDIS, *Pinacoteca del Museo Nazionale di Napoli*, Naples, 1928.

De Rinaldis 1928–29
A. DE RINALDIS, 'Cristo legato alla colonna di Michelangelo de Caravaggio', *Bollettino d'Arte*, 1928–29, p. 49–54.

De Rinaldis 1929
A. DE RINALDIS, *La Pittura Italiana del '600 nell'Italia Meridionale*, Verona, 1929.

De Rinaldis 1948
A. DE RINALDIS, *Catalogo della Galleria Borghese*, Rome, 1948.

De Saint Non 1781–85
ABBE J.C.R. DE SAINT NON, *Voyages pittoresques ou descriptions des royaumes de Naples et de Sicile*, Paris, 1781–85; another edition 1829.

De Seta 1969
C. DE SETA, *Cartographia della città di Napoli. Lineamenti dell'evoluzione Urbana*, Naples, 1969.

De Seta 1973
C. DE SETA, *Storia della Città di Napoli dalle Origini al Settecento*, Bari, 1973.

De Seta 1980
C. DE SETA, 'Topografia urbana e vedutismo nel Seicento: a proposito di alcuni disegni di Alessandro Baratta', *Prospettiva*, XXII, 1980, p. 48–49.

De Simone 1845
G. DE SIMONE, *Le Chiese di Napoli*, Naples, 1845.

Detroit 1965
Art in Italy 1600–1700, exhibition catalogue, Detroit 1965.

De Vito 1982
G. DE VITO, *Recerche sul 600 Napoletano*, Motta Visconti, Milan, 1982

Diaz del Valle 1656
L. DIAZ DEL VALLE, 1656–59, in Sánchez Canton, *Fuentes literarias para la Historia del Arte Español*, Madrid, 1923–41 (5 vols), II, 1933.

Di Carpegna 1961
N. DI CARPEGNA, 'I Recco', *Bollettino d'Arte*, 1961, p. 123–32.

Disertari 1966
B. DISERTARI, 'Il Domenichino pittore, musicista', *Atti dell' Accademia Roveretana degli Agiati*, VI, 1966, p. 5–23.

Di Stefano 1940
G. DI STEFANO, *Pietro Novelli*, Palermo, 1940.

Dizionario Biografico 1960–
Dizionario Biografico degli Italiani, Istituto della Enciclopedia Italiana, Rome, 1960– (in course of publication).

Doria 1964
G. DORIA, *Il Museo e la Certosa di San Martino*, Naples, 1964.

D'Orsi 1938
M. D'ORSI, *Paolo Finoglia Pittore Napoletano*, Bari, 1938.

Dowley 1964
F. DOWLEY, 'Art in Italy 1600–1700 at the Detroit Institute of Arts', *Art Quarterly*, XXVII, 1964, p. 519–26.

Du Gué Trapier 1952
E. DU GUE TRAPIER, *Ribera*, New York, 1952.

Fagliolo dell'Arco 1968, 1969
M. FAGIOLO DELL' ARCO, 'Le "Opere di Misericordia": contributi alla poetica del Caravaggio', *L'Arte*, 1968, p. 37–61; reprinted Milan 1969.

Fagliolo dell' Arco 1970
M. FAGIOLO DELL' ARCO, M. MARINI, 'Rassegna degli studi caravaggeschi 1951–1970', *L'Arte*, n.s., 11–12, 1970, p. 117–28.

Faldi 1957
I. FALDI, *Palazzo Pamphilj*, Rome, 1957.

Faraglia 1885
N. FARAGLIA, 'Notizie di alcuni artisti che lavoravano nella chiesa di San Martino e nel Tesoro di San Gennaro', *Archivio Storico per le province Napoletane*, 1885, p. 435–54.

Faraglia 1892
N. FARAGLIA, 'Notizie di artisti che lavorarono nella Chiese di S. Martino Sopra Napoli', *Archivio Storico per le province Napoletane*, XVII, 1892, p. 657–78.

Félibien 1685
A. FELIBIEN, *Entretiens sur les vies et les ouvrages des plus excellents peintres*, Paris, 1685.

Felton 1969
C. FELTON, 'The Earliest paintings of Jusepe de Ribera', *Wadsworth Atheneum Bulletin*, 1969, p. 211.

Felton 1971
C. FELTON, *Jusepe de Ribera, A Catalogue raisonné*, Pittsburgh, 1971.

Ferrante 1900
D. FERRANTE, 'Notizie di artisti che lavorarono a Napoli nel sec. XVII dal diario del Fuidoro', *Napoli Nobilissima*, VIII, 1900, p. 27–31; IX, 1900, p. 77–79.

Ferrari 1962
O. FERRARI, 'Seicento Napoletano a Sarasota', *Napoli Nobilissima*, 3 ser., 1962, 1, p. 235–38.

Ferrari and Scavizzi 1966
O. FERRARI and G. SCAVIZZI, *Luca Giordano*, 3 vols., Naples, 1966.

Ferrari 1969
O. FERRARI, 'Pittura napoletana del Seicento e Settecento', *Storia dell'Arte*, 1/2, 1969, p. 217f.

Ferrari 1975
O. FERRARI, 'The Entombment: a Youthful work by Luca Giordano', *Bulletin of the Detroit Institute of Arts*, 54, 1975, 1, p. 24–32.

Ferrari 1978
O. FERRARI, 'Le arti figurative nel Seicento' in 'Nuove conoscenze e prospettive del mondo dell'arte', supplement to *Enciclopedia Universale dell'Arte*, Rome, 1978.

Filangieri 1877
G. FILANGIERI, *Catalogo generale dell'arte antica*, Naples, 1877.

Filangieri 1884
G. FILANGIERI, *Documenti per la storia, le arti e le industrie delle province di Napoli*, Naples, 1884.

Filangieri 1888
G. FILANGIERI, *Catalogo del Museo Civico G. Filangieri*, Naples, 1888.

Filangieri 1891
G. FILANGIERI, 'Documenti per la storia, le arti e le industrie delle province napoletane', *Indice degli artefici delle arti maggiori e minori*, Naples, 1891, p. V–VI.

Fiocco 1924
G. FIOCCO, 'Francesco Maffei' *Dedalo*, V, 1924, p. 219–50.

Fiocco 1929
G. FIOCCO, *La Pittura Veneziana dei Seicento e Settecento*, Verona, 1929.

Fiordelisi 1899
A. FIORDELISI, 'La Trinità delle Monache', *Napoli Nobilissima*, VIII, 1899, p. 145–50, 181–87.

Fiorillo 1979
C. FIORILLO, 'Un inedito e qualche nota su Charles Mellin a Napoli', *Antologia di Belle Arti*, 9/12, 1979, p. 77–83.

Fitz Darby 1942
D. FITZ DARBY, 'Some cases of Mistaken Identity: a study of Ribera's Hermits in American Museums', *Art in America*, XXX, 1942, p. 40–53.

Fitz Darby 1957
D. FITZ DARBY, 'Ribera and the Blind Man', *Art Bulletin*, XXXIX, 1957, p. 195–217.

Florence 1911
Mostra del ritratto italiano dalla fine del secolo XIV all'anno 1861, exhibition catalogue, Florence, 1911.

Florence 1922.
Pittura italiana del Seicento e del Settecento, exhibition catalogue, Florence, 1922.

Florence 1966

Disegni napoletani del '600 e '700, exhibition catalogue ed. W. Vitzthum, Florence, 1966.

Florence 1969
Artisti all corte Granducale, exhibition catalogue ed. M. Chiarini, Florence, 1969.

Florence 1970
Caravaggio e caravaggeschi nelle gallerie di Firenze exhibition catalogue ed. E. Borea, Florence, 1970.

Florence 1980
Gli Uffizi, Catalogo dei dipinti, Florence, 1980.

Frangipane 1929
A. FRANGIPANE, *Mattia Preti il Cavalier Calabrese*, Milan, 1929.

Frangipane 1931
A FRANGIPANE, *La pittura e il dramma di Mattia Preti*, Naples, 1931.

Frankfurter 1965
A. FRANKFURTER, 'Museum Evaluations, 2 : Toledo', *Art News*, 1965.

Freise 1911
K. FREISE, *Pieter Lastman*, Halle, 1911.

Friedlaender 1955[1]
W. FRIEDLAENDER, *Caravaggio Studies*, Princeton, 1955.

Friedlaender 1955[2]
W. FRIEDLAENDER, 'Réflexions sur les problèmes posés à l'Exposition', *Cahiers de Bordeaux*, II, 1955, p. 29.

Frizzoni 1889
G. FRIZZONI, 'Il Museo Filangieri in Napoli', *Archivio Storico dell'Arte*, II, 1889, p. 293–300.

Frohlich-Bume 1961
L. FROHLICH-BUME, 'Londoner Ausstellungen', *Weltkunst*, VI, 1961.

Fulco 1978
G. FULCO, 'Il sogno di una "Galeria", nuovi documenti sul Marino collezionista', *Antologia di Belle Arti*, IX–XII, 1978, p. 84–99.

Galante 1975
L. GALANTE, 'Coppola, Fracanzano e altri fatti di pittura in Puglia', *Annali della Scuola Normale Superiore di Pisa*, V, ser. III, 1975, p. 1491–1510.

Galanti 1742
G. GALANTI, *Breve descrizione della città di Napoli e del suo contorno*, Naples, 1742, another ed. 1829.

Galanti 1829
G. GALANTI, *Napoli e Contorni*, Naples, 1829; other editions 1838, 1849, 1872.

Gallichi Schwenn 1961
I. GALLICHI SCHWENN, 'Note su Giacomo Farelli, pittore "Napoletano" del 600', *Partenope*, 1961, p. 200–13.

Gallo 1828
A. GALLO, *Elogio storico di Pietro Novelli da Monreale*, Palermo, 1828.

García Chico 1946
E. GARCÍA CHICO, *Documentos para el estudio del Arte en Castilla*, III, I, Pintores, Valladolid, 1946.

Gaya Nuño 1958
J. GAYA NUÑO, *La pintura espanola fuera de España*, Madrid, 1958.

Gaya Nuño 1961
J. GAYA NUÑO, 'Peinture Picaresque', *L'Oeil*, 1961, p. 53–61.

Genoa 1969
Pittori genovesi a Genova nel '600 e nel '700, Genoa 1969.

Genoa 1971
La Pittura a Genova e in Liguria, 1971.

Genoa 1977
Rubens e Genova, exhibition catalogue, Genoa 1977–78.

Giannone 1773
O. GIANNONE, *Giunte sulle vite de'pittori napoletani*, Naples, 1773, ed. O. Morisani, Naples, 1941.

Giglioli 1922
O. GIGLIOLI, 'Le Mostre d'Arte Antica a Firenze', *Rassegna d'Arte*, XXII, 1922, p. 201–31.

Gonzales Palacios 1979
A. GONZALES PALACIOS, 'Domenico Antonio Vaccaro's "St. Michael"?', letter in *Burlington Magazine*, CXXI, 1979, p. 518.

Gregori 1957
M. GREGORI, 'Un nuovo Battistello', *Paragone*, LXXXV, 1957, p. 105–07.

Gregori 1973
M. GREGORI, 'Notizie su Agostino Verrocchi una ipostesi per Giovanni Battista Crescenzi', *Paragone*, CCLXXV, 1973, p. 51

Gregori 1975
M. GREGORI, 'Significato delle mostre caravaggesche dal 1951 a oggi', *Novità sul Caravaggio*, Atti del Convegno internazionale di studi caravaggeschi, (1974), Bergamo, 1975.

Gregori 1976
M. GREGORI, 'Addendum to Caravaggio : the Cecconi 'Crowning with Thorns' *Burlington Magazine*, CXVIII, 1976, p. 671–80.

Grieco 1963
M. GRIECO, *Francesco Guarini da lofra nella pittura napoletana del '600*, Avellino, 1963.

Grimm 1977
C. GRIMM, *Natura in posa – Olanda*, Milan, 1977.

Griseri 1961
A. GRISERI, 'Luca Giordano "alla maniera di"', *Arte Antica e Moderna*, 13–16, 1961, p. 426–27.

Grosso-Cacopardo 1821
G. GROSSO-CACOPARDO, *Memorie de' pittori messinesi e degli esteri*, Messina 1821.

Harris 1963
E. HARRIS, 'Spanish painting in Paris', *Burlington Magazine*, CV, 1963, p. 321–24.

Haskell 1963
F. HASKELL, *Patrons and Painters – A study in the relations between Art and Society in the Age of the Baroque*, London and New Haven, 1963, second edition, 1980.

Heil 1942
W. HEIL, 'Neapolitan Baroque Paintings in the De Young Museum', *Pacific Art Review*, II, 1942, p. 10–14.

Heinz 1960
G. HEINZ, *Katalog der Graf Harrach'schen Gemäldegalerie*, Vienna, 1960.

Heinz 1962
G. HEINZ, 'Zwei wiedergefundene Bilder aus der Galerie des Erzherzogs Leopol Wilhelm', *Jahrbuch der Kunsthistorischen Sammlung in Wien*, 58, 1962, p. 169f.

Herzog 1968
E. HERZOG and J. LEHMANN, *Unbekannte Schatze der Kassler Gemälde-Galerie*, 1968.

Hess 1954
J. HESS, 'Modelle e modelli del Caravaggio', *Commentari*, V, 1954, p. 271–89; republished with addition in *Kunstgeschichtliche Studien zu Renaissance und Barock*, Rome, 1967.

Hibbard 1965
H. HIBBARD, M. LEWINE, 'Seicento at Detroit', *Burlington Magazine*, CVII, 1965, p. 370–72.

Hinks 1953
R. HINKS, *Michelangelo Merisi da Caravaggio, his Life, his Legend, his Works*, London, 1953.

Hohenzollen 1980
J. G. VON HOHENZOLLEN, *Staatsgalerie Schleissheim*, Munich, 1980.

Holmes 1925
C. J. HOLMES, *The National Gallery*, London, 1925.

Hoogewerff 1923–34
G. J. HOOGEWERFF, 'Nature morte italiane del 600 e 700', *Dedalo*, IV, 1923–24, p. 599–624.

Hoogewerff 1943
G. HOOGEWERFF, 'Hendrick van Somer, Schilder van Amsterdam, navolger van Ribera', *Oud Holland*, 1943, p. 158–72.

Houston 1981
A Guide to the Collection, Houston Museum of Fine Arts, 1981.

Ivanoff 1933
N. IVANOFF, 'Intorno al Langetti', *Bollettino d'Arte*, 1933, p. 320–22.

Jaffé 1977
M. JAFFE, *Rubens in Italy*, Oxford, 1977.

Jullian 1955
R. JULLIAN, 'Caravage à Naples', *Revue des Arts*, V, 1955, p. 79–90.

Jullian 1961
R. JULLIAN, *Caravage*, Lyon and Paris, 1961.

Justi 1903, 1959
C. JUSTI, *Velasquez und sein Jahrhundert*, 1903; Italian ed., Florence, 1959.

Juynboll 1960
JUYNBOLL, 'Bernardo Cavallino' *Bulletin Museum Boymans van Beuningen*, 1960, p. 80–91.

Kallab 1906–07
W. KALLAB, 'Caravaggio', *Jahrbuch der kunsthistorischen Sammlungen des allerhöchsten Kaiserhauses*, 26, 1906–07, p. 272–92.

Kitson 1969
M. KITSON, *The Complete Paintings of Caravaggio*, London, 1969.

Konečný 1973
L. KONECNY, 'Another "postilla" to the *Five Senses* by Jusepe de Ribera', *Paragone*, XXIV, 1973, p. 85–91.

Kurz 1935
O. KURZ, 'Guido Reni', in *Old Master Drawings*, 1935, p. 14–16.

Labrot 1979
G. LABROT, *Baroni in Citta: Residenze e Compartamenti dell' Aristocrazia Napoletana 1530–1734*, Naples, 1979.

Lafuente Ferrari 1953
E. LAFUENTE FERRARI, *Breve historia de la pintura española*, Madrid, 1953.

Lalande 1769
J. J. DE LALANDE, *Voyage d'un Français en Italie fait dans les années 1765–66*, Venice and Paris, 1769, 8.

Landolfi 1852
L. LANDOLFI, *De' Dipinti e della vita di Francesco Guarini da Solofra*, Naples, 1852.

Lasarte 1947
J. AINAULD DE LASARTE, 'Ribalta y Caravaggio', in *Annales y Boletin los Museos de Arte de Barcelona*, V, 1947, p. 345–413.

Lasarte 1955
J. AINAULD DE LASARTE, 'Le Caravagisme en Espagne', *Cahiers de Bordeaux*, 1955, II, . 22–'5.

Lattuada 1980
R. LATTUADA, 'Napoli Vicereale: il Seicento', *Napoli e la Campania*, Rome, 1980, p. 269–319.

Lattuada 1982
R. LATTUADA, 'Problemi de filologia e di committenza nelle opere di Francesco Guarino alla Collegiata di S. Michele Arcangelo a Solofra', *Annali della Facoltà di Lettere e Filosofia dell' Università di Napoli*, forthcoming publication.

La Valletta 1970
The Order of St. John in Malta, exhibition catalogue, La Valletta, 1970.

La Valletta 1978
The Church of St. John in Valletta 1578–1978, La Valletta, 1978.

Leli 1975
C. LELI, 'Dipinti di Mattia Preti nella Germania Ovest', *Brutium*, II–III 1975, p. 75.

LEVEY 1962
M. LEVEY, 'Notes on the Royal Collection, II Artemisia Gentileschi's "Self-Portrait" at Hampton Court', *Burlington Magazine*, CIV, 1962, p. 79–80.

Levey 1964
M. LEVEY, *Later Italian Paintings in the Collection of Her Majesty The Queen*, Lndon 1964.

Levey 1970
M. LEVEY, 'The order of St. John in Malta, Exhibition at La Valletta', *Burlington Magazine*, CXII, 1970, p. 554–57.

Levey 1971
M. LEVEY, *National Gallery Catalogues: The Seventeenth and Eighteenth Centuries*, London, 1971.

Levey 1973
M. LEVEY, 'Solimena's "Dido receiving Aeneas and Cupid disguised as Ascanius"', *Burlington Magazine*, CXV, 1973, p. 385–90.

Libertini 1937
G. LIBERTINI, *Il Castello Ursino e le raccolte artistiche comunali di Catania*, Catania, 1937.

Liebmann 1968
M. J. LIEBMANN, 'A Signed Picture by Bernardo Cavallino in the Pushkin Museum, Moscow', *Burlington Magazine*, CX, . 456–/9.

Linnik 1975
LINNIK and OTHERS, *Caravaggio and his followers, Paintings in the Soviet Museums*, 1975.

London 1913–14
Exhibition of Spanish Old Masters, exhibition catalogue, Grafton Galleries, London, 1913–14.

London 1930
Exhibition of Italian Art 1200–1900, exhibition catalogue Royal Academy, London, 1930.

London 1950
Paintings by Old Masters, exhibition catalogue P. & D. Colnaghi, London, 1950.

London 1950–51
Works by Holbein and Other Masters, exhibition catalogue, Royal Academy, London, 1950–51.

London 1952
Vasari to Tiepolo, exhibition catalogue, Hazlitt Gallery, London, 1952.

London 1960
Italian Art and Britain, exhibition catalogue introduced by E. K. Waterhouse, Royal Academy, London, 1960.

London 1961
Paintings by Old Masters, exhibition catalogue, P. & D. Colnaghi, London, 1961.

London 1962
Primitives to Picasso, exhibition catalogue, Royal Academy, London, 1962.

London 1971
Fourteen Important Neapolitan Paintings, exhibition catalogue, Heim Gallery, London, 1971.

London 1973
England and the Seicento, exhibition catalogue, Agnews, 1973.

London 1975
Paintings by Luca Giordano, exhibition catalogue, Heim Gallery, London, 1975.

London 1979
Old Master Paintings and Drawings, exhibition catalogue, Colnaghi & Co., London, 1979.

London 1981
Important Italian Baroque Paintings 1600–1700, exhibition catalogue, Matthiesen Gallery, London, 1981.

Longhi 1915
R. LONGHI, 'Battistello', *L'Arte*, 1915; p. 58–75; 120–35.

Longhi, 1916[1]
R. LONGHI, 'Gentileschi padre e figlia', *trte*, XIX, 1916, p. 246–316.

Longhi, 1916[2]
R. LONGHI, review of *Mattia Preti* by B. Chimirri and A. Frangipane', *L'Arte*, 1916, p. 370–71.

Longhi 1920
R. LONGHI, Note in *L'Arte*, XXIII, 1920, p. 89–91.

Longhi 1927
R. LONGHI, 'Un S. Tommaso de Velasquez e le congiunture italo-spagnole tra il '5 e il '600', *Vita Artistica* 1927, p. 4–12.

Longhi 1928–29
R. LONGHI, 'Me pinxit' and 'Quesiti caravaggeschi', *Pinacotheca* 1, 1928, p. 17–33; 5–6, 1929, 258–320; reprinted in *Opere complete*, IV, Florence, 1968.

Longhi 1935
R. LONGHI, 'I pittori del realtà in Francia, ovvero i Caravaggeschi francesi del Seicento' *Italia letteraria*, January, 1935, p. 1; reprinted in *Paragone*, CCLXIX, 1935, p. 3–18.

Longhi 1943[1]
R LONGHI, 'Ultimi studi sul Caravaggio e la sua cerchia', *Proporzioni*, 1943, p. 5–63.

Longhi 1943[2]
R. ONGHI, 'Ultimissime sul Caravaggio', in *Proporzioni*, I, 1943, p. 99–102.

Longhi 1950
R. LONGHI, 'Velasquez 1630, la rissa all'ambasciata di Spagna', *Paragone*, 1950, 1, p. 28–34.

Longhi 1952
R. LONGHI, *Il Caravaggio*, Milan, 1952.

Longhi 1957[1]
R. LONGHI, 'Due dipinti del Battistello', *Paragone*, LXXXV, 1957, p. 102–04.

Longhi 1957[2]
R. LONGHI, 'Una traccia per Filippo Napolettano', *Paragone*, 1957, p. 33–62.

Longhi 1959
R. LONGHI, 'Un' opera estrema del Caravaggio', *Paragone*, CXI, 1959, p. 21–32.

Longhi 1960
R. LONGHI, 'Un' originale di Caravaggio a Rouen e il problema delle copie caravaggesche', *Paragone*, CXXI, 1960, p. 23–36.

Longhi 1961
R. LONGHI, *Scritti Giovanili*, Florence, 1961, reprinted 1980.

Longhi 1968
R. LONGHI, *Caravaggio*. Rome and Dresden, 1968.

Longhi 1969
R. LONGHI, 'G. B. Spinelli e i naturalisti napoletani del Seicento', *Paragone*, CCXXVII, 1969, p. 42–52.

Los Angeles 1976
Women Artists 1550–1950, 1976, exhibition catalogue ed. Ann Sutherland Harris & Linda Nochlin, 1976.

Luzio 1913
A. LUZIO, *La Galleria dei Gonzaga venduta all' Inghilterra nel 1627–28* Milan, 1913.

Madrazo 1872
P. DE MADRAZO, *Catalogo de los quadros del Museo del Prado*, Madrid, 1872.

Mahon 1951[1]
D. MAHON, O. GREEN, 'Caravaggio's Death, A New Document', *Burlington Magazine*, CXIII, 1951, p. 202–04.

Mahon 1951[2]
D. MAHON, 'Egregius in Urbe Pictor: Caravaggio revised', *Burlington Magazine*, CXIII, 1951, p. 223–34.

Mahon 1952
D. MAHON, 'Addenda to Caravaggio', *Burlington Magazine*, CXIV, 1952, p. 3–23.

Mahon 1956
D. MAHON, 'Un tardo Caravaggio ritrovato', *Paragone*, LXXVII, 1956, p. 25–34, reprinted in *Burlington Magazine*, CXVIII, 1956, p. 225–28.

Mahoney, 1964
M. MAHONEY, in Minneapolis Institute of Art Bulletin, LIII, 1964, p. 69.

Mâle 1932
E. MALE, *L'art réligieux après le Concile de Trent*, Paris, 1932.

Maltese 1956
C. MALTESE, 'La formazione culturale di Vincenzo Gemito e i suoi rapporti con il Caravaggio', *Colloquio del sodalizio tra studiosi dell' arte*, II, Rome, 1956.

Malvasia 1678
C. MALVASIA, *Felsina Pittrice*, 2 vols., 1678, 1841 edition.

Mancini 1956–57
G. MANCINI, *Considerazioni sulla pittura*, c. 1619/21, ed. A. Marucchi and L. Salerno, 2 vols, Rome, 1956–57.

Mander 1603
K. VAN MANDER, *Het Leven der Moderne oft dees-tijtsche doorluchtighe Italiaensche Schilders*, Alkmaar, 1603.

Mantz 1881
P. MANTZ, "La collection de Roxard de la Salle', *Gazette des Beaux Arts*, XXIII, 1881, p. 249–57.

Marangelli 1967
F. MARANGELLI, 'Paolo Finoglio', *Archivio Storico Pugliese*, 1967, p. 195–210.

Marangelli 1979
F. MARANGELLI, 'Paolo Finoglia attraverso i documenti', *Quaderni Conversanesi*, 1979, p. 1–19.

Marangoni 1922
M. MARANGONI, *Il Caravaggio*, Florence, 1922.

Mariani 1929
V. MARIANI, *Mattia Preti a Malta*, Rome, 1929.

Mariani 1973
V. MARIANI, *Caravaggio*, Rome, 1973.

Marini 1971
M. MARINI, 'Tre proposte per il Caravaggio meridionale' *Arte Illustrata*, 43–44, 1971, p. 56–65.

Marini 1973[1]
M. MARINI, 'Due inediti di Battistello Caracciolo', *Paragone*, CCLXXIX, 1973, p. 77ff.

Marini 1973[2]
M. MARINI, 'Caravaggio 1607: la 'Negazione di Pietro *Napoli Nobilissima* XII, 1973, p. 189–94.

Marini 1974[1]
M. MARINI, *Io Michelangelo da Caravaggio*, Rome, 1974, first edition published privately 1973.

Marini 1974[2]
M MARINI, *Pittori a Napoli, 1610–1656 – Contributi e schede*, Rome, 1974.

Marini 1976
M. MARINI, 'Mattia Preti: Magnum picturae decus', *Ricerche di Storia dell' arte*, 1976.

Marini 1979[1]
M. MARINI, 'Michael Angelus Caravaggio romanus', *Studi barocchi*, I, Rome, 1979.

Marini 1979[2]
M. MARINI, Caravaggio a Genova', *Bollettino del Musei Civici Genovesi*, I, 4–3, 1979, p. 28–36.

Marini 1981
M. MARINI, 'Caravaggio e il naturalismo internazionale', *Storia dell'arte italiana*, Turin, 1981.

Marino 1968
A MARINO, 'Un Caravaggesco fra Controriforma e
Barocco, Antiveduto Gramatica', L'Arte, I, 1968, nos 3–4,
p. 47–82.

Marrow 1978
D. MARROW, 'A Massacre of the Innocents and the
Neapolitan Baroque', Bulletin of Philadelphia Museum of
Art, LXXIV, 1978, p. 22–11.

Masciotta 1942
M. MASCIOTTA, 'La Bella Maniera del Cavallino', Primato
1942, p. 147–48.

Masson 1981
A MASSON, The Pictorial Catalogue. Mural Decoration in
Libraries, Oxford, 1981.

Mayer 1908
A. MAYER, Jusepe de Ribera, Lo Spagnoletto, Leipzig,
1908.

Mayer 1923
A. MAYER, Jusepe de Ribera, Leipzig, 1923.

Mayer 1929
A MEYER, 'Genrebilder der Velázquez-Schule', Belvedere,
XIV, 1929, p. 261–64.

Melchiorri 1837
G. MELCHIORRI, 'S. Maria Egiziaca di Aniello Falcone',
L'ape italiana delle Belle Arti, 1837, p. 52–53.

Meroni 1978
U. MERONI, 'Lettere ed altri documenti', Fonti per la
pittura e scultura antica, VIII, 1978.

Middione 1982
R. MIDDIONE, La Quadreria dei Girolamini, Naples, 1982.

Miele 1963
M. MIELE, O.P., La Riforma Domenicana a Napoli nel
Periodo post-Trientino (1583–1725), Rome, 1963.

Milan 1929–39
Enciclopedia Italiana di Scienze Lettere ed Arti, 36 vols. with
supplements, Milan, 1929–39.

Milan 1951
Caravaggio e Caravaggeschi, exhibition catalogue, Palazzo
Reale, Milan, 1951.

Milan 1967
33 opere del seicento, exhibition catalogue ed. G. Testori,
Milan, 1967.

Milan 1981
Natura morta in Italia antica moderna e contemporanea,
exhibition catalogue, Milan, 1981.

Milicua 1954
J. MILICUA, 'Ineditos de Bernardo Cavallino', Goya, 1954,
p. 68–78.

Millar 1972
O. MILLAR, Inventories and Valuations of the King's
Goods 1649–51, Walpole Society, XLIII, 1970–72.

Milward 1926
I. MILWARD, 'The Carvalho Collection of Spanish Art',
International Studio, LXXXIV, 1926, p. 13–24.

Minneapolis 1970
Catalogue of European Paintings in the Minneapolis
Institute of Arts, Minneapolis, 1970.

Missirini 1823
M. MISSIRINI, Memorie della Accademia di S. Luca,
Rome, 1823, p. 470.

Mitchell 1973
P. MITCHELL, European Flower Painters, London, 1973.

Mitidieri 1913
S. MITIDIERI, 'Mattia Preti detto il Cavaliere Calabrese',
L'Arte, XVI, p. 428–50.

Moir 1967
A. MOIR, The Italian Followers of Caravaggio, 2 vols,
Cambridge, Mass., 1967.

Moir 1970

A. MOIR, 'Some Caracciolo Drawings in Stockholm',
Art Bulletin, LII, 1970, p. 184–87.

Moir 1976
A. MOIR, Caravaggio and his Copyists, New York, 1976.

Molajoli 1951
B. MOLAJOLI, La Galleria del Banco di Napoli, Naples,
1951.

Molajoli 1953
B. MOLAJOLI, Opere d'Arte del Banco di Napoli, Naples,
1953, p. 46.

Molajoli 1957
B. MOLAJOLI, Notizie su Capodimonte, Naples, 1957,
revised ed. 1965.

Mongiello 1979
L. MONGIELLO, 'Carlo Rosa: analisi e rapporti della sua
opera pittorica ed architettonica, Cultura e societa a Bitonto
nel sec. XVII. Bitonto, 1979.

Montalto 1920
L. MONTALTO, 'Il passaggio do Mattia Preti in Napoli',
L'Arte, XXIII, 1920, p. 207–25.

Montini 1952
R. MONTINI, Profilo storico dell'arte in Campania, Naples,
1952.

Morgan 1824
S. MORGAN, Life and Times of Salvator Rosa, 2 vols., 1824.

Mormone 1962
R. MORMONE, 'Domenico Antonio Vaccaro arcitteto' il
Palazzo Tarsia', Napoli Nobilissima, 1962, p. 216–27.

Mormone 1963–64
R. MORMONE, 'Un Battistello inedito' Napoli Nobilissima,
1963–64, p. 136–40.

Mravick 1978
L. MRAVICK, 'Un dipinto ritrovato del Battistello', Acta
historiae artium, 1978, p. 261–71.

Munster 1979
MUNSTER, BADEN-BADEN, Stillenben in Europa,
exhibition catalogue 1979–1980.

Naples 1938
Pittura napoletana dei secoli XVI, XVII, XVIII e XIX,
exhibition catalogue ed. S. Ortolani, Naples, 1938

Naples 1953
III Mostra di restauri, exhibition catalogue, Naples, 1953.

Naples 1954
La Madonna nella pittura del '600 a Napoli, exhibition
catalogue ed. R. Causa, Naples, 1954.

Naples 1955
Opere d'arte nel salernitano dal XII al XVIII secolo, Naples,
1955.

Naples 1960
IV Mostra di Restauri, exhibition catalogue ed. R. Causa,
Naples, 1960.

Naples 1963
Caravaggio e i caravaggeschi, exhibition catalogue
ed. G. Scavizzi, Naples, 1963.

Naples 1964
La natura morta italiana, exhibition catalogue ed. C. Volpe,
Naples, 1964; introductory essay by S. Bottari.

Naples 1966
Disegni napoletani del Sei e del Settecento nel Museo di
Capodimonte, exhibition catalogue ed. W. Vitzthum and
R. Causa, Naples, 1966.

Naples 1967
Arte Francese a Napoli, exhibition catalogue ed. M.
Casanova, Naples, 1967.

Naples 1972–73
Il secolo d'oro della pittura napoletana, exhibition catalogue
ed. R. Causa and N. Spinosa, Naples, 1972–73.

Naples 1975–76
Acquisizioni 1960–1975, exhibition catalogue ed, R. Causa,
Villa Pignatelli, Naples, 1975–76.

Naples 1977
Carlo Sellitto, exhibition catalogue, Naples, 1977.

Naples 1978
Storia dell'Arte Medioevale e Moderna, Università di Studi di Napoli, Naples, 1978–79 (forthcoming-*sic*).

Napoli Signorelli 1786
P. NAPOLI SIGNORELLI, *Vicende della Coltura delle Due Sicilie*, Naples, 1786.

Nappi 1980
E. NAPPI, *Aspetti della società e dell'economia napoletana durante la peste del 1656*, Naples, 1980.

Nasse 1911
H. NASSE, 'Gemälde aus der Sammlung des Univ.-Professors Dr. Freih. Fr. W. Von Bissing zu Münchner', *Jahrbuch der Bildenden Kunst*, VI, 1911, p. 94–117.

Neumann 1966
J. NEUMANN, *Die Gemäldegalerie der Prager Burg.*, Prague, 1966.

New York 1962
Neapolitan Masters of the XVII and XVIII centuries, exhibition catalogue, New York, 1962.

New York 1967
Masters of the Loaded Brush – Oil Sketches from Rubens to Tiepolo, exhibition catalogue, New York, 1967.

Newcastle 1960
Primitives to Picasso, Hatton Gallery, Newcastle, 1960, Paris 1962.

Newcome 1978
M. NEWCOME, 'A Castiglione-Leone problem', *Master Drawings*, 1978, p. 163–72.

Nicolson 1963
B. NICOLSON, 'Caravaggesques in Naples', *Burlington Magazine*, CV, 1963, p. 209–10.

Nicolson 1974[1]
B. NICOLSON, 'Recent Caravaggio Studies', *Burlington Magazine*, CXVI, 1974, p. 624–25.

Nicolson 1974[2]
B. NICOLSON, 'Caravaggio and the Caravaggesques: Some Recent Research', *Burlington Magazine*, CXVI, 1974, p. 603–16.

Nicolson 1979
B. NICOLSON, *The International Caravaggesque Movement*, Oxford, 1979.

Nobile 1855, 1863
G. NOBILE, *Descrizione della città di Napoli e delle sue vicinanze*, Naples, 1855, another edition 1863.

Novelli 1974
M. NOVELLI, 'Agostino Beltrano uno "stanzionesco" da riabilitare', *Paragone*, 1974, p. 67–82.

Novelli 1978
M. NOVELLI, 'Appunti per il pittore Niccolò di Simone, *Napoli Nobilissima*, 1978, p. 21–28.

Novelli Radice 1974
M. NOVELLI RADICE, 'Precisazioni cronologiche su Massimo Stanzione', *Campania Sacra*, 1974, p. 98–103.

Novelli Radice 1976
NOVELLI RADICE, 'Contributi alla conoscenza di Andrea e Onofrio De Leone', *Napoli Nobilissima*, 1976, p. 162–69.

Nugent 1930
M. NUGENT, *Alla mostra della pittura italiana del '600 e '700. Note e impressioni*, San Casciano Val di Pesa, 1930.

Ojetti 1924
U. OJETTI, N. TARCHIANI, L. DANI, *La pittura italiana del Seicento e del Settecento all mostra di Palazzo Pitti*, Milan, 1924.

Oretti 1760–80
M. ORETTI, *Notizie de' Professori del disegno . . .* MS B. 125, Biblioteca Communale, Bologna.

Orbaan 1920
J. A. F. ORBAAN, *Documenti sul Barocco in Roma*, Rome, 1920.

Ortolani 1922.
S. ORTOLANI, 'Cavalliniana', *L'Arte*, 1922, p. 190–99.

Ortolani 1938
S. Ortolani, 'La pittura napoletana dal Sei all'Ottocento', *Emporium*, XLIV, 1938, p. 173–93.

Ortolani 1970
S. ORTOLANI, *Giacinto Gigante e la pittura di paesaggio a Napoli e in Italia dal '600 all'800*, Naples, 1970.

Ottino Della Chiesa 1967
A. OTTINO DELLA CHIESA, *L'opera completa del Caravaggio*, introduction by R. Guttuso, Milan, 1967.

Ozzola 1908
L. OZZOLA, *Vite e opere di Salvator Rosa*, Strasbourg, 1908.

Ozzola 1951
L. OZZOLA, *I pittori di battaglie nel Seicento e nel Settecento*, Mantua, 1951.

Pacelli 1977[1]
V. PACELLI, 'Le arti visive, dal Cinquecento al Seicento', *Campania Venezia*, 1977, p. 350–470.

Pacelli 1977[2]
V. PACELLI, 'New Documents concerning Caravaggio in Naples, *Burlington Magazine*, CXIX, 1977, p. 819–29.

Pacelli 1978[1]
V. PACELLI, 'Caracciolo studies', *Burlington Magazine*, CXX, 1978, p. 493–97.

Pacelli 1979[1]
V. PACELLI, 'La collezione di Francesco Emanuele Pinto, principe di Ischitella', *Storia dell'Arte*, 36/37, 1979.

Pacelli 1979[2]
V PACELLI, 'Da Caravaggio a Mattia Preti', *La Voce della Campania*, October 1979, p. 732–37.

Pacelli and Bologna 1980
V. PACELLI and F. BOLOGNA, 'Caravaggio, 1610: la "Sant'Orsola confitta dal Tiranno" per Marcantonio Doria', *Prospettiva*, XXIII, October 1980, p. 24–45.

Palomino 1796
A. PALOMINO, *El parnaso espanol pintoresco laureado*, Madrid, 1796.

Paris 1804
Galerie du Musée Napoléon, Paris, 1804.

Paris 1960
La peinture italienne au XVIII siècle, exhibition catalogue, Paris, 1960.

Paris 1962, see Newcastle 1960.

Paris 1963
Les trésors de la Peinture espagnole, Eglises et Musées de France, exhibition catalogue ed. M. Laclotte, J. Batiche and M. Mesuret, Paris, 1963.

Paris 1965
Le Caravage et la peinture italienne du XVII siècle, exhibition catalogue, Paris, 965.

Paris 1967
Le dessin à Naples du XVIe siècle au XVIIIe siècle, exhibition catalogue ed. C. Monbeig Goguel, W. Vitzthum, Paris, 1967.

Paris 1974
Valentin et les caravagesques français, exhibition catalogue ed. A. Brejon de Lavergnée and J. Cuzin, Paris, 1974.

Pariset 1948
G. PARISET, *Georges de la Tour*, Paris, 1948.

Parisi 1842
C. PARISI, *Cenno ssorico-descrittivo del × a città di Castellammare di Stabia*, Florence, 1842.

Parks 1954
R. PARKS, 'Ribera's Early Drunken Silenus', *Bulletin of the Art Association of Indianapolis,*, 1954.

Parrino 1692
D. PARRINO, *Teatro eroico e politico de' governi de' Vicerè del Regno di napoli*, Naples, 1692.

Parrino 1700
D. PARRINO, *Napoli Città Nobilissima*, Naples, 1700.

Parrino 1725
D. PARRINO, *Nuova guida de' forastieri*, Naples, 1725.

Parro 1857
S. R. PARRO, *Toledo en el maño*, Toledo, 1857.

Pascoli 1736
L. PASCOLI, *Vite de' pittori, scultori e architetti moderni*, Rome, 1736.

Passeri ed. Hess 1934
G. B. PASSERI, ed. J. Hess, *Die Kunstlerbiographien von Giovanni Battista Passeri*, Leipzig – Vienna, 1934.

Pavone 1980
M. PAVONE, *Angelo Solimena*, Salerno, 1980.

Pée 1971
H. PEE, *Johann Heinrich Schönfeld. Die Gemälde*, Berlin, 1971.

Pelaggi 1972
A. PELAGGI, *Mattia Preti e il Seicento italiano*, Catanzaro, 1972.

Pepper 1972
D. PEPPER, 'Caravaggio riveduto e corretto: la mostra di Cleveland', *Arte Illustrata*, 1972, p. 170–78.

Percy 1965
A. PERCY, Doctoral Thesis on G. B. Castiglione, Pennsylvannia State University, Department of Art History, 1965.

Perera 1955
J. PERERA, 'En torno a Bartolomé Passante', *Archivo Español de Arte*, XXVIII, 1955, p. 266–73.

Perera 1957
J. PERERA, 'Bartolomé Passante y el "Maestro del Anuncio a los pastores"', *Archivo Español de Arte*, XXX, 1957, p. 211–22.

Perez Sanchez 1961
A. PEREZ SANCHEZ, 'Una nueva obra del "Maestro del Anuncio a los pastores"', *Archivo Español de Arte*, XXXIV, 1961, p. 325–27.

Perez Sanchez 1965
A. PEREZ SANCHEZ, *Pintura italiana del siglo XVII en España*, Madrid, 1965.

Perez Sanchez, 1968
A. Perez Sanchez, 'Nouveaux chefs-d'oeuvre au Prado', *L'Oeil*, 1968, p. 34

Perez Sanchez 1978
A. PEREZ SANCHEZ, *Los Ribera de Osuna*, Seville, 1978.

Perotta 1830
V. PERROTTA, *Descrizione storica della chiesa e del monastero di San Domenico*, Naples, 1830 (2nd ed. 1842).

Petraccone 1919
E. PETRACCONE, *Luca Giordano*, Naples, 1919.

Petrucci 1938
A. PETRUCCI, 'Linguaggio di Marcantonio', *Bollettino d'Arte*, XXXI, 1938, p. 403–18.

Pevsner 1927–28
N. PEVSNER, 'Eine Revision der Caravaggio-Daten', *Zeitschrift für bildenden Kunst*, 1927–28, p. 386–92.

Pevsner and Grautoff 1928
N. PEVSNER, O. GRAUTOFF, *Barockmalerei in den romanischen Ländern*, Wildpark-Potsdam, 1928.

Philadelphia 1971
G. B. Castiglione, Master Draughtsman of the Italian Baroque, exhibition catalogue ed. A. Percy, Philadelphia, 1971.

Piacentini 1939
M. PIACENTINI, 'Gli artisti a Roma nel 1634', *Archivi*, VI, 1939.

Pietri 1634
F. DE' PIETRI, *Historia napoletana*, Naples, 1634.

Pigler 1931
A. PIGLER, 'Pacecco De Rosa müvézetéhez (mit deutschem Auszug: Beitrage zur Kunst des P.De R.)', *Archaeologiai Ertesitö 45*, Budapest, 1931.

Pigler 1934
A. PIGLER, 'Valère Maxime et l'iconographie des temps modernes', *Hommage à Alexis Petrovics*, Budapest, 1934.

Pigler 1956
A. PIGLER, *Barockthemen*, Vienna 1956

Pillsbury 1982
E. PILLSBURY, 'Recent Painting Acquisitions: the Kimbell Art Museum', supplement to the *Burlington Magazine*, CXXIV, 1982, p. i–viii.

Pinelli 1981
A. PINELLI, 'Un sublime fotogramma', *Il Messagero*. 4 April, 1981.

Ponz 1776
A. PONZ, *Viaje en España*, Madrid, 1776, reprinted Madrid

Posner 1962
D. POSNER, review of W. Crelly, 'The Paintings of Simon Vouet', *Art Bulletin*, XLV, 1963, p. 286–91.

Princeton 1980
Italian Baroque Paintings from New York Private Collections, exhibition catalogue ed. J. Spike, Princeton, 1980.

Prohaska 1973
W. PROHASKA, *Caracciolo*, doctoral thesis, University of Vienna, 1973.

Prohaska 1975
W. PROHASKA, 'Carlo Sellitto', *Burlington Magazine*, CXVII, 1975, p. 3–12.

Prohaska 1978
W. PROHASKA, 'Beiträge zu Battistello Caracciolo', *Jahrbuch der Kunsthistorischen Sammlungen in Wien*, LXXIV, 1978, p. 153–269.

Prohaska 1980
W. PROHASKA, 'Untersuchungen zur "Rosenkranzmadonna" Caravaggios', *Jahrbuch der kunsthistorischen Sammlungen in Wien*, LXXVI, 1980, p. 111–32.

Prota Giurleo 1952
V. PROTA GIURLEO, 'Un complesso familiare di artisti napoletani del secolo XVII', *Napoli-Rivista Municipale*, 1951, p. 19–32.

Prota Giurleo 1953
V. PROTA GIURLEO, *Pittori napoletani del Seicento*, Naples, 1953.

Prota Giurleo 1957
V. PROTA GIURLEO, *Documento per le Chiese dei SS Apostoli a Napoli*, Naples, 1941.

Prota Giurleo 1962
V. PROTA GIURLEO, *I Teatri di Napoli nel '600*; Naples 1962.

Pugliatti 1977
T. PUGLIATTI, *Agostino Tassi*, Rome, 1977.

Putaturo-Murano 1975, 1976
A. PUTATURO-MURANO, 'Filippo Napoletano incisore', *Archivio Storico per le Province Napoletane*, IV, XIV, 1975, reprinted 1976, p. 185–209.

Quarta 1939
G. QUARTA, 'Documenti estratti dall'Archivio Storico del Banco di Napoli', *Rassegna Economica*, 193, p. 477–80, 517–20, 557–60.

Ratti 1780
C. RATTI, *Descrizione delle pitture . . . dello Stato ligure*, Genoa, 1780.

Réau 1958
L. REAU, *Iconographie de l'art chrétien*, Paris, 1958.

Refice 1951

C. REFICE, 'Ancora del pittore Bernardo Cavallino', *Emporium*, 1951, p. 259–70.

Refice 1970
C. REFICE, *Mattia Preti. Contributi alla conoscenza del cavaliere calabrese*, Naples, 1970.

Richard 1770
J. B. RICHARD, *Description historique et critique de l'Italie*, Paris, 1770.

Rinehart 1961
S. RINEHART, 'Cassiano dal Pozzo (1598–1657). Some unknown letters', *Italian Studies*, XVI, 1961, p. 35–59.

Ritschl 1926
H. RITSCHL, *Katalog der Erlaucht Graflich Harrachschen Gemälde Galerie in Wien*, Vienna, 1926.

Rizzi 1970
A. RIZZI, 'Una tela inedita di Mattia Preti in Slovenia', *Napoli Nobilissima*, 1970, p. 20–23.

Roberti 1910
M. ROBERTI, *Sta. Maria della Stella ovvero la chiese e il converto dei P. P. Minimi in Napoli*, Naples, 1910.

Roethlisberger 1975
M. ROETHLISBERGER, 'Around Filippo Napoletano', *Master Drawings*, XIII, 1975, p. 23–24.

Roettgen 1969
H. ROETTGEN, 'Caravaggio Probleme', *Münchner Jahrbuch der bildenden Kunst*, XX, 1960, p. 143–70.

Rolfs 1910
W. ROLFS, *Geschichte der Malerei Neapels*, Leipzig, 1910.

Romanelli 1815
D. ROMANELLI, *Napoli antica e moderna*, 3 vols., Naples 1815, another edition 1834.

Rome 1950
I Bamboccianti pittori della vita popolare nel Seicento, exhibition catalogue ed. G. Briganti, Rome, 1950.

Rome 1956–57
Il Seicento Europeo. Realismo o Classicismo Barocco, exhibition catalogue ed. L. Salerno, A. Marabottini, Rome, 1956–57.

Rome 1958
Pittori napoletani del '600 e del '700, exhibition catalogue ed. Nolfo di Carpegna, Rome, 1958.

Rome 1973[1]
I Caravaggeschi francesi, exhibition catalogue ed. A. Brejon de Lavergnée and J. Cuzin, Rome, 1973.

Rome 1973[2]
Il Cavalier D'Arpino, exhibition catalogue, Rome, 1973.

Rome 1974
Caravaggio e i caravaggeschi, atti del colloquio, 12–14 February, 1973, Accademie Nazionale dei Lincei, no. 205.

Rome 1980
Napoli e la Campania, exhibition catalogue ed. R. Lattuada, Rome, 1980.

Rome 1982
Claude Lorrain e i pittori lorenesi in Italia nel XVII secolo, exhibition catalogue, Rome 1982.

Rosci 1971
M. ROSCI, *Baschenis, Bettera, Mercato della natura morta del 600 in Italia*, Milan, 1971.

Rosci 1977
M. ROSCI, *Natura in posa*, Italia, Milan, 1977.

Rosenberg 1968
P. ROSENBERG, 'Une toile de Bernardo Cavillino au Musée des Beaux-Arts', *Bulletin des Musées et Monuments Lyonnais*, IV, 1968, p. 149–156.

Rotterdam 1965
Het Italiaanse Stilleven, exhibition catalogue, Rotterdam, 1965.

Rouchès 1920
G. ROUCHES, *Le Caravage*, Paris, 1920.

Rubsamen 1980
G. RUBSAMEN, *The Orsini Inventories*, Malibu, 1980.

Ruffo 1916
V. RUFFO, 'La Galleria Ruffo nel secolo XVII a Messina', *Bollettino d'Arte*, X, 1916, p. 21f, 95f.

Ruggiero 1902
M. RUGGIERO, 'Il Monte della Misericordia', *Napoli Nobilissima*, XI, 1902, p. 7–10.

Ruotolo 1973
R. RUOTOLO, 'Collezioni e mecenati napoletani del XVII secolo', *Napoli Nobilissima*, 1973 XIII, p. 118–19, 145–53.

Ruotolo 1977
R. RUOTOLO, 'Aspetti del collezionismo napoletano: il Cardinale Filomarino', *Antologia di Belli Arti*, 1977, I, p. 71–82.

Ruotolo 1979
R. RUOTOLO, 'Brevi note sul collezionismo aristocratico napoletano tra Sei e Settecento', *Storia dell'Arte*, XXXV, 1979, p. 29–38.

Ruotolo 1982
R. RUOTOLO, *Mercanti-collezionisti fiamminghi a Napoli. Gaspare Roomer e i VandenEynden*, Meta di Sorrento, 1982.

Saccà 1906
V. SACCA, 'Michelangelo da Caravaggio pittore', *Archivio Storico Messinese*, VII, 1906, p. 40–69.

Sade 1775–76
D. DE SADE, 'Voyage d'Italie', *Oeuvres complètes du Marquis de Sade*, ed. C. Tchou, Paris, 16 vols., 1961–67.

Salazar 1895
L. SALAZAR, 'Documenti inediti intorno ad artisti napoletani del secolo XVII', *Napoli Nobilissima*, 1895, IV, XII, p. 187; V, VIII, p. 123–25.

Salerno 1955
Opere d'arte nel salernitano dal XII al XVIII secolo, exhibition catalogue ed. F. Bologna, Naples, 1955.

Salerno 1958
L. SALERNO, 'Per Sisto Badalocchio e la cronologia del Lanfranco', *Commentari* IX, 1958, p. 60.

Salerno 1963
L. SALERNO, *Salvator Rosa*, Milan, 1963.

Salerno 1975
L. SALERNO, *L'opera completa di Salvator Rosa*, Milan, 1975.

Salerno 1977–82
L. SALERNO, *Pittori di paesaggio del Seicento a Roma*, 3 vols., Rome, 1977–82.

Salerno and others 1966
L. SALERNO, D. KINKHEAD, W. WILSON, 'Poesia e simboli nel Caravaggio' *Palatino*, April, June, 1966, p. 106–17.

Salerno 1970
L. SALERNO, 'Il vero Filippo Napoletano e il vero Tassi', *Storia dell'Arte*, 6, 1970, p. 139–50.

Sarasota 1961
The Baroque Painters of Naples, exhibition catalogue ed. C. Gilbert, Ringling Museum, Sarasota, 1961.

Sarnelli 1685
P. SARNELLI, *Guida de' forestier curiosi di vedere e intendere le cose più notabili della città di Napoli e del suo amenissimo distretto*, 1685 and many subsequent editions.

Saxl 1939–40
F. SAXL 1939–40 'The battle scene without a hero. Aniello Falcone and his patrons' *Journal of the Warburg and Courtauld Institutes*, III, 1939–40, p. 70–87.

Scannelli 1657
F. SCANNELLI, *Il Microcosmo della Pittura*, Cesena, 1657.

Scaramuccia 1674
L. SCARAMUCCIA, *Le finezze de' pennelli ammirate e studiate da Girupeno (Perugino) sotto la scorta di Rafaello d'Urbino*, Pavia, 1674.

Scavizzi 1963, see Naples 1963

Scharf 1950
A. SCHARF, 'Francesco Desiderio', *Burlington Magazine*, XCII, 1950, p. 18–22.

Schleier 1965
E. SCHLEIER, 'Lanfrancos Malerien der Sakramentskapelle in S. Paolo fuori le Mura in Rom' (III), *Arte Antica e Moderna*, 31–32, p. 363f.

Schleier 1968
E. SCHLEIER, 'Una postilla per i Cinque sensi del giovane Ribera', *Paragone*, CCXVII, 1968, p. 79–80.

Schleier 1971
E. SCHLEIER, 'Caravaggio e caravaggeschi nelle Gallerie di Firenze. Zur Austellung im Palazzo Pitti', *Kunstchronik*, 1971, p. 100–02.

Schleier 1975
E. SCHLEIER, 'Unbekanntes von Francesco Guarino. Beitrage zur Neapolitanischen Seicentomalerei', *Pantheon*, XXXIII, Heft I, 1975, p. 27–33.

Schleier 1976
E. SCHLEIER, 'Charles Mellin and the Marchesi Muti', *Burlington Magazine*, CXVIII, 1976, p. 837–44.

Schleier 1979
E. SCHLEIER *Von Caravaggio und Poussin bis Tiepolo*, Gemäldegalerie Berlin, series Museum, Brunswick, 1979, p. 79.

Schleier 1980
E. SCHLEIER, 'Due opere "toscane" del Lanfranco', *Paragone*, CCCLIX–CCCLXI, 1980, p. 29–31.

Schneider 1933
A. VON SCHNEIDER, *Caravaggio und die Niederländer*, Marburg 1933.

Schudt 1942
L. SCHUDT, *Caravaggio*, Vienna, 1942.

Schwanenberg 1937
H. SCHWANENBERG, *Leben und werk des Massimo Stanzioni. Ein Beitrag zur Geschicht der Neapolitanischen Malerei des XVII Jahrhunderts*, Bonn, 1937.

Seghers 1981
P. SEGHERS, 'L'invitation aux Enfers', *Connaissance des Arts*, 1981, p. 41–46.

Sergi 1927
A. SERGI, *Mattia Preti e il seicento italiano*, Acireale, 1927.

Sestieri 1920
E. SESTIERI, 'Cenni sullo svolgimento dell'arte di Bernardo Cavallino', *L'Arte*, p. 245–69, 1920, XXIII, p. 245–69.

Sestieri 1921
E. SESTIERI, 'Ricerche su Cavallino', *Dedalo*, II, 1921, p. 188–97.

Sestieri 1972
E. SESTIERI, 'Due Luca Forte', *Commentari*, IV, 1972, p. 376–80.

Seville 1973
Caravaggio y los caravaggistas en España, exhibition catalogue, Seville, 1973

Sigismondo 1788
G. SIGISMONDO, *Descrizione della città di Napoli . . .*, Naples, 1788.

Sluys 1954
F. SLUYS, 'Le lorrain Didier Barra est identifié aujourd'hui avec l'énigmatique Monsu Desiderio peintre des cataclysmes', *Les Beaux-Arts*, no 655, 1954.

Sluys 1961
F. SLUYS *Monsù Desiderio*, Paris, 1961.

Soehner 1955
H. SOEHNER, 'Die Malerei in Frankreich und Spanien um Caravaggio', *Kunstchronik*, VIII, 9, p. 250.

Soprani 1674
R. SOPRANI, *Le vite de' pittori, scoltori et architetti genovesi*, Genoa, 1674.

Soprani 1768
R. SOPRANI, G. RATTI, *Vite de' pittori, scultori e architetti genovesi*, Genoa, 1768.

Soria 1954
M. SORIA, 'Some paintings by Aniello Falcone', *Art Quarterly*, XVII, 1954, p. 3–15.

Soria 1960
M. SORIA, 'Andrea De Leone, a master of the bucolic scene', *Art Quarterly*, 1960, p. 23–35.

Soria 1961
M. SORIA, 'Spanish paintings in the Bowes Museum', *The Connoisseur*, August 1961, p. 30–37.

Spear 1968
R. SPEAR, 'Preparatory Drawings by Domenichino', *Master Drawings*, 1968 p. 111f.

Spear 1975, see Cleveland 1975.

Spear 1980
R. SPEAR, 'Princeton-Italian Baroque Paintings', *Burlington Magazine*, 1980, CXXII, p. 716–20.

Spielmann 1913
M. SPIELMANN, *The Angel appearing to the Shepherds by Velasquez*, 1913.

Spike 1978
J. SPIKE, 'Mattia Preti's passage to Malta', *Burlington Magazine*, CXX, 1978, p. 497–507.

Spike 1979[1]
J. SPIKE, 'The Feast of Absalom by Mattia Preti', *Annual Bulletin – National Gallery of Canada*, 1979.

Spike 1979[2]
J. SPIKE, 'Documents for Mattia Preti and the renovation of the Chapel of France, 1633–1668, in the co-Cathedral of St. John, Valletta', *Storia dell'Arte*, XXV, 1979, p. 5–10.

Spinazzola 1902
V. SPINAZZOLA, 'La Certosa di S. Martino', *Napoli Nobilissima*, XI, 1902, p. 97–103, 116–21, 133–39, 161–70.

Spinosa 1978
N. SPINOSA, *L'opera completa del Ribera*, introduction by A. E. Perez Sanchez, Milan, 1978.

Spinosa 1979
N. SPINOSA, 'More unpublished works by Francesco Solimena', *Burlington Magazine*, CXXI 1979, p. 211–20.

Spinosa 1982
N. SPINOSA, 'Aggiunte a Giovan Battista Spinelli', *Paragone*, 1982 in course of publication.

Stechow 1956
W. STECHOW, review of W. Friedlaender, *Caravaggio Studies*, Art Bulletin, XXXVIII, 1956, pp. 58–63.

Sterling 1952
C. STERLING, *La Nature Morte*, Paris, 1952.

Sterling 1959
C. STERLING, *La nature morte de l'Antiquité à nos jours*, Paris, 1959.

Stirling-Maxwell 1848
W. STIRLING-MAXWELL, *Annals of Artists in Spain*, 1848.

Storia di Napoli
Storia di Napoli, Naples, XI vols. 1967–82.

Stoughton 1973
M. STOUGHTON, *The Paintings of Giovan Battista Caracciolo*, Doctoral Thesis, Ann Arbor (Mich.) 1973.

Stoughton 1977
M. STOUGHTON, 'Recensione alla mostra didattica di Carlo Sellitto: primo caravaggesco napoletano', *Antologia di Belle Arti*, 1977, 4, p. 366–69.

Stoughton 1978
M. STOUGHTON, 'Giovan Battista Caracciolo: New Biographical Documents', *Burlington Magazine*, CXX, 1978, pp. 204–205.

Strazzullo 1955
F. STRAZZULLO, *Documenti inediti per la storia dell'arte a Napoli*, Naples, 1955.

Strazzullo 1965
F. STRAZZULLO, 'Documenti per la chiesa di S.Maria del
Pianto', *Napoli Nobilissima*, ns. IV, 1965, p. 222–25.

Strazzullo 1973
F. STRAZZULLO, *Edilizia e Urbanistica a Napoli dal '500 al
'700*, Naples, 1968.

Strazzullo 1978
F. STRAZZULLO, *La Real Cappella del Tesoro di S.
Gennaro – Documenti Inediti*, Naples 1978.

Sutton 1957
D. SUTTON, 'Seventeenth-Century Art in Rome', *Burlington
Magazine*, XCIX, 1957, p. 109–15.

Tarchiani 1911
N. TARCHIANI, 'La Mostra del Ritratto Italiano dalla fine
del secolo XVI all'anno 1861, in Palazzo Vecchio a Firenze',
Rassegna d'Arte, XI, 1911, p. 77–92.

Testori 1975
G. TESTORI, 'Tre nuovi Caravaggio che faranno discutere',
Corriere della Sera, 8 October, 19)5.

Thieme, Becker 1911
U. THIEME, F. BECKER, *Allgemeines Lexikon der
bildenden Kunstler* Leipzig, 1907–50.

Thompson and Brigstocke 1970
C. THOMPSON and H. BRIGTOCKE, *Shorter Catalogue of
the National Gallery of Scotland*, 1970.

Thuillier 1960
J. THUILLIER, *Poussin et ses premiers compagnons français
à Rome*, Paris, 1960.

Thuillier 1962
J. THUILLIER and W. VITZTHUM, 'Un nouveau dessin de
Poussin pour Marino', *Art de France*, 1962, p. 265.

Thuillier 1981
J. THUILLIER, *Charles Mellin "très excellent peintre"*,
Foundations Nationales dans la Rome Pontificale, Rome,
1981 Atti del Convegno.

Ticozzi 1818
S. TICOZZI, *Dizionario dei Pittori*, Milan, 1818.

Toledo 1976
The Toledo Museum of Art. European Paintings, Toledo,
1976.

Tormo 1924
E. TORMO, *España y el arte napolitano*, Madrid, 1924.

Torriti 1963
P. TORRITI, *Il Palazzo Reale di Genova e la sua Galleria*,
Genoa, 1963.

Torriti 1967
P. TORRITI, *La Galleria del Palazzo Durazzo Pallavicini a
Genova*, Genoa, 1967.

Tramoyeres Blasco 1911
L. TRAMOYERES BLASCO, 'Un colegio de pintores en
Valencia', *Archivo de investigationes historicas*, 1911, II,
p. 521 f.

Tufari 1854
R. TUFARI, *La Certosa di S.Martino in Napoli*, Naples,
1854.

Turin 1972
*Dizionario Enciclopedico Bolaffi dei pittori e degli incisori
italiani*, ed. M. Minicuci, Turin, 1972–76.

Turin 1975
Mostra di Fiori e frutta nel XVII, XVIII et XIX secoli,
exhibition catalogue, Galleria Carretto, Turin, 1975.

Tutini 1898, 1899
C. TUTINI, De'Pittori, Scultori, Minitori et Architetti
napoletanie regnicoli' Misc. Brancacciana II, A, 8 to C 91,
Napoli Nobilissima, 1898, VII, p. 121–24; 'Nota seicentesca
al Baldinucci', *Napoli Nobilissima*, 1899, p. 163f.

Tzeutschler Lurie 1969
A. TZEUTSCHLER LURIE, 'Bernardo Cavallino's Adoration
of the Shepherds', *Bulletin of the Cleveland Museum of Art*,
1969, p. 136–50.

Tzeutschler Lurie 1982
A. TZEUTSCHLER LURIE, *European Paintings of the 16th,
17th and 18th Centuries*, The Cleveland Museum of Art
Catalogue of Paintings, Cleveland, 1982.

Tzeutschler Lurie and Mahon 1977
A. TZEUTSCHLER LURIE in collaboration with D.
MAHON, 'Caravaggio's Crucifixion of Saint Andrew from
Valladolid', *The Bulletin of the Cleveland Museum of Art*,
LXIV, 1977, p. 3–24.

Valle 1854
F. R. VALLE, *Descrizione storica, artistica, letteraria della
chiesa, del convento e dei religiosi illustri di San Domenico
Maggiore di Napoli*, Naples, 1854.

Venturi 1910
L. VENTURI, 'Studi su Michelangelo da Caravaggio',
L'Arte, XIII, 1910, p. 191–201, 268–284.

Venturi 1921
A. VENTURI, 'Bernardo Cavallino nella Galleria Nazionale
di Stoccolma e nella raccolta Harrach di Vienna', *L'Arte*,
XXIV, 1921, p. 209–14.

Venturi 1925
A. VENTURI, 'Mattia Preti: Il Cavalier calabrese', *Grandi
Artisti Italiani*, Bologna, 1925.

Villari 1967
R. VILLARI, *La rivolta antispagnola a Napoli. Le origini
(1585–1647)*, Bari, 1967.

Vitzthum 1971
W. VITZTHUM, *Il Barocco a Napoli e nell'Italia
meridionale*, Milan, 1971.

Volpe 1972
C. VOLPE, 'Annotazioni sulla mostra caravaggesca di
Cleveland', *Paragone*, XXIII, 1972, p. 50–76.

Volpe 1974
C. VOLPE, 'I caravaggeschi francesi alla mostra di Roma'
Paragone, XXV, 1974, p. 29–44.

Volpe 1981
C. VOLPE, *Natura morta Italiana*, Milan, 1981.

Volpicella 1846
S. VOLPICELLA, *Principali edifici della città di Napoli*,
Naples, 1846.

Volpicella 1850
S. VOLPICELLA, *Descrizione storica di alcuni dei principali
edifici della città di Napoli*, Naples, 1850.

Voss 1911
H. VOSS, 'Spatitalienische Bilder in der Gemäldesammlung
. . . des Herzoglichen Museum zu Braunschweig',
Münchner Jahrbuch der Bildendes Kunst, 1911, p. 235–55.

Voss 1925
H. VOSS, *Die Malerei des Barock in Rom*, Berlin, 1925.

Voss 1927
H. VOSS, 'Neues zum Schaffen des Giovanni Battista
Caracciolo', *Jahrbuch der Preussicher Kunstsammlungen*,
XLVIII, 1927, p. 131f.

Voss 1957
H. VOSS, 'Die "Mostra del Seicento Europeo" in Rom',
Kunstchronik, 1957, p. 87–93.

Voss 1964
H. VOSS, *Johann Heinrich-Schönfeld, ein schwabischer
Maler des 17. Jahrhunderts*, Biberach, 1964.

Waagen 1854, 1857
G. WAAGEN, *Art Treasures in England*, 3 vols, 1854;
supplement 1857

Wagner 1958
H. WAGNER, *Michelangelo da Caravaggio*, Berne, 1958.

Wallace
R. WALLACE, 'Salvator Rosa's "Democritus" and
"L'Umana Fragilità"', *Art Bulletin.*, L, 1968, p. 21–32.

Washington, New York, Chicago, San Francisco 1949–50
Art Treasures from the Vienna Collections, exhibition
catalogue, Washington etc. 1949–50.

Waterhouse 1960
E. WATERHOUSE, 'A Note on British Collecting of Italian Pictures in the late Seventeenth Century', *Burlington Magazine*, CII, 1960, p. 54–58.

Waterhouse 1962, 1969
E. WATERHOUSE, *Italian Baroque Painting*, London, 1962, 2nd edition 1969.

Wethey 1967
H. WETHEY, 'The Spanish Victory, Luca Giordano, and Andrea Vaccaro', *Burlington Magazine*, CIX, 1967, p. 678–86.

Wiesbaden 1938
Gemäldesammlung H. Schaufelen, Stuttgart-Oberlenningen, Wiesbaden, 1938.

Wild 1966
D. WILD, 'Charles Mellin ou Nicolas Poussin', *Gazette des Beaux Arts*, LXVIII, 1966, p. 177–214.

Wild 1980
D. WILD, *Nicolas Poussin*, 2 vols, Geneva, 1980.

Wittkower 1958
R. WITTKOWER, *Art and Architecture in Italy: 1600 to 1750*, Harmondsworth, 1958.

Woodward 1960
J. WOODWARD, *Paintings in Birmingham Art Gallery*, 1960.

Wright 1972
C. WRIGHT, 'Preti's Martyrdom of St. Bartholomew', *The Currier Gallery of Art Bulletin*, 1972.

Young 1970
E. YOUNG, *Catalogue of Spanish and Italian Paintings*, Bowes Museum, Barnard Castle, 1970.

Zahn 1928
L. ZAHN, *Caravaggio*, Berlin, 1928.

Zampetti 1966
P. ZAMPETTI, *Note sparse sul '600*, Venice, 1966.

Zeri 1959
F. ZERI, *La Galleria Pallavicini*, Florence, 1959.

Zeri 1976
F. ZERI, in *Storia d'Italia*, VI, 1976.

Zurich 1964
Das Italianische Stilleben, exhibition catalogue, Zurich, 1964–65.

Index of Lenders

Also owners who prefer to remain anonymous.

Photographic Acknowledgements

The exhibition organizers would particularly like to thank the Laboratorio Fotografico (Naples), Rizzole Editore (Naples), Gabinetto Nazionale (Rome) and Gabinetto Fotografico degli Uffizi (Florence). The following also kindly made photographs available. All other photographs were provided by the owners of the paintings.

Arte Fotografica Cat. 65, 84
A.C. Cooper Cat. 59, 68, 69
Courtauld Institute of Art Cat. 79, 98
Prudence Cuming Associates Ltd. Cat. 24, 68 (colour), 145
De Vito Collection Cat. 108, 148
Photo-Studios Cat. 137
Pisani Collection Cat. 144, 153

Royal Academy Trust

The Friends of the Royal Academy

PATRON H.R.H. The Duke of Edinburgh, KG, KT

The Friends of the Royal Academy receive the following privileges
FRIENDS £15.50 annually
FRIENDS (Concessionary) £12.50 annually for full-time Museum Staff and Teachers
£10.00 annually for Pensioners and Young Friends under the age
of 25 years
Gain free and immediate admission to all Royal Academy Exhibitions **with a guest** or
husband/wife and children under 16.
Obtain catalogues at a reduced price.
Enjoy the privacy of the Friends' Room in Burlington House.
Receive Private View invitations to various exhibitions including the Summer Exhbition.
Have access to the Library and Archives.
Benefit from other special arrangements, including lectures, concerts and tours.

COUNTRY FRIENDS £10.00 annually for Friends living more than 75 miles from London
Gain free and immediate admission to Royal Academy Exhibitions on 6 occasions
with a guest or husband/wife and children under 16.
Receive all the other privileges offered to Friends.

ARTIST SUBSCRIBERS £25.00 annually
Receive all the privileges offered to Friends.
Receive free submission forms for the Summer Exhibition.
Obtain art materials at a reduced price.

SPONSORS £500 (corporate), £150 (individual) annually
Receive all the privileges offered to Friends.
Enjoy the particular privileges of reserving the Royal Academy's Private Rooms when
appropriate and similarly of arranging evening viewings of certain exhibitions.
Receive acknowledgement through the inclusion of the Sponsor's name on official documents.

BENEFACTORS £5,000 or more
An involvement with the Royal Academy which will be honoured in every way.

Further information and Deed of Covenant forms are available from
The Friends of the Royal Academy, Royal Academy of Arts, Piccadilly, London W1V ODS

Benefactors and Sponsors

BENEFACTORS
Mrs. Hilda Benham
Lady Brinton
Mr. and Mrs. Nigel Broackes
Keith Bromley, Esq.
The John S. Cohen Foundation
The Colby Trust
Michael E. Flintoff, Esq.
The Lady Gibson
Jack Goldhill, Esq.
Mrs. Mary Graves
D. J. Hoare, Esq.
Sir Antony Hornby
George Howard, Esq.
Irene and Hyman Kreitman
The Landmark Trust
Roland Lay, Esq.
The Trustees of the Leach Fourteenth Trust
Hugh Leggatt, Esq.
Mr. and Mrs. M. S. Lipworth
Sir Jack Lyons, CBE

The Manor Charitable Trustees
Lieutenant-Colonel L. S. Michael, OBE
Jan Mitchell, Esq.
The Lord Moyne
Mrs. Sylvia Mulcahy
G. R. Nicholas, Esq.
Lieutenant-Colonel Vincent Paravicini
Mrs. Vincent Paravicini
Richard Park, Esq.
Phillips Fine Art Auctioneers
Mrs. Denese Rapp
Mrs. Adrianne Reed
Mrs. Basil Samuel
Eric Sharp, Esq., CBE
The Revd. Prebendary E. F. Shotter
Dr. Francis Singer
Lady Daphne Straight
Mrs. Pamela Synge
Harry Teacher, Esq.
Henry Vyner Charitable Trust
Charles Wollaston, Esq